ART IN THE HELLENISTIC AGE

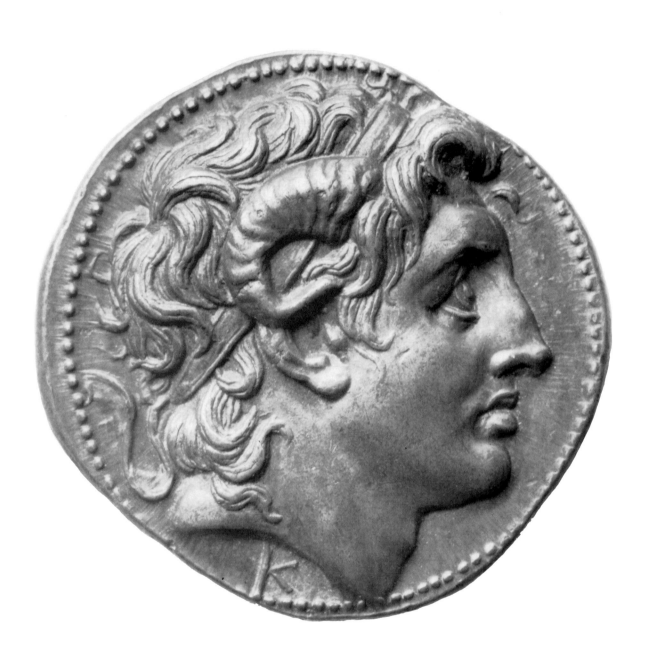

ART IN THE
HELLENISTIC AGE

J. J. POLLITT

Sterling Professor of Classical Archaeology and
History of Art, Yale University

CAMBRIDGE
UNIVERSITY PRESS

PUBLISHED BY THE PRESS SYNDICATE OF THE UNIVERSITY OF CAMBRIDGE
The Pitt Building, Trumpington Street, Cambridge, United Kingdom

CAMBRIDGE UNIVERSITY PRESS
The Edinburgh Building, Cambridge CB2 2RU, UK
32 Avenue of the Americas, New York, NY 10013–2473, USA
477 Williamstown Road, Port Melbourne, VIC 3207, Australia
Ruiz de Alarcón 13, 28014 Madrid, Spain
Dock House, The Waterfront, Cape Town 8001, South Africa

http://www.cambridge.org
Information on this title: www.cambridge.org/9780521276726

First published 1986
Twelfth printing 2006

Printed in the United Kingdom at the University Press, Cambridge

British Library Cataloguing in Publication data
Pollitt, J. J.
Art in the Hellenistic age.
1. Art, Greek – History 2. Art, Roman – History
I. Title
709′.38 N5610

Library of Congress Cataloguing in Publication data
Pollitt, J. J. (Jerome Jordan), 1934–
Art in the Hellenistic age.
Bibliography: p. 293
Includes index.
1. Art, Hellenistic. I. Title.
N5630.P55 1986 709′.38 85–11010

ISBN-13 978-0-521-27672-6 paperback
ISBN-10 0-521-27672-1 paperback

To

S.B.M.

CONTENTS

Frontispiece Silver tetradrachm depicting Alexander · ii
Acknowledgments · viii
Preface · ix
Map 1 · x
Map 2 · xii
Introduction: Hellenistic art and the temperament of the Hellenistic age · 1
Prologue: The phases of Hellenistic art · 17

1 Royal iconography · 19
2 Lysippos and his school · 47
3 Personality and psychology in portraiture · 59
4 The sculpture of Pergamon · 79
5 Hellenistic baroque · 111
6 Rococo, realism, and the exotic · 127
7 Rome as a center of Hellenistic art · 150
8 Style and retrospection: neoclassicism and archaism · 164
9 Pictorial illusion and narration · 185
10 Hellenistic mosaics · 210
11 Hellenistic architecture: theatrical and scholarly forms · 230
12 Alexandria and the Pharaoh · 250

Appendices
I The chronology of Hellenistic sculpture · 265
II The ruler cult and its imagery · 271
III Aspects of royal patronage · 275
IV Bactria and India · 284
V The tomb at Belevi · 289

Abbreviations · 291
Bibliography · 293
Notes · 303
Sources of illustrations · 321
Index · 325

ACKNOWLEDGMENTS

My first and greatest debt of gratitude is to my wife, Susan B. Matheson, who has given me invaluable help with every aspect of this book – intellectual, editorial, and logistical. The dedication of the book to her is inadequate recognition of the extent to which I have drawn upon her time and benefitted from her good judgment.

It is perhaps a truism of academic life that a teacher invariably learns as much from his students as they do from him. Dialogue with students in a series of graduate seminars in Hellenistic art over a number of years has greatly helped to stimulate my thought on many subjects, and I wish to acknowledge my debt to all my present and former students.

Kallimachos's admonition, *mega biblion, mega kakon* (see p. 14), comes to be taken seriously by anyone who works on a long book over a long time. For providing me with a conspicuous example of cheerful perseverance, forbearance, and enthusiasm that repeatedly inspired me to press on in spite of occasional weariness I am grateful to my friend Maximilian d'Orange.

For valuable editorial advice I am grateful to Edward Tripp and Karen Wilson.

Special thanks are due to Linda Merk for her expert conservation work on the Yale Demosthenes [56] and for completing the job in time for me to have new photographs made for this book.

For their generosity in providing me with photographs, I wish to express special thanks to Professor Manolis Andronikos, Dr Yousseff El Gheriany, Professor Günter Grimm, Professor Eugene Vanderpool, and Dr Cornelius C. Vermeule III. The following colleagues have been especially courteous in helping me to obtain illustrations of and information about objects in the collections of their institutions: Sümer Atasoy, Archaeological Museum, Istanbul; Alfred Bernhard-Walcher, Kunsthistorisches Museum, Vienna; Huberta Heres, Staatliche Museen, East Berlin; Mogens Jørgensen, Ny Carlsberg Glyptotek, Copenhagen; and Oscar Thue, National Gallery, Oslo. Thanks are also due to Cornelia Weber-Lehmann, Hans-Ulrich Cain, and Wilfred Geominy of the German Archaeological Institute in Rome, and to Eve Dambra of Yale University. The expertise of Geraldine T. Mancini in the preparation of new prints and negatives has been greatly appreciated.

Finally my thanks to Pauline Hire of Cambridge University Press for her interest in the book, for her sound editorial advice, and for her encouragement when it was most needed.

PREFACE

The chapters of this book have two aims. One is to explore the ways in which Hellenistic art is an expression of the cultural experience and aspirations of the Hellenistic age, to create, in other words, something like a cultural portrait of the period with particular emphasis on art. The other is to present a selective history of the formal development of this art organized around those genres, schools, or styles which seem to me to have been of particular importance. In each chapter I have tried to emphasize what was original, or when not original at least distinctive, about the art of the Hellenistic period, and have hence concentrated on areas where Hellenistic artists went beyond, or modified, or, in the end, revived the achievements of their Archaic and Classical predecessors.

Because a number of important developments in Hellenistic art were closely bound up with prominent political leaders, their policies, the places where their policies were put into effect, and the military consequences of their policies, I have included general historical introductions to two chapters (on Pergamene sculpture and on the rise of Rome as a center of Hellenistic art). Five appendices deal with scholarly and historical problems, literary sources, and some unusual monuments, all of which are alluded to in the preceding chapters but not discussed in detail.

The bibliographical references given in the notes are directed to specific points of interpretation, controversy, or documentation. General bibliography, arranged chapter by chapter and topic by topic, is given at the end of the book. When full citation of a particular work appears in the bibliography, it is often given in shortened form in the notes. Frequently cited works have been given standard abbreviations (see p. 291).

The translations of passages from Classical authors, unless otherwise indicated, are my own.

In the spelling of Greek proper names I have for the most part used the Greek spelling, but I have not hesitated to use Latinized forms when they seemed more natural and familiar.

The time has probably long passed when any serious, informed student of Hellenistic art would refer to it as decadent. Who can deny the power of works like the Nike of Samothrace or the bronze boxer in the Terme, even if they do lack the idealism and restraint of the greatest works of Classical Greek art? The best reason to study Hellenistic art is for its own sake. I would suggest, however, that there is an additional quality that should make the art of the Hellenistic age of particular interest to modern audiences: the fact that in background and content it was the product of an age in many ways similar to our own. Like the art of the twentieth century, but unlike the art of Classical Greece or Pharaonic Egypt, Hellenistic art was not tied to a single country or ethnic group; rather, like Hellenistic culture as a whole, it was both adopted and produced by diverse peoples in widely separated geographical areas. Further, it throve in a world where many of the familiar figures of the modern 'art world' – private patrons, collectors, and even dealers – made their first appearance. The Hellenistic age also seems to have been the first epoch in western art in which an intense sense of 'art history' influenced art itself. Systematic histories of art were first written during the period; artists revived the styles of earlier centuries; sculptors' workshops began to specialize in the reproduction of 'old masters;' different styles came into simultaneous use. The result of these historical conditions was an art which, like much modern art, was heterogeneous, often cosmopolitan, increasingly individualistic, and frequently elitist in its appeal. The question of whether or not there is a message in this, i.e. that certain types of cultures inevitably produce an art with certain characteristics, is one which I leave the reader to contemplate.

J.J.P.

New Haven
1984

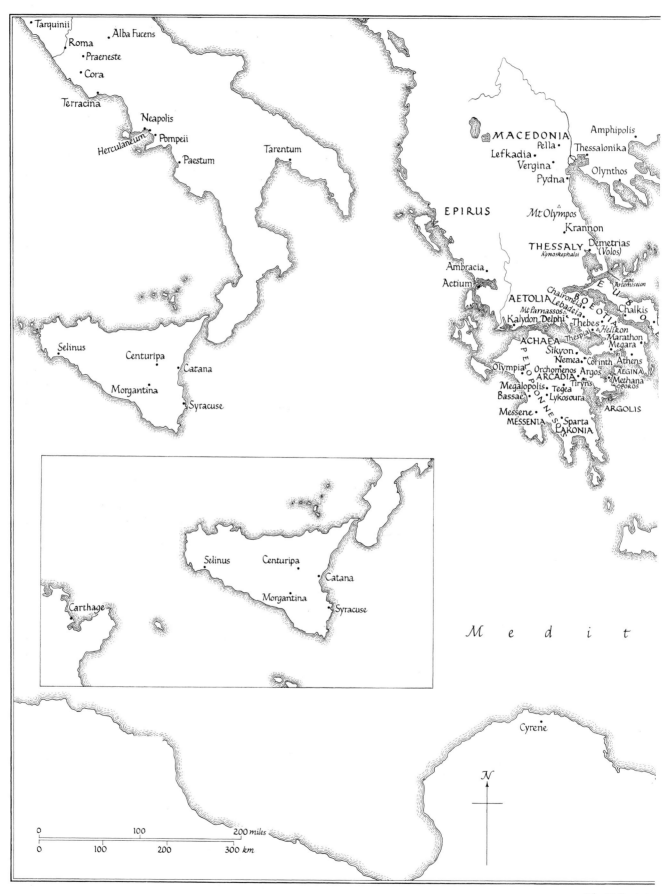

• Tarquinii

Roma • Alba Fucens
• Praeneste
• Cora

Terracina

Neapolis
Herculaneum • Pompeii
Paestum

Tarentum

Selinus
Centuripa
Morgantina
• Catana
Syracuse

MACEDONIA

Amphipolis
Pella •
Lefkadia • Thessalonika
Vergina •
Pydna • Olynthos

Mt Olympos

EPIRUS Krannon

THESSALY Demetrias
Kynoskephaloi (Volos)

Ambracia •
Cape
Actium • Artemision

Chaironeia
AETOLIA Lebadeia BOEOTIA Chalkis
Mt Parnassos
Kalydon Delphi Thespiai Thebes Helikon
Marathon
ACHAEA Megara
Sikyon Nemea • Corinth Athens
Olympia • Orchomenos Argos AEGINA
ARCADIA Tiryns Methana
Megalopolis Tegea POROS
Bassae • Lykosoura
Messene • Sparta
MESSENIA LAKONIA ARGOLIS

M e d i t

Selinus Centuripa
Catana
Morgantina
Syracuse

Carthage •

Cyrene

N

0 100 200 miles
0 100 200 300 km

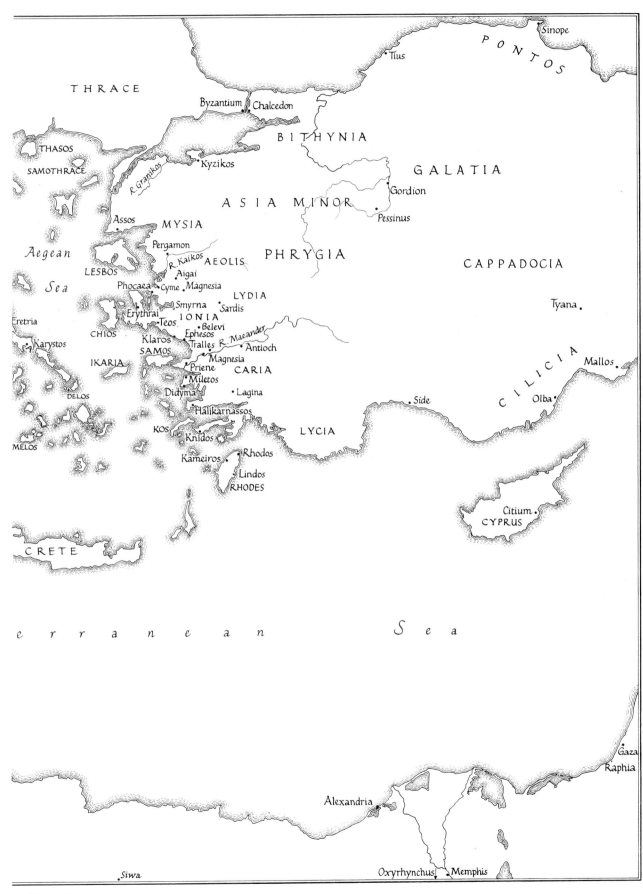

world (west)

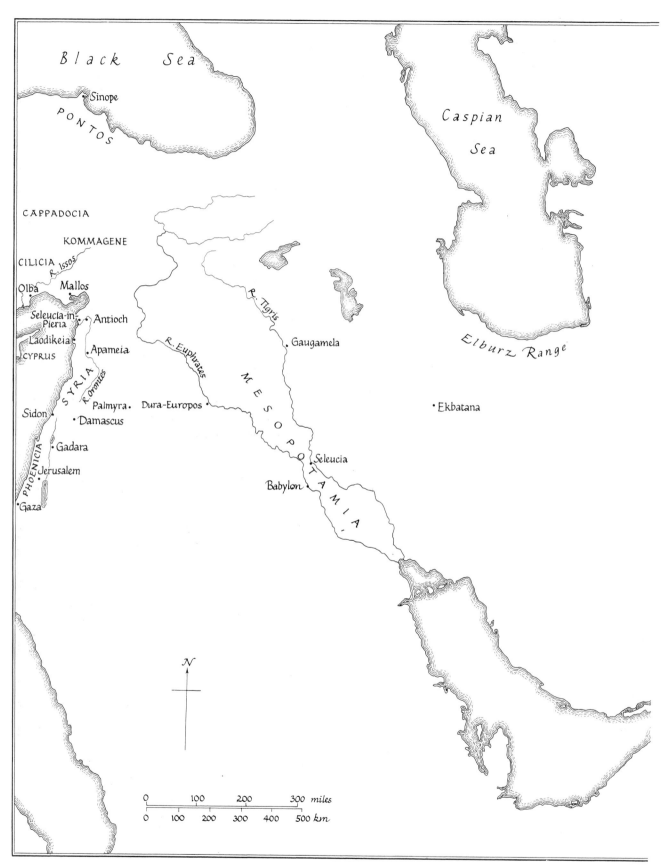

Black Sea

PONTOS

•Sinope

Caspian Sea

CAPPADOCIA

KOMMAGENE

CILICIA

R. Issos

Olba• •Mallos

Seleucia-in-
Pieria •Antioch

Laodikeia• •Apameia

CYPRUS

SYRIA

R. Oronies

Palmyra•

Sidon• •Damascus

•Gadara

•Jerusalem

PHOENICIA

•Gaza

R. Euphrates

MESOPOTAMIA

R. Tigris

•Gaugamela

Dura-Europos•

Seleucia

Babylon•

Elburz Range

•Ekbatana

N

| 0 | 100 | 200 | 300 miles |
| 0 | 100 | 200 | 300 | 400 | 500 km |

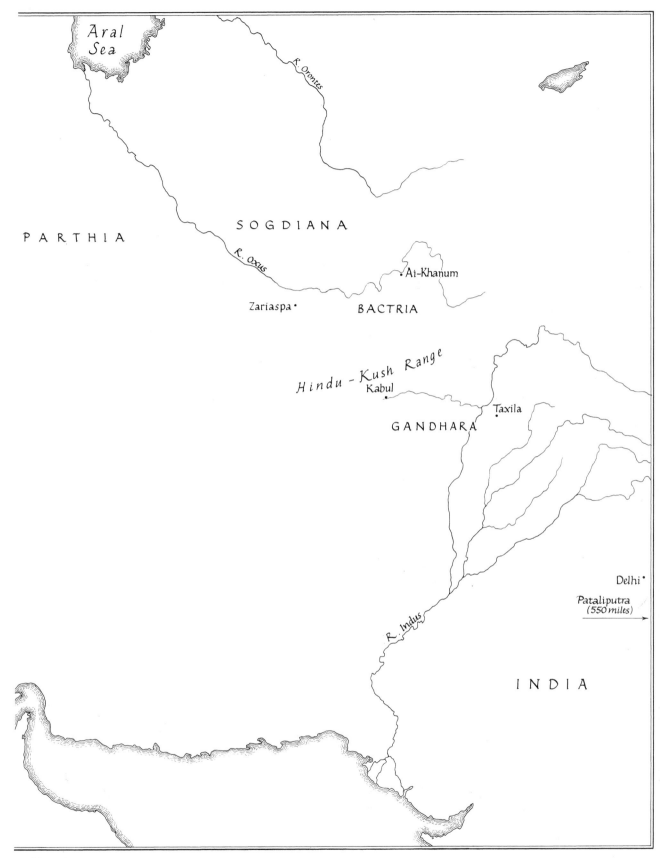

Aral
Sea

R. Orontes

PARTHIA

SOGDIANA

R. Oxus

•Ai-Khanum

Zariaspa•

BACTRIA

Hindu – Kush Range

Kabul
•

Taxila
•

GANDHARA

R. Indus

Delhi •

Pataliputra
(550 miles)
⟶

INDIA

world (east)

Introduction:
Hellenistic art and the temperament
of the Hellenistic age

The Greeks and Macedonians who shaped Hellenistic culture played out their lives in a world which was much vaster than the one that most of their ancestors had known. Most Greeks of the Classical period developed their view of life within the confines of a single, small city-state. This had been an intensely group-oriented experience, one in which an individual's ideals, aspirations, and prejudices were normally so thoroughly merged with those of the community that the possibility of leaving that community permanently in order to live a more idiosyncratic or exotic life in another country was seldom considered, except under duress. A Classical Greek might voluntarily wander away for adventure, but once that adventure was experienced he was intent on coming home to the small, familiar, and reassuring society where his identity was established.[1]

The conquests of Alexander and the founding of the Hellenistic kingdoms set off a series of migrations and political realignments that broke open the relatively sealed world of the Classical *polis*. Thousands of Greeks flocked to the new cities, great and small, of the Hellenistic East to seek their fortunes. In these new communities there must inevitably have been a certain feeling of strangeness and rootlessness that provoked anxiety. One did not always know, for example, who one's fellow citizens were or what to expect from them, since many of them were migrants from unfamiliar cities and even, in some cases, unfamiliar cultures. Nor could one be certain what one's role in the community would turn out to be. There was always the thought that one might experience a spectacular turn of fortune. With a little luck one might become a royal favorite and see a door open to immense wealth and power; but there was also always the possibility that one's city might be overrun by some other king's army of Greek mercenaries or foreigners and that one would be completely destitute or even sold into slavery. Kings, the ultimate source of authority even in cities which were self-governing in their day-to-day affairs, were also a source of anxiety because for most people they were remote and uncontrollable. Royal patronage, as the age of the Diadochoi, the Successors of

Alexander, proved, was transient and unpredictable. In the space of just a few years, for example, one's dependence on Lysimachos could shift to Seleukos, and then to Ptolemy Keraunos.

Even in old Greece, where the city-states had firmer foundations, horizons expanded in the Hellenistic age, and the world became less stable. Cities that once treasured a querulous independence now united into federal leagues. Bastions of social rigidity, like Sparta, were swept by social revolution. Areas that had seemed almost primitive, like Aetolia, became powers to be reckoned with. And even cities that held on to a semblance of their ancient autonomy and importance, like Athens, had to wend their way cautiously through the power struggles of kings and larger states.

Some people no doubt felt excited and challenged by the opportunities and tumult of the Hellenistic age, but many others, as the preoccupations of Hellenistic philosophy make clear, felt acutely insecure when they contemplated the unstable and unpredictable nature of the times. But whether one embraced or shrank from the social and political changes of the Hellenistic world, they compelled those who experienced them to adopt attitudes toward life that were markedly different from the group-oriented values of the Classical period. These new attitudes color Hellenistic literature and philosophy in many obvious ways, and in the following chapters it will be suggested that they also color, even if it is in a less obvious and explicit way, its art. Five attitudes, or states of mind, are particularly characteristic of the Hellenistic age: an *obsession with fortune*, a *theatrical mentality*, a *scholarly mentality*, *individualism*, and a *cosmopolitan outlook*. For the sake of clarity, each of these will be discussed separately, but it will become obvious that they are all interdependent and together constitute something like a Hellenistic *Zeitgeist*.

An obsession with fortune

After describing the defeat of King Perseus and the collapse of the kingdom of Macedonia (see p. 151),

Polybios pauses in his narrative to meditate on the meaning of the events that he has just described. As he does so, he calls to mind a treatise on Fortune, *Tyche*,[2] written by one of the chief intellectuals of the Hellenistic age, Demetrios of Phaleron. 'In his treatise on Fortune,' Polybios observes, 'wishing to provide men with a vivid reminder of her mutability, he fixed upon the time when Alexander destroyed the Persian Empire and made the following observations:

'For if you take into account not an endless expanse of time nor even many generations, but rather only the last fifty years, you should be able to understand from them the harshness of Fortune. For do you think that the Persians, or the King of the Persians, or the Macedonians, or the King of the Macedonians, even if one of the gods had prophesied the future for them, would ever have believed that the very name of the Persians would have vanished utterly – they who were the masters of the whole world – and that the Macedonians, whose name was scarcely known earlier, would now rule over all? But since this is the case, it seems to me now that Tyche, who makes no treaties with this human life of ours, who devises all sorts of new twists to confound our calculations, and who shows her power in completely unexpected ways, is demonstrating to all men, by settling on the Macedonians the prosperity that had once belonged to the Persians, that she has merely lent them these blessings until such time as she decides to do something else with them.' (Polybios 29.21.3–6)

After quoting Demetrios, Polybios then turns his attention to King Eumenes of Pergamon, who, after years of political success, was about to lose favor with the Romans and to see his kingdom invaded by yet another tribe of Gauls, and adds: 'For Fortune is quite capable of wiping out reasonable expectations with unforeseeable turns of events, and if she gives aid to anyone and tips her balance in his favor, she will eventually, as if she regretted the help, tip the scale against him and instantly ruin his successes' (29.22.2–3).

What Demetrios, the Peripatetic philosopher, expressed in the context of history and philosophy, his friend the playwright Menander, who often presented Peripatetic ideas in a popular form in his plays, expressed time and again in a general way:

Fortune observes no rules by which she decides human affairs. Nor is it possible, while still alive, to say, 'I will not suffer this fate.' (fragment 355 K)

Menander's lines could serve as something like a motto for Hellenistic society. Every individual and every social group no doubt feels anxiety at one time or another when faced with the uncertainties of life, but social conditions in the Hellenistic age seem to have made this anxiety so intense that its personified source, Fortune, became an obsession. Tyche became a virtual goddess, the deity whom most men feared, because she seemed to be not only unpredictable but usually, in the long run, malign. Men like Perseus were seen to rise to exalted positions only to end up in humiliating captivity. Whole countries,

like Epirus under Pyrrhos, were seen to flourish in one century only to be devastated by the Romans in the next.

Various opinions existed about just what the nature of Tyche was. Some saw her as pure chance, but others, perhaps most others, felt that there was a design, however inscrutable, in her workings and that she was, in effect, not just Fortune but also Fate. On a philosophical level only the Epicureans seem really to have believed that existence involved simply a series of random happenings. The Stoics were probably closer to expressing what most men felt when they described the universe as an unalterable process guided by something like a cosmic mind. But whether they believed in random fortune or inscrutable fate, men devoted a good deal of thought to ways in which the potential inflictions of Tyche might be coped with or, if one believed it possible, controlled. Hellenistic philosophers sought to arrive at invulnerability through the cultivation of detachment; the devotees of Hellenistic mystery religions took refuge in deities who, they felt, had the power to take them beyond the confines of fate; and other people looked to magical charms and images to protect them and bring them good luck.

One very important corollary of the concept of predetermined fortune or fate was the belief that particular individuals and communities had their own particular destiny within the grand scheme of things. A man had his own individual *tyche* and so did the city in which he lived. This belief in turn led to the conviction that, while most men's fortunes were mixed and disquieting, there were a few instances in which a particular person's fortune was so favorable that he was virtually irresistible. The fortune of such an individual became almost indistinguishable from his personal nature, his *daimon* or 'spirit' as the Greeks called it. A particularly powerful *daimon* was nearly equivalent to Tyche herself, and the wisest thing for an ordinary man to do was to defer to such personalities and try to absorb some of their beneficent influence. Hence for centuries one swore by the *tyche* of Alexander the Great. Other kings too could be felt, or hoped, to have powerful, favorable fortunes, and since most men's fortunes were bound up with those of a king, the royal *tyche* was taken seriously. Clear evidence of this is the fact that official oaths were frequently solemnized by invoking the fortunes of rulers like Ptolemy Soter.[3]

The influence of this preoccupation with Fortune on Hellenistic art is detectable in a number of forms. The most obvious is the popularity of images of Tyche. A few sculptured figures of Tyche personified are known to have existed in earlier periods, and there is some indication that they may have begun to become increasingly popular in the fourth century B.C., which often anticipated major developments of the Hellenistic period. Praxiteles, for example, made a statue of Tyche for a temple in Megara (Pausanias 1.43.6) and also a figure of

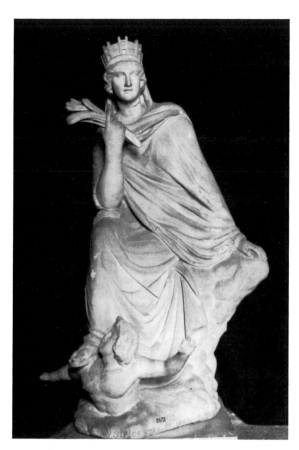

1 Tyche of Antioch. Roman copy. Marble. 300 B.C. Rome, Vatican Museums. H. 0.895 m.

Agathe Tyche, 'Good Fortune,' which once stood in Athens and was later taken to Rome (Aelian, *Var. Hist.* 9.39; Pliny, *NH* 36.23).[4] It was in one of the first great public sculptures of the Hellenistic period, however, the Tyche of Antioch by Eutychides [1], that a standard format for images of Tyche was arrived at. The personification of cities and countries as females wearing 'city wall' crowns was a type already established for use on coinage in the fourth century B.C.[5] In his image of Tyche, which is known from a variety of copies dating from the Roman period and from representations on coins, Eutychides extended the expressive potential of this earlier type by adding new attributes to it and by using the many-sided composition which was characteristic of the Lysippan school (a composition which in this case was perhaps thought to suggest the complexity and variability of Fortune) for its overall design (see p. 55). In time a version of Eutychides' creation seems to have graced most Hellenistic cities, even remote border towns like Dura-Europos. It is important to emphasize that while these Tyche figures had an allegorical content that was typical of their age, and that while they probably

served the same function that flags and state seals do in our own time, they were not simply symbols. In most cities Tyche was the recipient of a cult, and the fortune of a city was understood as something very real, even if unknown. People's prosperity, their hopes, their very lives were seen to depend on it. In fact, far from being purely learned creations, figures of Tyche may have taken on a kind of magical quality, like good luck charms. In propitiating and glorifying the image in which one's future was hidden, there was always the possibility that one might actually be able to charm a benign fortune out of it. Perhaps it was an attitude of this sort that inspired the creation of miniature figures of Tyche in the form of statuettes, gems, and even glass bottles.[6] They were probably both amuletic and apotropaic, images both of hope and anxiety.

Another way in which this preoccupation with fortune was expressed in Hellenistic art was in the continuing popularity of images of Alexander the Great (see pp. 20–31). The attraction which Alexander's image had in later times clearly sprang from something more than simply a nostalgic sense of history. Alexander had always seemed to be favored by good fortune, and there was a belief, best expressed in Plutarch's essay *On the Fortune versus the Virtue of Alexander the Great*, that when ill fortune menaced him, he was able to master it and turn adversity into success. Almost everyone aspired to have a fortune like Alexander's. Athenaios records that a flatterer, in trying to win the favor of the Macedonian King Antigonos Doson, sought to please the king by assuring him that the royal fortune was clearly 'Alexandrized' (251D). Aristotle may have been taking the high philosophical road when he advised Apelles to paint the deeds of Alexander 'because of their undying quality' (*propter aeternitatem rerum*; Pliny, *NH* 35.106), but for most people, royal as well as humble, images of Alexander seem to have been treasured in the hope that some of his good fortune would 'rub off' on them.

Still another, and quite different, element in Hellenistic art that might have been stimulated by the period's preoccupation with fortune is an interest in depicting dramatic reversals of fortune. Scenes of dramatic crisis abound in Hellenistic art and, as I shall suggest, were influenced by other concerns besides this preoccupation with fortune. There are a number of works, however, in which a sudden reversal of fortune, and the pathos that accompanied it, seems to have been the artist's central theme and primary focus. One renowned example is the Alexander Mosaic from the House of the Faun at Pompeii [2]. It is a curious fact that, although the mosaic (and the painting on which it was based) ostensibly celebrated one of the great victories of Alexander (see p. 46), its dominant figure, both from the standpoint of composition and dramatic interest, is not Alexander but rather the Persian ruler Darius. It is the harried figure of

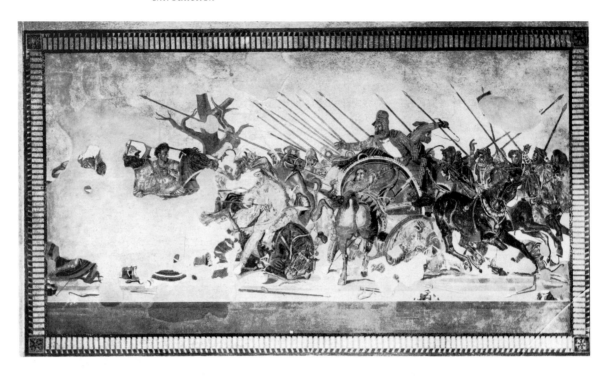

2 Alexander Mosaic. 2nd century B.C. Naples, Archaeological Museum. H. 3.42 m.

the Great King, torn between the need to save himself on the one hand and compassion for his fallen comrades on the other, which most stirred the imagination of the artist who created the picture. Perhaps this was because it was Darius whose fortune had reached a crisis and a point of incipient collapse, while Alexander's irresistible *daimon* pressed steadily onward. Whatever the magical appeal of Alexander's image, it was Darius's that struck a note of anxiety in the minds of most viewers and provoked both sympathy and understanding.

Less grandiose in its subject matter but even more explicit in its depiction of a sudden and devastating turnabout of fortune is the painted grave stele of Hediste from Demetrias-Pagasai (modern Volos; see p. 194) [3]. Hediste, whose grave the stele marked, died in childbirth, as did her infant. The painted scene on the stele shows the immediate aftermath of this tragedy. Hediste's pain-wracked body still lies on the bed and is contemplated by her grief-stricken husband. In the background of the bed-chamber an old woman holds the body of the dead child. It is not just the sadness of the death but its suddenness that interested the painter of the stele, and the poignant epitaph carved at its base leaves no doubt that it was Tyche who was seen as the author of this suddenness:

> A painful thread for Hediste did the Fates weave from their spindles when, as a young wife, she came to the throes of childbirth.
> Ah wretched one! For it was not fated that she should

cradle the infant in her arms, nor moisten the lips of her new-born child at her breast.
One light looks upon both and Fortune has brought both to a single tomb, making no distinction when she came upon them.

The theatrical mentality

The theater in all ages has always served to provide a reflection of, or analogue of, life, but in the Hellenistic period one gets the impression that life was sometimes seen as a reflection of the theater.

A comparison of 'New Comedy,' the characteristic product of the Hellenistic theater developed by the Athenian playwright Menander (*ca.* 342–289 B.C.) and by others whose work has not survived, with the 'Old Comedy' of Classical Athens is instructive. The plays of Aristophanes were quasi-religious choral rites in which the role of the audience was more that of a participant than a witness. They dealt with contemporary public issues – war, peace, social change, women's rights, new intellectual trends – that were of immediate and vital concern to the community as a whole, and they abounded in 'inside jokes' that only members of the community could understand. In order fully to appreciate the comedies of Aristophanes one had to be a citizen of the Athenian *polis*. By contrast, the 'comedies' of Menander are highly generalized melodramas dealing with situa-

4

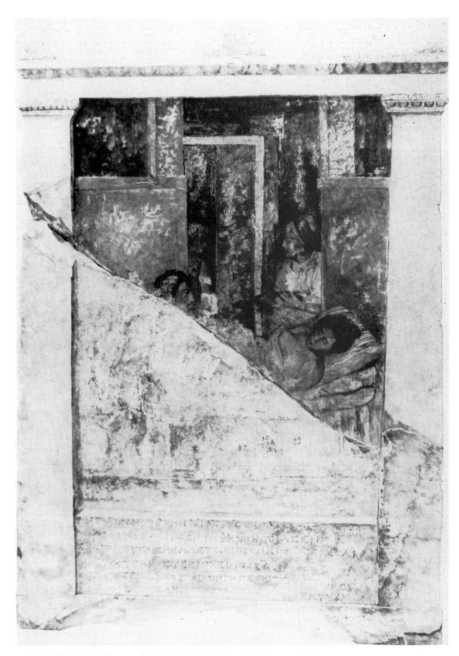

3 Stele of Hediste. *Ca.* 200 B.C. Volos, Archaeological Museum. H. 0.73 m.

tions and emotions which are personal and universal (in the sense that little or no cultural conditioning is required in order to understand them) rather than communal. Stock themes such as misunderstandings in love, the discovery of long lost children, and cases of mistaken identity provided the plots for New Comedy, and common human types – querulous fathers, aggressive sons, shy daughters, scheming servants, braggarts – served as its characters. Further, like much of the population of the Hellenistic world, these characters are often represented as being in transit, about to depart for another city on business or for mercenary military service. The substance of New Comedy, in short, reflected experience that was as familiar at Alexandria or Antioch, or anywhere that urban life existed, as it was in Athens.

Menander was admired in Antiquity as an extremely realistic playwright.[7] This judgment may at first seem surprising because, while the types of characters that he portrayed undoubtedly seemed familiar and 'real' in their time, the complicated plots of his plays, with their extra-

5

ordinary coincidences, could not have been a matter of everyday experience for most people. It was probably not in the details of his plots, however, but rather in his depiction of the force which seemed to create and resolve human problems, Tyche, that he seemed realistic. Time and again the characters of Menander propound the view that Fortune, either in the form of chance or an inscrutable fate, rather than human will and reason dictates the events of life. Even though many of Menander's lines about Tyche occur in fragments for which a context is lacking, the sheer number of them makes it reasonably certain that they present, if not his own view of the world, at least a common view of his time.

In the plays of Menander many characters see life as a kind of performance put on by Fortune, a spectacle over which they have no control and which they can hence view with a certain distance and objectivity. Now since Menander's depiction of life was generally felt to be highly realistic, one is drawn to conclude that many people in the Hellenistic age thought of their own lives as roles in a great 'fortune play' and adjusted their outlook accordingly. That is to say, they thought of themselves at times as actors who were playing a part and at times as members of an audience who expected to be entertained with remarkable, wondrous, novel events.

It is undoubtedly both significant and symptomatic that the man who was probably the most influential popular philosopher of the Hellenistic age, Bion of Borysthenes, chose to illustrate his version of the doctrine that peace of mind was to be found in detachment with images of the playwright and the actor. One did not have to reject the world in order to be detached from it, Bion argued; one simply played one's assigned part. Bion's image is epitomized vividly in one of the brief sermons of the Cynic Teles:

Fortune is like a playwright who designs a number of parts – the shipwrecked man, the poor man, the exile, the king, the beggar. What the good man has to do is to play well any part which Fortune assigns to him. You have been shipwrecked. Very well, give a fine rendering of the part of the shipwrecked man. You were rich and have become poor. Play the part of the 'Poor Man' as it ought to be played. (ed. Hense, p. 40. lines 1–6)

To live the life of a detached actor in the sense that Bion and Teles meant it required an intellectual self-control and depth of philosophical conviction that were beyond the capability of the average person. On a more popular level the theatrical mentality of the Hellenistic period expressed itself not so much through the outlook of an actor as through the attitude of a spectator, with its expectation of being dazzled by a good show. Many of the political leaders of the period grasped this fact and learned how to manipulate the theatrical mentality to their own advantage with the sort of festivals, parades, and displays that are recorded in literary descriptions of public events in Alexandria and Antioch (see pp. 280–3).

Some political leaders, however, did not need festivals and parades to appeal to the theatrical mentality of the age. They made their very lives a dramatic performance. Perhaps the most theatrical of all such leaders was King Demetrios Poliorcetes of Macedonia. Plutarch clearly felt this to be the case. Theatrical images and phrases recur with the regularity of a *leitmotiv* in his skillfully composed *Life of Demetrios*. It was an appropriate way to deal with the life of Demetrios, since Demetrios himself had used theaters and theatrical costumes to influence his friends and his enemies. When, for example, his army forced its way into Athens in 297 B.C., after the city which had once adored him had subsequently shut its gates to him, the following scene, as recorded by Plutarch, occurred:

. . . Demetrios, upon coming into the city and ordering all the Athenians to assemble in the theater, packed the stage building with a guard of armed men and surrounded the stage with spear-bearers; then he himself came down onto the stage from one of the upper passageways, just as tragic actors do. All this made the Athenians even more terrified. But with the beginning of his speech he put their fears to rest, for he avoided sharpness in his tone of voice and in his choice of words, and he effected a reconciliation with them while chiding them softly, in a friendly spirit . . . (*Demetrios* 34.3–4)

Later, in 289 B.C., when Demetrios had established himself as king of Macedonia and had come into conflict with Pyrrhos of Epirus, Plutarch relates that some of the Macedonian soldiers, who had grown weary of the king's flamboyance, were thinking of defecting to Pyrrhos. To these soldiers Pyrrhos, because of his heroic personality, was a true successor of Alexander the Great, 'whereas others,' Plutarch observes, 'and especially Demetrios, would simply impersonate Alexander's gravity and dignity, as if they were on stage.'

And, to tell the truth, there was a good deal of the tragic actor in Demetrios. Not only did he extravagantly crown himself with double-mitred hats and wrap himself in purple robes with hems of gold but he also adorned his feet with gold-embroidered shoes of the purest purple felt. Further, there was a certain cloak which was woven for him over a long period, a remarkable work, showing images of the cosmos and of the celestial bodies in the sky. This was left half-finished when Demetrios met with reversals in his affairs . . . (*Demetrios* 41.3–5)

When the defection from Demetrios to Pyrrhos began to reach disastrous proportions, a delegation of his soldiers came to him and urged him to flee before it was too late.

And so, going to his tent, and behaving not as a king but as an actor, he put on a gray cloak in place of that usual theatrical costume, and stole away unnoticed. (*Demetrios* 44.6)

Even in death, with the help of his son Antigonos Gonatas, Demetrios managed to put on a good performance. After he had drunk himself to death in refined captivity, Seleukos, his captor, agreed to send his body back to Macedonia for burial. Plutarch finishes the story:

There was, moreover, a certain dramatic and theatrical quality even about his funeral. For when Antigonos learned that the remains were being sent home, he put out with all his ships and met them in the islands. After receiving the remains, which were in a golden urn, he put them on the largest of his flagships. Of the cities at which the fleet put in to shore, some decorated the urn with garlands and others sent men in mourning costume to escort the urn and assist in the burial. When the fleet sailed in to Corinth the urn was displayed in a prominent position on the stern of the ship draped in royal purple and decorated with a royal diadem. Seated near the urn was the most noteworthy flute player of the time, Xenophantos, who played a sacred melody. To this melody the beat of the oars kept time, like a lament, following the cadences of the sound of the flute. (*Demetrios* 53.1–3)

Why was theatrical display so prominent and seemingly so necessary in the life of Demetrios? Plutarch's insight probably provides the right answer:

In the case of no other king does Fortune seem to have taken such great and sudden turns, nor in the careers of others was she ever at one time so small, at another so great, passing from splendor to humiliation, and again from lowliness to great power. (*Demetrios* 35.2)

In this intellectual climate, and with patrons like Demetrios, the Hellenistic artist became a kind of playwright, actor, and stage director in one. He was obliged to put on a good show. The artist who first sensed this keenly was the sculptor Lysippos, the prescient genius of the Hellenistic age. Along with his pupils he developed and added to the Greek artistic tradition several new genres, each of which took into account the theatrical mentality – dramatic portraiture, expressing an inner drama of the spirit, as in his famous portraits of Alexander; large historical groups capturing the fortune and trials of heroes in moments of crisis, as in his Granikos Monument; and works which were designed to dazzle viewers through their sheer technical virtuosity, particularly colossal statues (see Chaps. 1 and 2).

A certain theatrical sense, most evident in a fondness for dramatic settings and for surprising, mysterious inner spaces, was also a distinctive feature of Hellenistic architecture (see Chap. 11), but it was in the sculptural style known as 'Hellenistic baroque' (see Chaps. 4 and 5) that the theatrical mentality of the age left what is probably its most familiar legacy. The typical features of this style – exaggeratedly massive, tension-filled bodily forms and pathetic facial expressions that seem to echo the masks of tragic drama – were used to convey a sense of dramatic crisis in such diverse monuments as portraits [122 and 123]; architectural sculpture with traditional subject matter, like the Gigantomachy on the great Altar of Zeus at Pergamon [99–109]; and propagandistic commemorative monuments, like the victory monuments of the Attalids [85–94].

In a more literal way, the theatrical mentality can also be said to account for the popularity and omnipresence of theatrical imagery in the decorative arts of the Hellenistic period, particularly in domestic mosaics where masks, actors, and theatrical scenes were often the principal motifs (see Chap. 10). Actors, it might be noted, were mostly professionals in the Hellenistic period. In Athens, the Peloponnesos, and Asia Minor they were organized into influential guilds which were so powerful that they could wring concessions from governments (such as exemption from military service and taxation). There is evidence that these guilds were patrons of the visual arts,[8] and their influence probably played a role in making images of the theater, as well as its spirit, popular.

Individualism

As life in the Hellenistic age became less intensely identified with, and less controlled by, small ancestral communities, men and women began to look elsewhere for a sense of belonging and for standards by which to guide their lives. Their search went in two distinct directions: one inward, into the private recesses of the human mind and personality, and the other outward, into what came to be called the *oikoumene*, all the regions of the world inhabited by human beings. Of these two directions the turn inward was probably the more intense and fundamental. In the Hellenistic world no standard of society, even of a utopian society, was more important than what the individual did, thought, and experienced.

The atmosphere of Hellenistic individualism was most vividly embodied by the Cynic philosophers who, following the model of their founder, Diogenes of Sinope (*ca.* 400–325 B.C.), 'dropped out' of society and took up the life of mendicant wanderers. Their goal was to achieve *autarkeia*, 'self-sufficiency,' through a life of austerity and self-discipline, and to do this they not only rejected but openly ridiculed the values that were prized by most members of society.

Although the renunciation and austerity of true Cynics like Diogenes and his disciple Krates of Thebes were too extreme to serve as models for the average person in the Hellenistic age, their individualistic outlook and spirit came to permeate many aspects of Hellenistic life and thought. The Cynic advocacy of the virtues of mendicancy and rootlessness, for example, may have had a reassuring effect on the minds of those who did not think of themselves as philosophers but found their lives in continual flux. The most conspicuous and familiar exemplars of this type of life in the Hellenistic world were mercenary soldiers, who moved from commander to commander and from country to country in search of fortune and adventure. Such mercenaries became so familiar in the Hellenistic age that even in a relatively conservative place like Athens they could be caricatured. Comic poets like Menander were able to forge a stock character out of boisterous and socially disruptive pro-

fessional soldiers who passed through the city.⁹ Wandering mercenaries were in a way political and military analogues of the Cynic philosopher, and they cultivated their own variety of *autarkeia*. Even the kings whom such soldiers served were at times forced to fall back on something like Cynic self-sufficiency. Several of the Diadochoi, Demetrios Poliorcetes, Antigonos Gonatas, and Seleukos, for example, were at one time wandering adventurers who followed their individual standards of conduct and in the end created their own homelands and societies.

Although the Cynics were the most outspoken, flamboyant, and notorious spokesmen for Hellenistic individualism, their commitment to it was no more intense than that of another prominent group of Hellenistic philosophers, the Epicureans. Epicureanism, in that it elaborated theories of cosmology and epistemology, was a more formally complete philosophy than Cynicism, but it was, like Cynicism, above all a philosophy of behavior designed to meet the problems and crises of daily living.

The goal of life, Epicurus (341–270 B.C.) maintained, is personal happiness, and personal happiness is a result of the cultivation of *hedone*, 'pleasure.' In spite of the fundamental importance that Epicurus assigned to pleasure, however, the type of life that he prescribed was more ascetic than hedonistic. True pleasure meant, he argued, the absence of pain, or at least the minimizing of pain. Hence, in order to experience personal happiness one should live one's life in such a way that one experienced only those pleasures that do not bring pain in their wake. Pain comes from unsatisfied desires. Hence, one should avoid those pleasures that are not easily satisfied – e.g. the pleasure that comes from political power or great wealth – and cultivate only those that are easily fulfilled, natural, and necessary – e.g. simple food, friendship, a quiet home. In this way one could find *ataraxia*, 'imperturbability,' the Epicureans' version of the Cynic's *autarkeia*, and be insulated as much as possible against the uncertainties of life.

The Epicureans maintained that the universe was a temporary, random aggregation of atoms, and that there existed in it no cosmic god, no soul, and no life after death. This may have been satisfying to tough-minded philosophers bent on attaining *ataraxia*, but it gave little consolation to the average person, who found it difficult to shed the hope that his individual self might amount to something more than a meaningless, mechanical accident. People who felt this way had yet another vision of the cosmos in which they could take refuge when confronted by the vicissitudes of Tyche, the vision contained in the mystery religions of the Hellenistic age.

Mystery religions were not new in Greece in the Hellenistic age, but their great expansion and diversification during the period is closely connected with both its individualism and its cosmopolitanism. The essential feature of mystery religions, and the basis of their appeal, was that, as a result of a secret initiation ceremony administered by the priesthood of a particular deity, an individual initiate came under the protection of that deity both in this world and in a life to come. These cults offered their devotees, in other words, personal salvation.

Although most of the early mystery cults of Greece had been connected with a particular city and were normally reserved for the citizens of that city (like the Athenian cult at Eleusis¹⁰), the mystery cults of the Hellenistic period that originated in Egypt and the East – Serapis, Isis, Atargatis (= Dea Syria), Cybele (= Magna Mater), and others – were international in character. As their votaries migrated from place to place, they spread to Italy, Greece, and other hellenized regions of the Mediterranean, and men and women with diverse backgrounds were initiated into them. The same was true of at least one of the native Greek cults, the mysteries of Dionysos.

To assess the appeal of a mystery cult to its devotees, we are compelled to turn to literary sources about the cult of Isis that date from the Roman period. These cannot be proved to represent thoughts that were current in the Hellenistic period, but it is extremely likely, given the conservatism and continuity of cults in the Graeco-Roman period, that they do. There are two principal sources which document the atmosphere of the cult of the Egyptian gods: a group of inscriptions recording hymns recited in praise of Isis, and the description of the initiation of Lucius contained in Book XI of the *Metamorphoses* (the proper name of the work often popularly called 'The Golden Ass') of Apuleius (written *ca.* 150–80 A.C.). The hymns in question are in the form of aretalogies, recitations in the first person, of the powers and qualities of the goddess. In their present form they date from the first or second centuries A.C., but the original text of which they seem to be variants was probably Hellenistic. In the following lines, excerpted from one version of the hymn found at Cyme in Asia Minor, it becomes clear how expressly and precisely the virtues of Isis were geared to the temperament and the anxieties of the Hellenistic age:

> I am Isis, the Ruler of every land . . .
> I established laws for men, and ordained statutes that
> no one is able to change . . .
> I separated the earth from the heaven,
> I showed the path of the stars.
> I ordered the course of the sun and the moon . . .
> I revealed mysteries unto men . . .
> I assigned to Greeks and non-Greeks their
> languages . . .
> I established punishments for those who commit unjust
> acts.
> I decreed mercy to suppliants . . .
> With me justice prevails . . .

I am in the rays of the sun.
I attend to the course of the sun.
Whatever I conceive of, this too shall be accomplished.
With me everything is reasonable.
I set free those in bonds . . .
I conquer Fate.
Fate harkens to me.[11]

Isis, in short, protected men from the great nemesis of the Hellenistic world, Tyche. She ordered the cosmos and gave it reason. She protected men from fortune both in the form of random, inscrutable disaster and in the form of irrevocable fate.

Many of the phenomena from which the Hellenistic mystery religions offered salvation were basic tenets of Greek philosophy (the Epicureans preached the randomness of nature, the Stoics pre-ordination), and it would thus be surprising to find the mystical spirit of these cults penetrating into Hellenistic philosophy. Yet, whatever its sources, the spirit is unexpectedly there. The most renowned expression of it is in the *Hymn to Zeus* of the Stoic philosopher Kleanthes (331–233 B.C.), in which the *logos* of the Stoic cosmos is praised with a rapture anticipating that of St Francis. In Kleanthes' hymn, in fact, the Stoic conception of an all-knowing providence, which Zeno, the founder of Stoicism, had probably intended to be understood in an impersonal sense, is transmuted into a vision of a caring, personal God.

The concern for the inner state of mind of the individual that was at the basis of Hellenistic philosophy and religion also pervaded much of the secular, non-philosophical literature of the age. In this literature, however, it is usually not so much prescriptions for peace of mind as it is descriptions of perturbation of mind that are typical. Hellenistic poets, like, as we shall see in subsequent chapters, Hellenistic painters and sculptors, were fascinated by the actions and expressions which accompany the changing psychological states of people who are excited by some strong stimulus (e.g. the description of the young and love-struck Medea in the third book of the *Argonautica* of Apollonios of Rhodes).

These attempts to probe the inner workings of the psyche reflect a strong feeling in the Hellenistic world that what the individual experienced was more interesting than what society as a whole experienced. It is therefore not surprising that biography, the form of literature which is most concerned with the nature of the individual, first became a recognized genre in the Hellenistic age. The earliest biographies dealt with the lives of particular philosophers and seem to have been inspired by the Peripatetic school's interest in collecting and organizing essential data about important fields of human thought and activity. Aristotle's pupil Aristoxenos of Tarentum, the eminent theoretician of music, seems to have inaugurated this tradition with a series of lives of earlier philosophers. Later Antigonos of Karystos, the versatile artist, critic, and writer who was also one of the sculptors who worked on the Attalid dedication at Pergamon, composed sketches of the lives of contemporary philosophers. Once the idea of writing biographies became established other writers broadened its scope and began to write about prominent figures in government, military affairs, and literature. Although only small fragments of the work of these early biographers survive, we can derive some idea of the character of the genre from the *Lives* of Plutarch, who knew and used their work.

Not only biography but also what is probably the most individualistic of all literary genres, the intimate personal autobiographical reminiscence, seems first to have come into its own during the Hellenistic period. There are, of course, autobiographical elements in the works of many Archaic and Classical Greek authors,[12] but if one looks for autobiographical memoirs which contained a wealth of details, including trivial details, that only the author could have known and which made it possible for the reader to become an intimate participant in the author's experience by giving him an 'eyewitness' account of that experience, one must look to works of the Hellenistic period.[13] Unfortunately all of the autobiographical memoirs of the Hellenistic period are known only through fragments or through allusions to them in the works of later writers, and it is impossible to determine what any single work was like *in toto*. Nevertheless in the few fragments that remain it is possible to detect a vivid intimacy of detail previously unknown in Greek literature. There is, for example, an excerpt from a reminiscence by Eratosthenes of a casual meeting with Queen Arsinoe III at the court in Alexandria which gives one the sort of 'inside view' of a public figure that one would expect to find today in the 'people' section or the gossip column of a magazine or newspaper. The fragment seems to refer to a time late in the reign of Ptolemy IV Philopator when the king's debauchery had provoked a melancholy repulsion in Arsinoe. The scene is in the royal palace of Alexandria. Eratosthenes and Arsinoe are conversing when a man passes them carrying a bundle of branches to a rustic festival which Ptolemy has arranged to be held within the royal dwelling. Arsinoe stops the man and asks him what sort of festival it is that he is celebrating. He explains that it is called the *Lagynophoria* (Flagon-bearing), and that in it each celebrant eats whatever is brought to him while sitting on a bed of rushes and drinking from his own wine jug. The aristocratic queen, accustomed to servants and the elegance of state dinners, is appalled by this. 'When the man had passed,' Eratosthenes records, 'she looked at us and said, "What an utterly uncouth get-together! A gathering that has set before it such a stale feast and in such an unseemly way can only be that of a motley mob."'[14] The reader is given an intimate glimpse of both the personal

life and the psyche of the Ptolemaic queen. It is a new sort of insight, one that could only come into being in an age that puts a high value on individual experience.

Another lost work in which the personal experience of an important figure in Hellenistic politics was recorded in order to be shared with others was the *Hypomnematismoi*, or 'Memoirs,' of Aratos of Sikyon. In this highly unusual document Aratos seems to have recounted his personal reminiscences about the course of his political career, presumably from his days as a youthful revolutionary to his days as the elder statesman of the Achaean League. He apparently did so, moreover, in a straightforward, businesslike style which, unlike most of the prose of his time, avoided rhetorical embellishment.[15] In Plutarch's *Life of Aratos* there are two vivid, seemingly 'eyewitness' accounts of commando raids led by Aratos in his early years, which have an immediacy about them that could only have come from Aratos' own reminiscences.

The existence of still other autobiographical memoirs in the third and second centuries B.C. is known from passing references.[16] What probably would have been the most colorful and engaging of these works, had it survived, was the *Hypomnemata* in twenty-four books of Ptolemy VIII Euergetes II, whose nickname, significantly, was 'pot belly.' The references to this work in Athenaios suggest that much of it had to do with food. It contained memories about the menus offered at dinner parties by fellow kings (Athenaios 229D), about fish and artichokes in Libya (71B), about the pheasants and other birds which were kept on the palace grounds at Alexandria (645D), and about the size of a pig which had been sacrificed, and presumably eaten, in Assos. The work also seems to have contained gossip about other Hellenistic monarchs (518F, 438D). It may have been the most personal, and hence the most individualistic, of all Hellenistic writings.

As subsequent chapters will show, this prevailing individualism of the Hellenistic age also permeated the visual arts. As with Hellenistic philosophy and literature, much of the distinct character of Hellenistic art stemmed from an interest among Hellenistic sculptors, painters, and even architects in exploring the inner experience and inner nature of the individual.

Perhaps the most striking development in this direction was the veritable revolution which took place in the art of portraiture (see Chap. 3). Hellenistic portrait sculptors produced not only some of the most brilliant works of the period but also, looked at in broad perspective, one of the most impressive genres in the whole of Greek art.[17] What makes the works of the best Hellenistic portrait sculptors so effective is the vividness with which they expressed not only the public role of individuals (as portrait sculptors had done in earlier periods) but also their inner character, temperament, and mental complexity. This emphasis on individual natures can be seen as an expression of the same sensibility that led to the popularity of biography and memoirs as genres of Hellenistic prose and that led the Cynics and Epicureans to make the private state of mind of the individual the principal focus of philosophical thought. (It is probably significant that among the earliest works in the new style was a portrait of Epicurus [60].)

Not only personalities but also familiar, yet individually experienced emotions and states of mind fascinated Hellenistic artists, as they did Hellenistic poets. The idealism and emotional restraint of Classical Greek art had already begun to yield in the fourth century B.C. to a growing interest in the expression of personal emotions – love, humor, even religious yearning – and this trend was intensified and expanded in the Hellenistic period. Not only personal emotions of the dramatic sort like pain and fear but also varieties of states of consciousness such as sleep and drunkenness became particularly popular among the artists who created the 'Hellenistic baroque' style (Chaps. 4 and 5). Even in the relatively conservative medium of Greek architecture the appeal to personal emotions, through such features as dramatic settings and mysterious inner spaces, made itself felt (Chap. 11).

Eventually this concentration on personal experience rather than cultural ideals as the principal subject of art led to a fundamental change in the nature of the Greek artistic tradition. The exalted themes and traditional subjects of the culture of the *polis* were increasingly abandoned in favor of works which permitted a 'hard look' at contemporary social conditions or indulged a private, domestically oriented sense of amusement (see Chap. 6).

The cosmopolitan outlook

As already noted, the expanded horizons and mobile population of the Hellenistic age brought the Greeks into close contact with a greater variety of peoples and social conditions than they had known in the Classical period. Once they had lived at close quarters with non-Greeks and shared a social setting with them, it became more difficult for a Greek simply to dismiss all non-Greeks as 'barbarians.' There had always been traces in Greek thought of a cosmopolitan outlook that vied with traditional Greek chauvinism, and in the Hellenistic period this outlook for the first time began to play a dominant role in Greek thinking about the nature of society.

The cosmopolitan outlook, or what is sometimes referred to as the 'universalism' of the Hellenistic period, has an integral relationship to the individualism just discussed. As Hellenistic thinkers began to look within themselves for qualities which were fundamental and natural, rather than conventional, it was quite natural that they should seek to find these same qualities in their

fellow men. Individualism presupposes universalism; one can be seen as a 'corollary,' to use Tarn's expression, of the other.[18]

In looking for the origin of the cosmopolitan outlook, and in fact of the very word 'cosmopolitan,' we are led once again to Cynicism. When Diogenes was once asked about where he came from (or probably more precisely, in what town he held citizenship) he replied, 'I am a *kosmopolites*,' a 'citizen of the world.'[19] He may have been the first Greek to use the term. The original point of Diogenes' remark was probably an essentially negative one: he probably meant that he rejected the conventions of all societies and belonged to none of them (rather than that he felt some sense of universal brotherhood and belonging). But as time went on, the positive implications of the word, the idea that there might be a common nature and common interests that unite all men, that one might, in some sense, be a citizen of the world, began to receive serious consideration. A fragment said to be derived from a tragedy written by the Cynic Krates, for example, suggests a positive attitude toward universalism, although admittedly we have no idea of the context in which Krates' lines appeared:

> My fatherland has no single tower, nor any one roof,
> The whole earth is our town and home,
> Ready for us to dwell therein. (Diog. Laertios 6.98)

In less rebellious and more pragmatic quarters of the Greek world than that of the Cynics, there was a trend toward a more positive form of universalism in which the nations and races of the world were viewed as a kind of community with each member having acknowledged virtues and a respected place. The most renowned and influential exemplar of this outlook, certainly in practice and somewhat more dubiously in theory, was Alexander the Great. Most scholars today are reluctant to accept the view, argued with eloquence and ingenuity in the 1930s by the great historian Sir William Tarn, that Alexander was inspired by a visionary belief in the unity of mankind and that in the organization of his empire he was attempting to make this vision a reality.[20] Such a view was also current in Antiquity, as Plutarch's essay *On the Fortune versus the Virtue of Alexander the Great* (329C) makes clear:

But Alexander believed that he came by divine will to be the common governor and mediator of all. Conquering by force of arms those whom he could not bring together by reasoned persuasion, he brought men from everywhere into a unified body, mixing together, as if in a loving-cup, their lives and characters and marriages and social customs. He commanded them all to think of the inhabited world as their fatherland, of the encamped army as their acropolis and guard, of good men as their kinsmen, and only of evil men as foreigners.

Yet, if Alexander was not the visionary that some have made him out to be, his outlook was nevertheless clearly more cosmopolitan and flexible than that of most of the Greeks of his time. He incorporated Persians, as well as men of other nationalities, into the administration of his empire because, it seems, he judged men on the basis of their ability and character, not on the basis of their ethnic or cultural background. Other Greeks and Macedonians of the later fourth century no doubt sympathized with Alexander's outlook. It was frequently expressed, for example, by characters in the comedies of Menander:

> . . . If nature has given a man
> Good character by birth, then he's well born
> Even though he comes from Ethiopia.
> (fragment 533, K)

Alexander's readiness to evaluate men on the basis of their characters rather than their ethnic backgrounds was inherited by, and endorsed by, the most influential geographer of the Hellenistic period, Eratosthenes of Cyrene (*ca.* 275–198 B.C.). After studying philosophy for a time in Athens, Eratosthenes accepted an invitation to the court of Ptolemy III Euergetes and eventually became the head of the library at Alexandria. He was a man of extraordinarily wide learning and wrote treatises on history, literary criticism, philosophy, mathematics, and astronomy. It was through his writings on geography, however, that he made his greatest impact on the ancient world. The Greeks had been producing treatises on geography and ethnography since the sixth century B.C. After Alexander's campaigns opened up the Near and Middle East, it became much easier for inquisitive Greek scholars to acquire a first-hand knowledge of the countries in this region. As research of this type went forward a substantial number of treatises on specific countries and peoples began to accumulate. Eratosthenes was the first to attempt a synthesis of all of this information. In his three books entitled *Geographika* he brought a new mathematical precision and apparently also a new systematic comprehensiveness to the description of the world as it was then known. Implicit in his geographical writing seems to have been, as H.C. Baldry has expressed it, '. . . the concept of a multi-racial and multi-lingual civilised humanity, put forward by a Greek whose picture of mankind included non-Greek centres of civilisation comparable with his own, to all of which the same standard must apply.'[21]

The world of Eratosthenes was becoming too big, too much subject to the influence of diverse and powerful cultural forces – Romans, Carthaginians, Persians, as well as Greeks – for an educated man to remain condescendingly provincial. As one came to know the character of non-Greek countries more thoroughly it was difficult not to conclude that other cultures had their virtues and strengths and that one's own culture, however much at home one felt with it, was not intrinsically superior in all things. The advent of the Romans in the Greek world undoubtedly helped to foster such an attitude. The Romans had a rich cultural tradition of

their own and took pride in it. Their capacity for political and military organization was in some respects superior to that of the Greeks. They were willing, at times eager, to absorb the intellectual and artistic richness of Greek culture, but they did not see themselves, in an overall sense, as inferiors and were not prepared to become so hellenized that they lost their identity. The Greeks could not fail to take a serious interest in Roman culture, particularly in the second and first centuries B.C., when it came to impinge on their lives in a very immediate way. The inquisitive and admiring, but not wholly uncritical, appraisal of the Romans by Polybios in his great history of the middle Hellenistic period is a monument to the new relativist view of culture fostered by the political conditions of the time.

Polybios (*ca.* 200–118 B.C.) did for historiography what Eratosthenes did for geography. A history, he felt, if it was to be 'useful and a source of pleasure' (1.4.11) for those who studied it, should attempt to provide as complete and broad a picture as possible of the events of the period with which it dealt (1.4.1–11). This meant that all the countries and peoples which were involved in the events of a particular period had to be given due consideration and the interrelationships between them had to be made clear. The reason for this, Polybios argued, was that since the late third century B.C. (or, as he expressed it, the 140th Olympiad, i.e. 220–216 B.C.) those who lived around the Mediterranean had entered into an international age:

> In earlier times events of the inhabited world took place in what one might call a disconnected fashion, owing to the fact that in planning, as well as in the outcome of the planning, and also in locale, each event took place without relation to any other. But ever since this time, history has gone forward as if it had organic unity, with the course of events in Italy and Libya being interwoven with those of Asia and Greece and all leading to one end. (1.3.3–5)

Histories of isolated localities and events, he felt, could not do justice to the complexity of the age; the world had become too much of a unity.

> . . . since Tyche has inclined almost all the affairs of the world to move towards a single destiny and has compelled all events to conform to one and the same end, it is necessary for the historian to put before his readers, in one synoptic view, the manipulations of Fortune, by means of which the outcome of all events has been brought to pass. (1.4.1–2)

It is this self-consciously universalistic attitude that makes Polybios's history remarkable. In practice his curiosity about the affairs of non-Greeks may not have been greater than that of Herodotus; and the universal applicability of the principles which inform his history is not as great as that of Thucydides' history of the Peloponnesian war. But his sober, reasoned internationalism could only have come about in the Hellenistic period.

Inherent in the cosmopolitan outlook of the Hellenistic historians, whether it was a spontaneous, pragmatic adaptation to the real conditions of the age (as with Polybios) or an expression of philosophical convictions (as with the Stoic polymath Poseidonios, who carried Polybios's narrative down to the time of the dictator Sulla), was the idea that all men were partners in a single world, that there was, in some sense, a unity of mankind. It was inevitable, therefore, that as cosmopolitanism became increasingly a fact of life in the Hellenistic age, some Greek thinkers would turn their attention to the question of whether or not such a unity really existed, and, if so, what its nature and extent were. The most influential philosopher to do so was the founder of Stoicism, Zeno of Citium (335–263 B.C.). It is not recorded what Zeno thought about the world as he knew it. Most probably, like any thoughtful man, he found in it a mixture of good and evil, of knowledge and ignorance. We do have some evidence, however, about what he felt the world ought to be like or would be like if all men were wise or dedicated to becoming wise. His *Politeia,* 'Republic' or 'Ideal State,' written in the tradition of the *Republic* of Plato and of a similar work, now lost, by Diogenes, was the best-known utopian writing of the Hellenistic age. Zeno wrote it in his early years, when he was still strongly under the influence of Cynicism, and apparently it contained some theoretical proposals about sexual freedom which were as shocking as the proposals of Diogenes had been and caused later Stoics to disown the work. The main idea in the *Politeia* was not, however, dependent on its controversial details and is vividly expressed by Plutarch in a passage that has troubled some modern scholars:[22]

> Indeed, the much-esteemed *Politeia* of Zeno, the founder of the Stoic school, can be summed up with this one main point: that we should not live our lives divided up into cities or nations, each having its own particular standard of justice, but rather that we should think of all men as countrymen and fellow citizens, and that there should be one common life and world order, like that of a herd grazing together in a common pasture. Thus Zeno wrote, creating a dream or phantom image of a well-regulated, philosophical society. But it took Alexander to translate the theory into practice. (*De Alex. Mag. fort. aut virt.* 329A-B)

Several other utopian tracts depicting frictionless and barrier-free societies are known to have been composed in the wake of Zeno's, and something is known of their content. The historian Diodoros, for instance, preserves excerpts from a work by an otherwise unknown writer named Iamboulos, probably written in the third century B.C., which describe a group of 'Islands of the Sun' located somewhere in the remote south where beautiful, healthy inhabitants lived long, untroubled lives, free of slavery, private property, and divisive institutions like marriage. Whatever work was necessary to maintain a simple life was shared, and the time not allotted to work was spent praising God.

The Greek work 'utopia,' however, means 'nowhere,' and in the Hellenistic period, as in all other periods including the present century, that is where visions of a harmonious, egalitarian, and joyful society generally remained. Aside from one obscure attempt by an eccentric brother of King Kassander to found an experimental community on the Akte peninsula near Mount Athos[23] the only cases in which there is even a possibility that a serious effort was made to put principles of social reform into practice are the two great social revolutions of the Hellenistic period, those of Kleomenes III at Sparta in the 220s B.C. and of the slaves who followed Aristonikos of Pergamon in 133–130 B.C. In both of these movements Stoic philosophers are said to have given advice to the leaders, but what the nature of the advice was is not known.

The main contribution of Hellenistic philosophy to the social outlook of the Hellenistic age may have been simply to reinforce a vague sense that there was such a thing as a family of mankind. This new sense perhaps helped men of different nationalities to encounter one another with less wariness and with a greater recognition of their common interest than had previously been the case, but it did not revolutionize existing societies. Cicero, for example, could write about *humanitas* with enthusiasm and still, like Aristotle before him, think of women as inferior and slavery as normal. In the final analysis, the cosmopolitan outlook of the Hellenistic age was much more a spontaneous feeling than a reasoned creed. Perhaps its most typical and sincere expression occurs in a poem by a hellenized Syrian, Meleager of Gadara (*ca.* 100 B.C.), who was, among other things, the compiler of the world's first anthology of poetry:

> My birthplace was of Syria
> The Attic haunt of Gadara
> My foster nurse was the island of Tyre
> And Eukrates I own for sire
> By Muses help the first to vie
> With Menippean Graces, I
> Am Meleager. Yes, and what
> If Syrian? Stranger marvel not.
> Own we not all one common earth . . . ?
>
> (*The Greek Anthology* 7.417,
> translation of Walter Leaf)

The ways in which this universalism or cosmopolitan outlook of the Hellenistic period was expressed in the visual arts will be explored in detail in subsequent chapters. For the moment I will simply note what seems to me its most obvious effect: the Hellenistic artist created images of a much broader spectrum of human types than had his Classical predecessor and also often showed considerably more sympathy for those whom he represented. Foreigners, cripples, derelicts, the aged, infants, and freaks now entered into Greek art and were treated not only with curiosity but also, at times, with insight and fellow feeling. The real world began to

undermine the ideal world in Greek art of the Hellenistic period, and as it did so something was both lost and gained. What was lost was that almost magical ability to harmonize, as in the Parthenon sculptures, a sense of the eternal and the unchanging with one's knowledge of the ephemeral. What was gained was a sympathetic feeling for the variety of the world of everyday experience and for the nobility which could be detected in seemingly ordinary things. The famous Pergamene group of the Dying Gaul and His Wife [86], for example, was, and is, appealing not only for its theatricality but also for the pathos of the figures' suffering and the strange, unreasoning dignity with which they meet it. The same sympathy and insight pervades the bronze boxer in the Terme [157], whose battered face, with its scars, broken nose, and cauliflower ears, is felt as heroic rather than servile. In the late Hellenistic period there is, in fact, a substantial genre of sculptural figures of time-worn elderly men and women, figures which have sometimes been described as 'rococo' but seem in fact to express a genuine, possibly sympathetic, and basically serious 'social realism' (see Chap. 6). Without the mental and emotional conditioning that the cosmopolitan outlook provided for Greek artists, particularly the interest in people of lowly station that was inherent in the teaching of popular philosophers like Bion and Teles, it is unlikely that such a genre would ever have come into existence.

The scholarly mentality

> I hate the cyclic poem, nor do I take
> pleasure in the road that carries many
> to and fro. I abhor too the roaming
> lover, and I drink not from every well.
> I loathe all common things.
>
> (Kallimachos, *Epigram* 30)

If cosmopolitanism was one of the Hellenistic age's basic contributions to western culture, so also, in a paradoxical way, was intellectual exclusiveness. As the qualitative distinction between Greek and barbarian became a less obsessive factor in the Greek intellectual tradition, its place came to be usurped by a new social distinction, that between the educated and the uneducated, between the refined and the crude. The roots of this new exclusiveness can perhaps be traced to institutions like the Museum and Library of Alexandria and the Library of Pergamon, which were ancestors of modern institutes for advanced research. In the protected environments of these institutions, under the patronage of Hellenistic kings, small groups of intellectuals could devote all their energies to specialized study without worrying about where their next meal would come from and about the need to justify their activities to society. The libraries gave rise not just to scholars, which Greece in a sense had long known, but to *professional* scholars, men who enjoyed learning for its own sake, whose work was of interest mainly to one

another, and who felt a certain disdain for the mass of men who knew so much less than they did.

When Ptolemy I, acting on the advice of his cultural and religious counselor, Demetrios of Phaleron, founded the Library of Alexandria, he began to use his wealth to acquire or copy manuscripts from Greece and other parts of the civilized world. Once this avalanche of manuscripts began to pour into Alexandria, those in charge of the Library were faced with the task of ordering, evaluating, and cataloguing its holdings. They were the first 'Classical scholars,' and their mission, like that of their modern counterparts, was to preserve a heritage. Demetrios may have made the mold for what the librarians were to be like when he wrote studies, now lost, entitled *On Homer, On the Iliad,* and *On the Odyssey.* Literary criticism, including textual criticism, of earlier Greek literature, and particularly of Homer, was to become one of the hallmarks of Alexandrian scholarship. For example, Demetrios's successor, and the man who probably first officially held the title of Chief Librarian, Zenodotos of Ephesos (Librarian *ca.* 285–270 B.C.), labored to establish authentic, official texts for the Homeric epics. It was he who first collated manuscripts, divided the epics into twenty-four books, obelized lines he thought to be spurious, and transposed or altered the text when he felt it was incomplete or faulty. The type of editing that Zenodotos began was carried on, not only in connection with Homer but with the texts of many other major Greek authors, by two great librarians of the second century B.C., Aristophanes of Byzantium (Librarian *ca.* 201–186 B.C.) and Aristarchos of Samos (Librarian *ca.* 175–145 B.C.). It is to these scholars that we owe the form of much Greek literature, particularly poetry, that has survived to the present day.

But in addition to preserving the Classical literary tradition for later generations, the scholars who worked in the Library also generated a new intellectual atmosphere, one that was characterized by a love of collecting, organizing, and making a display of knowledge, including extremely recondite learning, and this new mood came to color both the literature and the art of the Hellenistic period.

The most influential purveyors of the new scholarly mentality were the scholar-poets associated with the Library, such as Lykophron of Chalkis (born *ca.* 320 B.C.) and Kallimachos of Cyrene (*ca.* 305–240 B.C.). They could not forget, or chose not to forget, that the audience whose judgment mattered was a learned elite who expected a display of erudition. If the average person could not understand their poems or was bored by what they wrote, it made little difference. It is inconceivable that the *Alexandra* of Lykophron, for example, could have been intended for any other audience than a clique of scholars. This poem, ostensibly a 'dramatic' monologue spoken by a messenger who reports in over 1,400

iambic lines the prophetic ravings of Kassandra on the day when Paris set out in quest of Helen, is one of the most obscure works in the history of literature. There is scarcely a single name or toponym in the work that is not couched in ambiguous terms and ornamented with puzzling allusions. Rhetorical embellishment abounds and novelty of language becomes an end in itself: 518 words in the poem, for instance, appear nowhere else in Greek literature. Less overtly obscure but, if anything, more learned, was Kallimachos's most famous work, the *Aitia* ('Causes'), which recounted in polished elegiacs the myths and legends that were thought to be the causes of various rites, historical events, place names, etc. Judging by the extant fragments, the stories told in the *Aitia* offered considerable potential for the exploration of dramatic anguish and romantic yearning, and it is characteristic of Kallimachos, and of the elitist tradition whose spokesman he was, that he studiously avoided this exploration. Vulgar emotions were among the 'common things' which, as announced in the epigram quoted at the beginning of this section, he loathed.

As one might expect, Kallimachos detested and quarreled with the one poet associated with the Library whose work had a certain popular appeal, Apollonios of Rhodes. Apollonios's *Argonautica*, which carried the epic tradition into the Hellenistic age, was dismissed by Kallimachos with one of his best known and most terse critical judgments: *mega biblion, mega kakon,* 'a big book is a big evil.' Yet Apollonios's work was in certain distinct ways a product of the same intellectual tradition as that of Kallimachos, and in spite of their differing preferences for certain literary forms, in spite of the insults that they hurled back and forth at one another, the two poets had a good deal in common. The unusual psychological realism of the *Argonautica*, which accounts for much of the work's appeal to modern readers, is balanced by, perhaps even outweighed by, many other passages which display typically Kallimachean taste and erudition (for example, learned geographical descriptions and discussions of the *aitia* of particular customs and natural phenomena). The atmosphere of the Alexandrian Library was seldom out of the mind of either poet for long.

The principal result of the application of the scholarly mentality to the visual arts of the Hellenistic age was the creation of works that were designed to be appreciated simultaneously on an immediately apparent level, to be grasped by all who saw them, and on a less obvious, learned level designed for the few who were qualified to understand. The great Gigantomachy of the Altar of Zeus at Pergamon, for example (see Chap. 4), undoubtedly impressed all its ancient viewers, like its modern ones, as a spectacular and technically astounding rendition of a familiar myth, but a few people, like the Stoic scholar Krates of Mallos, who seems to have had a major

4 Relief by Archelaos. *Ca.* 220–150 B.C. London, British Museum. H. 1.18 m.

influence on its design, and those who were attuned to his way of thinking, probably saw in it not only a variety of literary allusions but also an allegory expressing the nature of the cosmos as envisioned by the Stoics. The same dichotomy in meaning was probably also involved in architecture, where, in works like the temple of Athena at Priene, the unlettered would have seen only a glittering surface, while those who were appropriately educated in its ornamental details and proportions would have been aware of an essentially didactic application of a series of 'rules' (see Chap. 11).

A secondary result of the scholarly attitude in art was the growth among artists and their patrons of a kind of historical self-consciousness, probably connected with the writing of the first 'histories of art' in the early Hellenistic period, and with this historical sense a series of revivals and reinterpretations of earlier styles of Greek art, e.g. archaism and neoclassicism (see Chap. 8). The details of these developments will be examined in greater detail in subsequent chapters.

As a typical example of the way in which the scholarly mentality came to permeate the visual arts in the Hellen-

istic period we may look at a well-known work which combines courtly taste, the politics of royal patronage, and learned didacticism: the relief by the sculptor Archelaos of Priene in the British Museum [4].

The Archelaos relief was found in Italy, but its subject matter is indisputably Alexandrian and suggests that it was made for a poet who had been victorious in some sort of poetic competition at Alexandria. The relief is divided into three registers, the uppermost of which depicts the peak and slopes of a mountain. At the peak sits Zeus with his scepter and eagle. To the right of Zeus stands a majestic female figure who looks up toward him and toward the peak of the mountain. She is Mnemosyne, 'Memory,' the ultimate source of poetic inspiration. The mountain whose summit they dominate must be Helikon or Parnassos, for distributed along the slope beneath them are their children, the nine Muses, embodying the various branches of poetic and literary endeavor. In the middle register, standing with one of the Muses in what seems to be a cave or shrine is the chief poet of the gods, Apollo. He holds a *kithara* in his left hand and wears the long dress of a *kitharoidos* (a poet who sings to the accompaniment of a *kithara*). The conical object in front of him is the stone called the *omphalos*, a symbol of his holy seat in Delphi. On the right edge of the middle register a poet stands on a pedestal in front of a tripod which is probably to be interpreted as a prize for victory in a poetic contest. He has sometimes been interpreted as Kallimachos or as Apollonios of Rhodes, but this is simply speculation. There were undoubtedly many poets of lesser renown who competed for royal largesse and for fame at the court of Alexandria.

In the bottom register of the relief we find ourselves on earth. The scene is a sanctuary in which a long curtain has been draped in front of a colonnade. The capitals of the columns are just visible. Seated on a throne before an altar is the Zeus-like figure of the poet Homer.[24] He holds a scroll in one hand and a scepter in the other. On either side of Homer's throne kneel figures which the inscriptions at the bottom of the relief identify as personifications of the *Iliad* and the *Odyssey*, his poetic children. Behind him, and crowning him with a wreath, are a winged male figure and a female figure with a tall headdress whom the inscriptions identify respectively as *Chronos* ('Time') and *Oikoumene* ('The Inhabited World'). The faces of these two figures are not the neutral, idealized faces of personifications, however, but rather portraits of historical individuals. Although there has been some debate about the identity of the portraits, the majority of scholars quite rightly adhere to Watzinger's identification of them as Ptolemy IV Philopator and his sister–wife Arsinoe III. This being the case,

the sanctuary depicted here is in all probability the *Homereion*, the temple to Homer in Alexandria which is known to have been founded by Philopator.[25] Before Homer is a cylindrical altar with a sacrificial bull standing behind it. On either side of the altar are Myth, represented as a boy standing in attendance with a sacrificial jug, and History, shown as a female figure sprinkling incense. To the right of them stands Poetry, holding two torches, and Tragedy and Comedy, each wearing appropriate theatrical costume. Finally at the far right a child called 'Human Nature' (*Physis*) lifts its hand toward four female figures who embody moral virtues – Excellence (*arete*), Mindfulness (*mneme*), Trustworthiness (*pistis*), and Wisdom (*sophia*).

Thanks to its didactic inscriptions the 'lesson' of the Archelaos relief is not difficult to read: Inspiration springs from Zeus (and one must remember that to Hellenistic intellectuals, particularly Stoics, 'Zeus' meant something like 'cosmic mind') and Memory and is passed from heaven to earth by the Muses. Its foremost recipient was Homer, who is both a patron god and symbolic ancestor of the victorious poet for whom the relief was made. Homer's epics will last for all time and are universal, hence he is crowned by *Chronos* and *Oikoumene*; they celebrate both myth and history; they are the fountainhead of the literary genres that came after epic (lyric poetry, tragedy, and comedy, arranged, in an appropriately learned fashion, in the historical order of their invention); and they have bestowed, like all worthy poetry, essential moral virtues upon human nature. In essence, the relief describes a literary man's cosmos and is the sort of work which must have appealed to the elite group who dwelt in the comfortable security of the Museum.

The date of the Archelaos relief has been sought for by most scholars in the form of the letters in its inscriptions. For many years it was generally held that the lettering confirmed a date of *ca.* 125 B.C. Recent studies suggest, however, that a somewhat earlier date is not only possible but perhaps even probable.[26] The Muses on the relief, it should also be noted, are variants of a popular Hellenistic group which has survived in many replicas. The style of the drapery of these Muses as well as the composition of many of the figures seem best dated to *ca.* 225–200, and that is probably when the original group was made (see p. 270). On balance it seems reasonable to conclude that the Archelaos relief was made in Alexandria during or near the time of Ptolemy Philopator (221–205 B.C.) and that it is in some way connected with the scholarly enthusiasm which must have accompanied the inauguration of the Homereion.[27]

Prologue: the phases of Hellenistic art

The following chapters attempt to put into perspective the most distinctive, original, and enduring achievements of Hellenistic art. Each chapter deals with a style, or genre, or school and discusses its development throughout the Hellenistic period. This arrangement seems a more effective way to bring out what is distinctive about Hellenistic art than a series of chapters on successive periods in which all genres and styles are treated simultaneously.

In spite of the fact that these chapters are not arranged in a rigorously chronological fashion, it is possible to correlate the first eight of them with three distinct phases within the Hellenistic period which I would call:

1. The Age of the Diadochoi: *ca.* 323–275 B.C.
2. The Age of the Hellenistic Kingdoms: *ca.* 275–150 B.C.
3. The Graeco-Roman Phase: *ca.* 150–31 B.C.

These titles, as opposed to 'early,' 'middle' or 'high,' and 'late Hellenistic,' have the virtue of emphasizing the close connections of Hellenistic art to social and political developments of the age. 'Early,' 'middle,' and 'late' also tend to imply a nascent, mature, and decadent series of phases, and such a sequence is not really appropriate to Hellenistic art, each phase of which has its own brand of sophistication and also its particular successes and shortcomings.

The *Age of the Diadochoi*, the period when the successors of Alexander competed with one another for dominance and in so doing shaped the major political divisions of the Hellenistic world, was marked by the birth and expansion of 'royal iconography' (Chap. 1), by new categories of sculpture made popular by Lysippos and his school (Chap. 2), and by the creation of a new type of portraiture, primarily in Athens (Chap. 3). The *Age of the Hellenistic Kingdoms*, when attitudes toward cultural life and standards of artistic taste emanated principally from the royal states which emerged out of the struggles of the period of the Diadochoi, saw the creation of what is usually considered the most distinctive style of the Hellenistic age, the 'Hellenistic baroque,'

and of the great Pergamene monuments which best exemplify that style (Chaps. 4 and 5). The final *Graeco-Roman Phase* refers, obviously, to the period after the battle of Pydna when Roman political dominance and Roman taste began to have an effect on how and where Hellenistic artists worked (Chap. 7). Diversity is the hallmark of this era. Some artists turned conservative and attempted to revive lost ideals embodied in styles of the past (Chap. 8). Others did exactly the opposite and shed traditional Greek idealism in favor of a realism that had scarcely any precedent in Greek art (Chap. 6). Still others reacted against the grandiosity that had typified Hellenistic baroque and created the playful style sometimes called 'rococo' (also Chap. 6).

These phases, it must be emphasized, are not air-tight compartments, and their boundaries must be allowed to vary slightly from place to place. Because of the early stability achieved in Ptolemaic Egypt, for example, the 'Age of the Hellenistic Kingdoms' could be said to begin there somewhat before 250 B.C., and in Pergamon it may be said to last somewhat beyond 150 B.C. The same flexibility has to be allowed in the case of subject matter. Royal iconography, for example, developed mainly in the first phase but existed in all three periods. The baroque style was primarily characteristic of the middle phase, but traces of it are detectable earlier, and there were remarkable revivals of it later. Allowing for these inexactitudes, however, a three-part division of the Hellenistic age does seem justified.

A more exact chronology than what is implied by these three phases must depend on a detailed analysis of the stylistic development of Hellenistic sculpture, since sculpture is the only branch of art in which there are enough works preserved to make this kind of analysis possible. There are, however, even in the case of sculpture, relatively few fixed chronological points, and the dates proposed by different scholars for problematical works sometimes vary by hundreds of years. The problems involved in dating Hellenistic sculpture, the most vexed in the study of Hellenistic art, are treated *passim* in Chapters 1 through 8 and are summed up in Appendix I.

In the case of Hellenistic painting and mosaics enough monuments survive to make it clear that there were important technical and stylistic innovations in the graphic arts, but not enough to make possible a strict, phase-by-phase developmental history. For this reason the innovative and characteristic features of these arts are discussed in separate and self-contained chapters (Chaps. 9 and 10). The same approach has been followed in the case of Hellenistic architecture, which was not radically innovative but offers interesting and revealing adaptations of traditional Greek architectural forms to suit the theatrical and scholarly mentalities of the age (Chap. 11). A final chapter is devoted to a discussion of how the unique cultural conditions of Ptolemaic Egypt gave its art a distinctively diverse character.

1

Royal iconography

Since the Hellenistic ruler cult (see Appendix II) served as the basis of and justification for much of the new political order of the Hellenistic age, it was clearly important that the subjects of the various Hellenistic kings be persuaded to accept and respect the institution. In an age when newspapers, electronic communication, and even an extensive book trade were not available to be enlisted as vehicles for political propaganda, the visual arts became one of the chief means by which this acceptance and respect were to be won and a ruler's policies and achievements conveyed.

Greek art in the Classical period had already been used in a modest way to convey political messages, as the monuments that lined the Sacred Way at Delphi, for example, attest. The most obvious form of such propagandistic monuments were votives which commemorated military victories, such as the Nike of Paionios at Olympia, or in a more general and complex way, the Periclean buildings on the Athenian acropolis. Although portraits of generals were sometimes included in such creations,[1] they were by and large impersonal monuments, emphasizing the events and the cities involved but placing little or no emphasis on specific personalities. By contrast, the major focus of much of the propagandistic art of the Hellenistic period was on the personality of the individual ruler who shaped events. One of the new tasks that confronted the Hellenistic artist was, therefore, the creation of a royal imagery that would make the nature of these individuals vivid.

In what perhaps deserves to be recognized as the first work of Hellenistic art, the funeral carriage of Alexander the Great, many typical elements of the sort of art that would long serve the institution of Hellenistic kingship are already apparent. The carriage, which was the principal feature of a funeral cortège that had been organized to carry Alexander's body back to Macedonia but was dramatically intercepted by Ptolemy, is described in detail by the historian Diodoros (18.26.3). From Diodoros's description it is clear that the fusion of Greek and oriental forms that typified Alexander's newly forged empire and his conception of kingship (see Appendix II) was a part of Hellenistic royal art from the beginning. The body itself was placed in a hammered gold anthropoid sarcophagus, a form familiar in Egypt and Phoenicia but unknown in Greece. This sarcophagus, encased in a second gold casket and covered with a purple robe, was placed, along with Alexander's armor, in a carriage that consisted of a vaulted roof supported by an Ionic peristyle, both made of gold. The vault was decorated with 'scales studded with jewels' and from its cornice projected goat-stag protomes, both oriental features which are echoed, if not directly imitated, on the lid of the Alexander Sarcophagus in Istanbul (see [32] and p. 38). At each corner of the vault, on the other hand, there were typically Greek akroteria representing figures of Nike bearing trophies. Inside the peristyle were nets woven of golden thread and draped like screens around the sarcophagus on four sides. On these nets were suspended four paintings; one depicted Alexander seated and holding a scepter in the presence of a special honor guard of Macedonians and Persians; a second showed a military procession with war elephants guided by Indian drivers and carrying Macedonian warriors; a third showed cavalry drawn up in battle formation; and the fourth depicted ships being fitted out for battle. The themes of these pictures – the majesty of the king, the greatness of his power and exploits, and the diverse cultural character of his realm – set the tone for much of later Hellenistic royal iconography. Only the theme of apotheosis, the celebration of the divine nature of the king, seems to have been lacking in an explicit form, and that theme quickly came to be attached to the monument as a whole when it reached Alexandria.

The influence of the forms and ideas of this funeral carriage on those who lived in the newly-forming kingdoms of the Hellenistic age was apparently considerable. 'It attracted many sightseers,' Diodoros tells us, 'because of its far-flung renown. For the whole population of every city along its route always turned out to meet it and again escorted it as it moved on, nor were people ever satiated with delight from looking at it.'

The royal portrait

Images of Alexander

No genre of art is more closely bound up with the nature of the individual than is portraiture, and it was only natural that the artists whose task it was to create the royal imagery of the Hellenistic age should devote much of their energy to the development of effective, persuasive royal portraits. The master of this art, the virtual creator of Hellenistic ruler portraiture, was the sculptor Lysippos of Sikyon, whose portraits so pleased Alexander the Great that the king made him his court sculptor and decreed, according to Pliny, Plutarch, and others, that no other artist was authorized to make his image.[2] The Lysippan portraits of the king, in other words, became the official image, the one that Alexander wanted his subjects to retain in their minds. The characteristics of this image, fortunately, are well described in two passages from Plutarch.

It is the statues of Lysippos which best convey Alexander's physical appearance (and he himself felt it proper that he should be modelled only by Lysippos). For it was this artist who captured exactly those distinctive features which many of Alexander's successors and friends later tried to imitate, namely the poise of the neck turned slightly to the left and the melting glance of the eyes. (Plutarch, *Alexander* 4.1)

When Lysippos first modelled a portrait of Alexander with his face turned upward toward the sky, just as Alexander himself was accustomed to gaze, turning his neck gently to one side, someone inscribed, not inappropriately, the following epigram:

> The bronze statue seems to proclaim, looking at
> Zeus: I place the earth under my sway; you,
> O Zeus, keep Olympos.

For this reason, Alexander decreed that only Lysippos should make his portrait. For only Lysippos, it seems, brought out his real character in the bronze and gave form to his essential excellence. For others, in their eagerness to imitate the turn of his neck and the expressive, liquid glance of his eyes, failed to preserve his manly and leonine quality. (Plutarch, *De Alexandri Magni Fortuna aut Virtute* 2.2.3)

Plutarch's language is revealing. The Lysippan images conveyed not only Alexander's *arete*, the virtues that society could be expected to admire, but also his *ethos*, his personal character. They were images of one whose role it was to rule and whose nature made him fit to rule. In them Lysippos created a new type in western art, the portrait of the 'ruler-hero,' a kind of historical Herakles endowed with great aspirations and capable of equally great deeds. The type became part of the standard royal iconography of the Hellenistic kingdoms and was used for centuries by lesser men who liked to see themselves as worthy successors of Alexander.

Although no original portrait of Alexander by Lysippos has survived, it is not difficult to identify the Lysippan features which Plutarch mentions – the turn of the neck,

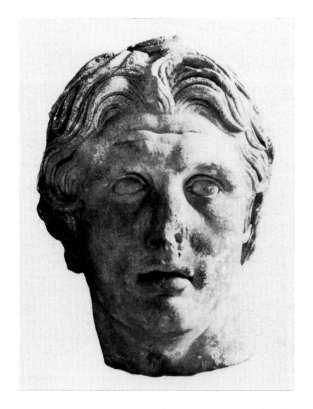

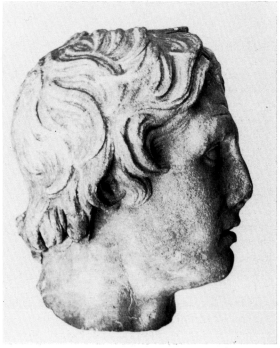

5 Head of Alexander from Pergamon. Marble. *Ca.* 200 B.C. Istanbul, Archaeological Museum. H. 0.41 m.

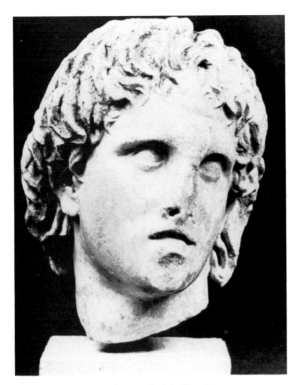

6 Head of Alexander from Pella. Marble. *Ca.* 200–150 B.C. Pella, Archaeological Museum. H. 0.30 m.

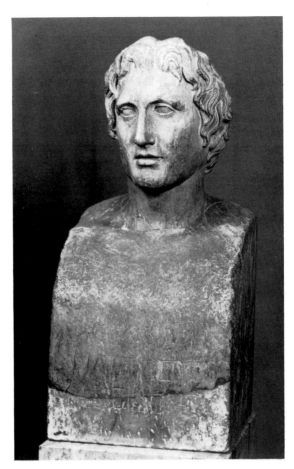

7 Head of Alexander known as the 'Azara herm.' Marble. Roman copy after an original of the later 4th century B.C. Paris, Louvre. H. 0.68 m.

the upward, aspiring glance – in later portraits of the king, both Hellenistic originals and Roman copies. It is considerably more difficult to decide, however, how closely these later works mirror the original Lysippan type. The well-known head of Alexander from Pergamon [5], for example, probably to be dated somewhere around 180 B.C. (see p. 29), conveys, one would like to think, the dramatic force of the Lysippan portraits, but its undulating, bulging surface, its constricted, rounded eyes, and its deeply drilled hair clearly belong to the high Pergamene style.[3] Perhaps closer to the original type is a less well-known head discovered in Yannitsa near the Macedonian capital at Pella [6]. The long mane of hair which typifies this head is a characteristic of images of the 'heroic Alexander,' the sort of image which came to express the spirit of the 'Alexander legend' (cf. [18]), and the portrait is probably to be dated to the time of Philip V or Perseus (i.e. *ca.* 200–175 B.C.). Its relative lack of dramatic exaggeration, however, and the way the general treatment of the eyes and hair approximates those of Greek sculpture of the late fourth and early third centuries B.C. suggest that, in some respects, it may be a close reflection of a Lysippan prototype.

The evidence of monuments which preserve what seem to be nearly contemporary and unheroized images of Alexander, such as the Alexander sarcophagus and the Alexander Mosaic [37 and 2], suggest that in his own lifetime Alexander was represented in a naturalistic fashion, with relatively short hair. For this reason, and also because it bears some resemblance to other works ascribed to Lysippos, the badly weathered and considerably restored portrait in the Louvre known as the 'Azara herm' has frequently been cited as the best surviving Roman replica of a Lysippan original [7]. That the Azara herm does represent Alexander is beyond doubt since it is inscribed 'Alexander, the son of Philip,' and even if the inscription did not exist, the portrait would probably be safely identifiable as Alexander because of the way the hair above the center of the forehead stands straight up. This *anastole* of the hair, Plutarch records (see *infra*), was a distinctive feature of Alexander's physiognomy.

Because the Azara head is in such poor condition, it does not help us much in visualizing the expression of the original Lysippan portrait, although, if one studies it closely, the typical features of the Lysippan prototype – turn of the neck, slightly open mouth, aspiring glance – can all be detected. The striking similarity, however, of the shape of the Azara head to the head on a small bronze

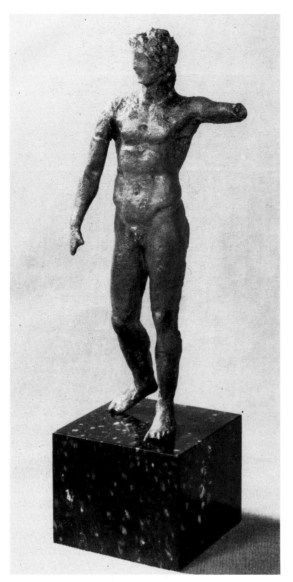

8 Statuette of Alexander with a lance. Bronze. Based on an original statue of *ca.* 330–325 B.C. Paris, Louvre. H. 0.165 m.

sculptured portraits of Alexander was a result of something more than a whim of personal taste on the part of the king. It clearly reflected the desire and need to have an official image, similar to those later cultivated by Roman emperors, for propagandistic purposes. This is made clear by the fact that the official image of Alexander that Lysippos developed in sculpture had its counterparts in other media. In painting, the exclusive responsibility, according to Pliny (*NH* 7.125), to shape the king's image was given to the renowned Apelles of Kos, and the responsibility of designing engraved images on gems and presumably also on coins was assigned to an artist named Pyrgoteles. Literary sources suggest that Apelles developed a surprisingly intimate, easy-going relationship with Alexander and was in a good position to evaluate the human qualities of the king's character.[5] His portraits, on the other hand, at least those of which some description survives, seem to have emphasized Alexander's superhuman qualities, and it may be that Apelles worked for Alexander only at a late stage of the king's career, when the idea of his divine nature became an increasingly important political theme.[6] The most famous image of Alexander by Apelles depicted him in the traditional format of Zeus *Keraunophoros*, i.e. Zeus holding a thunderbolt, and was placed in the great temple of Artemis of Ephesos, where many people could be expected to see it and be reminded that Alexander was not only the son of Zeus but also, in the new world of Hellenistic politics, wielded the power of Zeus. Aside from the presence of the thunderbolt, the appearance of Apelles' portrait is purely a matter of conjecture. It is likely that it depicted Alexander seated on a throne. This at least would have been the most formulaic format for representing Zeus *Keraunophoros*, one that Pheidias's great sculptured image in the temple of Zeus at Olympia had made a virtual archetype. A remote echo of Apelles' work may be preserved in the representation of a Zeus-like figure in the House of the Vettii at Pompeii [9]. It has been suggested, in fact, that the figure in the Pompeiian painting is a copy of Apelles' portrait.[7]

In addition to the *Keraunophoros*, we know something about the details of two more of Apelles' representations of Alexander, both of which were later exhibited in the Forum Augusti in Rome. Judging by Pliny's description of them (*NH* 35.94), they probably had a more specifically historical character and were replete with important political symbolism. One depicted Alexander in the company of Nike and the Dioscuri and was perhaps connected with a naval victory or expedition (the *periplous* of the Indian Ocean or the expedition down the Indus?), since the Dioscuri were patrons of sailors. Probably few educated viewers would have failed to note that Alexander was in significant and appropriate company in this painting. The Dioscuri were sons of Zeus, and they had been among the chief participants in one of the great

statuette [8] also in the Louvre suggests that both the herm and the statuette are derived from the same original, and if this is in fact the case, it becomes easier to evaluate the effect of the total composition involved in Lysippos's portrait.[4] The statuette, which presumably depicted Alexander with a lance, exemplifies the open, exocentric composition which typified the 'role portrait' of the fifth and fourth centuries B.C. (see p. 62). Like the Lateran Sophocles [54], it was designed to convey the idea that influence and power radiated from the man whom it represented.

The exclusive right that was given to Lysippos to make

9 Painting of Alexander as Zeus(?), perhaps based on an original by Apelles. Pompeii, House of the Vettii. 1st century A.C.

10 The Neisos gem. Carnelian. Late 4th or 3rd century B.C. Leningrad, Hermitage. 29 x 20 mm.

eastward expeditions of Greek legend, the voyage of the Argonauts. The second picture in the Forum Augusti depicted Alexander in a triumphal chariot along with a personification of War (*Polemos*) with his hands bound, a reference perhaps to the final conquest of the Persian Empire.

The details of the portraits created by the third of Alexander's court artists, the engraver Pyrgoteles, are not described in any ancient source and hence are even more a matter for conjecture than Apelles' paintings. Conjecture is stimulated in the case of Pyrgoteles, however, by the fact that there is a small corpus of gems and coins of very high quality which can plausibly be connected with his influence.

Because of stylistic revivals and imitations, gems after the Archaic period are notoriously difficult to date, and it is virtually impossible to assert that any particular gem is from the time of Pyrgoteles and therefore possibly by him. There are, however, a few impressive gems which

many scholars feel can be dated to the late fourth or early third centuries B.C. and are worth examining here because, whatever their date, they do seem to document the type of royal imagery that Pyrgoteles and artists like him created at the beginning of the Hellenistic period. Of these the one that seems most closely associated with the ideas developed in sculpture and painting is a carnelian ringstone now in Leningrad which is inscribed with the name of one Neisos, probably its owner at some point rather than its maker [10]. The proportions and, to a degree, the pose of the figure on this gem are reminiscent of Lysippos's 'Alexander with a lance' type, but instead of a lance he holds a thunderbolt in his left hand and a sheathed sword in his right.[8] An aegis is draped over his right forearm. To his left is the eagle of Zeus; to his right a shield. Certainly this must be Alexander as Zeus, a fusion of the aspiring-hero type of Lysippos with the god-like type of Apelles. If the stone is by, or influenced by, Pyrgoteles, one could conclude that his work for Alexander, like that of Apelles, belonged to the later stage of Alexander's career, when the king's divinity became part of official policy. The facts that his shield has been put aside, his sword sheathed, and the attributes of Zeus taken up would suggest that the conquering-hero phase of Alexander's career is behind him and his role as the all-pervading ruler is the focus of attention.

More famous but far more problematical are two large cameos, one in Vienna and the other, like the Neisos gem, in Leningrad, bearing the heads of figures who have sometimes been identified as Alexander and his mother Olympias.[9] The decoration on the helmet of the male

11 The 'Vienna cameo.' Sardonyx. Probably early 3rd century B.C. Vienna, Kunsthistorisches Museum. 115 x 113 mm.

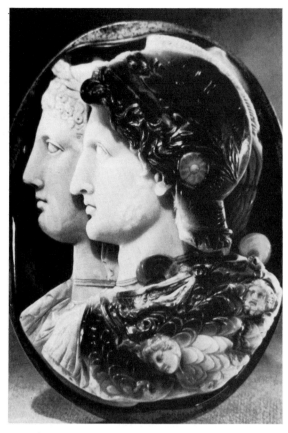

12 The 'Gonzaga cameo.' Sardonyx. Probably 1st century A.C. Leningrad, Hermitage. 155 x 122 mm.

figure on the Vienna cameo [11] – a snake on the dome, the head of Zeus Ammon on the side, and a thunderbolt on the cheek-piece – are certainly appropriate for Alexander,[10] but the profile of the face of the figure, in spite of its bulging forehead and aquiline nose, is quite different in its effect from that of the coin portraits of Alexander. It seems likely, as several scholars have suggested, that these figures are portraits of a Ptolemaic king and queen, probably Ptolemy II and Arsinoe II,[11] whose superimposed profiles were a familiar device on the coins issued by Philadelphos. These 'sibling gods' were offered worship during their lifetimes in the shrine of Alexander (see p. 273), and it would not be surprising, therefore, to find Ptolemy II clad in the attributes of Alexander.

The cameo in Leningrad [12], usually, but apparently erroneously, referred to as the 'Gonzaga cameo,'[12] has the same general format as the Vienna cameo, but the decorative details of the male figure's armor differ. On his shoulder is an aegis with the Gorgon's head and also a bearded male head, perhaps that of Zeus Ammon, worked into it. On the bowl of the helmet the snake again appears, but here it is winged and surmounts a laurel wreath. The workmanship of this cameo, particularly

details of the hair of the female figure and of the aegis, has the sharply defined, didactic quality of a neoclassical style and suggests that it belongs to the Roman period. In a recent detailed study, the cameo has been assigned to the time of Tiberius, and the figures have been identified as portraits of Tiberius and Livia.[13] This date is argued very convincingly, but the identification of the figures, particularly the female, who does not look much like Livia, remains an enigma. Cameo carving, for example the Tazza Farnese (see p. 257) was a sophisticated, courtly art in Alexandria, designed for a small audience which could appreciate allegory, personification, and subtle political allusions. Roman imperial cameos were produced in the same atmosphere.[14] The artist who carved the Gonzaga cameo perhaps deliberately represented the emperor and the accompanying female figure in very generalized form so that they would simultaneously evoke the imagery of a Ptolemaic cameo and, through it, the imagery of Alexander.

Because royal portrait gems are relatively few in number and because their dates are so difficult to establish, it is very difficult to draw conclusive generalizations about iconography from them. Perhaps a more promising genre

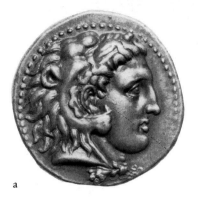

a b

13 Coins depicting Alexander: (a) Head ostensibly of Herakles, perhaps a portrait of
 Alexander, on a silver tetradrachm issued by Alexander in 325 B.C. Berlin, State Coin
 Collection. Diam. *ca.* 29.5 mm. (b) Bronze coin with Alexander as Herakles on the
 obverse and Alexander with his horse Boukephalos on the reverse, issued by the Emperor
 Gordian III, 238–244 A.C, Boston, Museum of Fine Arts. Diam. 28.5 mm.

in which to search for the influence of Pyrgoteles and his contemporaries is coinage. Ancient coins, it must be remembered, were struck from carved dies, one die being set in an anvil and the other carved into a punch. Designing of coins was therefore really an offshoot of gem-carving. The same technique of intaglio carving that was used for most gems was also used to make coin dies. Thus it would not be surprising if Pyrgoteles served Alexander as a *sculptor* not only of gems but also of coin dies.[15] One wonders, in fact, if designing coins was not Pyrgoteles' primary commission from Alexander. Gems, with the exception of official seals, would have had a limited private circulation, but coins, and their images, would have penetrated into every part of the new empire. At any rate, the coins issued by Alexander himself and the coinage representing Alexander issued by the Diadochoi, whether connected with Pyrgoteles or not, document in a more vivid and detailed way than any other medium the genesis of Hellenistic royal imagery.

Of all the forms of the visual arts in Antiquity through which political ideas could be broadcast none was more important than coinage. To be influenced by a sculptured portrait or a painting one had to be in a certain place at a certain time and also had to be in a receptive frame of mind. Coinage, on the other hand, was handled every day by virtually everyone in a city or state. It would be almost impossible not to notice and be affected by the portraits and symbols on coins. Although a certain veiled political symbolism can be detected in Greek coins long before the time of Alexander – for example, in the famous Demareteion type issued by Gelon of Syracuse after his defeat of the Carthaginians in 480 B.C. – pre-Hellenistic coinage had by and large been designed with the ideas of consistency and recognizability (and hence stability and reliability) in mind. Archaic and Classical Greek coins

were impersonal. Coin portraits of living men did not appear until the fourth century B.C., and then only tentatively (see p. 64), and symbolism on coins was limited to subjects like the patron deity or hero of a city or its particular emblem. It was not until the rise of the Hellenistic monarchies that the potential of coinage to propagate the personality, achievements, and policies of individual rulers was appreciated and exploited. The closest analogy in modern times to the ways in which Hellenistic coinage was used is found not in coinage but rather in commemorative postage stamps.

Upon his accession in 336 B.C. Alexander introduced a new type for silver coinage which in a few years was to become one of the most common and far-flung coins of the ancient world. On the obverse of these coins was the head of Herakles wearing the skin of the Nemean lion [13a] and on the reverse was a seated Zeus holding an eagle and a scepter. The motifs used on these coins were not completely new in Macedonian coinage. Since the Macedonian royal house claimed descent from Herakles, several earlier Macedonian kings had already used the head of Herakles on their coins, and Philip II had also used the head of Zeus.[16] It is instructive to see how, as Alexander's career progressed, these rather conventional motifs were developed so as to take on increasingly broad yet specific meanings. There appear to have been two phases in this development. In the first, more traditional phase of the symbolism of these coins, the hero Herakles can be seen as a prototype for Alexander, a conquering hero and ancestor whose deeds of valor subdued barbaric forces and brought glory to Greek culture, of which the hero himself was a kind of embodiment. Zeus, as the father of Herakles, could be seen in this phase not only as the ultimate ancestor of the Macedonian line but also as the arbiter and judge of heroic achievement. This is just

the sort of symbolism which would have suited Alexander when, like a young Herakles, he was organizing the Greeks and Macedonians into a panhellenic force to support him in a great Heraklean labor, the attack on the Persian Empire. The use of a seated figure of Zeus, rather than simply the head which had been used on Philip's coins, was a carefully considered decision, because a seated Zeus would undoubtedly have called to mind for many Greeks the most panhellenic of all the god's images, Pheidias's great cult image at Olympia.[17]

After Alexander's conquest of the Persian Empire, his visit to the oracle at Siwa, and the official promulgation of the idea that he was to be viewed as a god (see p. 271), one senses a new phase in the symbolism of his coins. The idea now is not simply that Alexander is a descendant of Herakles but rather that he *is* Herakles, a living son of Zeus whose heroic labors, like those of Herakles, have led to his becoming a god. The outward expression of this idea seems to have taken place on the coins produced *ca.* 325 B.C. by the mint of Alexandria, Alexander's own city and the one in which the idea that he was a son of Zeus was first seriously promulgated [13a]. On the best of these coins we can observe the subtle transformation whereby the head of Herakles became the head of Alexander. Features familiar from the sculptured portraits – the bulging forehead, the narrow mouth with almost pouting lips, even something of the aspiring gaze – are detectable. Although some scholars have doubted it, these representations (particularly when judged by the definition of portraiture proposed in the third chapter (p. 59) seem clearly to have been intended as portraits of Alexander. As such they stand at the beginning of a long and splendid series of Hellenistic royal coin portraits.

In addition to its effectiveness as a vehicle to express Alexander's heroic and divine nature to the Greeks, the Alexander as Herakles image was probably valued for its adaptability as a royal image among the king's eastern subjects. As Charles Seltman put it: '. . . the Phoenician was to see in the obverse type his own god Melqart . . . the Babylonian, though he might not be able to read the Greek name of Alexander, was to look on pictures that might recall his own Gilgamesh, the lion-slayer.'[18] Royal imagery in the Hellenistic world had not only to be appealing to the eye; it also had to be international in spirit, and no one succeeded better in meeting this requirement than the creators of Hellenistic coinage.

Posthumous portraits of Alexander

After his death Alexander's image was perpetuated with reverence and circulated even more widely than it had been during his lifetime. The reasons for this were, first, that he became a kind of patron deity, the archetype of the divine ruler-hero, in whose mold later rulers, both Hellenistic and Roman, wished to cast themselves; and second, the fact, already mentioned, that a talisman-like

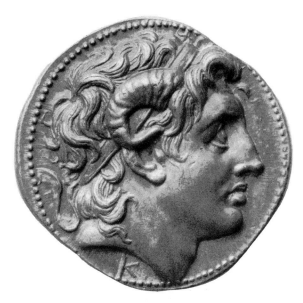

14 Silver tetradrachm depicting Alexander with the horns of Zeus Ammon, issued by Lysimachos. 306–281 B.C. London, British Museum. Diam. *ca.* 30 mm.

quality was popularly attributed to his image.

One of the first and finest of all the posthumous images was a portrait of Alexander adorned with the horns of Zeus Ammon on a series of gold and silver coins issued by Lysimachos after he, like the other Diadochoi, took the title of king in 306/305 B.C. [14]. The emphasis of this series is clearly on the divine Alexander, the son of Zeus Ammon. Lysimachos, of course, aspired, like the other Diadochoi, to succeed Alexander as the 'Great King' and hence sought to invoke him on these coins as both a political ancestor and a patron deity. This type is one of the most beautifully conceived medallions in ancient art, the masterpiece of a skilled gem-maker. One wonders if Pyrgoteles survived long enough to be its creator. At any rate it is not surprising that the type was also used on gems, for example a quartz ringstone in the Ashmolean Museum, probably made at about the same time as the coin of Lysimachos; and that its influence survived long enough to leave its mark on the coins issued by the Roman magistrates who governed Macedonia in 93–88 B.C., after it had become a Roman province.

On the coinage of Ptolemaic Egypt the evolution of an image of the divine Alexander followed a somewhat different course. Ptolemy I, when he was nominally still only a regional governor for Alexander's legal successors, Philip III and the infant Alexander IV, continued to issue the familiar coins of Alexander; that is, the type with the head of Herakles on the obverse and a seated Zeus on the reverse. After the murder of Philip III by Olympias, it must have become obvious to Ptolemy that the legal

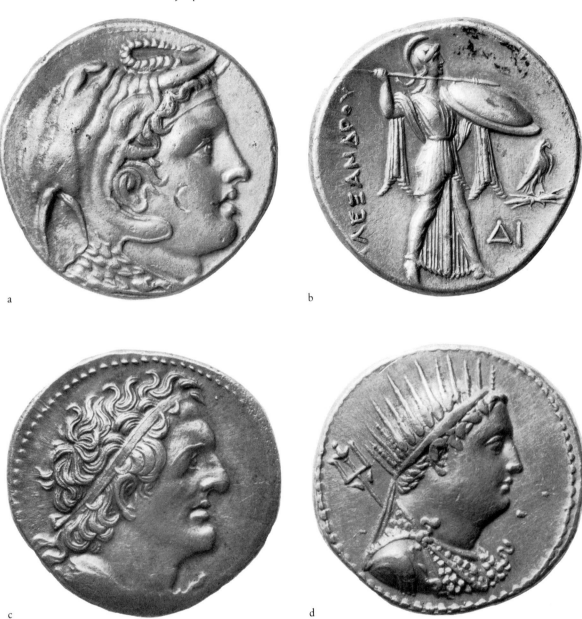

15 Ptolemaic coins: (**a**) Silver tetradrachm issued by Ptolemy I, *ca.* 318–315 B.C., with Alexander wearing an elephant-scalp helmet on the obverse and (**b**) an archaistic Athena on the reverse. Diam. *ca.* 26 mm. (**c**) Silver tetradrachm with portrait of Ptolemy I. Private collection. Diam. *ca.* 29 mm. (**d**) Gold octadrachm with portrait of Ptolemy III (246–221 B.C.). London, British Museum. Diam. *ca.* 28 mm.

successor of Alexander would not long survive, and he began to issue a new series of coins which were probably designed to invoke Alexander as a patron deity of Egypt and to imply that he, Ptolemy, was a natural successor. Alexander's association with Egypt, through his visit to the shrine of Zeus Ammon and the founding of Alexandria, was already strong during his lifetime, and the fact that his body was now entombed in Egypt must have given this association a lasting, spiritual character. The Ptolemies could argue that the legacy of Alexander had fallen naturally into their hands.

The new Ptolemaic coins depicted Alexander himself, rather than Herakles, on the obverse, adorned, as on the coin of Lysimachos, with the horns of Zeus Ammon but also with an elaborate elephant-scalp helmet [15a]. This helmet seems to have had complex political associations. It undoubtedly evoked Alexander's Indian campaign and his memorable victory over the elephant-mounted forces of King Poros. (Hence the later kings of Bactria and India used it. See p. 285.) It perhaps also alluded in some way to the oriental triumph of Dionysos, which seems to have become a symbol of the triumphant progress of a divine king. (See p. 148. One of the titles assumed by a later Ptolemy was the 'New Dionysos.') But the elephant scalp perhaps also had associations with Africa, and hence with the homeland of the Ptolemies. (Part of the wealth of the Ptolemaic kings came from the exploitation of African ivory, and they also made an attempt to develop African elephants for warfare.)[19]

This new coin type originally had a seated Zeus on the reverse, but after a few years Ptolemy replaced it with an archaistic representation of an armed Athena, which is reminiscent of the image of the goddess on contemporary Panathenaic amphorae, the vessels awarded as prizes at Athens's greatest cultural festival [15b]. It was at about this time that Ptolemy began to attract to Alexandria from Athens and elsewhere that circle of scholars and artists who would help him found the greatest intellectual center of the Hellenistic world, the Library and Museum of Alexandria (see p. 14), and it may be that the Athena on this coin was intended to convey the idea that the city of Alexandria was destined to be the heir not only of Alexander's temporal power but also of the cultural heritage of Classical Athens. It is noteworthy that on some of the coins with the armed Athena the familiar inscription *Alexandrou*, 'of Alexander,' is replaced by *Alexandreion*, meaning perhaps 'an Alexandrian coin.'

When Ptolemy took the title of king in 305 B.C. and began to issue a series of coins bearing his own portrait [15c] (one of the great coin portraits in the realistic tradition, see p. 71), the image of Alexander still continued to be revered. On a special series of gold staters with the head of Ptolemy on the obverse, for example, the reverse depicts Alexander in an elephant-drawn chariot. This image was probably intended to evoke the great

festivals in Alexandria, like the elaborate one of *ca.* 276 B.C., described by Kallixeinos of Rhodes (see Appendix III), in which an image of Alexander was paraded in triumph.

After the various Diadochoi, like Ptolemy, had taken the title of king for themselves, the image of Alexander tended to be replaced in royal coinage by the portrait of a reigning monarch or of a dynastic founder. In areas outside of royal jurisdiction, however, the head of Alexander remained popular on Hellenistic coinage and was eventually adopted for use on coins issued under Roman authority, both during the Republic and under the Empire. The type of Alexander as Herakles, which, as already noted, seems to have originated late in Alexander's own reign, proved to be, in fact, one of the most enduring images in ancient art. It was used early in the third century B.C. by Sikyon and later, in the late third and early second centuries, was widely used by the nominally free cities of Asia Minor and the Aegean islands – e.g. Priene, Miletos, Sardis, and Kos [13]. There was no doubt a certain conservative, practical appeal to these coins; they were a familiar and widely recognizable type that would be acceptable in Asia as a medium of exchange. But it also seems probable that the image of Alexander was favored, as already observed, because it seemed auspicious, or perhaps just plain lucky – the sort of image that would appeal to an age obsessed with Fortune.

In the Roman Empire, in any case, which inherited Hellenistic traditions about Alexander, there is clear evidence that such an idea was entertained. Even the sober and restrained Augustus is said to have used a gem-portrait of Alexander as his personal seal (Suetonius, *Divine Augustus* 50), and the Gonzaga cameo [12] seems to show Tiberius adorned with the attributes of Alexander. In the third century Alexander's image was especially promoted by Alexander Severus, no doubt in an effort to magnify his own prestige through association with his more famous namesake, and was also used by the Emperors Elagabalus, Gordian III [13b], and Philip 'the Arab.' Political symbolism clearly played a role in the selection of Alexander's image for the coinage of these emperors, since each of them, like Alexander, had been actively involved in (or in the case of Elagabalus, at least associated with) a campaign in the East against the Persians.[20] But the magical, theurgical quality of the image – that quality which prompted Alexander Severus to place a portrait of Alexander in his private chapel along with those of Apollonios of Tyana, Christ, Abraham, and Orpheus (*Historia Augusta, Alexander Severus* 29.2 and 31.5) – seems to have been the principal source of its popularity. In the time of the Emperor Gallienus (253–68 A.C.), for example, a rebel officer named Titus Macrianus is said to have had Alexander's image worked into his family's jewelry, tableware, and clothing

because, as the author of this section of the *Historia Augusta* observes '. . . it is said that whoever wears an image of Alexander rendered in relief on either gold or silver is aided in his every action' (*Historia Augusta, Thirty Tyrants* 14.6). This numinous quality associated with Alexander's image probably accounts for its perpetuation even into the fourth and fifth centuries after Christ, when it was used on the coin-like tokens known as 'contorniates.' Reverence for the image hung on, in fact, even in the face of Christian condemnation. Around 400 A.C. St John Chrysostom felt called upon to rebuke the people of Antioch for wearing coins of Alexander as good luck charms (*Ad Illuminandos Catachesis* 2.5).

Sculptured images of Alexander were produced for almost as long as, and in a greater variety than, the numismatic images. In a general way the sculptured portraits can be divided into two types: an *heroic type*, seemingly descended from the portraits by Lysippos, and a *divine type*, perhaps descended from painted portraits by Apelles and stimulated by the Alexander legend. In the heroic type, the anguished, aspiring, struggling aspects of Alexander's personality that Lysippos expressed through the turn of the neck and an upward glance are repeated and exaggerated. The most renowned example of this type is the over-life-size head from Pergamon, already mentioned [5], which may be from an image that stood in the shrine of the ruler cult at Pergamon. The bulging forehead, almost dilated eyes, and the frenzied effect of the deeply carved strands of hair that radiate from the *anastole* at the crown of the forehead all connect this head with the 'baroque' style of the Pergamon altar (see p. 102) and suggest that it dates from somewhere around 180 B.C. Probably no other image captures as effectively that legendary *pothos*, the heroic yearning that tradition attributed to Alexander. As it was passed down through the centuries, the basic format of the heroic type remained intact, but surface details were modified to suit the reigning style of the time. Thus, for example, a head from the sanctuary of Asklepios at Kos, dating from the latter part of the second century B.C., has a smoothness of surface that reflects the growing neoclassical taste (see Chap. 8) of that period [16]. By contrast, a head in the Capitoline Museum in Rome [17] which seems to represent Alexander as Helios[21] exaggerates the features of the Lysippan Alexander and adds to it a luxuriant, deeply carved shock of hair that calls to mind the Hellenistic baroque style (see Chap. 5). The Capitoline head itself probably dates from the second century A.C. and betrays something of the eclectic taste of its time (smooth surfaces and hard lines in the neoclassical tradition), but its basic features probably go back to a prototype of *ca.* 200–150 B.C. Finally, in a head from Ptolemais on the Libyan coast, now in Boston, the stagey, exaggerated qualities of the Capitoline head survived and came back into vogue in the third century A.C. when, as noted above,

16 Head of Alexander from Kos. Marble. 2nd century B.C. Istanbul, Archaeological Museum. H. 0.315 m.

17 Portrait of Alexander as Helios. Marble. 2nd century A.C., based on a Hellenistic prototype. Rome, Capitoline Museum. H. 0.583 m.

Alexander's image on coins once again became popular.

By contrast, the 'divine type' of Alexander projects a more serene image, that of the son of Zeus who has transcended human limitations. One of the earliest examples of this type, dating from around 300 B.C., is a statuette (about one third life size) found in a house dedicated to the cult of the deified Alexander at Priene. In the rather schematically regularized features of the statuette, with the Lysippan turn of the neck retained but the upward glance eliminated, the uncertain *pothos* of the hero has yielded to the certain power of a god. As time went on the element of strict portraiture in the divine type seems to have been attenuated in favor of a more imaginary image that suited requirements of the Alexander legend. Such is the character and effect, for example, of the great head from Alexandria now in the British Museum [18] with its seemingly dreamy and horizonless stare; or the statuette in Cairo depicting Alexander with an aegis; or of the Apollo-like figure from Magnesia on the Maeander [19]. All of these probably date from the second half of the second century B.C., and each in its own way represents later Hellenistic embroidery upon earlier styles and iconography. The head in the British Museum is conceivably a romantic elaboration upon the so-called 'Eubouleus type,' which, it has been proposed, may be a portrait of Alexander as a boy, perhaps by Leochares.[22] The statuette in Cairo is probably a votive object, perhaps one intended for the sanctuary of Alexander in Alexandria, and is a modification of the type created in the famous painted portraits of Apelles. In the case of the statue from Magnesia, the divine quality of the figure stems from the fact that the prototypes for its format are cult images created during the 'baroque' phase of Hellenistic sculpture, for example the Poseidon of Melos [290] and the majestic Zeus found in the temple of Hera at Pergamon [112]. The partially preserved sword in its left hand also connects this image with the symbolism of the Neisos gem [10].

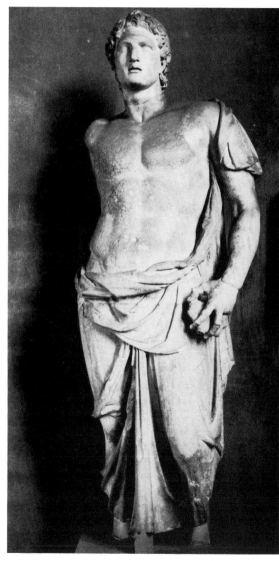

18 Head of Alexander. Marble. Probably late 2nd century B.C. London, British Museum. H. 0.37 m.

19 Statue of Alexander from Magnesia. Marble. 2nd century B.C. Istanbul, Archaeological Museum. H. 1.90 m.

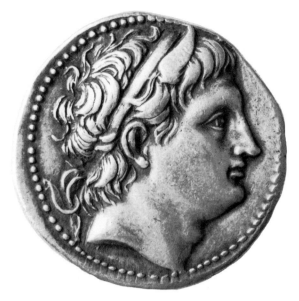

20 Silver tetradrachm of Demetrios Poliorcetes with portrait of Demetrios on the obverse and
Poseidon on the reverse. *Ca.* 290/289 B.C. Private collection. Diam. *ca.* 29 mm.

Although not enough Hellenistic painting survives to make an informed judgment possible, literary sources suggest that painted representations of Alexander were as popular as those in sculpture. Unfortunately these sources refer only to artists of Alexander's own time or to the time of the Diadochoi, and it is impossible to say how the painted images of Alexander may have developed over the centuries. In the last quarter of the fourth century B.C., however, it is clear that a considerable variety in these representations already existed. The influential portraits by Apelles have already been discussed (p. 22). Since Apelles was the official portrait painter of Alexander, it seems likely that the other painters who represented him did so only after his death. This was clearly the case with Apelles' chief rival, Protogenes of Kaunos, whose last work, 'Alexander and Pan,' was done some time after 305 B.C.[23] Another prominent painter of this period, Antiphilos, did an 'Alexander as a boy' and an 'Alexander and Philip' (Pliny, *NH* 35.114). These might sound like contemporary rather than posthumous portraits, but the facts, also attested by Pliny, that Antiphilos was born in Egypt and later painted one of the Ptolemies suggest that he was an Alexandrian who worked after Alexander's death. Aetion, a painter whose native city is not recorded but who worked at one time in Olympia, seems to have created one of the first examples of Hellenistic rococo (see pp. 130, 141) in his 'Marriage of Alexander and Roxane,' a description of which is preserved by Lucian (*Herodotus Sive Aetion* 4); and Philoxenos of Eretria painted the battle scene with Alexander and Darius that may be copied in the famous Alexander Mosaic from Pompeii (see p. 45).

Portraits on the model of Alexander

There were two basic varieties of ruler portrait in the Hellenistic age. One, derived from the Athenian 'psychological portrait' of the early third century B.C. (see Chap. 3), emphasized the sober, reflective, professional qualities of the ruler, his judiciousness and good sense. The other, derived from the Lysippan and post-Lysippan portraits of Alexander, emphasized the idea of the ruler as a divinely favored hero and special child of Fortune. The portraits of Alexander represented not just a man but also an idea; and it is not surprising that later rulers who were attracted to that idea tried to assimilate elements of the Alexander type into their own portraits.

The first ruler to do this in a marked way was the most Alexander-like (at least in intention) of the Diadochoi, Demetrios Poliorcetes. Demetrios, like the other Hellenistic kings, was quick to grasp the propagandistic value of coinage. After his great naval victory over Ptolemy off Cyprus in 306 B.C. he began to issue a series of silver tetradrachms with a figure of Poseidon, the god of the sea and the god from whom Demetrios claimed to be descended, on the reverse and with, on the obverse, a figure of Nike blowing a trumpet of victory as she descended upon the battered prows of the ships which Demetrios had captured. About a decade later, after he had wrested the kingship of Macedonia from the successors of Kassander, the Poseidonian imagery of this first coin was extended further in a new series of tetradrachms. On the reverse was a figure of Poseidon in the format of the sculptural type known as the 'Lateran Poseidon,' a type generally thought to have been created

by Lysippos; and on the obverse Demetrios placed his own portrait with tousled, Alexander-like hair bound up in a royal diadem from beneath which projected two bull's horns, the horns of Poseidon *Taureos* [20]. This issue, which has been claimed to be 'the first portrait of a living man to appear on a European coin,'[24] clearly emulated the Alexander tradition in a number of ways and attempted to draw some of the luster of that tradition to Demetrios. The bull's horns were intended to announce that Demetrios stood in the same relationship to Poseidon as Alexander did to Zeus Ammon. The famous Alexander type issued by Lysimachos [14] was almost certainly its prototype. And by choosing a Lysippan format for Poseidon, Demetrios saw to it that the image of his patron deity, his own equivalent of Alexander's seated Zeus, would be associated in the minds of educated men with artistic traditions dating from the time of Alexander.

With this coin of Demetrios, and a few others similar to it, a familiar genre of western art, the portrait with symbolic attributes, first became firmly established. In earlier Greek art the use of attributes to characterize and identify a particular being, like the aegis of Zeus and Athena, the crown of solar rays of Helios, the caduceus of Hermes, and so on, had been confined to the gods and to a few legendary heroes closely associated with the gods (e.g. the winged boots of Perseus). It was with the portraits of Alexander (particularly, it would appear, those of Apelles) that the line between the human and the superhuman was crossed, or at least confused, and it became permissible (and later normal) to use divine attributes to express the qualities of a human potentate. The barrier may have been broken when Apelles represented Alexander with an aegis, although it is not completely certain that Apelles' portrait of Alexander as Zeus was done during the king's lifetime. The horns of Zeus Ammon, however, were applied to him only after his death when his apotheosis had become a widely accepted idea. By 300 B.C., in any case, Demetrios and also Seleukos I did not hesitate to have themselves represented with the horns of divinity while they were active, mortal, fallible men.[25] In time the use of such attributes for portraits on coins and other media led to the development of an elaborate symbolic language. On a series of gold and silver coins issued *ca.* 240 B.C. by Ptolemy III Euergetes, for example, the king had himself represented with a diadem made of alternating solar rays and horns, with an aegis around his neck, and with a winged scepter-trident on his shoulder [15d]. The image he tried to project, as Charles Seltman put it, was that of 'Helios-Ammon-Poseidon-Hermes-Zeus in one.'[26]

The horns on the coin portraits of Demetrios Poliorcetes have made it possible to propose plausible identifications of two sculptured portraits of him. Both of these are from the 'Villa of the Papyri' (see p. 162) at

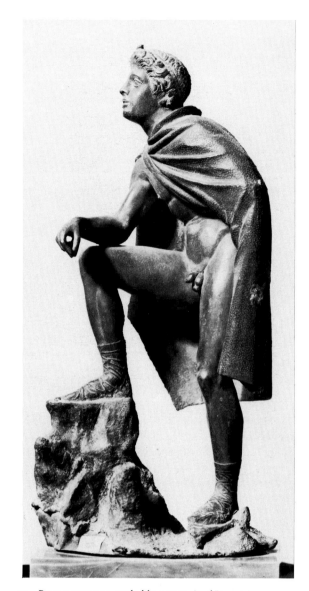

21 Bronze statuette, probably a portrait of Demetrios Poliorcetes. 1st century B.C. or A.C., based on an original portrait of *ca.* 290 B.C. From Herculaneum, now in Naples, Archaeological Museum. H. 0.54 m.

Herculaneum and are now in Naples. One is a bronze statuette depicting Demetrios in the pose of the Lysippan Poseidon, the figure chosen for the reverse of his portrait coins [21]. He wears a Macedonian soldier's cloak, and on his head, in addition to the symbolic horns, he wears a royal diadem. The other portrait is a marble head [22], a rather hard and lifeless Roman copy, which is probably based on the same original as the statuette. Although this portrait is not flamboyantly Alexander-like, the choice of the pose, and the slight turn of the neck and upward glance, clearly put it in the Lysippan tradition. It is

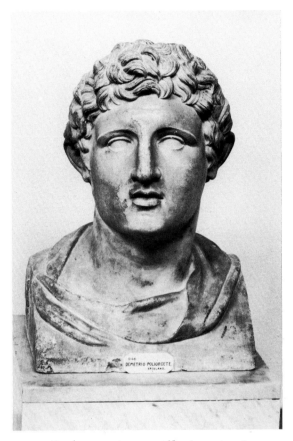

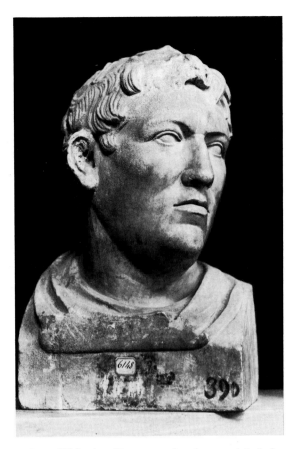

22 Bust of Demetrios Poliorcetes. Roman copy based on an
original of *ca.* 290 B.C. Marble. From Herculaneum, now
in Naples, Archaeological Museum. H. 0.33 m.

23 Bust of Philetairos. Roman copy based on an original of
the 3rd century B.C. Marble. From Herculaneum, now in
Naples, Archaeological Museum. H. 0.40 m.

probable, in fact, that the original of the type preserved in
the two figures from Herculaneum was a work of the
Lysippan school. Pliny (*NH* 34.07) mentions a portrait of
Demetrios by the sculptor Teisikrates of Sikyon, who was
a pupil of Euthykrates, Lysippos's son, and whose style
was thought to be almost indistinguishable from that of
Lysippos.

The owner of the Villa of the Papyri at Herculaneum
clearly had a lively interest in Hellenistic culture in
general and in Hellenistic rulers in particular. Portraits of
other Hellenistic rulers have been recovered from the
Villa, and several of them document the continuing
influence of the Alexander model.[27] One of these is
generally agreed, on the basis of its similarity to coin
portraits, to represent Philetairos, the founder of the
Pergamene kingdom [23] (see p. 79). The later Attalids
chose to use Philetairos's portrait in the same way that
Lysimachos and Ptolemy I had at first used Alexander's.
That is to say, after his death Philetairos was deified by
Eumenes I and became a patron god of the dynasty.
Thereafter his portrait regularly appeared on Pergamene

coins throughout the history of the kingdom. In addition,
as was the case with Alexander's portrait, the image of
Philetairos was also propagated through the medium of
high-quality gems, like the yellow chalcedony ringstone,
probably datable to the later third century B.C., now in
the British Museum. Philetairos's fleshy, tough-looking
face, with its narrow eyes and heavy jaw, might not seem
the appropriate raw material to be cast in the mold of
Alexander. It would seem, however, that the mannerisms
of the Lysippan portrait of Alexander quickly became,
like horns or the aegis, familiar attributes, part of a
language of forms that could be applied to a variety of
subjects, even those who were not in any obvious way
Alexander-like. They were one way of saying to the
educated public: 'This man is both a conqueror and a
ruler.' The stylistic incongruity which resulted from fus-
ing a realistic, unromantic face with the posture of a
romantic hero may have been less disturbing to ancient
viewers, thoroughly accustomed to this symbolic langu-
age, than it is to modern eyes. In any case, other examples
of this fusion of a relatively matter-of-fact, realistic

33

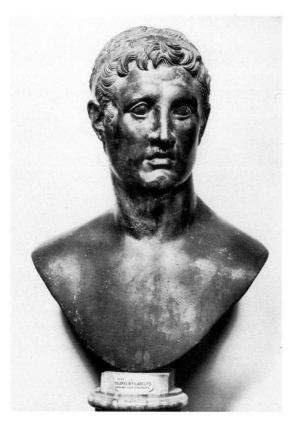

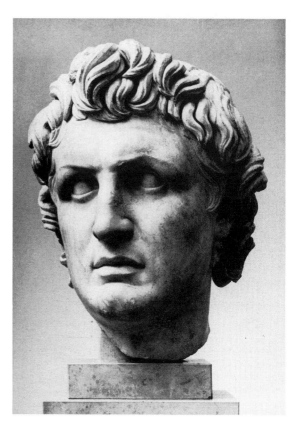

24 Bronze portrait, probably representing Ptolemy II. From Herculaneum, now in Naples, Archaeological Museum. H. 0.55 m.

25 Portrait identified as Attalos I, from Pergamon. Marble. *Ca.* 200 B.C. East Berlin, Staatliche Museen. H. 0.395 m.

portrait with elements of the Alexander-type can be found throughout the Hellenistic period. Among portraits dating from (or based on originals dating from) the early third century B.C., for example, one detects it in yet another portrait from the Villa of the Papyri at Herculaneum, this one plausibly identified, again on the basis of coin portraits, as Ptolemy II Philadelphos. The head is similar to a bronze head, also from Herculaneum, which has also been identified by some as Ptolemy Philadelphos but by others as Antigonos Gonatas [24].[28] Later in the third century, there is the great portrait from Pergamon, now in Berlin, generally agreed to represent Attalos I [25] (see p. 274); for the early second century B.C. one can cite the portrait in Copenhagen of an unidentified ruler crowned with a wreath of oak leaves;[29] and for the late second and early first centuries B.C. there is the striking series of portraits from Delos representing Greek, Italian, and Asiatic merchants who throve on the slave trade and other enterprises [75–77] (see p. 73). In these latter, the often grimly realistic faces of the subjects quash all illusions of romantic heroism and thus completely override the effect of the Alexander pose. It finally becomes a hollow cliché. Hollow or not, however, it

lingered on among the Greek sculptors who came to be employed in the new and thriving art market of Rome and left its mark, in a memorable if not altogether inspiring way, on the portrait of Pompey the Great [26], who, ancient sources tell us, cultivated what he thought was a personal resemblance to Alexander:

There was a slight *anastole* in his hair and a fluidity in the shape of his face around the eyes that produced a resemblance, more talked about than obvious, to the portraits of Alexander the King. Because of this likeness, and since many applied the name Alexander to him from his early years, Pompey did not repudiate the name, and the result of this was that some came to call him Alexander in a mocking way. (Plutarch, *Pompey* 2.1)

When a modern viewer looks at Pompey's all too human face – mundane, middle-aged, perhaps a trifle overweight – he may feel an element of absurdity in this affectation of the features of Alexander. From Pompey's point of view, however, the decision to affect an 'Alexander look' was probably more pragmatic than aesthetic. Like Alexander, he was a general who had campaigned in the East and been victorious. This achievement was an asset in the world of Roman politics, and he wanted his constituents to be reminded of it. The formal language of portraiture was one means of doing so.

34

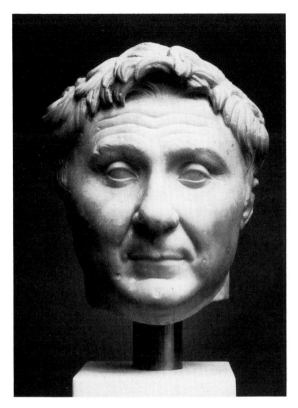

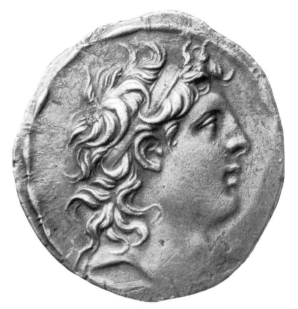

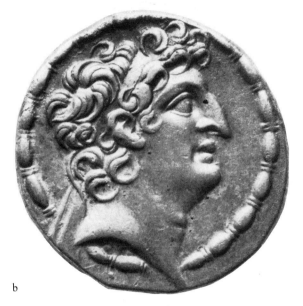

26 Portrait of Pompey. Marble. 1st-century A.C. copy of an
original of *ca.* 60–50 B.C. Copenhagen, Ny Carlsberg
Glyptotek. H. 0.26 m.

b

27 Seleucid coins: (a) Silver tetradrachm with portrait of
Tryphon. *Ca.* 142–139 B.C. Diam. *ca.* 30 mm. (b) Silver
tetradrachm with portrait of Antiochos VIII Grypos.
Ca. 108–97 B.C. Diam. *ca.* 25 mm.

Along with these hybrid portraits which blended the
heroic features of Alexander with historical realism,
there also survived a more 'pure' portrait type based on
the Alexander model, the purpose of which seems to have
been to convey the idea that the subject of the portrait
was a virtual re-embodiment of Alexander. This may
have been the idea, for example, behind the portrait of
Antiochos I issued on the coins of Antiochos II and also of
the portraits of Tryphon, the officer who usurped the
Seleucid throne in 142 B.C. [27a]. Tryphon seems to have
wanted to show himself as a new Alexander with an
excited, leonine mane of hair, one lock of which overlaps
his diadem and seems to echo Alexander's ram's horns
[27a]; and on the reverse of one type that bears this
portrait the message is reinforced by showing a
Macedonian helmet decorated with the eagles and
thunderbolts of Zeus and fitted with a large horn. What
were perhaps memories of the work of Alexander's
master engraver Pyrgoteles evidently survived in Syria for
centuries.

The most vivid of these artistic reincarnations of Alex-
ander, however, are seen in the portraits of the last
effective defender of the Hellenistic world against the
dominance of Rome, Mithradates VI Eupator of Pontos

[28–29]. When Mithradates launched his campaign of
resistance to Roman domination of the East beginning in
88 B.C., he was hailed by many in Asia Minor and the
Aegean area as a liberator from Roman oppression, in the
same way that Alexander about 250 years earlier had
been hailed as a liberator from the Persians. The artists
who served Mithradates quickly developed the necessary
images to reinforce this idea of the king as a new
Alexander. On coins issued from various mints on the

35

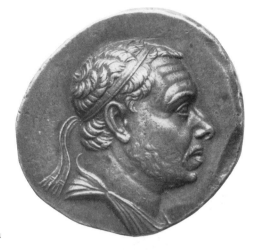

a

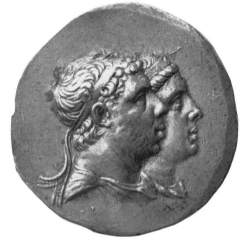

b

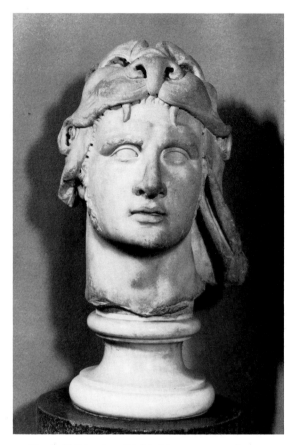

29 Head of Mithradates VI. Marble. 1st quarter of 1st century B.C. Paris, Louvre. H. 0.35 m.

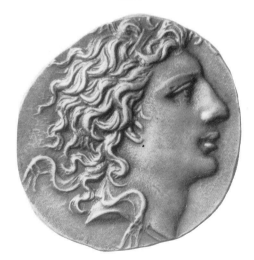

c

28 Coins of Pontus: (a) Silver tetradrachm of Mithradates III (*ca.* 220–185 B.C.). London, British Museum. Diam. *ca.* 30 mm. (b) Silver tetradrachm of Mithradates IV and Queen Laodike (*ca.* 170–150 B.C.). Paris, Cabinet des Médailles. Diam. *ca.* 28 mm. (c) Silver tetradrachm of Mithradates VI Eupator, 'The Great.' *Ca.* 75 B.C. London, British Museum. Max. diam. *ca.* 35 mm.

coast of the Black Sea and from Pergamon, which for a time became his chief residence and base of operations, Mithradates is depicted with the leonine mane of hair, the *anastole*, and the unlined youthful features of Alexander [28c]. The similarity of this portrait to the images of Alexander on the now venerable coins issued by Lysimachos and on the contemporary coins of Roman quaestors in Macedonia is unmistakable and quite obviously deliberate. The contrast of this heroic, romantic image with the sternly realistic images on the coins of Mithradates' ancestors [28a-b] must have been startling to contemporary observers and probably enhanced the propagandistic significance of Mithradates' coins.

In sculptured portraits the analogy between Mithradates and Alexander was apparently given a more complex dimension. A marble head now in the Louvre represents Mithradates wearing the lion-skin cap of Alexander–Herakles [29]. The long sideburns and general profile identify the portrait; otherwise it might be taken as one of the many posthumous portraits of Alexander.[30] This head has been seen by a number of scholars

as providing the key to the significance of a group of statuettes discovered in the north stoa of the Athena sanctuary on the acropolis of Pergamon [30]. The statuettes are of Parian marble and range from 0.41 to 0.73 m in height. They were apparently dowelled to the rear wall of the stoa in which they were placed and thus functioned like relief sculptures. The group consists of an agonized figure of Prometheus bound to a rock adjacent to a personification of the Caucasus mountains and approached by a figure of Herakles. Herakles' pose suggests that he is firing an arrow at the eagle who torments Prometheus. The face of this Herakles, with its sloping, furrowed forehead and bulge at the eyebrows, is not a typical image of the legendary hero. Gerhard Krahmer was the first to suggest that the features are those of Mithradates.[31] If so, and the identification seems probable, the whole group should almost certainly be taken as an allegory in which Mithradates frees the old Hellenistic world from torturous oppression by the Romans. Such an interpretation is completely in keeping with the scholarly taste of late Hellenistic art, and one wonders, in fact, if the idea was not suggested to Mithradates by someone from the nearby library of Pergamon. Even in the most embattled circumstances, Hellenistic art could remain self-conscious and learned.

Royal exploits and monuments

In addition to creating appropriate royal portraits to show the world what the king looked like (or wanted to

30 Statuette of Mithradates as Herakles, from Pergamon, view and details of the head. Marble. Early 1st century B.C. East Berlin, Staatliche Museen. H. 0.73 m.

look like), the artists who created the royal imagery of the Hellenistic period also had the task of creating monuments to commemorate what the king did. The king's bravery and generosity, and at times also his piety, the things which made him worthy of being a king, all required formal expression. Three types of subjects in the visual arts quickly came to be considered suitable for conveying these qualities – hunting scenes, battles, and religious or military processions. In the development of the first two of these genres, the influence of Lysippos once again looms large and in the case of the last of them, although the evidence is very limited, the hand of Apelles seems to be detectable.

The royal hunt, particularly the lion hunt, was a venerable subject in the art of the ancient Orient. It occurred frequently in the art of Pharaonic Egypt and was a common motif in the art of Mesopotamia from the third millennium B.C. down into the centuries just preceding the Hellenistic period. From Mesopotamia the motif spread into other cultural areas of the Near and Middle East and is familiar in Phoenician, Urartian, and Achaemenid Persian art. Perhaps the most vivid renditions of it are the hunt scenes from the reliefs that decorated the palace of the Assyrian king Assurbanipal at Nimrud.

While it seems probable that kings in the ancient Orient did hunt lions and other large animals from time to time, one gets the impression that it became a standard practice to show them doing so whether they actually did so or not; in other words, that the hunt became a kind of gesture of royalty, something that a king was expected to do. In Near Eastern art it is also possible that such scenes, particularly lion hunts, had religious associations and were intended to associate the king with the epic hero Gilgamesh, who was often depicted as a lion-slayer.

One of the most famous of all representations of Alexander in art was a sculptural group at Delphi depicting him engaged in a lion hunt. According to Plutarch the group commemorated an actual hunt in which Alexander risked his life not only to test his own mettle but also to convince his officers that they should not allow themselves to grow soft in the wake of their victory over the Persians. 'Krateros set up a memorial of this hunt at Delphi and had bronze statues made of the lion and the dogs, and also of the King locked in combat with the lion, and of himself coming to the King's aid. Some of these figures were made by Lysippos; others by Leochares' (Plutarch, *Alexander* 40.4). Part of the purpose of this 'Krateros Monument' was no doubt simply to celebrate Alexander's bravery, but it was also probably intended to function as a symbol of a political fact. Most educated Greeks probably would have recognized a depiction of a lion hunt as the sort of monument that was characteristic of an eastern potentate. It was a reminder to the Greeks that Alexander himself was now the Great King, the

master of Asia.[32] Possibly the monument contained an even subtler allusion to Alexander's divinity. Lion-slaying had been one of the chief exploits of another son of Zeus, Herakles, whose image had merged, as already noted, with that of Alexander on the latter's coinage.

In addition to the Krateros monument, there are other literary references to royal hunting scenes in early Hellenistic sculpture and painting. Pliny mentions an 'Alexander hunting' at Thespiai by the sculptor Euthykrates, the son of Lysippos (*NH* 34.66), and a 'Ptolemy hunting' by the Alexandrian painter Antiphilos (*NH* 35.138). Taken together these references suggest that hunting scenes quickly became a familiar genre. Although the monuments mentioned in these passages have not survived, there are several extant and approximately contemporary hunt scenes which preserve something of their character, and perhaps elements of their patterns of composition. One of these, a relief from a cylindrical base or altar found in Messene and now in the Louvre, shows a hunter in Macedonian dress and may, therefore, as has often been suggested, be a direct 'quote' from the Krateros monument [31]. The most elaborate and impressive scenes of this sort, however, occur on the remarkable 'Alexander Sarcophagus,' now in Istanbul [32–33, 37–38]. At the very least this sarcophagus documents in a vivid way the importance of the royal hunt as a motif in Hellenistic art. It was found in the latest of seven grave chambers in the royal necropolis at Sidon in Phoenicia (modern Lebanon). Although not provable, it is highly probable that the sarcophagus was made for Abdalonymos, the last king of Sidon, who was installed on his throne by Alexander after the battle of Issos (333 B.C.) and ruled until his death in 311 B.C. Since a sarcophagus was sometimes made during the lifetime of the person whose body it was intended to contain, an exact date for the production of the Alexander Sarcophagus cannot be specified, but it almost certainly was designed between 325 and 311 B.C.[33] The six relief panels, one on each long side, one on each end, and one in each of the gables at the ends of the lid, represent battles and hunts peopled by figures in Persian dress (with leggings and caps) and with figures who are either Macedonians or Greeks. Some of the latter wear short tunics and armor like real Greek soldiers, but others are depicted with the 'heroic nudity' familiar from Classical Greek architectural and funereal sculpture.

These sculptures fall right on the borderline between the Classical and Hellenistic phases of Greek art and have elements of both. On the one hand the faces of the figures have a generalized youthful quality, like, for example, the figures of the frieze of the Parthenon; on the other hand some of the figures are certainly portraits of particular individuals – Abdalonymos, Alexander, and others – and commemoration of their particular characters was probably the chief function of the sarcophagus. Many of the

31 Relief depicting a lion hunt. Marble. Probably 3rd century B.C. From Messene, now in Paris, Louvre. H. 0.595 m.

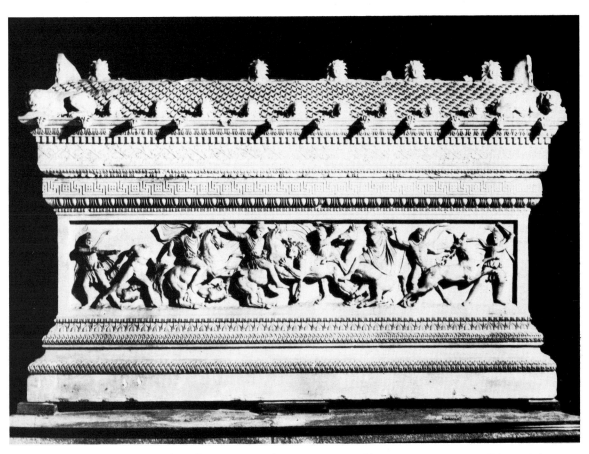

32 Alexander Sarcophagus, lion hunt scene. Marble. *Ca.* 325–311 B.C. From Sidon, now in Istanbul, Archaeological Museum. Length at base 3.18 m.

39

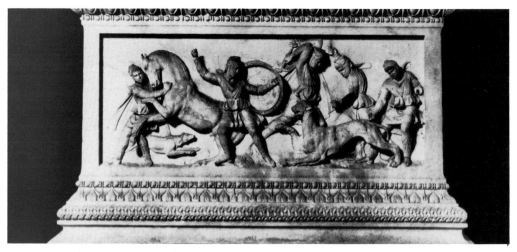

33 Alexander Sarcophagus, hunt scene at one end. Width at base 1.67 m.

motifs and compositions of the various panels are straight out of the Classical tradition and can be paralleled by monuments like the frieze of the Nike temple on the Athenian acropolis;[34] but the dense massing of figures on the relief plane anticipates Hellenistic developments. The idealized feeling of some faces contrasts with the pathos of others, as Hellenistic individualism and historicity struggle to emerge from the beautiful but anonymous language of forms of the Classical past.

In the center of what seems to have been the main panel of the sarcophagus,[35] the lion hunt on one of its long sides, a majestic figure in Persian dress, almost certainly Abdalonymos, is seen driving his spear into a lion which has leaped up to attack his horse [32]. To the right, behind the lion, a companion in Persian dress is about to strike the lion with an axe. Flanking this central group two hunters in Greek dress ride toward the center to spear the lion. (The spears, as well as some other weapons on the sarcophagus, were of metal and are now missing.) On the head of the rider to the left there is a cutting for the attachment of a royal diadem. Although his features are rather generalized, like all the heads on the sarcophagus, and are therefore difficult to identify with certainty, this figure is in all probability Alexander. The rider to the right is perhaps Alexander's intimate companion, Hephaistion.[36] At the left end of the panel a Persian archer and a Greek spearman assist in the hunt; while at the right end a Greek spearman and a Persian with an axe are engaged in killing a stag. Although the stag has sometimes been interpreted as a decoy animal for the lion, it is more probably simply a variant motif within the general theme of the royal hunt. The purpose of this panel on Abdalonymos's funeral monument was to enhance his royal image by showing him engaged in what was *par excellence* the sport of kings and engaged in it, moreover,

in the company of the conqueror who had become the Great King of Asia.

On the right end of the sarcophagus (when viewed from the side with the lion hunt) there is a second, smaller hunting scene in which five figures in Persian dress struggle with an angry, snarling wounded panther [33]. We must assume here that 'Persian' dress is to be taken as a generic characteristic of an oriental and that these figures are in fact Sidonians. Probably the figure with a shield in the center of the composition is to be taken once again as Abdalonymos. In any event, the function of this panel would seem to be to tell the viewer that, even without the presence of illustrious Macedonians, a great hunt was a normal event in the life of the king of Sidon.

Although as a motif the royal hunt appears to be of Asiatic origin, it had already been adopted for use as part of the royal iconography of the rulers of Macedonia in the fourth century B.C. The recent discovery at Vergina of a large fresco painting depicting a hunt for lions and boars on the façade of a Macedonian tomb (Vergina tomb II, identified by some as the 'tomb of Philip II,' see p. 192) may indicate, in fact, that the motif was in use even before Alexander launched his campaign against the Persians.[37] By the time of the pebble mosaic pavements found in the Macedonian capital at Pella [34, 35], one has the impression that the lion hunt and the slaying of the stag have become familiar, adaptable royal symbols which required no specific context to explain their meaning. These mosaics decorated two large residential buildings which are in effect palatial expansions of the ordinary house plan of northern Greece, as known from sites like Olynthos. Whether these buildings were parts of the actual royal residence of Pella or simply the homes of important Macedonian nobles cannot be determined. It is certainly possible that they were part of the palace of

Kassander (ruled 316–297 B.C.) or perhaps even of Antigonos Gonatas (firmly in power, 272–239 B.C.).[38] At any rate their occupants were clearly patrons who had the resources to hire the finest artists of their time. The rooms in which the pebble mosaic pavements were laid were distributed around large colonnaded courtyards and were presumably used for dining and leisure. One would like to think that some of them at least were dining rooms where important matters of state were discussed in the presence of the appropriate symbols of royal authority. In a mosaic depicting a lion hunt from the easternmost of the two buildings in question [34] a spearman to the left and a swordsman to the right advance upon an angry but suitably majestic lion. The artist who designed this and the other mosaics in the east building had, like the designer of the Alexander Sarcophagus, strong roots in the Classical tradition. There is scarcely any overlapping of his figures. The crisp profiles of the two hunters use the 'heroic diagonal' that had become a common stylistic mannerism in Greek relief sculpture and vase painting in the second half of the fifth century B.C. and had become virtually a signature of the relief sculpture of the fourth century B.C. (e.g. the friezes of the Mausoleum of Halikarnassos).[39] The sharpness of the profiles of the hunters is emphasized by laminations inserted among the pebbles at various points to produce straight edges. Shading, used principally on the cloaks of the hunters, is employed with restraint.

The style of the lion hunt mosaic contrasts strikingly with that of a remarkable mosaic representing a stag hunt from the west building at Pella [35]. In this composition depth and mass, creating a dramatic stage for the figures, are stressed. The hunters' dog overlaps the deer, which in turn overlaps the hunters. Amazingly subtle gradations of shade among the pebbles give the figures a roundness and solidity. It is as if they have emerged from surrounding darkness into a spotlight. These elements of technique contribute a feeling of pathos which is also evident in the conception of the scene. Blood flows from the flank of the stag where it has been bitten by the hunting dog; the stag's tongue hangs out, as an indication of its exhaustion and agony; in the heat of the struggle the swordsman's travelling hat pops off his head, its strings waving in the breeze. It is fitting that the artist who conceived this powerful scene, Gnosis, should have left his signature on it, the earliest mosaicist's signature to survive. Gnosis was clearly a master technician whose pictorial skills rivalled those of contemporary painters, and he was also one of the originators of the pathetic spirit that would come to dominate much of later Hellenistic art (see Chap. 5). His signature probably bears witness not only to his pride but also to his reputation.

In tracing the origin of the second great genre of monuments that celebrate royal exploits, i.e. battle scenes, literary references are once again of great value and once again document the inventiveness and influence of Lysippos. Perhaps the most influential battle monument in all of ancient art was Lysippos's 'Granikos Monument,' a group set up at Dion in Macedonia to commemorate those who had died in Alexander's first major victory over the Persians. The Granikos Monument consisted of at least twenty-five bronze equestrian

34 Pella, pebble mosaic, lion hunt. *Ca.* 330–300 B.C. Pella, Archaeological Museum. 4.90 x 3.20 m.

41

35 Pella, pebble mosaic of stag hunt, by Gnosis. *Ca.* 330–300 B.C. *In situ.* H. of figured panel 3.10 m.

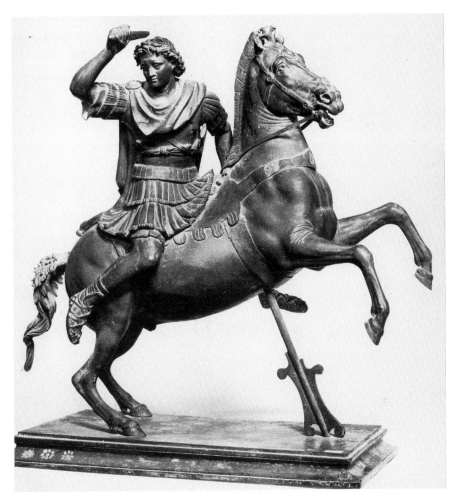

36 Bronze equestrian statuette of Alexander. From Herculaneum, now in Naples,
Archaeological Museum. 1st century B.C. or A.C., based on a work of *ca.* 330 B.C.
H. 0.49 m.

figures, including a portrait of Alexander himself, and perhaps also some figures of infantrymen.[40] As noted at the outset of this chapter, monuments commemorating military victories had had a place in Classical Greek art and some of the Classical monuments included portraits, but nothing on the scale of the Granikos Monument had been attempted before. Like many of the works of Lysippos, it seems to have been a crucially influential monument for the Hellenistic period. Its historicity appealed to Hellenistic individualism; its apparent battlefield realism appealed to the theatrical mentality of the age; and its triumphant image of Alexander must have called to mind the king's irresistible fortune and thus have appealed to the Hellenistic obsession with Tyche.

The Granikos Monument was transported to Rome by Metellus in 146 B.C., and no certain trace of it survives. Some have speculated that a bronze statuette from Herculaneum [36] may be a diminutive copy of the

equestrian portrait of Alexander,[41] but even if this is the case, a single statuette cannot convey to us what the dramatic effect of the massing of figures in the Granikos Monument must have been like. Once again, the surviving work which probably brings us closest to the effect of the Lysippan group is the Alexander Sarcophagus. The dramatic confrontations in the main battle scene of the sarcophagus [37] (which the surviving paint on the eyes of the figures, creating an intensity of expression, makes particularly vivid); its pathos; its clear sense of a sudden 'turn of fortune' as Alexander, riding in from the left, spears his falling and terrified Persian opponent; and its historicity (not only is the figure of Alexander with the lion-skin cap of Herakles a portrait but so also is the young Macedonian rider with a helmet in the center and the older rider with a helmet at the far right) are all features which Lysippos inaugurated and which became typical of Hellenistic art. This battle scene is certainly not

37 Alexander Sarcophagus, battle scene, long side.

38 Alexander Sarcophagus, battle scene at one end.

a copy of the Granikos Monument. The style of the figures, with their relatively large, round heads and stocky bodies, is Attic rather than Lysippan, and is rooted in Classical Athenian art. This is particularly true of the nude Greek warrior facing a Persian rider just to the right of center and of the kneeling Persian in front of them, which are conventional figures from the Classical past rather than examples of Hellenistic dramatic and historical realism. Nevertheless it is highly likely that an echo of the Granikos Monument is at work here. Not only the heroic figure of Alexander but also the two helmeted warriors seem as if they might have been from the Lysippan group. The helmeted warriors have been variously identified. The younger one in the center is often identified as Hephaistion and the older figure to the right has been called Antigonos, or Parmenion, or Perdikkas; but they might equally well be based on the portraits of the Companions who fell at the Granikos.

As was the case with hunt scenes, it seems that Abdalonymos used the main battle scene on the sarcophagus to emphasize his connection with Alexander and then employed subsidiary battle scenes to record his own exploits and experiences. On the left end of the sarcophagus (when viewed from the side with the lion hunt) the mounted warrior in Persian dress who, along with others in Persian dress, fights a group of Greeks with mixed results, is probably Abdalonymos himself [38]. Just what battle, if a specific one is intended, this is is difficult to say. Little is known of Abdalonymos's career after the death of Alexander, but it is probable that he at some point became enmeshed in the wars of the Diadochoi, and that one of the many battles of the period is depicted here. The same is probably also true of the enigmatic gables of the sarcophagus, where, on the right, Persians again fight Greeks, and, on the left, Greeks fight one another. But whatever the specific significance of these scenes was, they obviously testify to the importance of battle scenes in Hellenistic royal imagery.

The most obvious successors of the type of royal battle memorial which the Granikos Monument began were the great Attalid groups in Pergamon and Athens commemorating victories over the Gauls (see Chap. 4), and there were probably numerous other monuments of this general type set up in the cities and sanctuaries of the Greek world. Pliny, for example, mentions a group by Lysippos's son Euthykrates depicting a cavalry battle (*NH* 34.66), and Pausanias describes a number of dedications which commemorated military exploits of the Hellenistic period (for example, the dedications relating to Seleukos, Demetrios Poliorcetes, and Antigonos at Olympia mentioned in 6.11.1, 6.15.7, and 6.16.2).

Literary sources also confirm that historical battle scenes featuring the exploits of kings played an important role in early Hellenistic painting. Pliny mentions, for example, a famous 'Battle of Alexander with Darius'

done for Kassander by Philoxenos of Eretria (*NH* 35.110), a 'Battle of Greeks and Persians' which probably also depicted Alexander, by Aristeides (*NH* 35.99), and a 'Kleitos [presumably Alexander's companion] with his horse hastening into battle' as well as a 'Neoptolemos [one of Alexander's officers] fighting the Persians on horseback' by Apelles (*NH* 35.93 and 96). There is also an inscription found in Athens which records that in 274 B.C. a partisan of Antigonos Gonatas, Herakleitos of Athmonon, paid honor to the king by decorating the Athenian stadium with paintings dedicated to Athena which depicted Antigonos's 'struggle against the barbarians for the deliverance of the Greeks' (*IG* II² 677). (The barbarians in question were Gauls, whom Antigonos had defeated in 277 B.C.) Presumably these paintings were historical in character and depicted specific exploits of Antigonos and his troops against the Gauls. Although no direct evidence confirms that a tradition of paintings of this sort continued in later Hellenistic art, it is likely that it did. One may reasonably assume, for example, that there were battle scenes among the paintings that Metrodoros did for Aemilius Paullus after the battle of Pydna (see p. 156).

The only Hellenistic painting from this genre of battle scenes to survive into modern times was unfortunately allowed to go to ruin late in the nineteenth century. It was a fresco adorning a Macedonian tomb at Naoussa, which is sometimes called the 'Kinch Tomb' after the Danish scholar who eventually published it. A watercolor of the painting made in 1889 obviously cannot be checked for accuracy, and conclusions drawn from it must be used guardedly; nevertheless it does seem to record the same sort of dramatic confrontation and pathos that one finds on the Alexander Sarcophagus. This drama and pathos is also an essential feature, as already pointed out in our discussion of the Hellenistic obsession with fortune, of the great Alexander Mosaic from the House of the Faun at Pompeii [2]. The widely held view that this famous work is a copy of a Greek painting of the late fourth century B.C. is justified by many features of the mosaic – its unidealized picture of Alexander; the historical accuracy with which it depicts the Persians; its attenuation of spatial depth, atmosphere, and topography in order to retain emphasis on the human figures; and its fascination with depicting reflections and highlights (which seem to have been among the proudest achievements of Greek painters in the fourth century). The often repeated suggestion that the mosaic specifically copies the painting by Philoxenos of Eretria mentioned above is more debatable but certainly possible.[42]

Whoever the artist of the original painting was, he was a master of dramatic narrative. His use of emotional interplay between the figures in the scene to heighten its dramatic tension surpasses in sophistication the Alexander Sarcophagus or any other work of Hellenistic art.

The basic action in the mosaic, as on the sarcophagus, is a violent clash in which Alexander spears a Persian rider, one of the 'Immortals' whose sacred duty it was to protect his king. The dramatic focus of the scene, however, is not the irresistible Alexander but the majestic and pathetic figure of Darius who, torn between sympathy and fear, gestures in anguish toward his fallen defender. His mouth is open as he calls out in alarm; his brow is creased; his eyes dilated. Darius's emotional crisis is further intensified by being contrasted and compared with the faces of those around him. His charioteer ignores the tragic plight of those below as he concentrates with an almost hypnotic single-mindedness on getting the king's chariot off the field; Darius's soldiers to the right of the chariot look toward him with the same alarm that he directs at Alexander's victim; and the face of the fallen warrior below the chariot, reflected in his shield, echoes the king's grief. The viewer's sympathy and fellow feeling are obviously drawn much more to the Persians than to the Macedonians. Why the artist designed the scene in this way and whether or not such an emphasis would have pleased Alexander or any other Macedonian patron are difficult questions to answer. The painting of Philoxenos was done, it will be remembered, for Kassander, who hated Alexander and hence would not have objected to seeing Alexander's heroism deemphasized in the painting. There is no evidence, however, that Kassander had any particular sympathy for the Persians. One wonders if the original painting behind the mosaic might not have been done for Alexander himself after Gaugamela, at the time when he was cultivating Persian support for his own role as king.[43] The seemingly realistic, unidealized, undivinized way in which Alexander is depicted would seem to go with the earlier phase of his career rather than with the period when he, and his successors, cultivated the idea of his divinity. But there are, of course, many other possibilities. Perhaps the artist was intent on expressing some of the same spirit of chivalry toward defeated opponents that Alexander was said to have shown. Or perhaps he was one of the first Hellenistic artists to realize that, by giving a certain grandeur to the enemy and making his plight seem real, one also magni-

fies the achievement of the victor. This was the approach that was later employed with such great effect in the Attalid victory monuments (see Chap. 4).

It is also difficult to determine just how strictly historical the scene in the mosaic is. Does it, that is, show a particular battle in Alexander's campaign or does it, in a more general way, try to invoke the campaign as a whole? The overall effect of the scene certainly fits well with Plutarch's description of Gaugamela (*Alexander* 33.3–5). Some features, however, call to mind the battles of Granikos and Issos. It was at the Granikos that Alexander is specifically said to have speared one of the Immortals and to have had his own helmet destroyed in the process (Plutarch, *Alexander* 16.5; Arrian, *Anabasis* 1.15); and at Issos Darius also fled from the battlefield in his chariot (Arrian 2.11). Most probably the artist wanted to fuse historical details into an artistic unity which expressed the essence of a series of historical events but which, in order to have the broadest possible significance, transcended the limitations of a particular time and place.

In addition to representations of royal hunts and battle scenes, there was probably a third category of monuments which celebrated the achievements of rulers, i.e. representations of military and religious processions. The evidence for them is exclusively literary, however, and very limited. Pliny mentions several paintings by Apelles which seem to fit such a category: 'War (*Polemos*) with his hands tied behind his back riding with Alexander in a triumphal chariot,' 'Castor and Pollux with Victory and Alexander' (*NH* 35.93), and 'Antigonos, wearing a cuirass, marching along with his horse' (*NH* 35.96). There were also works of sculpture which, if they did not actually depict processions, were at least made for use in processions. In the great procession of *ca.* 276 B.C. in Alexandria described by Kallixeinos (see Appendix III) there were images of Alexander and Ptolemy accompanied by such figures as Virtue, Victory, and a personification of the city of Corinth. These references call to mind Roman triumphal paintings and sculpture and suggest that Hellenistic art may have had some influence on them.

2

Lysippos and his school

Lysippos

In the preceding chapter the achievements of Lysippos of
Sikyon have been mentioned many times. Lysippos was
probably the single most creative and influential artist of
the entire Hellenistic period. During the first 75 years of
the period, in particular, he and his pupils created new
types of monuments and made stylistic innovations that
would be used in Hellenistic art for centuries. The aim of
the present chapter is to summarize what has already
been said about the achievements of Lysippos, to sup-
plement that discussion with additional examples, to put
the overall achievement of the school into its proper
perspective, and to discuss surviving sculptures which
have been plausibly related to the Lysippan tradition.

Ancient sources suggest that Lysippos had a long and
prolific career, stretching from perhaps as early as 370 or
360 B.C. to as late as *ca.* 305 B.C.[1] One consequence of
this long period of activity was that he spanned two eras
and had something of a split artistic personality. He was
both a late Classical sculptor, a contemporary of Prax-
iteles and Skopas, and also one of the creators of Hellen-
istic art.

It seems that from early in his career Lysippos was an
innovator, but in the earlier, Classical phase of his career
his innovation took place within a well-defined tradition,
a tradition which had been made famous by Lysippos's
most illustrious predecessor in the Peloponnesos,
Polykleitos. Although Polykleitos did a number of images
of gods and heroes, the majority of his works, and the
most renowned ones, were statues of young men which
were set up in the sanctuary at Olympia to commemorate
athletic victories. It was apparently for such works that
Polykleitos worked out the famous canon of proportions
which was illustrated by his most admired creation, the
Doryphoros, or Spear Bearer, a work which was
sometimes simply referred to as 'the Canon.'[2] Since the
earliest works of Lysippos seem also to have been statues
of athletes,[3] since Cicero tells us that Lysippos made the
Doryphoros of Polykleitos his 'master' (*Brutus* 86), and
since Pliny tells us that Lysippos used a canon of propor-

tions, it might be tempting to see Lysippos, in the first
phase of his career, as a rather conventional follower of
Polykleitos. There is, however, a seeming contradiction
of this supposition in our sources. Pliny also relates that
Lysippos was originally simply a bronzesmith and that he
was inspired to become a sculptor when he heard the
Sikyonian painter Eupompos remark that nature, and
not another artist, was his model (*NH* 34.61). On the one
hand, then, Lysippos is presented to us as a naturalist,
and on the other he is said to have been a devotee of ideal
canons of proportion. Are the two compatible? The
solution to this contradiction can probably be found in
the unusually specific description which Pliny gives of
Lysippos's canon:

He is said to have contributed much to the art of casting statues
by representing the hair in detail, by making the head smaller
than earlier sculptors had, and by making the bodies slenderer
and more tightly knit, as a result of which the height of his
statues seems greater. There is no Latin term for [the Greek
word] *symmetria* which he observed with the utmost precision
by a new and previously unattempted system which involved
altering the 'square' figures of the older sculptors; and he used
commonly to say that by them [that is, the earlier sculptors] men
were represented as they really were, but by him they were
represented as they appeared. What seem to be especially
characteristic of his art are the subtle fluctuations of surface
which were apparent even in the smallest details. (*NH* 34.65)

What this passage tells us is that Lysippos did, like many
of his predecessors, aspire to incorporate an ideal set of
proportions in his statues, and hence developed his own
canon, but that his canon took into account one's ordi-
nary optical experience of objects in space. He did not
simply want his statues to be tall, he wanted them to *seem*
tall (*proceritas signorum maior videretur*), and he modi-
fied proportions to achieve this effect.

In surviving works which can be plausibly associated
with Lysippos one can detect three specific stylistic
features which were practical consequences of Lysippos's
principles of design. First, the heads of his statues, as
Pliny specifically notes, are smaller than had been the case
in earlier Greek sculpture (about one eighth the height of

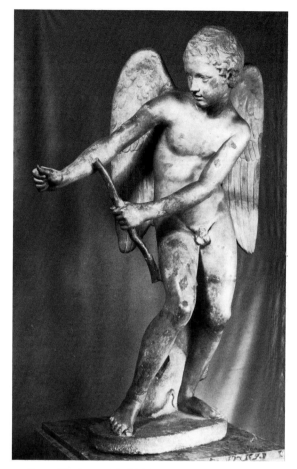

40 Eros of Lysippos. Marble. Roman copy of an original of *ca.* 340–330 B.C. Paris, Louvre. H. 1.30 m.

39 Apoxyomenos of Lysippos. Marble. Roman copy of an original of *ca.* 340–330 B.C. Rome, Vatican Museums. H. 2.05 m.

the body, as opposed to about one seventh). Second, torsion is used in the composition of the body in such a way that there is no single point of view from which the statue may best be studied. The viewer is made to adapt to the statue's space rather than vice versa. And third, arms and knees are made to project out of the traditional closed spatial envelope, thus intruding once again on the viewer's space. All of these features had the effect of making the viewer come to terms with his statues 'as they were seen' or 'as they appeared' (*quales viderentur*) in addition to 'as they were' (*quales essent*, that is, as they could be known by measurement and defined by numbers). The work which best embodies these hallmarks of Lysippos's Classical phase is the Apoxyomenos, 'Athlete scraping himself with a strigil,' in the Vatican [39], a work almost universally accepted as a Roman copy in marble of an original Lysippan bronze. (The original is known to have been in Rome in the time of Tiberius.)[4]

Perhaps also from the sculptor's early phase, and, if so, a good example of the versatility which was to make him so influential in the Hellenistic age, is the Eros [40], known through a number of Roman copies. The original was in all likelihood the bronze Eros at Thespiai mentioned by Pausanias (9.27.3) which Lysippos perhaps intended to rival a famous marble image of the god in the same city by Praxiteles. The action in which the Lysippan Eros is engaged is apparently that of unstringing the bow and was perhaps chosen by Lysippos because it gave him an opportunity to use bodily torsion and projecting limbs, features which must have contrasted startlingly with the static elegance that seems to have characterized the Praxitelean Eros.[5]

The early Lysippos, then, was an artist with a strong sense of tradition but also an innovator who was particularly concerned with appearance and with the effect which his work had on viewers. He seems to have been endowed with a subtle and sophisticated form of what I have called the 'theatrical mentality' in the sense that

many of his works were designed to startle, surprise, and emotionally engage those who saw them. It was probably this theatrical sense, along with his almost legendary technical virtuosity, which made him so successful in the next phase of his career, already described in some detail (see p. 20), when he was the acclaimed court sculptor of Alexander. His heroic portraits of Alexander made their subject come alive like a character in a drama and engage the emotions of viewers. Kassander is said to have trembled with fear when he confronted one of these portraits at Delphi. Likewise the great royal commemorative groups, the Granikos Monument and the Krateros Monument, must have been highly theatrical in character, rather like stage sets with the actors turned to bronze.

Except for those works which were executed expressly for Alexander, scarcely any of Lysippos's sculptures can be dated on the basis of indisputable evidence. His career extended beyond Alexander's death, but for exactly how long is not certain. An inscription found at Delphi records that the Krateros Monument was dedicated by a son of Krateros. Since Krateros died in 321 B.C., it is assumed that the group at Delphi was made sometime after that date (otherwise Krateros would have dedicated it himself), but even this conclusion is not inevitable (the making of the group could have preceded its dedication by some years). The most firm date for the later phase of Lysippos's activity is provided by Athenaios (784) who records that Kassander commissioned Lysippos to design a distinctive wine jar in connection with the founding of the city of Kassandreia in 316 B.C.[6] Because the chronological evidence is so limited, any reconstruction of what happened in the later stage of Lysippos's career, when he and his pupils were in effect creating Hellenistic sculpture, must necessarily be subjective and intuitional.

My own intuitional reconstruction of his career at this stage sees him as an unusually famous figure (for an artist) whose association with Alexander made him much in demand and led to his being deluged with commissions. This success in turn resulted in the formation of a substantial school, in which his sons and disciples shared his prosperity. He continued to be an innovator, and his innovations were guided by and geared to his perceptions about the changing nature of the society in which he lived. Perhaps as a result of travels with Alexander, he came very quickly to grasp the nature of the larger stage on which Greek art would henceforth play its role. He saw both that the temperament of kings would have to be taken into account and also that, in the cities founded by these rulers, the audience for which new works in the Greek tradition would be created could not be expected to have the homogeneous cultural background that was taken for granted in the old Greek city-states. The new art would therefore have to contain features that were dependably universal in their appeal or it would have to be designed for particular individuals or special classes

within a mixed society. Assuming that Lysippos's perception ran somewhat along these lines, it is not surprising to find that his innovations were apparently concentrated in three specific areas: a continuing theatricality, achieved in particular by manipulations in sculptural scale; a continuing exploration of the emotional expressionism that he had inaugurated in his portraits of Alexander; and an expanded interest in symbolism and allegory.

Lysippos's manipulation of scale for effect is best illustrated by the fact that he brought colossal sculpture back into vogue. In the Archaic period, when Greek sculptors were still in close contact with the Near East (from which they had learned much of their technique), colossal sculptures had been common. In the Classical period, however, perhaps as a result of the prevailing humanistic, anti-oriental spirit that followed the Persian wars, the use of colossal scale seems to have been rejected, except in the case of special groups of cult images, most notably the Athena Parthenos and Zeus Olympios of Pheidias. Lysippos's decision to bring colossal scale back into public sculpture (that is, sculpture in public places and in sanctuaries out in the open air) may have been stimulated by a rebirth of interest in and of influence by the Orient. Alexander and his followers may have been dazzled by the ancient colossal sculptures of Egypt, Babylon, and Persia and have wanted to recreate some of that grandeur in the west. But Lysippos also probably valued the colossal scale for its theatrical effect. Anyone could be dazzled by it; cultural conditioning was not required in order to appreciate it.

Two of the best known works of Lysippos were colossal bronzes of Zeus and Herakles at Tarentum. It is not known when these two great creations were made, but it seems highly probable that the sculptor would not have received such grand commissions until after he had won world-wide fame as Alexander's court sculptor.[7] The Herakles was carried off to Rome by Fabius Maximus in 209 B.C. and set up on the Capitoline (see pp. 153–4). Later it was moved to Constantinople and was finally destroyed during the Frankish sack of that city in 1204 A.C. The Zeus, perhaps because of its size (40 cubits or about 18 m high) rather than Fabius's reputed piety, remained in Tarentum, where it was seen (presumably) and described by the elder Pliny in the first century A.C. (*NH* 34.40). In addition to being enormous, this statue, according to Pliny, was equipped with some sort of device (gears? internal counterweights? wheels?) which made it possible to move it by hand (*mirum in eo quod manu, ut ferunt, mobilis*) and yet it could not be overthrown even by the most violent storms. Whatever this device was, it seems likely that Lysippos used it in order to make an already startling statue even more startling.

In addition to the colossal bronze at Tarentum, Lysippos executed several other renowned figures of Herakles, and the evidence regarding the scale of these figures, as

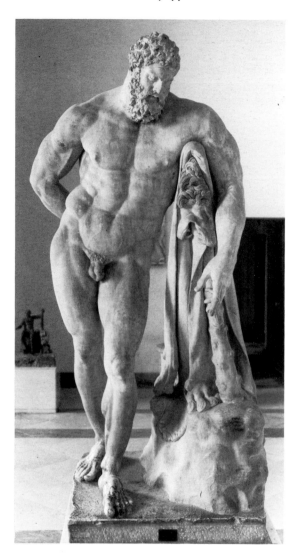

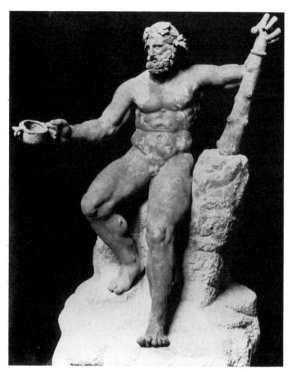

42 Herakles Epitrapezios of Lysippos. Bronze. Roman version of an original of the late 4th century B.C. Naples, Archaeological Museum. H. 0.75 m.

41 Herakles Farnese. Marble. Early 3rd century A.C., based on a prototype of the late 4th century B.C. Naples, Archaeological Museum. H. 3.17 m.

known from both literary sources and Roman copies, suggests that a continual variation of the scale of established sculptural types may have been a major feature of the Lysippan school. The most often copied and imitated Lysippan Herakles in Antiquity was the 'Herakles Farnese' type, the weary Herakles leaning on his club, of which the colossal statue in Naples, the name-piece of the type [41], is the most famous example.[8] The statue in Naples is about twice life-size and is characterized by heavy, dramatically exaggerated musculature. It comes from the Baths of Caracalla in Rome and is signed by a copyist Glykon of Athens, who perhaps made it specifically for the Baths in the early third century A.C. Many other versions of the type exist. Some are

miniature, some are life-size, some are over life-size. Some have heavy musculature and a dramatic elaboration of the features of the face which ties them to the Hellenistic baroque tradition (see Chap. 5). Others are slender and restrained in the manner of the late fourth century B.C. Given these variations scholars have devoted considerable energy to defining the scale and the features of 'the original,' i.e. the work of Lysippos from which the existing types descend. Pausanias (2.9.8) mentions (but does not describe) a bronze Herakles by Lysippos in the agora at Sikyon, and it is sometimes assumed that this was the original work. Are we obliged to conclude, however, that there was only one 'original' of the Herakles Farnese type? Pliny records a tradition that Lysippos made as many as 1,500 works (*NH* 34.37). Even given the fact that the sculptor had a long career this seems an incredible, in fact, impossible, number. It becomes less incredible, however, if one assumes that once Lysippos designed a certain type, his workshop would produce a number of versions of it on various scales (as has been done, for example, with the works of Rodin) in order to meet 'demand.'

That the Lysippan school might have followed such a procedure is suggested by the extant versions of another Lysippan Herakles, the Herakles Epitrapezios [42]. This type, which depicted the hero seated, and banqueting, is

described by the Roman poets Martial (9.44) and Statius (*Silvae* 4.6.32–47), who record that it was a miniature work, 'one foot high,' which had once belonged to Alexander but in their time (late first century A.C.) had come into the possession of a Roman collector named Novius Vindex. That this work really existed is confirmed by several copies of it on the appropriate small scale. In 1960, however, a colossal version of the type was unearthed at Alba Fucens, a Roman colony in central Italy. The Alba copy seems to date from *ca.* 200 B.C. and was probably transported to Italy in the first century B.C. It seems more reasonable to conclude that the Epitrapezios type was produced from the beginning on several scales rather than that the Alba type is a 'blow up' of a single Lysippan original. The original of the miniature may well have been a *jeu d'esprit* produced by Lysippos for Alexander's table, as the Roman poets say. It has been suggested, in fact, that the work may have been a westernized version of the miniature images of gods which were popular in Phoenicia and were sometimes placed on ship's tables.[9] Alexander and Lysippos may have encountered such table pieces during the siege of Tyre. The conceit of compressing a familiar version of Greece's biggest hero into this small form perhaps amused and diverted Lysippos and his patron. The miniature may have provided a private surprise in the same way that the newly created colossi were creating a public one.

Lysippos's figures of Herakles also offer a good illustration of the second of his lines of innovation, that is, the development of emotional expressionism. The colossos at Tarentum and the Herakles Farnese type are both notable not only for their size but also for a certain pathos. Both depicted the weary Herakles, the hero who, having done great deeds and endured the trials of life, yearns for rest. In the Farnese Herakles the scale and the massive musculature of the figure contrast ironically with its weariness and heighten its poignancy. The contrast is so effective and expressive that one feels there must have been at least one Lysippan prototype which had the same scale and some of the same massiveness. A Byzantine writer's description of the Tarentine colossos indicates that it too had this contrast and poignancy.

He sat there with no quiver slung upon him, neither bearing a bow in his hands nor brandishing a club before him, but rather stretching out his right foot and also his right hand as much as was possible, while bending his left leg at the knee and leaning on the elbow of his left arm, with his forearm stretched upward, thus gently supporting his head in the palm of his hand, a figure full of despondency. (Niketas Choniates, *De Signis Constantopolitanis* 5)

A stone head in Tarentum which has been dated to the third century B.C. and thought to be a free copy on a reduced scale of the Lysippan colossos [43] suggests that the pathos inherent in the composition of the figure was

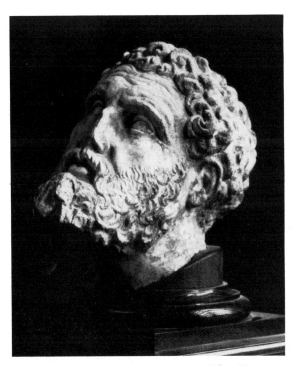

43 Head of Herakles from Tarentum. Marble. Perhaps 3rd century B.C. Taranto, Archaeological Museum. H. 0.31 m.

also vividly expressed in its face. Its time-worn, even haggard brow and eyes, if they do stem from a Lysippan original, reaffirm the idea that Lysippos played an important role in initiating the style which, in a later stage of the Hellenistic period, is often referred to as baroque (see Chaps. 4 and 5).

Herakles is in many ways a projection of, and a spontaneous symbol of, the Greek cultural psyche. In the youthful and vigorous art of the Archaic period he was usually depicted as confidently thrashing his opponents or joyfully banqueting on Olympos. In the Classical period he was seen as the self-controlled hero and ally of the gods who are his helpmates (as on the metopes of the temple of Zeus at Olympia). The shift in emphasis which Herakles figures undergo during the Hellenistic period, a shift in which weariness and a yearning for an end to labor replace violence and confidence, was undoubtedly meaningful. It may be that in initiating this shift Lysippos may have had in mind Herakles' analogue in real life, the sculptor's patron Alexander, and also those Diadochoi who aspired to be like him. Alexander, as we have seen, not only claimed to be a descendant of Herakles but also had Herakles, and perhaps himself as Herakles, depicted on his coins (see p. 25). Like Herakles he accepted great toil, performed great deeds, and in the end went beyond mortal limitations and became a god. It seems to have been the penultimate phase of this cycle that fascinated

44 Portrait identified as Aristotle. Marble. Roman copy of an original of *ca.* 330 B.C. Vienna, Kunsthistorisches Museum. H. 0.29 m.

45 Portrait of Socrates. Marble. Roman copy of an original of *ca.* 340–320 B.C. Rome, National Museum of the Terme. H. 0.355 m.

Lysippos, the stage when the hero's *ponos*, labor, and *pothos*, great yearning, have been worked out, and a higher, superhuman existence is on the horizon, an existence which shed the pains of ordinary life. Such an existence, whether achieved by philosophical insight or religious ecstasy, was one of the ideals of Hellenistic thought (see pp. 8–9). Both the Cynics and the later Stoics used Herakles as a symbol of the human aspiration for final peace achieved through great effort.[10] Lysippos may have had an early understanding of this drift in Hellenistic philosophy and have striven to give it concrete form. His Herakles figures were perhaps intended to capture a stage of the human psyche beyond the aspiring, aggressive one so brilliantly captured in his portraits of Alexander. Because they did so, they had an innate appeal not only to the Hellenistic age but also to the Roman and late antique periods, and were imitated and reproduced for centuries.[11]

If the weary Herakles type is fairly interpreted in this way, the Herakles Epitrapezios type may also deserve a more serious interpretation than it seems to call for at first sight. The small scale of the most familiar version of the type and the fact that it appears to have been a table ornament, have naturally suggested to most scholars that *Epitrapezios* means 'on the table.' The discovery of the

colossal version of the type at Alba Fucens has suggested a reinterpretation, however, in which the cognomen is taken to mean 'at the table' and to be a reference to Herakles banqueting on Olympos after attaining immortality.[12] Perhaps Lysippos intended the type to express the end of the journey of the heroic and philosophical psyche.

The poignancy of Lysippos's Herakles figures, which was also a feature of his portraits of Alexander and which is also detectable in his presumed portrait of Aristotle [44] (see p. 66), can be found in still other works which are somewhat more dubiously, but at least plausibly, connected with him. One of these is a portrait of Socrates. The historian of philosophy Diogenes Laertios (third century A.C.) records that the Athenians set up a portrait of Socrates in the Pompeion, a building just outside one of the main gates of Athens, 'soon after' Socrates' death, and that this portrait was a work of Lysippos (Diog. Laert. 2.43). For Lysippos to have been the sculptor 'soon after' would have to mean something like 70 years, but

perhaps from Diogenes Laertios's viewpoint this may have seemed soon. It has been suggested that the portrait was set up at the time when the conservative Athenian leader Lykourgos was commissioning monuments to glorify Athens's cultural traditions,[13] but it is also possible that it was set up by Alexander at the suggestion of Aristotle. There are two major types of Socrates portraits preserved in Roman copies. One ('Type A') depicts the philosopher as nearly bald, with relatively simple strands of hair on the side of his head and over his ears, and a compact triangular beard. This type is usually dated to the early or middle fourth century B.C. and is sometimes ascribed to Silanion, who also did a portrait of Plato (see p. 64). The other type ('Type B') is similar in its basic structure but has much more copious, deeply carved hair and a wrinkled brow which adds a certain pathos to the face. It is this latter type which is ascribed to Lysippos [45].[14]

Following the insight of Frederick Poulsen that the work bears a strong structural resemblance to the Lysippan Socrates, Sjöqvist and others have also attributed to Lysippos the figure of a dancing satyr known as the 'Borghese Faun' or 'Borghese Marsyas' [46]. The torsion of the satyr and its slenderness do seem to recall Lysippos's canon for figures of athletes. If not by Lysippos, it is at least in the Lysippan tradition. The innovative quality of the satyr and the thought which it may express are eloquently summed up by Sjöqvist:

In the fifth century the satyrs in Greek art were the uncomplicated, frolicking, ithyphallic companions of Dionysus and the maenads. In the Borghese figure it is a basically tragic problem child who stares at us. Not divine, not human, nor animal, he is another example of the complicated border figures, who, on a different level, were exemplified by Alexander the Great and Socrates. The tension and the insoluble problem involved in being both superhuman and subhuman, of combining an elevated and a base nature in one and the same personality, results in a tragic conflict expressed in the tense features of the Borghese head.[15]

The last of the new directions in which Lysippos helped to steer Hellenistic art, that is, an increasing fondness for allegory, symbolism, and personification, is represented by his 'Kairos,' 'Opportunity' or 'The right moment.' Because of its obviously literary quality this work is described in some detail by a number of ancient authors, and from these descriptions it has been possible to recognize echoes of the work in later decorative reliefs [47] and gems. The original was a bronze in Sikyon.[16] Because an epigram of Poseidippos describes it as being ἐν προθύροις, which could mean 'in the doorway' or 'on the porch' or 'in the portico,' some have assumed that Lysippos set it up on the porch or portico of his own house and that it was a kind of personal manifesto.[17] Poseidippos does not say, however, where this porch or portico was; it could have belonged to a public building.

46 The 'Borghese Faun.' Marble. Roman copy of an original of the later 4th century B.C. Rome, Villa Borghese. H. 2.06 m.

The epigram of Poseidippos, who was active *ca.* 270 B.C. and perhaps saw the work not long after it was made, describes in brief the basic features of the Kairos. (The epigram takes the form of a dialogue between a questioner and the statue itself):

Anth. Graec. 2.49.13 (*Anth. Pal.* 16.275), an epigram by Poseidippos: Questioner – 'Who was the sculptor and where was he from?' Statue – 'He was a Sikyonian.' Q. – 'And what was his name?' S. – 'Lysippos.' Q. – 'And who are you?' S. – 'Opportunity, the all conqueror.' Q. – 'Why do you stride on the tips of your toes?' S. – 'I am always running.' Q. – 'Why do you have pairs of wings on your feet?' S. – 'I fly like the wind.' Q. – 'Why do you carry a razor in your right hand?' S. – 'As a sign to men that my appearance is more abrupt than any blade [is sharp].' Q. – 'And your hair, why does it hang down over your

47 Relief based on the Kairos of Lysippos. Marble. Torino Museum. H. o.6o m.

face?' S. – 'So that he who encounters me may grab it.' Q. – 'By Zeus, and why is the back of your head bald?' S. – 'Because nobody, once I have run past him with my winged feet can ever catch me from behind, even though he yearns to.' Q. – 'For what reason did the artist fashion you?' S. – 'For your sake, stranger. And he placed me before the doors as a lesson.'

Poseidippos's picture is supplemented by later and longer descriptions by the late antique rhetoricians Kallistratos and Himerios (fourth century A.C.), who inform us that it held a scale in its left hand and stood on a globe. Although not all of the features so described can be found on any single surviving illustration of it, such as the relief from Torino illustrated here [47], all of them can be found on one copy or another.

The full significance of the Kairos, in Lysippos's own mind, and in the minds of his contemporaries, has recently been the subject of ingenious speculation. The most obvious interpretation is that the work was an allegorical elaboration of the proverbial ideas that opportunities appear only for a moment and can never be recaptured if missed and that the turn of human events is delicately balanced, as if on the edge of a razor. These are notions that Lysippos, having witnessed the fortune-filled career of Alexander and the subsequent opportunistic careers of the Diadochoi, might well have taken to heart. In the Introduction we have discussed how an obsession with the mutability of fortune and with the ups and downs of life for which fortune was thought to be responsible became the chief philosophical concern of the early Hellenistic period. That Lysippos shared this preoccupation and undertook to create a form that expressed it is by no means improbable. The form in which he did express the idea, moreover, was also thoroughly in keeping with the spirit of the age. A didactic, 'readable' visual allegory would have appealed to men like Demetrios of Phaleron, for example, and others who were busy shaping the new scholarly mentality of the period.

It has also been proposed, however, that in addition to its obvious allegorical content, Lysippos also intended the Kairos to express his personal artistic credo. Perhaps, for example, it was intended to express the fact that his art dealt with the temporal and ephemeral (things 'as they appeared') whereas his predecessors dealt with timeless essences (things 'as they were').[18]

The school of Lysippos

With a few exceptions the works of Lysippos's sons, pupils, and grand-pupils are known only through literary references. A brief survey of these references makes it clear that each of them, in one way or another, carried on his innovations and broadcast them throughout the Hellenistic world. His son Euthykrates, for example, who was said to have favored the austere and perhaps theoretical side of his father's style rather than its elegance, was remembered for a group of 'Alexander hunting,' a 'Cavalry battle,' and a figure of Herakles (Pliny, *NH* 34.66), all apparently in the tradition of some of Lysippos's most famous works. Another son, Daippos, did a *Perixyomenos*, 'Man scraping himself all over with a strigil,' a work which sounds as if it was in the tradition of the Apoxyomenos (*NH* 34.87).[19] Chares of Lindos, who was a pupil of Lysippos, took his cue from his teacher's colossi at Tarentum and created the largest and most famous colossos of them all, the Colossos of Rhodes. This was a bronze representation of Helios, a favored deity on Rhodes, and measured 32 m high. It apparently stood on a mole at the entrance to the harbor of Rhodes and was erected *ca.* 280 B.C. In 224 B.C. a great earthquake shook it to the ground, where it lay for centuries as one of the wonders of the ancient world. Lysippos no doubt would have been pleased by the effect that his pupil's work produced. We have no hard evidence for what the colossos looked like, but it is tempting to think that a head of Helios now in the Archaeological Museum in Rhodes [48] may have been modelled on it. The head's turbulent shock of hair and turn of the neck are reminiscent of the Lysippan Alexander portraits.[20] Teisikrates, who was a pupil of Euthykrates and hence a grand-pupil of Lysippos, seems to have stressed the Lysippan tradition in portraiture (*NH* 34.67). He was remembered particularly for his portrait of Peukestes, the shield-bearer of Alexander who had saved the king's life during the eastern campaigns and subsequently became satrap of Persia; and for a portrait of Demetrios Poliorcetes, a copy of which (as already described, p. 32 [22]) may be preserved in a bust from Herculaneum. Lysippos's intellectual side was carried on with particular distinction by one of Teisikrates' pupils, the sculptor and art historian Xenokrates (*NH* 34.83).

The statue by a Lysippan pupil which we can best appreciate today is the Tyche of Antioch [1] by Eutychides, a work whose intellectual background has already been discussed (p. 3).[21] It depicted the goddess seated on a rock with a personification of the river Orontes beneath her, with the city wall as her crown, and with sheaves of grain in one hand. From the point of view of style what puts the Tyche most squarely in the Lysippan tradition is the complexity of its composition, which,

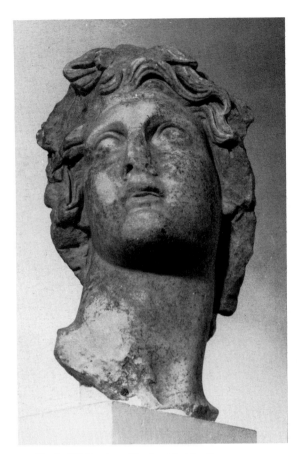

48 Head of Helios from Rhodes. Marble. *Ca.* 200–150 B.C. Rhodes, Archaeological Museum. H. 0.55 m.

as in the works of Lysippos, uses contrasting axes, torsion, and projecting knees and arms to create a sense of spatial freedom. The crossing of the figure's legs creates thrusts and major surfaces to the right and left of the figure, the latter of which is counteracted by the movement of the river god. The strong diagonal created by the stretching of the drapery from the left hand to the right shoulder is counteracted by the turn of the head to the viewer's right. These internal forces seem to make the energy of the goddess radiate in many directions and compel the viewer to study it from many angles. In addition to its composition, the use of attributes – the city-wall headdress, the sheaves of grain, the rock, and the personified river – to create a kind of allegorical statement in the tradition of the Kairos (i.e. the goddess who bestrides the hill beside the river wears the city as a crown and gives it prosperity) also gives the Tyche a Lysippan flavor.

Beyond works like the Tyche and the Demetrios portrait which can be connected with specific followers of Lysippos, there are several prominent surviving works which, though anonymous, are very frequently connec-

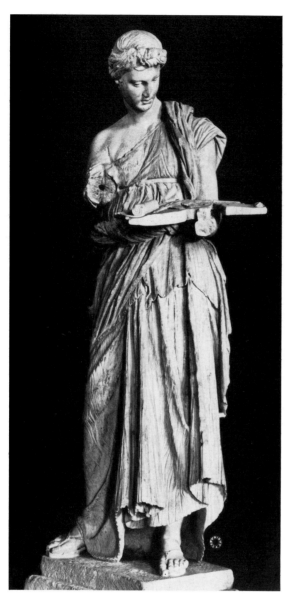

49 The 'Anzio Girl.' Marble. Roman copy of an original of the first half of the 3rd century B.C. Rome, National Museum of the Terme. H. 1.70 m.

attendants, serving in her role as priestess of Aulis.[23] The chief reason for placing the work in the Lysippan tradition is its spiral torsion, beginning from the right foot and revolving smoothly in a counter-clockwise direction toward the tray and head. Once again there is the familiar Lysippan spatial freedom, with its multiplication of important aspects. Recognizing a Lysippan quality in the work, Adolf Furtwängler in 1907 made the ingenious suggestion that the Anzio girl might be a work by one of the pupils of Lysippos which is mentioned in Pliny, the *Epithyousa*, 'Woman offering sacrifice,' by the sculptor Phanis (*NH* 34.80).[24] That this statue should be the very work so obscurely mentioned by Pliny, however, seems to strain coincidence. The date of the original, furthermore, has with good reason been thought to be too late for one of the direct pupils of Lysippos. Most estimates of the statue's date proceed from an assessment of its drapery. In most female figures of the Classical period drapery is subordinated to the structure of the body and arranged in harmonious parallel folds which serve to model the form of the body. In the Anzio girl the drapery is massive and tends to be arranged in independent forms which conflict with and obscure the structure of the body. Her *himation*, for example, is wound up in a thick roll which is strung around her waist; the *chiton* is belted twice, once under the breasts and once at the waist, beneath the rolled *himation*, and a portion of it which has been pulled up over the belt falls down beneath the *himation*. The result is a series of independent drapery surfaces, each with its own pattern and mass. Some of this segmentation can also be found on the copies of the Tyche of Antioch, but in the Anzio girl the process seems carried a stage farther. The *chiton* has a crinkly, ribbed texture which appears on some of the copies of the Tyche, but has its closest parallel in a portrait of a priestess named Nikeso from Priene [287], datable by inscription to the first half of the third century B.C. Finally, at the edge of the *chiton* which stretches diagonally from the left shoulder to the right arm, a separate strip of material has been sewn on to hold pleats in place. This feature also appears on the 'Queens' vases' (see p. 273) from Alexandria and was perhaps an Alexandrian fashion of the mid-third century B.C. Putting all the evidence together, it seems most likely that the original of the Anzio girl dated from *ca.* 250 B.C. and that it was a relatively late echo of, if not a product of, the Lysippan school, which in other ways anticipated some of the features of Hellenistic baroque (see p. 111).

Another female type often attributed to the Lysippan school is the 'Crouching Aphrodite' [50], a work which was apparently extremely popular in the Roman period and survives in numerous copies and variants. Aphrodite is depicted in a position that would enable her to pour water over her back during a bath. In essence the sculptor has taken the famous Praxitelean motif of the nude,

ted with his school. Of these the finest and most obviously Lysippan from the standpoint of composition is the marble figure known as the 'Girl of Anzio' [49]. This figure was found in 1878 at Anzio in the remains of a villa of early Roman Imperial date. Although it has sometimes been called an original, most scholars take it to be a high-quality Roman copy of what was probably a bronze original.[22] It depicts a young woman holding a tray of sacrificial implements in her left hand. Presumably she is a priestess or a priestess's attendant. Because of the very smooth, youthful face, it is possible that the figure may represent the young Iphigeneia or one of her

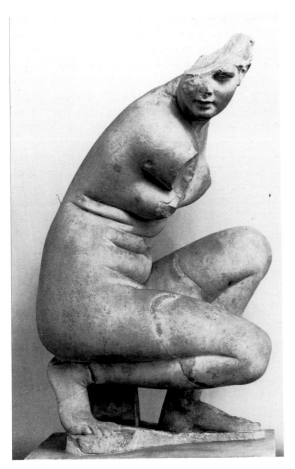

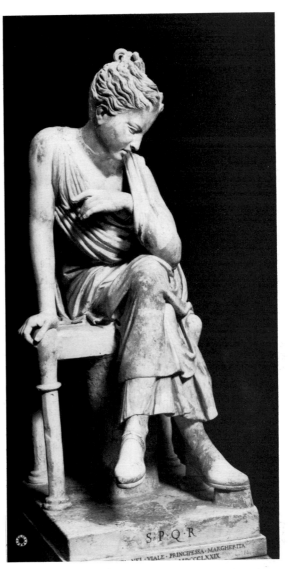

50 Aphrodite attributed to Doidalsas. Marble. Roman copy
 of an original of *ca.* 250 B.C. Rome, National Museum of
 the Terme. H. 1.06 m.

51 Seated girl. Marble. Roman copy of an original of the 3rd
 or 2nd century B.C. Rome, Capitoline, Palazzo dei
 Conservatori. H. 1.03 m.

bathing Aphrodite and given it a twisted, multifaceted
form in the tradition of Lysippos. The Crouching
Aphrodite type is usually attributed to a Bithynian sculp-
tor named Doidalsas, who is thought to have been a
member of the Lysippan school. This attribution is based
on the assumption that the 'Aphrodite bathing herself' by
Doidalsas which was in the Porticus Octaviae in Rome in
Pliny's time (*NH* 36.35) was the original of the Crouch-
ing Aphrodite type. The naturalism of the Aphrodite,
seen in its ungainly pose and in the rolls of flesh at the
stomach, may owe something to the tradition of the
sculptor who preferred to depict things 'as they
appeared,' but to a greater extent it seems to anticipate a
later Hellenistic taste for frank realism (see Chap. 6).

A third female figure frequently ascribed to the Lysip-
pan school is the 'Seated girl' now in the Conservatori
wing of the Capitoline Museums in Rome [51]. Again it is
the twisting, polyaxial composition with crossed legs and
projecting elbow that prompts the attribution.[25] The

spirit of this work, however, seems much more akin to
works like the 'Boy with a goose' [132] and other works
which probably date to the later Hellenistic period and
which are often subsumed under the term 'rococo' (see
Chap. 6). Exactly what is represented by the statue is not
clear, but it seems rather like the generic groups of
women in conversation that form a subject for Hellenistic
terracottas. A Lysippan style of composition does not
force us to date the work in the third century B.C. Later
Hellenistic art was strongly eclectic, and many stylistic
traits from earlier phases of Greek art were revived and
fused.

Finally, there is the bronze Hermes from
Herculaneum, now in Naples [52], whose unsettled,

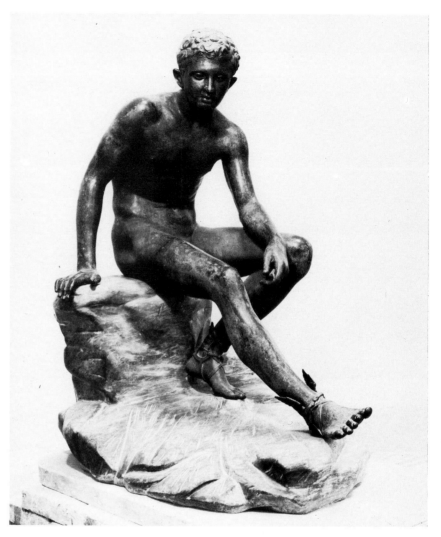

52 Hermes. Bronze. Roman copy of an original of *ca.* 250 B.C. From Herculaneum, now in Naples, Archaeological Museum. H. 1.05 m.

turning pose, implying that he might be about to fly away, has suggested to some a kinship to works like the Kairos. Rhys Carpenter, for example, saw in the figure a 'series of imaginary horizontal axes which pass through the two ankles, through the knees, the hips, the shoulders, and the ears, [and which] turns like a revolving compass needle through a full quadrant of the circle, bringing the uppermost axis at right angle to the lowermost. All frontality of pose is thus destroyed by confronting the entire circuit of possible viewpoints with simultaneous silhouetted and foreshortened aspects . . .'[26] The body of the Hermes *does* seem Lysippan, but the head looks like a late Republican or early Roman

Imperial portrait. Most probably the Hermes is a pastiche in the tradition of the 'pseudo-athlete' of Delos (see p. 75).

Lysippan stylistic mannerisms, like Praxitelean and, eventually, Polykleitan mannerisms, became part of the Hellenistic heritage and were used for centuries in a variety of eclectic creations. It is probably futile to attempt to fit every work which has Lysippan features into the third century and to find a place for it in the school of Lysippos and his immediate followers. But the fact that there are so many works which tempt scholars to do this testifies to the great influence of the school.

3

Personality and psychology in portraiture

The Hellenistic age was the first period in the history of western art in which a serious attempt was made to probe, capture, and express through the medium of portraiture the inner workings of the human mind. Portraiture was introduced into the Greek tradition either in the late sixth century B.C. or in the early fifth.[1] It seems probable that the impetus for its creation came from Egypt, where portraiture of a specialized type had existed for thousands of years.

A portrait may be defined as an intentional representation of a person containing a sufficient number of specific features to make the representation recognizable to others. The word *intentional* must be emphasized. Portraiture is an interpretative art. Just as a biographer selects, emphasizes, and suppresses facts about his subject in order to capture what he feels is the subject's essential character and significance, so too a portraitist includes or omits what he feels is important in his subject's appearance. In doing so the portraitist is guided not only by his own insight into the nature of his subject but also, consciously or subconsciously, by what his society values and responds to. Portraits can be highly generalized and controlled by a single format that permits only slight variations, like most Egyptian portraits; or they can indulge a fascination with the aberrant details of the individual human face and hence seem highly realistic, as in the case of some Hellenistic and Roman portraits. One style is not necessarily better or even more sophisticated than another, but each style does reflect the mentality of the society in which it was created.

Egyptian portraiture seems to have originated as a form of funeral art. The first portraits were apparently designed to serve as surrogate bodies by inhabiting which the soul of the deceased survived for eternity. Although there were some surprisingly naturalistic variations as the tradition developed, the majority of Egyptian portraits quite naturally took on an idealized, formulaic character. The function was to portray the subject *sub specie aeternitatis*. By the time of the Middle Kingdom (*ca.* 2052–1786 B.C.) the Egyptians had extended the func-

tion of portraiture and begun to set up portrait statues in temples, where the subject was intended to be seen in his most pious aspect both by fellow worshippers and by the gods. In the first millennium B.C., when the Greeks encountered Egyptian culture, most if not all Egyptian portraits were religious votives of this sort. But even when Egyptian portrait statues became public monuments, the timeless element originally developed for funeral portraits seems to have endured. Although their features could be varied with considerable subtlety to capture the appearance of a particular individual, their formulaic character probably remained very strong because the Egyptian formula was felt to be an expression of the essential and abiding spiritual element in human beings; and it was just this spiritual element, rather than the vicissitudes and vagaries of the individual personality, that the Egyptian portraitist wanted to emphasize.

The first Greek portraits, like their Egyptian counterparts, seem to have been set up in sanctuaries or at tombs. Secular portraits, for example portraits of political leaders set up in places other than sanctuaries, were rare until the second half of the fourth century B.C.[2] Perhaps because of their context and the obviously pious intention with which they were set up, early Greek portraits have a generalized quality, a quality which if it cannot be called formulaic can at least be called impersonal, that seems to be inherited from Egyptian portraiture. It may be, in fact, that the *kouroi* of the sixth century B.C. were thought of by their creators as portraits, but because the formulaic element in them is so strong, the intended portrayal is difficult for us to perceive. In any case, even the recognizable portraits of the mid-fifth century B.C., like those of Pericles and Anacreon [53], both probably set up in a religious context on the Athenian Acropolis, seem designed to present their subjects as ideal embodiments of a type of human being – the statesman, the poet – which society respected.[3] They are examples of what we might call the 'role portrait,' the portrait which emphasizes the public aspect of an individual, his fulfillment of an important role in his society. Such portraits

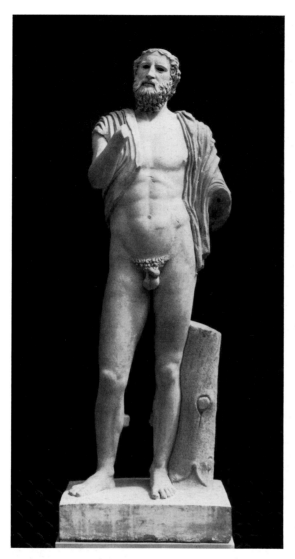

53 Portrait of Anacreon. Marble. Roman copy of an original
of *ca.* 440 B.C. Copenhagen, Ny Carlsberg Glyptotek. H.
1.90 m.

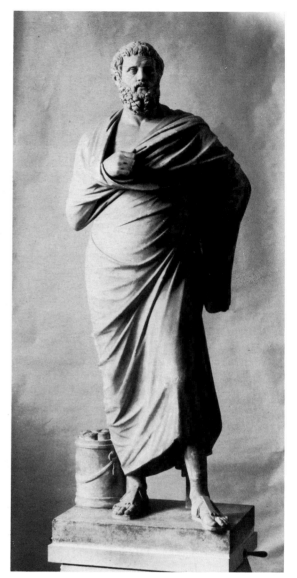

54 Portrait of Sophocles. Marble. Roman copy of an original
of *ca.* 340 B.C. Formerly Lateran Collection, now in the
Vatican Museums. H. 2.04 m.

largely ignore the inner complexities and contradictions
of their subjects' minds and character, because, like their
Egyptian predecessors, they seek to convey what their
society appreciated as permanent values.

Greek portraits, until late in the Hellenistic period,
were full-length portraits, not simply portrait busts, and
in the Classical period the composition of the body was as
important, if not more important, for expressing the
nature of the subject than were the details of the face. In
the portrait type of the poet Anacreon, of which there is a
substantially preserved Roman copy in Copenhagen
[53], it is the exocentric, declamatory composition of the
body, with the head turned upward and outward, the

arms extended (probably to hold a lyric poet's attribute –
a lyre or a wine cup), that conveys the effect and meaning
of the work, rather than the essentially generalized face.[4]
It is the poet Anacreon, more than the man Anacreon,
who is presented to us. Likewise if the body type
represented by a bronze statuette from Orchomenos goes
with the head of Pericles preserved in several excellent
Roman copies, we can reconstruct in our minds a vision
of Pericles *qua* statesman, an almost Zeus-like figure,
probably identical with the 'Olympian Pericles' ascribed
by Pliny to the sculptor Kresilas.[5] Judging by the limited
number of body types preserved, the exocentric 'role

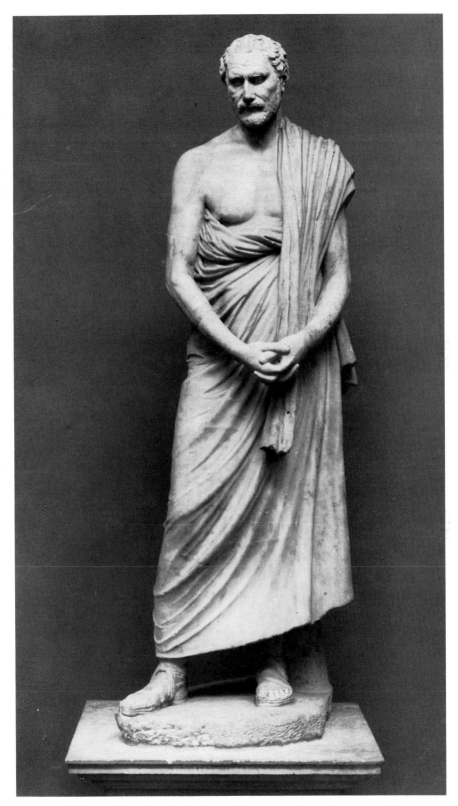

55 Portrait of Demosthenes by Polyeuktos. Marble. Roman copy of an original of 280 B.C.
Copenhagen, Ny Carlsberg Glyptotek. H. 2.02 m.

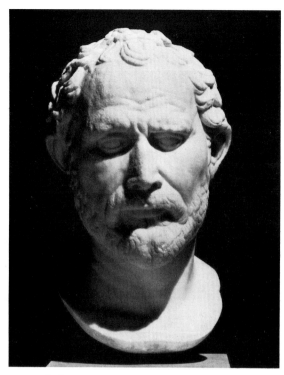

56 Head of Demosthenes by Polyeuktos. Marble. Roman
copy. New Haven, Yale University Art Gallery.
H. 0.363 m.

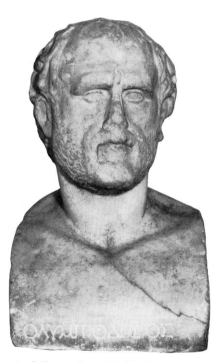

57 Portrait of Olympiodoros. Marble. Roman copy of an
original of the early 3rd century B.C. Oslo, National
Gallery. H. 0.51 m.

portrait' dominated Greek portraiture down to the time
of Alexander. The formula remains vivid in works like
the Lateran Sophocles [54] and the portrait of the orator
Aeschines, in both of which the spiraling folds of the
himation suggest a central coil of outwardly radiating
energy, as if each figure were a center from which public
proclamations might ring out.[6]

Although the 'role portrait' never went altogether out
of favor in the ancient world (as works like the Augustus
of Prima Porta and many other Roman Imperial portraits
attest), a new type of portraiture, one which concentrated
on the psychological make-up and the character of its
subjects, was developed early in the Hellenistic period
and remains one of the most impressive artistic achieve-
ments of the age. These 'psychological portraits,' as we
may for convenience call them, appear to have been
developed principally in Athens. One of the first, and
arguably the greatest of them, was the posthumous
portrait of Demosthenes by the sculptor Polyeuktos [55–
56], which is known from a literary reference (Pseudo-
Plutarch, *Lives of the Ten Orators* 44) to have been set up
in the Agora in Athens forty-two years after Demos-
thenes' death, that is, in 280 B.C. Fortunately there are
two quite well-preserved examples of the body of the
portrait, and the one detail that might still be open to
doubt in the copies – its tightly interlaced hands – is
confirmed by another literary reference to the statue.[7] It is
thus possible, as with the Lateran Sophocles (to which the
Demosthenes makes such a striking contrast), to assess
the total effect of the portrait.

Before we attempt to judge the success and appropri-
ateness of Polyeuktos's portrayal of Demosthenes, it will
be worthwhile to contemplate for a moment the charac-
ter of the man he was charged with portraying. The life of
Demosthenes, as recorded for us mainly in Plutarch's
biography, was from its beginning to its end marked by
struggle and tension. His father died when he was young,
and his patrimony was squandered by his guardians,
against whom he had to initiate legal action when he
came of age. He suffered from physical infirmities,
including, when he was young, a speech impediment.
Only by will-power and rigorous self-discipline did he
become Athens's greatest orator. Throughout most of his
political career, from 351 to his death in 322 B.C., he was
caught up in a bitter struggle against the rising power of
Macedonia and against those of his fellow citizens who,
like Aeschines, were more sympathetic to Macedonia.
Political infighting was seldom out of his life. He
denounced and prosecuted his enemies, and they did the
same to him. Although not physically strong, he fought
against the Macedonians at the battle of Chaironeia in
338 B.C. and was, in typical fashion, accused of
cowardice by his enemies. His political fortunes in
Athens hit a low point in 325/4 when his opponents
accused him of taking a bribe and managed to have him

exiled. Even then, however, his combative spirit did not desert him. When Alexander died he became instrumental in rallying Greek resistance against the Macedonian regent Antipater and was recalled from exile. But this final success was short-lived and ended tragically. After the battle of Krannon in 323 B.C., Demosthenes was proscribed and obliged to flee Athens with Macedonian agents in relentless pursuit. Finally, in 322 B.C. on the island of Poros, realizing that he had nowhere to turn, he chose to commit suicide by drinking poison rather than be taken by the Macedonians.

Polyeuktos must have sensed that the self-confident, expansive, untroubled image of the public man which had dominated the Classical period would have had a hollow, even trite ring, if applied to Demosthenes. Something new was required. In his portrait of Demosthenes one senses that for the first time the psychological make-up and character of the subject rather than his public image are the basic themes of the work. It may be that the circumstances under which the portrait was set up inspired Polyeuktos to attempt to catch the inner man in a way that had not been done before. At any rate his creation brought a new dimension of expressive power to Greek portraiture. The Demosthenes who confronts us is the tense, taut, haggard man we would expect to meet [56]. His brow is knotted in concentration, and an anxious feeling pervades the face. His hands are clenched together nervously; the body is spare, worn, and austere. One has a sense of will-power exerting itself to keep tumultuous forces under control. Compared to the outgoing images of the previous century, like the Lateran Sophocles or the portrait of Demosthenes' arch-rival Aeschines, the Demosthenes seems closed-in, guarded, pre-occupied with its own thoughts. It will be obvious how much the body of the statue contributes to this total effect. Contemporary psychologists have come to recognize that there is such a thing as 'body language.' Subconsciously the body assumes postures that spring from and express one's inner state of mind. Gestures can reveal as much about what a person is thinking as words, and sometimes more. Polyeuktos clearly grasped this principle. Even if the head of his portrait had not been preserved, it would still be a powerful, arresting image.

The portrait of Demosthenes was set up at a time when the Athenians, led by the general Olympiodoros, had largely shaken off Macedonian control and Demosthenes' nephew Damochares had introduced a decree which honored and restored the reputation of his famous uncle. There is some reason to think that the portrait of Demosthenes was but one of a group of statues set up at this time to honor heroes of the anti-Macedonian resistance. There is, for example, an inscribed herm portrait of Olympiodoros [57] now in Oslo which, with its wrinkled forehead, knotted brow, and intense expression, is reminiscent of the Demosthenes, so much so, in

fact, that one wonders if the original of it might not have been a work of Polyeuktos.[8] Another portrait, which on the basis of its style would seem appropriate for such a group, has, suitably enough, been identified as the orator Hypereides [58].[9] Like Demosthenes, Hypereides was one of the Athenian leaders who was proscribed by the Macedonians in 322 B.C., and his execution was undoubtedly remembered as a kind of martyrdom by Athenians of the next generation. The inclusion of Hypereides in a cycle of portraits celebrating heroes of the anti-Macedonian resistance is, simply because of historical circumstances, not an unreasonable hypothesis, and there is one interesting fragment of written evidence which may confirm the idea. A papyrus from Oxyrhynchus in Egypt records that 'the Athenians, after they recovered their freedom, honored him [Hypereides] with . . . statues.'[10] This 'freedom' has been interpreted as the liberation of Athens from the control of Demetrios of Phaleron and Kassander in 307 B.C.[11] That 'freedom,' however, was short-lived, and the Athenians were soon occupied with expelling their liberator, Demetrios Poliorcetes. The year when the Demosthenes portrait was set up, 280 B.C., would seem a more appropriate time.[12] Admittedly our evidence for the character of these two portraits (and in the case of Hypereides even the identification) is less solid than it is for the Demosthenes. Nothing is known about the body types that went with the heads, there is only one copy of the Olympiodoros, and the six replicas of the Hypereides vary in their details. But to the extent that they can be trusted as evidence, these two heads seem to confirm that the 'psychological portrait' was created in Athens.

In emphasizing the contrast between the Classical 'role portrait' on the one hand and the Hellenistic 'psychological portrait' on the other, the impression may have been left that the creation of the psychological portrait happened very suddenly. As always in the history of art, however, there were precursors which anticipated the mature form of the genre, and before going on to look at later Hellenistic developments, it will be useful to turn back for a moment to the fourth century B.C. in order to look at the background out of which works like the Demosthenes emerged.

The word 'realistic' is used rather loosely in the discussion of portraiture to refer to works which incorporate enough of the idiosyncratic, aberrant, or irregular features of their subject's appearance to make him or her seem unique and familiar. 'Realistic' portraits are usually contrasted with 'idealistic' portraits, works which suppress idiosyncratic features in order to make the subject more conformable to a general type. When used in connection with Greek portraiture neither of these terms, it must be remembered, is absolute. There are idealistic and realistic elements in all Greek portraits, and depending on which traits seem to dominate, we speak of

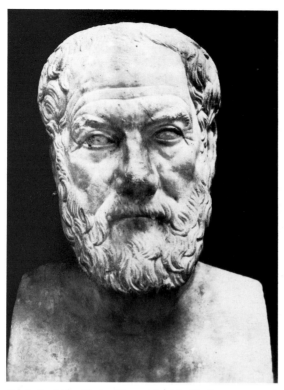

58 Portrait identified as Hypereides. Marble. Roman copy of
an original of the early 3rd century B.C. Rome, Museo
Torlonia. H. of head 0.27 m.

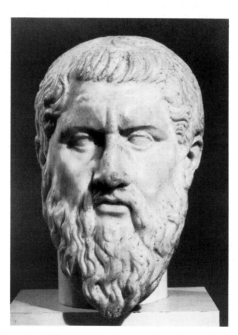

59 Portrait of Plato. Marble. Roman copy of an original of
the middle of the 4th century B.C. Cambridge, Fitzwilliam
Museum. H. 0.355 m.

individual works as representing one style or the other.
Furthermore, the point at which one concludes that
realism has come to dominate idealism or vice versa is a
matter of subjective judgment.

Perhaps the first portraits in which realism, as defined
above, seems to outweigh idealism are those on the coins
of the Persian satraps Tissaphernes and Pharnabazus.
These coins were minted in Greek style in *ca.* 400–395
B.C. by the satraps in order to pay their Greek mercenary
troops. Tissaphernes and Pharnabazus were virtually
regional monarchs, and their coins can be seen as anti-
cipatory of, in fact, possibly even serving as a model for,
the royal portrait coins of the Hellenistic period discussed
in the previous chapter. A similarly individualistic
character is also found in the colossal sculptured portrait
from Halikarnassos which is often identified as that of
the Persian satrap Mausolos of Caria (ruled *ca.* 377–353
B.C.). The fact that these early essays into relatively
realistic portraiture occurred in the hellenized East has
suggested to some scholars that such portraiture origin-
ated in this region.[13] Portraiture which emphasized the
personality of individual men, it is argued, was inimical
to the group-oriented culture of the Greek city-states, and
only in an area where the typical Greek restraints upon
individual ambition and power did not exist could a
highly personal type of portraiture make headway.

Clear and satisfying as this explanation is, however, it
is probably not strictly correct. There are indications
that, along with the dominant 'role portrait,' attempts at
a more personal and individualistic type of portraiture
also occurred in old Greece at an early stage in the fourth
century. For example, an Athenian sculptor named
Demetrios of Alopeke, who was active at the beginning of
the century, was remembered even in the Roman period
for the remarkable realism of his portraits. Although no
certainly identifiable work of Demetrios survives,
attempts have been made to reconstruct his portrait of an
aged priestess named Lysimache (the prototype,
apparently, for Aristophanes' Lysistrata).[14] Around the
middle of the century there is a demonstrable example of
a shift towards a more personal and analytical approach
to portraiture in the portrait type of Plato [59], which
was probably the work of a prominent Athenian sculptor
named Silanion.[15] The distinctive broad forehead, close-
set eyes, and serious, thoughtful expression of this
portrait seem to bring before us a particular person, not
simply a 'philosopher type,' and to anticipate the great
philosopher portraits of the third century. The facts that
Demetrios of Alopeke and Silanion were Athenians and
that it was Athens, and not one of the large cities of the
Hellenistic East, which fostered the creation of the first
Hellenistic 'personality portraits' make it clear that the
drift toward realism in the fourth century was as much at
home in old Greece as it was on Greece's eastern fringes.
Nor, if one recalls the intellectual history of the fourth

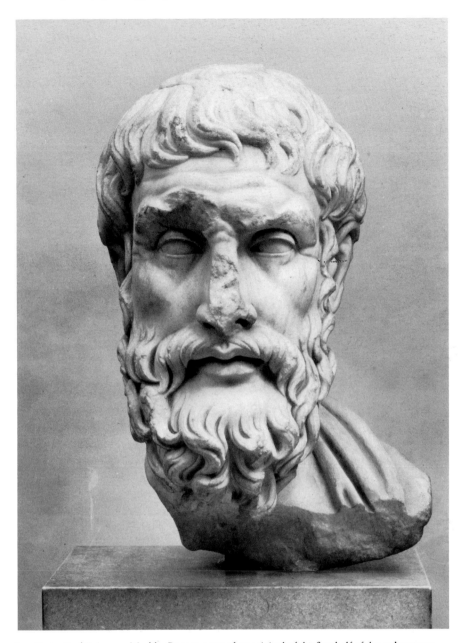

60 Portrait of Epicurus. Marble. Roman copy of an original of the first half of the 3rd century B.C. New York, Metropolitan Museum. H. 0.404 m.

century, is this particularly surprising. The society which produced Diogenes the Cynic (see p. 7) and which in other ways developed an inward-looking disposition and a preoccupation with the private life of the individual was fertile ground for the growth of the type of portraiture which probes the inner nature rather than the public façade of its subjects. Greece, and particularly Athens, in the fourth century B.C. witnessed the beginning of most of the patterns of thought, social behavior, and artistic

expression that typify the Hellenistic period, and portraiture is no exception.

To what extent the realistic portraits of the early and middle fourth century were intended to go beyond a certain surface realism and probe the natures of their subjects is difficult to determine because the evidence is so limited. The first artist of whom we can say with confidence that he deliberately set out to capture the character of his subjects was Lysippos. His portraits of Alex-

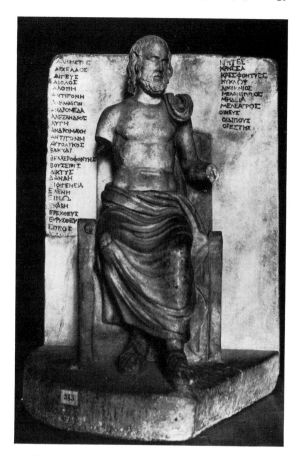

61 Portrait of Euripides. Marble. Roman copy of an original of *ca.* 340 B.C. Paris, Louvre. (The head is restored.) H. 0.55 m.

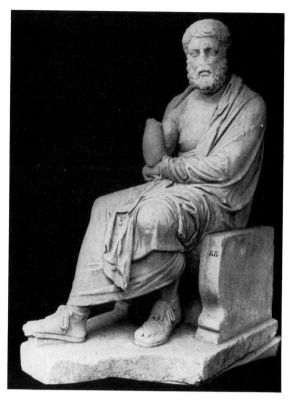

62 Portrait of Hermarchos. Marble. Roman version of an original of the early 3rd century B.C. Florence, Archaeological Museum. H. 1.07 m.

ander, which have already been examined (see p. 20), combined features of the traditional role portrait with those of the newly-forming personality portrait and seemed, in fact, to stress Alexander's *ethos* more than his political position. Lysippos, like many who knew Alexander, seems to have sensed that it was Alexander's inner make-up, and not simply the commanding role which society had assigned to him, which made him a leader, and the Lysippan portraits were designed to convey what that inner make-up was. In portraits where there was less need to celebrate the heroism and power of the subject, it may be that Lysippos indulged his interest in character analysis in an even more thoroughgoing fashion. If there is any validity to the somewhat fragile line of reasoning that ascribes to him the powerful portrait identified as Aristotle[16] [44], we must conclude that Lysippos had the ability to capture an *ethos* quite different from that of Alexander, one whose dominant characteristic was a ruminative concentration and inner tension. Since the composition and bearing of the body was essential to all Greek portraits and since the body type for the Aristotle

portrait is not known, it is impossible to make a full critical evaluation of this work; but judging by the face alone, it is tempting to see it as the first convincing portrait in Greek art of the 'thinking man' as opposed to the 'man of public importance.'

If Lysippos did not create the first great portraits of the thinking man, the sculptors of the early third century B.C., to which we now return, did, and once again Athens seems to have been the place of creation. Approximately contemporary with the Demosthenes of Polyeuktos is an expressive and arresting portrait of the philosopher Epicurus [60], whose gaunt, lined face seems to express the anxiety and sensitivity to pain which he sought to combat by the force of his thought (see p. 8). From battered replicas of the body of the Epicurus portrait we can appreciate once again how 'body language' was used to enhance the effect of the portrait. The philosopher was depicted as seated and wrapped in a himation which was draped over his shoulders and covered his legs in heavy swaths. His right arm seems to have been bent up toward his chin; the left arm is placed horizontally across his lap, close up against the torso, and is largely covered by the mantle which is stretched out from his shoulder to his wrist like a kind of shield.[17] The effect of this composition

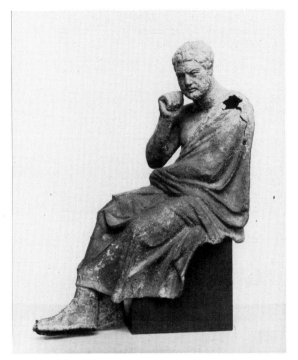

63 Bronze portrait, perhaps of Kleanthes. Roman version of an original of the 3rd century B.C. London, British Museum. H. 0.51 m.

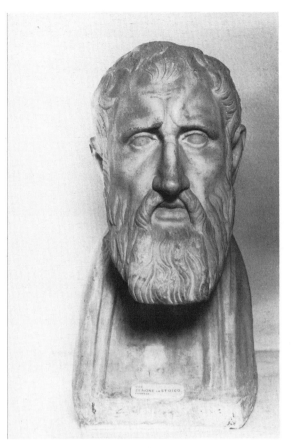

65 Portrait of Zeno. Marble. Roman copy of an original of the 3rd century B.C. (perhaps *ca.* 250 B.C.). Naples, Archaeological Museum. H. 0.44 m.

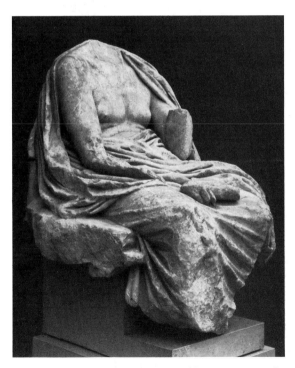

64 Portrait of Metrodoros, torso. Marble. Roman copy of an original of the first half of the 3rd century B.C. Copenhagen, Ny Carlsberg Glyptotek. H. 1.01 m.

is to close the body off and turn all its forces inward so that the viewer is made to feel that what is important about the figure is his interior life, the world of his thought, and not his potential for external action. The body type used for the Epicurus portrait contrasts in a revealing fashion with the format used in the fourth century for a portrait of Euripides [61] which is thought to have been designed along with the Lateran Sophocles [54] for Lykourgos's reconstruction of the theater in Athens (*ca.* 335 B.C.). Like the Sophocles, the Euripides portrait has an open form, its energy seeming to radiate outward as the poet's message to his fellow citizens is declaimed in public dramatic performances.

The 'thinker format' which had been worked out for the portrait of Epicurus seems quickly to have become a standard type for the representation of philosophers. It was soon used effectively for a portrait of Epicurus's successor Hermarchos [62], as well as in another portrait which has been tentatively identified as the Stoic Kleanthes [63], and a variant of it was applied in a portrait of Epicurus's close friend and colleague Metrodoros [64].

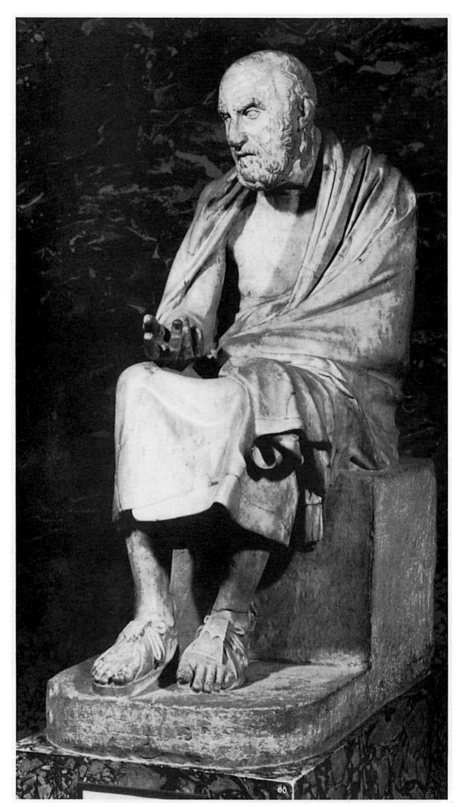

66 Portrait of Chrysippos, composite restoration with a marble torso in the Louvre and a cast from a head in the British Museum. Based on Roman copies of an original of the later 3rd century B.C. Paris, Louvre. H. of restoration 1.20 m.

Although the faces of Metrodoros and Hermarchos have an individualistic stamp, they bear a structural resemblance to the head of Epicurus in the arrangement of the hair and beard and in a certain elongation of the face. This similarity may reflect the fact that the Epicureans cultivated an 'Epicurean look' modelled on that of the founder of the school, but it could also be an indication that the three Epicurean portraits were the work of one artist.

If the sculptors who were busy creating these psychological portraits designed an 'Epicurean look,' they may also have worked out a 'Stoic look.' This at least is suggested by the austere intensity which characterizes the faces of Zeno [65] and Chrysippos [66] (*ca.* 280–204 B.C., the third head of the Stoic school). Nothing is known of the body type which went with the head of Zeno, but in the case of Chrysippos a reasonable reconstruction of the whole statue has been proposed, and it is revealing. A complex assemblage of ancient literary sources seems to imply there was a seated statue of Chrysippos in the Kerameikos in Athens which showed him with one hand extended while counting on his fingers. Just such an action seems to be depicted in a life-size headless statue in the Louvre, and replicas of the head of Chrysippos have been plausibly combined with this statue [66]. Since Pliny (*NH* 34.88) refers to a statue *digitis computans* by a sculptor named Euboulides, this artist is sometimes identified as the creator of the portrait so reconstructed, even though Pliny does not say whom Euboulides' statue represented.[18] Although the format of the Chrysippos portrait is very close to that of the Epicurean portraits, the extension of its hand and the action of the fingers give it a more outgoing, communicative quality which was appropriate to its subject. Chrysippos, as a Stoic, was more concerned with the affairs of the world than were the reclusive Epicureans. He was also renowned as one of the most argumentative of ancient philosophers, and it may be that in this portrait we see him 'ticking off' the points of an argument on his fingers.

Among these expressive philosopher portraits of the third century there is one Hellenistic original which documents the same inventiveness in the use of body language that has been detected in reconstructions from Roman copies. This is a bronze statuette in New York [67] which has been identified on the basis of its facial features as either Epicurus or, more probably, Hermarchos.[19] Its sagging body and protruding paunch are a striking example of the new realism (compare it with the youthful, athletic body given to Euripides in the previous century). It is perhaps intended to convey a philosopher's lack of concern with outward appearances as well as an Epicurean's preference for a life without stress. There is also an inwardness suggested by the overall poise of the figure. The loose, unspecific gesture of

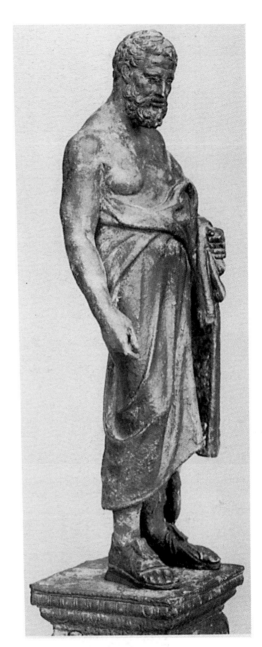

67 Bronze statuette of a philosopher, probably Hermarchos. Roman version of an original of the 3rd century B.C. New York, Metropolitan Museum. H. 0.263 m.

the right arm and the way the head is turned downward and to one side suggest that the philosopher has stopped for a moment, lost in thought.

The creased, thoughtful, introspective visage that was so brilliantly developed for portraits of philosophers in the third century B.C. continued to be used throughout the Hellenistic period, although later examples of the type are less plentiful. In the second century B.C. the most

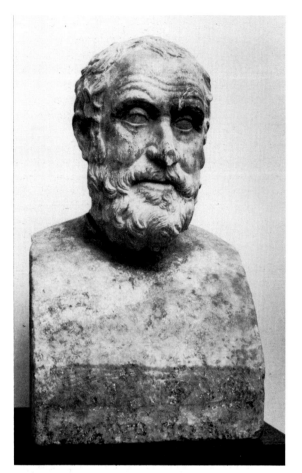

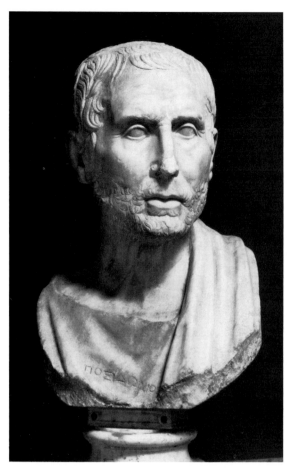

68 Portrait of Karneades. Marble. Roman copy of an
original of the mid-2nd century B.C. Ravenna, Museo
Nazionale. H. 0.51 m.

69 Portrait of Poseidonios. Marble. Roman copy of an
original of the early 1st century B.C. Naples,
Archaeological Museum. H. 0.44 m.

successful example of it is a portrait of the head of the
Academy in Athens, Karneades [68], whose eloquence
and quickness of mind dazzled the Romans during a visit
to Rome in 155 B.C.; and in the first century the most
impressive example is the portrait of Poseidonios [69].[20]

The introspective qualities of the personality portrait
might seem to negate the appearance of heroic dynamism
that many Hellenistic rulers cultivated, but it is neverthe-
less a fact that some rulers did choose to have themselves
depicted in the realistic mode which had been developed
for philosophers and democratic politicians. Although,
as we have already seen, the model of the inspired and
inspiring hero which Lysippos created in his Alexander
portraits continued to be an appealing one for many
rulers throughout the Hellenistic period, some kings, for
reasons that we can only guess, felt that their purposes
were better served by a more sober, sometimes even
grimly realistic, image. One of the finest portraits in the
latter class is a head with a royal diadem in the Louvre
which, on the basis of its resemblance to his coin

portraits, has frequently and probably rightly been iden-
tified as Antiochos III [70].[21] There is a time-worn quality
in the face, a suggestion of melancholy born of
experience. Is this Antiochos in his later years cultivating
the appearance of a philosopher king? Or has the sculp-
tor in a spontaneous way caught the look of the battered
psyche which had to endure the humiliation of Magnesia
and its aftermath (p. 151)? The irregularities in the face of
Antiochos, seen in his uneven, wrinkled brows and
sunken cheeks, represent a controlled, selective realism in
the tradition of the portraits of Demosthenes and Epi-
curus. It does not altogether shed, however, that feeling
of aloof nobility that was part of the Classical heritage.

The Classical legacy does, however, seem to be rejected
completely in a portrait of Antiochos's contemporary
and sometime rival, Euthydemos I of Bactria [71].[22]
Euthydemos's wide, pouchy face, his beady, irregularly
shaped eyes, his thick neck, his set jaw, all combine to
form one of the most startling faces in Greek art. Those
whose ideal in the Greek tradition is the timeless youth of

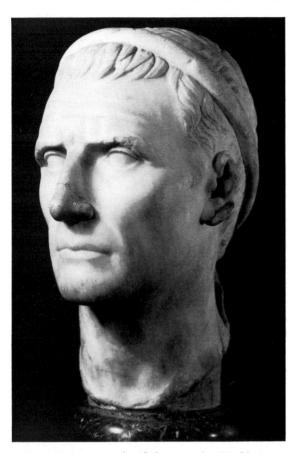

70 Portrait, sometimes identified as Antiochos III of Syria.
Marble. Early 2nd century B.C. Paris, Louvre. H. 0.35 m.

the figures of the Parthenon frieze may be horrified by its brutal realism; yet it is a powerful, honest work, a portrait, one feels, that must have been appropriate for its subject. The Bactrian kings who carved out realms for themselves in the wild mountains on the far horizon of the hellenized world lived in a state of constant struggle, not only with one another but also with the barbarians who surrounded them (see Appendix IV). Only tough, hard-bitten men could survive and be dominant in such a world, and apparently the Bactrian kings wanted to commemorate that fact. Most of the faces on their coins have a ferocious or at least experienced, battle-hardened quality [299]. They seem to be designed to tell the kings' subjects what kind of men they would be dealing with if they chose to revolt or make trouble. The Apollonic look probably would not have impressed anybody in Bactria, and both the Bactrian rulers and their portraitists knew it.

It may be that the unrestrained realism favored by Euthydemos and his colleagues was designed by Greek artists for a primarily non-Greek public which could not

be expected to respond to the subtle allusions of a more idealized style. This would explain the popularity of the realistic style in Pontos and Bithynia, where the royal courts aspired to a certain standard of Hellenism, but most of the population, including many aristocrats, was Anatolian and Iranian. Greek art gives us no more realistic set of faces than those of the Pontic kings of the second century B.C. [28].

Seemingly realistic portraits, like those on Pontic coins, are, of course, not necessarily psychological portraits as we have defined them. In the true psychological portrait the artist selects and arranges details in order to fix and express the inner nature of his subject. To what extent many ostensibly realistic surviving busts, mostly Roman copies and coin portraits, could be classed as true psychological portraits in the tradition of Demosthenes is difficult to say in view of the fragmentary nature of the evidence. One feels instinctively that the portraits of Antiochos III [70] and Euthydemos [71] qualify for the title. In other instances, however, one gets the feeling that mannerisms of the psychological portrait – knotted brows, creases, focused expressions – have gone into a general reservoir of stylistic options and have been eclectically fused with quite different traditions.

An eclectic approach to Hellenistic portraiture seems to have begun as early as the first half of the third century B.C. There were, as we have seen, two dominant types of portraits created at the beginning of the Hellenistic period – one the heroic type, represented by the Alexander portraits of Lysippos, and the other the psychological portrait represented by the Demosthenes of Polyeuktos. In a few portraits, beginning as early as the third century B.C., there seem to have been attempts to fuse these two basic types. A head from the Villa of the Papyri at Herculaneum, which has, on the basis of its similarity to coin portraits, been identified as Philetairos of Pergamon [23], has unassumingly realistic features (i.e. the fleshy chin and small eyes) but is composed on the heroic model of an Alexander portrait, with the head turned aside and upward. The same fusion of styles also occurs on another herm portrait from Herculaneum which probably represents Ptolemy II Philadelphos [24]. The most renowned example of this fusion, however, is the well-known bronze head from Delos [72], a late Hellenistic original dating from *ca.* 100 B.C. Whom the head represents is not known. Presumably it was set up by one of the Greek or Italian businessmen or magistrates on Delos (see *infra*). The fluid, anti-classical surface of this head, seemingly alive to ephemeral expression and ordinary concerns, blends uncomfortably, if not incongruously with its heroic pose, and the viewer is left wondering what the sculptor and the dedicator really intended it to express.

There are so few full portraits preserved from the later Hellenistic period that it is difficult to generalize about

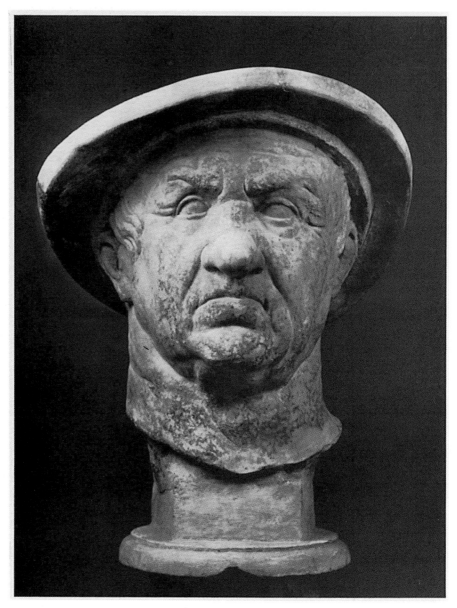

71 Portrait identified as Euthydemos I of Bactria. Marble. *Ca.* 200 B.C. Rome, Villa Albani. H. 0.33 m.

the role which eclecticism may have played in determining the body types of portrait statues. What evidence there is, however, suggests that the careful construction of body types that characterized the portraits of Demosthenes, Epicurus, and Chrysippos yielded in the second and first centuries to formulaic assemblages in which the realistic portrait head had little meaningful stylistic relation to the body which bore it. A conspicuous example of this kind of formulaic construction is the 'pseudo-athlete' from Delos [73]. A more renowned example of it is represented by the one large-scale and complete original Greek portrait statue that has come down to us, the bronze figure in Rome generally known as the 'Hellenistic ruler' [74]. This over-life-size figure (it is 2.2 m high) has been identified on the basis of coin portraits as Demetrios I of Syria, but the identification is far from certain, and many other suggestions have been made.[23] The torso of the Hellenistic ruler is a somewhat heavy version of the formula developed for statues of athletes by Polykleitos in the fifth century B.C. (a chiastic arrange-

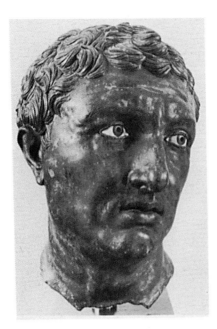

72 Bronze portrait from Delos. Late 2nd or early 1st century
B.C. Athens, National Archaeological Museum.
H. 0.325 m.

73 Delos, 'Pseudo-athlete.' Marble. Late 2nd–early 1st
century B.C. Athens, National Archaeological Museum.
H. 2.55 m.

ment of the knees, hips, and shoulders, and a striding yet
stable stance), while the arms of the statue seem to 'quote'
a Lysippan tradition (the left arm recalls the Alexander
with a lance [8]; the right recalls the Farnese Herakles
type [41]). In contrast to this somewhat lumbering body,
with its familiar and time-honored, if not time-worn,
eclectic features, the head of the Hellenistic ruler projects
a crisp, worried intensity which seems both psychologi-
cally and, because of its small scale (relative to the torso),
physically alien. The position and scale of the head,
which is turned sharply toward the right shoulder and
raised slightly upward, was perhaps also intended to
quote the Alexander with a lance, but because the body
lacks the integrating torsion and slimness of the Lysippan
portrait, the head simply contributes further to the styl-
istic incongruity of the figure. The total effect of the head
and torso, it is true, creates an 'open form' of the sort that
was particularly in vogue in the mid-second century B.C.
(see p. 268), but in contrast to the Poseidon of Melos
[290] or the Zeus from Pergamon [112], the Hellenistic
ruler's open form seems pieced-together and artificial.

Nowhere is the multiplicity of stylistic options that was
available to a late Hellenistic portrait sculptor more
clearly illustrated than in the portraits found at Delos
dating from the early first century B.C.[24] These portraits
record the faces of merchants from various areas of the
Hellenistic world but are all the work of Greek sculptors.
Some of them follow the tradition of the bronze head

described above and mix realism, pathetic expression-
ism, and heroic composition [75]. Others have the
serious, concentrated, inward quality of the early Hellen-
istic psychological portraits [76]; and still others have a
stark, severe, matter-of-fact quality that binds them to
Roman Republican portraiture [77].

Since there are no artists' signatures connected with
the Delos portrait heads, it cannot be positively
demonstrated that they are the work of Athenian artists,
but there is one piece of evidence which suggests that they
probably were, and which, in any case, helps to illumi-

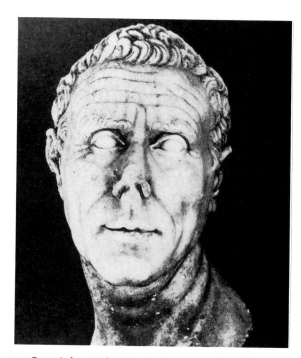

75 Portrait from Delos. Marble. Late 2nd–early 1st century B.C. Delos Museum. H. 0.44 m.

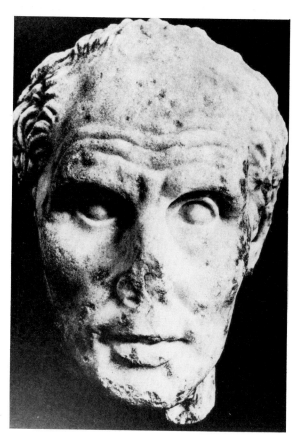

74 Bronze portrait known as the 'Hellenistic ruler.' Probably mid-2nd century B.C. Rome, National Museum of the Terme. H. 2.22 m.

76 Portrait from Delos. Marble. Late 2nd–early 1st century B.C. Delos Museum. H. 0.281 m. ▶

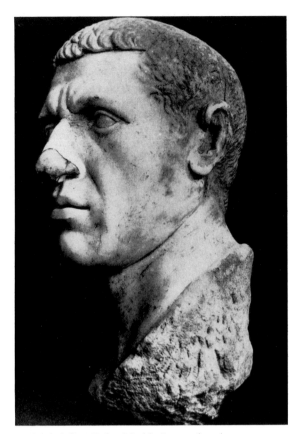

77 Portrait from Delos. Marble. Late 2nd–early 1st century
B.C. Delos Museum. H. 0.492 m.

78 Portrait of C. Ofellius Ferus from Delos. Marble. Second
half of the 2nd century B.C. Delos Museum. H. 2.43 m.

nate the artistic atmosphere on the island during the
Athenian Hegemony. The torso from Delos of a portrait
statue of an Italian businessman named C. Ofellius Ferus
[78] is signed by two of the most prominent Athenian
sculptors of the late second century B.C., Dionysios and
Timarchides (on whom see pp. 162, 174). Were it not for
the identifying inscription, one might have assumed that
this torso was the image of a youthful god done in a (by
this time) conservative Praxitelean style. The head of the
Ofellius portrait is missing, but we may make a reason-
able guess as to what it was like by looking at the 'pseudo-
athlete' [73]. Here we have a very similar torso (perhaps
intended to be that of Hermes, the Italian Mercury, who
was the patron god of businessmen and the special god of
the Italian traders on Delos) surmounted by the uncom-
promisingly realistic head of a man who is partly bald
and whose ears stick out. He is surely one of the Italian
traders, and his portrait symbolizes the strange fusion of
cultures and artistic traditions that was taking place on
Delos in the late Hellenistic period. The attempt to fuse
Greek classicism, idealism, and elegance with Roman
matter-of-factness admittedly takes on a kind of

grotesque quality in the 'pseudo-athlete,' but other
Delian portraits did it more successfully and paved the
way for such strikingly successful fusions as the great
portrait of Cicero [81] in the first century B.C.

The generation of Greek portrait sculptors that fol-
lowed those who worked on Delos almost certainly
helped to create the stern realism of Roman Republican
patrician portraiture. The 'Republican portrait' as it is
generally understood – that is, the stern, wrinkled,
Catonian, no-nonsense, business-like face that summed
up the integrity of powerful public leaders and exalted
their ancient lineage [79] – was a relatively late creation.
It seems to have originated around the time of the
dictatorship of Sulla when there was a significant
resurgence of the influence of the Senatorial Order and of
ancient Roman families in Roman politics. There can be
little doubt that the typical Roman portrait was intended
to evoke the appearance of the busts and masks of the
renowned ancestors of prominent families which were
kept in the *atria* of patrician households and paraded in

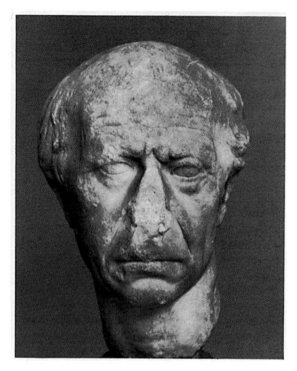

79 Roman Republican portrait. Marble. *Ca.* mid-1st century B.C. Copenhagen, Ny Carlsberg Glyptotek. H. 0.31 m.

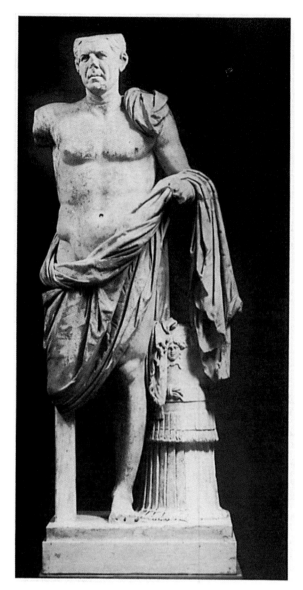

80 Roman general, from Tivoli. Marble. *Ca.* 80–60 B.C. Rome, National Museum of the Terme. H. 1.88 m.

public at funeral ceremonies. The existence and use of these masks, which were made of wax or plaster, or of some combination of the two, is attested in the second century B.C. by Polybios (6.53). To go from plaster masks or wax busts to fully finished stone or bronze portrait busts or full-length statues, however, is a major technical jump, one which could only have been achieved by artists thoroughly familiar with the techniques of working stone and casting bronze. These artists were undoubtedly Hellenistic Greeks. Late Republican portraiture is really a creation of Greek sculptors who adapted familiar techniques and forms to suit the taste and needs of Italian clients. 'The typical Roman Republican portrait,' as a renowned historian of Roman art has put it, is 'a special variant on Hellenistic realism.'[25] It is quite possible that the first steps in the creation of this typical genre of the Graeco-Roman phase of Hellenistic art were taken at Delos, where Greek artists and Roman patrons lived in proximity for many years.

The direction in which the Greeks developed this 'portrait of the stern patrician' type can be appreciated by comparing the impressive statue of a general from Tivoli [80] with the well-known Barberini *togatus*, now in the museum of the Palazzo dei Conservatori. The general, which seems to date from the 70s or 60s B.C., is still very much in the Greek tradition as found at Delos. The head with its stern, wrinkled, fluid facial features rests on a

heroic, athletic body which is in the tradition of the 'Hellenistic ruler' but which has been partially draped so as not to offend a Roman sense of propriety. (The general's cuirass, which reflects his role and was part of his normal garb, is set to one side, almost as if it were an attribute.) By contrast the Barberini *togatus*, wrapped in a toga and holding masks of his ancestors, is fully Roman. The original head of the *togatus* (the present head is ancient but not originally part of the statue) was perhaps a classicizing head of the Augustan period, the period when the statue was made. The ancestor busts are in the styles of the mid- and late first century B.C. and

76

81 Portrait of Cicero. Marble. Copy, substantially restored, of an original of *ca.* 50 B.C. Florence, Uffizi. (The bust is not ancient.) H. of head 0.37 m.

82 Portrait of Menander. Marble. Roman copy of an original probably dating from the early 3rd century B.C. Boston, Museum of Fine Arts. H. 0.515 m.

document steps between the general and the *togatus*. In the latter it is not so much a case of Hellenistic traditions being suppressed as of Hellenistic techniques merging so thoroughly with the Roman ethos that they have lost their separate identity.

If the sculptors of the late Hellenistic period created the 'Republican portrait' for their more conservative Roman patrons, they also seem to have kept alive the tradition of the early Hellenistic psychological portrait for their more philhellenic and cosmopolitan patrons. The finest example of the genre in its last significant incarnation is the thoughtful portrait of Cicero [81]. Its creator probably wanted it to express the fact that Cicero was both a Roman man of affairs and a philhellenic intellectual. The Roman politician in Cicero is brought out in the portrait's highly naturalistic details – receding forehead, somewhat sagging cheeks and chin, and the fluid surface with its wrinkles and furrows. His other side – the literary man, the connoisseur of Greek art and philosophy – is captured in the poise of the head and in the arrangement of his hair. The head is turned slightly to one side and downward in the manner of a Greek philosopher (rather

than upward in the heroic manner of Alexander); and his hair is brushed forward on one side of his head, backward on the opposite side, and horizontally, in relatively long strands, across the top of his forehead.

The model for these Hellenic features in the head of Cicero appears to have been another famous Greek portrait created in Athens in the great era of early Hellenistic portraiture, that of Menander [82]. Because several features of this portrait – its hair, the turn of its neck, and certain details of the face such as the long horizontal creases in the forehead and sharp vertical lines at the junction of the bridge of the nose with the brow – bear a close resemblance to the portraits of the first century B.C. such as those of Cicero, Octavian (the 'Actium type' of Augustus), and in a somewhat more general way, the Poseidonios [69], a number of eminent scholars have proposed and vigorously defended the view that the 'Menander' is in reality a portrait of Virgil and dates from the second half of the first century B.C.[26] Although the recent appearance of a small inscribed bust in bronze seems to clinch the identification as Menander, many of the observations put forward by 'the Virgilians'

in support of their view remain valuable.[27] There *are* close similarities between the 'Menander' and several important portraits of the first century, and the reason for this similarity is apparently that the later portraitists used the Menander (and perhaps other third-century portraits similar to it) as their model. In addition to being a sensitive and serious portrait of a literary man whom the Romans greatly admired (there are over 50 Roman copies of the head), the Menander had the virtue of being beardless, and was therefore a particularly suitable model for the Romans, who, until the time of Hadrian, were regularly clean shaven.

It is probably fair to call the head of Cicero the last great work of Hellenistic portraiture. A few decades after it was created Augustus used the force of his patronage to turn Roman portraiture in a neoclassical direction. Although his first major portrait type, created in the wake of Actium, still has features of the early Hellenistic tradition, particularly in the arrangement of its hair, there is already a smoothness of surface that anticipates the neoclassical look of later Augustan portraiture. The models for this later portraiture are found in the art of Classical Greece, particularly Periclean Athens. Augustus wanted the art of the Golden Age which he intended to create in Rome to evoke that of the Golden Age of Greece. He knew that art can create and shape a cultural mentality. The stylistic features of Hellenistic portraiture were probably too closely associated in his mind with the turbulent personalities and politics of the Republic to make them suitable for the new age. Cicero's portrait may have embarrassed Augustus in the same way that Demosthenes' must have embarrassed the Macedonians. Like Demosthenes, he had been executed for political reasons and he symbolized an old political order which a new order was trying to expunge. Like Demosthenes the power of his writings continued to keep his thought alive in later generations, and like Demosthenes his image, shaped by a master Hellenistic portraitist working in the most arresting stylistic tradition of the age, kept his personality alive.

4

The sculpture of Pergamon

The historical setting of Pergamene art

Pergamon, in the area of northwestern Asia Minor called Mysia, was an insignificant village until King Lysimachos chose it as the site where his royal treasury was to be stored. The town was far enough away from the sea to be safe from sudden attacks yet near enough to make communication by sea convenient; and it had an impressive citadel with a commanding view in all directions. To the south of the citadel lay the fertile valley of the river Kaikos, which meant that provisions for a military garrison could easily be obtained.

Sometime after 302 B.C. Lysimachos entrusted the command of his treasury at Pergamon, amounting to some 9,000 talents, to an officer named Philetairos. Philetairos's family-line may ultimately have been of Macedonian origin (the name of his father, Attalos, seems to have been Macedonian), but he himself was a native of the small city of Tios on the southern coast of the Black Sea. For over fifteen years he guarded Lysimachos's treasury faithfully, but when a behind-the-scenes struggle for Lysimachos's favor among factions in his family seemed to pose a real threat to Philetairos's position, he decided to defect to Seleukos (282 B.C.), and when Seleukos defeated Lysimachos at the battle of Korupedion in 281 B.C., Philetairos accepted the nominal role of a favored Seleucid vassal. Shortly afterward, however, when Seleukos was assassinated and Asia Minor was without an obvious ruler, he began to govern Pergamon as a virtually independent state.

Since he had retained Lysimachos's treasury, Philetairos was not only independent but also rich, and he prudently decided to invest some of his wealth in Pergamon's future security by making generous donations to cities in the surrounding area. Some of his resources were also devoted to improving the fortifications on the citadel of Pergamon and to building new temples, most notably the temple of Athena on the acropolis [83]. It seems that from the beginning the Attalids, as Philetairos and his successors came to be

called, recognized the importance of art and architecture as vehicles to express the character, policies, and achievements of the state and were prepared to spend lavish sums on artistic projects. In the following century and a half they made Pergamon itself one of the most splendid cities of the Hellenistic world (see Chap. 11), and their patronage of the arts outside their own city was unrivalled.

Philetairos died in 263 B.C. at about the age of eighty. Since he had no children, he was intent on seeing that his relatives should continue to rule Pergamon as a dynasty, and, in the first of the orderly, bloodless successions that made Pergamon so unusual in the Hellenistic world, he was succeeded by his nephew Eumenes. Philetairos had continued to tolerate the fiction that he was a Seleucid subject up until his death, but shortly after assuming power, Eumenes, recognizing that Antiochos I's control of Asia Minor was weak, decided to issue a formal proclamation of Pergamon's independence. His assertion was quickly tested and confirmed on the field of battle. In 262 B.C. Antiochos I of Syria marched against him but was soundly defeated in an engagement near Sardis.

Little is known of Eumenes I's career after his defeat of Antiochos. Inscriptions attest that he had difficulties with mercenary troops in his army and that he expanded Pergamon's territory in a modest way. The most interesting fact that we learn about him, however, is Diogenes Laertios's (4.38 and 5.67) assertion that he was a patron of philosophers, in particular of Arkesilaos, the head of the Platonic Academy in the 240s B.C., and of Lykon, head of the Peripatetic School between *ca.* 269 and 244 B.C. Apparently the Attalids' view of themselves as the patrons and preservers of Greek culture in general and of Athenian culture in particular was part of the dynasty's thinking from the beginning.

The force that gave Pergamon its first important push toward greatness in the Hellenistic world was, however, not Greek culture but rather a kind of barbarism. Migrating tribes of Celts, whom the Greeks called *Galatai* and the Romans *Galli*, had invaded Macedonia in 279 B.C. and had advanced into Greece as far as Delphi before

83 Pergamon, model of the acropolis by H. Schleif.

they were halted. Later, after being defeated by Anti-gonos Gonatas while he was vying for the throne of Macedonia, they moved into the central uplands of Asia Minor between the rivers Sangarios and Halys. In this area, which subsequently came to be referred to as Galatia, they settled down after a fashion. These 'Gauls,' as it is now the convention to call them, were largely impervious to Greek culture. In their new homeland they continued to speak their own Celtic language and to live in loose federations of villages just as their ancestors had done in central and western Europe. Raiding and pillag-ing were a way of life with them, and they periodically victimized the surrounding areas of Asia Minor, where their large stature, shaggy appearance, and fierce demeanor made them objects of terror [85–87]. Although strong forces could control them, as Antigonos Gonatas and Antiochos I of Syria had shown, most of the small states of Asia Minor were forced to buy them off. In return for an annual ransom, the Gauls would leave their

land intact; if payment was not forthcoming, a devastat-ing raid would follow. Although the Gauls were never brought completely under their control, the Seleucids had some success in confining them to Galatia up until the time of a civil war among the Seleucids. In that conflict Antiochos Hierax, who shared power with his brother Seleukos II and aspired to complete hegemony, hired a large contingent of Gauls as mercenary soldiers, and it was largely due to their fighting skill that he managed to defeat his brother in a battle near Ankara in 236 B.C. The only significant outcome of that battle, however, was that it shattered Seleucid control of Asia Minor and allowed the Gauls to run wild. Naturally they soon headed for the rich city of Pergamon and demanded a large ransom.

Eumenes I had died in 241 B.C. and had been succeeded by Attalos I, an adopted son who seems actually to have been the son of one of his cousins. Attalos recognized that if Pergamon was to become an important power in the Hellenistic world, it could not yield to brigands any more

than it could to the Seleucids. He rallied his forces and refused to pay the Gallic tribute. Sometime in the 230s, probably in 233 B.C., he was attacked by a single Gallic tribe, the Tolistoagii, whom he defeated in the Kaikos valley without much difficulty. Later, however, most probably in 229–228 B.C., a larger force came against him, this time consisting of a coalition of Gallic tribes and of a Seleucid force led by Antiochos Hierax. This time the fighting seems to have come right up to the walls of Pergamon, but once again Attalos prevailed. The Gallic menace was broken, and Hierax was reduced to the level of a wandering adventurer without a base of power. Attalos I now used the momentum of his victory to go on the offensive. In *ca.* 228 B.C. he swept eastward, defeating Hierax in three separate battles and seizing control of most of Seleucid Asia Minor north of Cilicia. In the wake of these triumphs he assumed the title of *Basileus*, the first of the Pergamene rulers to do so, and a royal diadem now appeared on the portraits of Philetairos on Pergamene coinage. Pergamon thus officially became a kingdom and an aspiring rival to the kingdoms founded by the Diadochoi.

Attalos's defeat of the Gauls not only gave Pergamon power and, for a time, territory but also gave the Attalids a sense of pride in their achievement and implanted in them a feeling that Pergamon had a vital role to play in the Hellenistic world as the champion and protector of the Greek cultural heritage. Just as an earlier generation of Greeks by repulsing a wave of barbarian invaders, the Persians, had made possible the cultural flowering of Classical Athens, so now it seemed that the Attalids, by repelling a second wave of barbarians, had opened the way for another great period of cultural efflorescence, this time at Pergamon. Pergamon was to become to the Hellenistic period what Athens had been to the Classical period, and just as Pericles had inaugurated a building program to glorify Athens's victories and accomplishments so now Attalos and his successors looked to the arts to make Pergamon a showcase of Greek culture.

The most immediate consequence of this outlook was the dedication on the Pergamene acropolis of several large victory monuments with bronze sculptural groups commemorating the defeat of the Gauls. Other dedications were offered at Delos and Delphi, and, apparently toward the end of Attalos's life, still another on the acropolis of Athens. The new power which they symbolized and the patronage which they reflected had the effect of bringing Pergamon by the late 200s into the artistic, as well as the political, mainstream of the Hellenistic world.

During the first half of the second century B.C., when Macedonia was broken by the Romans, when Antiochos the Great was humiliated, and Greece slowly fell under Roman domination (see pp. 150–3), the Kingdom of Pergamon throve and reached a level of grandeur which

the ruins of the city still make palpable. Pergamon's success was in a large part due to the sagacity and resourcefulness of King Eumenes II, the eldest son of Attalos I, who succeeded his father in 197 B.C. and presided over a period of unparalleled growth in the kingdom until his death in 159 B.C. Because of his consistent pro-Roman policy over many years Eumenes was condemned by some of his contemporaries, especially, of course, his enemies, as a traitor to Greek culture. The fact is, however, he was neither more nor less moral than Philip, or Antiochos, or any other Hellenistic ruler of his time. He simply was more adept at choosing sides.

When Eumenes came to the throne his kingdom consisted simply of the city of Pergamon and a few surrounding towns. Antiochos the Great, then at the peak of his power, dominated Asia Minor. By playing an active role in embroiling Antiochos in his war with Rome and then by giving Rome his full support and distinguishing himself on the battlefield at Magnesia (see p. 151), Eumenes decisively changed this situation. Following the Peace of Apameia most of Seleucid Asia Minor and a portion of Thrace came under Pergamene control. With these new territories came wealth and influence but also conflicts. Territorial disputes soon drew Eumenes into an unusual war in 186–183 B.C. with the neighboring kingdom of Bithynia and immediately thereafter into another struggle, from 183 to 179, with the kingdom of Pontos. Although these Bithynian and Pontic wars are of no particular importance in the broad stream of Hellenistic political history, they are important for the history of Hellenistic art, because the Pergamene victories in them were undoubtedly among the principal stimuli for the building of, and perhaps even for the iconography of, the great Altar of Zeus at Pergamon.

In the war against King Prousias of Bithynia, Pergamon once again found itself in conflict with 'barbarians.' The Bithynians, although partly Hellenized, were of Thracian origin and their chief allies were the notorious Gauls. Furthermore, as their leading military commander they had the Carthaginian Hannibal who, after the defeat of Antiochos, had been welcomed at the court of Prousias. The details of this war are imperfectly known. An inscription datable to 184/3 B.C. records a great victory over Prousias and the Gauls as a result of which Eumenes, like Attalos I before him, took the title of *Soter*. Presumably this battle, supplemented by the efforts of a Roman commission dispatched to negotiate a settlement, ended the war. At some point in the struggle there was a remarkable battle in which Hannibal devised a strategy that, from the Pergamene point of view, exhibited barbaric cunning. He instructed his sailors to collect a large number of poisonous snakes in jars and to throw these jars on the decks of the Pergamene ships when they drew near. When the Pergamene sailors realized what was happening they withdrew, and Han-

nibal scored a temporary victory. It is tempting to think that this snake-attack so impressed itself upon the consciousness of the Pergamenes that there is an indirect allusion to it in the snake-infested quality which pervades the Gigantomachy frieze on the Altar of Zeus (see *infra*). If so, it was Hannibal's last and most lasting contribution to the history of his time. In 183 the Roman peace commission ordered Prousias to surrender the hated Carthaginian to them. Feeling that Prousias would probably do so and that he had nowhere else to flee, Hannibal made his final escape from Roman vengeance by committing suicide.

With the defeat of Bithynia, the territory of the Gauls, Galatia, was also incorporated into the kingdom of Pergamon. This acquisition of the homeland of one of Pergamon's most ancient enemies was a considerable symbolic triumph for Eumenes, but it soon brought him into conflict with Pharnaces I, king of Pontos, who had recently captured the city of Sinope on the coast of the Black Sea and was aggressively expanding his realm in every possible direction. Although few details about this war are known, it seems clear that Pergamon, now in alliance with Bithynia and other neighboring states, had the upper hand from the beginning. Eumenes seems to have been ill at the start of the struggle and the command of the army was left to his loyal brother Attalos, later to be King Attalos II. Attalos had forced Pharnaces into peace negotiations early in the war, but in *ca.* 180 B.C. Pharnaces broke an existing truce and invaded Galatia. Eumenes responded by driving the Pontic army out of Galatia and forcing the Gauls to submit once again to Pergamon. When further peace negotiations broke down, Eumenes at last invaded Pontos, forced Pharnaces to surrender (179 B.C.), and compelled Pontos to cede various territories to Pergamon and its allies.

The Pontic war seems never to have been viewed as a crisis at Pergamon. It was simply one more involvement that served to reaffirm the Pergamenes' view of themselves as protectors and saviors of Greek culture. In 182 B.C., while the war was in progress, in fact, Eumenes founded a great new Panhellenic cultural festival at Pergamon, called the *Nikephoria*, in honor of Athena. To enhance the inauguration of this festival, the sanctuary of Athena on the acropolis of Pergamon was expanded and refurbished, and the terrace on which the great altar of Zeus was to be built was laid out. Most probably these constructions were the first steps in an overall building program that Eumenes and his architects had begun to formulate at the end of the Bithynian war and that was to continue for four decades. In the end it was to bring an external grandeur to Pergamon that was matched by no other Hellenistic city. Even today, when its history is largely forgotten, the physical remains of the city are widely studied and admired.

The decade of the 170s, coming in the wake of satisfy-ing triumphs over assorted barbarians, was a peaceful one for Pergamon. Eumenes had accumulated wealth as well as power, and he now had an opportunity to spend it. That he chose to invest his wealth not in private luxury or gross self-aggrandizement but rather in a library, theater, substantial facilities for education, temples, and shrines testifies to the sincere humanistic inclinations that he shared with all the other members of the Attalid line. Eumenes may have felt that the 170s and 160s in Pergamon were analogous to the 440s and 430s in Periclean Athens, where victory, wealth, and a deep humanism had combined to produce the most inspired building program of Classical Greece. He and his brother Attalos appear to have viewed themselves not only as saviors of Greek culture, as their father Attalos I had seen himself, but also as its promulgators. Their donations to the perpetuation and enrichment of Greek cultural institutions went beyond Pergamon itself, with Athens, as one might have expected, being one of the chief beneficiaries.

At the end of the 170s Eumenes' fortunes were, as already recounted, once again intertwined with those of Rome. Fearing that Perseus's alliances with Bithynia and the Seleucids were aimed at destroying Pergamon, it was he, more than anyone else, who persuaded the Romans to undertake the campaign that eventually led to the defeat of Macedonia at Pydna (see p. 152). Pergamene troops and transports rendered the Romans substantial help during the war with Perseus right up to its end, when the king's brother Attalos commanded a Pergamene corps in the army of Aemilius Paullus. Because of Eumenes' alleged attempt to negotiate with Perseus prior to Pydna, however, the sentiment of the Roman Senate turned sharply against him in the 160s. (Whether he actually did attempt to negotiate with Perseus or whether Perseus spread the story that he had attempted to do so in order to discredit him in the eyes of the Romans, is unclear from our sources.) In an effort to patch up his strained relations with the Senate, Eumenes sent his brother Attalos on an embassy to Rome. The Senate, however, was implacable, and instead of accepting Eumenes' good wishes, it attempted in fact to persuade Attalos to join in a plot to depose his brother and assume the kingship himself. What is remarkable about this turn of events is not that the Senate plotted to overthrow its old ally – such plots were a familiar part of Hellenistic politics – but that Attalos, a mature, able, and ambitious man, refused to join the conspiracy. There seems to have been a genuine sense of fraternal and filial loyalty, rare in any age and quite astounding in the Hellenistic period, among the members of the Attalid family; and it may have been this loyalty, quite as much as military successes, that gave Pergamon its stability while the Ptolemies and the Seleucids fell into recurrent chaos. Polybios (22.20) attributes the strong fraternal bond between the four sons of

Attalos I to the influence of their mother, Apollonis, who lived at least into the late 180s and was widely admired for her piety and benevolence. This bond was tested on more than one occasion. When the attempt was made on Eumenes' life at Delphi, for example, and an erroneous report claiming that the king was dead quickly reached Pergamon, Attalos declared himself king and, according to some sources, immediately married Eumenes' wife and presumed widow. When it turned out that Eumenes was alive, these actions were, willingly if not cheerfully on Attalos's part, annulled, and there were no hard feelings between the two brothers.

During the final years of his reign Eumenes displayed an increasing independence of Rome that won him belated popularity among his fellow Greeks. In 167 B.C. there was a dangerous rebellion among the Gauls, who had been repeatedly quashed and subjugated in the 180s. The Romans, hoping that he would be overthrown, refused to aid Eumenes in his efforts to suppress this rebellion. When he successfully quelled it, they then issued a decree stipulating that the Gauls should be independent. Eumenes ignored it. Although the Romans, urged on by Bithynia and the Gauls, continued their attempt to stir up trouble in his kingdom, he held fast and even twitted the Romans by his support of the anti-Roman side of the Seleucid royal line. In the end Eumenes was his own man. When he died in 159 after steering Pergamon through 38 flourishing years, Polybios paid him a rare tribute:

He was a man who was in most matters second to none among the kings of his time, but particularly in matters that were of the greatest importance and involved the greatest refinement he was even greater and more brilliant. It was he who, in the first place, after inheriting from his father a kingdom confined to a few nondescript towns, made a realm of his own which rivalled the greatest among the powers of his day, and he managed to do this not, for the most part, with the help of Fortune, nor by taking advantage of any catastrophic turn of events, but rather by means of his own sagacity, industry, and initiative. In the second place, in his eagerness to earn renown, he was a benefactor to more Greek cities than any other king of his time, and he also provided personal fortunes for more individual men. And third, he had three brothers who were close to him in age and virtually equal to him in practical ability, and yet he maintained all of them as loyal subjects and as guardians and protectors of the royal dignity. For this last achievement one scarcely finds a parallel. (Polybios 32.8.2–7)

At the age of 61, Attalos II, at long last, succeeded his brother. Probably because of his long-standing popularity with the Romans, Pergamon's traditional association with Rome seems to have been quickly revived, and during the twenty-one years of Attalos's reign each party in the association received help from the other. The Romans helped to settle, in Attalos's favor, another war with Bithynia (156–154 B.C.), now governed by Prousias II, and Pergamon repaid Rome for its

assistance against Prousias by sending troops to assist the Romans in their final pacification of Greece. Attalid soldiers were with Metellus when he quelled the revolt of Andriskos and with Mummius when he took Corinth (see pp. 152–3).

Pergamon seemed at first to profit by Corinth's disaster. A portion of the spoils from the sack of the city were given to Philopoimen, Attalos's general in the campaign, and were dedicated at Pergamon, where they were still visible in the second century A.C. (Pausanias 7.16.8). Allowing Pergamon to be enriched at the expense of Corinth's annihilation may seem hypocritical for a kingdom whose rulers saw themselves as protectors of Greek culture, but the fact is that we do not know what the Pergamene attitude toward the sack of Corinth was and how much, if any, control Attalos II had over the situation. His attempt to buy for a large sum the painting 'Dionysos' by the famous artist Aristeides (Pliny, *NH* 35.24) may simply have been the attempt of a cultured man to obtain a masterpiece for his own art collection; or it may have been a high-minded attempt to salvage what could be salvaged from an unexpected cultural disaster. In any case, Pergamene prosperity did not survive Attalos.

After Attalos II's death in 138 B.C. Pergamon's long association with Rome finally swallowed it up. In 133 B.C. Attalos III, a haunted and embattled ruler far different in character from his magnanimous predecessors, left Pergamon to Rome in his will.

The following sections of this chapter will be devoted to the most conspicuous and influential artistic product of Attalid Pergamon, its sculpture. Pergamene mosaics are treated in Chapter 10, and the city plan of Pergamon is discussed in Chapter 11.

The monuments of Attalos I

The victories of Attalos I over the Gauls and the Seleucids between *ca.* 233 and 223 B.C. not only established Pergamon as an important political and cultural power but also served as the catalyst for Pergamon's development as the single most important center for Hellenistic art in the late third and early second centuries B.C. It was in commemoration of these victories that Attalos along with his officers and troops commissioned a series of sculptural monuments at Pergamon and elsewhere which left a lasting mark on the stylistic development of ancient art. The style which is sometimes called 'Hellenistic baroque' had tentative antecedents in earlier Hellenistic art and may have had its origin in the works of Lysippos (see Chaps. 2 and 5), but it first reached maturity in the early Attalid victory monuments.

To carry out his artistic projects Attalos hired a number of prominent sculptors from various cities in Greece who probably worked under the general supervision of a

native Pergamene sculptor, Epigonos the son of Charios. The Attalids' aspiration to make Pergamon be for the Hellenistic period what Athens was for the Classical period has already been discussed. It may be that in assembling a group of artists to adorn the acropolis of Pergamon, Attalos had the precedent of the Athenian acropolis in mind and hoped that he and Epigonos would be to Pergamon what Pericles and Pheidias had been to Athens. Thanks to a valuable reference in Pliny, supplemented by other literary sources and inscriptions, we know the identity of several of the artists who worked for Attalos and even something about their careers: 'Several artists have made representations of the battles of Attalos and Eumenes against the Gauls, Isogonos, Pyromachos, Stratonikos, and Antigonos, who wrote treatises about his art' (*NH* 34.84). Such evidence as there is about the date of these artists suggests that they were all active in the late third century B.C., and that the 'Attalos and Eumenes' referred to by Pliny must therefore be Attalos I and Eumenes II.

Pliny's 'Pyromachos,' whom he elsewhere dates in the third century B.C., is almost certainly identical with the Athenian sculptor Phyromachos, who made a famous image of Asklepios for the god's sanctuary in Pergamon.[1] Phyromachos worked closely with another Athenian sculptor named Nikeratos, who is also known to have been employed by the Attalids, even though he is not mentioned by Pliny. The names of Nikeratos and Phyromachos appear together on a base from Delos dating from the mid-third century B.C. and also on a dedication to Athena at Pergamon dating from the time of Attalos I.[2] Nikeratos is also known to have been the sculptor of a monument on Delos, dedicated by one Sosikrates, celebrating victories over the Gauls by Philetairos (to be discussed below). Since the surviving inscription for this monument is datable by the form of its letters to the later third century B.C., it seems likely that Nikeratos's group was commissioned by Attalos I to honor the founder of the Pergamene dynasty. Outside of their work on the Attalid victory monuments, Nikeratos and Phyromachos appear to have won prominence as portrait sculptors. A recently discovered inscription suggests that Phyromachos was the creator of the portrait of the Athenian philosopher Antisthenes (*ca.* 445–360 B.C.) [84], which has long been known through Roman copies (see p. 120). Nikeratos did a portrait of Alcibiades, and perhaps also a series of portraits on Delos depicting or associated with early rulers of the region which eventually came under Pergamene control.[3] All of these portraits were probably 'imaginary,' that is, imaginative evocations of the faces of interesting historical figures who had lived centuries earlier. Nikeratos and Phyromachos may have been, in fact, the principal creators of the imaginary historical portrait, a genre which ultimately was distinguished by such great works as the

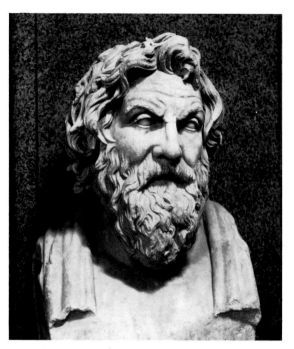

84 Portrait of Antisthenes. Marble. Roman copy of an original of 200–150 B.C. Rome, Vatican Museums. H. 0.56 m.

'Blind Homer' [122] and the 'Pseudo-Seneca' [123]. Who commissioned such works? There is no evidence on the question, but the Attalids, with their keen historical sense and their interest in celebrating the Greek cultural past at Pergamon, are a strong possibility.

Of the other sculptors mentioned by Pliny, Stratonikos is probably the same as Stratonikos of Kyzikos, a famous silversmith whose works are referred to in a Delian inscription datable to 235/234 B.C.[4] Antigonos 'who wrote treatises on his art' is generally agreed to be identical with Antigonos of Karystos, one of the fathers of Greek art history, who is datable to the third century B.C. by the fact that he was a contemporary of the philosopher Menedemos of Eretria, the friend of Antigonos Gonatas. Only in the case of the first of the sculptors mentioned by Pliny, the obscure Isogonos, do we find no additional information about his career and works. It seems highly likely in this instance that the name of the artist has been distorted in the manuscripts of Pliny and that it should, as suggested long ago by Michaelis, be 'Epigonos.'[5]

The name of Epigonos of Pergamon, the son of Charios, is preserved or plausibly restored on seven inscriptions, two of which are on the bases of major Attalid victory monuments on the Pergamene acropolis.[6]

He was apparently the only native of Pergamon among the major sculptors who worked for Attalos I. This fact, along with the two signatures on the acropolis dedications, make it likely, as already suggested, that he was Attalos's artistic overseer and perhaps the principal author of the new style which came to flourish at Pergamon. In a separate passage from the one in which he cites the other sculptors who worked for Attalos, Pliny does mention Epigonos and praises in particular two famous works by him, a 'Trumpeter' (*tubicen*) and an 'Infant pitifully caressing its slain mother' (*NH* 34.88). Although Pliny does not mention Pergamon in this passage, it nevertheless is quite possible, in fact even probable, that these two works had some connection with the Gallic victory monuments of Epigonos. The 'Trumpeter' has convincingly been associated with the famous Dying Gaul in the Capitoline Museum [85], and there is some evidence that the child and its slain mother were also figures of Gauls (see *infra*).

While there are no certifiably original fragments of the Gallic victory monuments which Epigonos and his colleagues created for Attalos, there is virtually universal agreement that some of the figures from them are preserved in Roman copies like the Capitoline Gaul. Before turning to these copies it will be helpful to review briefly what traces of these monuments have survived in Pergamon, because these remains naturally play a crucial role in attempts to reconstruct the groups as a whole. The sacred precinct of Athena on the Pergamene acropolis occupies a terrace just above the slope of the city's theater. In the second century B.C. this terrace was enveloped by porticoes, including those which led to Pergamon's famous library [83], but presumably it had always been enclosed by a wall of some sort with an entrance on its east side. Approximately in the center of the Athena sanctuary there survives a large round base 3.15 m in diameter. In the Roman period this base was remodelled in order to bear the statue of an emperor, probably Augustus, but in origin it goes back to the time of Attalos I. When the Romans remodelled the base they removed a group of capping blocks, which have been recovered in the excavations of Pergamon and bear an Attalid inscription. With these original blocks in place, the height of the base came to 2.48 m. The dedicatory inscription has been restored to read as follows: 'King Attalos having conquered in battle the Tolistoagii Gauls around the springs of the river Kaikos [set up this] thank-offering to Athena.' The battle against the Tolistoagii, as already described, seems to have been Attalos's first victory over the Gauls and to have taken place *ca.* 233 B.C.

Fragments of a second inscribed monumental base, in this case a rectangular one which can be restored as having a height of slightly over 1 m and a length of more than 2.36 m, have been recovered from a Turkish wall later built along the south edge of what was once the Athena sanctuary. Its inscription reads: 'King Attalos, Epigenes and the Officers and Soldiers, those who fought together in the battles against the Gauls and Antiochos [set up these] thank-offerings to Zeus and Athena, works of Epigonos.' Epigenes was one of Attalos's most important generals. The Antiochos referred to is, of course, Antiochos Hierax, and the battle commemorated is most probably one that took place in Caria in 228 B.C. in which the Seleucid pretender was soundly defeated. The fact that 'King Attalos' at the beginning of the inscription is in the accusative probably signifies that the monument represented Attalos and was set up in his honor by his troops.

Finally there are substantial remains of a third and very large monument usually referred to as the 'long base.' It has been restored as having a height and depth of slightly over 1 m and a length of perhaps over 19 m. This base probably stood along the south edge of the Athena sanctuary, so that one first saw its short side when entering the sanctuary from the east. On this short side was a dedicatory inscription: 'King Attalos, from the contests in war [set up these] thank-offerings to Athena.' The long façade of this base was divided into eight sections by engraved lines, each section apparently correlating with a particular sculpture or sculptural group. From cuttings designed for the attachment of the sculptures to the base it can be deduced that they were of bronze and that equestrian figures as well as foot soldiers were included. On each of the eight sections of the base small two-line inscriptions were placed which identified the battle which the sculptures above the base commemorated. The first of these inscriptions reads: 'From the battle against the Tolistoagii Gauls around the springs of the river Kaikos,' and the third reads: 'From the battle around the Aphrodision against the Tolistoagii and Tektosages Gauls and Antiochos.' The six remaining inscriptions are fragmentary, but it looks as if they referred to other single battles and that the monument as a whole commemorated all the important campaigns between *ca.* 233 and 223 B.C. by which Attalos established Pergamon's military power. In addition to the small inscriptions there was also an inscription in larger letters on the front of the long base, and it was apparently a sculptor's signature. A surviving fragment of it read *onou e . . .* and has plausibly been restored as '*[Epig]onou e[rga]*,' that is, 'works of Epigonos.'

Of the Roman copies which can plausibly be associated with one or the other of these bases the two most renowned are the Dying Gaul in the Capitoline [85] and the Gallic chieftain with his wife in the Museo Nazionale delle Terme in Rome [86]. That the two warriors represented on these monuments do in fact represent Gauls has been recognized since the eighteenth century. Their facial features and in particular their bushy hair

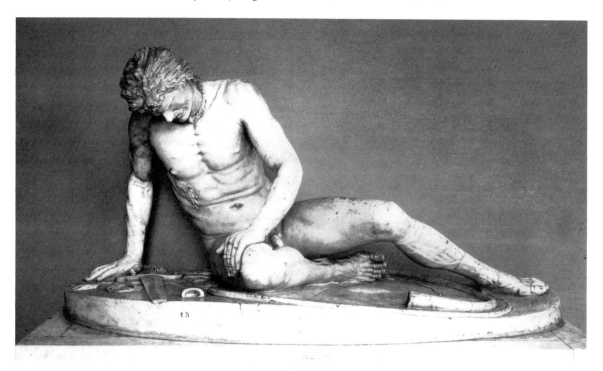

85 Dying Gaul. Marble. Roman copy of a bronze original dating from *ca.* 230–220 B.C. Rome, Capitoline Museum. H. 0.59 m.

and mustaches correspond with a description of the Gauls by Diodoros Siculus (5.28.1–3), and other features, such as the torque which the Capitoline Gaul wears on his neck, are also known to have been typical of Gauls. The connection of these figures with the Attalid dedications mentioned by Pliny was first suggested by Heinrich Brunn in 1853 and is now almost universally accepted, although the question of exactly to which Attalid monument each is to be assigned remains controversial.

The most striking features of these two famous works are their pathos and drama. In the faces of both a kind of animal ferocity has been infused with an unusual sort of dignity, not the dignity of the traditional Greek intellectual or hero but the dignity of the fanatical and fearless opponent whom one both fears and respects. The Capitoline Gaul has been stabbed in his right side; blood gushes from the wound. He has collapsed on an oval shield, on which also rests a coil-shaped trumpet. (Diodoros 5.30.3 records that the Gauls customarily carried trumpets into battle. The one represented here is partially restored and is difficult to parallel.) The sword near his right hand is a restoration but may well have been in the original. According to Diodoros the Gallic nobles usually shaved their beards while ordinary Gallic warriors kept middle-length beards; so we may assume that the Capitoline Gaul, like the figure in the Terme, was a

chieftain. Empathy for his physical anguish as his strength ebbs away is stimulated not only by the lines of pain in his face but also by a taut and tortured feeling in the musculature. The flesh clings tightly to his uncomfortably twisted torso. Deep stark lines crease it above the navel and down the center of the chest. Dilated veins are visible on the arms and legs. We encounter here a stylistic device that became increasingly typical of Pergamene art, to the point where it finally became one of its hallmarks. Individual anatomical features – bulges on the brows, wrinkles on the forehead, and individual muscles in the chest – are rendered in exaggerated depth, as if they have become swollen by some explosive force, so that they become almost independent expressionistic motifs conveying a sense of anguish, tension, and crisis. If the Capitoline Gaul is in fact a copy of the '*Tubicen*' of Epigonos mentioned by Pliny, Epigonos must be recognized as the chief creator of the stylistic devices which came to typify Hellenistic baroque.

The unrestrainedly pathetic and theatrical quality of the Gallic chieftain and his wife in the Terme is even more marked. There are many restorations on the figure, most notably the Gaul's right arm, most of the sword, and the wife's left arm, but the nature of the action is clear enough. Rather than allowing themselves to be taken prisoner the Gauls have chosen death. The chieftain has stabbed his wife under the left arm, and as she collapses

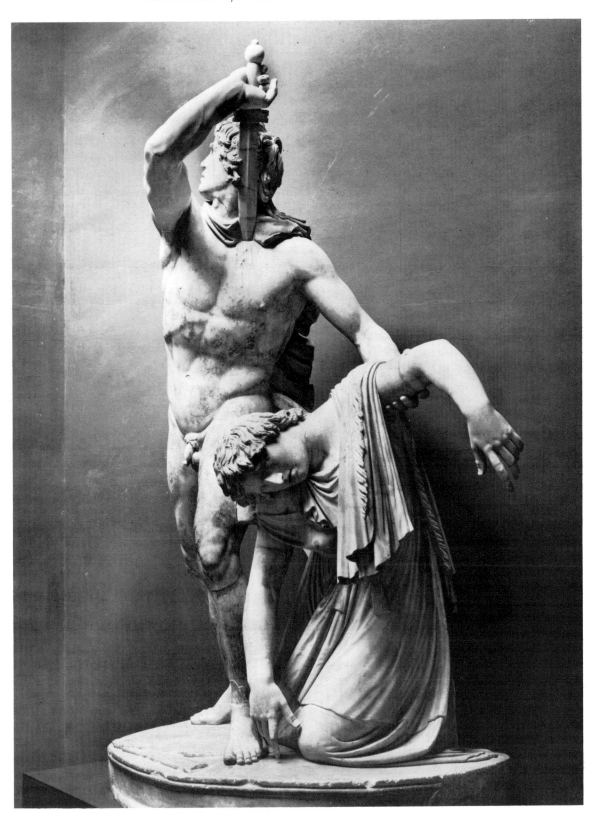

86 Gaul and wife. Marble. Roman copy of a bronze original of *ca.* 230–220 B.C. Rome, National Museum of the Terme. H. 2.11 m.

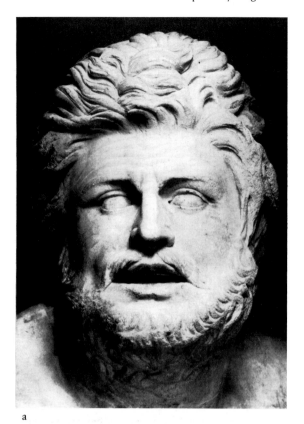

a

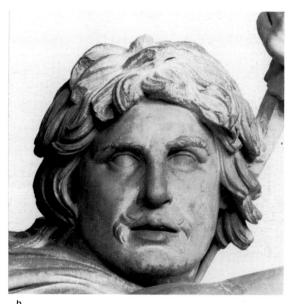

b

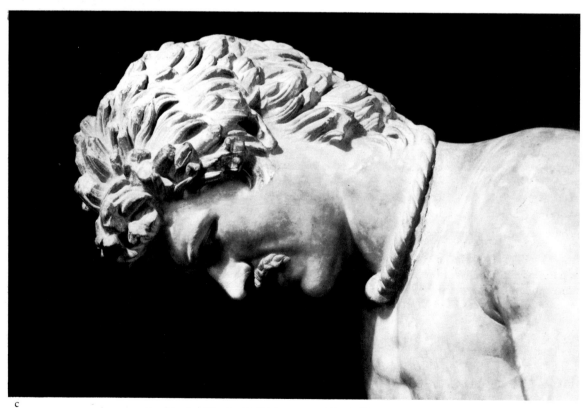

c

87 Heads of Gauls: (a) Chiaramonti Gaul. Marble. Roman copy of an original of *ca.* 230–220
B.C. Rome, Vatican Museums. H. 0.35 m. (b) Detail of [86]. (c) Detail of [85].

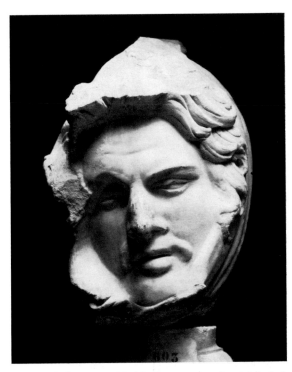

88 Head of a Persian. Marble. Roman copy of an original of
the late 3rd century B.C. Rome, National Museum of the
Terme. H. 0.335 m.

he drives his sword into his own neck just inside the collar
bone. Blood is once again shown flowing from the
wound. The wife's mouth is open in a dying gasp, and her
eyes begin to close; her husband glances dramatically
upward in final defiance at what we can assume was an
equestrian opponent. A Gallic oval shield and the sheath
of the sword lie at their feet. The same magnification and
intensification of anatomical features found in the
Capitoline Gaul also occur here.

In addition to these two nearly complete copies several
other fragmentary sculptures, also copies, have
frequently been associated with the dedications of
Attalos I and Pergamon because of their scale, style, and
subject matter. One of these is a torso in Dresden, which
is very similar in structure and surface detail to the torso
of the Capitoline Gaul. Another is a head of a Gaul in the
Museo Chiaramonti of the Vatican [87a]. It has the
familiar bushy hair, traces of a torque on the neck, and
the short beard of a Gallic foot-soldier. A third is the
tiara-clad head of a Persian found on the Palatine in
Rome in 1867 and now in the Terme [88]. This head
belonged to a recumbent figure, and its eyes make it clear
that the Persian was depicted as dead or dying.

The question of to which, if any, of the extant bases the
bronze prototypes of these copies belonged is a totally
speculative one, and no proposal is provable, nor even

perhaps overwhelmingly probable. This limitation has
not deterred scholars, however, from hazarding answers
to the question. The best-known and most often repro-
duced solution is one proposed by Arnold Schober in
1936 in which he put the Gaul and his wife, the dying
trumpeter, and three other hypothetically restored
figures on the round base in the center of the Athena
sanctuary.[7] Schober's reconstruction has the virtue of
taking into account and doing justice to the multi-faceted
composition of the Gaul and his wife group, one which
requires the viewer to move around it and to study it from
many angles. One of Schober's major arguments for this
reconstruction was that the plinths of both the Capitoline
Gaul and the Terme groups are curved and that in the
case of the Capitoline figure the curve of the plinth seems
to duplicate the curve of the round base.

As attractive as Schober's reconstruction is, there are
several good arguments against it. One is that the round
base was too high (2.48 m, or somewhat over 8 feet) to
enable the viewer to see what were apparently important
details of the sculptures, such as the Capitoline Gaul's
trumpet. Another is that the composition of the
reconstructed group has no parallel in ancient art.[8] When
remodelled in the Roman period, it is worth remember-
ing, the round base seems to have held only one large
figure, an emperor. This may also have been the case in
the time of Attalos. The figure need not, furthermore,
have been a Gaul, and Künzl's suggestion that the base
held a large Athena similar to the Athena Promachos on
the acropolis in Athens is worth considering.[9]

If the round base is eliminated from consideration
most of the figures, if they are to go anywhere, must go on
the long base. Even with this limitation, however, there is
little agreement about what went where. Among recent
commentators, for example, Ernst Künzl puts all the
figures except the Chiaramonti head [87a] on the long
base. The Terme Persian [88], he assumes, represented
one of the oriental soldiers in the army of Antiochos
Hierax. As for the Chiaramonti head, he notes that it has
a piece missing at the top and he assumes that this was
because a hand was originally grasping the hair or a
horse's hoof was striking it. This hand or hoof, he
concludes, were probably connected with a represen-
tation of Attalos, and the Chiaramonti head therefore
probably belongs to the figures on the base dedicated by
Epigenes and the army.[10] Robert Wenning, on the other
hand, feels that the long base only dealt with battles
against Gauls and therefore excludes the Terme Persian.
He also excludes the Gaul and his wife group because its
many-sided composition seems inappropriate for the
long base and because its style seems to him to have an
idealizing quality when compared to the Dying
Trumpeter.[11] (The argument about composition should
be taken seriously; the subtle stylistic distinctions,
however, given the fact that we are dealing with marble

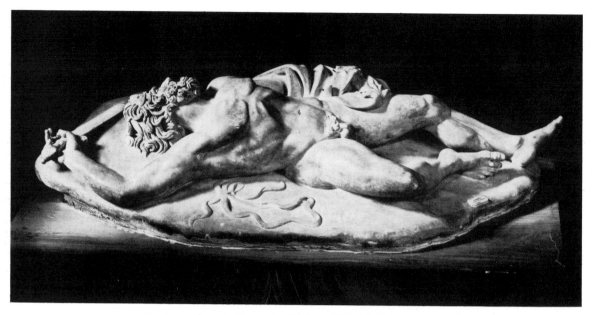

89 Giant, from the 'Lesser Attalid Group.' Marble. Roman copy of a bronze original of *ca.* 200
B.C. Naples, Archaeological Museum. L. 1.34 m.

copies of bronze originals, seem futile. Copies of the same
work often vary widely in their details.) These ideas are
cited simply to give the reader a sense of the lines along
which speculation has run. It seems more probable than
less that the original of the Dying Trumpeter belonged to
the long base; beyond that one scholar's guess is not
much better than another's.

Of the Attalid dedications outside of Pergamon, the
most elaborate was a large group set up in Athens, on the
south side of the acropolis. Pausanias, who saw the
sculptures still in place in the second century A.C., des-
cribes them briefly: 'Toward the south wall [of the
acropolis] Attalos set up [figures representing] the
legendary war of the Giants ... as well as the battle
against the Amazons, the deed of the Athenians at
Marathon, and the destruction of the Gauls in Mysia;
each figure is about two cubits in scale' (1.25.2).
Pausanias's casual mention of the scale of these figures,
about half to two thirds life size, has provided an invalu-
able clue for the identification of copies of the group, the
originals of which were almost certainly of bronze. As
early as the 1860s Heinrich Brunn recognized that scat-
tered through various European museums there were
several less than life-size marble figures of Gauls and
Persians, and at least one Amazon and one Giant [89–
94], which, because of their stylistic resemblance to
larger Gallic groups already discussed and because of
their scale, must be connected with the Pergamene group
in Athens.[12] Since the nineteenth century, other figures
have been added to the list, and the total number of
attributions now numbers over twenty.[13]

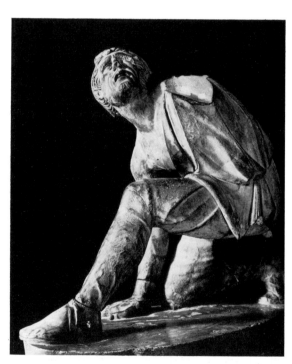

90 Persian from the 'Lesser Attalid Group.' Marble. Roman
copy. Aix-en-Provence, Museum. H. 0.64 m.

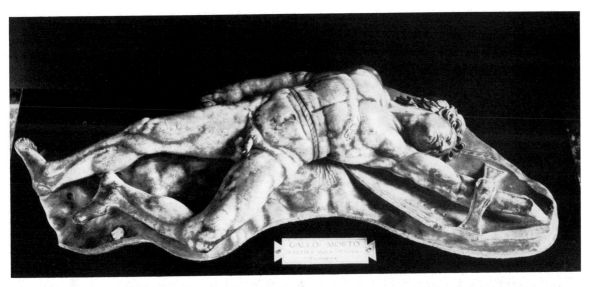

91 Dead Gaul from the 'Lesser Attalid Group.' Roman copy. Venice, Archaeological Museum.
L. 1.37 m.

The date of the original group has become a matter of controversy. The most probable date for its dedication is 200 B.C., when Attalos I paid a triumphal visit to Athens (described by Polybios, 16.25–6). Pausanias does not specify, however, which 'Attalos' he is referring to when he mentions the group, and some scholars have argued that it was a dedication of Attalos II and should be dated to *ca.* 150 B.C.[14] Their reasons for coming to this conclusion are basically that the figures of the 'Lesser Attalid dedication' (as the group is often called, to distinguish it from the dedications on the Pergamene acropolis) seem to b⎯⎯⎯⎯⎯, almost stereotyped versions of the large ⎯⎯⎯⎯⎯ttalos I and that some of them appear to ⎯⎯⎯⎯⎯he sculptures of the great Altar of Zeus, ⎯⎯⎯⎯⎯he time of Eumenes II (see *infra*). These ⎯⎯⎯⎯⎯stionably have some merit. There is in ⎯⎯⎯⎯⎯ures from the Lesser Dedication a ⎯⎯⎯⎯⎯hetic expression, a tendency toward ⎯⎯⎯⎯⎯he subtle sympathy that has been ⎯⎯⎯⎯⎯e the Dying Trumpeter. And it is ⎯⎯⎯⎯⎯ the heads from the Lesser Dedication, ⎯⎯⎯⎯⎯nple that of the giant in Naples [89], have a close connection with heads from the Altar of Zeus (for example, [103]). The conclusion that has been drawn from these observations, however, namely that the group must date from after the time of the Altar of Zeus, is not an inevitable one. In the first place, it should be remembered that we are dealing with marble copies, probably made in Asia Minor in the second century A.C., of bronze originals and that much of the 'mannerism' that has been detected in them may stem from the sculptors of the Roman period, to whom figures of slain and captive barbarians

were a routine subject. Furthermore, even if this mannerism was a feature of the originals, there is no reason why it could not have evolved by 200 B.C., some thirty years or so after the time of the first dedications of Attalos I. If this was the case, it is just as possible that the figures from the Lesser Dedication influenced the style of the Altar of Zeus as that they were influenced by it. Quite possibly the same sculptors worked on both monuments.

Although Attalos II did have minor skirmishes with the Gauls, it remains a fact that the Attalos whose victories over the Gauls were the most momentous and worthy of commemoration was Attalos I. Those who date the Lesser Dedication to the time of Attalos II assume that this king commissioned the monument as a poignant way of associating his own long-delayed and essentially undramatic reign with the glorious achievements of his father. They also assume that there was another version of the Lesser Dedication, usually referred to as the 'parallel monument' at Pergamon itself.[15] That this piling of hypothesis upon hypothesis brings one closer to the truth of the matter is very doubtful, and those who would prefer to think that Attalos I set up the Lesser Dedication in Athens when he visited the city in 200 B.C. have both Pausanias and historical probability on their side.

Since the question of date is ultimately unresolvable let us turn to the more rewarding question of how the Lesser Dedication in Athens made its impact on those who saw it. To the degree that we can make such judgments from copies, it is clear that the stylistic mannerisms of larger Attalid dedications have been perpetuated, in a standardized if not mannered form. The exaggerated swelling and deepening of facial and anatomical features

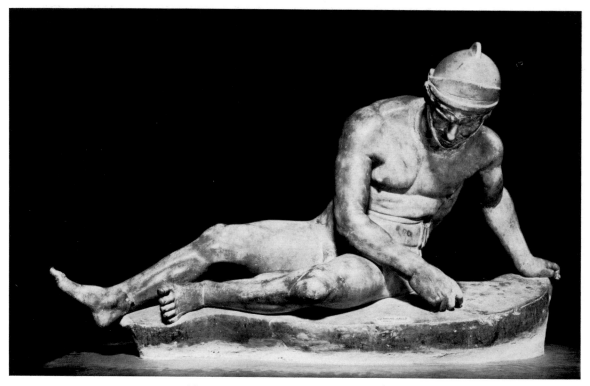

92 Gaul from the 'Lesser Attalid Group.' Marble. Roman copy. Naples, Archaeological Museum. H. 0.59 m.

to create anguished, stress-filled figures who are either caught in a crisis or victims of a calamity is everywhere. In some figures, most notably the Persian in Aix [90] and the dead Gaul in Venice [91], this intensification of surface details is more marked than in others, but whether such distinctions were true of the originals and were a result of the varying styles of different sculptors is impossible to say. Realistic details, such as bleeding wounds and appropriate articles of dress and armor, were also inherited from the earlier dedications at Pergamon. So also, apparently, was the interest in varying states of consciousness. In the Dying Gaul and his wife in the Terme and the Dying Trumpeter in the Capitoline, it will be remembered, three physical conditions, or states of consciousness, were depicted. The Terme Gaul was still conscious and defiant, the Trumpeter was still conscious but near collapse, and the wife was unconscious, or nearly so. The same conditions are found in the figures from the Athenian dedications. Some of the Gauls and Persians are fallen but still defiant [90]; others, like the Dying Gaul wearing a helmet in Naples (a figure clearly modelled on the Dying Trumpeter), are near collapse [92]; and many, like the Gaul in Venice [91] and several of the figures in Naples, are pathetic corpses.

The theatrical effect of these figures when brought together in one composition must have been striking, even in an age grown accustomed to dramatic realism. Walking around or through the group must have been like walking through a battlefield when the battle is nearly over. Surrounding one were bleeding corpses, dying warriors, and a few pockets of final resistance. The work seems to have been designed to provoke in its viewers an imaginary experience, to inspire them to live through, in their imaginations, the events which the monument commemorated.

Two important but difficult questions about the Attalid dedication in Athens remain. Where and exactly how was it set up on the acropolis? And were the victors – Gods, Athenians, and Pergamenes – represented in it? The answer to the latter question has usually been assumed to be yes, because of what seems to be a reference in Plutarch to a figure of a victor, the god Dionysos. In his *Life of Antony* (60.2), Plutarch records that among the evil portents that preceded Antony's war with Octavian was a windstorm in Athens which blew the 'Dionysos in the Gigantomachy' down into the theater. (Antony had presented himself as a 'New Dionysos,' hence the event was seen as a bad omen.) Since the theater is on the south slope of the acropolis, it has been assumed that this Dionysos was part of the Gigan-

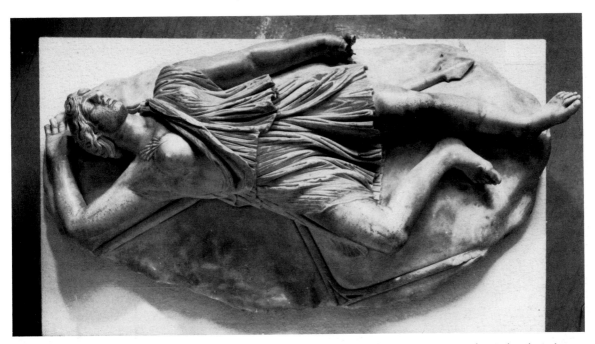

93 Amazon from the 'Lesser Attalid Group.' Marble. Roman copy. Naples, Archaeological Museum. L. 1.25 m.

tomachy of the Attalid dedication, which Pausanias describes as being 'at' or 'by' the south wall (πρὸς δὲ τῷ τείχει τῷ Νοτίῳ) of the acropolis. Plutarch does not actually specify, however, what Gigantomachy the figure belonged to. Of the few figures that have been proposed as copies of the Greek victors from the Attalid dedication, none is particularly convincing, and some of them have in fact been called Gauls.[16] In view of this it is at least worth considering the possibility that Plutarch's Dionysos belonged to some other group and that victors were not represented in the Attalid group at all.

The question of where and how the group was set up depends to some extent on how many figures one thinks belonged to it. Twelve different figures of Gauls have been ascribed to the group. If one assumes that there were equivalent numbers of Giants, Persians, and Amazons, plus an appropriate number of victors, one ends up with a group of over, perhaps well over, 50 sculptures. It is difficult to envision how so many figures could be arranged in a meaningful way along the wall to the southeast of the Parthenon (where they would have to have been, if the Dionysos which fell into the theater was a part of the group). It has been suggested that the victors were placed on top of the wall and the vanquished on a platform just inside it; or that all the figures were on a large stepped base leading up to the top of the wall.[17] To convey effectively its battlefield feeling, the different groups would have had to be rather widely spread out,

but just how much space was available for it in the area where the present-day Acropolis Museum stands we have no way of determining.[18]

We have already discussed the Attalids' aspiration to make Pergamon into the Hellenistic world's chief protector of and inheritor of the finest achievements of Greek culture. Perhaps no monument expressed this aspiration more clearly than the Lesser Attalid Dedication in Athens. Its designers blended mythology, legend, and history in a way that brought Pergamon into the mainstream of Greek culture. The battle of the Gods and Giants celebrated the foundation of Greek religion and moral law. The defeat of the Amazons, who had been allies of the Trojans and who had besieged the acropolis in the time of the hero Theseus, commemorated the glories of the Heroic Age and the importance of Athens as a bulwark against barbarism. The defeat of the Persians celebrated the salvation of Greek culture as a whole and the consequent flowering of Classical Athens. Each of these themes was already present on the acropolis. The Gigantomachy and Amazonomachy formed the subjects of the east and west metopes of the Parthenon, in whose shadow the Attalid dedication stood, and the whole Periclean acropolis celebrated the defeat of the Persians. The sculptors of the Attalid dedication thus subsumed the heroic past that was already celebrated on the acropolis, linked the new Attalid monument with it, and added a new chapter of their own. They were saying in

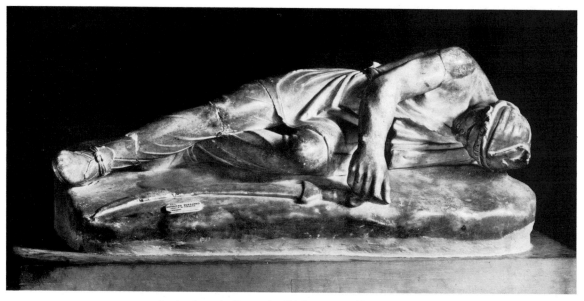

94 Persian from the 'Lesser Attalid Group.' Marble. Roman copy. Naples, Archaeological
Museum. L. 0.96 m.

95 Gaul from Delos. Marble. *Ca.* 100 B.C. Athens, National
Archaeological Museum. H. 0.93 m.

96 Head of a Gaul from Mykonos. Marble. *Ca.* 100 B.C.
Mykonos Museum. H. 0.29 m.

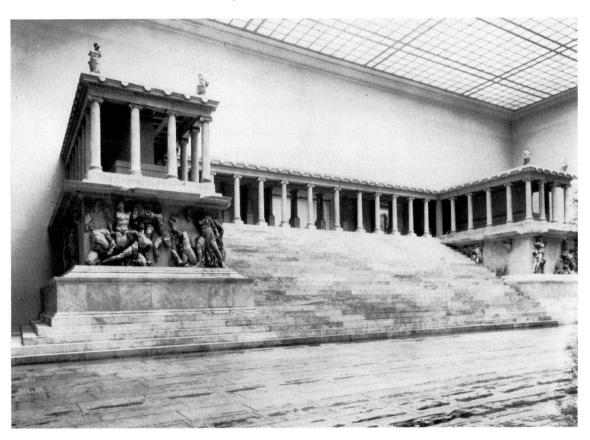

97 Altar of Zeus from Pergamon, view as restored in Berlin.

effect that the Gallic victories of the Attalids were of the same magnitude as the earlier battles depicted in the monument because they had ensured once again the survival of Greek culture.

Much less can be determined about the character of the Gallic victory monuments on Delos. One of these, it will be remembered, was set up by one Sosikrates, most probably a Pergamene aristocrat acting on behalf of Attalos, and consisted of sculptures by Nikeratos which commemorated victories over the Gauls by Philetairos.[19] Another was set up in front of the South Portico at Delos, a structure built toward the middle of the third century B.C., probably by Attalos I himself.[20] Unfortunately there are no surviving sculptures which can be proved to have come from these monuments. At one time it was thought that an impressive torso of a fallen Gaul, found on Delos and now in Athens [95], and a head in the Museum at Mykonos were part of an Attalid group [96], but a more recent assessment of their style suggests that they are late Hellenistic works.[21] The torso was found in the Agora of the Italians on Delos and probably dates from shortly after the time of the construction of that complex, *ca.* 110 B.C. In the same area there was found still another

sculptured head which appears to be that of a Gaul. It, the torso, and perhaps also the Mykonos head may all have been part of a late Hellenistic monument which was modelled on earlier Attalid monuments. The heads have the shaggy hair and excited expression of Pergamene Gauls, one recalling the Museo Chiaramonti head and the other the dolorous expression of many of the figures which are thought to be copies of the Attalid monuments in Pergamon and Athens. The torso also calls to mind some of the figures ascribed to the Lesser Attalid Dedication, although its composition, with little torsion, sharp profiles, and one essential angle of view, perhaps betrays its later date.

Taken as a whole, the dedications of Attalos I can be understood as among the most powerful expressions of several of the dominant intellectual trends that we have identified in the Hellenistic age. The most obvious symptoms of the 'theatrical mentality' are found, of course, in the anguished expression of many of the figures and in their theatrical settings and situations (the moment of suicide, poignant death on the battlefield, and so on). But a dramatic quality was also conveyed in a more subtle way by placing so much emphasis on the

West
frieze

TRITON AMPHITRITE NEREUS OKEANOS
Doris *Tethys*

South
frieze

Rhea *Klymene Iapetos Tithonos* *Eos* *Helios* *Theia*

East
frieze

Hekate *Artemis* LETO *Apollo* *Demeter* *Hephaistos Iris*

North
frieze

APHRODITE DIONE **Heoos** *Phaethon* *Phobos* *Hemere* *Aither* *Nyx*
Eros

98 The identity of the gods on the Gigantomachy frieze of the Altar of Zeus from Pergamon.

vanquished rather than the victors. As we have seen, it is not certain that the victors were represented in the major Attalid dedications at all, and even if they were, the fact that later copyists seem to have all but ignored them indicates that they were not the most striking figures. In earlier Greek art the defeated had usually been routinely represented in battle scenes, but never without their conquerors. Epigonos and his colleagues seem to have realized that by leaving out, or at least minimizing the presence of, the victors and by magnifying the ferocity, power, and even dignity of the enemy, they enhanced the effect of the victors' triumph. The vividness of the defeated Gauls forced the viewer to put himself in the position of Attalos and his soldiers, compelled him to realize what they had overcome, and hence helped him to understand how great their achievement was. It is perhaps significant that in two of the major inscriptions from the monuments on the Pergamene acropolis the

conflict with the Gauls is described as an *agon* (struggle, contest) or a *mache* (battle), not simply as a *nike* (victory). The inscriptions, like the monuments, were designed to emphasize the dramatic confrontation and crisis that the Gallic campaigns involved, to make it clear that the peril for the victors was real, the outcome was in doubt, and their victory a hard-won achievement. An additional reason why Epigonos and the others favored representations of the defeated barbarians may have been that their depiction of unbridled emotion in such figures did not run counter to the Greeks' sense of propriety. The Greeks themselves were expected to retain a certain aloofness and calm, even under duress. One could not have depicted Attalos screaming. This restriction did not apply to the Gauls, however, and hence the tumult and pathos of the struggle could be conveyed more vividly through them.

The Attalid dedications also embody elements of Hel-

POSITION AND NAME CERTAIN
Position certain; name partially preserved
NAME CERTAIN; POSITION CONJECTURED
Name partially preserved; position conjectured
Inscription not preserved; meaning conjectured

West
frieze

NYMPHS *Maia* *Dionysos* **Semele**
Hermes SATYRS

South
frieze

Selene *Mnemosyne* *Astraios* *Uranos* THEMIS *Phoibe* ASTERIA

East
frieze

Hera Euros *Notos* HERAKLES *Zeus* ATHENA GE *Nike* ARES
Hebe? Boreas *Zephyros*
(four winds)

North
frieze

Erytheia KLOTHO ENYO *Keto* *Pontos* POSEIDON
Hesperethusa *Lachesis* *Pemphredo*
Serpent of the Hesperides *Atropos* (Graces)
(Fates)

lenistic individualism and of the cosmopolitan outlook. The fact that Gallic physiognomy, dress, and armament seem to have been represented with meticulous accuracy implies a curiosity about what the Gauls were really like. These sculptures also seem to have conveyed, at least in the larger groups at Pergamon, a certain basic human sympathy for the Gauls as people. There is poignance and a hint of fellow feeling in the way the suicide of the Gaul and his wife, or the death of the Trumpeter, are depicted. Rather than contempt or disdain there is an inquiring spirit and also insight.

The Altar of Zeus

The sculptures which decorated the Altar of Zeus at Pergamon were discovered in 1878–86 by a German expedition and are now, except for a few fragments, in East Berlin. This most renowned of all Hellenistic sculp-

tural monuments was probably begun *ca.* 180 B.C. in the wake of Eumenes' victories over Pontos and Bithynia and the founding of the Nikephoria festival.[22] When one speaks of the 'Great Altar' today, one actually means the structure that enclosed the altar proper. This consisted of a courtyard set on a high base, surrounded by an Ionic colonnade, and reached by a broad stairway from the west [97]. The dimensions of the building were 36.44 m on the east and west sides and 34.20 m on the north and south. It was constructed on a terrace on the Pergamene acropolis south of and below the temple of Athena [83, 247]. This terrace was entered through a propylon from the east so that one first saw what was, properly speaking, the back of the building. The great frieze of the altar ran along the outside of the base of the building just beneath the surmounting colonnade [83 and 97].[23] On the east, north, and south it covered the entire length of the building; on the west it ran along projecting wings

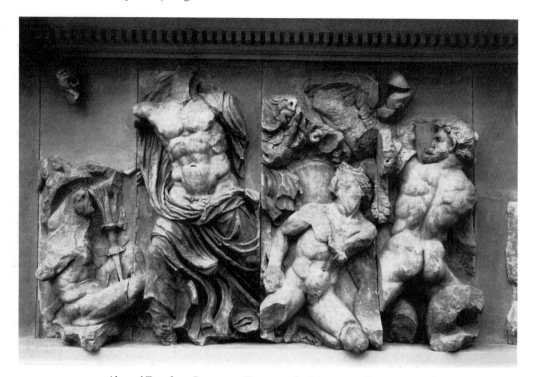

99 Altar of Zeus from Pergamon, Gigantomachy frieze, east side. East Berlin, Staatliche Museen.

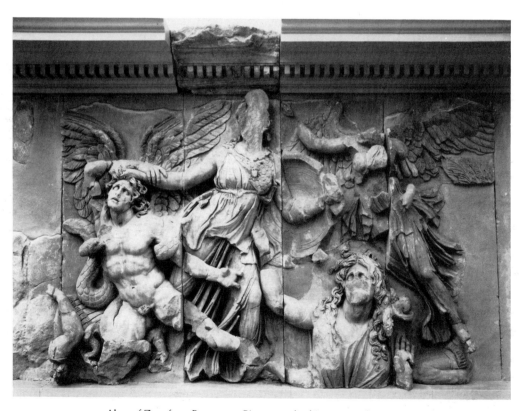

100 Altar of Zeus from Pergamon, Gigantomachy frieze, east side.

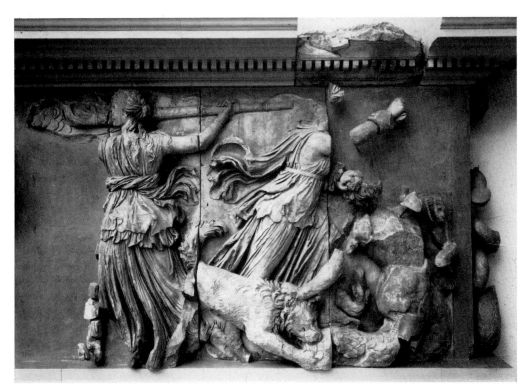

101　Altar of Zeus from Pergamon, Gigantomachy frieze, south side.

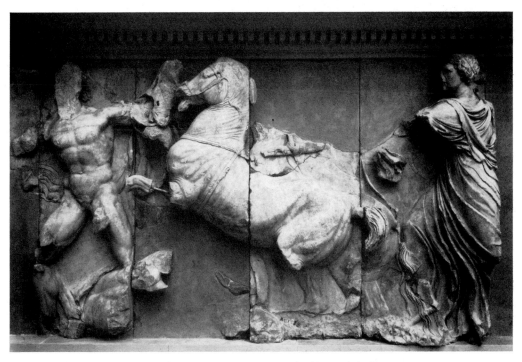

102　Altar of Zeus from Pergamon, Gigantomachy frieze, south side.

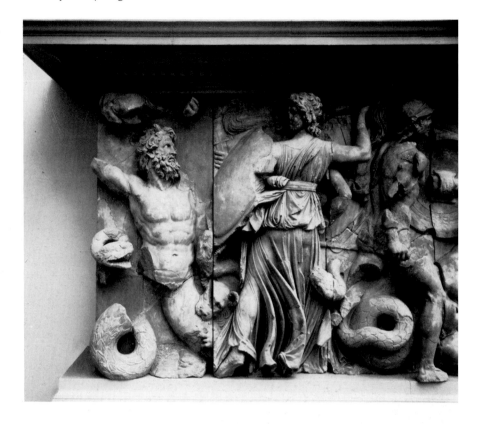

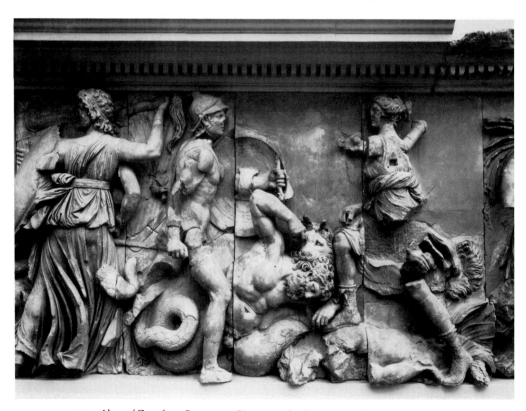

103 Altar of Zeus from Pergamon, Gigantomachy frieze, east side.

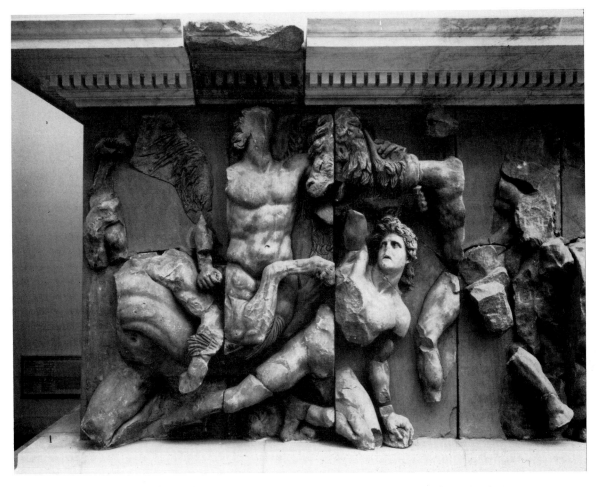

104　Altar of Zeus from Pergamon, Gigantomachy frieze, west side.

which flanked the grand stairway [97].

The frieze depicts the battle of the gods and Giants. The Giants were a monstrous race of warriors born of Ge (Earth) and Ouranos (Sky, or the Heavens), the chief deities of the older generation of gods whose place had been usurped by Zeus and the Olympians. Like their half-brothers the Titans, the Giants are probably to be associated in Greek religious history with pre-Hellenic cults, and their defeat by the Olympians was perhaps an ancient memory, as well as a symbol, of the establishment of the fundamental values and institutions of Greek culture. Hence it was a popular theme among those who, like the Attalids, saw themselves as preservers of Greek culture. The story had often been represented in earlier Greek art, but the scale on which it was presented in the frieze of the Altar of Zeus had no precedent. The frieze is 2.3 m high and about 120 m long; its single longest stretch, on the east side, runs to 36.44 m. Approximately 84 figures (depending on how one allots fragments), not counting animals, are preserved, and the original number

must have been close to 100 (see [98]).

The challenge of identifying a sufficient number of gods to fill this vast frieze and of arranging them all in a coherent program must have fallen not only on the sculptor or sculptors who designed it but also on the intellectuals, like the Stoic theoretician and literary critic Krates of Mallos, who worked in the Pergamene library. It is clear that behind its tumultuous, writhing, theatrical surface, the frieze is a very learned, perhaps at times even academically obscure, monument. What was a challenge for the scholars of Antiquity is also a challenge for the scholars of today. Much of the research which has been devoted to the Altar of Zeus has gone into the problem of identifying individual figures and of discovering the key to its overall program. Fortunately there is a certain amount of hard evidence for the identification of some of the figures and also for their position in the frieze. On the cavetto molding above the dentils in the entablature which surmounts the frieze the sculptors inscribed the name of each god. Likewise, on the base molding below

101

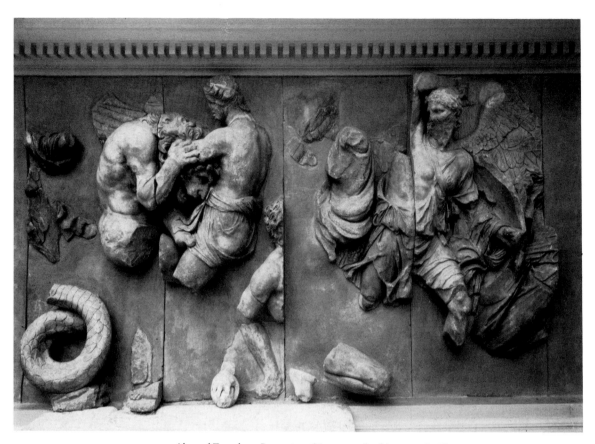

105 Altar of Zeus from Pergamon, Gigantomachy frieze, south side.

the frieze, the names of the Giants were inscribed (except along the stairway). In the case of the gods there are 18 certain names and restorable fragments of 8 more. Needless to say these inscriptions play a crucial role in efforts to reconstruct the design and meaning of the frieze. In addition to the names of the gods and Giants there are several series of 'positioning marks' inscribed by the builders on blocks of the cornice above the frieze. These marks fall into alphabetical series and sub-series, so that their order relative to one another can be determined. Combining them with grooves, dowel marks, and other indications on the blocks, it is possible to determine from them in some cases what inscription belonged to what figure. The position of 18 figures is thus certain, and of these the identity of 14 is certain. Beyond this hard evidence one must rely on the descriptions of the Gigantomachy in Greek literature and on one's own intuition in order to reconstruct the frieze's iconography.

Before turning to the difficult problem of the program of the frieze, its most obvious and overwhelming feature – its style – must be considered. The rendering of surface details in the sculptures of the great frieze involves the same intensification and exaggeration of small details

that typified the dedications of Attalos I, but here they are carried to an unparalleled extreme in order to convey the tension of a cosmic crisis. Anatomy in the frieze almost becomes a vehicle for abstract expressionism. In the torso of the great figure of Zeus from the east frieze, for example, every conceivable muscle and tendon is swollen and surrounded by furrows that set it in deep relief [99]. The same swelling and deep carving is applied to the faces of the Giants, whose earthy nature, like that of the Gauls, precludes emotional restraint and leads them to complete self-abandon. The brows of the Giant whose hair is grasped by Athena [100], for example, ripple like waves with great swellings at the bridge of the nose; on his forehead the wrinkles are cut so deeply that they seem like wounds; deep slots are carved over the eyelids and around the outside of the eyes, immersing them in dark shadows. The same mannerism, exaggerated to the point of hysterical demonic ferocity, characterizes the face of the Giant who bites the arm of the beleaguered ally of the gods on the north frieze [109]. Hysteria is also instilled into the Giants' hair, which is carved in thick, rope-like strands separated by deep grooves and writhes in a deliberately snake-like fashion to echo the snaky legs of

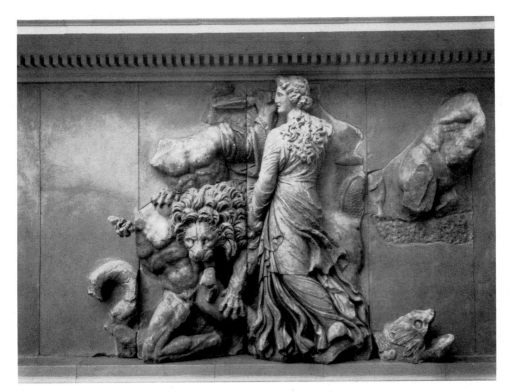

106 Altar of Zeus from Pergamon, Gigantomachy frieze, north side.

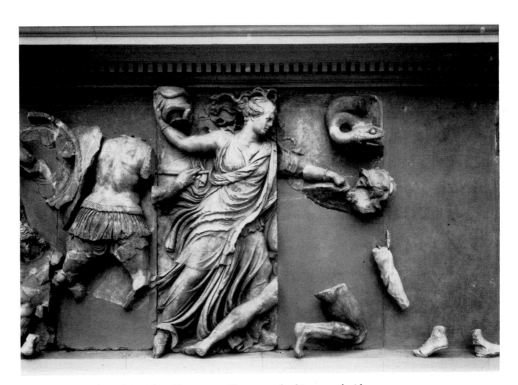

107 Altar of Zeus from Pergamon, Gigantomachy frieze, north side.

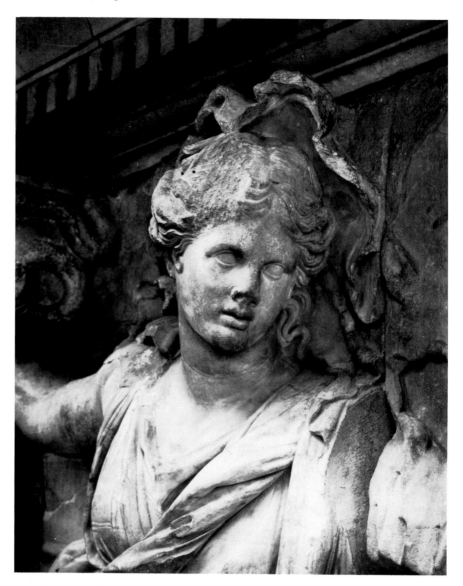

108 Altar of Zeus from Pergamon, Gigantomachy frieze, north side.

many of the Giants. The drapery of the gods is rendered as if it has been stirred up by strong winds, and when it is not pressed up against the body it undulates into deep billows whose depth is lost in shadows (as, for example, between the legs of the figures of Zeus and Athena [99–100]). In addition to its depth and excited movement, the drapery of the gods has what one might call an 'anti-anatomical' character which adds to its expressive power. In Classical Greek sculpture drapery, however elegant and florid it became, was normally subordinated to the structure of the body which it covered. On the sculptures of the Great Altar, by contrast, patterns of drapery are often created which either ignore anatomy altogether or actively conflict with it. The drapery of the

goddess Asteria [101], for example, is formed into a billowing cone which all but obscures her hips and thighs; the same is true of the cloak of the god Helios, which swirls around him in corkscrew fashion [102]. In the case of the goddess from the south frieze who is probably to be identified as Eos, the structure of the body is clear enough, but criss-crossing currents of rope-like folds fall like a net over the body and run counter to its basic structural lines. The same is true of the grand figure, probably to be identified as the goddess Nyx, from the center of the north frieze [107]. The drapery of the great frieze, in short, has a life and, in a general sense, 'meaning' of its own.

The turbulent surface of the Pergamene Gigantomachy

was necessary to sustain the continuing dramatic crescendo in which its scenes are envisioned. Musical metaphors come naturally to mind. All the stops are pulled out, and the stage rumbles with thunderous orchestral explosions. Animals and animal appendages, which are attributes of the gods, contribute greatly to this effect. Zeus's eagle descends ferociously on the skin-covered arm of a Giant whose snaky legs twist in circles and rise to fight. The thunderbolt of Zeus, still burning fiercely, cruelly pierces the leg of an agonized Giant [99]. The beating wings of Nike, as she comes to crown Athena, compete with those of the Giant whom Athena is dispatching. Athena's snake wraps around the Giant and bites his chest [100]. Artemis's dog bites a Giant on the back of the neck, while the Giant's snaky legs snap at Hekate [103]. Lions attack Giants [105]; lion-headed Giants wrestle with gods [105]. The horses of Helios rear against a Giant [102]; Triton, envisioned as a Hippocamp, tramples a falling opponent [104].

Running counter to the tumult which is in evidence everywhere is one strongly and deliberately classicizing feature, the faces of the gods. Particularly in the case of the goddesses, and of the Olympian gods, an unruffled serenity prevails. The majesty of the divine proves impervious to the passionate assault of earthly forces. (This is basically true of all the gods, but those whose home was closer to earth and farther from Olympos, like the sea god Nereus and the goddess, perhaps Keto, with a lion on the north frieze, are permitted to show a greater degree of excitement and involvement than the Olympians [106, 107].) Some of the heads, like the beautiful face of 'Nyx' [108], have the small mouth and essentially circular designs found in the sculptures of the Parthenon. This was undoubtedly deliberate. It was yet another way of communicating the Attalids' vision of themselves as the preservers of the Classical Greek heritage. It probably also appealed to the Stoic principles of the scholarly advisors who contributed to the design of the frieze. (Philosophical calm and aloofness in the face of others' passions and the pressures of the outer world was a characteristic of the Stoic wise man.) The classicism of the heads of the gods was complemented at times by classicizing patterns of composition. The most often cited examples are the panels depicting Zeus and Athena [99–100], which appear to have been modelled on the west pediment of the Parthenon. Other figures, like the Giant who is being trampled by Triton, seem to quote familiar motifs from battle scenes of the later fifth and fourth centuries B.C.[24]

This classicism is one indication of the learned sophistication of the designers of the frieze and perhaps of some of its potential audience. The same is undoubtedly true of the overall program of the frieze. As noted earlier, identifying the key to the program which underlies the Gigantomachy is a very complicated, widely disputed problem, and the identification of individual figures on the frieze depends to a great extent on what one is willing to accept as its key. A complete review of all the identifications which have been proposed for the different figures is beyond the scope of this book, but it will be useful to review the basic unifying conceptions that have been suggested for the composition as a whole. The point of departure for all interpretations is, of course, the figures which are identified and located by inscriptions. These, and the more important suggestions about the identity of the figures which surround them, are summarized in [98].

The first major interpretation of the frieze, and the one which until recently has been by far the most influential, was developed between 1888 and 1895, not long after the sculptures were transferred to Berlin from Pergamon, by Carl Robert and Otto Puchstein.[25] Robert and Puchstein had no difficulty in determining that the eastern frieze was devoted to the Olympian gods, accompanied by appropriately related figures such as Nike and Herakles, and all subsequent writers have accepted this view. Even when no inscription is extant, the identity of most of the figures on the east side, like Artemis with her hunting boots, quiver, and dogs, is beyond doubt. The general character of the deities on the wings which project from the west side of the altar building is also relatively uncontroversial. On the northwest wing four deities related to water and the sea – Triton, Amphitrite, Nereus, and Okeanos – are all identified by inscription. On the southwest wing Satyrs and Nymphs are identified by inscriptions, and another figure is almost certainly Dionysos. The theme here seems to be deities of earth and vegetation. On the south frieze only Asteria, sister of Leto and mother of Hekate, is identified by inscription, but Robert and Puchstein proposed that the theme of this side was deities of the sky and celestial light because at least three such figures, Helios (Sun), Eos (Dawn), and Selene (Moon), were identifiable with reasonable certainty by their attributes. It was the north frieze, where only Aphrodite and her mother Dione at the eastern end are identified, that posed the greatest problem for Robert and Puchstein, as it has for most subsequent interpreters.

The key to the meaning of the north frieze, most scholars have assumed, is the beautiful striding goddess with the youthful face [108]. She occupies the center of the design and is depicted in the act of hurling a snake-entwined urn at the opposing Giant to the right. Puchstein and Robert identified her as Nyx, the goddess of night, and proposed that most of the deities grouped to the left (east) of her were the stars and constellations of the night sky. This theory seemed to provide an adequate explanation of several puzzling figures. On the left side of the frieze between Nyx and Aphrodite, for example, there are fragments of a god who wields a club and wears a lion skin. Such a figure would naturally have been

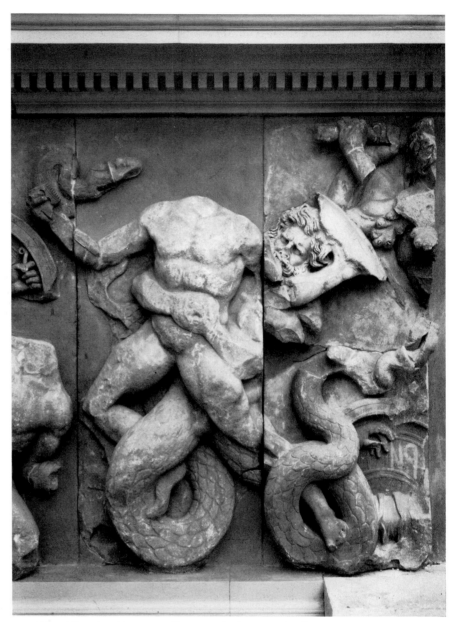

109 Altar of Zeus from Pergamon, Gigantomachy frieze, north side.

identified as Herakles were it not for the fact that Herakles already appears on the east frieze. Puchstein and Robert concluded that he was the hunter Orion. To the left of this figure the famous 'biting group' [109] also posed a problem. This is the one case where a god seems to be getting the worst of the battle. The Giant has lifted his opponent off the ground and seems to be crushing his ribs while he bites his arm. Puchstein and Robert concluded that this beleaguered figure and the male god to his left were the Dioscuri, the twin sons of Zeus, Kastor and Polydeukes, of whom the former was a mortal and the latter an immortal. Naturally the figure who seemed

in danger of defeat by a Giant would be the mortal twin, Kastor. To the right (west) of Nyx, balancing these bright deities of the night, Puchstein and Robert identified a group of 'dark' deities, children of Night, such as the Furies (Erinyes).

The interpretation of Puchstein and Robert is attractive because it puts the deities of the frieze into a kind of cosmological allegory which seems in keeping with Hellenistic taste. Facing the entrance to the sanctuary in which the altar stood were the supreme deities of the Greek pantheon, the Olympian gods. On the south, the sunlit side of the structure, were Helios and the other

principal heavenly lights, who could be seen as providing a transition between the deities of earth (on the south wing of the west side) and the heavenly deities on the east. The north side, perpetually in shade, evoked the deities of night, who again provided a transition between Olympos and the sea (represented by the water deities on the north wing of the west side) into which the sun plunged as darkness fell on the earth. The earth and water deities of the west wings, moreover, faced both the Aegean sea and the fertile coastal plains of Asia Minor. For the names of deities to fill this allegorical cosmos Puchstein and Robert turned mainly to the *Theogony* of Hesiod and secondarily to the *Bibliotheke* of Apollodoros, except on the controversial north side, where they depended mainly on the popular astronomical poem of Aratos, the *Phainomena*.

Although for approximately eighty years after the Robert–Puchstein interpretation appeared, its basic lines of interpretation were widely followed, the identifications of individual figures, particularly on the north frieze, were from time to time disputed. H. Winnefeld, who published the frieze in the official excavation reports, disputed the identity of 'Nyx,' whom he considered Demeter, and was skeptical about the identification of other figures on the north frieze. Robert himself, in 1911, modified some of his earlier views about the north frieze by proposing the identity of some additional constellations and stars and restoring the Moirai, 'Fates,' to a position on the frieze from which Puchstein had banished them. One of his most ingenious new suggestions was that the beleaguered god in the biting group [109] was not Kastor but rather Engonasin, 'the man on his knees,' a constellation described by Aratos in the *Phainomena*, ll.63ff. In 1948 Heinz Kähler in his thorough monograph on the Altar of Zeus proposed a completely new approach to the east end of the north frieze. In place of Robert's constellations Kähler proposed to see in the figure to the left (east) of Nyx Enyo, a goddess of war who was usually a companion of Ares, and, with her, other warlike deities, her brother Polemos, 'War,' and also Phobos, 'Panic,' and Deimos, 'Terror' (the god in the 'biting group'). In support of Kähler's view was the fact that Enyo's name appears in the inscriptions, and it was difficult to find a place for her elsewhere on the frieze. The only substantial deviation from the principles of Robert and Puchstein during this period was the theory of G. von Lücken, endorsed and amplified by Charles Picard, that the figure usually identified as Nyx was, in fact, the river Styx and that all the deities of the north frieze were river gods and other deities connected with water. The von Lücken–Picard theory is so at variance with the clear genealogical principles followed by the designers elsewhere in the frieze that scarcely any other scholars have accepted it.

It was not until 1975, when Erika Simon's *Pergamon und Hesiod* appeared, that a serious challenge to the overall pattern of the Puchstein–Robert interpretation was mounted. Simon argues with considerable persuasiveness that the entire program of the frieze is taken from the *Theogony* of Hesiod and that there is no need to resort either to the *Phainomena* of Aratos or the *Bibliotheke* of Apollodoros. The details of her interpretation are too intricate to summarize here. Suffice it to say that all the gods on the frieze are seen to fall into groups which correspond to the three major families of deities cited near the beginning of the *Theogony* (lines 105–7) and subsequently described – the descendants of Pontos (on the north wing of the west side), the descendants of Nyx (on the north side), and the descendants of Ge and Ouranos (the Titans on the south frieze and the Olympians on the east) [98]. One particularly brilliant suggestion arising from this pan-Hesiodic interpretation is that the distressed 'god' in the biting group is Phaethon, a mortal whom Aphrodite made the guardian of her shrine (*Theogony* 987–90). Not only does he appear in Aphrodite's section of the frieze, but the object which he holds in his right hand, previously taken to be a dagger, is, Simon demonstrates, a large key.[26]

Simon's elucidation of the frieze is the most coherent that has ever been offered, and it seems completely in keeping with the literary and philosophical bent of the Hellenistic intellectuals whose learning informed the frieze. Although the neat cosmology of the Puchstein–Robert interpretation cannot be completely sustained if one uses only Hesiod (the stars and constellations on the north frieze vanish), the frieze's connection with specifically Stoic cosmology becomes, if anything, even more marked in Simon's interpretation. It has been noted that the position of the gods on the frieze seems to accord in detail with a four-part division of the Cosmos developed by Krates of Mallos on the basis of allegorical readings of certain texts in Homer and Hesiod. Krates, for example, put the realm of dawn in the south rather than the east, and it is on the south frieze that Dawn (Eos) appears in the frieze. The elevation of the Titans, symbols of old age and of the older order of things, to a level where they are allies of the Olympians in their struggle against Chaos, was also a Stoic idea.

Had they known that scholars who lived many centuries after their time would rack their brains to find the 'key' to the Gigantomachy frieze of the Great Altar, its designers would undoubtedly have been pleased, and they would have taken satisfaction in knowing that the debate would continue without the prospect of a unanimously accepted solution. Simon's Hesiodic 'key,' for example, has been challenged by Michael Pfanner, who, in the tradition of Robert and Puchstein, feels that the frieze depicts an attack by the Giants on areas of a balanced cosmos which are defended by their appropriate ruling deities: the Olympians on the east; gods of the

110 Head of Herakles from Pergamon. Marble. *Ca.* 200–
150 B.C. East Berlin, Staatliche Museen. H. 0.505 m.

112 Zeus from Pergamon. Marble. *Ca.* 200–150 B.C.
Istanbul, Archaeological Museum. H. 2.31 m.

111 The 'beautiful head' ('schöner kopf') from Pergamon.
Marble. *Ca.* 200–150 B.C. East Berlin, Staatliche
Museen. H. 0.30 m.

sea and deities connected with Asia on the projecting
wings of the west; deities of day and night on the south;
and, on the controversial north side, chthonic deities and
gods of the underworld. The designer of the frieze, he
proposes, gave distinct identity to these realms by 'fram-
ing' them within symmetrically balanced patterns of
composition. One of Pfanner's most striking observa-
tions is that the goddess on the north side who is usually
identified as Nyx [107] is in fact probably Persephone,
because the fillet which can be seen running behind her
head and over her left arm ends in a pomegranate flower,

113 Personification of Tragoidia from Pergamon. Marble.
Ca. 200–150 B.C. East Berlin, Staatliche Museen.
H. 1.80 m.

an attribute of the Queen of the Underworld. As the debate continues, art historians will no doubt continue to rethink these questions and from time to time make new proposals, but however the interpretation of it may change, the Altar of Zeus's place as a monument to what we have called the 'scholarly mentality' of the Hellenistic period will remain intact.

Before leaving the question of the program of the great frieze, a word should be said about the Giants. Although there are 26 names of Giants partly or fully preserved in the inscriptions from the base of the frieze, it has not

proved possible to ascribe any of these names to particular figures with complete certainty. (There is a separate set of positioning marks for the blocks on which the Giants' names were inscribed, but its code has yet to be deciphered.) The one useful source for determining which Giant is most likely to have fought which god is Apollodoros's relatively brief description of the battle in the *Bibliotheke* (1.6.1–3). On the basis of Apollodoros, Hekate's opponent has been identified as Klytios, the fallen Giant next to Apollo as Ephialtes, the Giant whose hair is grasped by Athena as Alkyoneus or Enkelados, and the snaky-tailed Giant who opposes Zeus as Porphyrion or Typhon.[27] Each of these identifications is, however, disputable. As was the case with the gods, the size of the frieze called for many more Giants than there were models for in earlier Greek art. Once again Hellenistic scholarship was probably called upon for inspiration. Some details in the representation of the Giants may have been inspired by Hesiod and other early authors, but it seems likely that the main inspiration was a Hellenistic work, very probably the Περὶ γιγάντων, *On the Giants*, of the Stoic Kleanthes of Assos. Nothing survives of this work, but one may guess that, in keeping with other Stoic writings on literature and mythology, it ascribed allegorical significance to the Giants. At any rate, the variety of form in which the Giants are cast has no precedent in Greek art and must be a reflection of contemporary scholarly research and speculation. Some of the Giants have purely human forms and wear armor (e.g. the opponent of Artemis), which is the way Hesiod (*Theogony* 185–6) describes them. Others have snaky legs which end in serpents' heads, not tails. This form has a few precedents in vase painting, but the altar of Zeus represents the first extensive use of it.[28] Its inspiration may come from Hesiod's description of Typhoeus or Typhon (*Theogony* 821–7), the monstrous offspring of Earth and Tartaros. Properly speaking Typhon was not one of the Giants. Nor apparently were the bull-headed and lion-headed monsters on the frieze, who are probably Hellenistic inventions. Clearly the word 'Giant' must be used in a loose, or at least broad, sense in connection with the frieze. The opponents of the gods seem to have included not only the Giants, who fought to attain immortality, but also immortal children of earth who challenged the cosmic order established by the Olympians. And all of these figures were probably 'readable' on many levels. The Attalids probably saw them as symbols of passions and other forces which disrupted cosmic harmony and obstructed philosophical insight; and the scholars in the Library perhaps saw them as exhibitions of subtle learning.

A large number of sculptors must have worked on the Gigantomachy frieze, perhaps as many as 40, but little is known about them. They inscribed their names on the socle of the frieze, below the names of the Giants, and

fragments of about 15 of these names survive.[29] In only one case has it been possible to assign a particular section of the frieze to one of these artists: Theorrhetos, probably a native of Pergamon, did the section along the stairway on the southwest wing where the Nymphs are depicted. Only one of the names in these inscriptions, that of Menekrates, seems to have been that of an artist whose fame is attested by literary sources. He was probably the Rhodian sculptor whom Pliny (*NH* 36.34) mentions as the father, or adoptive father, of Apollonios and Tauriskos, the sculptors of the original of the 'Farnese Bull' (see p. 117). It has been suggested that this Menekrates is identical with the architect whose fame was remembered even in the fourth century A.C. by Ausonius (*Mosella* 307) and that he might in fact have been the architect and chief designer of the whole Altar of Zeus. Whether this is true or not, the style of the great frieze of the Altar does seem to have found a home on Rhodes (see p. 113), and there is a strong likelihood that Rhodian sculptors played an important role in creating it.

Pergamene free-standing sculpture of the second century B.C.

In the next chapter we shall see how the style developed in the great frieze of the Altar of Zeus was widely used in its own time and had an afterlife which lasted into the early Roman Empire. Since many of the works discussed in that section will be Roman copies, or Greek works of uncertain origin and problematical date, it will be useful here to look at a group of original sculptures from Pergamon which can with reasonable confidence be dated between 197 and 138 B.C. (the reigns of Eumenes II and Attalos II). All of them, in one way or another, show distinctive features of the Gigantomachy frieze adapted to less dramatic contexts. The massiveness of facial features and strands of hair that typifies the Giants of the frieze, for example, is seen in the impressive head of Herakles [110], now in Berlin. The pathos of the Gauls is, of course, toned down for this image of a mortal who became a god. Some of that pathos is retained, however, in the famous portrait of Alexander [5], where a Lysippan prototype has been given a Pergamene baroque surface. This portrait, it will be remembered, was prob-

ably made early in the reign of Eumenes II and may have been part of an image in the Temenos of the Ruler Cult at Pergamon (see p. 274). It is conceivable that it is a work of one of the sculptors of the Great Altar. The facial features of the female figures on the frieze are perpetuated in a head frequently referred to as the *schöner Kopf* (beautiful head) [111]. Its resemblance to the face of 'Nyx' on the frieze [108] has often been noted.

The massive anatomy of the figures on the frieze is most clearly perpetuated in an image of Zeus [112] which was found in the temple of Hera at Pergamon, built in the time of Attalos II. In many ways it is a quiet version of the god who fights on the east frieze of the Altar. The 'open' composition of this figure appears to be characteristic of the mid-second century B.C. (see p. 268) and may have been a contribution of the artists who worked on the Altar to the evolution of Hellenistic free-standing sculpture. Finally, the anti-anatomical style of drapery that characterizes Helios, Eos, and other figures on the great frieze is found on a number of female figures from Pergamon, most notably in the figure which has been interpreted as the personification of Tragedy [113] and in another which was conceivably a Muse.[30] In both these the rope-like criss-crossing of folds and rolls of drapery tends to obscure natural anatomical divisions and create independent, self-sufficient structures.

These particular works have been singled out because they illustrate the perpetuation and diversity of the 'baroque' side of Pergamene sculpture, which is unquestionably its most original and distinct side. The 'beautiful head,' however, should remind us of another strain which was always present at Pergamon and which by the middle of the second century B.C. was perhaps beginning to gain the upper hand. This other strain is neoclassicism, the style of the great Athena from the Pergamene library [171]. At Pergamon classicism was usually brought into an easy harmony with the dynamism of the baroque, and this harmony functions as a major factor in the appeal of the best Pergamene sculpture. Crescendo and quietude work together. After *ca.* 150 B.C. classicism seems to have been cultivated, like Hellenistic rococo and perhaps also social realism, as a reaction to the ponderosity of baroque. These reactions will form the subject of subsequent chapters (see Chaps. 6 and 8).

5

Hellenistic baroque

Since early in the twentieth century the term 'baroque' has been used frequently, but rather loosely, to refer to the style of certain prominent works of Hellenistic art, like the Gigantomachy from the Altar of Zeus, which seems to have a kinship in spirit with European art between *ca.* 1600 and 1750. When applied to Hellenistic art the term really makes sense only when used in connection with sculpture. A recently discovered painting at Vergina [204] admittedly has a certain dash that reminds one of Italian baroque painting, but there simply are not enough examples of Hellenistic painting extant to permit broad stylistic generalizations (see pp. 188–92). In architecture, there are some theatrical elements in planning and design which one might choose to call baroque (see pp. 230–42), but fundamentally, the basic forms of Hellenistic architecture remained very much in tune with the Classical tradition from which they derived.

The stylistic properties of Hellenistic sculpture which have led to its being compared to, for example, Italian sculpture in the time of Bernini are, first, a theatrical manner of representation which emphasizes emotional intensity and a dramatic crisis and, second, the formal devices by which this theatrical excitement is achieved – restless, undulating surfaces; agonized facial expressions; extreme contrasts of texture created by deep carving of the sculptural surface with resultant areas of highlight and dark shadow; and the use of 'open' forms which deny boundaries and tectonic balance.

The term has been adopted in this book not only because it seems to the author that there are, in fact, some close analogies between certain Hellenistic sculptures and later baroque sculpture, but also because the term is a convenient one, being less limited and prejudicial than phrases like 'high Pergamene' or 'middle Hellenistic.' It should be emphasized, however, that the use of 'baroque' here is not meant to imply that Hellenistic sculpture betrays all the stylistic features which have been ascribed to European sculpture in the seventeenth century (Wölfflin's spatial recession, for example, seems to have played only a small role in Hellenistic sculpture).[1] Nor is it meant to imply that there is some sort of inevitable cycle in which a baroque style will always follow a 'classic' style. 'Baroque' here simply refers to that style, already described, which reached its peak in the Attalid sculptures described in the preceding chapter.

Although the Hellenistic baroque style reached its mature form in the period between *ca.* 225 and 150 B.C., its chronological range extends beyond this period at both ends. There are both precursors of it in the late fourth and early third centuries B.C., and late representatives of it, like the famous Laokoön, that appear to carry us into the first century A.C. In seeking a starting point for specific features of the stylistic tradition in Greek sculpture which gives priority to pathetic expression and restlessness of surface, it may be that we should go back as far as the sculptures from the pediments of the temple of Asklepios at Epidauros and related works of *ca.* 380 B.C. The point at which *all* the features of the style came together, however, was most probably in the later phase of the career of Lysippos. Dramatic expression and open form were features, as we have seen, which Lysippos had already developed in his famous portraits of Alexander, and there is some evidence to suggest that he also developed that restlessness and massiveness of surface details which later became such a distinctive feature of Pergamene sculptures. It is tempting to speculate, in fact, that the style in which anatomical features are exaggerated and magnified by being surrounded with shadowy recesses was an outgrowth of the revival of colossal sculptures by Lysippos and his pupils (see pp. 49ff.). A certain massiveness in articulation was inevitable in colossal sculptures, and in time this may have come to be applied to sculptures on any scale. It is noteworthy that the head of Herakles from Tarentum [43], which has plausibly been thought to reproduce the features of Lysippos's colossos in that city, has exaggeratedly deep, rippling furrows on its brow and that these contribute significantly to the pathos of expression which led a Byzantine writer who saw it to describe it as 'full of despondence.'[2] It is also possible, as already suggested, that the original, or one of the originals, of the

114 Figure from a metope of a Tarentine Tomb. Limestone. *Ca.* 300–275 B.C. Taranto, Archaeological Museum. H. 0.392 m.

Farnese Herakles type [41] was colossal and had some of the massiveness of detail that characterizes the Roman copy.

Whether it is a coincidence or not, Tarentum, the home of two famous colossal statues by Lysippos, was also the home of a group of relatively humble funeral monuments which clearly betray baroque features before the time of Attalos I and Eumenes II. These are the Tarentine tomb sculptures. Recent research has shown that to the east of the agora of Tarentum there was a section of the city with a grid plan of streets that was partly a residential area and partly a necropolis. The straight streets of this necropolis were flanked by tombs built in the form of small temples (*naiskoi*), which, on the basis of the pottery found with them, can be dated to between 325 and 250 B.C., with most of them datable to before the end of Pyrrhos's campaign of 275 B.C. These *naiskoi* were richly decorated with sculpture in the form of akroteria, pedimental and metope reliefs, and occasionally also with reliefs on the columns or on the base of the buildings. These sculptures represent a variety of subjects:

stories, like that of Persephone; stories involving battle scenes, both mythical and historical; abductions; encounters at a tomb, for example Orestes and Electra; scenes from everyday life such as hunting, sports, and banqueting; and processions, most notably the marine or Dionysiac *thiasos*. All of these were probably intended to convey the message that the deceased had become a hero (in the Greek sense, that is, a demi-god) who dwelt in the tomb or had been transported to a Dionysiac Elysium.

The Tarentine tombs were private monuments, and the technical skill of the sculptors who made them was modest, but the style to which they were aspiring is clear enough. One of the best examples of it is found in the metopes from a *naiskos* discovered in 1959 and dating to *ca.* 275–250.[3] One of them represents a bearded warrior who is perhaps to be interpreted as a chief from one of the local barbarian tribes that fought with the Tarentines [114]; another depicts a nude warrior who seems to be stabbing in the direction of a horse which is rearing over the body of a fallen comrade [115] (the horse is now missing except for one hoof, just to the left of the fallen warrior's shield). The face of the bearded warrior with its deep carving and voluminous curling beard anticipates the faces of the Giants from the Pergamon altar; and the anti-anatomical drapery which obscures his waist foreshadows the principle employed for many of the gods on the Pergamon frieze. On the metope with the two warriors the musculature of the figure to the left, particularly around his hips and rib cage, has the same exaggerated quality found on many of the Pergamene figures, and the fallen warrior, however crudely carved, sprawls in a contorted, inelegant way that complements the pathos of his face and calls to mind the Gauls from the Lesser Attalid dedication [89–94].

Also anticipating fully developed Hellenistic baroque, and of much finer quality than the Tarentine grave reliefs, is a relief in Athens depicting a groom attempting to restrain a nervous, snorting horse [116]. Its date has been debated but is probably early third century B.C.[4] The excited face of the groom and the bulging muscles and veins of the horse create the familiar sense of tension and restless energy. This war-horse-like massiveness in horses seems to have been an early Hellenistic phenomenon that was carried on in the Gigantomachy frieze at Pergamon (e.g. in the horses of Ares and Helios), and it is tempting to speculate that it stemmed from the horses in Lysippos's Granikos Monument.

The sculptors who worked at Pergamon in the late third and early second centuries B.C., then, intensified and perfected a style which had been evolving from the very beginning of the Hellenistic period. Many of these artists, probably in fact the majority of them, were not Pergamenes, and what might seem, because of the fame of the Attalid monuments, to have been a Pergamene style was undoubtedly the property of workshops in

115 Battle scene from a metope of a Tarentine tomb. Limestone. *Ca.* 300–275 B.C. Taranto, Archaeological Museum. H. 0.43 m.

many cities. Outside of Pergamon, however, there are very few works in the mature baroque style which can be connected with particular locales, and it is therefore difficult to determine what these other centers were. The one partial exception to this dictum is Rhodes. As we have seen, Rhodian sculptors like Menekrates worked at Pergamon, and it is clear that they played an important role in disseminating and perpetuating the Hellenistic baroque style.

Most probably a Rhodian work, and if so, the most splendid example of the mastery of baroque texture and setting by the sculptors of Rhodes, is one of the most admired original sculptures of the Hellenistic period, the Nike of Samothrace [117]. The Nike was discovered in 1863 on the site where it was originally set up in the sanctuary of the Great Gods at Samothrace. It is one of

those rare ancient Greek free-standing statues whose original setting can be accurately reconstructed and whose effect on contemporary viewers can therefore be visualized. The base of the statue is in the form of a ship's prow, and the goddess is depicted as if she has just alighted on the ship, with her wings still beating and her drapery fluttering in the wind, in order to crown its victorious commander and crew. The dramatic effect of the goddess's arrival was enhanced by placing the ship's prow in a two-level pool or fountain. A shallow upper basin held the ship, while in the lower basin were large boulders, probably intended to suggest the shoreline or the home harbor of the ship. This illusionistic effect was further enhanced by the fact that the whole assemblage was erected on a terrace above the theater of Samothrace, from which one had a dramatic view across the whole

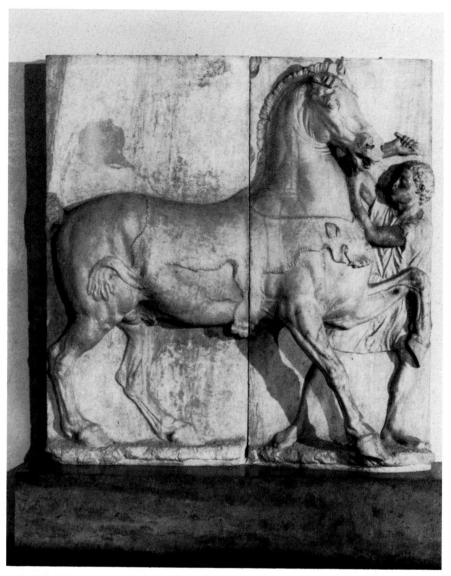

116 Relief of horse and groom. Marble. Perhaps early 3rd century B.C. Athens, National
Archaeological Museum. H. 2.00 m.

sanctuary and down a small valley to the actual sea and
coastline.

Statues of Nike alighting with emblems of victory were
not new in Greek art (there is, for example, the famous
Nike of Paionios from Olympia), and the type depicting
the goddess on the prow of a ship had apparently already
been used by Demetrios Poliorcetes for a monument
commemorating his victory off Cyprus in 306 B.C.[5] The
dramatic effect of the Nike in her setting at Samothrace,
however, with rippling water reflecting on the deeply
carved, billowing furrows of her drapery and the massive
feathers of her wings, could only have been created in the
period which produced the 'Hellenistic baroque.' In style
alone one would be inclined to date the figure *ca.* 200 B.C.
and there is epigraphical evidence which makes such a
date probable. A fragmentary inscription found with the
base of the Nike has letters which are very similar in form
to several inscriptions on the island of Rhodes, some of
which bear the signature of the sculptor Pythokritos. In
addition, there is a relief of a ship's prow at Lindos on
Rhodes, signed by Pythokritos, which is very similar in
form to the prow which forms the base of the Nike.[6] This
evidence, coupled with the fact that the base at Samoth-
race is made of Rhodian marble (the statue itself is

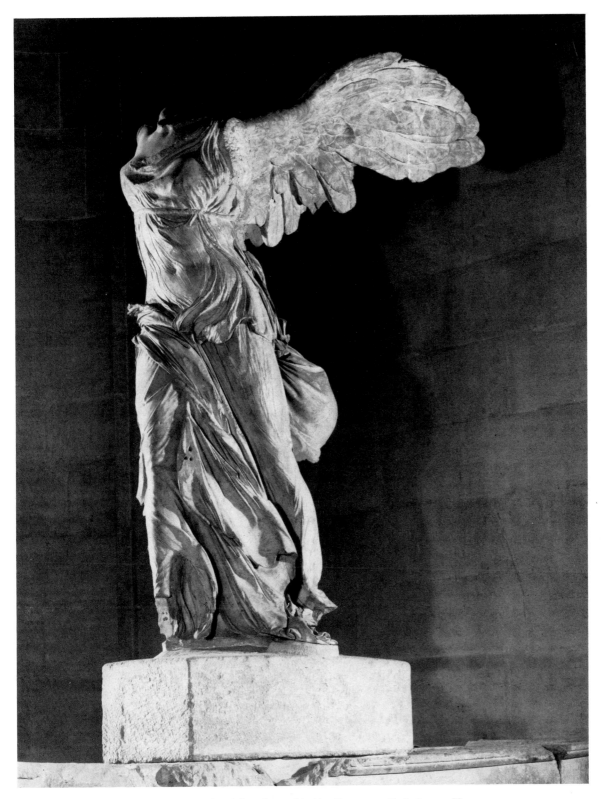

117 The Nike of Samothrace. Marble. *Ca.* 200 B.C. Paris, Louvre. H. 2.45 m.

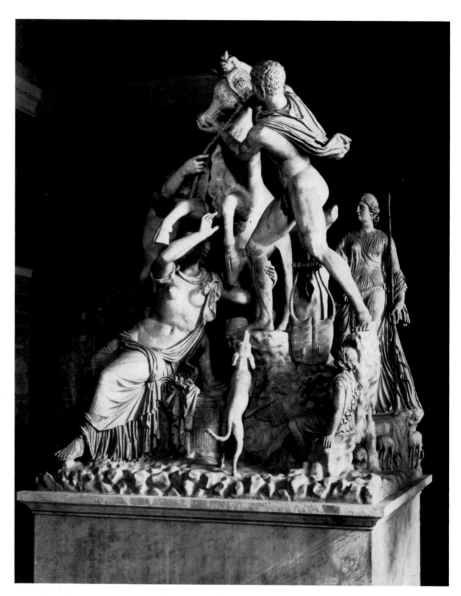

118 The 'Farnese Bull' group. Marble. Roman adaptation of an original of *ca.* 150 B.C. Naples, Archaeological Museum. H. 3.70 m.

Parian) strongly suggests that the Nike is a Rhodian work and that it may well be a work of Pythokritos, who was active in the early second century B.C.

In the light of the previous chapter it may also be noted how similar details of the Nike are to many figures at Pergamon. The feathers of her wings are close to those of some of the 'monstrous Giants' as well as to those of Zeus's eagle; the swirl of her chiton and the deep folds of her himation are akin to those of several of the goddesses in the Gigantomachy. It is not unlikely that Pythokritos was also one of the sculptors of the Great Altar.

Although it is not provable, there is a strong likelihood

that the Nike was dedicated at Samothrace by the Rhodians to celebrate naval victories over the forces of Antiochos III. After being driven from Greece in 191 B.C. by the Romans and their Greek allies, among whom were the Rhodians, Antiochos had raised a new fleet which he hoped to use to prevent the Romans from pursuing him into Asia, but in 190 B.C. an allied fleet commanded by a brilliant Rhodian admiral named Eudamos shattered the Seleucid force in battles off Side (in Cilicia) and Myonnesos (near Teos in Ionia). It does not stretch the imagination to think of Eudamos returning in 190 B.C. to his home island, fresh and exultant from these victories, and

119 The 'Pasquino group.' Restoration by Bernhard Schweitzer based on a variety of copies.

commissioning one of the prominent artists of his time to create a stunning monument that was to be set up in the Panhellenic sanctuary at Samothrace, where the presiding deities were, among other things, the protectors of sailors.

Apparently also a Rhodian work belonging to about the middle of the second century B.C. was the original of the 'Farnese Bull' group in Naples [118]. It depicted Zethos and Amphion, the sons of Antiope, tying the Boeotian queen Dirke to a bull as punishment for the

cruelty she had inflicted on their mother. Pliny (*NH* 36.34) records that the group was the work of Apollonios and Tauriskos of Tralles (in Asia Minor), who became the adopted sons of Menekrates. The surviving version of the work was made for the Baths of Caracalla in Rome in the early third century A.C. In spite of odds and ends added by the copyist and of modern restorations, what must have been the basic effect of the original can still be appreciated. Dirke seems to have had the pathetic expression and gesture of Ge on the Pergamon altar, and the efforts of the sons to restrain the ferocious energy of the bull carry on the tradition of the groom relief [116] in Athens. Every feature of the work seems to have been designed to wring emotional involvement from the viewer and make him identify with its violent, dramatic crisis. A pyramidal form with realistic 'landscape' beneath the figures and a pronounced 'many-sidedness' were also very probably properties of the original.

The Farnese Bull as well as the Attalid Gallic monuments suggests that free-standing sculptural groups were particularly favored in the late third and second centuries, undoubtedly because the potential for pathos and dramatic crisis in them was greater than that of single figures. Judging by the number of Roman copies of it, one of the most admired of such groups in Antiquity was the so-called 'Pasquino group' [119]. As reconstructed from various fragmentary copies, it depicts Menelaos carrying off the body of the slain Patroklos from the battlefield at Troy.[7] The pyramidal form of the group, the dramatic turn of Menelaos's head as he 'faces down' his opponents, and the pathetic, limp figure of Patroklos are all reminiscent of the Dying Gaul and his wife in the Terme [86]. It was these similarities which prompted Bernhard Schweitzer to date the original which he so impressively reconstructed to the end of the third century B.C., and although it has frequently been challenged, Schweitzer's dating seems justified.[8] Schweitzer also felt that, along with its pathos, the group's literary content (it illustrates *Iliad* 17.580–1) and what seemed to be allegorical figures on the helmet of Menelaos associated it with the learned tone and spirit of Pergamene art that we have already examined in connection with the Altar of Zeus.[9] He accordingly attributed it to the historian-scholar-sculptor Antigonos of Karystos, who was one of the sculptors of the Attalid dedication at Pergamon (see p. 84). There is absolutely no proof for this attribution, but the general observations that prompted it are reasonable.

Other groups with the essential composition and atmosphere of the Pasquino group have been reconstructed, notably an Artemis and Iphigeneia and an Achilles and Penthesileia, but the evidence for them is too limited to permit a serious evaluation of their quality and effect. The emotional effect of another famous group with a quite different composition, however, the 'Hanging Mar-

120 Hanging Marsyas. Marble. Roman copy of an original of *ca.* 200–150 B.C. Istanbul, Archaeological Museum. H. 1.305 m.

syas group,' is unmistakable even in copies [120–121]. Once again the number of surviving copies of the Marsyas suggests that it too was widely admired in Antiquity. The story depicted concerns the horrible fate of the Satyr Marsyas who discovered flutes cast aside by Athena and became so adept in playing them that he had the temerity to challenge Apollo to a musical contest. Apollo accepted the challenge on the condition that the loser would have to accept any punishment laid upon him by the victor. When Apollo won (by playing his lyre upside-down, a feat Marsyas could not match with his flutes), he decreed

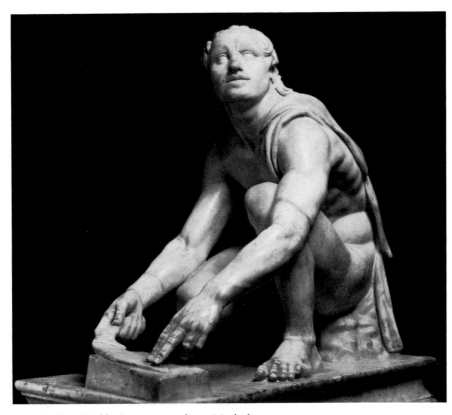

121 Scythian. Marble. Roman copy of an original of *ca.*
200–150 B.C. Florence, Uffizi. H. 1.06 m.

that the Satyr be flayed alive by a Scythian servant. When
the story had been depicted in a sculptural group in the
fifth century B.C. the emphasis had been on Marsyas's
discovery of the flutes and his consequent excitement.[10]
The Hellenistic artist, by contrast, turned, as one might
expect, to the pathos and horror of Marsyas's punish-
ment. The dramatic force which must have characterized
the original seems well preserved in one of the best
replicas of the Marsyas, in Istanbul [120].[11] The Satyr is
shown bound hand and foot to a tree, with the flutes at its
base. His body is painfully and vulnerably stretched out
as it awaits the Scythian's knife. His face, distorted with
pain, is in the tradition of the Giants of the Pergamon
altar. The Scythian, preserved in a replica in Florence
[121], is shown sharpening his knife on a whetstone as he
stares with an animal-like curiosity at the anguished
Satyr. The anthropological realism of his face with its
receding forehead, pronounced cheekbones, and tufts of
facial hair place him in the tradition of the Gauls on the
dedications of Attalos I. He is an ominous, brutal figure,
yet is looked at with understanding. Some scholars would
add to the group a figure of Apollo, found in Pergamon
and now in Berlin.[12] If it belongs, this classicized post-

Praxitelean figure of the god would add the same contrast
to the group that is provided by the gods on the Pergamon
altar. Pathos, realism, drama, and classicism do not
prove that the Hanging Marsyas group is a Pergamene
work of the early second century B.C., but they make, as
many scholars have recognized, a strong case for it.

Along with these mythological figures and groups
there are two great works of portraiture which must be
counted among the masterpieces of Hellenistic baroque,
the 'Blind Homer' [122] and the enigmatic type known
conventionally as the 'Pseudo-Seneca' [123]. The Homer
is, of course, an imaginary portrait in which the sculptor
strove to create in his imagination a form which would
express what Homer was. Greek sculptors had been
conjuring up images of their most revered poet since the
early fifth century, and several pre-Hellenistic Homer
types are known. These pale into insignificance, however,
beside the Hellenistic realization of the poet's face. All the
devices of Hellenistic baroque – an undulating surface,
an almost independent animation of individual facial
features, deep carving and its resultant shadows – com-
bine to produce the rapt face of a visionary whose mental
force is focused on an interior world of imagination

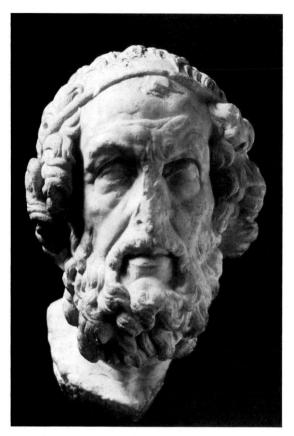

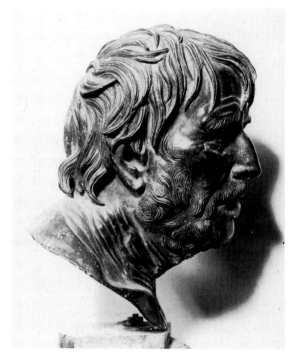

123 The 'Pseudo-Seneca.' Bronze. Roman copy of an original of *ca.* 200–150 B.C. Naples, Archaeological Museum. H. 0.33 m.

122 Blind Homer. Marble. Roman copy of an original of *ca.* 200–150 B.C. Boston, Museum of Fine Arts. H. 0.41 m.

which sends echoes of its excitement to the surface but has no need for the blind physical eyes.

The 'Pseudo-Seneca' was one of the most frequently copied portraits of Antiquity and must clearly have represented a literary figure of great importance.[13] More than two dozen proposals about its identity have been made, and while none of them is free from objection, the one most likely to be right is the suggestion that the type represents Hesiod. The aged, intense, somewhat haggard face would suit the dour yet inspired Boeotian poet. Where and when the originals of these two great portraits were made can only be guessed. Their style certainly would have been at home in Pergamon, and it is tempting to think that they were made for the great library there in the time of Eumenes II. Homer and Hesiod were favorite subjects for the Stoic allegorizing of Krates of Mallos, and the influence of Hesiod on the sculptural program of the Altar of Zeus was, as we have seen, all-pervasive. The likelihood that such portraits were created at Pergamon has perhaps been enhanced by the recent discovery that Phyromachos, one of the sculptors who worked at Pergamon in the late third century, was the author of the

portrait, known in Roman copies, of the proto-Cynic philosopher Antisthenes [84].[14] Since Antisthenes' dates were *ca.* 445–360 B.C., Phyromachos's portrait was either an imaginary one, or at least a dramatically enhanced, baroque version of an earlier type. Phyromachos, who was an Athenian, could, of course, have made the Antisthenes portrait for someone other than the Attalids. But the idea that there was a tradition of imaginary portraits of literary figures in the baroque style complementing the powerful Attalid portraits of political figures (see pp. 33–4) is worth considering.

Probably the most famous and often admired work in the Hellenistic baroque tradition is the group of Laokoön and his sons in the Vatican [124]. If discussion of this renowned work has seemed unduly delayed, it is because recent scholarship strongly suggests that it is a product not of the heyday of Hellenistic baroque, as was until relatively recently thought, but rather the product of a powerful afterlife, or revival, of the Hellenistic style that took place in the first century A.C. The Laokoön was discovered in 1506 in the structure on the Mons Oppius which had once been part of the Golden House of Nero and had apparently been incorporated into a new dwelling for the Emperor Titus.[15] It was probably in this very location that Pliny saw the work in the time of the Flavian emperors. He describes it as being in the *Domus* of the

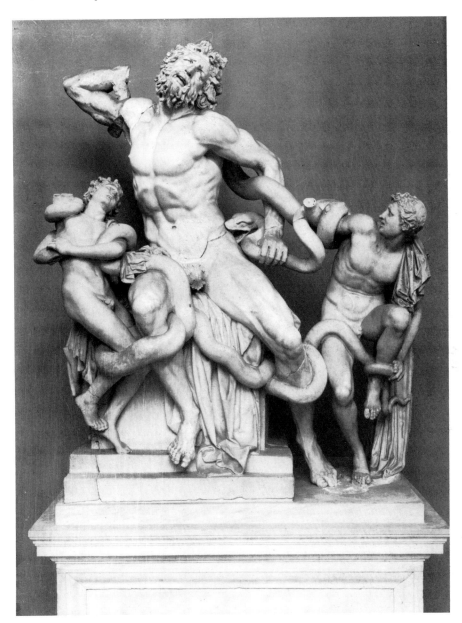

124 The Laokoön group. Marble. 1st century A.C. Rome, Vatican Museums. H. 1.84 m.

Emperor Titus and extols it as 'preferable to all other works of art, either of painting or sculpture' (*NH* 36.37). Pliny's enthusiasm was matched by Renaissance antiquarians and artists, Michelangelo among them, who were present when the work was discovered, and although its melodramatic style has gone in and out of fashion in succeeding centuries, the pure technical virtuosity of the Laokoön has always continued to be admired. In addition to documenting the location of the work and expressing his enthusiasm for it, Pliny also performed the invaluable service of preserving the

names of its sculptors: Hagesandros, Polydoros, and Athenodoros of Rhodes.[16]

Laokoön was a Trojan priest who tried to warn the Trojans not to bring the fateful Trojan horse into their city. Before he could convince them, however, two large serpents, sent by the gods who were hostile to the Trojans, rose from the sea and strangled Laokoön and his son, or sons, while they were sacrificing at an altar. The most renowned description of the story is that of Virgil in *Aeneid* 2.199–277, but earlier versions of it existed in Greek poetry, the first of which was apparently in the

Iliou Persis (*Sack of Troy*) of Arktinos, an epic poet of the eighth or seventh century B.C. In the Greek versions of the story it seems that only one son was strangled by the serpents, as opposed to two sons in Virgil's version. Since the presence of a second son has been used to support a post-Virgilian date for the sculpture in the Vatican, the point is not entirely pedantic.

The close connection in both style and conception between the Laokoön group and the Gigantomachy frieze of the Altar of Zeus at Pergamon hardly needs to be emphasized. As on the altar, a moment of maximal violence and agony has been chosen to sum up the story. As Laokoön falls back on the altar at which he has been sacrificing, one serpent entwines his shoulders, as well as those of his elder son, and curls around to bite him on the hip. The other serpent enmeshes the legs of all three figures and seems to have squeezed the life out of the younger son (to the left). As Laokoön struggles to get free he lets out a cry of pain. His contorted face, open mouth, and massive wreath of hair call to mind, of course, the agonized Giants of the altar, particularly the figure whose hair is grasped by Athena [100]; and the serpents, likewise, have their counterparts in the snakes of Athena as well as the snaky legs of the Giants on the altar. The massiveness of Laokoön's musculature and the deep drilling in his hair and beard also have analogies, in a general way, to the Pergamene style. That the Laokoön is in the tradition of the sculptures of the Altar of Zeus is, then, indisputable. There are, however, some clear differences between the two. The face of Laokoön, when compared to the Giants, is more fluid and quivering. On the hair of the Giants, the drill has been used to outline long, sinuous, rope-like strands of hair, whereas on the Laokoön the hair is grouped into rather impressionistic clumps, which are then set off as separate units by deep drilling. Drapery admittedly plays little role in the Laokoön, but what there is of it is tepid and conventional, and unlike Pergamene drapery, adds nothing to the effect of the work.

Are these differences simply attributable to a different workshop, or do they indicate a difference in date? Or, putting the question more directly, what is the date of the Laokoön? Since the late nineteenth century, when a relatively scientific approach to this question began, estimates have varied considerably. For many years the work was usually dated in the first century B.C., primarily because several signatures of a Rhodian sculptor named Athanodoros, the son of Hagesandros, were preserved in inscriptions, and all of these were datable to the first century B.C. This Athanodoros was assumed to be, of course, one of the sculptors mentioned by Pliny, as was his father Hagesandros. In 1954, however, Gisela Richter mounted a major challenge to this dating.[17] Her feeling was that the Laokoön is so close to the high Hellenistic style of the Pergamon altar that it must belong to the

second century B.C. and not to the subdued, classicizing phase of late Hellenistic art. Rhodes, she argued, was more likely to have produced a major work like the Laokoön during its era of greatest prosperity, before the battle of Pydna, rather than afterwards. Richter noted that the names Athanodoros and Hagesandros were in common use in Rhodes for several generations and that there is no evidence at all regarding the date of Polydoros, the third sculptor mentioned by Pliny. The inscriptions, therefore, fall far short of proving a date in the first century for the Laokoön, and its style would certainly make the second century more likely. Richter's case seemed to be prevailing until the astonishing discovery in 1957 of the 'Grotto of Tiberius' at Sperlonga, on the coast of Latium south of Rome. In this cave were found not only an inscription with the signatures of Athanodoros, Hagesandros, and Polydoros but also, almost unbelievably, other spectacular sculptures by these three artists [125–130]. Since the date of the Laokoön has now become indissolubly connected with the Sperlonga sculptures let us suspend this question until we have looked at the latter.

The grotto at Sperlonga is a natural cave which was incorporated into an early Imperial (perhaps Augustan) villa as a summer banqueting room. In order to make the cave more comfortable and diverting for its users, the Roman architects rounded off its natural pool into a neat circle, paved the surrounding area, and equipped two sub-grottoes within it with fountains [125]. It was apparently in this cave that the commander of the Praetorian Guard, Sejanus, protected the Emperor Tiberius when a portion of its roof collapsed (Tacitus, *Annals* 4.59; Suetonius, *Tiberius* 39); hence the name 'Grotto of Tiberius.'

It was probably in the time of Tiberius, or at least not far from it, that the cave was lavishly adorned with sculptural groups connected with the exploits and wanderings of Odysseus. From the vast remains of fragments of these groups it has been possible to piece together four major subjects: the blinding of Polyphemos by Odysseus and his men; the assault of Scylla on Odysseus's ship; the theft of the Palladium (a venerable image of Athena) from Troy; and a version of the 'Pasquino group.' On the ship of the Scylla group is an inscription which identifies the artists who made it: 'Athanodoros son of Hagesandros, and Hagesandros, son of Paionios, and Polydoros the son of Polydoros, Rhodians, made this.' The signatures of the sculptors of the Laokoön at Sperlonga naturally created a sensation when first discovered.[18] Since all the sculptured groups are made of the same type of marble, it may be that the three Rhodian artists were responsible for all of them, although the signatures, it should be emphasized, belong only to the Scylla group.

The most spectacular of the Sperlonga groups is that of

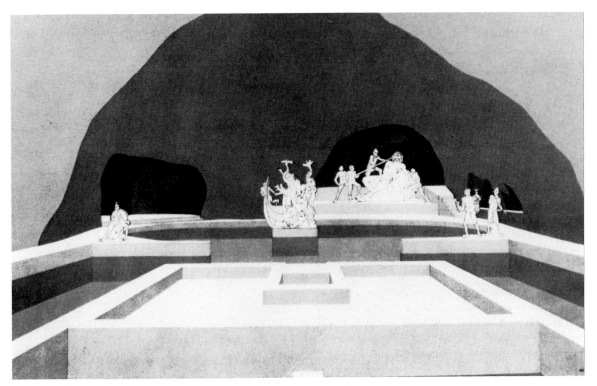

125 Sperlonga. Restoration of the 'Grotto of Tiberius.'

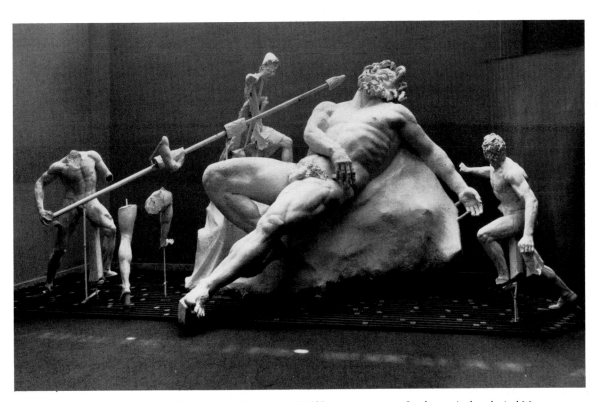

126 Sperlonga, Cyclops group. Marble. 1st century A.C. Sperlonga, Archaeological Museum.

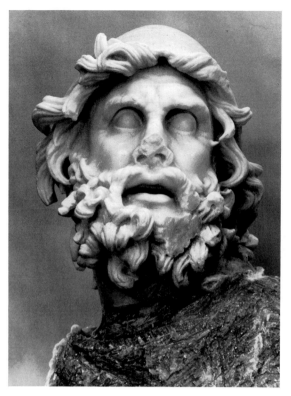

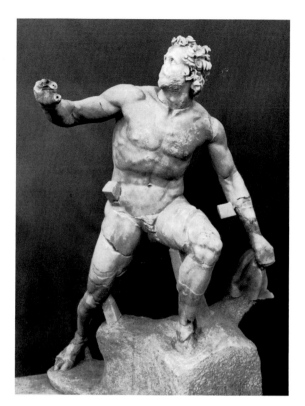

127 Sperlonga, head of Odysseus. Marble. 1st century A.C. Sperlonga, Archaeological Museum. H. 0.635 m.

128 Sperlonga, Wineskin bearer. Marble. 1st century A.C. Sperlonga, Archaeological Museum. H. 2.21 m.

the blinding of the Cyclops, the format of which can be reconstructed from other representations of the same subject, most notably a sarcophagus in Catania [126]. The group was placed in the small sub-grotto on the south side of the pool [125], thus fancifully evoking the cave of Polyphemos in the *Odyssey*. Odysseus and his men are about to ram, or have just rammed, the burning stake into the eye of the drunken Cyclops, and their faces show the stress and excitement of the moment [128 and 130]. The similarities in the dramatic expression, in rippling musculature, and in style of carving to the Laokoön and ultimately to the Pergamon altar need not be belabored.

The Scylla group stood on a base in the middle of the circular pool and was hence, illusionistically and appropriately, envisioned as being in the sea. The excitement, drama, and pathos that one would expect from the sculptors of the Laokoön are unmistakable in the heads of the sailors who are being bitten and mauled by the dog-headed tentacles of Scylla and in the figure, perhaps Odysseus or perhaps his helmsman, who clings desperately to the stern of the beleaguered ship [129–130].

Only fragments of the Palladium group (mainly an endearing archaistic image of Athena) and of the

Pasquino group survive. Since the 'Theft of the Palladium,' like the two large groups, also depicts an exploit of Odysseus, the Pasquino group, which is normally taken to represent Menelaos and Patroklos, appears to be a thematic anomaly, and Bernard Andreae's suggestion that the Sperlonga version was altered to represent Odysseus with the body of Achilles deserves serious consideration.[19]

The same problems that arise in connection with the date of the Laokoön also apply to the Sperlonga sculptures. When, where, and for whom were they made? There are four possible answers: (1) they are Hellenistic originals, probably made in Rhodes, in the second or first centuries B.C.; (2) they are Roman copies of Hellenistic originals; (3) they are not so much copies as free variants of Hellenistic prototypes made in the Roman period; (4) they are original creations of the Roman period. Of these possibilities, a combination of numbers (2) and (3) seems most likely for two reasons. First, the lettering of the inscription with the sculptors' signatures belongs, by the consensus of most epigraphers, to the first century A.C. Second, the scale and the subject matter of the Polyphemos and Scylla groups harmonize so well with the spots in the grotto where they were set up that it is probable that they were made for those spots. If this is the

129 Sperlonga, Helmsman from shipwreck group. Marble. 1st century A.C. Sperlonga, Archaeological Museum. L. 1.60 m.

130 Detail of [129].

case they can only date to the Roman period, since the cave was not developed as an architectural complex until early Imperial times. The Pasquino group and the 'Theft of the Palladium' must be essentially copies of Greek originals, although even in their case there may have been some modification of the original form to suit the cave. In the case of the Polyphemos and Scylla groups, some scholars have hypothesized the existence of original prototypes, perhaps of bronze, on Rhodes, where grottoes with sculptures are known to have existed.[20] There is, however, no evidence among the surviving sculptures of Rhodes, or among the many versions of the Scylla and Polyphemos stories in Hellenistic and Roman art, which would suggest the existence of early works which anticipated the Sperlonga sculptures in scale and complexity. It seems more likely that the Scylla and Polyphemos groups are new assemblages designed in the Roman period and composed of free variants drawn from a variety of Hellenistic originals.

The same is probably true of the Laokoön. In addition to the evidence of the Sperlonga sculptures, another purely archaeological consideration appears to point to a relatively late date. Although the figures of Laokoön and his sons are of Rhodian marble, a piece of the altar behind them is made from Italian Luna marble, and it appears that this marble did not come into general use until shortly before the Augustan period.[21] Hagesandros,

125

Athenodoros, and Polydoros perhaps created the Laokoön in Rome during the same period when they were working at Sperlonga, and like the large Sperlonga sculptures, the Laokoön was perhaps their own free elaboration upon a Hellenistic prototype. P. von Blanckenhagen has suggested that this prototype may have been a pyramidal group consisting of Laokoön and the younger son to his right, and that the second son on his left is an addition by the Rhodian sculptors made under the influence of Virgil's rendition of the story, in which two sons are strangled by the serpents.[22]

On balance it seems most reasonable to view the Sperlonga sculptures and the Laokoön as neither purely Hellenistic nor purely Roman but rather as exemplars of a mixed tradition which has been called 'the magnificent afterlife of the Hellenistic baroque.'[23]

6

Rococo, realism, and the exotic

Rococo

'Rococo,' like 'baroque,' is a term which has been borrowed from later European art and frequently applied to Hellenistic art. In the case of 'rococo,' however, there is considerable doubt as to whether the term should be applied to the Hellenistic period at all, and, if it should, as to what its scope should be. The word comes from a playful fusion of the French *rocaille*, denoting decorative shell work used to adorn the surface of artificial grottoes, with the Italian *barocco* (baroque). It was coined in France in the eighteenth century for a highly ornamental and playful style of interior decoration that was developed for the town houses of the French nobility in Paris. From France the style quickly spread to other European countries and in time came to be used in churches, monasteries, and public buildings as well as domestic interiors. While many cultural currents of the eighteenth century contributed to the creation of the rococo style and its causes should not be oversimplified, one of the motivations behind it was clearly a sophisticated reaction against the weighty emotions and occasional pomposity of the baroque. As an antidote to theatrical religiosity, the rococo artists turned to playful eroticism. Gods and saints yielded to satyrs and nymphs. Heroes gave way to children. The new cast of characters, moreover, often mimic their baroque predecessors.

The adaptation of 'rococo' to describe certain classes of Hellenistic sculpture and also to denote a rather vaguely defined phase to which these sculptures belonged was the work of an Austrian scholar, Wilhelm Klein, and was most fully explained in his book *Vom antiken Rokoko*, published in 1921, which is still the basic work on the subject. Klein separated the Hellenistic sculptures which he considered rococo into four categories: Dionysiac figures, mostly satyrs and nymphs; decorative figures of women; figures of children; and certain types of ornamental reliefs, most of them neoclassical or archaistic. In all of these Klein saw a decorative, light-hearted style, often tinged with eroticism, which appeared to have its origin in the second quarter of the second century

B.C. and to be a reaction against the weightiness of the Hellenistic baroque at Pergamon and elsewhere. The categories isolated by Klein were later considerably expanded by Margarete Bieber in the tenth chapter of her standard book on Hellenistic sculpture (1955; revised 1961). Figures of aged peasants, animals, dwarfs, grotesques, actors in costume, and familiar figures from daily life such as schoolteachers, Bieber felt, could all be fitted into the rococo category because of their decorative and playful qualities.

While there is some justification for the use of 'rococo' to describe certain types of Hellenistic sculptures, it can also be argued that the term has been badly overworked and that many works which have been given the label do not really bear it comfortably. This is particularly true, as will be argued below, with the figures of old men and women, which were conceivably serious attempts at social realism, not intended to be funny or playful. The chronological range of Hellenistic rococo, if one chooses to acknowledge its existence, is, moreover, very problematical. The great majority of works that have been lumped into the category are not datable with any precision. Some may belong to the third century B.C. and be contemporary with works in the Hellenistic baroque style. Others may belong to the Roman period and not be Hellenistic creations at all. Hellenistic rococo, in fact, has tended to become a kind of scholar's junk bin, into which works which are otherwise difficult to classify and date have been tossed out of desperation. Still another factor complicating one's evaluation of Hellenistic rococo is that some of the ancient sculptures which have been classed as rococo were known in the eighteenth century and used as models (as, for example, the Cupid and Psyche of Claude Michel Clodion (1738–1814) in the Frick Collection, New York, which echoes the Hellenistic group in Rome [131]). Thus there are some very real, formal similarities between the products of the Hellenistic period and the eighteenth century, and yet it is not necessarily true that the tone or meaning of the works of each period are the same.

Before attempting to arrive at a reasoned assessment of

132 Boy wrestling with goose. Marble. Roman copy of an
original of disputed date, probably *ca.* 150 B.C. Rome,
Capitoline Museum. H. 0.85 m.

131 Eros and Psyche. Marble. Roman copy or adaptation of
an original of *ca.* 150–100 B.C. Rome, Capitoline,
Palazzo dei Conservatori. H. 1.25 m.

what, if anything, deserves to be called 'Hellenistic
rococo,' let us take a somewhat undiscriminating look at
the sort of ancient works which have been given the label.
The first and most obvious category is children. Playful-
ness and light-heartedness are qualities generally
ascribed, whether rightly or wrongly, to children, and it is
quite natural that Hellenistic artists' particular fascina-
tion with children should be seen as one aspect of a desire
to capture these qualities in art. In pre-Hellenistic Greek
art, it might be noted, children were most often shown as
miniature adults and there is no particular interest in
them *per se*. One of the most admired images of children
in Antiquity, judging by the excellent Roman copies
made of it, is the figure of a boy wrestling with a goose
[132]. This type has frequently been ascribed to the
sculptor Boethos of Chalcedon whose 'Boy strangling a

goose' is mentioned by Pliny (*NH* 34.84) and whom
Klein saw as one of the creators of Hellenistic rococo.
Another sculptural type with the same subject [133] has,
however, also been ascribed to Boethos, and both his date
and *oeuvre* are controversial. We will return to this
question below. For the moment let it simply be noted
that whoever the author of the 'boy strangling a goose
type' may be, it has often been taken as one of the chief
exemplars of rococo sophistication in Hellenistic art.
Geese were kept as pets in Antiquity, and hence it is
possible that the chubby, enthusiastic child in [132] was
looked upon with the same affectionate, sentimental
warm-heartedness that would be applied today to the
picture of a freckle-faced boy and his dog in an advertise-
ment for dog-biscuits. Boys and puppies, incidentally,
found a place in ancient art [134]; so did little girls with
doves, 'cutely' frightened by snakes. The more devilish or
violent side of children was also treated in what seems to
be a carefree fashion, as in the terracotta in Baltimore,
where a cockfight is watched with appreciation.

133 Boy and goose. Marble. Roman copy of an original of disputed date, probably 2nd century B.C. Vienna, Kunsthistorisches Museum. H. 0.55 m.

134 Boy and puppy. Marble. (Legs, left arm, and details are restored.) Roman copy or adaptation of an original dating from the 2nd or 1st century B.C. Rome, Capitoline, Palazzo dei Conservatori. H. 0.483 m.

135 Sleeping Eros. Bronze. Probably 150–100 B.C. New York, Metropolitan Museum. L. 0.781 m.

136 Erotes Mosaic from Alexandria. Late 3rd–early 2nd century B.C. Alexandria, Graeco-Roman Museum. 4.60 x 3.35 m.

Sometimes this aspect of children is seen on the mythological level, as when the infant Herakles strangles snakes, or a child Eros, having sufficiently plagued his elders, takes a nap [135]. In other cases children, particularly in the form of Erotes, 'cutely' mimic adult situations, as when they hunt on a mosaic in Alexandria ([136]; see pp. 141, 212) and play with adult armor, as in a painting by the late-fourth-century artist Aëtion.[1]

Another category of works often classed as Hellenistic rococo involves amorous or erotic groups, like the Eros and Psyche in Rome [131]. To modern eyes this work has a sentimentalism which seems sufficiently quaint to perhaps qualify as rococo. Whether the sculptor who made it felt that way is, of course, anybody's guess. Most of the erotic groups involve satyrs or Pan, in both of whom an amusingly animal nature lurks close to the surface. One which seems to have been particularly admired was a group in which Pan is ostensibly giving a music lesson to a shepherd boy [137]. Many replicas of the type exist, and it has sometimes been connected, through tortuous reasoning, with a group depicting Pan and Olympos by the sculptor Heliodoros in the Porticus

Octaviae complex in Rome (Pliny, *NH* 36.35). Pliny, however, describes Heliodoros's group as a *symplegma*, which normally refers to wrestling or at least struggling figures, often of an erotic character. It has been suggested that Pliny misinterpreted the group and that the shepherd depicted was Daphnis, who was Pan's pupil, rather than Olympos, the pupil of Marsyas.[2] That the shepherd in [137] is Daphnis seems quite likely, but there is probably no connection at all between this group and the work of Heliodoros. Heliodoros's group, which Pliny describes as *nobilis* (perhaps meaning 'noble,' but possibly also simply meaning 'prominent'), was perhaps a high-minded work like the Pan and Olympos and the Cheiron with Achilles in the *Saepta* in Rome (*NH* 36.29) (the latter of which may have resembled a painting of Cheiron instructing Achilles which has survived from Herculaneum).[3] Our group of Pan and Daphnis, on the other hand, was probably intended as a playful parody of such works. Pan seems clearly motivated more by lechery than by the noble impulse to teach music. This, in any case, is clearly what is on Pan's mind in the technically crude but amusing group from Delos [138], in which

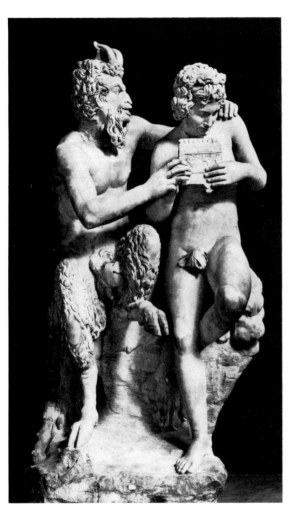

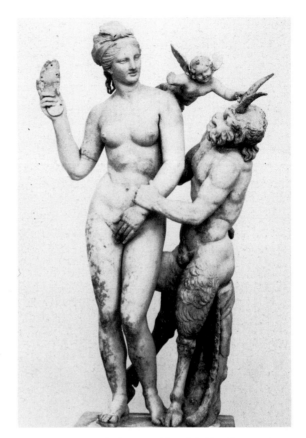

138 Aphrodite with slipper and Pan. Marble. *Ca.* 100 B.C.
Athens, National Archaeological Museum. H. 1.32 m.

137 Pan and shepherd boy. Marble. Roman copy of an
original of *ca.* 150–100 B.C. Naples, Archaeological
Museum. H. 1.58 m.

Aphrodite wards off Pan's advances by swatting him
with her slipper. This work, it should be noted, is datable
by its dedicatory inscription to *ca.* 100 B.C. and is thus
one of the few works in the rococo category whose
chronological position can be stated with confidence. Of
the satyr–maenad groups the most demure is the type
known as the 'invitation to the dance' [139], in which a
satyr who is beating rhythm by snapping his fingers and
tapping a kind of castanet with his foot invites a seated
nymph to join him. The original form of the group can be
reconstructed on the basis of numismatic evidence and by
combining features from a number of incomplete copies.
More overtly erotic are the *symplegmata* of a herm-
aphrodite warding off a satyr [140] and of a nymph
pulling the hair of an amorous satyr [141]. In both cases
the faces of the satyrs are distorted with pain, rather like
the faces of Giants and Gauls in Hellenistic baroque. Are

those figures rococo parodies of the titanic pathos of
works like the Gigantomachy of the Pergamon altar? It is
difficult to divine, at any rate, what their purpose was.
Were they, for example, votive sculptures with a serious
underlying purpose set up in a Dionysiac sanctuary
somewhere? Or were they simply caprices, commis-
sioned and designed to be decorative? The latter alterna-
tive is probably the way they would have been viewed in
the eighteenth century. But there is very little evidence for
privately commissioned sculpture and for private art-
collecting in the Greek (as opposed to the Roman) world.
Even grave stelai were public monuments. The question
of what much of that sculpture which is classed as
'Hellenistic rococo' was for remains mysterious.

Whether the erotic *symplegmata* parody Hellenistic
baroque or not, there are other works which seem clearly
to do so, and these should perhaps be classed as still
another category of Hellenistic rococo. One of the most
obvious of these parodies is a strange group in Rome in
which satyrs have been substituted for gods in the Gigan-
tomachy and grapple with snaky-legged Giants [142].
Here the parody seems to be not simply of the Hellenistic

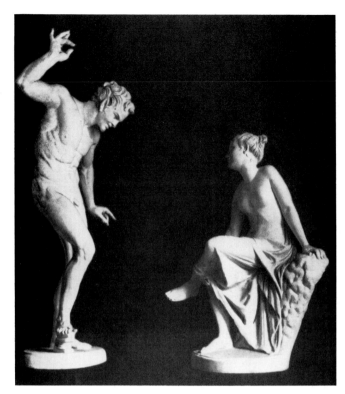

139 'Invitation to the Dance group,' reconstructed by W. Klein from a variety of copies and numismatic evidence. H. 1.39 and 1.07 m.

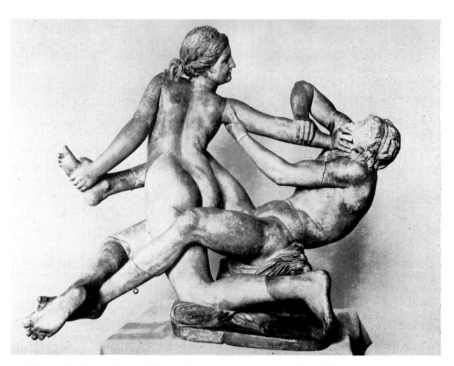

140 Hermaphrodite and Satyr. Marble. Roman copy of an original probably dating from the 2nd century B.C. Dresden, Skulpturen-Sammlung. H. 0.91 m.

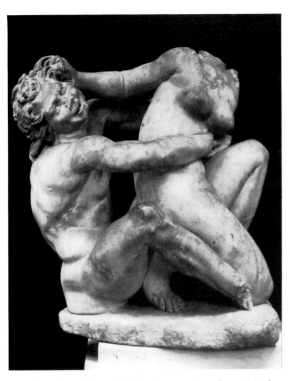

141 Nymph and Satyr. Marble. Roman copy of an original of *ca.* 100 B.C. Rome, Capitoline, Museo Nuovo. H. 0.60 m.

baroque style in general but specifically of the great Attalid monuments of Pergamon. One of the embattled satyrs, for example, seems modelled on the Dying Trumpeter of Epigonos [85]. Another group found in Split in Yugoslavia depicts three satyrs attacked by a giant snake. It is tempting to think of it as a parody of a Laokoön group, although not necessarily the famous group in the Vatican. Less specific in their model, but seemingly also parodies of Hellenistic baroque, are several groups in which Pan pulls a thorn from the foot of an agonized satyr [143]. In all of them the satyr is made to grimace with the tragic intensity of Laokoön. Somewhat along the same lines, although less facetious in its reduction of baroque pathos to triviality, is the figure of an aged centaur taunted by Eros [144]. This figure also belonged to a group, its companion piece being a younger centaur who bounces along joyfully and snaps his fingers like a dancing satyr. Both centaurs survive in excellent copies, the finest being the pair in dark grey marble, signed by the sculptors Aristeas and Papias of Aphrodisias, from Hadrian's villa at Tivoli [145]. The signatures are thought to be those of copyists, and the originals, it is hypothesized, were Hellenistic works, probably of bronze. In the original each centaur apparently had a little figure of Eros on his back, and the point of the group was to express, in the fashion of a Hellenistic love poem, the joy love brings to youth and the torment it brings to old age. The old centaur has his hands tied behind his

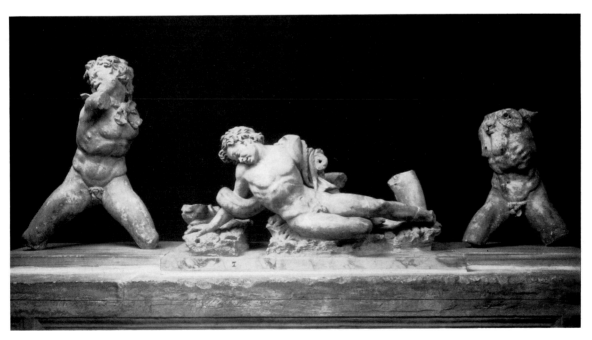

142 Battle of Satyrs and Giants. Marble. Roman copy of an original group of *ca.* 150 B.C. Rome, Capitoline, Palazzo dei Conservatori. H. of left Satyr 0.70 m.

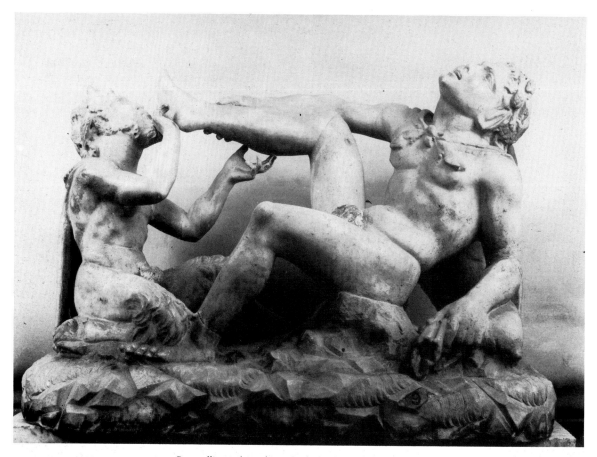

143 Pan pulling a thorn from the foot of a Satyr. Marble. Roman copy of an original of the late 2nd or early 1st century B.C. Rome, Vatican Museums. H. 0.515 m.

back and suffers with the majesty of a Laokoön as Eros reaches up to pull his hair.

Along with the groups thus far described there are many other single figures of a Dionysiac character – dancing satyrs, drunken satyrs, satyrs carrying the infant Dionysos – which have been classed as Hellenistic rococo. The most famous of these is the 'Barberini Faun' in Munich [146]. Heavy restorations on the Faun added by Bernini in the seventeenth century (the right leg, left knee and foot, left forearm, and other details) now give the figure a sprawling, ungainly look which has a comical effect to modern eyes. Bernini, it should be noted, pulled up and spread out the right leg far more than was the case in the original. To the eye of Wilhelm Klein the Barberini Faun seemed sufficiently humorous, decorative, and tinged with low-key eroticism to qualify as rococo, and he dated the work in the first century B.C.[4] Many others have felt, however, that the massiveness of the figure's surface features, and its emotional realism (his sleep seems to be a real, exhausted sleep) connect it with the art of Pergamon and make a date in the third century B.C.,

around the time of the greater Attalid dedications, more likely.[5] The ominous, potent, natural force, temporarily subdued by wine, that the Faun represents was a subject of considerable curiosity and anxiety to the Greeks. One can easily think of this figure as a votive sculpture, perhaps part of a group, set up in a Dionysiac sanctuary and offered with a seriousness quite foreign to the supposed atmosphere of rococo.

Finally, two categories of figures which are found mostly, but not exclusively, in small terracottas, scenes from daily life and caricatures with a grotesque quality, have sometimes been classed under the heading of Hellenistic rococo. Such subjects as a nervous bride and groom [147], women playing with knucklebones, nurses with babies, and schoolteachers with their students fall into the 'daily life' category. The caricatures often seem to involve dwarfs or physically deformed people [148]. Whether the ancient Greeks, like French aristocrats in the eighteenth century, found such subjects amusing may be debated, but it is true that they often laughed at things which tend to evoke pity in the modern mind. From a

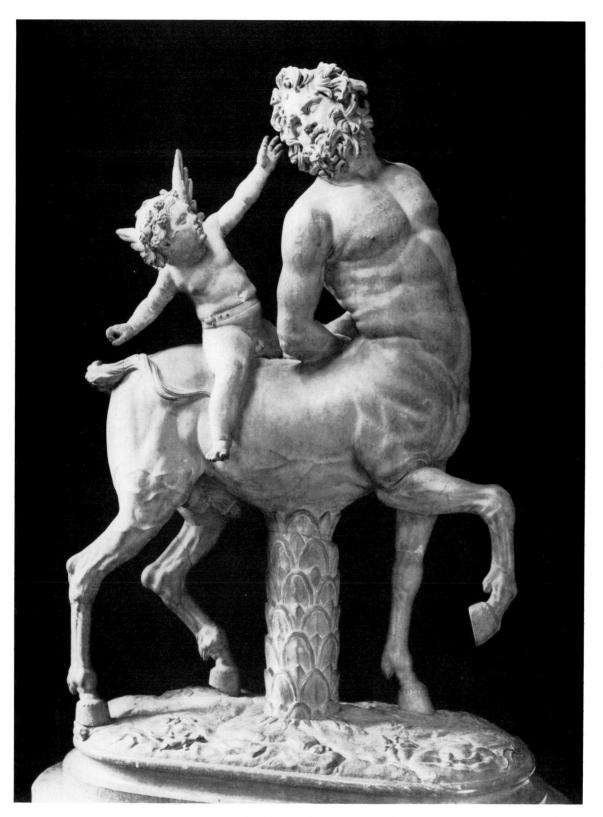

144 Centaur taunted by Eros. Marble. Roman copy of a (probably) bronze original dating from the later 2nd century B.C. Paris, Louvre. H. 1.47 m.

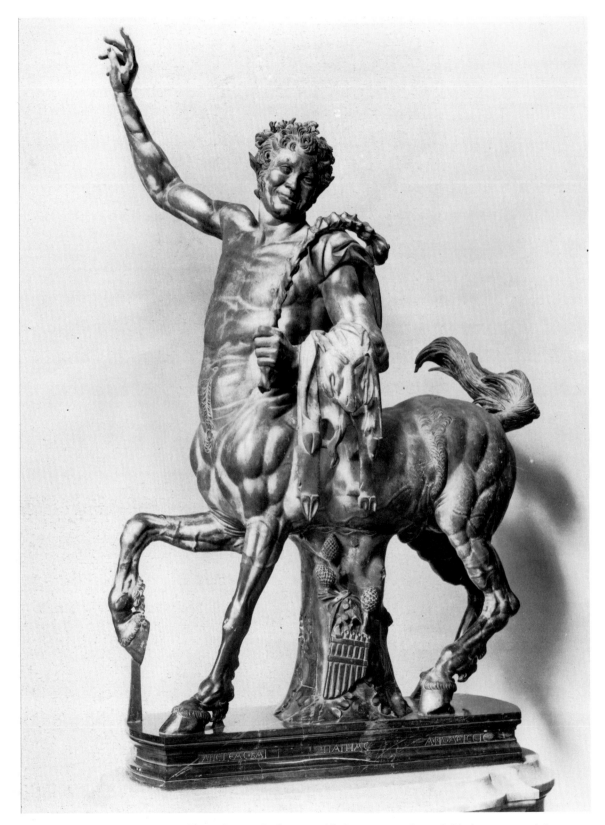

145 Young Centaur. Dark gray marble. Roman copy of a (probably) bronze original dating
from the later 2nd century B.C. Rome, Capitoline Museum. H. 1.56 m.

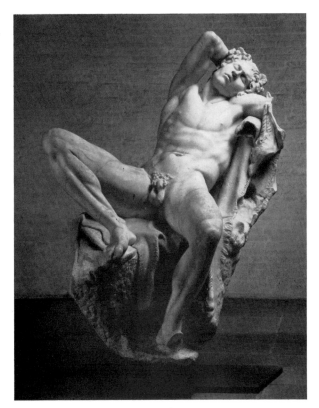

146 The 'Barberini Faun.' Marble. Probably *ca.* 200 B.C.
Munich, Glyptothek. H. 2.15 m.

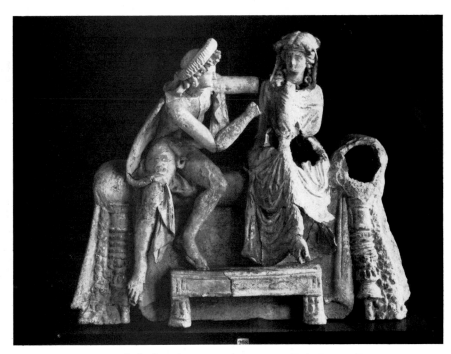

147 Terracotta group of a bride and groom. 2nd century B.C. Paris, Louvre. H. 0.28 m.

technical point of view, the most impressive examples of this category are two dancing female dwarfs in bronze [149], found in a shipwreck near Mahdia off the Tunisian coast. Are these caricatures of the many elegant dancing female figures in Greek art [292]? Or do they simply record the fact that dwarfs, like other people, engaged in religious dances? As was the case in our other categories, the claim of these figures to the title 'rococo' is problematical.

To assign most of the foregoing works in a definitive way to their proper conceptual place in Hellenistic art we would have to know much more about their original purpose than we do. A statue which may seem to have a rococo playfulness to us may not have had the same effect on ancient viewers. The sleeping Eros in New York [135], for example, may look 'cute' to us, but the Greeks may have looked upon him as a formidable, even dangerous, being. The same may have been true, as already pointed out, with some of the Dionysiac figures. Likewise, figures like aged schoolteachers, dwarfs, etc., may reflect a strong strain of social realism in Hellenistic art (see *infra*)

◄ **148** Statuette of a hunchback. Ivory. Probably later 2nd century B.C. London, British Museum. H. 0.105 m.

149 Dwarfs from the Mahdia shipwreck. Bronze. *Ca.* 150–100 B.C. Tunis, Bardo Museum. H. **(a)** 0.32 m. **(b)** 0.315 m.

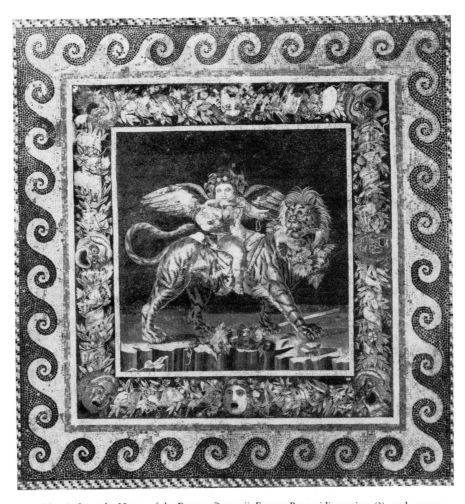

150 Mosaic from the House of the Faun at Pompeii. Eros or Putto riding a tiger (?). 2nd century
B.C. Naples, Archaeological Museum.

and may have been quite the opposite of playful in their intention. In spite of these reservations, however, there does seem to be some justification for a limited use of the term 'rococo' in Hellenistic art. In particular, the groups like the satyr *symplegmata* which seem deliberately to mock the soberness of the baroque style have an unmistakably playful and sophisticated feeling about them. One gets the impression that, even if they were religious votives, their function was primarily decorative. The same also seems to be true of some of the figures of children, particularly those who play charmingly with their pets or who mimic adult activities. Hellenistic mosaics, it might be noted, offer particularly valuable evidence on this point because in their case we can be reasonably sure that the function of the images *was* primarily decorative. Erotes riding on the back of tigers, as in the mosaic from the House of the Faun at Pompeii [150], may have called to mind images of the Indian

triumph of Dionysos; and Erotes hunting [136] probably called to mind the hunting scenes of early Hellenistic royal iconography, but they did so with a playfulness which seems fairly described as 'rococo.'

Accepting the fact that there is at least a limited number of ancient images which can be classed as rococo, can one then date them? Many of the works are assumed to derive from Hellenistic originals but cannot be proved to be so. Others are presumed to be Hellenistic originals but cannot be fitted into an archaeological context that would enable one to make a scientific estimate of their date. Amid all this uncertainty, however, there are a few fixed points, and these are important because they do confirm the fact that at least some of the works which have been classed as rococo are Hellenistic. One of these is the Aphrodite and Pan from Delos [138], which, as already noted, can be dated to *ca.* 100 B.C.; another is the dancing dwarfs from the Mahdia shipwreck [149]. The

pottery and lamps in this ship's cargo date the wreck to *ca.* 100 B.C. or shortly thereafter, thus providing a *terminus ante quem* for the sculpture. It is most probable that they are works of the middle or late second century B.C.

The Mahdia shipwreck brings us back to the problems revolving around the date and work of Boethos of Chalcedon. Whether one makes Boethos's career a fixed point in the history of Hellenistic rococo depends upon what works one is willing to ascribe to him. The date of a Boethos, who may be *the* Boethos, can be fixed in the middle of the second century B.C. by two inscriptions, one the signature found on Delos from a portrait statue of Antiochos Epiphanes (175–164 B.C.) and the other a signature from Lindos on Rhodes datable to 155–150 B.C.[6] One signed original by him is preserved, the bronze group of a winged boy leaning on a herm [151]. It was found in the Mahdia shipwreck and is now in the Bardo Museum in Tunis. The figure is generally agreed to represent Agon, the personification of athletic contests, or Eros Enagonios, Eros as the patron of competition.[7] Although the Agon is a very fine work from a technical point of view and confirms the statement of Pliny that Boethos was a master metal worker,[8] it is, from the standpoint of style, an eclectic and not very inventive creation. The herm is properly archaistic and the torso mixes Praxitelean, Polykleitan, and Lysippan elements. The style of the Agon, in any case, does not prepare us for the playful originality of another work that is ascribed to Boethos by Pliny, the group of a boy strangling a goose.[9] The most popular version of this subject is the captivating group, already mentioned, of a *standing* boy and goose, known from several good Roman copies [132], and it seems most probable that this is the work of Boethos that caught Pliny's attention. That one artist, Boethos the son of Athanaionos, of Calchedon, working in the middle of the second century B.C., made the Agon and the boy with a goose, and also a portrait of Antiochos Epiphanes, does not seem inherently improbable. Evidence from Delos suggests that later Hellenistic sculptors could vary their style to suit the taste of the patron and the nature of the commission (see p. 163). Scholars have complained that the Agon, being a 'one-aspect' (*einansichtig*) work, must belong to the late second or first centuries B.C. and could not be contemporary with a pyramidal work like the boy and goose, which derives from patterns of composition characteristic of the late third century. These judgments are based, however, on artificial schematizing which has led to chronological categories for which the evidence is, at best, tenuous. There is nothing that precludes our dating both of these works to the middle of the second century. It was perhaps versatility that gave Boethos his reputation. When making a rather routine work for a gymnasium like the Agon, he turned to a kind of historicism; when he did his portrait for Antiochos, he probably

151 The 'Agon' of Boethos. Bronze. Mid-2nd century B.C. Tunis, Bardo Museum. H. 1.40 m.

adopted realism; when he did his famous metal vases he perhaps espoused a kind of florid neoclassicism (cf. pp. 172–3); and when he made the boy and goose, he adopted (perhaps, in fact, as Klein thought, invented) the rococo style.

For the record it must be admitted that there are some facts which muddy the waters of the clear pool in which Boethos's image has just been reflected. One is that the third-century mimist Herondas also mentions a sculptural group of a boy strangling a goose (*Mime* 4.31), although he does not say who the sculptor was. Some have assumed that this must be the work of Boethos mentioned by Pliny; that there were therefore two

Boethoi, one belonging to the third century and one to the second; and that the pyramidal boy and goose type is a work of the third century.[10] Herondas, however, calls the goose in his group a *chenalopex*, which is a small species of Egyptian goose, too small, some learned commentators have felt, for the goose in the pyramidal group. This quandary has led to the identification of another type of boy and goose, a smaller seated type [133], as the work mentioned by Herondas and, perhaps, made by Boethos.[11] We may leave this subject, as Lucian once said about the technical details of painting, 'to those whose job it is to know about such things.'

In addition to a few datable sculptures, there are also several mosaics which help to give a date to ancient rococo. The general background of these works will be described in a separate chapter (Chap. 10), but they deserve mention here because of the nature of their subjects. One of them, already mentioned, is the mosaic from Alexandria depicting Erotes hunting a stag, seemingly a rococo parody of the theme of the royal hunt [136] (see pp. 130, 212). Estimates of the date of the work range from the third to first centuries B.C., but all commentators at least agree that it is Hellenistic. That a work of this sort could be as early as the mid-third century is suggested by Lucian's description of the painting by Aëtion in which playful Erotes mimic adult activities during the wedding of Alexander and Roxane. Assuming that this Aëtion was the painter of the late fourth century B.C. who is mentioned by Pliny, Lucian's description documents the creation of a rococo subject at the very beginning of the Hellenistic period.[12] Several late Hellenistic mosaics from Pompeii, such as the 'Genius of Autumn' from the House of the Faun [150], also have what can be described as rococo subjects. The style of the pavement in connection with which they are found would seem to date them to the late second or early first centuries B.C.

There are, then, datable works of a rococo character in Hellenistic art. Whether one can legitimately go farther than this and say that there was a definable rococo phase in Hellenistic art is doubtful. There are simply not enough datable works. If there was such a phase, however, it is most likely to have occurred, judging by the few securely datable and unproblematical works, in the second half of the second century B.C.

Realism

In the foregoing section an interesting group of sculptures representing old women, fishermen, and shepherds [152–156] has been omitted from discussion even though the group has sometimes been seen as one of the expressions of a rococo spirit in Hellenistic art. It seems better to treat these sculptures as a separate group, since it is possible that the impulse behind their creation was quite different

from that of Hellenistic rococo. They may express not a playful love of the quaint but rather a certain type of social realism.

'Realism,' as we have pointed out in our discussion of Hellenistic portraiture, is a term which is used more often than it is defined in art criticism. What I take it to mean is an attempt to reflect one's experience of the natural and human world without the intercession of some notion of an ideal or perfect form. 'Realism' in art is a relative concept, and within any specific artistic tradition expresses an intention more than a specific set of forms. Early Attic red-figure vase painting, for example, may seem highly 'stylized' by the standards of Pompeiian or European baroque paintings, yet within the context of its time it expressed a significant outburst of realism. In Greek art of the Archaic and Classical periods, the representation of nature had generally been controlled and restrained by the desire to express an essence, an underlying perfect form or 'idea' in the Platonic sense, of which specific objects in nature were distorted or incomplete embodiments. Hence for centuries there was a resistance in Greek art to depicting the fluctuations and seemingly random variations of ordinary experience. Specifics were of interest only to the extent that they reflected the generic. As Greek culture developed, the nature of the *eide*, meaning both 'ideas' and 'forms,' underlying experience was periodically redefined or re-envisioned, but until the fourth century B.C. the urge to express such forms seldom wavered, and it was not until the Hellenistic period that the possibility of abandoning them altogether was seriously entertained.

The weakening of idealism naturally leads to an interest in the variety of experience rather than the essence of it. And an interest in the variety of experience focusses attention on the mutability of the world and also on those features which make individual beings unique rather than similar. Change and individuality become more attractive than perfection and the result is realism. The first major intimation of such a shift of outlook in Greek art came in the fourth century B.C., when ordinary human emotions and attitudes, such as anguish, humor, and tenderness, came to be represented with increasing frequency and when portraits of specific individuals became increasingly common. It was in the Hellenistic period, however, when social and political changes shattered many entrenched patterns of Greek cultural life, that realism began to show signs of superseding idealism. The expression of temporary emotional conditions, pain and suffering, for example, and erotic arousal, increased in intensity in the Hellenistic period and were supplemented by a new interest in the variations of consciousness represented by sleep and drunkenness. The sleeping children [135], deities, heroines, and the drunken or sleeping Hermaphrodites [160], satyrs [146], or women [154] of Hellenistic art are something new in the Greek sculptural

152 Old woman. Marble. Late 2nd or early 1st century B.C. New York, Metropolitan Museum. H. 1.26 m.

153 Old shepherdess. Marble. (The head is a restoration, now removed.) Roman copy of an original of the late 2nd or early 1st century B.C. Rome, Capitoline, Palazzo dei Conservatori. H. without plinth 0.93 m.

tradition and spring from a desire to explore and to embody in monumental form what these passing states are really like. Another aspect, as we have seen (Chap. 3), of the trend toward realism among Hellenistic artists was the interest in capturing unique personalities through the art of portraiture. Still another was the sympathetic interest in different ethnic and racial types – e.g. Gauls, Scythians, and Africans [85–87, 268, 121, 116]. This last can also be seen, as we have said, as an expression of the cosmopolitan outlook of the Hellenistic period (see p. 10). Encountering a variety of racial types was a part of ordinary everyday experience for many people, and depicting these types in art was simply an expression of social realism.

It is against this background of social realism that the group of sculptures mentioned at the beginning of the section are perhaps most meaningfully studied. Along with a variety of ethnic types, was it also a matter of

common experience in the Hellenistic world to encounter haggard or drunken old women in the market [152 and 154], emaciated old shepherdesses [153], or fishermen with varicose veins and bodies worn by work and poverty [155–156]? Have Hellenistic sculptors in these figures finally shed all vestiges of the age-old idealism of Greek art and taken a frank 'hard look' at what they saw around them? Or does the seeming realism of these figures express an aristocratic contempt for the ugliness of the low-born?

Before attempting to answer these questions let us look more closely at the figures themselves. The one such work which has been claimed to be a Hellenistic original is the figure of an old woman in the Metropolitan Museum [152]. Her stooped posture, wrinkled face, furrowed neck, and sagging breasts are all rendered in an unrelentingly realistic style which complements the theme of the sculpture. She is probably depicted in the act of hailing

154 Drunken old woman. Marble. Roman copy of an original of disputed date. Late 3rd or, more probably, late 2nd century B.C. Munich, Glyptothek. H. 0.92 m.

potential customers in a market square, hoping to sell the chickens and the basket of fruits and vegetables that she holds in her left hand. The ivy wreath on her head may be intended to indicate that she is selling (or possibly offering) these goods as part of a religious, probably Dionysiac, festival. The spiritedness of the woman in New York yields to a realism tinged with a sense of pathos in the desiccated old shepherdess with a lamb in Rome [153] and in the almost spectral drunken old woman in Munich [154]. The latter is sometimes ascribed to a Hellenistic sculptor named Myron of Thebes, who is thought to have worked at Pergamon, but the attribution is based on such slender and problematical evidence that it is better avoided.[13] If one chose to connect the drunken old woman with a geographical or cultural milieu, Alexandria and its festivals would be the most likely. The wine bottle that she hugs is a *lagynos*, such as was used in the rustic drinking festival that aroused the contempt of Queen Arsinoe III (see p. 9); and her garment seems to be the *peronema* or *peronetris*, a kind of tunic fastened with buckles, which was both worn and admired by the excited women who are depicted as attending a Ptolemaic festival of Adonis in the 15th *Idyll* of Theokritos (see lines 21 and 79). (This garment, it should be noted, places the old woman, in spite of her drunkenness, in a respectable social class, like the women in Theokritos's poem. She differs in that respect from the shepherdesses and other old women of this genre.)

The feeling of pathos, and perhaps sympathy, that many modern viewers have felt underlies the representation of these old women is also apparent in their most expressive counterpart among male figures, the old fisherman who seems to have been depicted as if he were wading in shallow water, perhaps to cast nets. Several copies of the type (sometimes referred to as the 'Seneca type') have survived, the most arresting of which is the one in dark marble in the Louvre [155]. The almost emaciated torso with its dilated veins is rendered with such care that it must have been considered essential to the statue's meaning. It gives, perhaps, a social context to the head of the figure, which can be likened to the Pseudo-Seneca [123] and the Blind Homer [122] and which to modern eyes has been felt to have a kind of nobility and dignity. The same feeling of realism combined with a seeming pathos and dignity has been thought to characterize a second type of fisherman that can be reconstructed from copies in New York and Rome [156]. But was this dignity that modern viewers have seen in these figures, an impression that led at one time to the interpretation of the Louvre fisherman type as the Stoic philosopher Seneca, really intended by the ancient sculptors and their patrons? Or is it a misreading stemming from the different cultural conditioning of modern and ancient viewers? H.P. Laubscher has argued that in ancient theories of physiognomics many of the features of these statues – stubbly beards, large ears, snub noses, protruding lips, and a set open mouth – were interpreted as signs of stupidity, lack of dignity, and even cowardice and that the verism of these figures in no way implies admiration for them.[14] This argument has literary evidence to support it and must be taken seriously. Yet one wonders, in spite of it, if modern reactions are completely wrong. The artists who made these fishermen, shepherds, and old women may not have been attuned entirely to their patrons' *hauteur*, and a certain sympathetic insight may have been infused into such images, even if unconsciously.

The facts that most of these sculptures were executed on a large scale by artists of great skill and that some of them exist in multiple copies indicate that we are dealing with works which were considered important in their time. Aberrant whimsies of a single artist can be worked out in a small, inexpensive medium like terracotta statuettes. Large stone sculpture, however, is time-consuming and expensive to produce, and it is not commissioned or executed unless the result is likely to have an important appeal or function. To whom, then, did these sculptures appeal? What was their function?

155 Old fisherman. Black marble with garment in alabaster. (Parts of the face and arms are restored.) Roman copy of an original of disputed date, probably 200–150 B.C. Paris, Louvre. H. 1.22 m.

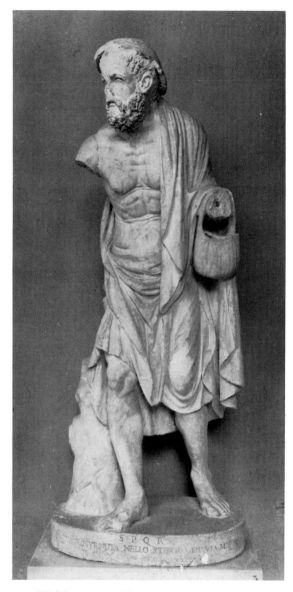

156 Old fisherman. Marble. Roman copy of an original of the late 2nd or 1st century B.C. Rome, Capitoline, Palazzo dei Conservatori. H. without plinth 1.20 m.

And when were they made? The answers to the first two questions are surprisingly obscure and to the third very uncertain. Most scholars who have studied these sculptures as a group have assigned them, or the originals of which they are presumably copies, to the late third, second, and first centuries B.C.[15] Yet it may be that all the extant figures date from the Roman period. Of the stone sculptures only the old market woman in New York has been called an original, and even this judgment has been disputed.[16] It may well date from the first century A.C. Myron of Thebes, who could anchor the type of the drunken old woman with the *lagynos* in the Hellenistic period, is probably a myth. It could be argued, therefore, that all of these aged figures were created in the Roman period to satisfy the bucolic yet down-to-earth sensitivities of men whose minds were conditioned by reading Horace and Virgil.[17] If that was in fact the case, they may have been used to create a fanciful, illusionistic rural atmosphere in villas or baths. (Some of the copies are known to have been used this way.) The only difficulty with this idea is that one feels an underlying seriousness in some of these figures that would be inappropriate to

such a setting. It seems unlikely that their emaciated forms and pathetic expressions were created simply to suit a caprice of domestic decoration.

Let us suppose, on the other hand, that the originals of these figures are, as is usually and probably rightly assumed, Hellenistic. There is nothing inherently improbable about this, since, as we have seen, realism of various sorts pervaded Hellenistic art. For what clientele and for what purpose would they have been made? These are not easy questions to answer. Throughout most of the

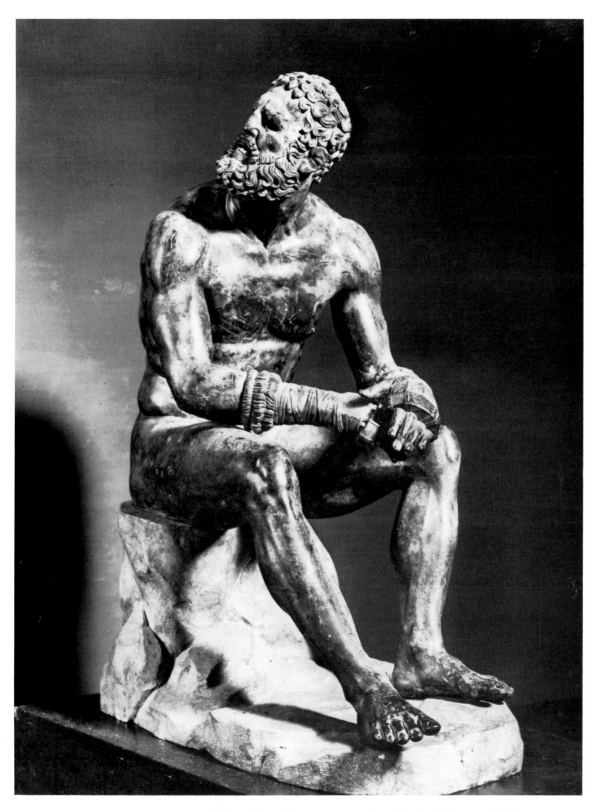

157 Bronze boxer. 2nd or early 1st century B.C. Rome, National Museum of the Terme. H. 1.28 m.

history of Greek art monumental sculpture had either a religious or a commemorative function, yet it is not obvious that these fishermen and old women had such a function. On the other hand, there is no evidence that the Greeks regularly made statues as *objets d'art* to be treasured by private collectors. Two serious possibilities as to the purpose of these works ought to be considered. One is that they are privately commissioned works created at the very end of the Hellenistic period when the influence of Roman art collectors was becoming all-pervasive. The other is that they are votive statues created in connection with popular urban, and perhaps specifically Alexandrian, festivals.[18] If one assumes that they were privately commissioned works, one could simply conclude that they had no serious purpose and treat them, as some have, as purely decorative creations. In this case they could be legitimately classed as examples of Hellenistic rococo. One could, however, also come to just the opposite conclusion, and see the fishermen and old women as expressions of the philosophical predilections of their owners. The amalgam of Stoicism and Cynicism that formed the basis of much of Hellenistic popular philosophy saw great virtues in a life of rustic simplicity, a life free of the complications and ties of the world of sophisticated urban intellectuals. Were these figures intended as reminders of the philosophical spirit preached by men like Bion of Borysthenes and Teles?[19] If, on the other hand, one assumes the figures were votive objects set up in public (and the fact that there are multiple copies of some of them suggests this), it seems most probable that they were connected with rustic festivals like the Lagynophoria at Alexandria. Ptolemy IV Philopator seems to have enjoyed this festival because it gave him a chance to 'play' at being a peasant. Perhaps the same attitude led to the Ptolemies' becoming patrons of artists who created rustic votive statues, visual equivalents of the rustic figures which populate the *Idylls* of Theokritos. It is perhaps significant that in the 21st *Idyll* the rustic figures, who are treated with a mixture of realism, sentimental sympathy, and yet aristocratic distance, are fishermen.[20]

On balance, it does seem likely that the originals of the old women and fishermen were Hellenistic and that they reflect a peculiar mixture of poetic fantasy and social realism. Which of these qualities is dominant in them will always depend on the subjective reaction of individual viewers. Whatever the truth is in their case, however, there is no doubt that an uncompromising social realism did play an important role in Hellenistic art and is, in fact, one of its most original features. An impressive example of such realism is the bronze boxer in the Terme [157], one of the most powerful sculptures to survive from the later Hellenistic period. Ancient boxing as it evolved in the Hellenistic and Roman periods became a particularly brutal sport in which the footwork and defensive tactics

158 The 'Belvedere torso,' signed by Apollonios, the son of Nestor. Marble. 1st half of the 1st century B.C. Rome, Vatican Museums. H. 1.59 m.

of modern boxing had a minor place. Boxers basically gave and took blows until one of the contestants collapsed or yielded. Boxing gloves consisted of heavy leather thongs, which in time became so thick that they had the effect of 'brass knuckles.' The Terme Boxer offers us a frank picture of a man who competed and survived in this sport. His nose is broken, his cheeks and forehead are scarred; his teeth are broken; and he has 'cauliflower ears' which seem to be bleeding. It is as unidealized a picture of an ancient athlete as one can find. Yet, as he sits wearily with the cruel gloves resting stiffly in front of him, he becomes a nobly battered figure who elicits sympathy, rather like Lysippos's images of the weary Herakles.

The date of the boxer is, naturally, a matter of dispute. It was once thought that the signature of Apollonios the son of Nestor, the sculptor of the famous 'Belvedere torso' [158], could be read on the thongs. If this were true the boxer would date to the first century B.C., when Apollonios was active.[21] The inscription, however, turns out to be a mirage, and hence other guesses about the date of the figure can be entertained. The abrupt upward and outward turn of the head, for example, is a feature of composition familiar from third- and second-century sculptural groups such as the Dying Gaul in the Terme

159 Jockey from Cape Artemiseion. Bronze. Late 2nd or 1st century B.C. Athens, National Archaeological Museum. H. 0.84 m.

[86] and the Pasquino group [119]. On the other hand, whether the boxer is by Apollonios or not, his torso is similar in structure and surface texture to the Belvedere torso.[22] That he is to be dated somewhere between the beginning of the second century B.C. and the middle of the first seems reasonably certain, but beyond that it is anyone's guess. Once again, as with most of the other statues in the rococo and realism categories, the function of the statue is enigmatic. Is it a votive statue of an athlete or, perhaps, as has been suggested, part of a mythological group?[23] The original context of the boxer is unknown, and the question is unanswerable.

Another bronze original in the realistic category probably was a votive statue connected with athletic games: the strikingly animated jockey, found in a sunken ship off Cape Artemiseion and now in Athens [159]. Part of a large horse was found in the same wreck and is now generally agreed, after considerable dispute, to be the horse which the jockey was riding. Although the brutality of the boxer is absent in the jockey, his down-to-earth features – tousled hair, excited urchin-like face, and generally dishevelled demeanor – make him a spiritual cousin of the larger bronze. He shows us that the children in Hellenistic art need not all be viewed as rococo

creations. He has nothing of the cuteness or the sophisticated playfulness of the boy and goose group [132]. Even if he is understood as a groom whose mount has gotten out of hand, the artistic intention seems to have been to make him appear vividly real rather than playful.

The exotic

Related to the sculptures and mosaics which we have discussed under the heading of rococo art is another group of works whose subject matter has a distinctly exotic flavor. Some of these seem to be playful, decorative creations and perhaps deserve the label rococo, but others are enigmatic and may relate to intellectual currents quite foreign to the spirit of rococo. So, it seems best to treat them as a separate, possibly related, category.

One of the many offshoots of the cosmopolitan outlook of the Hellenistic age was an interest in 'wonders,' a taste for the exotic, novel, colorful things and experiences which arrest the attention of travellers as they discover new lands and cultures. One characteristic, if largely trivial, reflection of this taste in Hellenistic literature was the rise of a group of writers called *paradoxographoi*, 'recorders of marvels.' The *paradox-*

ographoi specialized in describing far-away or exotic places, strange natural phenomena, weird social customs, and the like. The motivation for, and the appeal of, their works seems to have been roughly equivalent to those of Ripley's *Believe It or Not*. One of the first such writers was Bolos of Mendes, a contemporary of Kallimachos, who wrote a work called *Thaumasia*, 'Wonders.' Kallimachos himself seems to have had a try at the genre in a work entitled *A Collection of Wonders in Places in All Parts of the Earth* and one of his pupils, Philostephanos of Cyrene, wrote a book called *Wondrous Rivers and Springs*. The one 'paradoxographical' treatise that survives is a work called *Collection of Wondrous Stories* by an author named Antigonos, possibly, but not certainly, the scholarly sculptor Antigonos of Karystos, who also wrote on art history and was one of the artists who worked on the victory dedications of Attalos I at Pergamon (see p. 84). Although paradoxographical treatises were the creations of scholars, the taste which they expressed was widespread and adaptable to other forms of artistic expression.

Hellenistic artists had their own version of paradoxography. One typical example of it is the frequent use of exotic animals (from the Greek point of view), such as parrots [234], cobras [240], and tigers and leopards [150, 230 and 231], as motifs in the decorative arts of the period. This trend is particularly well illustrated in the cycle of mosaics which accompanied the famous Alexander mosaic in the House of the Faun at Pompeii (see Chap. 10). (Pompeii, it will be remembered, is more accurately described as Italo-Hellenistic rather than Roman up until the refounding of the town as a Roman colony in 80 B.C.) For example, one of these, which was placed on the threshold of the room leading to the Alexander mosaic, depicted a hippopotamus along with ducks, a cobra, and other creatures sporting in the Nile [240]. Egypt was naturally a prime source of strange creatures for the Greeks, and Nilotic scenes which celebrated its exotic qualities seem to have become a popular genre early in the Hellenistic period. The painter Nealkes, for instance, was already incorporating crocodiles in his paintings in the third century B.C. (Pliny, *NH* 35.142). The most majestic example of the type is the great Barberini mosaic which was installed *ca.* 80 B.C. in a building adjacent to the temple of Fortuna at Praeneste, near Rome (see p. 205). Here the depiction of the Nile becomes an almost visionary one, with the upper area of the mosaic depicting the Nile enshrouding remote mountains in Ethiopia, where hunters with bows and arrows pursue wild animals, and the lower section showing the Nile running through Egypt and dotted by temple compounds, the reed huts of peasants, open shrines in which Egyptian priests worship gods in animal form, and islands occupied by a panoply of exotic animals such as the rhinoceros, the leopard, and once again the hippo-

potamus and the crocodile. Another mosaic in the House of the Faun, now badly damaged, showed a lion standing over a prostrate tiger. This subject was also part of a genre, and other examples of it have been found, for instance a particularly fine mosaic apparently from Hadrian's villa at Tivoli and now in Holkham Hall. They perhaps functioned as something like carnival curiosities in the dining rooms of the affluent patrons whose houses they decorated. ('What would happen if a lion fought a tiger?' was perhaps the sort of question used to open conversation at convivial symposia.)

Another theme which lent itself particularly well to this sort of interest and accordingly became a popular decorative motif was the return of Dionysos from India. There were probably some important political implications underlying the frequent use of this myth in art. According to Arrian, Alexander had thought of himself as a new Dionysos and had looked upon Dionysos's triumphant return from India as a divine prototype for his own triumphant return from the conquest of Asia. Later Hellenistic rulers also liked to cast themselves as a 'New Dionysos,' which probably explains, among other things, the remarkable mixture of Dionysiac and political imagery in the famous Ptolemaic procession of *ca.* 276 B.C. (see p. 280). To the general public, however, the appeal of the Indian triumph of Dionysos was probably its exotic details – panthers, elephants, camels, exotic dress. For the most part we must attempt to appreciate the details of such scenes from Pompeiian paintings and Roman sculptured sarcophagi, which seem to be based on Hellenistic models.[24] Confirming the fact that such scenes went back to the Hellenistic period, however, are the remarkable mosaics depicting Dionysos or a Dionysiac *daimon* riding a leopard and tiger respectively from the House of the Masks and the House of Dionysos on Delos [230 and 231] (see Chap. 10), which appear to be excerpts from the usual iconography of the Indian triumph.

The creation of exotica was also a factor in Hellenistic sculpture, although relatively few examples of it survive. Pliny records that Pompey the Great decorated his huge theater in Rome, dedicated in 55 B.C., with statues depicting 'famous miraculous events' (*NH* 7.34). Among them was an image of a woman named Alkippe, who had given birth to, of all things, an elephant. This statue of Alkippe is also mentioned by the early Christian writer Tatian, who records that its sculptor was the Athenian Nikeratos, an artist, as we have seen, active at Pergamon in the third century (see p. 84).[25] Among the several obscure figures named Alkippe in Greek mythology, one was the sister of the river god Kaikos (the river which ran through the territory of Pergamon). This suggests that the statue in Pompey's theater may have originally been set up in Pergamon and taken from there by Pompey during his campaigns in the East. In any case, the Alkippe was

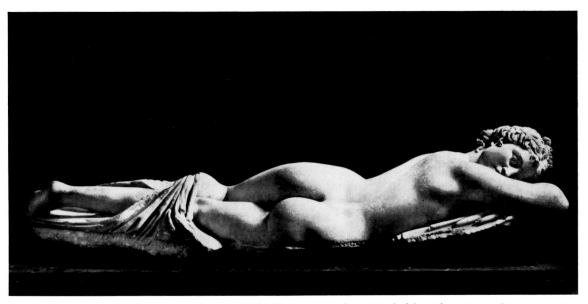

160 Hermaphrodite. Marble. Roman copy of an original of the 2nd century B.C. Rome, National Museum of the Terme. L. 1.48 m.

certainly a work of Hellenistic art, as were, perhaps, all the 'miracle statues' in Pompey's theater.

The most famous and, to modern eyes, enigmatic of the Hellenistic exotica is the 'Sleeping Hermaphrodite,' known through several excellent copies [160]. Hermaphroditos (the name is male) was a son of Hermes and Aphrodite who was transformed into a bi-sexual creature by the Nymph Salmacis after he had repulsed her advances. Normally 'he' is depicted as having the lithe body of an athletic woman but with the addition of male genitals. Some Hermaphrodites are represented in a quiet, almost innocent neo-Praxitelean style, as in an example from Rhodes; others are shown frolicking playfully with amorous satyrs [140]; but none of these has the uneasy, seemingly tormented quality of the sleeping Hermaphrodite. The work was probably designed and positioned so that one saw first the sinuous female contours of its back and also, because of the extreme turn of the neck, its face. If one then asked who was this beautiful creature who sleeps so restlessly and walked around it in order to investigate further, the answer would have come as a typically Hellenistic theatrical surprise. Tossing and twisting with the same uneasy sleep that we have seen in other puzzling Hellenistic works (the 'Ariadne' type[26] and the Barberini Faun [146], for exam-

ple), he is an ominously strange apparition. What is the meaning of such a work? Unlike the Hermaphrodite of the *symplegma* group [140], it does not seem simply to be a rococo joke. Perhaps it is a serious votive connected with a fertility cult. Hermaphroditic figures have a long history in the eastern Mediterranean, particularly in the cult of Aphrodite on Cyprus. Or does it express a complex psychological and philosophical view of the psyche, the Platonic idea that on a spiritual level the natures which we call female and male become one? Is it an expression of the same instinct that led Hellenistic artists to give an increasingly effeminate form to the gods Apollo and Dionysos [e.g. 182]? Like many of the works examined in this chapter the significance and function of the Hermaphrodite are enigmas. So also, as one might expect, is its date. If the work is the *Hermaphroditus nobilis* (*nobilis* here probably meaning 'well-known' rather than 'noble') by the sculptor Polykles mentioned by Pliny (*NH* 34.80), it can safely be dated to the second century B.C. (on Polykles, see pp. 162, 173). Since the number and quality of the extant copies substantiate that the Romans admired the figure, this attribution is not improbable; but it is, of course, not provable. Given its formal relationship to other sleeping figures, a designation as 'late Hellenistic' seems safe and is widely adopted.

7

Rome as a center of Hellenistic art

In the late Hellenistic period the conventional distinction that art historians are accustomed to make between 'Greek' and 'Roman' art to a great extent breaks down. As will be seen in the following three chapters the late second and first centuries B.C. saw a fusion of Greek artistic traditions with Roman taste and patronage – principally in sculptured portraits, decorative reliefs, painting, and mosaics – that resulted in an art that is most aptly termed 'Graeco-Roman.'

The hellenization of the visual arts that took place in Rome during this period has well-known analogies in Roman literature (this was the era when Plautus and Terence adapted the plays of Menander, Lucretius wrote an epic-like poem on Epicurean philosophy, and the neoteric poets adapted the verse forms of Kallimachos and others), but there is one significant difference between the two. In literature the poets who adapted Greek forms and traditions were Romans, or at least Latin-speaking Italians; in the visual arts the creators of the new forms were almost all Greeks, many of them recent immigrants to Rome from other cities of the Hellenistic world. Graeco-Roman art is therefore in a very real sense a direct extension of Hellenistic art (and not simply hellenized Roman art), and Rome at this time must be viewed as a center of Hellenistic art equal in importance to traditionally important centers such as Athens.

This chapter will undertake to set the stage for the Graeco-Roman period of Hellenistic art by describing how the Romans first had significant contact with the art of the Greeks and how they reacted to it; and then how they eventually became important patrons of Hellenistic art, created a new art market, and inspired Greek artists to flock to Rome.

Conquest and its effects

The Romans were first drawn into the political and military affairs of Greece by King Philip V of Macedonia, who had made himself an ally of Hannibal at the time when Rome was locked in a desperate struggle with Carthage and had connived against Roman interests in the Adriatic. To keep Philip in check the Romans concluded an alliance with Attalos I of Pergamon and the Aetolian League (212 B.C.), but while their hands were tied by the demands of the Punic War, Philip generally prevailed over this alliance and continued an aggressive policy of expansion which was marked by devastating and often brutal attacks on free Greek cities (Athens being one of them).

After the Carthaginians were finally defeated in 202 B.C., the Romans were in a mood for vengeance against Philip, and when Attalos I and the Rhodians, who feared that Philip was about to launch an attack on Asia Minor, appealed to Rome for help, an army was dispatched to Greece (199 B.C.). In the following year this army was turned over to the Consul T. Quinctius Flamininus, an experienced soldier, who extricated his forces from the mountain passes and in a slow and undramatic way that was typical of Roman military maneuvers, pursued Philip's retreating army across central Greece. Finally, at Kynoskephalai in Thessaly in 197 B.C. Philip took a stand, and a Roman army met a Greek army in a major battle on Greek soil. On the uneven ground of the field, the flexible Roman legions finally outmaneuvered the heavy Macedonian phalanx. The Macedonians were routed, thousands were killed or taken prisoner, and Philip managed to escape only because the Aetolians were so busy plundering his camp that they neglected the task of pursuing him.

Considering the trouble he had given them, the Romans dealt leniently with Philip after Kynoskephalai. He was confined to Macedonia, forced to pay a war indemnity, and compelled, whether he wanted to or not, to become a Roman ally; and his fleet was confiscated. But he retained his throne and still had complete control over the internal affairs of Macedonia. Having dealt with Philip, Flamininus turned his attention to southern Greece. At the Isthmian games in 196 B.C., while the spectators in the Panhellenic stadium were busy watching athletic contests, he sent a herald into the stadium to make an announcement that would give him, for a time, a

popularity unequalled by that of any other military leader in Greek history. He announced that all Greek cities and states would have their freedom restored to them. Neither Rome nor Macedonia would control them. The shout of joy that went up from the stadium was so great, according to Plutarch, that crows were knocked out of the sky (Plutarch, *Flamininus* 10.6). Satisfied with his immense popularity as the liberator of Greece, Flamininus, after settling the affairs of Sparta, prepared to withdraw from Greece.

His settlement of Greece did not last much more than a year. The Aetolians were angry with Flamininus's liberation decree because it had cost them control of a number of cities in central Greece, and they soon set out to undo the Roman settlement. They played skillfully upon the ego of King Antiochos III, the Great, of Syria, challenging him, perhaps, to live up to his reputation and surname, and persuaded him in 192 to provide Greece with yet another 'liberation,' this time from its newly-won freedom. The lure of adding still another victorious military campaign to a long list was too attractive to resist, and Antiochos agreed to invade Greece.

Antiochos's invasion seems to have been poorly thought out, perhaps even impulsive. He landed in 192 with a relatively small force of 10,000 men. Most Greek cities, which expected something more grand from the 'second Alexander,' and in any case were not unhappy with Flamininus's settlement, remained aloof from him. Even the Aetolian League, disappointed at his small force, gave him only token support, and the Achaean League viewed him as an enemy. Antiochos managed to make a few initial conquests in Thessaly and Euboea, but in 191 B.C. a Roman army led by the Consul Acilius Glabrio came to Greece. With the help of their new, if reluctant, ally Philip V (who had received no help from Antiochos during the Macedonians' war with the Romans and was now prepared to even the score), the Romans forced Antiochos to take a stand near the pass of Thermopylae where his army was annihilated. The Romans resolved to pursue Antiochos into Asia, and as a first step sent a combined Roman, Rhodian, and Pergamene fleet. Antiochos escaped by sea to Asia Minor, where he was pursued by the Romans and their eager ally Eumenes II of Pergamon and finally defeated decisively in a great battle near the city of Magnesia under Mt Sipylos.

The Romans were content to withdraw once again from Greece, but before doing so they had one final score to settle. Their former ally, the Aetolian League, had not only turned against them but bore the major responsibility for stirring up the war with Antiochos. Even before the defeat of Antiochos the Romans had driven the Aetolians back to their homeland, where for a time they made a stand. In 189 B.C., however, the Consul Fulvius Nobilior besieged, captured, and plundered the Aetolian stronghold of Ambracia, and the Aetolians were forced to surrender most of their territory and lost the right to conduct their own foreign policy. Although the League continued to exist for another twenty-one years (until the Romans broke it up altogether) it ceased to be a significant power in the Greek world.

Although Philip V's aggressive instincts remained intact and provided the Romans with diplomatic problems in the eighteen years after Kynoskephalai, it was not until he was succeeded by his son Perseus in 179 B.C. that Macedonian policy forced Rome once again to intervene directly in Greece. Perseus continued the policy, which had dominated Philip's last years, of reasserting Macedonian power in Greece. Soon after his accession he marched through northern Greece to Delphi, subduing portions of Thessaly as he went. On the diplomatic front he formed alliances in the East by marrying a daughter of Antiochos IV and by giving his sister in marriage to King Prousias of Bithynia. He also seems to have played a behind-the-scenes role in the politics of Greece by supporting disenfranchised and potentially revolutionary elements in various Greek cities. In spite of all this, however, he continued to profess a desire for friendly relations with Rome, and the Romans were at first willing to treat him as an ally rather than to embark on another Macedonian campaign.

Eumenes II of Pergamon, however, traditionally an ally of Rome and an enemy of Macedonia, was particularly hostile to Perseus, probably because Perseus's new alliances in the East seemed to threaten Pergamon. In 172 B.C. Eumenes journeyed to Rome and went before the Senate with a speech that itemized a long series of charges against Perseus and urged the Romans to declare war on him. Eumenes was apparently endowed with a dramatic persuasiveness, and after some deliberation the Romans decided, for a number of reasons but mainly because he was hated by Roman allies, to declare war on Perseus (171 B.C.) and to send a consular army to Greece.

Partly because his cause seemed hopeless and partly because an ingrained parsimony prevented him from giving adequate financial support to potential allies, Perseus stood virtually alone against Rome, Pergamon, Rhodes, and the Achaean League. Yet in spite of the odds against him, he did not at first fare badly. By 168 B.C. the Roman campaign had stalled so completely that Rome's allies began to lose confidence, and some of them, including even Eumenes, undertook tentative peace talks with Perseus. Realizing that some decisive action was necessary to regain their prestige, the Romans sent out an experienced and skillful commander, the Consul L. Aemilius Paullus, to take command of the army. With the help of a daring flanking movement, the Romans managed to get through the Olympos passes and forced Perseus to withdraw to plains around Pydna in southern Macedonia. Perseus hoped that an eager but tired Roman army would attack as soon as it came through the passes

and thus fight him at a disadvantage. Paullus, however, calmly rested his men for a day, and on the following morning declined to initiate the battle, hoping to lure Perseus into a weaker position. For the better part of a day in June 168 B.C. the two armies faced one another. Finally, at about three in the afternoon, a minor skirmish precipitated an all-out clash, and in the following hour there was fought one of those battles that are important not so much for their tactical details but because they punctuate major changes in human history. The Macedonian phalanx, which had carried Alexander and the Diadochoi to so many triumphs, made its last awesome charge. As the Romans at first faltered before the Macedonian long spears even a hardened commander like Paullus confessed that he felt anxiety and that he 'had never seen a more fearful sight' (Plutarch, *Aemilius Paullus* 19.2). But as the irregularities of the terrain began to break up the tightness of the Macedonian formation, Paullus made a strategic adaptation that was decisive. He broke up his flexible legions into smaller units and ordered them to infiltrate the emerging gaps in the phalanx. Once the Romans got by the points of the Macedonian spears they had Perseus's infantry, who were otherwise armed only with small daggers, at their mercy, and a rout ensued. By late afternoon 25,000 Macedonian troops lay dead on the field, and the kingdom that had once overthrown the Persian Empire was itself overthrown.

Perseus did not, as Paullus seems to have expected and thought proper, commit suicide. He fled with his treasure and his family first to Pella and then to Samothrace, where he claimed asylum. Eventually he was robbed and betrayed while trying to escape to Asia Minor and was captured by the Romans. Along with his family the last Macedonian king was taken to Rome, where he underwent the humiliation of being forced to march among the captives in Paullus's triumphal procession. Some time later he died in Rome, either by suicide or as a result of a psychological breakdown.

The Roman settlement of Greece after Pydna was drastically different from that of Flamininus thirty years earlier. Instead of liberating Greece, Paullus presided over a series of purges and massacres directed against anti-Roman factions in various parts of the country. In Epirus 150,000 people were sold into slavery, thus substantially depopulating the area and ensuring that the kingdom to which Pyrrhos had brought brief prominence played no further significant role in ancient history. In Aetolia 500 people were executed on trumped-up charges. Macedonia, strangely, was treated more leniently and more imaginatively. The country was divided up into four republics, each with its own elected senate and magistrates.

For about seventeen years the Macedonian experiment in republicanism fared surprisingly well. In 150/149 B.C.,

however, there appeared a pretender to the Macedonian throne named Andriskos. Andriskos procured support in Thrace, invaded Macedonia, defeated levies raised by the republics, rallied local support, and declared himself king of a reunited Macedonia. The Romans seem to have been unable to take the situation seriously until a small force sent out under the command of one of the praetors was annihilated by Andriskos. Finally, in 148 B.C., a stronger Roman army under the command of Q. Caecilius Metellus invaded Macedonia and put an end to Andriskos. This time Rome's liberal attitude toward Macedonia was exhausted. Macedonia was converted into a Roman province ruled by a Roman governor and ceased to be of political importance in the ancient world.

The final events leading to the fall of an independent Greece took place in the Peloponnesos. By 150 B.C. the Achaean League had been an ally of the Romans for nearly half a century. During the years from 180 to 150 the League had been dominated by a resolutely pro-Roman government which, in its efforts to keep the League's actions in line with Roman policy, had made many enemies. The government was primarily responsible, for example, for selecting the 1,000 exiles who were transported to Rome after Pydna. Naturally these exiles were its political enemies, as were the friends and relatives whom they left behind. Life was admittedly not altogether bad for the exiles in Rome. Polybios, for example, became a close associate of Scipio Aemilianus (the second son of Aemilius Paullus and the general who, in 146 B.C., destroyed Carthage) and thus part of a prominent group of philhellenic military leaders and intellectuals (the 'Scipionic circle', see p. 160). The wider horizons opened up to Polybios by these contacts undoubtedly influenced the scope and quality of his history. In spite of this, however, the very fact that the Achaeans in Rome were held against their will could not help but breed resentment, and when, in 151 B.C., the Romans decided to let them go home, they must have taken some of this resentment with them.

When the pro-Roman party in the Achaean League was weakened by the death of its leader in 149 B.C., the long smoldering resentment of the anti-Roman party finally caught fire. What seems to have been an irresistible longing for a confrontation with the Romans reached its peak when a group of Roman ambassadors who had been sent out to arbitrate a dispute between the League and Sparta were jeered and even threatened with physical violence. Later when Metellus attempted to arbitrate matters from his command post in Macedonia, his envoys too were hooted off the speaker's platform in Corinth. Rather than mollify Metellus, the Achaeans chose in fact to send an army northward to Thessaly to punish a minor and restive member of the League. By its intemperance the Achaean League had finally sown the seeds of its destruction, which soon followed. Metellus

smashed the League's army with such thoroughness that few of its members ever returned to the Peloponnesos. He then marched south to the Isthmus where, when his period of command expired, he was preparing for an assault on Corinth. His successor Lucius Mummius finished the job with devastating effect. Although the Greek army made a valiant last stand, the Romans overwhelmed them, captured Corinth, and dissolved the Achaean League (146 B.C.). Southern Greece was put under the supervision of the Roman governor of Macedonia. Mummius then undertook to punish Corinth for its insults to the Roman ambassadors in a way that would be remembered. Those Corinthians who were not killed were sold into slavery. The city was plundered and then destroyed so thoroughly that it virtually ceased to exist until Julius Caesar refounded it just over a century later.

Shortly before the cycle of events just described was set in motion, the Romans had also assumed control of the ancient centers of Greek culture in Sicily and southern Italy. Sicily for most of the third century B.C. had been dominated by one of the most remarkable of Hellenistic kings, Hieron II of Syracuse, who ruled for over half a century (269–215 B.C.) and presided over a period of unprecedented prosperity and calm. During his reign Syracuse and other cities were remodelled in a tasteful, conservative tradition, and the arts and sciences flourished. The quality of Hieron's long rule is perhaps best conveyed by the fact that he was for many years the friend and patron of the great mathematician, physicist, and inventor Archimedes, and by the fact that a perceptive historian like Polybios (7.8) paid him one of the most generous tributes that he accorded to any Greek leader. The secret of Hieron's success lay to a great extent in the fact that he contracted an alliance with Rome early (263 B.C.) in his reign and stuck to it for forty-eight years, even during the Punic wars. The disastrous result that ensued when his successors changed this policy seems to confirm the soundness of his judgment.

Upon his death in 215 B.C. Hieron was succeeded by his son Hieronymos. At this time, early in the Second Punic War, there were apparently a pro-Carthaginian and a pro-Roman party in Syracuse. Hieronymos flirted with the idea of Carthaginian alliance and was murdered. In spite of the fact that some elements in the quasi-democratic government that succeeded him remained favorable to Rome, the Romans now began seriously to fear that Syracuse would eventually be drawn into the Carthaginian camp. To forestall this possibility they sent an expeditionary force under the command of M. Claudius Marcellus to Sicily. Marcellus's army committed so many atrocities on the road to Syracuse that it achieved the result it was supposed to prevent: Syracuse, along with a number of other Greek cities, formed an alliance with Carthage. Thus the stage was set for Marcellus's epic siege of Syracuse. For two years (213–211 B.C.) the Syracusans, aided by immense fortifications and by catapults and other devices designed by Archimedes, held off the Roman assault; but in the end the city was opened to the Romans by treachery, and Marcellus turned his troops loose within it. Archimedes, among others, died in the slaughter, and the city was looted. The fall of Syracuse is an important landmark in the history of Hellenistic art and culture, since it resulted in the first really massive influx of works of Greek art into Rome and gave enormous impetus to the Hellenization of Roman taste in the arts (see *infra*). It also signalled the effective end of an independent, un-Romanized Greek culture in Italy. Soon after the siege the former Syracusan kingdom was incorporated into the Roman province of Sicily.

In contrast to Sicily, the Greek cities in peninsular Italy succumbed to Roman and Italic control at a very early stage, and with the exception of Tarentum (Greek Taras) faded into insignificance in the third century. The Tarentines caused serious problems for the Romans early in the century when, after sinking some Roman ships in a minor naval skirmish, they invited King Pyrrhos of Epirus to Italy to protect them from Roman vengeance. This led to the costly and bloody Pyrrhic Wars (280–275 B.C.), but when Pyrrhos grew tired of his Italian adventures and returned to Greece, the Romans took control of Tarentum and installed a garrison there. The city continued to have a measure of prosperity and independence, however, until it went over to Hannibal. This change of sides brought to Tarentum the same fate that had befallen Syracuse. It was besieged, captured, and plundered by the Romans under the command of Fabius Maximus in 209 B.C. and ceased to be a significant center of Hellenistic culture.

Many Romans probably got their first good look at Greek art in the form of plunder. It was an ancient Roman custom after military victories to have elaborate triumphal processions, partly religious and partly political in character, in which booty captured from the enemy was transported through the city with considerable pomp. In the Hellenistic period, when the Romans enjoyed a long series of triumphs over various Greek opponents, first in southern Italy and later in Greece itself, this booty consisted to a great extent of works of art – sculptures, painting, ornamental metalwork, and jewelry. Over a period of years, beginning with Marcellus's sack of Syracuse in 211 B.C. (for the Roman reaction to which see *infra*) and culminating with Mummius's sack of Corinth in 146 B.C., Rome became flooded with works of Greek art, some of them dedicated in public sanctuaries and others retained in private collections, and in the long run it was inevitable that these would have an effect on Roman taste and sensibility.

An idea of the scope and character of the plunder that

the Romans took from the Greeks is effectively conveyed by descriptions of it preserved in the narratives of several ancient historians and also by a few rare archaeological traces of it. For example, when Tarentum was sacked in 209 B.C. after its collaboration with Hannibal, Livy records that the Romans carried off 'a huge amount of silver, both wrought and coined, 83,000 pounds of gold, and statues and paintings which will almost have equalled the decorations taken from Syracuse' (27.16.17). Among the statues carried off was the colossal Herakles by Lysippos. It was ultimately dedicated by Fabius Maximus on the Capitoline in Rome (Pliny, *NH* 34.40; Strabo 6.278). As to the quality and influence of the paintings which the Romans carried off, there is not enough evidence to permit us to formulate an indisputable judgment, but it has been speculated on the basis of similarity between certain Pompeiian paintings and scenes on Tarentine (Apulian) red-figure pottery of the fourth century B.C. that a school of Tarentine painters may have created the type of 'dramatic landscape' found in Romano-Campanian paintings of the first centuries B.C. and A.C.

In the case of the 'wrought silver' which Livy mentions, however, it seems that we can, through a remarkable stroke of luck, form an idea of the artistic quality of what the Romans took with them. In 1896 during the construction of a modern street in Taranto a treasure of silver vessels (a *pyxis*, two cups, a *kantharos*, and an incense burner) was discovered which equals in interest that found at Touk-el-Qaramous in Egypt (see p. 255). In the *pyxis* from the treasure was found a group of Tarentine coins dating to the early third century B.C. Presumably the vessels were interred, or abandoned in panic, during the Roman assault on Taras in 272 B.C. and never recovered. There are enough similarities between these vessels and other products of Apulia, both in metal and terracotta, to justify the view that they were made in the region of Tarentum. Assuming this to be the case, one can conclude that Tarentine decorative metalwork, like that of Alexandria, had a cosmopolitan quality. In the wake of Alexander's conquest of the Persian empire, there arose a taste for interweaving oriental decorative motifs with Greek mythological figures and narratives. The *pyxis* from the Tarentine treasure is a good example of this mixture and suggests that the taste of the royal courts of the Diadochoi quietly came to pervade the whole Hellenistic world [161]. The feet of the *pyxis* are in the form of sphinxes. Inside it is a lush rosette with a garnet dotting its center and smaller floral motifs sprinkled around it. Both of these forms are ultimately of oriental origin but were quite at home in Greek art of the fourth century B.C. Their purpose was probably to provide an exotic 'setting' for whatever precious objects were kept in the *pyxis* and to enhance the holiness of the three images on the lid of the vessel: Zeus seated between Apollo and

161 *Pyxis* from the Tarentum treasure, side and top views. Silver. Early 3rd century B.C. Taranto, Archaeological Museum. H. 0.11 m.

Artemis. The Apollo, with his languid, hip-shot pose recalls the style of Praxiteles; the Artemis may echo Praxiteles' Artemis Brauronia on the acropolis in Athens; the Zeus seems generally Pheidian but with an infusion of Lysippan torsion. These figures, and the *pyxis* as a whole, are the work of a sophisticated craftsman with an eclectic bent, and we are in the unusual but fortunate position of knowing his name. Behind the figure of Zeus, in addition to a Delphic tripod, he depicted a stele which bears his signature: 'Nikon made it.' Whether or not Nikon was a Tarentine, his work undoubtedly illustrates what the prevailing taste of aristocratic Tarentines in the early Hellenistic period was like.

In the triumphs and celebrations that came in the wake of the Macedonian Wars and the wars with Antiochos artistic treasures from the mainland of Greece began to supplement the plunder from Italy and Sicily. Livy informs us, for example, that when Flamininus took control of the city of Eretria on Euboea (previously under Macedonian control) he seized not only money but 'statues and paintings of ancient workmanship' (Livy 32.16.17), and that when he returned to Rome and celebrated a three-day triumph in 194 B.C., he exhibited 'statues in bronze and marble, more of which were expropriated from Philip than were captured from the cities of Greece' (34.52.4–5). Likewise, in 187 B.C., when Fulvius Nobilior sacked the Aetolian capital at Ambracia, he carried back to Rome, according to Polybios, 'votive offerings (*agalmata*), statues and paintings from the city; there were a great many of these owing to Ambracia's having been the royal city of Pyrrhos' (Polybios 31.30.9). Livy itemizes 285 bronze statues and 230 marble statues in this particular triumph (Livy 39.5.16). In connection with the triumph of L. Scipio after his defeat of Antiochos we hear not only of 'captured' statues and paintings (Pliny, *NH* 33.149–50) but also of furniture, textiles, and gold and silver plate (Livy 37.59.35 and 39.6.7).

The triumphal procession celebrated in Rome to honor Aemilius Paullus in 167 B.C. appears to have emptied Macedonia of art treasures. It lasted, according to Plutarch, for three days. 'The first day was just barely sufficient for seeing the statues which had been seized, and the paintings, and the colossal images, all carried along on 250 wagons drawn by teams.' On the second day, in addition to armor, 'silver mixing bowls, horn-shaped goblets, offering bowls, and drinking cups' were exhibited, each specimen being 'outstanding in size and in the density of its engraving.' On the third day more metalwork was exhibited, including 'the Antigonid and Seleucid . . . cups and all the gold utensils used at the table of Perseus' (Plutarch, *Aemilius Paullus* 32–3). Although the vast array of objects in Paullus's triumph is not further described, it is probably fair to assume that engraved offering bowls, horn-shaped goblets (*rhyta*) and the like were similar to the objects from the treasures at Tarentum, already described, and from the treasure at Touk-el-Qaramous in Egypt (see p. 256). Of the statues in the procession one was probably the Athena by Pheidias which Paullus later dedicated in the temple of Today's Fortune on the Palatine in Rome (Pliny, *NH* 34.54). Some of the paintings in the procession may have resembled in style the grave stelai from Pagasai, now in Volos (see Chap. 9), which must date from the time of Philip or Perseus, or both. A more significant fact for the history of ancient painting, however, was Paullus's decision to hire an Athenian painter named Metrodoros to prepare some new paintings for the adornment of his

162 Delphi, Monument of Aemilius Paullus, restoration. 168–167 B.C.

triumphal procession (Pliny, *NH* 35.135). This Metrodoros was also a respected philosopher and was retained by Paullus not only as a painter but also as a tutor for the Roman commander's children. He thus became not only one of the first Greek artists to paint what must have been in essence Roman subjects for a Roman patron but he also became one of the first of a long line of Greek artists who migrated to Rome to take advantage of the new and growing Roman art market.

Although the basic effect of Aemilius Paullus's campaign on the art of Greece was to drain it of its

163 Frieze of the Monument of Aemilius Paullus. Marble. Delphi Museum. H. 0.31 m.

resources, Pydna did result in the erection in Greece itself of one monument of which parts survive and which is of considerable significance in the history of late Hellenistic and early Roman art. Shortly after Pydna, Paullus embarked on a tour of Greece, and when he reached Delphi he found, in the courtyard directly in front of the temple of Apollo, a partially completed quadrangular pillar which was being erected as a base for a portrait of King Perseus. Whether the monument was being erected by Perseus or by the Delphian administration is not clear. At any rate, Paullus immediately ordered that the monument should be converted into a memorial to himself and to the Roman victory at Pydna, noting that 'it was only proper that the conquered should give way to the victors' (Plutarch, *Aemilius Paullus* 28).[1]

This 'Monument of Aemilius Paullus' [162] was one of

three such commemorative pillars standing before the Apollo temple. The other two were dedicated to Eumenes II of Pergamon and Prousias of Bithynia. Paullus apparently instructed the designer of his monument to be certain that it dominated the other two. The complete pillar is estimated to have been 9.58 m tall; its upper plinth which supported the bronze equestrian statue of Paullus measured about 1.25 × 2.45 m. The cuttings which mark the points where the statue was fastened to the plinth suggest that the horse was in an animated, rearing position, perhaps like the equestrian statuette of Alexander from Herculaneum [36].[2] Near the base of the pillar was a dedicatory inscription, which has survived: L. AIMILIUS L. F. INPERATOR DE REGE PERSE MACEDONIBUS QUE CEPET, 'L. Aemilius, son of Lucius [set this up from the spoils which he] took from King Perseus and the

Macedonians.' The most interesting element of the monument, however, is a fragmentary frieze which decorated the top of the pillar just below its crowning entablature [162–163]. The frieze depicts a battle scene in which the combatants are clearly identifiable by their armor as Romans and Macedonians (or as the Gallic and Thracian allies of the Macedonians).[3] It depicts, in other words, not a mythical or legendary combat like the battle of Gods and Giants or the Trojan War but rather a contemporary, historical combat, Pydna itself. The frieze, which is 0.31 m high and runs for a length of about 6.5 m, is carved on three blocks. Some figures are carved so as to overlap the joints between the blocks, and there is hence no doubt about the order of the figures. The scenes on each of the four sides are self-contained compositional units, and since the 'terrain' depicted beneath the feet of the figures terminates at the ends of each side, it seems probable that each side was designed to be read as a separate episode in the battle. The beginning of the battle is in all likelihood depicted on the long side whose center is occupied by a riderless and bridleless horse [162]. Both Plutarch and Livy record that the long-delayed battle of Pydna finally broke out when a loose horse belonging to the Romans dashed between the two armies. Contingents from both sides rushed out to catch it and in the process became engaged in a fight which precipitated the general battle (Plutarch, *Aemilius Paullus* 18; Livy 44.40.4–10). The end of the battle would seem to be represented on one of the short sides where Roman infantrymen and cavalry stride over the bodies of fallen Macedonians while one Macedonian rider offers final resistance [163].

Among the figures in the intermediate episode represented on the other short and long sides, one is of particular interest. It depicts a rider whose horse is portrayed at a diagonal so that its shoulders, neck, and head vanish into the plane of the relief. The rider brandishes what seems to be a short Roman sword against an infantryman who covers his head with his shield. Because of the unusual (for relief sculpture) spatial freedom with which the figure is depicted, it attracts particular attention, and this attention is intensified when one sees that the face of the rider, unlike the generalized faces of all the other combatants, seems to be a portrait [164]. It is the face of a seasoned veteran with a hint of a double chin. Kähler's suggestion that this might be Aemilius Paullus, then about 60 years old, is appealing.[4]

When viewed from the standpoint of Greek art, there is nothing particularly original or startling about the Aemilius Paullus frieze. Its immediate historicity is a feature that had already been fully worked out by the time of Alexander in the Granikos Monument and can be seen in works like the Alexander Sarcophagus and the Alexander mosaic (see Chap. 1). If the recently proposed interpretations of the frieze of the temple of Athena Nike on the Athenian acropolis are correct, in fact, the depic-

164 Frieze of the Monument of Aemilius Paullus, detail.

tion of specific historical scenes in Greek relief sculpture may go back to the fifth century B.C.[5] As in most earlier Greek friezes the figures on the Paullus frieze fill up the relief plane and dominate an essentially neutral background which gives only minimal indications of a spatial setting for the battle. The fact that some of the figures, like the rider just discussed, seem to penetrate the relief plane in an effort to convey a sense of depth is quite normal for the period and reflects the strong influence that painting had on relief sculpture in the second century B.C., an influence that can be seen in other, nearly contemporary reliefs, like the Telephos frieze from Pergamon (see Chap. 9).

The spatial organization of the Aemilius Paullus frieze, with its lack of any significant hint of landscape, make it, in fact, a rather conservative monument. There is even a hint of incipient neo-Attic classicism about it (see Chap. 8). Some of its figures, for example the rider at the right end of the 'second' long side [163], resemble figures from the Nike temple frieze in Athens, so much so, in fact, that one wonders if the designer of the Delphi frieze did not have the Athenian prototype in mind. The Attic and painterly qualities of Paullus's monument tempt one to speculate, as many scholars have, that this designer was Paullus's specially selected painter, the Athenian Metrodoros.

The frieze of the Aemilius Paullus monument illustrates better than any other work the interdependency of the Greek and Roman artistic traditions in the later Hellenistic period. In style the frieze is Greek; in subject, intention, and function it is Roman. From the Greek point of view it was a fairly familiar type of monument; from the Roman point of view it was a

landmark, in that it was perhaps the first of the great tradition of historical reliefs in Roman art. As we have seen in connection with portraiture, it is often difficult to make a distinction between 'Greek' and 'Roman' in the final, Graeco-Roman phase of Hellenistic art. In the second century Greek painters like Metrodoros began to create 'Roman' monuments, and Roman architects, like Cossutius (see p. 248), were hired to create Hellenistic temples. The conquests of Paullus, Metellus, and Mummius meant that Roman patronage would increasingly dictate the directions in which Hellenistic art would develop but also that Roman taste would continue to be hellenized.

The triumph celebrated by Metellus after the final conquest of Macedonia in 148 B.C. was in some ways even more influential than that of Aemilius Paullus because in addition to bringing one of the greatest masterpieces of Hellenistic sculpture into the heart of Rome it also seems to have stimulated the spread of Hellenistic architecture in the city. From the Macedonian city of Dion, where it was first set up, Metellus confiscated the great Granikos Monument which Lysippos had created for Alexander (see pp. 41–3). In order to provide a proper setting for the approximately 25 bronze equestrian figures that made up this group, Metellus set aside an area in the Campus Martius and surrounded it on four sides with a portico, known as the Porticus Metelli. Within the portico he incorporated a recently-built temple to Juno Regina and constructed another, dedicated to Jupiter Stator. Facing these he set up the Granikos Monument. Velleius Paterculus, who is the source of this information, also states that Metellus built the first marble temple in Rome. Most probably his remark refers to the Jupiter temple within the Porticus Metelli.[6] From Vitruvius we learn that the architect of the temple of Jupiter Stator was a Greek named Hermodoros of Salamis (Vitr. 3.2.5). It may have been Hermodoros, with the encouragement of his patron Metellus, who first brought the heritage of Hellenistic architecture, modified for local consumption, into the heart of Rome. Although there is no evidence to help us reconstruct what these temples looked like, it is probable that they were similar to, and perhaps the prototype for, the slightly later temple of 'Fortuna Virilis' which still survives in Rome; that is, Tuscan in plan but Hellenistic in their formal components.

Although there is no detailed description of its after-effects, Mummius's devastating sack of Corinth in 146 B.C. seems to have flooded Rome with more Greek art than ever before. Strabo (6.381) states that the 'greatest number and best of the public monuments of Rome came from it.' The most interesting facts that we learn from the literary sources which mention the sack relate to the problems surrounding the Romans' growing taste for and understanding of Greek art. Amid the plunder carried off from Corinth, for example, was a wealth of bronze objects, apparently both statuettes and tableware, known collectively as 'Corinthian bronzes.' These were avidly sought by a growing circle of Roman art collectors, but as with collectors in any age, it seems that the Romans did not always know what they were getting. Corinthian bronzes were still being collected in the first century A.C., and Pliny, writing *ca.* 70 A.C., has left a telling picture of the problems and foibles of Roman collectors.

. . . The technique of casting precious works in bronze has degenerated to such a point that for a long time now not even chance [*Fortuna*] has had the privilege of producing this kind of artistry. But among the ancient glories of that art Corinthian bronze is praised most highly. This is a mixture which occurred by accident at Corinth during the time when it was captured and burned, and the attraction which this metal has had for many people has been indeed remarkable. In fact there is a tradition that, for the sake of this metal and no other, Verres, whom M. Cicero convicted, was proscribed by Antony along with Cicero; for Verres had refused to surrender to Antony his collection of Corinthian bronzes. And it seems to me that the great part of these collectors more often merely pretend to have real knowledge about this bronze, so that they may stand out from the common run of men, and that less often do they really have a very subtle understanding of the subject. I will briefly illustrate what I mean. Corinth was captured in the third year of the 158th Olympiad, which was the 608th year of our city [146 B.C.], by which time there had not been any outstanding sculptors in metal for ages, yet, even so, these collectors today call all statues 'Corinthian.' . . . There do exist, then, a certain number of real Corinthian vases, which these 'men of taste' sometimes have converted into dishes and sometimes into lamps or even into wash basins with no consideration for the subtle points of their style. (Pliny, *NH* 34.5–7)

Not all Romans, furthermore, were cut out by nature to be collectors. Mummius, in particular, seems to have had his limitations in this regard, and later writers record with some amusement his lack of sophistication in coping with the spoils of Corinth.

L. Mummius, whose victory won him the cognomen *Achaicus*, was the first to enhance the esteem which is publicly accorded to foreign paintings at Rome. For when, during the sale of the booty [from Corinth] King Attalos [II of Pergamon] bought a painting by Aristeides, *The Father Liber*, for six hundred thousand denarii, Mummius, amazed at the price and having begun to suspect that there might be something good in the painting which he himself did not comprehend, demanded that it be brought back, and, over the prolonged protests of Attalos, placed it in the sanctuary of Ceres; this, I believe, was the first foreign picture to become public property in Rome. (Pliny, *NH* 35.24)

Mummius, however, was so lacking in culture that, when he had captured Corinth and was arranging for the transportation to Italy of paintings and statues, which were masterpieces by the hands of the greatest artists, he warned those in charge of the transportation that if they destroyed any of the statues and paintings, they would have to replace them with new ones. (Velleius Paterculus 1.13.4)

In the next century Mummius's boorishness would yield to the complex philhellenic sophistication of men like Cicero, who, as we shall see, began to treat the artistic treasures of Greece with a new reverence.

The Roman reaction: connoisseurship, collecting, and patronage

From the point of view of a Hellenistic Greek of the second century B.C., the Romans may have seemed to be a barbaric force which was slowly destroying the Hellenistic world. In the world of politics, there would clearly have been some justification for this view, although it could be argued that in warfare and statecraft the Romans were really no more barbaric than most Hellenistic kings. In the areas of culture, art, and social life, however, gloomy prognostications about the dire effects of Roman domination on the Greek cultural heritage would have been misguided. The uncouthness of Mummius and his soldiers at the sack of Corinth in 146 B.C. was not so much a portent of things to come as a late expression of 'growing pains' in the Roman world, for in the century which followed the plundering of Corinth Rome itself became transformed into a major cultural center, a haven for Hellenistic scholars and philosophers and a fertile field of opportunity for artists.

The major consequence of the military ventures described above was, as has been noted, that Rome was inundated with works of art in the form of triumphal booty. As the captured works of art were distributed throughout the city in temples and public buildings as well as in private collections and became part of the cultural environment of Rome, they began to exert a transforming influence on the Roman psyche and to elicit strong reactions. Some Romans were disturbed by the artistic Hellenization of the city, and saw it as a threat, but equally many others appear to have been excited and dazzled by it. Those who, like the Elder Cato, found Greek art distasteful saw it as a potential source of decadent effeteness which could only bring corruption into a world of stalwart, simple farmer-soldiers (for such was their romantic and already nostalgic vision of Rome). Those who were enthralled by the beauty of Greek sculptures and paintings, on the other hand, saw them as a liberating force, an avenue of escape from an almost embarrassing cultural backwardness into a life of sophistication and refinement. Plutarch, writing *ca.* 100 A.C., sensed this tension in Roman life in the late third and early second centuries B.C. and gives a particularly vivid picture of it in connection with the sack of Syracuse.

When the Romans recalled Marcellus to the war with which they were faced at home, he returned bringing with him many of the most beautiful public monuments in Syracuse, realizing that they would both make a visual impression of his triumph and also be an ornament for the city. Prior to this Rome neither had nor even knew of these exquisite and refined things, nor was there in the city any love of what was charming and elegant; rather it was full of barbaric weapons and bloody spoils; and though it was garlanded with memorials and trophies of triumphs, there was no sight which was either joyful or even unfearful to gentle and refined spectators ... For this reason Marcellus was even more respected by the populace – he had decorated the city with sights which both provided pleasure and possessed Hellenic charm and persuasiveness – while Fabius Maximus was more respected by the older Romans. For Fabius neither disturbed nor carried any such things from Tarentum when he took it, but rather, although he carried off the money and other valuables of the city, he allowed the statues to remain, adding this widely remembered remark: 'Let us leave,' he said, 'these aggravated gods to the Tarentines.' The elders blamed Marcellus first of all because he made the city an object of envy, not only by men but also by the gods whom he had led into the city like slaves in his triumphal procession, and second because he filled the Roman people (who had hitherto been accustomed to fighting or farming and had no experience of a life of softness and ease, but were rather, as Euripides says of Herakles, 'vulgar, uncultured but good in things which are important') with a taste for leisure and idle talk, affecting urbane opinions about the arts and about artists, even to the point of wasting the better part of a day on such things. But Marcellus, far from feeling this way, proclaimed proudly even before the Greeks that he had taught the Romans, who had previously understood nothing, to respect and marvel at the beautiful and wondrous works of Greece. (Plutarch, *Marcellus*, 21)

Marcellus clearly expressed the liberal, philhellenic side of the dispute which accompanied the artistic and cultural transformation of Rome. The conservative, 'old Roman' side is best represented in a speech which Livy ascribes to Cato:

You have often heard me complaining about the extravagances of women and often about those of men – not only of private citizens but even of magistrates – and how the state suffers from two diverse vices, avarice and luxury, those pests which have overturned all great empires. I come to fear these even more as the fortune of the Republic becomes greater and more pleasant every day and the empire grows – now we have even moved over into Greece and Asia, places which are full of every sort of libidinous temptation, and we are even putting our hands on royal treasures – for I fear that these things will make prisoners of us rather than we of them. They are dangers, believe me, those statues which have been brought into the city from Syracuse. For now I hear far too many people praising and marveling at the ornaments of Corinth and Athens and laughing at our terracotta antefixes of the Roman gods. I prefer these gods, who are propitious and will remain so, I hope, if we permit them to remain in their proper places. (Livy 34.4.1–4)

The antefixes at which the philhellenic Romans directed their uneasy ridicule were in all likelihood those on Rome's more venerable temples, temples built in the Etruscan Archaic and post-Archaic style. The ultimate origin of this style was, of course, also Greek, and in time the Romans would come to rediscover and venerate it (see pp. 175ff.). In the second century B.C., however, it is probable that what really dazzled the Romans was late

Classical and Hellenistic art of the more sensuous and flamboyant variety.

By the middle of the second century B.C. it began to become clear that Marcellus's attitude toward Greek art and culture would ultimately dominate Cato's, although a Catonian strain would persist in Roman thinking about art for some time.[7] The progress of the philhellenic attitude in Rome was undoubtedly made easier by the support and patronage of a group of Roman nobles who are loosely referred to in modern scholarship as the 'Scipionic Circle.' This circle had no formal organization, like a political party, but was rather a spontaneous association of like-minded, educated, and cosmopolitan Romans. Its dominant figure was Scipio Aemilianus, the second son of Aemilius Paullus and the most influential figure in Roman politics and foreign affairs between 150 and 130 B.C. He held the consulship twice and was the general who directed both Rome's final defeat of Carthage in 146 B.C. and the successful siege of Numantia (133 B.C.), which snuffed out resistance to Roman rule in Spain. Plutarch records that the sons of Aemilius Paullus, as previously mentioned (p. 155), were given an enthusiastically philhellenic education, including even instruction in sculpture and drawing (*Aemilius Paullus* 6.8). The effects of this education shaped Aemilianus's intellectual interests and choice of associates and also guided his actions in later life. He was a close friend of the historian Polybios and undoubtedly helped to stimulate in the historian, and through him in other Hellenistic Greeks, an appreciation of Roman traditions and values. Another of his close associates was the influential Stoic philosopher Panaitios, who accompanied him as an advisor when he travelled in the eastern part of the Hellenistic world. Aemilianus's familiarity with Greek art (which, one suspects, may have been furthered by Metrodoros, the painter whom his father brought to Rome) also bore fruit in one small but very significant way. After the defeat of Carthage, he undertook to restore to their original Sicilian Greek owners a number of works of art which had been plundered by the Carthaginians (Cicero, *Verrines* 2.2.86). Up to this time the Romans themselves had been the chief plunderers of the Greek world. Now we find a sophisticated Roman general acting as a connoisseur, acknowledging the value of works of art to men of refined sensitivity, and seeing to it that such works remained in the hands of those who appreciated them. The example set by Scipio Aemilianus in this instance helped to establish an ethical code regarding works of art among Roman political leaders in the next century. In 99 B.C., for example, when the aedile C. Claudius was arranging a temporary but sumptuous embellishment of the Forum, he borrowed rather than expropriated a statue by Praxiteles from its Sicilian owner. Cicero's reflection on Claudius's behavior expresses the changed, sophisticated attitude of his time: 'It is

only recently that men of noble rank have behaved this way ... it is only for the briefest time that we have seen those who decorate the Forum do so not with spoils from the provinces but with works of art belonging to their friends, lent by their hosts' (*Verrines* 2.4.6).

As Cicero's remark indicates, the ruthless plundering of the second century B.C. had come to seem boorish, and it yielded in the first century to the more refined world of collecting and connoisseurship. In the wake of this change there arose what we today would call an 'art market,' the first such market to appear in western history and possibly in world history. All the familiar features which we would associate with an art market today were there: passionate collectors, dealers (both honest and unscrupulous), forgers, restorers, appraisers, continual changes in fashion, and continually inflating prices. No aspect of late Republican Rome has a more modern feeling to it.

Cicero, who was for a time an avid collector, has left us an interesting portrait in his letters of the states of mind which came over those who were active in the art market. As he writes in 68/67 to his friend Titus Pomponius Atticus, who lived in Athens and acquired works of art on his behalf, we catch glimpses of his excitement about new purchases, his eagerness for further finds, his daydreams about how acquisitions will look in his villas, and his impatience at the delay in their arrivals.

I have paid L. Cincius 20,400 sesterces for the Megarian statues in accordance with what you wrote me. As for those herms of yours in Pentelic marble with heads of bronze, about which you wrote me, they are already providing me in advance with considerable delight. And so I pray that you send them to me as soon as possible and also as many other statues and objects as seem to you appropriate to that place, and to my interests, and to your good taste – above all anything which seems to you suitable for a gymnasium or a running track. For I am in such an emotional transport owing to eagerness for this subject that I am deserving of help from you, if also perhaps of censure from others. If there is no ship belonging to Lentulus, have them loaded at any port you wish. (*ad Atticum* 1.8.2)

I am awaiting eagerly the Megarian statues and the Herms about which you wrote me. Anything which you have in any category which seems to you worthy of the 'Academy,' do not hesitate to send, and have confidence in my treasure chest. This sort of thing is my voluptuous pleasure. I am enquiring into those things which are most *gymnasiode*. Lentulus promises his ships. I beg you to see to this project diligently. (*ad Atticum* 1.9.2)

As for my statues and the *Hermerakles*, I implore you in accordance with what you have written, to ship them at the first opportune moment which appears, and also anything else which seems to you suitable for this place, with which you are not unacquainted, and especially for a wrestling court and gymnasium. As a matter of fact, I have been writing to you while seated in that very location, so that the place itself informs me of what it needs. In addition I commission you to procure some reliefs which I could insert into the wall of my *atriolum* and also two well-heads ornamented with figures. (*ad Atticum* 1.10.3)

Several years later we find that Cicero's passion for collecting has cooled considerably, and in a letter written to M. Fadius Gallus in 61 B.C. he expresses some familiar-sounding exasperation about a few of the typical frustrations which collectors encounter: '. . . everything would have been easy, my dear Gallus, if you had bought only those statues I wanted and at the price which I was willing to pay . . . I quite understand that you bought up things which pleased you . . . acting not only on the impulse of your native zeal but also out of affection. But I would be happy if Damasippos would adhere to his stated intention. For the truth is that out of all those works purchased there is not one which I really want' (*ad Fam.* 7.23.1). Damasippos, whom Cicero mentions here, seems to have been a dealer who specialized in garden sculptures. Apparently he had promised to buy some unwanted sculptures from Cicero but had failed to do so, probably because he had gone bankrupt.[8]

The price of 20,400 sesterces which Cicero paid for the Megarian statues referred to above was probably about average for works of Greek art which had no particular pedigree or famous name attached to them. Works by famous artists naturally brought higher prices. Crassus paid 100,000 sesterces, for example, for some cups by a famous Greek engraver of the Classical period named Mentor (Pliny, *NH* 33.147) and the orator Hortensius paid 144,000 for a painting by Kydios, a Greek painter of the fourth century B.C. (*NH* 35.130). One can only imagine how much might have been paid for a work of Praxiteles if one had been available. In any case, there can be no doubt that a vast amount of wealth was poured into the art market of late Republican and late Hellenistic Rome.

What role did contemporary, that is, Hellenistic, artists play in these developments? And what exactly did most collectors collect? While there are no simple and comprehensive answers to these questions, it does seem that Roman collectors had a strong preference for works which were in the Classical Greek style and that the contemporary artists who won the greatest acclaim in late Hellenistic Rome worked in a classicizing or 'neoclassical' style (see Chap. 8). There were a number of causes which account for the strongly classicistic taste which began to develop *ca.* 150 B.C. and lasted for several centuries in the Roman world. It can be explained in part as simply one aspect of an all-encompassing retrospective atmosphere that pervaded the late Hellenistic world and infected Greeks quite as much as Romans. As the most intense creative forces of Greek culture began to wane, men began to look back, with the clarifying perspective of time and with a certain awe and nostalgia, to the great figures of the past in Greek philosophy, literature, and art. Socrates, Plato, Euripides, Demosthenes, Pheidias all suddenly ceased to be simply predecessors and became instead hallowed exemplars. The

past became more engrossing and more appealing than the present. Added to this was the fact that when young Romans of aristocratic lineage were given a philhellenic education, their tutors more often than not were Greek philosophers and rhetoricians who were imbued with this retrospective outlook. Their pupils thus quite naturally also absorbed it, and when they reached the age at which it was normal to have something like a 'college year abroad,' they often headed first for the citadel of Classical culture, Athens, where their reverence for the great monuments and thoughts of the Classical past was further reinforced by excitement and adventure.

Not only did the intellectual atmosphere of the age and the Roman educational system inspire a taste for classicism in art but so also did the city of Rome itself, for as a result of the plunder of the third and second centuries B.C., it had become a veritable museum of Classical Greek sculpture. By the end of the Hellenistic period the public buildings and sanctuaries of Rome contained 14 works by Praxiteles, 8 by Skopas, 4 by Lysippos (counting the Granikos Monument, with 25 or so separate statues, as one work), 3 by Euphranor, 3 by Myron, 2 by Pheidias, 2 by Polykleitos, and many others. Among the paintings by famous Greek artists were 4 by Aristeides, 4 by Nikias, 3 by Apelles, 3 by Nikomachos, and also a variety of works by Zeuxis, Parrhasios, Antiphilos, Polygnotos, Timanthes, and Pausias.[9] A Roman connoisseur had only to look around him in order to absorb the Classical spirit.

If a contemporary sculptor wanted to flourish in this atmosphere he could do so in one of two ways. He could make actual copies or free-hand variants of ancient masterpieces, or he could create new works in the Classical style. Some sculptors probably did both. The copying industry of the second and first centuries B.C. arose from the fact that there were simply not enough original Greek masterpieces to satisfy the demands of the Roman art market. Every gymnasium could not have a Doryphoros of Polykleitos, but every gymnasium could, like the one in Pompeii, acquire a copy of it, either in the form of a bronze cast or a marble replica made with the help of a pointing machine. The villas, baths, and gymnasia of the Roman world eventually became filled with such copies, just as many archaeological museums are today. Judging by those which survive, the vast majority of the copies made were replicas of Greek sculptures of the fifth and fourth centuries B.C. The one exception to this general rule would seem to be portraiture. A great many of the sculptured portraits which survive in copies are clearly Hellenistic works. The copyists were thus not only themselves products of the Hellenistic age, but they also helped to disseminate and preserve some of the period's more distinctive products.

An unusually complete picture of the artistic environment which collecting, supplemented by the copying

165 Sleeping Faun, from the Villa of the Papyri at Herculaneum. Bronze. 1st century B.C. or A.C. Naples, Archaeological Museum. H. 1.42 m.

industry, created for aristocratic Romans can be formed from the remains of the remarkable villa known as the 'Villa of the Papyri' at Herculaneum. This great structure, which stretches for 240 m along a terrace above the Bay of Naples, is thought to have belonged to the Piso family, perhaps specifically to Cicero's enemy Lucius Calpurnius Piso Caesonius. The Pisones (having produced a number of important government leaders including consuls) were one of Rome's most distinguished aristocratic families, and assuming that the villa did belong to them, we can assume that its contents represent the taste of the uppermost levels of Roman society. What is most striking about the sculpture collection in the Villa of the Papyri is its eclectic character. It contained the inevitable copies of Classical masterpieces, for example a bronze bust of the Doryphoros of Polykleitos [173], a copy of one of the famous Classical Amazon types, a Praxitelean Artemis, and a bust of the Praxitelean Dionysos known as the 'Sardanapalus' type. There was also a vast array of portraits of various types and styles representing Hellenistic political figures, e.g. a Ptolemy [24], Philetairos [23], and Demetrios Poliorcetes [22]; philosophers, such as Zeno and Epicurus; and literary figures, such as the blind Homer type and the bronze

'Pseudo-Seneca,' which is perhaps Hesiod [123]. In addition there were a few works that seem to have been Hellenistic originals, such as a sleeping faun which is in the tradition of the famous Barberini Faun [165], and a pornographic group of Pan and a she-goat; also some ambitious works in the archaistic and neoclassical styles which developed as responses to the retrospective attitude discussed above (see also Chap. 8), an archaistic Athena, for example [193], and a group of bronze dancers done in a loose version of the Early Classical style. What the sculptures of the Villa of the Papyri show more than anything else is that Rome and its surroundings in the late Hellenistic world became a center for historicism in art, rather like Victorian England. Not only did copies of 'old masters' abound but several earlier styles were revived and applied to new but 'old-looking' creations and caprices.

Hellenistic artists in Rome

As early as the 180s B.C. L. Scipio had assembled a group of Greek artists and taken them to Rome to assist in creating adornments for a festival that he had vowed at the time of his war with Antiochos (Livy 39.22.9–10). In the following decades more and more Greek artists decided to migrate to Italy in order to take advantage of burgeoning Roman patronage, and in time a few of these immigrants became famous and prosperous.

Metrodoros, the Athenian painter who attached himself to the family of Aemilius Paullus, has already been mentioned. The sculptors who seem to have had the greatest impact on Rome in the second century B.C. were the Athenians Timarchides and his sons Dionysios and Polykles. These artists seem to have taken part in a revival of the Pheidian style in the second century B.C. (see Chap. 8),[10] and they were also perhaps among the inaugurators of the copying industry, since Pausanias (10.34.8) tells us that they made an image of Athena for a temple at Elateia in Boeotia and decorated the shield of this image with figures copied from the shield of Pheidias's Athena Parthenos in Athens. After his conquest of Macedonia, Metellus apparently followed the example set by Aemilius Paullus and brought a group of Greek artists to Rome in order to construct and adorn the Porticus Metelli and its temples (see p. 158). In addition to hiring an architect, who has already been mentioned, he evidently also retained Timarchides and his sons as sculptors, since Pliny (*NH* 36.35) records that Dionysios did the cult image of Juno in her temple within the Porticus Metelli, Polykles and Dionysios together did the image in the Jupiter temple, and Timarchides did an image of Apollo which continued to be exhibited in or near the building even when it was remodelled into the Porticus Octaviae. (For possible copies of this Apollo see p. 174.)

The versatility of Dionysios and Timarchides seems to have been remarkable and was perhaps typical of artists who were determined to be successful in the Graeco-Roman period of Hellenistic art. Back in Greece, as already described (p. 75), they executed a down-to-earth portrait of the Italian businessman, C. Ofellius [78]. Yet in Rome they had no difficulty in responding to their patron's neoclassical taste. It would seem that they were prepared to give their clients what they wanted. For Roman intellectuals and potentates they could design a weighty neo-Pheidian cult image; for Italian businessmen they could do realistic portraits; and for an Asiatic shipper whose taste ran to the florid if not to the tacky, they would work up something in a rococo style (similar to [138]).

In the first century B.C. the artists who achieved the greatest renown were the sculptors Arkesilaos and Pasiteles. Arkesilaos was closely associated with L. Lucullus, who was his patron. Pliny, with Varro as his source, records that Lucullus paid Arkesilaos the huge sum of a million sesterces to make an image of Felicitas, but that both the patron and the artist died before it was finished (*NH* 35.155–6). L. Lucullus the general died in 56 B.C., but since Arkesilaos is also recorded to have made the cult image for the temple of Venus Genetrix in the Forum of Caesar, which was not dedicated until 46 B.C., the reference in this instance may be to Lucullus's son. Or, possibly, the cult image of Venus was installed before the Forum of Caesar was completely finished and dedicated. In any case, Arkesilaos's main period of activity was clearly in the first half of the first century B.C.

The style of Arkesilaos appears to have been florid and graceful, adapting the 'flying drapery style' of late fifth-century Athens to playful, rococo subject matter. Pliny records that Arkesilaos's contemporary (and Pliny's source), Marcus Varro, possessed a work by the sculptor representing 'a lioness and winged Cupids playing with her; some of the Cupids, having tied the lioness up, were holding her, others were compelling her to drink from a horn, and still others were providing her with slippers as footwear' (*NH* 36.41). Another work mentioned by Pliny, 'Satyrs carrying off Nymphs,' in the collection of Asinius Pollio in Rome (*NH* 36.33), also has a rococo 'ring' to it. One wonders, in fact, if Arkesilaos was not the foremost disseminator of the Hellenistic rococo style in Rome.[11]

Another very interesting fact that we learn about Arkesilaos from Pliny is that plaster or clay models for his works, called *proplasmata*, were wont to sell at higher prices than even the finished works of others. As an example, Pliny notes that when a Roman knight named Octavius wanted Arkesilaos to make a krater for him, the sculptor made a model of it in plaster for one talent (*NH* 35.155–6). What the information suggests is that the copying industry had brought about a kind of mass-marketing of new works of art: Arkesilaos would design his works in plaster and then hand them over to copyists who would turn out as many copies as the collecting public would buy. (An analogy is provided by the replicas of the Borghese krater in the Louvre. See p. 173.) In other words, the creations of the famous late Hellenistic masters were treated in the same way as the creations of old masters like Polykleitos.

The other great sculptor of the first century, Pasiteles, was a Greek born in south Italy who received Roman citizenship after the Social Wars (89/88 B.C.). In addition to being a prominent sculptor and engraver, he was also a scholar and writer. Varro and Pliny were apparently strongly influenced by his treatise in five volumes on masterpieces of sculpture.[12] Like Arkesilaos, Pasiteles had prominent commissions in Rome, for instance an ivory cult image of Jupiter in the temple built by one of the Metelli in the Campus Martius (*NH* 36.39). Pliny also tells us that Pasiteles never made a work without doing a model of it beforehand (*antequam finxit*, *NH* 35.156), which suggests that, again like Arkesilaos, his works could be distributed in multiple copies. Although no sculpture which is definitely ascribable to Pasiteles survives, there is an extant work by his pupil Stephanos [183], and assuming that the pupil's style was like that of his master, there can be no doubt that Pasiteles was a thoroughgoing neoclassicist (see Chap. 8).

The most eminent Roman art collector of the first century B.C. was the stalwart Republican statesman and historian Gaius Asinius Pollio (76 B.C.–4 A.C.). Asinius undertook responsibility for the restoration of a building called the Atrium Libertatis, which contained the offices and records of the censors (Suetonius, *Div. Aug.* 29). To enhance his restoration he added a public library to the building, and in that library he put his famous collection of sculpture on exhibition. The importance that was attached to the works of the great sculptors of the late Hellenistic period in Rome can be deduced from the fact that, in addition to works by Skopas and Praxiteles, Asinius's collection contained a 'Centaurs carrying off Nymphs' by Arkesilaos and 'Nymphs of the Appian Waters' by Stephanos, the pupil of Pasiteles.

Since the purpose of this chapter has been to put the careers of Arkesilaos, Pasiteles, and their contemporaries into historical perspective, these observations will suffice for the moment. A closer examination of the actual works which can be associated with them will be undertaken in the next chapter as part of a general analysis of neoclassical sculpture in the Hellenistic period.

8

Style and retrospection: neoclassicism and archaism

In discussing the evolution of Rome as a center of Hellenistic culture in the second and first centuries B.C., reference has already been made to the retrospective and nostalgic intellectual atmosphere which began to pervade the Hellenistic world during this period. As the creative impulse in Greek culture began to wane, and as the political dominance of Rome spread throughout the Mediterranean and made the Romans increasingly the chief patrons of Greek philosophy, literature, and art, the achievements of Classical Greece came to be looked upon with an awe and reverence that only time and distance can create. Looking back over the gulf of two or three centuries, late Hellenistic Greeks began to think of men like Socrates and Plato, Sophocles and Euripides, Isocrates and Demosthenes, Pheidias and Praxiteles, not just as 'predecessors' but as almost superhuman figures. The Classical Greeks seemed to have lived in a golden age when freedom and the power to shape one's own world fueled a creative intensity that the sprawling, heterogeneous, and largely supine late Hellenistic world could not easily match. The age-old tradition in Greek art and thought, going back to early in the first millennium B.C., that each generation could, and probably would, improve upon the achievements of its predecessors by refining old genres and striking out in new directions, finally began to die out.

It is true that in the visual arts there were still, right up to the end of the Hellenistic period, forays into areas which had not been explored or mastered in earlier periods – social realism, for example, and atmospheric illusionism in painting. But while these last fires of invention flickered modestly, a new principle of artistic action began to be asserted: not competition but emulation, not to outdo the past but to revive it. With the spirit of revival there also arose an increasingly scholarly attitude towards the history of art, particularly sculpture, which parallels developments in the rhetoric and literary criticism of the period. 'Old masters' were analyzed, categorized, and assigned places in a hierarchy of excellence, and their styles became paradigms to be studied and recreated.

The late Hellenistic period was the most stylistically self-conscious of all the eras of Greek art. The artists of the Classical period largely ignored the Archaic art that had come before them. Early Hellenistic artists, although aware of and at times willing to 'quote' stylistic features of Classical Greek art, were firm in their determination to create styles of their own. In the eyes of late Hellenistic artists, however, the whole stylistic history of Greek art came to be viewed as a vast pageant-like procession of forms, a heritage from which one could select, and sometimes combine, a wide variety of styles, each of which had its own charm and evocative power. The most obvious products of this eclectic historicism are the sculptural traditions which are today usually subsumed under the terms 'neoclassical' and 'archaistic.'

Neoclassicism

The neoclassical tradition in Hellenistic sculpture gets its name, of course, from the fact that the sculptors who developed it consciously revived and imitated the forms, and sometimes the subjects, which had typified Greek sculpture between *ca.* 480 and 340 B.C. Within the tradition there is not only a certain amount of variety but also a clear-cut historical development. In the early and middle second century B.C. there is a group of sculptors whom I will call the 'early' or 'free' neoclassicists. These artists devoted their efforts principally to recreating a style like that of Pheidias in original works of their own. In the second half of the second century B.C. another school developed which specialized in close imitations of specific Classical models. Since most of the models imitated and most of the artists who did the imitating were Athenian, the products of this school are commonly referred to as 'neo-Attic.' The same sculptors who created the neo-Attic tradition also developed the contemporary copying industry (see pp. 161, 169), and the only difference between a neo-Attic 'original' and a pure copy is that in the neo-Attic works Classical models are combined in new ways, and sometimes slightly varied, for decorative effect. A third phase in the development of

Hellenistic neoclassical sculpture is that of a group of sculptors who specialized in variations of Classical prototypes which were close enough to their models to be recognized as 'quotations' and yet different enough to stand as original works. For convenience I will label this group of artists the 'adaptors.' The most famous of them were Pasiteles and Arkesilaos, the historical setting of whose careers has already been discussed.

Free neoclassicism
Of the early neoclassicists the best appreciated today is Damophon of Messene. A number of large sculptural groups by him, all in the Peloponnesos, are described by Pausanias, and portions of one of the groups which Pausanias saw, the images from the temple of Despoina at Lykosoura in Arcadia, have actually survived.[1] In describing the sculptures which Damophon made for various temples in Messene, his home town, Pausanias mentions in passing that Damophon at one time received honors from the people of Elis for repairs which he made on Pheidias's great statue of Zeus at Olympia after its ivory had cracked (Pausanias 4.31.6). It has been calculated that the cracks in the ivory of the Olympian Zeus may have occurred as the result of an earthquake of *ca.* 183 B.C. This date, combined with epigraphical evidence, seems to fix Damophon's career in the first half of the second century B.C.[2] Damophon may have received this commission because he was already known as a respected sculptor with neoclassical leanings, but it is equally possible that he became a neoclassicist as a result of it, i.e. that this intimate contact with Pheidias's masterpiece inspired him to revive the Pheidian style in his own work. Like Pheidias he seems to have specialized in cult images, some of them on a colossal scale.

The images in the temple of Despoina (the 'Maiden,' a variant of Kore, i.e. Persephone) are described in some detail by Pausanias:

The images of Despoina and Demeter themselves, the throne on which they sit, and the stool beneath their feet are all of one stone. No part of the drapery, nor any of the parts carved around the throne, nor any other part of the stone is clamped by iron or cement, but all the parts are from one piece of stone. This stone was not brought [to the sanctuary] by them, but they say that, following a vision in a dream, they dug into the earth within the sanctuary and found it. The size of both of the images is about like that of the Mother in Athens. Demeter carries a torch in her right hand, while the other hand rests upon Despoina. Despoina holds a scepter and has what is called 'the *cista*' on her knees. Beside the throne by Demeter stands Artemis who is wrapped in the skin of a deer and has a quiver slung over her shoulders; in one of her hands she holds a torch and in the other two serpents. Alongside Artemis, a dog of the type which is suitable for hunting is reclining. Near Despoina stands Anytos, who was represented in the form of an armed warrior. Those around the sanctuary say that Despoina was brought up by Anytos, and that Anytos was one of those who are called Titans. (Pausanias 8.37.3–5)

In 1889 a substantial number of fragments of this group were recovered, including three large heads. One of them, a bearded male with rich Zeus-like hair, is clearly Anytos [166]; another a large head of a female with a veil [167] is usually identified as Demeter, but could be Despoina; a third, that of a younger-looking female figure with a ribbed hairstyle, has been called either Despoina or Artemis [168]. The unifying factor in the neoclassicism of these heads lies in their smoothness of surface and a certain largeness and simplicity in their features. In the 'Demeter' [167], in particular, the large eyes, roundish profile of the head, and narrow mouth are reminiscent of figures on the frieze of the Parthenon and also (judging by what we know of its appearance from disparate copies) of Pheidias's Athena Parthenos. Damophon clearly felt free, however, to modulate his Pheidianism with mannerisms from other stylistic traditions. The Anytos, for example, was probably based on Pheidias's Olympian Zeus, but the deep and turbulent carving of his hair and beard betray a familiarity with the Hellenistic baroque style. The hairstyle and rounded lips of the 'Artemis' [168], on the other hand, seem to allude to the style of Praxiteles (perhaps specifically to Praxiteles' Artemis Brauronia on the acropolis in Athens), but the sensuousness of the Praxitelean style is toned down by means of a very smooth, fifth-century type of surface.

The heads from Lykosoura make an interesting contrast with the works of two roughly contemporary, or perhaps slightly later, Athenian sculptors, Euboulides and Eukleides. Euboulides worked with another sculptor named Eucheir, and both were perhaps descendants of an earlier Euboulides who is credited with a portrait of Chrysippos (see p. 69). Their names are preserved on several inscriptions which can be dated to the second half of the second century B.C.,[3] and they are also mentioned by Pausanias, who saw some of their works in the second century A.C. – an Athena, Paion, Zeus, Memory, and the Muses and Apollo. Several of these were in a structure in Athens called the 'house of Poulytion,' which was part of a gymnasium dedicated to Hermes somewhere between the Dipylon Gate and the Agora (Pausanias 1.2.5). The head of the Athena from this group has survived [169] along with a portion of its dedicatory inscription. Its smooth surface, large features, and the sharply-etched lines around the eyes, along the bridge of the nose, and in the hair over the forehead create a mannered, exaggerated version of the Classical style. In its almost scholarly reverence for the style that was its prototype it calls to mind the academic classicism of the eighteenth century. By contrast, the works of Damophon convey a certain spontaneity and creative freedom. Damophon, one feels, made the Classical style his own because he had a genuine feeling for it, and not simply because it was old, or respectable, or even noble.

Eukleides, who is also mentioned by Pausanias,

166 Anytos by Damophon. Marble. 200–150 B.C. Athens,
National Archaeological Museum. H. 0.79 m.

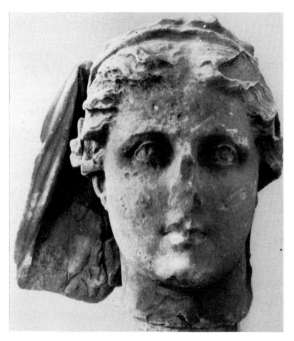

167 Demeter by Damophon, from Lykosoura. 200–150 B.C.
Athens, National Archaeological Museum. H. 0.75 m.

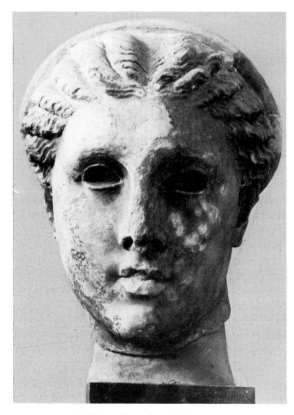

168 Artemis by Damophon, from Lykosoura. 200–150 B.C.
Athens, National Archaeological Museum. H. 0.48 m.

executed several cult images, using his native Athenian
Pentelic marble, for temples in Achaea (Pausanias 7.25.9;
7.26.4). One of these, a head of Zeus from Aigeira,
survives [170]. The evidence for Eukleides' date is open
to dispute,[4] and he has been placed by some earlier than
the second century B.C. The broad forehead of the Zeus,
however, and the way its rich wreath of hair stands out
from the forehead, resemble other neoclassical heads of
late Hellenistic period and support a date in this period.

Another center, along with the Peloponnesos and
Athens, where early neoclassicism flourished was
Pergamon. This is not surprising, of course, since the
whole tenor of Pergamene culture was, as we have seen,
revivalist. As part of their goal of making Pergamon into
a new Athens, the Attalids were eager to introduce
Classical Athenian art, or allusions to it, wherever they
could. A group of surviving statue bases suggests that
original works by Myron, Praxiteles, and other masters
were acquired and set up in Pergamon as immediate

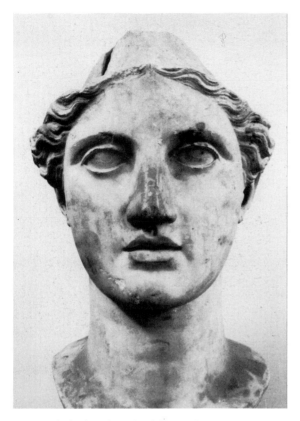

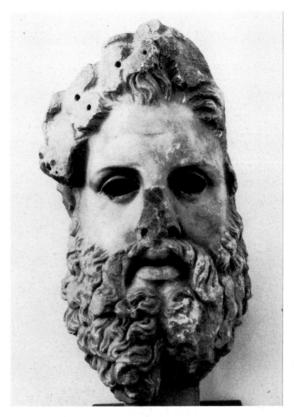

169 Head of Athena by Euboulides. Marble. 150–100 B.C. Athens, National Archaeological Museum. H. 0.60 m.

170 Head of Zeus from Aigeira, by Eukleides. 150–100 B.C. Athens, National Archaeological Museum. H. 0.87 m.

exemplars of the Classical heritage;[5] and among original Pergamene works there are several, like the 'beautiful head' [111], which must be classed among the masterpieces of early neoclassicism. Even within the ostensible tumult of the Hellenistic baroque, as in the Gigantomachy of the Altar of Zeus, there are classicizing flourishes (see p. 105). The character of Pergamene neoclassicism is perhaps best embodied by the large (3.105 m high) marble statue of the Athena Parthenos that was set up, presumably during the time of Eumenes II, in the main reading room of the library at Pergamon [171]. This figure is not so much a copy of Pheidias's colossal image in the Parthenon as a free-hand recreation of it. Although there can be no doubt that it was designed to be recognized as a descendant of the Pheidian image (its base, in fact, reproduced some of the figures from the story of Pandora that decorated the base of the statue in Athens), the Pergamene Athena has its own character. The freer swing of the body (when compared to other replicas of the Pheidian original), the longer, more narrow profile of the face, and the deep carving of the drapery all reflect the sensitivities of contemporary

Pergamene art. Even her helmet is of a type found on the reliefs of the Altar of Zeus and other Pergamene monuments. The overall design of the figure, however, and the use of sharp edges to delineate the features of the face and the hair are deliberately used to evoke the feeling of the fifth-century prototype. It has the same evocative freedom that characterized the images of Damophon and that would soon be replaced by a more slavish form of classicism.

Probably the most famous work that exhibits traits of free neoclassicism is the Aphrodite of Melos, better known by its gallicized title, the 'Venus de Milo' [172]. The body of the Aphrodite is a conspicuous example of the 'open form' generally associated with the Hellenistic baroque (see pp. 110, 268), but its small mouth, smooth brow, marked nose bridge, and linear exactitude around the eyes and in the strands of hair along the side of the head all evoke precedents of the fifth and fourth centuries B.C. The figure's mixture of diverse baroque and neoclassical traits would seem to place it *ca.* 150–125 B.C., and the letter forms of a partially preserved sculptor's signature on its base support such a date.

171 Colossal Athena from Pergamon. Marble. *Ca.* 175 B.C.
East Berlin, Staatliche Museen. H. 3.105 m.

172 The Aphrodite of Melos. Marble. *Ca.* 150–125 B.C.
Paris, Louvre. H. 2.02 m.

173 Head of the Doryphoros of Polykleitos. Bronze.
Roman copy of an original of *ca.* 440 B.C. Naples,
Archaeological Museum. H. of head 0.30 m.; of herm
0.53 m.

The neo-Attic tradition

From the middle of the second century B.C. onward there
is ample evidence for the existence of a group of pros-
perous workshops, at first in Athens and later in Rome,
which devoted their efforts primarily to producing copies
of earlier Greek masterpieces, rather than essentially
freehand neoclassical creations, for avid Roman collec-
tors. These workshops appear to have become something
like family companies and some of them seem to have
survived for several generations. One such company was
that of a line of sculptors named Apollonios and Archias
in alternate generations, a late member of which signed
the bronze copy of the Doryphoros of Polykleitos from
Herculaneum [173].[6] Another prosperous family which
at least started out in the copying business was that of
Polykles, Timarchides etc. (see p. 162 and *infra*).

An offshoot of the copying industry, inspired by the
same historical conditions and appealing to the same
market, is the genre of late Hellenistic sculpture known as
'neo-Attic.' This term was coined in the mid-nineteenth
century as a convenient designation for a group of

sculptors of the late Hellenistic and Roman periods, like
Apollonios the son of Archias, who used the designation
'the Athenian' in their signatures but had to be differenti-
ated from sculptors of the Classical period.[7] The sculp-
tures by these artists were seen to have retrospective,
neoclassical qualities, and consequently, in the first
thorough study of such sculptures, Friedrich Hauser's
Die Neu-Attischen Reliefs in 1889, 'neo-Attic' was also
applied to them and to other works like them. The most
typical form of neo-Attic art is relief sculpture, sometimes
simply on flat panels but often on stone vessels and
cylindrical well-heads, in which forms from earlier Greek
art are freely copied but also usually modified in order to
achieve a light decorative effect. The most common
source of the prototypes for these decorative sculptures
are Athenian works of the late fifth and fourth centuries
B.C., but models from the Archaic and even from the
Hellenistic period are sometimes used. 'Neo-Attic' is
therefore not strictly equivalent to 'neoclassical.' In this
chapter, however, archaistic neo-Attic reliefs will be
treated in a separate section, and our focus will be on the
Classical strain in neo-Attic, which is unquestionably its
most important component.

Neo-Attic sculpture was produced over several cen-
turies and can be divided into three phases. The first of
these falls between *ca.* 150 B.C. and Sulla's sack of Athens
in 86 B.C., when the copying industry was just getting
started and the center of activity was in Athens. The
second falls between 86 B.C. and the time of Augustus,
when the headquarters of the industry seems to have
moved to Rome. The third phase, which is beyond the
scope of this book, belongs to the time of the Roman
Empire, particularly the Antonine period. One gets the
impression that quotation of famous prototypes was
particularly important in the first phase and that a less
learned and more purely decorative elegance was favored
in the second phase; but no hard and fast distinction can
be drawn between the style and subject matter of the first
two phases.

Since the number of neo-Attic sculptures which survive
is large and a wide spectrum of prototypes is reflected in
them, a few typical examples must suffice to introduce
the genre. A particularly instructive example of a neo-
Attic decorative panel is the relief in Florence depicting
two female figures and a bull which are adapted from slab
11 on the parapet of the temple of Athena Nike on the
Athenian acropolis (*ca.* 420 B.C.) [174]. The date of the
relief in Florence is probably *ca.* 100 B.C.[8] Neo-Attic
artists had a particular fondness for the flamboyant,
calligraphic decorative qualities of the 'flying drapery'
style of the late fifth century, and when they used proto-
types in this style they seem to have made every effort to
exaggerate these qualities, even if the exaggeration took
place at the expense of content and narrative coherence.
Thus in the Florence relief the wings of the Nikai are

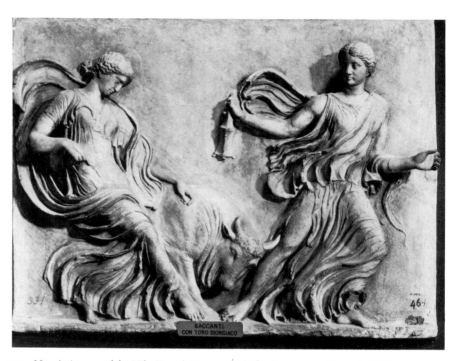

174 Neo-Attic copy of the Nike Temple Parapet. Marble. *Ca.* 100 B.C. Florence, Uffizi. H. 0.67 m.

175 Neo-Attic Maenad types as identified by F. Hauser.

eliminated and the female figures come to seem more like dancing Maenads, an extremely popular subject in neo-Attic sculpture. The sense of an elegant, decorative, but perhaps essentially meaningless dance is also brought out by other means. The left leg of the figure on the left is here placed behind her right leg to create a dance step. In the prototype both legs were placed forward to brace the Nike as she attempted to restrain a rearing bull. In the neo-Attic relief the bull's head is lowered and carries on the line of the female figure's left arm, almost as if he is dancing along with her. The way the rightward (from the viewer's point of view) movement of the female figure on

the right is exaggerated and her right leg is exposed also calls to mind the atmosphere of dancing Maenads. For all their striving for decorative elegance, however, the neo-Attic sculptors had difficulty reproducing the virtuoso-like complexity and sophistication of the drapery of the Nike parapet. In spite of its curls and swirls, there is a cold, linear, derivative quality about the drapery of the figures on the Florence relief. Their forms are simplified without being clarified and are devoid of spontaneity and inventiveness.

As further illustrations of typical neo-Attic reliefs we may pass from would-be Maenads to real Maenads. In

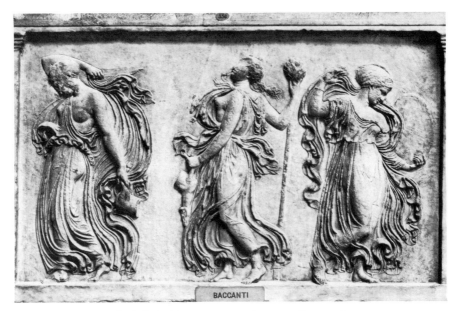

176 Neo-Attic Maenad relief. Marble. *Ca.* 100 B.C. Florence, Uffizi. H. 0.59 m.

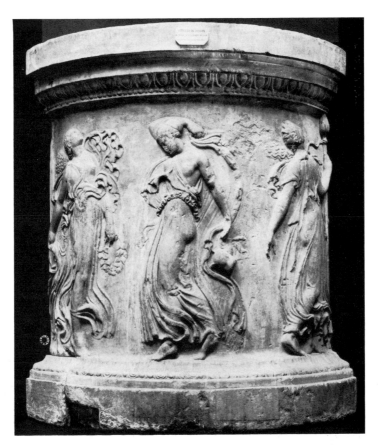

177 Neo-Attic base with Maenad reliefs. Marble. Later 1st century B.C. Rome, National
Museum of the Terme. H. 1.15 m.

his pioneering work on neo-Attic reliefs, Hauser recognized that a group of eight Maenad figures, all bedecked in the flamboyant drapery style of the late fifth century B.C., reappeared time and again in neo-Attic art, sometimes in combination and sometimes separately [175]. Over the years many scholars have endorsed the plausible but unprovable hypothesis that these Maenads (Hauser's nos. 25–32) derive from an original work by Kallimachos, the meticulous sculptor in the late fifth century B.C. who was famed for the extensive use of the (running?) drill in his sculptures and earned the epithet *katatexitechnos* ('the ultra-refiner') because of his love of detail (Pliny, *NH* 34.92; Pausanias 1.26.6).[9] Whether this is true or not, it does seem certain that the figures go back to *some* late fifth-century prototype. To get a sense of how these Maenads, each of which became an independent 'motif,' could be combined and used we need only look at a selection of typical works, each of which depicts three of the Maenad types: an early neo-Attic (*ca.* 100 B.C.) relief in Florence [176], a round base from the second half of the first century B.C. in the Museo Nazionale (Terme) in Rome [177], and two works which break through the usual anonymity of neo-Attic works and provide us with signatures of their creators, the amphora of Sosibios in the Louvre dating from *ca.* 50 B.C. [178] and the rhyton of Pontios in the Musei Capitolini in Rome [179], dating from the time of Augustus. Each of these depicts the Maenad who holds a sacrificial animal and raises a knife above her head (Hauser no. 25), a figure which may have been considered the key figure of the original, since it is the one most commonly copied, and combines it with two others. The Florence relief uses the Maenad who dances with a tambourine (no. 27) and the ecstatic Maenad who holds a *thyrsos* (Dionysiac wand) and a sacrificial animal (no. 28); the amphora of Sosibios uses the seemingly weary Maenad who is usually known by her Italian name 'La Stanca' (no. 26) and also no. 27; the round base uses the ecstatic Maenad with her head thrown back (no. 29) and the Maenad with the garland (no. 31); and the rhyton of Pontios combines nos. 28 and 29. Clearly an artist was free to choose whatever figures appealed to him in order to make a decorative design. Concern for the fine points of the original seems to have diminished as time went by. On the relief in Florence one still has a strong sense of the variegated texture of the drapery and the subtlety of surface which must have characterized the original, but in the later works the Maenads seem to become increasingly stereotyped. By the time Pontios made his rhyton one feels that the figures may have been rather arbitrarily chosen and mechanically reproduced from a picture book. In the case of decorative stone vessels this may have been true, in fact, even earlier. A relatively early neo-Attic krater in Naples signed by the Athenian sculptor Salpion, for example, depicts a scene of Hermes, followed by two

178 Amphora by Sosibios. Marble. *Ca.* 50 B.C. Paris, Louvre. H. 0.67 m.

satyrs and a Maenad, handing over the infant Dionysos to a seated Nymph (Hauser nos. 22–24, 14–15) [180]. All of these figures, as well as the standing draped Nymph to the right of the seated one, occur on other neo-Attic reliefs, and it has been plausibly hypothesized that they all derive from a statue base of the late fourth century B.C. Worked in with this group, however, is a female figure leaning against a tree which seems to derive from a Hellenistic Hygieia type of *ca.* 160 B.C. and also, behind the seated Nymph, a Silenus which appears to be Hellenistic in origin.

Neoclassical adaptors

The stone vessels of Salpion, Sosibios, and Pontios provide an appropriate transition point to turn to the work of other sculptors of the second and first centuries B.C. whom I would call the 'adaptors.' It is clear that within this genre of vessels decorated with relief sculptures there are a few examples which must be classed as original works of the Hellenistic period rather than as neo-Attic pastiches. One such would seem to be the type best

179 Rhyton by Pontios. Marble. Late 1st century B.C. Rome, Capitoline, Palazzo dei
Conservatori. H. 1.12 m.

180 Krater by Salpion. Marble. Later 2nd century B.C.
Naples, Archaeological Museum. H. 0.99 m.

preserved by the Borghese Krater in the Louvre [181],
which depicts a Dionysiac revel in high Hellenistic style.
Several other replicas of this type exist, including two
from the Mahdia shipwreck (see pp. 139–40), which
prove that the original must have been made before the
time of Sulla. It is conceivable that the Borghese Krater
itself is the original. In any case it is a product of the
workshop of a gifted artist of the second century B.C. who
throve by applying the mass-production techniques of
the copying industry to his own creations.[10]

A later artist who did the same thing was Arkesilaos,
whose career has already been discussed (p. 163). It will
be remembered that, among the various works which
earned Arkesilaos a fortune, one was a plaster model for
a krater. This model was presumably made to serve as the
basis for a number of copies in stone and bronze. What it
looked like we can only guess. Perhaps, as suggested
earlier, it was in the playful and amiable style of 'Hellen-
istic rococo.' In any case there can be little doubt that it
was an original work.

Another group of sculptors who should probably be
classed as adaptors were the sons and grandsons of the
Athenian sculptor Polykles (*supra* p. 162). Pliny men-
tions Polykles as one of the artists who participated in a

181 The 'Borghese Krater.' Marble. Later 2nd century B.C. Paris, Louvre. H. 1.71 m.

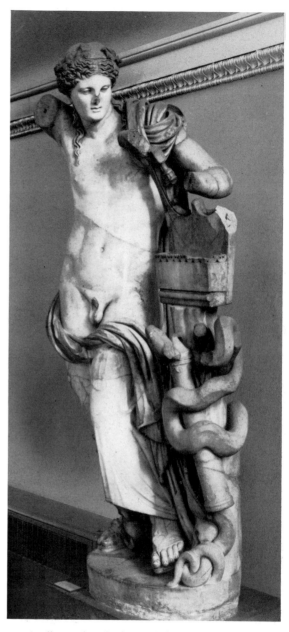

182 Apollo, attributed to Timarchides. Marble. Roman copy of an original of *ca.* 150–100 B.C. London, British Museum. H. 2.29 m.

neoclassical revival *ca.* 156 B.C.,[11] and the role of his sons Timarchides and Timokles in the development of the copying industry has already been noted. The sons of Timarchides, Dionysios and Polykles the younger, were among the first Athenian artists, it will be recalled, to have had the benefit of Roman patronage and to have traveled to Rome. Probably created at the same time as their cult images for the temples within the Porticus Metelli was an Apollo with a *kithara* by Timarchides, which in Pliny's time seems to have stood in or near the Porticus Octaviae, an Augustan structure built to replace Metellus's building (*NH* 36.35). Whether this Timarchides was the father of Dionysios and Polykles II or his grandson, 'Timarchides the Younger,' who seems to have been the son of Polykles II, is uncertain.[12] In any case, there is a languid, neoclassical, late Hellenistic type of Apollo *Kitharoidos*, which has plausibly been connected with the Apollo of Timarchides [182]. The prototype for this work was apparently an even more languid work by Praxiteles, the Apollo Lykeios.[13] In the Hellenistic work, however, the Praxitelean softness and languor have been altered first by the use of rather hard, neoclassical lines to articulate the features of the face and hair, and second by the use of the twisting, multiplanar 'open' form that

characterizes many figures of *ca.* 150 B.C. (Compare the Aphrodite and the Poseidon of Melos [172 and 290].) The work mixes, in other words, Classical and Hellenistic elements, both in its surface details and composition, and provides one of our clearest examples of how a Classical prototype could be adapted to the temperament of the later Hellenistic world.

When the centers of activity for the production of

183 Statue of a youth, perhaps Orestes, by Stephanos. Marble. *Ca.* 50 B.C. Rome, Villa Albani. H. 1.44 m.

neoclassical sculpture shifted from Athens to Rome after 86 B.C., the dominant role which had been played by the family of Polykles in the second century B.C. seems to have been assumed by the school of Pasiteles (see p. 163). Although many guesses have been made, there is no work which can be ascribed with certainty to the hand of Pasiteles himself. There are, however, two signed works by members of his school which provide us with quite a

good idea of what the products of the Pasitelean school were like. A figure of a standing youth in the Villa Albani in Rome bears the signature of 'Stephanos, the pupil of Pasiteles' on its base [183], and a group in the Museo Nazionale in Rome is signed by 'Menelaos, the pupil of Stephanos' [184]. The 'Stephanos Youth,' as it is usually called, is the best example we have of the sort of work which the neoclassical adaptors made popular. It is basically designed to evoke the feeling of a work of the Early Classical or 'Severe Style' of Greek sculpture such as the Omphalos Apollo. Hence its compact bonnet of hair, its broad shoulders, and its characteristic stance with both the feet flat on the ground but the weight borne by only one leg. That the Stephanos Youth is not, however, a copy of an Early Classical original but rather an eclectic neoclassical original of *ca.* 50 B.C. is clear from other features. Its small head and slender proportions are in the tradition of the school of Lysippos, and the subtle, soft modulations of its musculature (in contrast to the relatively sharp, linear demarcations between muscles on an Early Classical original) call to mind Attic sculpture of the fourth century B.C. The group by Menelaos, which is usually interpreted as Orestes and Electra and was probably made in the first half of the first century A.C., is similarly eclectic. The heads are done in a somewhat hardened version of the style of the late fourth century B.C., while the drapery fuses the complicated style of Hellenistic baroque with Roman forms and mannerisms.

Like Arkesilaos and the sculptor of the Borghese Krater, the artists of the school of Pasiteles seem to have harnessed the technology of the copying industry in order to produce many replicas of their creations. This was a practice peculiar to the late Hellenistic period. To the best of our knowledge there was only one Doryphoros of Polykleitos or Discus Thrower of Myron, but there were many Stephanos Youths. Seventeen whole or partial replicas, in fact, survive, and two of these occur in conjunction with other figures, one of them a youth (in the Louvre [185]) and the other a girl (in Naples [186]), which look as if they might also be works of Stephanos. Taken together the three figures have been identified as Orestes (the Stephanos Youth), Pylades, and Electra. But whether all the replicas of the Stephanos Youth should be interpreted in this way, or whether the meaning of each replica could be varied to suit its particular use, is uncertain.

Archaism

When used in connection with Greek art the term 'Archaism' and its accompanying adjective 'Archaistic' refer to the use of features of the mature Archaic Greek style, i.e. the style of the second half of the sixth century B.C., after that style had gone out of common use after *ca.*

184 Group by Menelaos, perhaps Orestes and Electra. Marble. Early 1st century A.C. Rome, National Museum of the Terme. H. 1.92 m.

185 Group incorporating the Stephanos Youth, perhaps Orestes and Pylades. Marble. Late 1st century B.C. Paris, Louvre. H. 1.45 m.

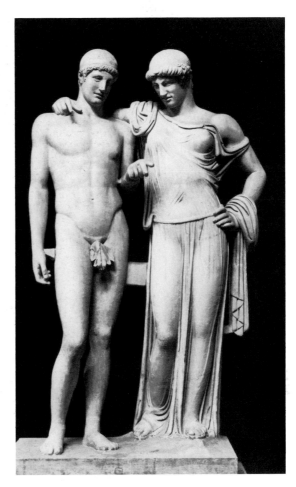

186 Group incorporating the Stephanos Youth, perhaps Orestes and Electra. Marble. 1st century A.C., based on types of the 1st century B.C. Naples, Archaeological Museum. H. 1.50 m.

480 B.C.[14] In present-day scholarship Archaism has become controversial. How it is to be defined and when it can be said to have begun are topics of active debate. Some scholars make a distinction between 'Archaizing,' i.e. the use of a few Archaic mannerisms in works which are primarily done in a later style, and full-fledged 'Archaism,' i.e. a comprehensive recreation of the Archaic style. Some see Archaism as an invention of the Hellenistic period; others see it beginning in the fifth or fourth centuries B.C. Even though the fine points of this debate may be of interest only to scholars, a brief review of it here is unavoidable if we are to put Hellenistic Archaism into proper perspective. Before becoming enmeshed in the world of contrary opinions, however, let us look at a few typical works of neo-Attic (that is, late

Hellenistic) Archaistic sculpture in order to get a sense of what the Archaistic style, in its most obvious form, is like. We shall concentrate at first on relief sculptures, since most of the controversy about Archaism has focused on reliefs.

A relief depicting Pan and the Graces in the Capitoline Museum in Rome, signed by a sculptor named Kallimachos[15] [187] and probably datable to the first century B.C., offers a good point of departure. The figures are evenly spaced, with their heads placed all on one level. The relief level is uniformly low in order to obviate any sense of spatial depth or bodily torsion. All the heads are in strict profile, and the arms of the Graces are kept away from the body in order to be seen in clear outline. The long fingers of the Graces make mannered gestures as they hold out flowers or grasp their drapery. All the figures stand on tip-toe, as if dancing. All have high

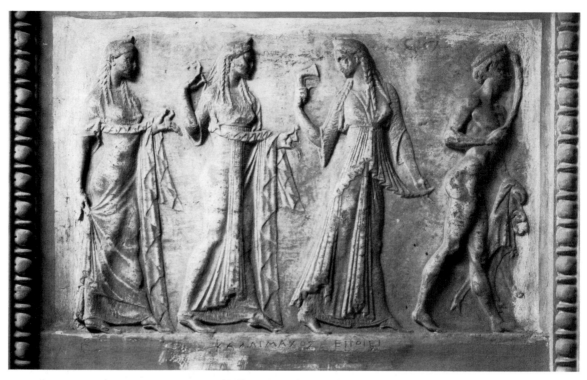

187 Archaistic relief by Kallimachos. Marble. 1st century B.C. Rome, Capitoline Museum. H. 0.455 m.

waistlines. The hips and legs of the Grace behind Pan are in profile, but her upper torso is frontal, a time-honored formula of early Archaic and Near Eastern relief sculpture. The profile of Pan's buttocks is particularly pronounced, in a manner reminiscent of Archaic *Kouroi* of *ca.* 540–525, while the Graces have long parallel curls, reminiscent of late Archaic *Korai*. The drapery of the Graces also involves a mannered exaggeration of Archaic formulae. Archaic zig-zag folds along the edges of garments form exaggerated 'swallow-tail' formations which project outward in an anti-gravitational way and resemble something like the edges of an umbrella. A large center pleat in the drapery of the first two Graces behind Pan forms a strong central axis. The two Graces to the left both wear over their chiton a long himation with a pronounced overfold decorated with zig-zag folds below the breasts and with a characteristic swallow-tail end projecting at the point where the robe is draped over the left arm.

Many of these same features can also be seen, rendered with more technical skill, on a three-sided base for a tripod from the Athenian agora [188] datable to *ca.* 100 B.C.[16] On this base it is interesting to note that the *chlamys* (short mantle) of the male figure with a club (Herakles or Theseus) is not rendered in an Archaistic

manner. The same blending of stylistic worlds is more obvious on a late Hellenistic relief in the Museo Barracco in Rome which depicts three Nymphs, led by Hermes, dancing before an altar, with the river god Acheloos seated to the left and with Pan seated in the background above [189]. Here only the Nymphs are done in the Archaistic style; the other figures evoke the style of late fourth-century votive reliefs. Clearly there was a certain formula for making Archaistic figures. The style only fitted certain types of figures in certain poses. It has been suggested in fact that there was a basic cartoon used by neo-Attic sculptors for the creation of all Archaistic figures and that this single formula was modified only by the addition of attributes or by variations in drapery.[17]

The Archaism of these late Hellenistic reliefs is clearly a coherent, consciously created, sophisticated style. Its main function, at least in relief sculpture, seems to have been decorative. It conveys quaintness, charm, nostalgia for a lost era in the same way that figures in pilgrim costumes do in American commercial art. Whether this was its only appeal, or whether religious conservatism, the desire to evoke ancient, venerable forms, also played a role in it, is difficult to say. In free-standing Archaistic sculptures, which often seem to reflect ancient cult images, the sense of sobriety is more apparent than it is in

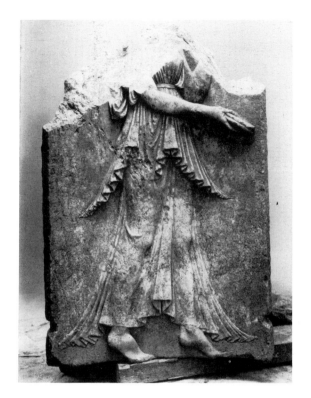

188 Archaistic reliefs on a tripod base from the Athenian
 Agora. Marble. *Ca.* 100 B.C. Athens,
 Stoa of Attalos. H. 1.09 m.

189 Votive relief with Hermes and the Nymphs, Acheloos, and Pan. Marble. Date disputed, perhaps early 1st century B.C. Rome, Museo Barracco. H. 0.42 m.

reliefs. Obviously such a style suited the atmosphere of the late Hellenistic period. Was it invented at this time, or did it exist earlier, as many feel, and survive only in a stereotyped form in the late second and first centuries B.C.?

At the outset, as we take up this question, it should be noted that no scholar disputes the fact that there were occasional revivals of features of the Archaic style well before the Hellenistic period. The question at issue is: when did a comprehensive Archaistic style with the features which we have just analyzed come into existence? Many scholars – Hauser, Furtwängler, Bulle, and more recently Harrison – have recognized an Archaistic style already in existence in the fifth century B.C. and argue that such a style was developed and used throughout the subsequent history of Greek art. Perhaps the majority of scholars, however, have endorsed the proposal of Eduard Schmidt in *Archaistische Kunst in Griechenland und Rom* (1922) that a comprehensive Archaistic style first developed in the fourth century B.C. and that the late Hellenistic Archaistic style is a revival of it. The most recently and most ardently advocated theory is that of Giovanni Becatti and Christine Havelock, who argue that comprehensive Archaism was a Hellenistic invention, datable to the third century B.C., and that the late Hellenistic style is a mechanical, formulaic echo of it.[18]

Before attempting to evaluate and choose among these disparate proposals, a review of some of the early, datable monuments with Archaistic features is in order. There are four basic categories of such monuments: representations on coins; representations on vases, particularly Panathenaic amphorae; representations of Archaic images in Classical relief sculpture and vase painting; and certain Classical free-standing sculptures, particularly the Hermes *Propylaios* and the Hekate ascribed to Alkamenes. The coins which most clearly betray Archaic features in the Classical period are Athenian silver issues with a head of Athena on the obverse. The Classical versions of this type continue to have the linear hair and profile eye of their Archaic predecessors. Panathenaic amphorae were awarded as prizes to victors in the Panathenaic games. They were regularly decorated with an armed Athena on one side and a scene depicting the contest in which the victor had won his prize on the other. These were conservative monuments and continued to be rendered in the black-figure style all through the Classical period, long after the style had gone out of vogue. In the fifth century B.C. the figure of Athena continued to be rendered in the Archaic format, with the goddess striding to the viewer's left. Around the middle of the fourth century B.C. a striking change took place. The Athena now faces right, ceases to stride, and is bedecked with Archaistic-looking swallow-

190 Panathenaic amphora. Painted pottery. 336/5 B.C.
London, British Museum. H. 0.824 m.

191 Herm by Alkamenes, from Pergamon. Marble. Roman
copy of an original of *ca.* 430–420 B.C. Istanbul,
Archaeological Museum. H. of head 0.40 m.

tail folds on the overfold of her peplos and on the mantle
around her shoulders ([190] dated to 336/5 B.C.).

The depiction of Archaic images in Classical sculpture
and vase painting can be illustrated, for the sake of
brevity, by a single well-known example, the panel from
the frieze of the temple of Apollo at Bassae (*ca.* 420–400
B.C.) on which a Lapith woman is shown grasping a small
Archaic-looking statue (frontal pose, corkscrew curls,
loosely zig-zag folds of drapery) as a Centaur attacks
her.[19] It is probable that many, if not most, of the cult
images in the shrines of Classical Greece were of Archaic
origin and that the artist's purpose in using Archaic forms
here was to make it clear to the viewer that the figure
depicted a statue.

A herm is a special type of image of Hermes with a
bearded head of the god placed on a quadrangular shaft
which is equipped with a representation of sexual organs.
In early Greece these herms were apparently road
markers or field markers for shepherds and wayfarers
and were intended to assure prosperity and fertility to

fields and flocks as well as to mark pathways. Eventually
they were imported into urban environments as old-
fashioned looking markers and protectors for roads and
gateways.[20] A herm of this sort found in Pergamon is
identified as a work of Alkamenes, the pupil of Pheidias,
by its inscription [191]. Since the inscription refers to the
work as the Hermes 'before the gates' (*pro pylon*), many

scholars assume it is a copy of the Hermes *Propylaios* seen by Pausanias (1.22.8) outside the Athenian acropolis, even though Pausanias does not say who its sculptor was. Another copy of a herm by Alkamenes, differing in some details from the Pergamon example, has been found in Ephesos. It seems probable that Alkamenes was the creator of at least two Herm types, although whether any of them stood before the Propylaia to the Athenian acropolis is not clear. The Archaic character of this and most other herms, aside from their unique format, stems from the bonnet of corkscrew curls over the forehead and the long strands of hair over the 'shoulders' of the image. Because the preponderance of evidence suggests that Alkamenes was active in the 430s and 420s B.C., the Hermes *Propylaios* cannot be viewed as a 'lingering Archaic' work and must be viewed as, in some sense, Archaistic. Another work by the artist, a triple-bodied image of Hekate which Pausanias (2.30.2) saw on the bastion of the temple of Athena Nike on the Athenian acropolis, may also have been Archaistic, since statues and statuettes of the three-bodied type (which Alkamenes is said to have invented) found in the Athenian agora show Archaistic features.[21]

Is it valid to call all these works 'Archaistic,' and, if so, in what sense? I would propose that there are really three types of Archaism in Greek art and that a distinction between them must be kept in mind in evaluating these and other Archaistic works.[22] First, there is *emblematic Archaism*, the desire to preserve an Archaic form because it is a badge or emblem of an object which one wishes to make recognizable, familiar, and traditional-looking in the eyes of later generations. The Athenian coins mentioned above clearly fall into this category. The officers of the Athenian mint which produced them undoubtedly decided to maintain the same devices that had been used in the Archaic period because sameness connoted stability, not because the Archaic style had an aesthetic appeal for them. Most of the Classical Panathenaic amphorae probably also fall into this category. They retained their old-fashioned look so that people could recognize them for what they were. A second type of Archaism could be called *representational Archaism*, that is, the revival of Archaic forms for the sake of narrative realism. The Archaistic images in Classical relief sculpture and vase painting clearly fall into this category. They are made to look Archaic because that was the way most images really looked, not because the style had, in itself, a particular charm for the artist. And finally, there is the sort of Archaism which we began by looking at, what I call *comprehensive Archaism*, the revival of Archaic forms, or the mannered adaptation of Archaic forms, for aesthetic effect, and their fusion into a coherent style.

Are there any works among the early monuments just described which qualify as examples of comprehensive

Archaism? The coins and most of the Panathenaic amphorae, as indicated, probably do not. In the case of the herms and Hekate of Alkamenes, however, the case is more difficult to judge. Were they examples of emblematic Archaism (i.e., they were given an Archaic form because that was the way herms and Hekate figures, by definition, were supposed to look), or did Alkamenes deliberately revive the Archaic style in order to achieve a particular effect? It has been argued that the Hermes *Propylaios* represents a 'simple formalization' of an Archaic type for 'hieratic reasons' and is not therefore really Archaistic.[23] It is more difficult to apply this argument to the Hekate, however, since Pausanias specifically says that Alkamenes was the inventor of its particular form. It seems reasonable to conclude, as Harrison has, that in the Hekate, Alkamenes 'created a conspicuous work of art containing forms that were used over and over again in what we call archaistic art.'[24]

If Alkamenes was one of the first artists to employ comprehensive Archaism, it would seem that his works were sporadic examples of the style, without immediate far-reaching influence.[25] We are thus still faced with the question of when a continuous, widespread Archaistic style began. Schmidt argued in 1922 that it began around the middle of the fourth century B.C. and that the monuments which most obviously indicate it are the new style of Panathenaic amphorae [190].[26] Becatti and Havelock have attacked Schmidt's conclusion about these amphorae by arguing that the swallow-tails on Athena's peplos and shawl are simply playful mannerisms created by painters who wanted to give a certain contemporary flourish to a worn-out, artificially preserved design.[27] Since some of the Athena figures on the late amphorae represent a distinctly new design and not simply an elaboration on an Archaic emblem, this criticism is not convincing. Schmidt was surely right when he saw a real Archaistic style in these late Panathenaic amphorae.

When one focuses specifically on sculpture, however, which was the principal medium for Archaistic art in Antiquity, Becatti and Havelock make a strong case for their view that comprehensive Archaism was principally a product of the third century B.C. They argue convincingly that late examples of the Archaistic style, like the Kallimachos relief [187], derive ultimately from, and are stereotyped mechanical reworkings of, a group of third-century reliefs, like the Louvre–Freiburg type [192], in which familiar Archaistic mannerisms like the tip-toe stance and projecting swallow-tail folds are applied to figures and scenes that otherwise have the spatial freedom and depth of Hellenistic art. They also make a strong case for the fact that most of the Archaistic reliefs that Schmidt assigned to the fourth century B.C., most notably a four-sided base in the Acropolis Museum in Athens, are really considerably later in date.[28] In fact, only two well-preserved Archaistic reliefs, a base from

192 The 'Louvre–Freiburg relief,' Dionysos and the Seasons. Marble. Incomplete Roman copy
of an original of the 3rd century B.C. Paris, Louvre. H. 0.32 m.

Epidauros and the frieze of dancers from the Propylon to
the Temenos at Samothrace, continue to be defended as
fourth-century works, and even the case for them has
been disputed.[29]

In the final analysis, it is probably not of much conse-
quence whether comprehensive Archaism began in the
late fourth century B.C. or in the early third. There is not
much point in being dogmatic about a borderline when a
borderline scarcely exists. By and large it seems fair to say
that, although sporadic examples of genuine Archaism
did occur in the Classical period, the mainstream of
Archaistic relief sculpture was a creation of the Hellen-
istic period.

The same disputes about date and classification that
have arisen about Archaistic relief sculpture also apply to
free-standing Archaistic sculpture. There is little doubt
that Archaistic statues, like the works of Alkamenes
alluded to above, existed in the fifth century B.C., but
what their purpose was and how widespread they were is
disputable. Heinrich Bulle, for example, the author of the
first serious attempt to sum up the development of
Archaistic free-standing sculpture, was willing to ascribe
a substantial number of works, some of them originals
and some of them copies, to the Classical period. Others,
like Becatti, see virtually all of them as Hellenistic or
Roman creations.[30] Rather than go over this disputed
ground again, it will be more useful to look at two

representative Archaistic statues of the late Hellenistic
period, the 'Herculaneum Pallas' [193] and the Artemis
type from Pompeii [194], and see what they tell us about
this genre of Hellenistic Archaism.

The Herculaneum Pallas [193] is an Athena *Pro-
machos* type in the tradition of the Athenas on
Panathenaic amphorae. There is evidence that armed
Athenas, either striding, as in the *Promachos* type, or
standing with legs together in the manner of an Archaic
cult image (the 'Palladion' type), formed one of the
earliest subjects for Archaism. In addition to the figures
on the Panathenaic amphorae there are, for example, an
Early Classical bronze statuette of the *Promachos* type
from the Athenian acropolis (dedicated by one Meleso)
and also an Athena on a red-figured *oinochoe* of the late
fifth century B.C. from the Athenian agora.[31] It has also
been suggested that the 'Palladion' which the Athenian
political leader Nikias dedicated on Delos, probably in
the 420s B.C., was an Archaistic image (Plutarch, *Nikias*
3).[32] The Pallas from Herculaneum stands, in other
words, toward the end of a long tradition. It is probably a
copy of an original Archaistic work of the second century
B.C. A head of the same type found in the Athenian agora
may, in fact, be from the original, which Harrison plaus-
ibly suggests was a votive statue dedicated on the
Athenian acropolis.[33] Like many Archaistic statues the
Pallas is an amalgam of stylistic features. The long

193 Archaistic Athena, the 'Herculaneum Pallas.' Marble. Probably a Roman copy of an original of the 2nd century B.C. Naples, Archaeological Museum. H. 2.00 m.

194 Archaistic Artemis from Pompeii. Marble. 1st century B.C. Naples, Archaeological Museum. H. 1.16 m.

vertical folds of its Ionic himation are a Hellenistic simplification of an Archaic pattern, but other details, like the sleeves, are based on Early Classical sculpture, and the face is purely neoclassical in the tradition of Euboulides (cf. [169]).

If the Pallas Herculaneum is an Archaistic product of the earlier, Athenian phase of neo-Attic sculpture, the Artemis from Pompeii [194] represents its second, Roman stage.

Like the Pallas it is eclectic, but its eclecticism has become more unified and 'correct.' Its face, for example, is given an Archaic smile and the curls and braid of the hair evoke Archaic texture and form. In many ways it is an Archaistic analogue of the Stephanos Youth [183]. Two other replicas of this striding Artemis exist, one in Florence and one in Venice.[34] Whether all three statues should be considered copies of an 'original' or whether,

again like the Stephanos Youth, they are simply variants of an eclectic type which could be produced for a variety of contexts, remains an open question.[35]

Perhaps the most significant feature about Archaistic free-standing sculptures when compared to their counterparts in relief is that they seem less formulaic and purely decorative. Some of them have a genuine air of solemnity which suggests that the sculptors who made them were sincerely trying to recapture some of the hallowed, awe-inspiring quality of early cult images and votives. The original of the Herculaneum Pallas, as noted, may have been a serious votive offering, and it has recently been shown that the striding Artemis was actually used as a cult-image in a substantial shrine in one of the houses of Pompeii.[36] They represent, perhaps, the most serious attempt of the retrospective artists of the Hellenistic period to capture the past.

9

Pictorial illusion and narration

Of all the surviving examples of Hellenistic painting, the most original in conception is the cycle known as the 'Odyssey landscapes' [195–200], now in the Vatican. These frescoes were found in 1848 in a house on the Esquiline hill in Rome, where they were incorporated into a system of wall-decoration (the Romano-Campanian 'second style') which can be dated with reasonable confidence to about the middle of the first century B.C. The cycle originally consisted of eleven panels depicting episodes in the wanderings of Odysseus separated by illusionistically painted pilasters. Of these, seven are well enough preserved to permit close analysis: panels 2–5 depicting the land of the Laestrygonians [195–197]; panel 6 depicting the palace of Circe [198]; and panels 8 and 9, showing Odysseus's arrival and sacrifice in the Underworld [199–200].[1] To modern eyes, conditioned by centuries of landscape painting since the Renaissance, the Odyssey landscapes may not at first seem very remarkable; yet, when viewed against the background of the ancient painting which had preceded them, they are epoch-making. For the first time in ancient painting the human figure is dominated by, at times almost enveloped and lost in, the immensity of nature. The human body and human activity are presented here not as the sole or primary object of artistic interest, as they were for centuries in earlier Greek painting, but rather as one facet of a vast cosmos in which atmosphere, misty vistas, the broad horizon of the ocean, rocks, hills, trees, and springs are essential and enduring elements. Further, as human figures are inserted into this cosmos, they begin to absorb some of its character and become themselves shadowy, fluid, and impressionistic. Even in the scene before the house of Circe, where the environment is more architectural than natural, a sense of enveloping vastness, conveyed by the sky overhead, the trees in the courtyard, and the shadowy hill to the left, impresses itself on the viewer's senses. Circe and Odysseus become almost incidental, and their conflict is almost forgotten.

Another remarkable fact about these paintings is that, were it not for the painted pilasters which frame the scenes but really seem to be artificially superimposed on them, the landscape could be read as a shifting but continuous terrain against which a set of characters, Odysseus and his men, periodically reappear to mark progressive stages in a continuing narrative. In the scene before the house of Circe, in fact, it seems that Odysseus and the sorceress appear twice against a single background setting. This form of narration, commonly referred to simply as 'continuous narrative,' anticipates familiar monuments of the Roman Empire, the frieze of the Column of Trajan, for example, and certain mythological reliefs on sarcophagi. Its Greek precedents, as will be discussed, are rare.

Most viewers who contemplate these remarkable paintings in the Vatican would probably be content to luxuriate in their soft, evocative, mysteriously poignant hues and to accept them for what they are – early examples of impressionistic mythological landscape paintings of the first century B.C. Scholars, however, are seldom content with such straightforward experiences, and a number of controversies, as usual, have come to hover around the Odyssey landscapes. For various technical reasons some feel that these frescoes must be looked on as copies selected from a more extensive original. It has been noted that when the paintings were in their original position in the house on the Esquiline they would have been viewed from a low vantage point, and yet the individual scenes are designed to give the illusion of being seen from a high vantage point. This suggests that the scenes were not originally conceived for the house in which they were found. There is also the fact that the selection of episodes from Odysseus's wanderings seems strangely out of balance. Four of the eleven panels deal with the Laestrygonian episodes while other episodes do not appear at all. This might be taken to indicate that the paintings from the Esquiline are excerpts from a more extensive cycle which depicted all the incidents in the wanderings of Odysseus.

Assuming, then, that the Odyssey landscapes are in some sense 'copies' of an earlier original, some scholars have proposed that their prototype must be a Hellenistic

195 Odyssey landscapes. Panel 2, Odysseus in the land of the Laestrygonians. *Ca.* 50 B.C. Rome, Vatican Museums. H. 1.16 m.

work and that their style developed in one of the great centers of Hellenistic art.[2] Others have contested this approach and argued that the Odyssey landscapes should be viewed as fundamentally Roman rather than Greek-Hellenistic creations.[3] They point out that the distinctive features of these paintings – misty atmosphere, impressionistically rendered landscape features, and diminutive human figures – abound in Romano-Campanian painting of the late first century B.C. and of the first century A.C. The very sensitivity which made the creation of such scenes possible, it can be argued, is an Italic phenomenon. It stems from a wistful, bucolic view of nature among the urbanized intellectuals of Roman Italy and is a reflection of the same impulse that led to the creation of fanciful gardens and grottoes in the houses of Pompeii and Herculaneum. Which of these views is right? Are the Odyssey landscapes basically 'Greek' or 'Roman'? And is the question of whether they are Greek or Roman really a meaningful one? Before attempting to answer these questions and assign the Odyssey landscapes to their proper

historical context, we must take a look at how pictorial space and the human figure's relation to it were dealt with in earlier Greek painting, mosaics, and pictorial reliefs.

Our understanding of how space and the natural environment were dealt with in Classical Greek painting is derived primarily from Greek vase painting and literary sources.[4] In Classical, as in Archaic, vase painting, space is for the most part neutral and designs are dominated, often to the exclusion of all else, by the human figure. Occasionally a column, a tree, a fountain, or another isolated object will be included to suggest, in a shorthand way, a setting, but such settings are never used to create an 'atmosphere' and are not allowed to detract from the primacy of the human figures.

Representations on painted vases were, of course, limited by, or at least controlled by, the demands of that medium (the artist's principal challenge was to decorate the curving surfaces of a hard object and not to create an illusionistic 'window'). An interest among some painters in creating a more complex pictorial space, however, is

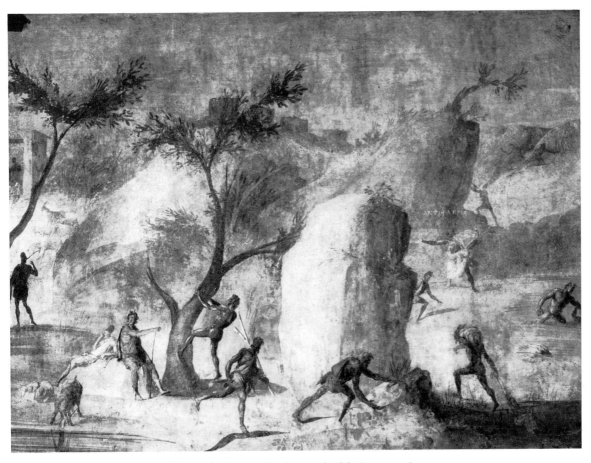

196 Odyssey landscapes. Panel 3, attack of the Laestrygonians.

attested by literary sources and by the evidence of a few Italian tomb paintings of the late sixth and early fifth centuries B.C. Pausanias's descriptions of the frescoes of Polygnotos of Thasos (active *ca.* 470–450 B.C.) clearly indicate that Polygnotos and a few of his contemporaries developed a pictorial terrain, probably with a horizon line, and filled it with mythological or historical characters. Exactly what the relationship between these figures and the terrain was like is impossible to state with any confidence, but if, as has often been thought, the well-known 'Niobid Krater' in the Louvre is a reflection of the Polygnotan style, Polygnotos's scenes were dominated by human figures, and the space which the figures occupied was unobtrusively conventional. Atmosphere and depth continued to be more symbolic than apparent.

The same may be said of the landscape scenes from the Etruscan Tomb of Hunting and Fishing at Tarquinia (*ca.* 510 B.C.) and the Tomb of the Diver from Paestum (*ca.* 480 B.C.). What makes these frescoes unusual is that the human figures in them are relatively small when measured against the total extent of the pictorial field. In other respects their pictorial space is not markedly different from what one finds in Greek vase paintings. Their spiny trees, rocks, and water are done in a kind of conventional shorthand and are all on the surface of the pictorial plane. The extent to which these two tombs reflect 'normal' Greek painting in the fifth century B.C. is also problematical. The Etruscan tomb may well be influenced by Egyptian or other Near Eastern prototypes, and the Paestan tomb was perhaps patterned after Etruscan models.

In the second half of the fifth century B.C. literary sources make it clear that there was considerable interest in the development of pictorial space and that the lead in this exploration was taken by Athenian painters who had the task of painting stage settings on wooden panels (*pinakes*) for performances in the Greek theater. The foremost among these artists was a painter named Agatharchos who was remembered in later centuries as the inventor of pictorial perspective.[5] (The word, signifi-

197 Odyssey landscapes. Panel 5, Odysseus's ship escaping from the land of the Laestrygonians.

cantly enough, that ultimately came to be used for perspective was *skenographia*, which literally means 'scene painting.') Exactly what the stage panels created by Agatharchos and his contemporaries were like is a matter for conjecture, but it seems more likely, judging by what we can learn about early Greek perspective from vase painting, that they depicted architectural façades, rendered in perspective, rather than a feeling of nature and atmosphere.

Although a system for the perspectival rendering of objects in space was an invention of Greek painters of the fifth century, it would seem that another nearly contemporary innovation, that of conveying a sense of mass through the modulation of light and shade, was more appealing to the Greeks, perhaps because it did not require a de-emphasis of the human figure in relation to its surroundings. The Greek term for this technique was *skiagraphia*, literally 'shadow painting,' normally translated simply as 'shading.' *Skiagraphia* was first developed in the later fifth century B.C. by an Athenian painter named Apollodoros and was increasingly refined

by a succession of famous artists who worked in the fourth century B.C., beginning with Zeuxis and ending with Apelles and Protogenes. Except for a few hints on Attic white-ground lekythoi of the fifth century B.C., there is no archaeological evidence documenting the early stages of the evolution of this technique, but the discovery of a series of remarkable Macedonian painted tombs in recent years now makes it possible to appreciate something of the quality of Classical and early Hellenistic Greek painting in its most mature (from a technical point of view) phase and also perhaps to make conjectures about the course of its evolution.

From the standpoint of technical proficiency, the finest paintings from these Macedonian tombs are a series of figures inserted in panels (approximately 0.19 m high) on the complex façade of a large tomb at Lefkadia [201] (see p. 240). These figures, placed above an illusory dado which ran between the engaged columns on the lower section of the façade, depicted (reading from left to right) the deceased Macedonian warrior, dressed in military garb, who was buried in the tomb; Hermes in his role as

198 Odyssey landscapes. Panel 6, the palace of Circe.

199 Odyssey landscapes. Panel 8 (left), Odysseus at the entrance to the Underworld.

200 Odyssey landscapes. Panel 9 (right), scenes in the Underworld.

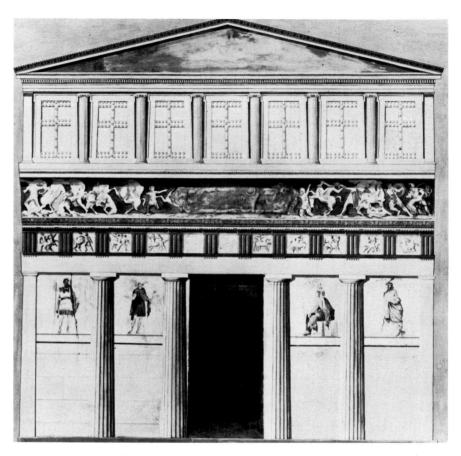

201 Lefkadia. Façade of Macedonian tomb. Drawing. *Ca.* 300 B.C. *In situ*. H. of façade 8.20 m.

Psychopompos, the guide of souls to the underworld; and two of the judges of the dead: Aiakos seated, and Rhadymanthos, standing and leaning on a staff [202]. Lefkadia may be the ancient Mieza where Aristotle tutored the young Alexander, and the eschatology of the panels perhaps represents the influence of Plato (cf. *Apology* 41A, where Socrates anticipates meeting the judges of the dead) via Aristotle. The technique by which a sense of three-dimensional mass in these figures has been achieved is a sophisticated one. As an expert in the subject has expressed it,

A dark is not just an area of darker pink or brown flesh tones; it has blues and greens running through a complex system of overlapping tones in which every individual stroke is a slightly different color . . . Accents of dark . . . are at the same time accents of color, representing interesting and sometimes unpredictable changes of hue of the kind that reveals a truly sophisticated color sense. The aesthetic of contour, of continuous outline, is gone, and the forms turn easily into depth with an atmosphere of space.[6]

The date of the tomb at Lefkadia, based on its architectural forms and other evidence, is thought to be *ca.* 300

B.C.[7] Its paintings form an interesting contrast with another approximately contemporary but much less sophisticated tomb at Kazanlak in Bulgaria (ancient Thrace). The principal scene in this tomb is painted on the conical dome of a circular chamber measuring 2.85 m in diameter and depicts a man and a woman seated at a banquet table attended by a retinue of standing figures including servants, musicians, warriors, and grooms with horses [203]. These figures have been interpreted as representing some sort of funereal or wedding banquet connected with the lives or deaths of a Thracian chieftain and his wife. The painters were probably itinerant Greek journeymen of modest abilities. In the Kazanlak paintings some of the technique that one associates with Greek vase painting survives. The figures are surrounded by strong outlines and their external contours remain of great importance. Dark lines which are intended to give a sense of texture and mass to drapery and flesh are always added in the same basic color as the drapery and flesh and tend to follow the outer contours. Additional shading is sometimes added by hatching in parallel lines. It seems probable that the technique used at Kazanlak was old-

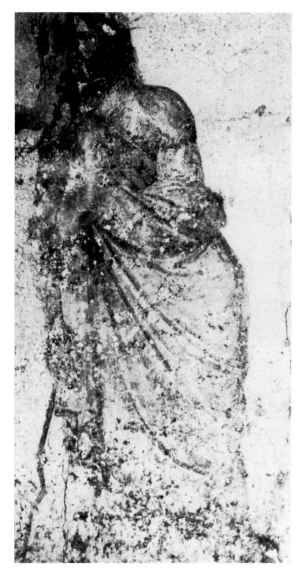

202 Lefkadia. Macedonian tomb. Figure of Rhadymanthos.
H. approx. 1.15 m.

fashioned for its time and may preserve the technique of the first generation of Greek painters who cultivated *skiagraphia*.

Almost forgotten amid the gold and glitter that accompanied the discovery of an unplundered Macedonian royal tomb at Vergina in 1976 (the tomb at first identified as that of Philip II, but now usually referred to more soberly as 'Vergina Tomb II') was a second tomb, 'Vergina Tomb I,' which, although robbed in Antiquity, still has well-preserved paintings on its walls. On the north wall of this tomb, measuring 1 m high by 3 m long, is a scene depicting Pluto abducting Persephone which is, from an art historian's point of view, one of the great archaeological discoveries of the twen-

tieth century [204].[8] The figures combine the dramatic bravura of Bernini's sculpture of the same subject with a remarkable, rapid brushwork technique which is reminiscent of G. B. Tiepolo and contributes to the sense of fleeting agitation that pervades the scene. A determined, ominous Pluto lifts the struggling, panic-stricken Persephone onto his chariot. To the right one of Persephone's attendants gestures in anguish and despair, while Hermes, to the left of the chariot, begins to guide it to Hades. From a technical point of view the Vergina painting would seem to lie somewhere between the styles of Kazanlak and Lefkadia. Its artist made considerable use of hatching with parallel lines and, judging by the publication available, developed the texture of drapery through different shades of the same color; on the other hand he avoids the use of outlines, and the free, 'impressionistic-painterly'[9] quality of brushwork is handled with a dazzling virtuosity which surpasses anything at Lefkadia. For the first time among the relatively sparse monuments of large-scale ancient painting one feels that one is looking at the inspired strokes of a really brilliant artist. Who this artist was we are unlikely ever to know. The excavators of the tomb suggest that he might have been Nikomachos, the son of Aristeides, who painted a famous version of the rape of Persephone (eventually taken to Rome and exhibited on the Capitoline) and who was famed for the rapidity of his brush technique (Pliny, *NH* 35.108–10). It seems unlikely that a painter of Nikomachos's standing would have come to Macedonia on relatively short notice to paint the walls of a relatively small tomb, but it is quite possible that these tomb paintings do betray the influence of Nikomachos's style. The excavators suggest a date of *ca.* 340 B.C., which does seem to fit the period when the artist was active.

Assuming that these tomb paintings give us a fairly accurate indication of the aims of Classical and early Hellenistic painting as a whole, it is clear that the most original achievement by the artists of this era was the discovery of the techniques for conveying the mass and texture of the figures and objects which they depicted. They were concerned with convincing the viewer that the objects in their paintings existed in three-dimensional space but, having achieved that effect, they had relatively little interest in that space in itself. In this sense, their work was not radically different in conception from that of earlier Greek vase painting. Human figures are all-important, and a sense of space is conveyed only to the extent necessary to give a context for the figures. This conclusion seems to hold true not only for single-figure panels like those at Lefkadia, where one would perhaps expect the depiction of spatial context to be minimal, but also for large scenes with many figures. The Alexander Mosaic, for example [2], which is assumed to be a copy of a painting of the late fourth century B.C. (see p. 45),

203 Kazanlak. Scene in dome of tomb. *Ca.* 300 B.C. Diam. of dome 2.65 m.

shows remarkable virtuosity in conveying a sense of mass and reflected light (e.g. the foreshortened horse in the center of the scene, the black horse to the far right, or the fallen warrior looking at his own reflection in a shield), is a masterpiece of dramatic narrative, and served as a provocative political symbol for its time; but the space in which the battle that it depicts takes place is held to the minimum required for coherency – a shallow, virtually unarticulated stage-like ground characterized by one barren tree and a few objects in the foreground. The evidence of the Alexander Mosaic must now be supplemented by the hunt scene depicted on the attic of the façade of Tomb II at Vergina [205] (datable from 336 to 317 B.C., depending upon whose tomb it is thought to be (see bibliography)). Because the condition of this long (5.56 x 1.16 m) frieze is not good and because it thus far has been published in only a sketchy fashion, it is difficult to draw definitive conclusions about it. Several hunters, some mounted and some on foot, along with their dogs, are depicted moving through a 'forest' of three barren trees to attack a lion and what seems to be a boar. Although admittedly more elaborate than that of any other known contemporary painting, the pictorial space in which the Vergina hunt takes place is still shallow and

dominated by its human inhabitants. Its topography gives a context to the hunt but is not a focus of interest in itself.

There is, in short, little in Classical or early Hellenistic painting which anticipates the art of the Odyssey land-scapes. The paintings of the Macedonian tombs stand in an anthropocentric tradition of representation in which large human figures dominate a minimal and unatmos-pheric spatial stage. This is not only the tradition of earlier Greek art but it can be seen as the dominant tradition in later Hellenistic and early Romano-Campanian painting as well. It is the tradition, for example, of Etruscan tomb painting of the Hellenistic period [206], of the painted stelai from Demetrias (Volos) [207], of Hellenistic painted pottery such as Centuripe ware [208], and of most of the walls of the Pompeiian 'Second Style,' such as the famous frieze from the Villa of the Mysteries at Pompeii [209] or the paint-ings from the villa at Boscoreale.

In the Etruscan tomb of Typhon at Tarquinia (*ca.* 150 B.C.), for example, the figure of the giant which gives the tomb its name offers a striking example of modelling through shading and borrows some of the pathos of high Pergamene art, but it floats in an essentially neutral space

204 Vergina, Tomb I. Abduction of Persephone by Pluto. *Ca.* 340–330 B.C. *In situ.* H. approx. 1.00 m.

205 Vergina, Tomb II. *Ca.* 336–317 B.C. Hunt scene on the façade and detail (right). *In situ.* H. 1.16 m.

[206]. This is also true of most of the figures on the painted grave stelai from Demetrias in Thessaly, which date for the most part from the late third century B.C. They have survived because they were built into fortification walls constructed either by Philip V or Perseus during the period of Macedonia's confrontation with the Romans (see pp. 150–1). The iconography of most of the stelai is in the tradition of earlier Greek sculptured grave stelai: that is, they show one dominant figure, the deceased, standing or seated, sometimes in the presence of a servant, child, or relative but also often alone [207]. The most interesting and remarkable of these monuments, the poignant stele of Hediste [3] which has already been discussed (see p. 4), is also the most anomalous. Here the artist clearly took some pains to create a realistic spatial setting which would enhance the dramatic effect of the subject, and, in diminishing the size of his figures in relation to the total pictorial space, he seems to be rebelling against the limitations of an inherited tradition. Yet even here the pictorial space, consisting of a chamber, a door, and an outer room of vague, indeterminable dimensions, remains very shallow.

The ornate vessels with polychrome painted decoration from Centuripe (Latin Centuripae, Greek Kentoripa) in the mountains southwest of Catania in Sicily [208] preserve a style which anticipates, if it does not

206 Tarquinia, Tomb of Typhon. *Ca.* 150 B.C. *In situ.* H. approx. 1.50 m.

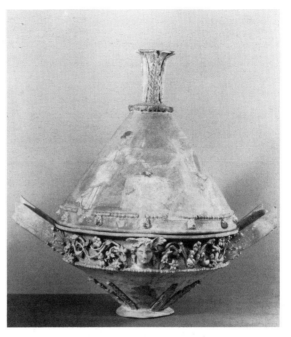

208 Painted terracotta vase from Centuripe. Date disputed, probably late 2nd or 1st century B.C. New York, Metropolitan Museum. H. 0.615 m.

207 Stele of Archidike from Volos. *Ca.* 200 B.C. Volos, Archaeological Museum. H. 1.105 m.

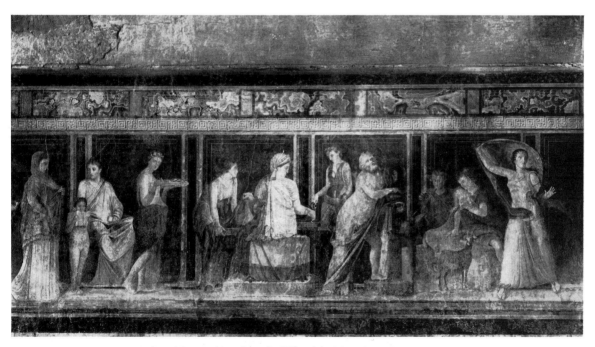

209 Mystery frieze from the Villa of the Mysteries at Pompeii. *Ca.* 50 B.C. *In situ.* H. 1.62 m.

210 Votive relief with sacrificial scene. Marble. Probably middle or late 2nd century B.C. Munich, Glyptothek. H. 0.79 m.

parallel, the style of the large-figure friezes of the Pompeiian Second Style. Their elegantly attired women and occasional Dionysiac figures set against a reddish background evoke a quiet domestic world. Perhaps they are all nuptial scenes of some sort. There is little direct evidence from the excavations to date the vessels, and they have been assigned anywhere from the third to the first century B.C. A later rather than an earlier date seems most likely. Probably they represent a miniature version of a large mural style which is best preserved in the Villa of the Mysteries [209]. In all of them, stately, statuesque figures dominate the pictorial plane and occupy a shallow stage set against an opaque background.

The Odyssey landscapes are clearly not a final evolutionary product of this mainstream in Greek painting, since the mainstream flows beside them and beyond them. Are there then any Greek precedents at all for the style of painting in which series of tiny figures are set in a vast atmospheric landscape and are used to narrate a continuing story? There are, but the features of these precedents are diverse and have to be fused in order to bring one to the stage found in the Odyssey landscapes. Four monuments, or groups of monuments, are of particular importance: (1) a group of pictorial reliefs, first studied by Theodor Schreiber, and labelled by him simply as 'Hellenistic reliefs,' (*Die hellenistische Reliefbilder*),

(2) the Telephos frieze from the Altar of Zeus at Pergamon, (3) the Nile Mosaic from the Temple of Fortuna at Praeneste, and (4) certain mold-made reliefs on bowls and tablets, most notably the 'Homeric bowls,' which may be related to a tradition of illustrated manuscripts.

In a series of publications between 1888 and 1896 (see bibliography) Schreiber assembled a corpus of relief sculptures which depicted human and animal figures set in a landscape of trees, rocks, pools, and, occasionally, buildings. In some of them figures were set above one another to suggest a receding landscape. In others they moved along a traditional base line, but a sense of spatial depth and atmosphere was created by leaving an unusual amount of open relief space above the heads of the figures. Schreiber saw these reliefs as pictorial counterparts of the bucolic poetry of Theokritos and others, assumed that they were created under Alexandrian influence, and assigned their origin to the third century B.C. His conviction that all of these reliefs were Hellenistic was challenged, even in his own time, and more recent scholars are virtually unanimous in the conclusion that many of the reliefs in Schreiber's collection – the Grimani reliefs in Vienna, for example, which he used as a point of departure, and the reliefs in the Palazzo Spada in Rome – date from the time of the Roman Empire.

196

211 Relief of Dionysos visiting a poet. Marble. Version from the 1st century A.C. of a type
originating in the early 1st century B.C. London, British Museum. H. 0.90 m.

There is, however, a residue of works which still seems datable to the second or first centuries B.C. and which could be viewed in some ways as modest predecessors or contemporary reflections of the spirit of the Odyssey landscapes. Probably the most significant of these is a votive relief in Munich depicting a family offering sacrifice at an altar before two deities [210]. The family, consisting of a man, a woman, and two children, stand behind an altar, shown in three-quarter view in the center. Behind them to the left is a large gnarled tree wrapped with votive fillets. A curtain, probably defining the perimeter of an open-air sanctuary, is attached to the tree and draped behind the two gods. In the distance, behind the tree, is a pillar surmounted by two archaistic statues. To the left, in front of the tree, is another group consisting of two women and two children who are shown on a much smaller scale than that of the figures at the altar. Perhaps they are to be thought of as being seen in the distance, and hence their scale is an attempt at perspectival diminution. The god who sits on a throne decorated with what seems to be a griffin with ram's horns may be Zeus–Osiris and the goddess who leans on a pillar could be Isis. The date of this votive relief has been disputed but it most probably belongs to the mid- or late second century B.C., shortly after the time of the Telephos frieze from Pergamon.[10] Although the Munich relief does not convey the richness of atmosphere of the Odyssey landscapes, it is noteworthy that, when compared to paintings and reliefs of the Classical and early Hellenistic periods, the scale of its figures in relation to the total relief

plane is considerably diminished. The same is true of a popular relief type, known in several copies of what was probably an original of the first century B.C., depicting Dionysos visiting the house of a poet [211]. The intoxicated god, accompanied by a retinue of satyrs, silenoi, and maenads, seems to have entered a courtyard where the poet reclines on a couch with a curtain draped behind him. Immediately behind them a wall and the roof of a low building are visible; behind these is a second large building draped with garlands; and still farther in the distance are what look like a plane tree and a palm tree. The culmination of this tradition in pictorial reliefs in which the human figure is progressively diminished to allow for an increasingly exotic landscape and cityscape is a relief in Munich showing a peasant driving a cow to market [212]. The peasant carries a basket of fruit and a hare tied to a pole; the cow is draped with two trussed-up sheep. They pass before the wall and gate of a rural shrine, with a temple visible behind the wall in the distance. Understood as being even farther away, on a rocky knoll at the upper left, is another small shrine. The branch of a large tree in the courtyard of the nearer shrine grows through its gateway. The top of the wall of this shrine is decorated with tambourines, and in the center it is broken away to reveal an elaborate columnar stand decorated with a torch surmounted by a *liknon* (a winnowing basket connected with various mystery cults). Here the whole ensemble of implements is most probably connected with the cult of Dionysos. The style of this relief is reminiscent of the mythological panels on the *Ara*

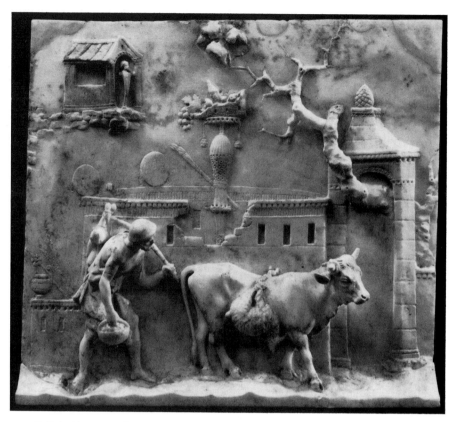

212 Relief with peasant driving a cow to market. Marble. Late 1st century B.C. Munich,
Glyptothek. H. 0.30 m.

Pacis Augustae (13–9 B.C.), and it probably dates to the last third of the first century B.C., just at the point where Hellenistic art merged with that of the Roman Empire.

Probably earlier than the earliest of these reliefs and quite possibly the source of inspiration for them is a work of considerably greater importance, the Telephos frieze from the Altar of Zeus at Pergamon [213]. Although the grandiose and more immediately overwhelming Gigantomachy on the exterior of the altar building has eclipsed it in fame, the Telephos frieze is nevertheless a work of nearly equal importance in the history of Hellenistic art. It ran around the upper section of the inside walls of the altar building behind the Ionic colonnade of its altar court. The frieze is 1.58 m high and its total length is estimated to have been from 80 to 90 m. Only about a third of this total length is now extant. The subject of the frieze was the life of Telephos, a legendary king of Mysia (the area of Pergamon) at the time of the Trojan war, who was adopted as an ancestor by the Attalids, presumably to give their dynasty a respectable pedigree analogous to those claimed by other Hellenistic royal families. Portions of the frieze remain unfinished, and this fact, combined with what may be covert allusions to Attalid political history in the frieze, suggest that it was executed during the latest stages of the building program of Eumenes II.[11] Work on it may have been abandoned at the time of Eumenes' death in 159 B.C. or perhaps at the time of the death of Attalos II in 138 B.C. At any rate, it is to be dated around the middle of the second century B.C.

The story of Telephos must be briefly summarized here because it is the elaborateness of the story told in the Telephos frieze which is one of its most unusual features. Aleos, king of Arcadia, had been warned by an oracle of Apollo that the sons of his daughter Auge would kill his, Aleos's, sons. In an attempt to forestall this fate Aleos made his daughter become a priestess of Athena, with the presumption that, like a Vestal Virgin, she would live a celibate life. Shortly thereafter, however, Herakles paid a visit to the court of Aleos at Arcadia and, as was often the case when Herakles was present, events took their course and Auge conceived by him a child named Telephos. When Aleos discovered the existence of the child, he was enraged and proceeded to banish Auge from Arcadia by setting her adrift in a raft in the Aegean. The child was exposed on a neighboring mountain with the expectation that he would die. Auge's raft drifted across the Aegean

North wall

Auge establishes | Landing of | The building of the raft | The exposure | Herakles | Herakles's | Aleos consults
the cult of | the raft | | of Telephos | espies | reception | the oracle
Athena in | | | | Auge | by Aleos
Pergamon

East wall

Telephos wounded | Further scenes | Heloros and Aktaios | Hiera in combat with | Telephos and | Teuthras | Telephos | Telephos is | Telephos lands in Mysia | Herakles
by Achilles | from the battle | fall in battle | the Argives | Auge separated | leads Auge | takes leave | armed | | discovers
| on the Kaikos | | | by the snake | to Telephos | of Auge | by Auge | | Telephos

Telephos is | Telephos among the Argive | Telephos's | Telephos disembarks
greeted by | princes asking to be healed | reception | in Argos
Teuthras | | in Argos

South wall

Telephos on | Founding of a cult | Telephos with the child
his deathbed | in Pergamon | Orestes at the altar

Flight of the
Argives to
the ships

213 Telephos frieze, Altar of Zeus, Pergamon. Diagram. *Ca.* 150 B.C.

and came to rest on the shores of Mysia, where she was graciously received by the local king, Teuthras. With the encouragement of Teuthras she proceeded to establish the cult of Athena in Mysia and became a respected figure in the kingdom. In the meantime the infant Telephos had survived, first by being suckled by a hind or a lioness (versions of the story differ) and then by being discovered by Herakles, who turned him over to a neighboring king for safekeeping. Predictably, when Telephos grew up, he fulfilled Apollo's oracle by slaying the sons of Aleos and then set out to find his mother. His search eventually brought him to Mysia where he too was cordially received by Teuthras. In return for this kindness the young hero gave help to the Mysian king in a war with local enemies, and as a reward for this help Teuthras arranged for Telephos to marry the most esteemed woman of the community, who was, of course, Auge. Before this awkward twist of fate could be fulfilled, however, a serpent sent by Athena intervened and led mother and son to mutual recognition.

Telephos eventually became king of Mysia and faced another difficult trial when the Greeks, during a prelude to the Trojan war, attacked his kingdom. Telephos and his allies fought valiantly against the invaders and had almost succeeded in driving them back to their ships when, for reasons not explained in our sources, Dionysos caused a vine to spring up on the battlefield. Telephos became entangled in it and while thus incapacitated was wounded in the thigh by Achilles. The Greeks left Mysia, but Telephos was left with a wound which would not heal. After considerable suffering he learned from an oracle that only some rust from the spear which had injured him could cure the wound. He therefore journeyed to the palace of Agamemnon at Argos where he confronted an assembly of Greek heroes and asked them to assist in his cure. At first they refused, but when Telephos seized Agamemnon's young son Orestes and threatened to kill him at an altar within the palace, the Greeks relented and Telephos was cured. Thereafter Telephos, grandson of Zeus, son of Herakles, and ancestor of the Attalids, and founder, at some point during his rule, of Pergamon, ruled with the statesman-like dignity which was appropriate to an ancestor of a monarch like Eumenes II.

The most remarkable fact about the Telephos frieze is that it narrated all of these complex events in detail [216–220]. Although the precise subject of some of the surviving panels is open to dispute and varying arrangements have been proposed, the overall character of the frieze is clear enough. It takes the form of a continuous narrative in which the history of Telephos from birth to death is told against a shifting but uninterrupted background consisting of landscape scenes, shrines, battlefields, ships, and architectural interiors. It is, in fact, the first securely datable example of continuous narration in ancient art

and as such the ancestor not only of works like the Odyssey landscapes but of a long line, as already noted, of prominent works of Roman art.

Since continuous narrative is a Hellenistic invention and one of the major contributions of Hellenistic art to the course of ancient art in general, it will be worthwhile to pause for a moment to put the invention into its proper historical perspective. In Classical Greek art artists normally strove to preserve a unity of time and space in narrative scenes. That is, actions were depicted as taking place at a single moment and in a single place. One might be reminded of events in the story preceding or following the incident depicted, but these were not actually shown. In Archaic art the limitations of this general principle were occasionally stretched by conflating one or more episodes of a story into a single scene. On a number of vases depicting the sack of Troy, for example, Neoptolemos is shown brandishing the body of Astyanax, the son of Hector, as if it were a weapon and menacing King Priam with it.[12] This image is best understood as a fusion of two separate incidents, i.e. the slaying of Priam and the hurling of Astyanax from the walls of Troy.[13] There are admittedly some gray areas in which it is difficult to determine whether Archaic and Classical artists were consciously violating the unity of time and space or not. Did the Kleophrades Painter view all the episodes in the sack of Troy on his great Vivenzio hydria in Naples as taking place at the same time?[14] Or, on various vases depicting the labors of Herakles or the deeds of Theseus did the artists think of the various scenes as successive stages in a continuing narrative? Or was each scene simply thought of as an isolated, independent image? Even on so familiar a monument as the frieze of the Parthenon, there is some doubt. Some view the various parts of the frieze as successive stages in a single procession; others feel that time was not really a factor in the designer's mind.[15]

Allowing for these gray areas, however, there is no precedent in Classical Greek art for the practice which arose in the Hellenistic period of dissecting even individual, limited episodes of a story into successive stages and repeating its characters several times in a continuous pictorial plane, thus creating series of snapshots, so to speak, which have a unity of time and space within themselves but which must be viewed as a group in order for their meaning to be completely understood. How did this continuous or cyclic method of narration come about, and exactly where and when? We may never know the answers for sure, but in addition to the Telephos frieze there is another group of monuments from the Hellenistic period which help us to make an educated guess. These are the 'Homeric bowls,' a sub-category of the terracotta mold-made bowls which are conventionally labelled 'Megarian' (see p. 256). The distinctive feature of these bowls is their decoration in

a

b

214 Homeric bowl with scenes from the *Odyssey* in relief. *Ca.* 175–125 B.C. East Berlin, Staatliche Museen. View (a) and drawing (b). H. 0.073 m.

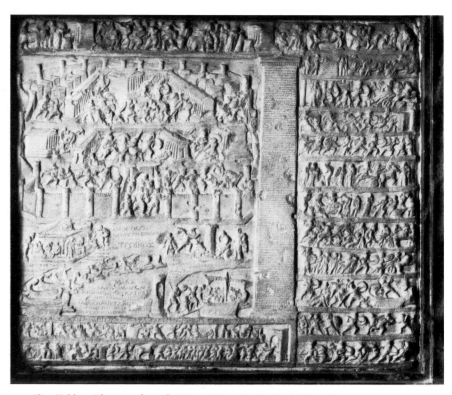

215 Iliac Tablet with scenes from the Trojan War. Marble. Probably early 1st century A.C.
Rome, Capitoline Museum. H. 0.25 m.

relief with scenes illustrating episodes from Greek epic poetry and drama. About sixty exist, and most if not all of them seem to come from Boeotia. Slightly more than half of those that survive have illustrations from the *Iliad*, the *Odyssey*, and the large lost poems of the 'epic cycle.' The remainder show scenes from the plays of the great Classical dramatists, most often those of Euripides. Although the date of the 'Homeric bowls' (as distinct from the entire corpus of Megarian bowls) has been disputed, the most authoritative study of them makes a strong case for assigning them all to the period between *ca.* 175 and 125 B.C., approximately contemporary with the Telephos frieze.[16]

As a typical example of these bowls we may look at an example in Berlin which illustrates episodes from Odysseus's fight with the suitors as described in the 22nd book of the *Odyssey* [214a, b]. On the left Odysseus's allies, the swineherd Eumaios and the cowherd Philoitios, are seen tying up the treacherous goatherd Melanthios; in the center Odysseus and Telemachos, accompanied by Athena, who has taken the form of Mentor, face the suitors in the great hall of the palace; and on the right Eumaios and Philoitios hang the bound Melanthios from the rafters of the palace (*Odyssey* 22.178–85). In a single

pictorial plane, as on the Telephos frieze (but here, of course, on a much humbler scale) a story is told, step by step, through a series of scenes in which one or more figures (in this case Eumaios and Philoitios) are repeated.[17] That the decoration of the bowl was designed to illustrate the actual text of the *Odyssey* is beyond doubt, since, in the background, there are inscriptions giving some of the relevant verses from Homer.

Related to the Homeric bowls and also of considerable importance in any general discussion of the origins of continuous narrative is a group of small marble reliefs generally known as *Tabulae Iliacae* or 'Iliac Tablets.' Like the bowls, they illustrate scenes from epic accompanied by the relevant texts. Although none of the surviving examples can be proved to be Hellenistic, their similarity to the Homeric bowls suggests that they carry on a Hellenistic tradition of illustration. (They are difficult to date, but most probably belong to the first century A.C.)[18] The most elaborate of the Iliac Tablets, in fact the example which gave the genre its name, is one in the Museo Capitolino in Rome depicting different episodes in the Trojan war and illustrating verses on this theme, as an inscription states, from the *Iliou Persis*, from a poem of Stesichoros, from the *Iliad*, and from the largely lost

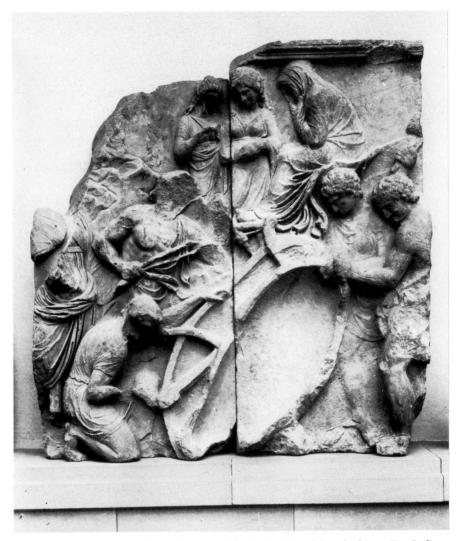

216 Telephos frieze, Altar of Zeus, Pergamon. Marble. Building of the raft of Auge. East Berlin, Staatliche Museen. H. 1.58 m.

Aethiopis of Arktinos and *Little Iliad* of Lesches [215]. At the top of the tablet to the left are scenes from the first book of the *Iliad* depicting the plague sent by Apollo and the quarrel of Achilles and Agamemnon. The figures in the narrative are identified by inscriptions beneath them. Running down the right hand side of the tablet are scenes from books *nu* through *omega* of the *Iliad*. To the left of these scenes is a densely inscribed stele-like panel which contains an index to the contents of books *eta* through *omega* (with a few omissions, apparently an oversight). This panel was probably balanced by another one on the left (where the tablet is now incomplete) itemizing the early books of the *Iliad*. In the center of the tablet the main scene depicts the sack of Troy according to Stesichoros. The city is depicted from a bird's eye view,

and within its walls familiar episodes – the Trojan horse, the slaying of Priam, etc. – are visible. Continuous narration, involving the repetition in at least one case of the same figure, is clearly employed: in the lower left corner of the scene Aeneas, identified by inscription, receives the sacred tokens which he will bear from Troy to Italy; again, before the gate, he is seen with his son Ascanius being led out of the city by Hermes; and finally in the section below (outside) the city walls, in the lower right, he sails from Troy. In this lower section, one also sees the Trojan women mourning at the tomb of Hector, the slaying of Polyxena, and the beached Achaean ships. Finally the two friezes at the bottom of the tablet depict scenes from the poems of Arktinos and Lesches. Just above these friezes is an inscription identifying the artist

or scholar who prepared the panel. His name is incomplete but was probably Theodoros. The tablet's purpose, as the inscription states, was a didactic one: to teach the order and content, within their proper mythological contexts, of the Homeric poems.

How did the continuous narrative or cyclic style employed on these disparate monuments come into being? Can we point to a single type of Hellenistic monument or institution which provided the impetus for its creation? The most likely answer is provided by one of the most eminent authorities on the question, Kurt Weitzmann:

What medium, then, actually could comprehend the enormous amounts of scenes of a fully illustrated Homer and at the same time easily be available to copyists of very disparate branches of art? In our opinion the only medium which can fulfill both requirements is the *illustrated papyrus roll* . . . If, therefore the papyrus roll can be considered as the ideal medium for the painter to develop his narrative and illustrative talents and at the same time as the only medium which could physically provide the space for the nearly unlimited number of single scenes, then it

seems only logical to conclude that the *cyclic method* itself is not only appropriate for the papyrus roll, but actually was invented for it.[19]

Since the remains of illustrated papyrus rolls from the Hellenistic period are so scanty, some have objected to this proposal,[20] but the remains of texts on the Homeric bowls and the close correlation of their scenes with a fixed number of verses (about 25 lines per picture, as if they were designed to be placed above standard columns of text) makes the idea persuasive.

The immediate models for the Homeric bowls, Ulrich Hausmann has suggested, were expensive silver bowls produced in Alexandria for the edification and pleasure of the Ptolemaic court.[21] (On Ptolemaic silver bowls and related works, see p. 256.) The models, in turn, for the illustrations on these silver bowls, it seems likely were illustrated scrolls which probably began to be produced on a systematic basis in the library of Alexandria in the time of Ptolemy II Philadelphos. To what extent a large sculptural monument like the Telephos frieze is indebted to illustrated scrolls is a more complex question. Whether

217　Telephos frieze. Aleos consulting the oracle; Herakles beholds Auge.

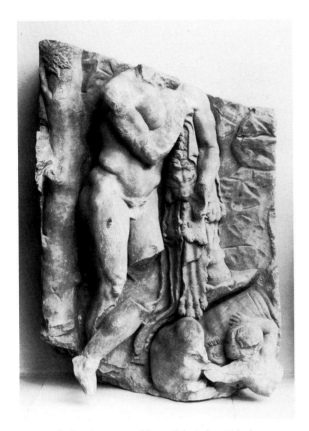

218 Telephos frieze. Herakles and the infant Telephos.

such scrolls sometimes had a running background, analogous to that of the Telephos frieze, or whether they consisted simply of independent scenes connected with each column of text is a disputed point.[22] If the former was the case, the argument for a close association between the Telephos frieze and book illustration becomes stronger. The Altar of Zeus in which the Telephos frieze was placed, it is worth noting, stood near a famous library, and the role of library scholars in planning its sculptural program, as has already been discussed (pp. 101–9), seems certain.

With this lengthy excursus into the narrative style of the Telephos frieze completed, let us return for a moment to its other distinctive feature, its treatment of pictorial space. The frieze is essentially a larger, more complex, and sophisticated exemplar of the style of the 'Hellenistic reliefs' described earlier. Its figures are relatively small in relation to the total pictorial plane, thus creating a sense of atmosphere, and an illusion of depth is created both by the suggestion of a receding terrain and by an apparent perspectival diminution of some figures. The panels most often cited and illustrated as typifying its style are those in which Aleos's men are seen constructing the

raft on which Auge is to be set adrift [216]. In the center foreground we see the raft tipped up on its edge and shown in a foreshortened view as four workmen, tools in hand, work on it. Above and behind this scene are three female figures represented on a smaller scale, as if seated on a hillside in the distance. The shrouded, mournful figure to the right is presumably Auge, attended by two distressed servants. At the far left is the partially preserved figure of a man in stately dress, perhaps Aleos himself. To the far right, on a separate panel which was apparently part of the same scene, a calm, dignified female figure (perhaps a mountain nymph, a personification of the mountain, or a goddess) sits on the hillside, while below a servant seems to stir a fire, probably to heat the caulking for Auge's raft.

The system of spatial representation on the Telephos frieze is essentially a two-tiered one with a lower foreground and an upper background. Within this simple system, however, a rich sense of atmosphere is evoked by the insertion of trees and rocks in landscape settings or of columns, pilasters, altars, and the like in scenes placed within an architectural setting. Particularly effective examples are the panels showing Aleos consulting the oracle in a tree-filled setting [217 left], Herakles being received by Aleos and espying Auge [217 right], Herakles discovering the infant Telephos suckled by a lioness [218], the scene showing Telephos descending the gangplank of a ship, either in Mysia or Argos [219], and the scene in the palace of Argos where Telephos, seated on the right, shows his wound to a Greek prince, while servants come forward with platters laden with refreshments [220].

While the treatment of pictorial space in the Telephos frieze may not be as complex as that of the Odyssey landscapes, it is clearly an important forerunner, linking what were probably rudimentary landscapes in early Hellenistic book illustration (and perhaps also in monumental painting) with the full-blown impressionistic landscapes of Graeco-Roman painting in the late first century B.C. and early first century A.C. Another, somewhat later link in this chain is the great Nilotic mosaic from Praeneste (Palestrina) in Latium, east of Rome [221]. This vast work, measuring 5.25 m high and 6.56 m wide, was set into the floor of an apsidal hall adjacent to the great temple of Fortuna Primigenia at Praeneste. According to Pliny (*NH* 36.189) mosaics (*lithostrata*) made of very small cubes (*tesserae*, see p. 211) became common in Italy in the time of the Dictator Sulla and Sulla himself was responsible for the installation of such a mosaic at Praeneste. Most scholars assume that the Nilotic mosaic is an example of the Sullan pavements mentioned by Pliny and that its date is therefore *ca.* 80 B.C. It was discovered in 1600, transferred to Rome in 1626 and returned to Palestrina in 1640. Since then it has undergone several more transfers and disman-

219 Telephos frieze. Landing of the ship of Telephos in Argos or Mysia.

220 Telephos frieze. Banquet scene.

221 Nilotic mosaic, Praeneste. *Ca.* 80 B.C. Palestrina, Archaeological Museum, Temple of Fortuna. 6.56 x 5.25 m.

tlings. As a result many sections of the mosaic, amounting to perhaps half its total area, are restored. Because the restorations seem to have been based on drawings of the original made by a baroque artist in the seventeenth century[23] the general design of the mosaic, as we now have it, is thought to be in the main reliable, but in evaluating its details one must exercise caution.[24]

The cultural background in which a taste for the sort of exotic subject matter seen on the mosaic came into vogue has already been discussed in an earlier chapter (see p. 147), and the technical characteristics of it and similar mosaics will be discussed in the next chapter. In the present context the importance of the mosaic lies in the way pictorial space is treated in it and how its particular style may have come into being. The arrangement of the Praeneste mosaic is something like that of a tourist map with the river as an undifferentiated background and particular locales set against it in the form of small three-dimensional islands. These islands are rich in depth and atmosphere, and to a greater extent than in any other work prior to the Odyssey landscapes the human figures on them are diminished in scale and dominated by their surroundings. A typical example is the scene in which a group of soldiers seem to be enjoying a banquet in front of a Graeco-Egyptian temple, from the gable of which a large awning has been suspended [222]. Behind the temple, in the distance, is an Egyptian tower and some verdant tropical foliage.

This subtle and evocative combination of map and landscape elements in the Praeneste mosaic would seem to be a suitable form for the type of painting which in Antiquity was called *topographia* (literally 'the painting of places'). Diodoros records that in 164 B.C., when the exiled Ptolemy VI Philometor took refuge in Rome, he availed himself of the hospitality of an Alexandrian painter, then resident in Rome, named Demetrios the

222 Nilotic mosaic, Praeneste. Detail.

Topographos (Diodoros 31.18.2). Is the Praeneste mosaic, with its Egyptian subject matter, a reflection of a type of topographical painting which was in vogue in Alexandria in the late third or early second century B.C. and was brought to Italy by migrant artists like Demetrios? And did such painting originate in the art of book illumination at Alexandria where it would have been appropriate both for the geographical studies of men like Eratosthenes and for the learned poems and prose essays of Kallimachos (e.g. his essay *On Rivers*)? The evidence does not permit us to answer 'yes' to these questions, although it is tempting to do so.

The foregoing analysis of space and narration in earlier Greek painting now leads us back to the point at which we started – the Odyssey landscapes. Before attempting an assessment of the place and significance of these paintings in Hellenistic art, several technical details about them should be noted. In the most acute of all analyses of the paintings, Peter von Blanckenhagen has pointed out four features which strongly suggest that the cycle as we have it is in some sense a copy of an earlier and presumably more extensive original.[25] (a) As noted earlier the various scenes in these frescoes are designed as if they were seen from above; yet in the house on the Esquiline where they were found, they were placed toward the top of the wall and seen from below. This disparity suggests that they were not originally designed

for the space in which they were found. (b) In the Esquiline house, the illusionistic pilasters, by means of which the frieze is made to conform to the 'Second Style' of Romano-Campanian architectural decoration, were painted over the frieze in such a way that they partially cover some of its figures. Clearly these figures would never have been painted if the pilasters were part of the original design. (c) The subject matter of the frieze seems unevenly divided, with a disproportionate amount of space devoted to one episode, the land of the Laestrygonians (panels 2–5). This disproportion suggests that the Odyssey landscapes have been excerpted from a larger cycle. (d) There are differences in the style of drawing between panels 2–5 on the one hand and 6–10 on the other which suggest that the latter group are copyists' adaptations. In figures 6–10 in particular the rendition of space, especially rocks, has less sculptural clarity, the drawing of human figures seems weaker, and some of the figures seem out of scale.

If, as this analysis suggests, the Odyssey landscapes are a copy, what are they a copy of? Blanckenhagen himself has suggested that the 'original' was a Hellenistic cycle of the second century B.C., perhaps created in southern Italy.[26] Others have connected the original with Alexandria, [27] and still others with late Hellenistic painting in general.[28] Opposing this school of thought which sees the prototype of the paintings as essentially Greek is another group of scholars who feel that both in style and feeling they are essentially Roman.[29] They note that in extant works of Hellenistic art earlier than the Odyssey landscapes, there may be attempts at increasing the range of pictorial space, but there is nothing like the deep, misty atmosphere of the Odyssey paintings. On the other hand, in Romano-Campanian paintings of the late first century B.C. and the early first century A.C. examples of this type of atmospheric setting are abundant; indeed, after a time they become almost the rule.

It seems to this writer that both schools of thought on this question are right and that at the same time both are wrong. Or, put another way, that the question of whether the Odyssey landscapes are Greek or Roman is a non-question. What they are is a late Hellenistic work of the first century B.C., and they are therefore, like the culture that produced them, 'Graeco-Roman.' Hellenistic art in Rome, as we have concluded in an earlier chapter, can only be described by this term. To relegate the Odyssey landscapes to the status of copies of some hypothetical Greek work of the second century B.C. when all the extant evidence suggests that no such work existed is perverse. On the other hand to deny that the Odyssey paintings represent the natural culmination of a developing tradition of Hellenistic landscape painting seems obtuse. They brought Hellenistic technique into a world increasingly dominated by Roman taste and are a product of the fusion of the two cultures.

Although it would be difficult to claim that the Odyssey landscapes are an 'exclusive original,' it is perhaps also not strictly accurate to call them 'copies' in the sense that many statues of the Roman period are copies, since, as a practical matter, it seems likely that they could only have been 'copied' from small pattern books. It seems more appropriate to call them 'versions of a genre' rather than 'copies.' That is to say, paintings of this type were common in the first century B.C., and the Odyssey landscapes are one version of the type. This is in fact implied in the often quoted passage in Vitruvius (7.5.2) in which he cites *Ulixis errationes per topia*, 'Odysseus's wanderings over the landscape,' as a common subject among the paintings done by artists who were active earlier in his own century.[30] The differences between panels 2–5 and 6–10 need not necessarily be between a faithful copy of 'the original' and copyists' adaptations. They may simply represent the differing hands of two or more painters.[31]

Having come back to the Odyssey landscapes and brought the wheel of our investigation full circle, I would conclude with a few reflections on how the style which they represent can be viewed as an expression of Hellenistic culture in general. From one point of view the style of narration that shows small men in a vast physical setting can be understood as a reflection, perhaps subconscious, of what we have called the 'cosmopolitan outlook' of the period. It was in the Hellenistic age that men first became conscious of the smallness of the individual and the uncertainty of his fate in a vast and varied *oikoumene*. From another point of view, paintings like the Odyssey landscapes, with their obvious love of texts and formal learning, are expressions of what we have called the Hellenistic 'scholarly mentality.' If they are, as has been suggested, ultimately derived from book illustration, their derivation would not be surprising or inappropriate. And finally, the style of the Odyssey paintings can be seen as an example of Hellenistic individualism in the sense that it makes its appeal, like some of the bucolic poetry of the Hellenistic period, to an essentially private emotion – nostalgia. In the Hellenistic period men of the Classical world lived for the first time in an urban setting on a mass scale, cut off to a great extent from the rural world. Because they were increasingly far from this world they could idealize it and dream about it. The romance of nature is an emotion of book-learned intellectuals rather than of farmers and shepherds. The Classical Greeks ruminated relatively little about nature, probably because they were still too close to the experience of what it really involved to run a farm, cultivate land, and live off it. But in the metropolises of Alexandria and Rome, the images of the *Idylls* of Theokritos or the *Georgics* of Virgil, and also the images filled with rocks and trees and air created by painters, seem to have had a compelling, almost mystical, charm.

10

Hellenistic mosaics

Mosaics in the form that most people are familiar with today, that is, inlaid pictures and patterns composed mainly from small cubes of stone and glass, are a Hellenistic invention. The subject matter and style of various important Hellenistic mosaics have already been discussed in several of the preceding chapters. In the present section our purpose is to summarize what is known about the technical development of mosaics in the Hellenistic period, to round out our picture of the subject matter of these mosaics, and to raise the question of how they are an expression of the taste and thought of their time.

The earliest Greek mosaics of any artistic significance are pebble mosaics; that is, designs made of small, naturally rounded pebbles set into a layer of fine cement. Because very early examples of mosaics in this technique have been found at Gordion in Phrygia (eighth century B.C.), some scholars have argued that it originated in Asia Minor or even farther east, but the possibility that the technique originated in Greece itself also has evidence to support it. Non-figural examples of pebble floor mosaics dating from the Bronze Age have been found at Tiryns, and although no example with a pattern has yet been found, pebble floors continued to be used in the first half of the first millennium B.C. Most probably the development of figural pebble mosaics in Greece, which began in the later fifth century B.C. and became widespread in the fourth, was simply the flowering of an old local tradition. The most extensive corpus of pebble mosaics before the Hellenistic period has been found in the Chalcidicean city of Olynthos, but examples dating from the fourth century have been found in many parts of Greece as well as in Asia Minor and Sicily.[1]

The finest works in this technique, works that can be considered the culmination of the tradition both artistically and technically, are the mosaics from the Macedonian capital at Pella, whose background has already been discussed in connection with royal iconography (p. 40).

The Pella mosaics, it will be remembered, were found in two buildings which may have been part of a palace complex built by Kassander. Like all other Greek mosaics, as far as we know, they were floor mosaics. They decorated the thresholds and centers of spacious dining rooms which faced equally spacious colonnaded courtyards. The mosaics in each of the two buildings at Pella were done by two distinct workshops, each of which had distinctive techniques. In the easternmost building ('Building I'), which contained the Lion Hunt already discussed [34], the mosaicists used cast leaden threads to create sharp outlines, and they avoided 'modelling' their figures through gradation of light and shade. The effect of the mosaics in this building is thus flat and linear like that of vase paintings. In the westernmost building ('Building II'), by contrast, there is an ambitious attempt, as in the Stag Hunt mosaic of Gnosis [35] (see p. 41) to create a sense of mass and depth through shading. There is thus a more subtle and complicated gradation of the pebbles in size and color. The use of leaden threads is avoided, although there are occasionally linear divisions created by small rows of black pebbles. Here the mosaicists seem to have been striving to reproduce the effect of fresco painting, like that of the tomb at Vergina [204], rather than vase painting. It is virtually certain that all the Pella mosaics were designed in the form of cartoons beforehand. (The leaden threads, which had to be 'custom made' to fit the contour of each figure, must have been cast on the basis of cartoons, before the work began on the actual mosaics.) A decision as to whether the mosaic would be linear and contour-bound in the tradition of Parrhasios or more 'painterly' in the tradition of Zeuxis was presumably made by the master who designed the cartoons.[2] At Pella the decision was clearly one of taste and not a reflection of the mosaicists' technical limitations.

The pebble mosaics that were created in the third century B.C. in the wake of the masterpieces at Pella show a distinct turning away from the painterly virtuosity of works like the Stag Hunt of Gnosis. Shading, complex polychromy, and the illusion of spatial depth tend to be attenuated in favor of bichrome designs, often with only one figure, that are flatter in their effect, more linear, and more purely decorative in character, as, for example, in

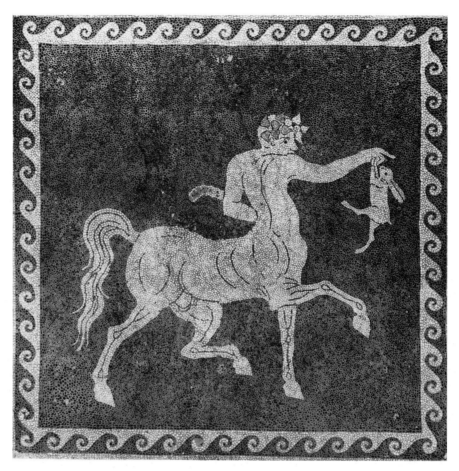

223 Centaur, pebble mosaic, Rhodes. *Ca.* 300–270 B.C. Rhodes, Archaeological Museum.
3.00 x 2.96 m.

the Centaur mosaic from a house in Rhodes [223]. Some of these qualities, as noted, are already apparent in the mosaics from Building I at Pella, which, if anything, look forward rather than backward in the history of pebble mosaics. This major stylistic change toward the end of the pebble mosaic tradition was almost certainly the result of conscious aesthetic decisions on the part of Greek mosaicists and may have stemmed from a conviction that, in spite of the success of a few master craftsmen like Gnosis, the pebble technique could not consistently do justice to the subtleties of contemporary painting.

It was perhaps the need to bring more of the technical subtleties of painting back into mosaics that led at some point in the third century B.C. to the abandonment of pebbles and to the adoption of small cubes made of stone, glass, and terracotta (called *tesserae*, 'cubes' or 'dice,' by the Romans) as the mosaicist's principal material. At any rate, once mosaics with tesserae became common, there was an enthusiastic return to polychromy and illusionism in Hellenistic mosaics. Mosaics made of such small cubes

are now customarily called 'tessellated' (from Latin *tessella*, 'small cube,' a diminutive of *tessera*). It is probably not accurate to think of tessellated mosaics as having evolved directly from pebble mosaics because there is also a tradition of Greek mosaics in the third century B.C. made of polygonal marble chips, or of a mixture of pebbles and chips, and it seems likely that these constituted a transitional technique between the pebble and tessellated techniques.[3] From an art historical point of view, however, pebble mosaics are clearly the most significant source for the iconography of tessellated mosaics and, to some extent, even for their style.

Just where tessellated mosaics originated, if indeed there was a single place of origin, is uncertain. One theory is that the technique originated in Sicily, probably in Syracuse, and was broadcast to Alexandria and elsewhere through the mosaics in the famous ship that Hieron II sent to one of the Ptolemies (see Appendix III.5). Some have seen support for this theory in the fact that what one might call 'proto-tessellated' mosaics have

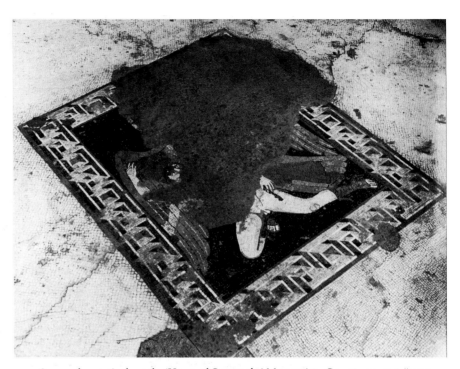

224 Ganymede mosaic, from the 'House of Ganymede,' Morgantina. *Ca.* 260–200 B.C. (exact date disputed). *In situ.* 1.05 x 1.30 m including frame.

been found at Morgantina in Sicily, the most important being the Ganymede mosaic from the 'House of Ganymede' [224].[4] The Ganymede mosaic is formed mostly from small tesserae, but it also contains laminations (long strips of limestone) and a few specially shaped pieces (e.g. the testicles of Ganymede). Another theory is that tessellated mosaics originated in Alexandria, because there are two Alexandrian mosaics which could be interpreted as documentation of the transition from pebbles to tesserae.[5] One of these is a partially preserved pebble mosaic depicting a battle scene surrounded by a border of griffins.[6] The other is the tessellated mosaic of Erotes engaged in a stag hunt [136] that has already been discussed in connection with Hellenistic rococo (pp. 130, 141). The date of neither mosaic is known for certain, but the pebble mosaic, which uses leaden threads like those in Building I at Pella, is so close to the Pella series in style and technique that it must date from around the same time. The fact that the Erotes mosaic has a few pebbles mixed in with its tesserae and that it has similarities to the pebble mosaic in its general composition and in individual motifs has suggested to some that it must belong to the third century B.C. and be one of the earliest tessellated mosaics.[7]

Good arguments have recently been put forward by Dieter Salzmann, however, for believing that tessellated mosaics originated in Greece at the end of the third or the beginning of the second century B.C., and that the technique of tessellation evolved from the transitional form, mentioned above, of mosaics made from polygonal stone chips. He argues that the Ganymede mosaic from Morgantina, usually dated to *ca.* 260–250 B.C. and therefore taken to point to an evolution of tessellation early in the third century B.C., more probably dates from the end of the third century and is contemporary with a few other mosaics that seem to show polygonal chips on the brink of becoming tesserae.[8]

Once *opus tessellatum*, as the Romans called the art of making tessellated mosaics, was invented, refinements in the technique, aimed at bringing mosaics closer to the subtlety of painting, were quickly worked out. The culmination of these refinements was the technique called *opus vermiculatum* (from *vermiculi*, 'little worms') in which tiny tesserae, sometimes as small as 1 millimeter on a side, were laid in curving, worm-like lines to create subtle contours and modeling. The labor and care that went into the making of mosaics in this technique is astounding. The Alexander mosaic [2], for example, consists of about one million tesserae, sometimes with as many as thirty tesserae clustered in a square centimeter.

The subject matter of Hellenistic mosaics, both pebble and tessellated, can be divided into five basic categories:

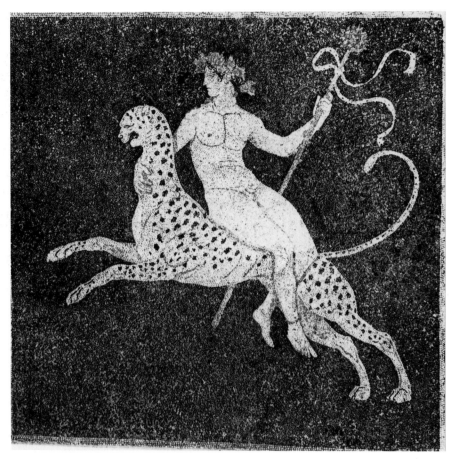

225　Pella, pebble mosaic, Dionysos riding a panther. *Ca.* 330–300 B.C. Pella, Archaeological Museum. 2.70 x 2.65 m.

(1) Mythological scenes. These are usually the most technically ambitious works, but they are, surprisingly, relatively rare. (2) Theatrical subjects, such as scenes from plays, actors in costume, and theatrical masks. These are quite common and reflect not only the general popularity of the theater as a form of entertainment in the Hellenistic world but also the spontaneous and perhaps subconscious 'theatrical mentality' of the age. (3) Generic decoration featuring animals and imaginary creatures such as centaurs and griffins, and winged Erotes. Such decoration is extremely common and is a rich source for the playful motifs in Hellenistic rococo. (4) Royal and political iconography, like the Alexander mosaic. Since mosaic floors are essentially decorative in spirit, such subjects are naturally rare. (5) Landscape scenes, like the Nilotic mosaic at Praeneste, as already described in the previous chapter. In addition to these basic categories the borders of Hellenistic mosaics might be seen as constituting a category in themselves. Neo-orientalizing animal frieze borders, like those on the two mosaics from Alex-

andria discussed above, derive from pebble mosaics of the fourth century B.C. (for example, those at Olynthos). The very elaborate and beautiful floral borders like that of the Gnosis mosaic at Pella [35] appear to be related to contemporary developments in Greek painting.[9] In later tessellated mosaics geometric motifs, such as perspective meanders and parapet borders, tend to be favored.

Rather than enumerate examples of these categories one by one, it will be more interesting and informative to see how they were woven together and given emphasis at the major sites from which Hellenistic mosaics have come – Pella, Delos, Pergamon, Alexandria, and Pompeii. At Pella, as we have seen (p. 40), at least two mosaics, the Lion Hunt from Building I and the Stag Hunt by Gnosis from Building II, can be plausibly related to the royal iconography of the early Hellenistic period. The other major mosaic of Building I, an elegant, sinuous Dionysos riding a panther [225], is more difficult to interpret. It may be simply decorative. Dionysos was the god of conviviality, and his image was appropriate for dining

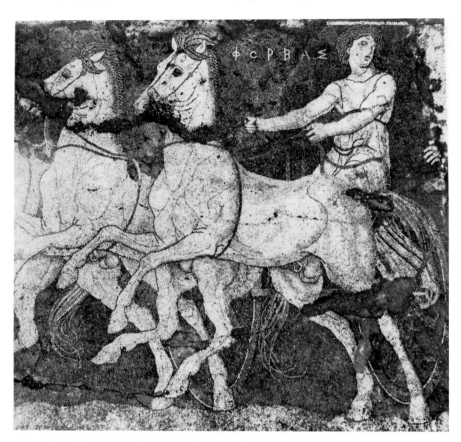

226 Pella, pebble mosaic, Abduction of Helen by Theseus. *Ca.* 330–300 B.C. Pella, Archaeological Museum. Pictorial field: 8.40 x 2.80 m.

rooms. It may be an allusion to the theater, of which Dionysos was the patron deity, or it may be simply mythological, an allusion to the triumph of Dionysos in which he normally rides upon, or is at least accompanied by, leopards or panthers. There was a fourth-century prototype of sorts for this subject in a mosaic from the 'Villa of Good Fortune' at Olynthos. (In this case Dionysos rides a chariot drawn by leopards and is accompanied by an Eros, Pan, and a border of Satyrs and Maenads.) If the Pella mosaic is an allusion to the Indian triumph, however, it too may have political overtones, since, as suggested earlier (p. 148), the Indian triumph seems to have been used in some instances as a symbol of the ruler cult. It may be that the theme of Dionysos on a panther was popular precisely because of its multiple significance. The learned men who dined at Pella may have found their conversation enriched by the challenge of interpreting it on a variety of levels.

The thresholds of the rooms with the two major mosaics in Building I offer early examples of generic decoration with animals and fantastic creatures. At the entrance to the room with the Lion Hunt are a male and a female centaur, the former drinking from a wine cup; and on the threshold of the room with the Dionysos mosaic is a griffin attacking a stag. Both of these motifs call to mind common decorative subjects in Archaic Greek art. Centaurs were popular in early Attic black-figure vase painting, and griffins were one of the most common forms deriving from the orientalizing phase of Greek art in the seventh century B.C. Accordingly there has been speculation that these thresholds preserve a memory of Archaic pavements or textiles. But there were also very recent developments in Greek art which could explain this neo-orientalizing taste in the mosaics, and it is probably not necessary to search for them in earlier centuries. The griffin and stag scene, for example, has parallels in particular with decorative trends in Athenian vase painting and gold work of the fourth century. A revived fondness for such creatures as griffins and arimasps in Athens at this time was apparently stimulated by Athens's new and lucrative trade with the non-Greek peoples who lived around the Black Sea. Likewise, the immediate inspiration for the centaurs may have been a very 'modern' painting, the 'Centaur Family' of Zeuxis.[10]

This famous work seems to have been essentially a playful caprice in which Zeuxis brought some of the same easy-going humor to traditional subjects in painting that Praxiteles brought to sculpture.

Besides the Gnosis mosaic, there are two others in Building II at Pella that have straightforward mythological subjects, and these give us some idea of the possible range in originality and technical skill which could be expected when the pebble mosaic tradition reached maturity. One of them, which represents a traditional Amazonomachy, is a hum-drum work depicting a time-worn subject and using patterns of composition that originated in the late fifth century B.C. The other, which depicts the relatively obscure story of the abduction of the girl Helen by Theseus [226], is a dramatic and technical masterpiece. Only parts of this enormous scene (approximately 8.40 m long) are preserved, but they are sufficient to indicate its quality. To the left, Theseus's charioteer Phorbas restrains four rearing horses, while to the right Theseus, having scooped up Helen, is about to jump onto the chariot. Helen and an attendant (labelled Deianeira) gesture toward one another in panic. The agitated glance of Phorbas and the distraught faces of the two women, the nervousness of the horses, and the flurry of billowing drapery all contribute to a sense of drama and excitement. The influence of dramatic fresco painting, like the Abduction of Persephone from Vergina [204], is obvious. The mosaicist has done all he could to make the relatively intractable medium of pebbles capture the subtle shading (note in particular Deianeira's drapery and the haunches of the horses) and foreshortening of large-scale painting. The pebble technique has here been carried as far as it will go, and it is not surprising that tessellated mosaics began to evolve shortly after this great work was created.

The most important examples of Hellenistic tessellated mosaics in Greece come from Delos. Most of them appear to date from between 166 and *ca.* 100 B.C., when Delos was a free port under Athenian control and its domestic quarters underwent rapid expansion. The bulk of the Delian mosaics fall under the heading of generic decoration or theatrical subject matter, but at least one fairly ambitious mythological scene has been found. This depicts the obscure story of the nymph Ambrosia and the

227 Delos, tessellated mosaic, Ambrosia and Lykourgos. *Ca.* 166–100 B.C. Delos, Ilot des bijoux. Approx. 0.69 x 0.73 m.

Thracian king Lykourgos [227].[11] When Ambrosia refused Lykourgos's advances, he attacked her with an ax. Ambrosia invoked the help of earth, who turned her into a vine which strangled her attacker.[12] In the mosaic we see Lykourgos swinging the ax over his head while the vine begins to emerge from the body of the prostrate nymph. The figures are executed in a relatively crude form of *opus vermiculatum*. Exactly what appeal and meaning a mosaic like this would have had in its original setting can only be a matter of speculation. Perhaps it was simply a conversation piece; perhaps it was an allusion to a poem or play; or perhaps it had a playfully gnomic message for the drinkers who used the dining room in which it must have been placed (i.e. 'This is what the vine can do to you. Be careful.').

The generic subjects at Delos very frequently have a marine quality (e.g. dolphins with anchors, Erotes riding dolphins, a Tritoness with an Eros) most probably because Delos in the second century B.C. was above all a shippers' town.[13] It was on theatrical imagery, however, that the most careful planning and the highest artistic skill were lavished. The most complete repertoire of such imagery is found in a house in the theater quarter known as the 'House of the Masks' [228]. Here we have something approximating a 'program' of theatrical subjects, a fact which has suggested to some that the house might have belonged to a guild or family of actors.[14] As with all other important Delian houses, the center of the House of the Masks is a Doric peristyle courtyard reached by a long passageway from the street. The columns on the

north flank of the courtyard are taller than those on the other sides, an arrangement presumably designed to admit more sunshine and warmth in the winter (Vitruvius 6.7.3 terms this type of courtyard 'Rhodian'). The architectural importance given to this north wing of the peristyle is further enhanced by the fact that it gives access to the four most important rooms of the house, and it is here that the mosaics of the house are found. In the main dining room directly to the north of the court (room g [228]) is a large pavement consisting of a center of perspective cubes flanked at each end by a border depicting five comic masks connected by vines [229]. The masks seem to be those of stock characters in New Comedy. Immediately to the west of this room is a smaller chamber in which the mosaic depicts a Silenos, or an actor in a comic mask, dancing to the music played by an accompanist on double flutes. At the northwest corner of the courtyard, still another dining room has dolphins at its threshold and a central mosaic depicting an amphora with a palm branch leaning against it and with a victor's wreath and a bird below it. Finally at the northeast corner of the court is the masterpiece of the program. In a central panel Dionysos, or at least a Dionysiac figure, is shown riding a leopard and holding a thyrsos and a cymbal or tambourine [230]. Flanking this central panel are two lozenges in which centaurs are depicted, one holding a kantharos (tall wine cup), the other a candelabrum.

The Dionysiac figure riding a leopard is one of the masterpieces of the *opus vermiculatum* technique. The mosaicist's ability to convey the texture and the play of light over the surface of the drapery, the leopard's fur, and the face of the rider rivals the technique of the Alexander mosaic. It is undoubtedly significant that the other great example of *opus vermiculatum* from Delos, a mosaic from the courtyard of the House of Dionysos in the theater quarter, depicts nearly the same subject [231]. Here a winged Dionysiac figure wearing an ivy crown and carrying a thyrsos rides a tiger. It seems probable that there was a master mosaicist on Delos who specialized in Dionysiac and theatrical subjects and whose shop offered its clients a pattern book or corpus of cartoons from which they could choose basic designs. The identity of these two Dionysiac figures is not altogether obvious. They are commonly called Dionysos, but Dionysos is not normally winged like the figure from the House of Dionysos, and even the sex of the figure from the House of the Masks is not certain. (Is it, in fact, a Maenad?) There is no doubt, however, that the figures are related to Dionysiac cult and myth. The range of significances which might be applied to Dionysos, or a Dionysiac figure, riding a feline has already been discussed in connection with the mosaics from Pella, and the same multiple meanings suggested there may also apply here, although, in the case of the figure from the House of the

228 Delos, House of the Masks. Plan.

217

229 Delos, House of the Masks, tessellated mosaic with theatrical masks. *Ca.* 166–100 B.C.
H. of heads 0.30 to 0.45 m.

Masks, it seems probable that the idea of Dionysos as the patron of tragedy is dominant.

It is very probable that the mosaics from the House of the Masks were viewed as an ensemble, but exactly how strictly the unity of the ensemble should be interpreted is debatable. In the basic publication of the house and its mosaics, Chamonard proposed that the Dionysiac figure symbolizes tragedy, that the masks refer to comedy, that the dancing figure relates to satyr plays, and that the

amphora mosaic symbolizes the spirit of competition that went into Greek athletic and theatrical festivals. (Panathenaic amphorae, palms, and wreaths were prizes and symbols of victory.) Thus, the three major genres of Greek theatrical festivals would be evoked by these mosaics. It has been pointed out, however, that the centaurs have no obvious connection with tragedy and that the dancing satyr may in fact be an actor in a scene from comedy.[15]

230 Delos, House of the Masks, Dionysos, or a Dionysiac figure, riding on a leopard. *Ca.*
 160–100 B.C. H. 1.08 m.

231 Delos, House of Dionysos, tessellated mosaic of Dionysos riding on a tiger. *Ca.* 166–100
 B.C. 1.29 × 1.57 m.

232 Preening doves, tessellated mosaic of the 2nd century
A.C. from Tivoli, based on a Pergamene mosaic of the
2nd century B.C. by Sosos. Rome, Capitoline Museum.
0.98 x 0.85 m.

233 Roman mosaic of the 2nd century A.C. by Herakleitos, based on the *asarotos oikos* of
Sosos. Found in Rome on the Aventine, now in the Vatican. Lateran Collection. L. of entire
mosaic 4.05 m.

234 Pergamon, Attalid Palace, tessellated mosaic of a parrot (partly restored). *Ca.* 180–150 B.C. *In situ*. H. approx. 0.45 m.

The city which seems to have been most famous for its mosaics, judging by the ancient sources, was Pergamon. Here the best-known mosaicist of Antiquity, an artist named Sosos, created a work, or group of works, which were frequently imitated in later times and are spoken of with admiration by Pliny:

The most famous artist in this genre [mosaic pavements] was Sosos, who laid the floor in Pergamon which they call the '*asarotos oikos*' [Greek: 'the unswept room'] because by means of small *tesserae* tinted in various colors he depicted on a paved floor the debris from a meal and other such things as are customarily swept away, making it seem as if they had been left there. A marvellous feature in that place[16] is a dove drinking water and casting the shadow of its head upon it, while other doves sun themselves and preen themselves on the rim of a large drinking vessel. (*NH* 36.184)

Sosos's preening doves, a classic example of 'generic decoration,' became one of the most popular motifs in

235 Tessellated mosaic from Thmuis, probably a personification of Alexandria, by Sophilos. 2nd century B.C. Alexandria, Graeco-Roman Museum. H. 1.25 m.

221

236 Pompeii, House of the Faun, vestibule, tessellated mosaic with masks and garlands. 2nd century B.C. Naples, Archaeological Museum. H. 0.49 m.

ancient mosaics. There is an example of it from Delos, and several from Pompeii and other sites in Italy.[17] The finest version of the genre is one from Hadrian's villa at Tivoli which could even be a copy of the original [232]. The *asarotos oikos* was a *jeu d'esprit* that defies classification. What it attempted to capture in an illusionistic fashion was the typical appearance of the floor of a Greek dining room while a banquet was in progress. (Diners would recline on couches and throw shells, bones, seeds of fruit, etc., on the floor for a servant to sweep up.) Something of its quality can be appreciated in what must be a Roman version of it, found on the Aventine and now in the Vatican, signed by a mosaicist named Herakleitos [233].

Where exactly Sosos's 'unswept room' was within Pergamon is not known. The major original remains of Pergamene mosaics come from the Attalid palace complex ('Palaces IV and V') built mainly during the time of Eumenes II (197–159 B.C.) on the citadel of Pergamon. It is likely that Sosos's mosaic was also in this complex. The surviving mosaics are fragmentary, but they are of high quality and seem to carry on the playful type of generic decoration that Sosos made famous. In addition to theatrical masks, there are elaborate garlands of flowers with fruits and also birds and various other types of animals. The most endearing of the latter is a big green parrot [234] done in excellent *opus vermiculatum*.

Two of the major mosaics surviving from Alexandria, the Erotes hunt and the pebble mosaic with a battle scene, have already been discussed. A third major find from Thmuis, now in Alexandria, is quite different from these and provides one of the rare examples of political imagery in mosaic. This is the mosaic signed by an artist named Sophilos which depicts a female holding a mast and yard arm and crowned with a headdress in the form of a ship's prow [235]. It is most probable that she is a personification of the city of Alexandria and hence an image in the tradition of works like the Tyche of Antioch [1]. The inner details of the figure are done in excellent *opus vermiculatum* enhanced by leaden threads. Her attributes, all of which relate to ships, are somewhat puzzling, since in the second century B.C., when the mosaic was made,[18] the Ptolemaic navy was no longer of great significance. One wonders if the mosaic did not have some connection with, perhaps even a prototype in, the *Alexandris*, the great ship sent by Hieron II to the Ptolemies (see Appendix III.5). A second, very similar mosaic has been found at Thmuis, and it seems likely that some familiar work in Ptolemaic Alexandria was the model for both it and the Sophilos mosaic.

The most varied and complete corpus of Hellenistic tessellated mosaics comes from Pompeii. Although one's natural instinct is to think of Pompeii as 'Roman,' it should be remembered that until the town was resettled as a Roman colony after 80 B.C., it is more accurately described as 'Italo-Hellenistic.' In the 'Tufa period' at Pompeii (*ca.* 200–80 B.C.), when the cultural refinement of the town reached its most sophisticated level and the influence of Greek culture in southern Italy was still an effective force, the artistic taste of the aristocrats who

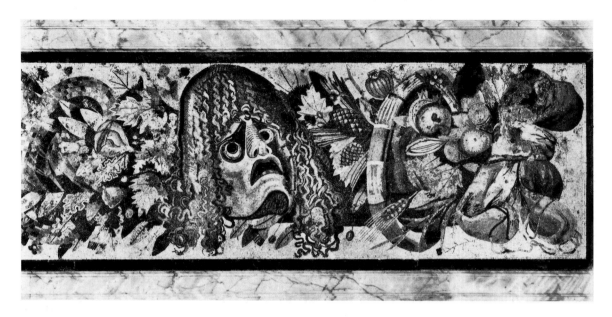

237 Pompeii, House of the Faun, cat mosaic. Naples,
Archaeological Museum. H. 0.53 m.

lived in the great houses like the 'House of the Faun' was
thoroughly Hellenistic. The House of the Faun, in fact,
provides the best introduction possible to the quality and
the variety of the Hellenistic mosaics at Pompeii. Upon
entering the house, at the inner end of the *fauces*

(entrance vestibule), one was immediately confronted
with the familiar motif of theatrical masks entwined in a
network of fruits, garlands, and flowers [236]. Proceed-
ing into the Tuscan atrium of the house one encountered
a series of delightful mosaics with generic decoration. In
the *ala* (wing) to the right a cat creeps through a larder
stocked with a partridge, ducks, fish, and shellfish [237].
This mosaic may have been intended to evoke the 'menu
paintings,' called *xeniai*, which Greek and Roman hosts
sometimes sent to their guests (see Vitruvius 6.7.4). In the
ala to the left, doves were depicted pulling a necklace out
of a casket. The mosaic which one sees today is techni-
cally very crude and is probably a late replacement,
inserted after the great earthquake of 62/63 A.C., for a
Hellenistic original. The motif, of course, is in the tradi-
tion of the famous doves of Sosos.

In the two small rooms flanking the *tablinum* (the main
room at the end of the atrium) were placed, to the right, a
vivid mosaic with fish and other sea creatures [238], and
to the left, a scene with a vine-crowned *putto* holding a
wine cup and riding a tiger [150]. The fish mosaic
represents an extremely common genre at Pompeii, the
most vivid of which is from House VIII.2.16[19] [239]. The
details of some of these mosaics are so similar that their
derivation from a common prototype, a cartoon or
pattern book in the shop of a local mosaicist, is beyond
doubt. These scenes were once again undoubtedly
appropriate conversation pieces for dining rooms. One
can imagine learned diners discussing recondite points of
ichthyology and pointing to the mosaic as they consumed

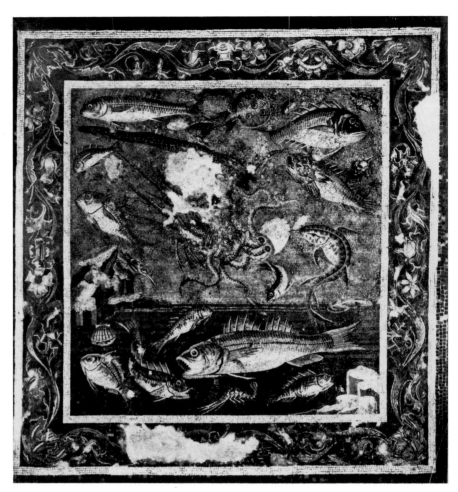

238 Pompeii, House of the Faun, fish mosaic from the *tablinum*. Naples, Archaeological
Museum. H. 1.17 m.

239 Pompeii, fish mosaic from House VIII.2.16. 2nd century
B.C. Naples, Archaeological Museum. H. 0.62 m. ▶

240 Pompeii, House of the Faun, Nilotic mosaic. Naples, Archaeological Museum. H. 0.64 m.

241 Mosaic from Pompeii by Dioskourides of Samos, scene from a comedy. *Ca.* 100 B.C. Naples, Archaeological Museum. H. 0.48 m.

their fish dinners. The mosaic with the *putto* on the tiger, as already suggested, seems to be a playful, rococo variation on the oriental triumph of Dionysos. The figure is sometimes identified as the 'Genius of Autumn' and taken to be a cheerful evocation of the time when grapes are harvested. Other versions of the same theme survive, most notably a medallion-shaped mosaic in the House of the Centaur.[20]

Moving through these rooms into the first courtyard one came to the culmination of the mosaic cycle of the house in the sumptuous exedra which contained the Alexander Mosaic (see pp. 3, 45, 191) [2]. At its threshold was a spirited example of the Nilotic scenes whose appeal in Italy in the late Republic has already been discussed (pp. 148, 205). Ducks, a cobra, a hippopotamus, and other creatures are scattered in and

along the Nile [240]. Finally, in a room to the right of the Alexander exedra there was a scene, now much damaged, of a lion and tiger in combat, the background of which has already been discussed (see p. 148).

The theater, food, fun, domestic tranquillity, history, politics, and the exotic all make their appearance in this cycle. Like other mosaics at Pompeii, those of the House of the Faun seem to have been designed to suit the taste not so much of maritime traders, as at Delos, as of aristocrats who derived their wealth from the local land and waters. Their intellectual horizons were primarily Greek. Only someone steeped in Hellenistic history and culture, someone with cosmopolitan interests, would have gone to the expense of commissioning an intricate and undoubtedly costly work like the Alexander mosaic. It is true that in the House of the Faun purely mythologi-

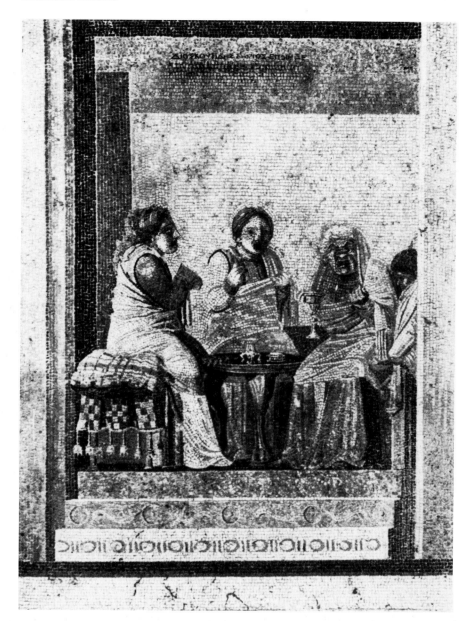

242 Mosaic from Pompeii by Dioskourides of Samos, scene from a comedy. *Ca.* 100 B.C. Naples, Archaeological Museum. H. 0.45 m.

cal scenes are missing and theatrical imagery is not prominent. These lacunae, if such they can be considered, are compensated for, however, elsewhere at Pompeii. From the villa conventionally called the 'Villa of Cicero' at Pompeii, for example, come two of the finest Hellenistic mosaics with theatrical subject matter, the scenes from New Comedy done by the mosaicist Dioskourides of Samos [241 and 242]. In the mosaic which bears Dioskourides' signature [241], two revellers, one with a tambourine, the other with clappers, dance to the music of the flutes played by a woman in the background. A child, perhaps a 'mute part,' stands to the left. All the figures wear comic masks. They seem to be placed on a narrow stage, and behind them is what seems to be a stage door. A scene something like this occurs in the *Mostellaria*, a Latin adaptation by the poet Plautus of a Greek New Comedy. The three seated women in comic masks depicted in the other mosaic [242] also appear to

243 Pompeii, mosaic of Theseus and the Minotaur. *Ca.* 100 B.C. Naples, Archaeological Museum. H. 0.75 m.

be from a specific scene in New Comedy, perhaps the *Synaristosai* ('Women at Breakfast') of Menander.[21] Since the polychromy, shading, and use of highlight of the Dioskourides mosaics seem to reflect the technical traditions of early Hellenistic painting and since the cup held by the old woman in the breakfasting scene seems to be a third-century form, it is likely that these mosaics are copies of early Hellenistic paintings. Judging by the shape of the letters in his signature, Dioskourides probably made them *ca.* 100 B.C.

The rarity of mythological scenes in the Hellenistic mosaics from Pompeii is probably to be explained by the fact that wall paintings were considered more appropriate for such subjects. There are, however, a few interesting examples which appear to be datable to the Hellenistic period by their style and technique. The best of them is a mosaic now in Naples depicting Theseus wrestling with the Minotaur while a group of anxious women look on [243]. This is one of four very similar mosaics, all of

which are probably based on a well-known Hellenistic painting.[22] (The pose of all the figures, the skeleton of one of the Minotaur's victims, and the object which probably depicts Theseus's spool of thread are duplicated in all the mosaics.) Compared to the Alexander or the Dioskourides mosaics, the technique of the Minotaur mosaic is of inferior quality. There is some fine work in the faces of Theseus and the Minotaur, but the twist of Theseus's torso is unconvincingly rendered and the structure of the architecture in the background is a puzzle. Perhaps there were very few mosaicists in the region of Pompeii who could handle the complex problems of lighting, depth, etc., called for in a mythological scene, and discriminating patrons preferred to hire painters for such subjects rather than pay the price for a master mosaicist.

What this survey has shown is that the great innovation in the art of mosaic-making in the Hellenistic period was a technical one. Hellenistic artists invented tessellated

mosaics. Once that invention was complete, mosaics seem on the whole to have followed the basic artistic trends of their time. If there is any feature which makes their development somewhat distinct from that of the other arts it is the popularity of subjects with a rococo character and this, of course, is probably to be explained by the fact that most mosaics had a purely decorative function.

11

Hellenistic architecture: theatrical and scholarly forms

Architecture was not the medium through which the artistic originality of the Hellenistic Age was most effectively expressed. For the most part, Hellenistic architects perpetuated, refined, combined, and occasionally varied the forms of Classical Greek architecture, and even those modest developments which could be termed formal innovations often have their roots in the earlier period. Nevertheless there are several distinctive and typical trends within the Hellenistic architectural tradition which deserve attention because they further illustrate how Hellenistic art is an expression of the experience and mentality of the age. Three trends are of particular interest: (1) a certain theatricality in planning and design, which is primarily a reflection of the theatrical mentality of the age but in some instances, particularly when it involves an increasing interest in the manipulation of interior space for emotional effects, may also be an expression of that tendency toward mysticism which was an aspect of Hellenistic individualism; (2) almost the antithesis of the above, a didactic tendency in the planning and proportions of buildings which is clearly an expression of the 'scholarly mentality' of the age; and (3) an ever expanding use of the Corinthian order to express a variety of religious and political ideas.

Theatricality

The theatrical mentality in Hellenistic architecture is expressed in the choice of dramatic settings for temples, in a fondness for dramatic vistas and exciting, unexpected spatial changes within buildings, and, although the evidence for it is scanty, in what seems to have been a taste for a kind of façade architecture, possibly influenced by stage settings.

Classical Greek temples were sometimes built in settings which seem to our eyes dramatic or picturesque (one thinks of the Parthenon, for example, or the temple of Poseidon at Sounion or the temples placed along the fortifications at Akragas), but their placement was fundamentally dictated by complex religious considerations. Most cult places were holy before temples even

began to be built. Occasionally cult sites of the Classical period, like the Athenian acropolis, were embellished with the intention of making them something like 'showcases' for the culture of their time, but even in these instances respect for hallowed cult traditions or the urge to express new religious conceptions were the controlling forces which guided both patrons and architects. It is really only in the Hellenistic period that one senses a desire to elaborate the architecture of sacred sites purely for the purpose of offering a kind of touristic thrill to those who visited them. Colonnades, stairways, ramps, gateways, etc., are used to 'set up' potential viewers so that they can gasp with delight as new vistas are successively opened up to them. Perhaps the most impressive of such arrangements is the Hellenistic setting of the temple of Athena at Lindos on Rhodes. The acropolis of Lindos is dramatic enough just as a geological structure, projecting as it does out into the sea like a great ship's prow [244]. On a high southwestern point on this acropolis a new Doric temple of Athena, replacing an older shrine of the Archaic period, was constructed *ca.* 330 B.C. Sometime after the construction of the new temple, probably in the second century B.C., the dramatic setting of the temple was enhanced by an architectural elaboration of the acropolis which screened off the crowning temple from immediate view and obliged one to ascend a series of stairways and pass through several gateways before the final vista was 'revealed' [245]. The visitor climbing the acropolis first encountered a wide winged Doric stoa (87 m long). Passing through the center of this he ascended a broad stairway to a propylaia building which on the outside, facing the stairway, took the form of a smaller Doric winged stoa, and on the inside, after one passed through its doors, of a colonnaded court in front of the temple. Architectural planning was thus used to create a series of stage settings which slowly led one to a dramatic climax. It is significant that the temple of Athena itself, a rather conventional Doric tetrastyle amphiprostyle temple, is not a particularly remarkable structure. It was the overall dramatic effect of the natural and architectural setting, not a single architectural gem,

244 Lindos, temple of Athena complex. 4th to 2nd century B.C.

that interested and challenged the planners of the site. A somewhat similar although much less well preserved plan seems to have been designed for the acropolis of Kameiros on Rhodes, and it may be that this type of planning was originally a creation of Rhodian architects of the Hellenistic age. A Rhodian architect, it will be remembered, may have designed the great Altar of Zeus at Pergamon, and the Hellenistic sculpture of Rhodes reveals a taste for the dramatic (see p. 113). Theatricality may have been 'in the blood' of the Rhodians.

Even when the natural terrain did not offer an obviously dramatic vista, as it did at Lindos, Hellenistic architects were able to create this sense of an ascending, progressively more enthralling experience by using their repertoire of ramps, colonnades, and gates in a calculated, coordinated way. In the great sanctuary of Asklepios on the island of Kos, for example [246], a rising series of terraces adorned with stoas, stairways,

temples, altars, and fountains seems to have been designed with the idea that visitors (mainly those who were ill and had come to the god to seek relief from disease) would move, in an almost ritual fashion, to successively more elevated (literally and metaphorically) levels of spiritual intensity. The lowest terrace, developed in the late fourth and early third centuries, consisted simply of a propylon, a U-shaped stoa, and a fountain house. Here presumably petitioners of the god purified themselves with holy water and followed a certain hygienic regimen under the supervision of priests and physicians. On the middle terrace, developed in the third century, an Ionic temple (*ca.* 280 B.C.) on the right faced an altar building which was similar in form to the famous Altar of Zeus subsequently built at Pergamon. A small stoa dating to the late third century was constructed on the left side of the terrace. Finally, *ca.* 160 B.C., the upper terrace, crowned by a new Doric temple of Asklepios,

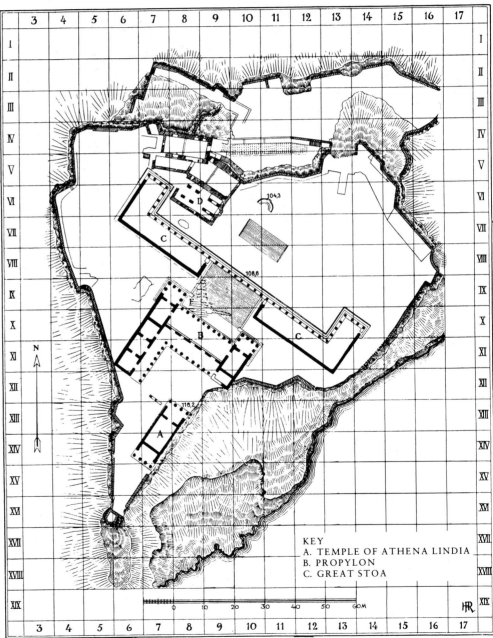

KEY
A. TEMPLE OF ATHENA LINDIA
B. PROPYLON
C. GREAT STOA

245 Lindos, temple of Athena complex. Plan and restoration.

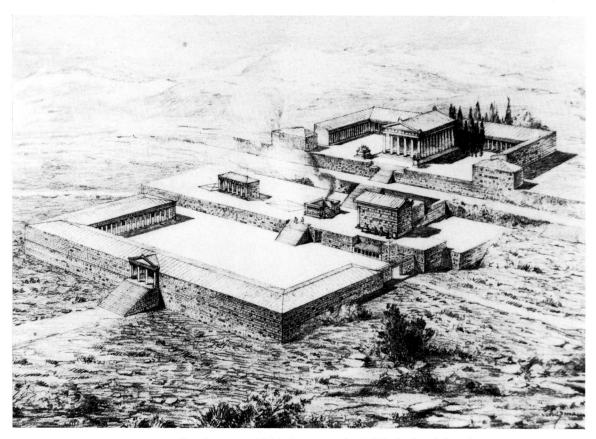

246 Kos, Sanctuary of Asklepios, restoration of fully developed plan. *Ca.* 160 B.C.

surrounded by another U-shaped portico, was construc-
ted. Inscriptions suggest that on the broad terrace
bounded by these porticoes, perhaps surrounding the
temple itself, a grove of sacred cypress trees was planted
in order to recreate the effect of a primeval woodland
shrine of Asklepios which presumably once existed on
the site. It was most probably in the porticoes of this
terrace, in the presence of the god and in an atmosphere
that seemed above worldly turmoil and care, with a view
out over the wide sea which gave one an intimation of
cosmic dimensions, that devotees slept and awaited the
miraculous visitation of the god with his curing power.

The greatest application of this Hellenistic ascending
plan with its masking gateways and porticoes leading to
new revelations was not a sanctuary but rather an entire
city: Pergamon. When Eumenes II and his architects laid
out their great plan for the expansion of the city early in
the second century B.C. (see p. 82) they decided to make
significant use not only of its majestic acropolis, and of
the plain of the Kaikos where most of the residential
sections of the city seem to have lain, but also of the
intervening slopes which connected the two. The

monumental parts of the city were accordingly dramati-
cally laid out on the south slope of the citadel (the north,
east, and west were too steep for construction) along a
rise, from the lowest gateway to the peak of the acropolis,
of some 275 m [83]. The designers of the monuments on
this slope seem to have thought of them as ascending in a
symbolic as well as a physical way, with the buildings
connected with mundane affairs of life at the bottom,
those connected with education and the development of
the mind in the middle, and those expressing divine
powers and supreme cultural achievements at the top.
Thus after passing through the great south gate [247] one
came first to the Lower Agora where the necessities of life
were bought and sold, and then followed a rising road
which took one, through a series of vaulted entrance
tunnels, into a complex of three gymnasia, the lowest one
for boys (up to age 14), the middle one for ephebes
(youths aged 15–17), and the upper one for young men
(age 18 and over). Gymnasia, it must be remembered,
were not simply structures for physical exercise, as the
modern term implies in English, but were rather schools
of the Greek world in which reading, writing, arithmetic,

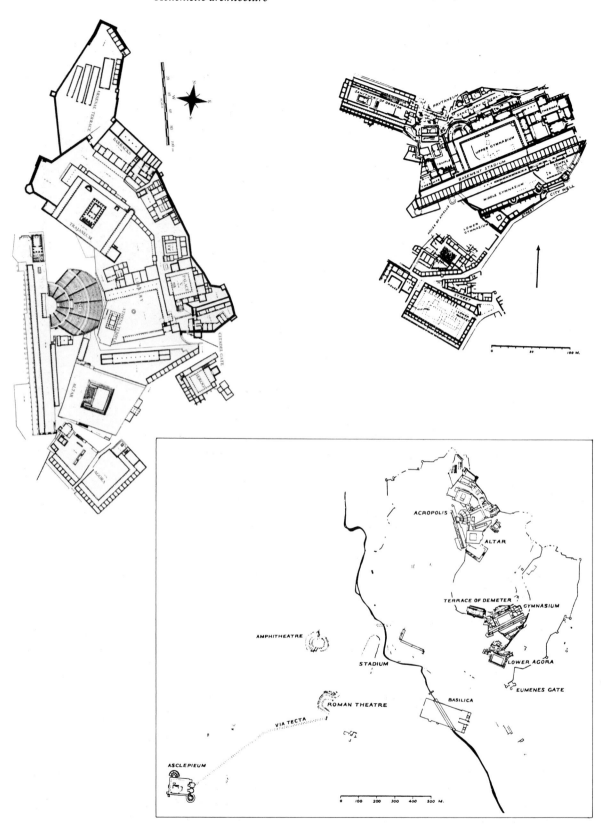

247 Pergamon, plan of the site. Above, left, detail of the acropolis. Above, right, detail of gymnasium area.

geometry, literature, music, and other subjects were taught. Upper level gymnasia, like the one at Pergamon with its large semicircular lecture hall, were important cultural centers where leading philosophers and orators perpetuated the most sophisticated traditions of Greek culture. Just above the level of the upper gymnasium the first sanctuaries of important (but not the supreme) deities of Pergamon, Hera and Demeter, appeared, anticipating the citadel. All of the structures, with the exception of some earlier (third century B.C.) stages of the sanctuary of Demeter, belong to the time of Eumenes II and Attalos II. Above them one followed a curving road which led to a porticoed area on the edge of the acropolis called the 'Upper Agora.' This structure dates to the third century B.C. and was probably in origin a purely commercial agora, but after the grand design of Eumenes II materialized, it seems to have been increasingly given over to legal and political uses. From here, ascending another 13 m or so one came, on the west, to the terrace of the supreme monument of the Olympian side of Pergamene religion, the great Altar of Zeus (see pp. 97ff.); and on the east to the chief shrine of the state religion, the 'Temenos of the Ruler Cult' (see Appendix II). A portico and another 26 m of rising terrain shielded one from the next dramatic revelation of a Pergamene cult, the venerable sanctuary of Athena with the earliest temple of the city, constructed by Philetairos. In the same complex with the temple of Athena, flanking the northern side of its precinct, was Eumenes' great library, which, with its colossal statue of Athena Parthenos, functioned as something like a holy shrine of culture and the intellect. This, together with the theater, which could be understood as a physical projection of the literary tradition preserved in the library, seems to have been understood as the symbolic summit of Pergamon. Behind it, to the east and north and largely masked from view, were the residence of the Attalids and buildings accommodating practical necessities, barracks for the palace guard and an arsenal.[1]

The impressiveness of this, the greatest city plan of Antiquity, stems from the fact that traditional, by now almost didactic formulae for the arrangement of individual sanctuaries and public buildings were adapted to the dramatic possibilities of the terrain. The often charming but essentially mechanical planning of sites like Priene (see *infra*) was rethought as part of the same burst of creative energy that produced the sculptures of the Altar of Zeus. Like these sculptures the plan of Pergamon was designed to engage the emotions as well as the mind, and in doing so it created an environment unparalleled by any other ancient city.

The dramatic settings and uses of controlled, ascending vistas that characterize the monuments thus far described were also found in Hellenistic Italy in temples which arose out of a fusion of Greek and Italic traditions.

248 Cori, temple of Hercules. Late 2nd century B.C.

One quite well preserved example is the temple of Hercules at Cori, in the hills of Latium southeast of Rome, dating from the late second century B.C. Perched precipitously on the edge of a steep slope, it even today, in spite of modern ramshackle buildings below it, makes a dramatic impression [248]. The temple itself, as at Lindos, is a relatively inconsequential structure, although it is of interest as an example of the mixed traditions of its time. Its spindly, attenuated Doric order, with the lower section of the columns unfluted and a thin, board-like architrave, derive from the secular form developed for stoas in the Hellenistic period, particularly in southern Italy (cf. the colonnade of the forum or the precinct of Apollo at Pompeii). Its deep porch, on the other hand, follows the tradition of Etrusco-Roman, or 'Tuscanic,' temples.

Another example of precipitous siting with a dramatic view to and from the sea, as at Lindos, is the temple of Jupiter Anxur at Terracina on the coast of Latium. It most probably dates from the time of Sulla (*ca.* 80 B.C.) and was constructed on a terrace attached to an important fortified military camp. The temple itself seems to have been a good example of late Hellenistic Corinthian, but in plan, with its deep porch and high podium, it was 'Tuscanic,' and the great cryptoporticus of stone-faced concrete on which it stood was, for its time, 'Roman ultra-modern.' Farther removed from Greek traditions, but probably betraying some Hellenistic influence in its overall conception, is the temple of Fortuna Primigenia at Praeneste. This great structure is perhaps the most important single monument in the history of the architecture of the Roman Republic, and a detailed study of it

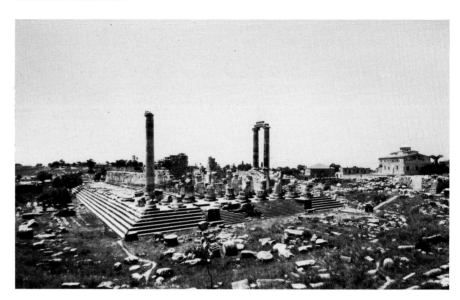

249 Didyma, temple of Apollo. Begun *ca.* 300 B.C.

falls outside the scope of a history of Hellenistic art. Its ascending plan, however, with its manipulation of the viewer's experience by a continual masking and opening up of vistas may, as a number of scholars have suggested, owe something to Hellenistic complexes like the Asklepieion at Kos. It would be claiming too much for Hellenistic architecture to assign the Fortuna temple to it, but in the case of Cori and Terracina one may fairly conclude that, like the Odyssey landscapes and many neoclassical sculptures, they are neither Greek nor Roman but rather 'late Hellenistic Graeco-Roman.'

In addition to dramatic siting, Hellenistic architects also indulged the age's taste for theatricality by manipulating the interiors of buildings to create unexpected, startling, and at times mysterious vistas and spaces. The most striking example of this manipulation is the great oracular temple of Apollo at Didyma, just south of Miletos [249–252], the most distinctively Hellenistic, as well as the most impressive, of all the temples of the period. The temple at Didyma culminated, and added a new dramatic quality to, an interest in varying, enriching, and evoking a sense of awe in temple interiors, that goes back to Iktinos's interior for the temple of Apollo at Bassae in the late fifth century B.C. and is traceable in such prominent monuments of the fourth century as the temples of Athena at Tegea, the temple of Zeus at Nemea, and the Tholos at Epidauros.

The Hellenistic temple at Didyma was begun *ca.* 300 B.C., but work on it continued throughout the Hellenistic period and even on into the Roman Empire. It replaced an Archaic temple on the same site which had been destroyed in 494 B.C. by the Persians, who carried off its cult image to Ecbatana. After the Macedonian conquest of Persia, Seleukos I recovered this image, which was a work of the Archaic sculptor Kanachos, brought it back to Didyma, and supplied funds to help the reconstruction of the temple get under way. The architects seem to have been Paionios of Ephesos, who was also one of the designers of the huge new temple of Artemis at Ephesos, and Daphnis of Miletos.[2] Their designs were probably embellished, at least insofar as ornamentation was concerned, by later architects, particularly in the time of the Emperor Hadrian, but the ground plan and basic disposition of spaces must have been the same from the beginning.

The temple was Ionic and, on the model of the famous Ionic temples of Hera at Samos and Artemis at Ephesos, designed on a large scale. Its stylobate was 51.13 m wide by 109.34 m long and its crepidoma, approached by 14 steps on the east and 7 on the other sides, was 3.15 m high. The Ionic colonnade was dipteral with rows of 10 columns on the ends and 21 on the flanks, and an additional 12 columns were placed inside the pronaos, giving a forest-like effect to the entrance of the temple. The columns were about 2 m in diameter and nearly 20 m high. Their bases were decorated with a rich variety of moldings and other ornaments, as were the wall bases, door frames, and ultimately (although it was not completed until a late stage) the frieze of the entablature. The whole effect was, and to an extent still is, one of overwhelming sumptuousness. Yet in its proportions, when viewed from the outside, it was an essentially traditional structure and reflected the rather scholarly taste of the early Hellenistic architect-theoretician Pythios of Priene (see *infra*).

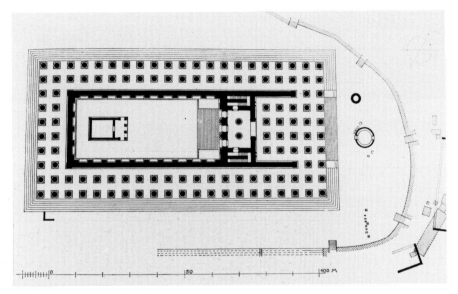

250 Didyma, temple of Apollo, plan.

In its interior, however, the temple at Didyma was unlike any other and must have surprised, as well as awed, those who had the privilege of access to it. As one passed inward through the center of the pronaos, one encountered a huge door which normally in a Greek temple would have marked the entrance to the cella [250]. Here, however, the threshold of the doorway was 1.46 m high with no steps. Such a doorway was clearly not designed to be passed through but rather designed as a kind of stage, probably to serve as the spot from which the *prophetes* of Apollo announced his oracular responses.[3] To enter the temple one moved instead to two vaulted and descending tunnels placed on either side of the great doorway. The form of these passageways in itself would have evoked an air of mystery. Vaults had begun to be used in Greece around the time of Alexander and were perhaps imported from Mesopotamia by architects who had traveled eastward in the wake of the Macedonian conquest. Their use in Greece was always limited and was mainly confined to tombs and tunnels for stadia. In temples vaults were altogether unusual, and one wonders if they were not intended to evoke the feeling of an oracular cave. (Perhaps significantly, the other major example of a vault in a Greek temple occurs in the subterranean chamber of the oracular temple of Apollo at Klaros, also begun *ca.* 300 B.C. but not finished until the time of Hadrian.) Descending these vaulted tunnels to a ground level considerably below that of the stylobate one found oneself not in the dark interior of a cella but rather in a great open air courtyard (for the temple was hypaethral) flanked by huge pilasters, and there, facing one at the far end of this court, was a second

small, traditional-looking tetrastyle temple. This was the actual oracular shrine of Apollo, surrounded by sacred laurel bushes and having within it, or adjacent to it, a spring of holy water. The Hellenistic temple at Didyma, in other words, was something like the churches of St Francis at Assisi, in which a small, ultra-sacred shrine is contained within a more sumptuous surrounding structure. Even this temple within a temple, however, did not exhaust the building's architectural surprises, for in turning back toward the east from within the courtyard one saw a broad stairway leading up to three doors which led in turn into the *adyton*, the room with the great eastern door from which oracles were announced. Between these doors were two half-columns in the Corinthian order, and within the adyton itself were two huge free-standing Corinthian columns. Corinthian columns, as will be discussed below, had by this time become a fairly familiar form in architectural interiors, but never before had they been designed on such a huge scale (what one might even call 'shock scale'). Their size alone gave a typically Hellenistic dramatic effect to these giant descendants of the first Corinthian columns, also created for Apollo, in his temple at Bassae. From within the adyton one was led to yet another type of mysterious, unexpected space. From each of the narrow ends of the adyton stairways led up to the roof of the temple. What the purpose of these stairways was is not known, but they must have played some role in the cult. They are referred to as 'labyrinths' in inscriptions and their ceilings are decorated with labyrinth-like maeander designs in stone relief [252]. This design seems to have become a symbol for religious mystery in the Hellenistic period, a symbol of the inscrut-

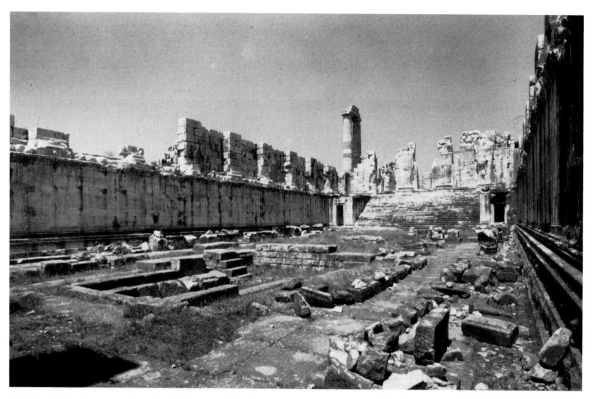

251 Didyma, temple of Apollo. View of interior.

ability of the divine will which only divination and revelation could unravel.

No other Hellenistic building offers the variety and complexity of interior spaces of Didyma, but there are other structures which reflect its fusion of theatricality with a genuine urge to express a sense of religious mystery. Most distinctive among these are the structures known as the Arsinoeion and the Hieron in the Sanctuary of the Great Gods at Samothrace [253–255]. The cult at Samothrace was pre-Greek in origin and encompassed mystery rites involving a number of deities, a great Mother goddess, a divine couple analogous to Hades and Persephone, and two demon-like figures called the Kabeiroi, who were sometimes associated with the Dioscuri and were the special patrons of sailors. The cult was already popular among Greeks in the time of Herodotos, but it seems to have enjoyed its greatest heyday in the Hellenistic period when it came under the patronage of the kings of Macedonia. (King Perseus, it will be remembered, sought refuge there before being captured by the Romans. See p. 152.) It was during the Hellenistic period that a complex of new buildings, apparently devoted to crucial stages in the initiation rites, were constructed on the sites of prehistoric cult places, sacred rocks, and other tokens, thus giving the sanctuary, for the first time, a

distinctive architectural character.

The Arsinoeion at Samothrace [253] was a circular structure with a conical roof which outwardly resembled, and would have made one expect to encounter, a tholos of the type which had become familiar in Greece in the fourth century B.C. It was constructed between 289 and 281 B.C. with the support of Arsinoe I, who was at that time the wife of Lysimachos. The prospective initiate who entered the structure would have been confronted, undoubtedly to his surprise, not with the rings of columns and circular inner chamber of a fourth-century tholos, but rather with a relatively vast (by Greek standards) open space unencumbered by interior supports. This was, in fact, the largest such space (the building is about 20 m in diameter) constructed before the Roman period. Decorating the upper third of the inner face of the thick drum of the structure was a loggia-like arrangement of Corinthian half-columns connected by a low parapet decorated with symbols of sacrificial rites in relief, *boukrania* (representations of the skulls of sacrificial bulls), and offering bowls [254]. The marble walls above the parapet and between the columns seem to have been pierced, at intervals, by windows. On the exterior of the building pilasters connected by a parapet and a Doric entablature balanced the arrangement of the interior.

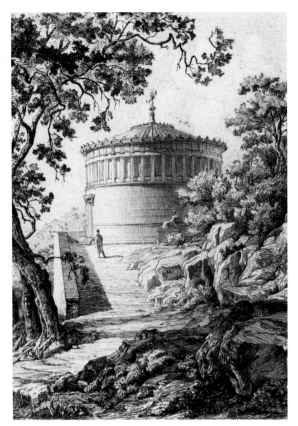

252 Didyma, temple of Apollo. Labyrinth pattern on ceiling
of interior passageway.

253 Samothrace, Arsinoeion, restoration. 289–281 B.C.

The Hieron of Samothrace, constructed *ca.* 325 B.C. and periodically refurbished [255], was the scene of the climactic revelation of the Samothracian mysteries. When one passed through its conventional-looking Doric porch one encountered a strange (for this period) long chamber with an apse at the far end and benches along its sides. The apse, if the reconstruction of the excavators is correct, was decorated with two huge torches and was perhaps also equipped with an opening for pouring libations on an outcrop of sacred rock. Painted stucco, arranged in panels to imitate stone revetments (analogous to the 'first style' of wall painting at Pompeii), decorated the wall of the chamber. The interior of the Hieron obviously resembles a Mithraeum of the later Roman Empire more than a traditional Greek temple and seems to look to the future rather than the past of the sacred architecture of Antiquity. Whether structures like the Arsinoeion and the Hieron are anomalous, original buildings for their time or examples of a general trend is a question that the extant monuments of Hellenistic architecture do not permit us to answer. If we knew more about the Sema or Serapeion of Alexandria (see

Appendix III.1) they might not seem so unusual; but in the light of present evidence they are unique.

The buildings examined thus far had their inception very early in the Hellenistic period, and it may be that this was the most creative and original phase of Hellenistic architecture. A more conservative, didactic tradition, that of the architect Hermogenes, seems to have dominated the later phases (see *infra*). Nevertheless at least one striking example of an interest in creating a dramatic architectural vista is documented even in the second century B.C. The temple of Artemis at Sardis in Asia Minor, another of the huge (99.16 m long) Ionic temples of the area, was begun *ca.* 300 B.C., and in its original form consisted of only a cella structure with a pronaos and opisthodomos placed on a broad, open podium (45.73 m wide). Whether a peripteral colonnade was originally planned for the structure is not known, but none was constructed, in any case, until 175–150 B.C. At this time a pseudo-dipteral Ionic colonnade was added [256–257] (that is, space was available for two rows of columns, as at Didyma, but only the outer one was constructed). The result was that on either side of the

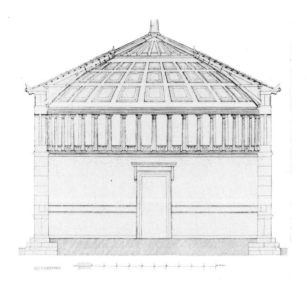

254 Samothrace, Arsinoeion, restoration of interior.

cella the pteromata became vast shaded corridors, approximately 100 m long, 10 m wide, and 18 m high. Hermogenes, who is said by Vitruvius (3.3.8) to have been the inventor of the pseudo-dipteral plan, may have devised the plan with this effect in mind. The stately, majestic spaces that it made possible were, in any case, unparalleled before the time of the great basilicas and baths of the later Roman Empire.

Along with dramatic siting and dramatic interiors there is a third way in which the theatrical taste of the Hellenistic era seems to have been expressed, i.e. in the creation of a kind of façade architecture. The evidence for such an architecture comes from the well-preserved Macedonian tombs discovered in recent years, whose paintings have already been discussed. Of these, the tomb at Lefkadia is the most remarkable [201]. Its façade was made of stucco applied to ashlar masonry, divided into five zones, molded into various architectural and sculptural forms, and painted. The lowest zone consisted of four Doric half-columns flanking the doorway of the tomb and of antae at the corners. Between the columns was an illusionistic parapet and in the spaces above this parapet were the painted figures already described (pp. 188ff.). Above this section was a Doric entablature

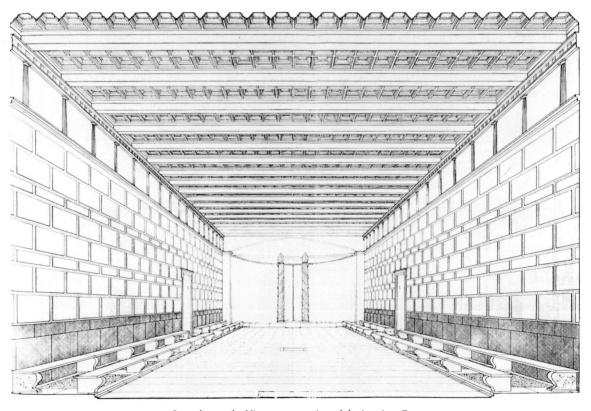

255 Samothrace, the Hieron, restoration of the interior. *Ca.* 325 B.C.

IA

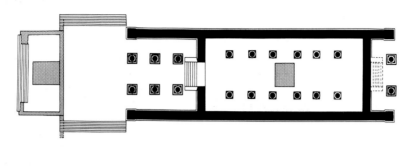

IB

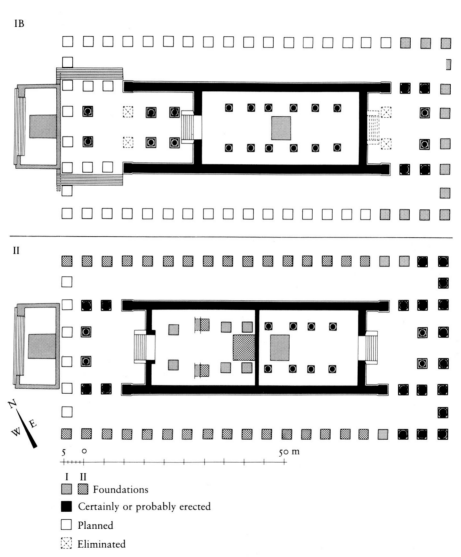

256 Sardis, temple of Artemis. Plan at various stages of construction. IA: *ca.* 300 B.C.; IB: *ca.* 175–150 B.C.; II: 2nd century A.C.

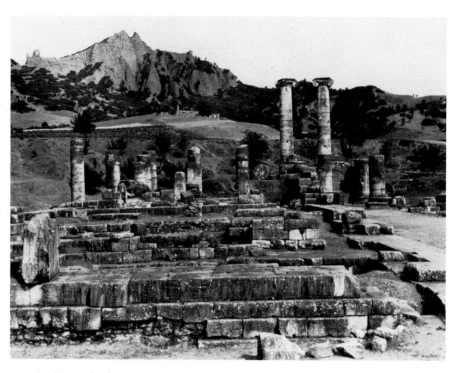

257 Sardis, temple of Artemis.

with metopes painted in grisaille representing the battle of Lapiths and Centaurs. Above the Doric entablature there was an Ionic frieze in painted relief representing an Amazonomachy. Then came an attic with seven illusionistic doors placed between corner antae and Ionic half columns, and finally, above this, a painted pediment. None of these decorations correlated in any meaningful way with the structure of the tomb, which consisted simply of an antechamber and a tomb chamber, both roofed with barrel vaults. The same is true with the somewhat simpler arrangement of Vergina Tomb II, where the Doric elements were surmounted by an attic decorated with a large painted hunt scene (see p. 192). In both cases the exteriors of the tombs are 'pure façade,' creating in part the illusion of a temple-like structure but adding to it elements, like the attic at Lefkadia, which seem to be architectural fantasies.

These tomb façades were presumably put together hastily upon the death of Macedonian dignitaries, in order to provide a dignified backdrop for their funeral ceremonies. After the customary rites were completed the tombs were covered with an earthen tumulus and seen no more. Was it their ephemeral role which led to their creation? That is, were they thought of as something like temporary stage-settings? And, if so, do they reflect stage-settings for the contemporary Greek theater? Or was there something in the domestic or palatial architecture of Macedonia which resembled them? Surviving fragments of the façade facing the court of the Macedonian palace at Vergina (ancient Aigai) suggest that there was a connection between tomb façades and 'real' architecture, but the evidence available is at present very limited.[4]

The didactic tradition

In the Introduction we described how scholarship, and in particularly a scholarly analysis of the arts, became one of the most familiar aspects of Hellenistic intellectual life. One of the by-products of this scholarship was a feeling that rules and canons of perfection for the various branches of art and literature ought to be established so that both teachers and students, in their continuing quest for cultural sophistication, would know what was good and bad, desirable and undesirable, in these fields of study. Thus in literary studies standard texts were codified, canons of exemplary authors were drawn up, polemics (like that between Kallimachos and Apollonios of Rhodes) were waged about what literary forms were most desirable, and learned commentaries on literary criticism began to issue from the great libraries.

The writings of certain Hellenistic architects about their profession appear to have constituted one influential branch of this general tradition of didacticism. Our evidence for such writings comes mainly from the Roman

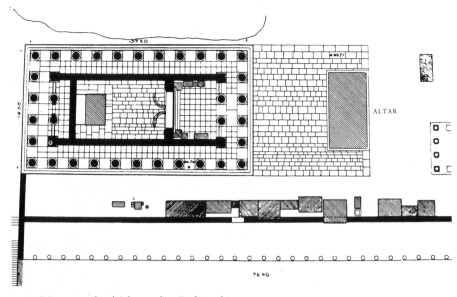

258 Priene, temple of Athena, plan. Dedicated in 334 B.C.

architect Vitruvius, whose own treatise, *De Architectura*, written early in the reign of Augustus, is in part a final compilation of the Hellenistic tradition. Vitruvius's citations of his Hellenistic sources suggest that the initiator of the whole tradition was an architect named Pytheos, who was perhaps a native of Priene. Pytheos was the architect of the temple of Athena at Priene (Vitruvius 7, praef. 12), dedicated by Alexander in 334 B.C., and also perhaps one of the architects of the Mausoleum at Halikarnassos (completed *ca.* 350 B.C.).[5] He was thus active at the very beginning of the Hellenistic period. Vitruvius quotes with satisfaction a statement from one of Pytheos's treatises to the effect that an architect ought to be versatile and able to accomplish more in the arts and sciences than the average person can accomplish in just one field (Vitr. 1.1.12); on the other hand, he criticizes Pytheos for not making a proper distinction between the *ratio* and the *labor*, the theoretical precepts and the practical details, of those fields in which an architect should be expected to have some knowledge (Vitr. 1.1.15). Taken together these passages imply that Pytheos's writings were not simply technical manuals but rather that they propounded the importance of architecture as a learned discipline and sought to establish standards for it. A further indication that this was the case is the fact that Pytheos also prepared a manifesto denouncing the Doric order as inherently imperfect and urging other architects to abandon its use (Vitr. 4.3.1). What seems to have offended his sensibilities was the age-old, and unresolvable, problem involved in positioning corner triglyphs in the entablature of a Doric temple.[6] There is probably no doctrine that expresses more vividly

the rigid, category-bound nature of the Hellenistic scholarly mind. Pytheos proposed to solve a problem which had fascinated and challenged the ingenuity of earlier Greek architects simply by passing a rule against it. By and large he seems to have been successful. Few Doric temples, and none of any great architectural importance, were built during the Hellenistic age.

The sort of architecture of which Pytheos approved, on the other hand, may best be illustrated by looking at his temple of Athena at Priene [258–259]. He is said to have written a commentary on the proportions of this building (Vitr. 7, praef. 12), and its substantial remains provide a good idea of the details which the commentary presumably described. The temple, several columns of which were re-erected in 1964, was, of course, Ionic, with a 6 x 11 disposition of the peripteral colonnade on a stylobate measuring 66 x 126 Attic feet (approximately 64 x 122 modern feet, or 19.53 x 37.17 m). This ground plan was inserted into a grid of squares each one measuring 6 x 6 Attic feet. Each column with its plinth and each space between the columns exactly filled one of these squares. The axial spacing of the columns, that is, the distance between the centers of two adjacent columns, was thus 12 Attic feet, and the dimensions of the rectangle drawn through the axes of the columns were exactly 60 x 120 feet. The cella was also centered in these grid squares, and when measured on the axis of the wall came to 36 x 96 Attic feet, with 40 x 100 Attic feet as its external dimension. The naos, or main chamber of the cella, occupied exactly half of the cella's length. The columns were 43 Attic feet high and the entablature surmounting them was 7 Attic feet in height, thus making a total height

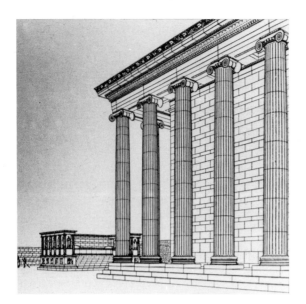

259 Priene, temple of Athena, reconstruction.

of 50 Attic feet, or half the length of the cella. One half of the entablature, or 3½ Attic feet, was allotted to the architrave and the ovolo molding above it, and the other half to the dentils, geison, and cornice. Further, each component of the entablature was measured in multiples of ¼ of an Attic foot (the architrave 11, the dentils 6, etc.).

When one remembers the greatest temple of the Classical period, the Parthenon, with its almost magical combination of geometric proportions and calculated irregularity, Pytheos's temple seems something like a textbook exercise. In particular, the use of a standard unit of measure, the Attic foot, as the module of the structure, and the multiplication of this unit into basic dimensions divisible by 10, has a particularly didactic ring. The temple has, of course, 'order' in an extreme degree, but it is a prescriptive and dogmatic, rather than an inspired, order. In other respects too, Pytheos's temple betrays an eclecticism that one might expect in the work of a scholar-architect. He used Attic units of measurement and an Attic plan for the cella, with an opisthodomos and projecting antae, but adopted the Ionic forms of Asia Minor for the columns (i.e. a two-part base with plinth) and entablature (an architrave with fasciae and dentils, but no frieze). All of this does not mean that there is anything 'bad' about the design of the temple of Athena. Its elegance is indisputable, but it is a kind of icy, intellectual elegance.

In the middle Hellenistic period the chief upholder of the didactic tradition initiated by Pytheos was the architect Hermogenes. The exact chronological range of his career is a matter of dispute, but there is no doubt that he

was active in the second century B.C., most probably *ca.* 150 B.C.[7] Hermogenes too condemned the Doric order as imperfect and devoted his energy to creating new forms, refinements, and rules for the Ionic order. Vitruvius credits him with being the inventor, as already mentioned, of the pseudo-dipteral ground plan for temples (Vitr. 3.3.8–9). That he was literally the inventor of this arrangement is not strictly true, since there are examples of it in Sicilian Doric temples as early as the Archaic period (e.g. 'Temple G' at Selinus), but Hermogenes may have been the first to apply it to the Ionic order,[8] and it is most probable that he was the first to offer a written rationale for its use.

Hermogenes' greatest influence on the architecture of his time, however, was exerted through a complex system of proportional relationships which he prescribed for the peripteral colonnades of temples (Vitr. 3.3.1–10). The basis of his system was that the interaxial of a colonnade and the height of its columns should have a consistent relationship: the narrower the interaxial, the taller the column and, conversely, the wider the interaxial, the shorter the column. Using the diameter of a single column as a module, Hermogenes devised and named five specific acceptable types of proportional relationship: the pycnostyle (the 'dense columnar system'; Greek *pyknos* = dense, *stylos* = column), systyle ('the close system'), diastyle ('open system'), araeostyle ('the far apart system') and the eustyle ('fair' or 'harmonious system'). In each of these systems, with the possible exception of the eustyle, the total of the interaxial and the column height was supposed to add up to 12½ column diameters. The proportional relationships prescribed for each of them are most easily expressed in diagrammatic form, with measurements given in column diameters:

	Inter-columniation	Inter-axial	Column height
Pycnostyle	1½	2½	10
Systyle	2	3	9½
Diastyle	3	4	8½
Araeostyle	3½	4½	8
Eustyle	2¼	3¼	9½ (or 9¼)*

*(Vitruvius says 9½. William Dinsmoor, in order to keep the total of 12½ intact, proposed that Vitruvius was mistaken and that Hermogenes' figure was 9¼.)[9]

Vitruvius implies that the eustyle system was particularly favored by Hermogenes and records that one of Hermogenes' well-known temples, that of Dionysos at Teos, was an example of it. Modern investigations of the limited remains of this temple have confirmed that it is indeed eustyle and have also defined other traits which seem to have been Hermogenean. Like Pytheos's temple of Athena at Priene (with which Hermogenes was obviously familiar, since he later constructed an altar for it) the temple at Teos had a columnar arrangement of 6 x 11, and its groundplan is inscribed in a neat series of

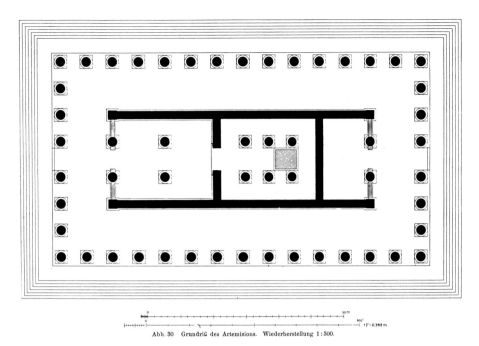

Abb. 30. Grundriß des Artemisions. Wiederherstellung 1:300.

260 Magnesia on the Maeander, temple of Artemis Leukophryene, plan. *Ca.* 200–150 B.C.

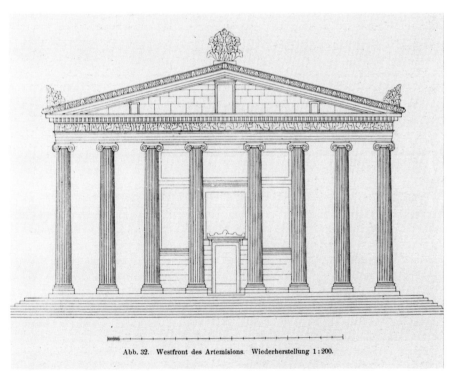

Abb. 32. Westfront des Artemisions. Wiederherstellung 1:200.

261 Magnesia on the Maeander, temple of Artemis Leukophryene, reconstruction.

245

squares with the cella walls exactly aligned with the peripteral columns. Unlike Pytheos, however, Hermogenes seems to have preferred proportions based on a given internal module rather than on a standard unit like the Attic foot. (The temple measures 18.63 x 34.98 m but does not seem to be divisible into even units of an ancient foot.) When it came to importing Attic features into the architecture of Asia Minor, Hermogenes went much further than Pytheos. He was perhaps spurred in doing so by the same impulse to revive and glorify the art of Classical Athens that inspired the neoclassical movement among the sculptors of his time. Not only did he use the Attic type of cella with an opisthodomos, as Pytheos had, but he also imported the Attic three-part Ionic column base (with a *scotia* between two *tori*, the form developed for the Ionic structures of the Periclean building program) and the Attic combination of a sculptured frieze with an architrave divided into fasciae. Hermogenes was, in fact, the ancient architect who finally codified the definitive form of the Ionic order which is so familiar to us today from courthouses, banks, libraries, post offices, etc. In a formal, if not a spiritual, sense he was, through the mediation of Vitruvius, one of the most influential artists of the ancient world.

The most prominent of Hermogenes' temples, judging by literary references, was that of Artemis Leukophryene at Magnesia on the Maeander [260–261]. This was a relatively large temple (36.60 x 57.89 m on the stylobate), was, as both excavation and Vitruvius (7, praef. 12) confirm, pseudo-dipteral, and had all the Attic features just mentioned.[10] Perhaps the most interesting fact about the temple is that the proportions of its colonnade, with an interaxial of $2\frac{4}{5}$ column diameters, does not fit into any of the Hermogenean systems described by Vitruvius. (It is nearly, but not quite diastyle.) This perhaps suggests that Hermogenes' system was more flexible and open to the influence of intuition than Vitruvius would lead us to believe.

The Artemis temple at Magnesia has been dated as late as 150–130 B.C. and probably represents Hermogenes' work in its full maturity. In the agora area of the same city there is another small (7.38 x 15.82 m, tetrastyle prostyle) temple dedicated to Zeus Sosipolis [262] which, it has been suggested, is an early work of Hermogenes.[11] It uses a frieze in the entablature, an opisthodomos in the cella, and has Attic-type moldings on its cella wall. Its column bases, however, are still of the eastern Ionic type used by Pytheos. The proportions of the temple, it is interesting to note, fit Vitruvius's description of the eustyle system (the interaxial is $3\frac{1}{4}$ column diameters and the column height is $9\frac{1}{2}$) and suggest that he, rather than his modern critics, is accurate on this point.

Whether or not one likes the scholarly, didactic, prescriptive approach to architecture taken by Hermogenes and other Hellenistic architects, one cannot deny its

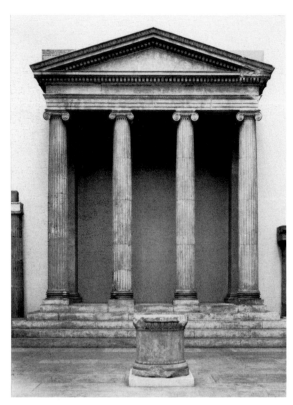

262 Magnesia on the Maeander, temple of Zeus Sosipolis. View as reconstructed in the Staatliche Museen, East Berlin. First half of the 2nd century B.C.

lasting historical importance. Vitruvius was clearly strongly influenced by it; through him its principles were passed on to Renaissance and post-Renaissance Europe; and, as already observed, many of our more formal and official modern buildings continue to keep the tradition alive.

Just as the theatrical tradition in Hellenistic architecture came to be reflected in city planning at Pergamon, so too did the didactic tradition, in its case at Priene [263]. The plan of Priene is probably the best known and most often illustrated of all ancient cities. To modern eyes its tidy compact grid, with groups of moderate size squares, systematically apportioned to houses, temples, and civic buildings, has an almost romantic charm, evoking as it does the spirit of the Classical *polis*. It is easy to envision the intimate but intense civic life that Aristotle attributes to the ideal city-state taking place at Priene.

From the standpoint of a cold-blooded, objective historian, however, Priene, for all its tidiness, is a rather conventional city plan for its time. Grid planning in the Greek world was developed as early as the seventh century B.C., primarily as a convenient way to apportion land in newly founded colonies. In the mid-fifth century

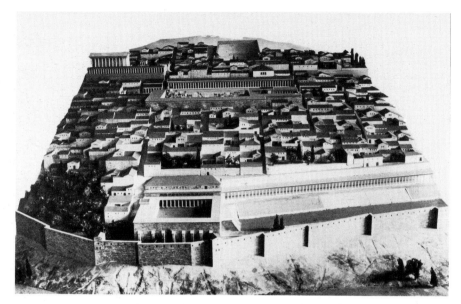

263 Priene, model of the city.

B.C. a philosophical and theoretical basis was instilled into this type of planning by the first well-known Greek city planner, Hippodamos of Miletos. Hippodamos, some of whose ideas are briefly summarized by Aristotle (*Politics* 2.5.1–4; 7.10.4), redesigned Peiraeus for the Athenians and probably left his most important mark on his native city of Miletos when its rebuilding was begun after the Persian Wars. In the later fifth and fourth centuries other newly founded or redesigned cities (e.g. Rhodes) also inherited the Hippodamian imprint. There was thus nothing new about the plan of Priene when the city came to be refounded on its present site in *ca.* 350 B.C. It might even be said to exhibit some of the same rule-bound, didactic inflexibility which characterized Pytheos's temple of Athena. One wonders, in fact, if it was not Pytheos who designed the new city.

The Corinthian order

The Corinthian order was not invented in the Hellenistic period, but it was in the hands of Hellenistic architects that it first came to be applied to the exterior of major structures. Once established as an exterior order Corinthian was adopted with enthusiasm by the Romans, and at the end of the Hellenistic period it became the principal architectural form used in the neoclassical architecture of Augustus. Augustan Corinthian was widely diffused and also repeatedly imitated and revived during the course of the Empire; and later, after centuries of decay, revived, imitated and diffused once again in the Renaissance and post-Renaissance world. The Corinthian order is thus one of the most visible symbols of the Hellenistic strain in European culture, and for that reason if for no other its development in the Hellenistic period would be worth reviewing briefly. There is, however, another more immediately relevant reason for doing so: the manipulation of Corinthian in relationship to the other orders perhaps tells us something about how Hellenistic architects and their patrons understood architecture's power to symbolize ideas.

The Corinthian order was invented, according to a story told by Vitruvius (4.1.9–10), by the sculptor Kallimachos, who conceived the idea from looking at Corinthian funeral monuments. The story as actually told by Vitruvius is fanciful, but the fact that there are on Attic white-ground lekythoi representations of funeral stelai which rather resemble Corinthian columns suggests that funereal forms may actually have had some influence on the creation of the Corinthian column.[12] In this connection, it is noteworthy that one of the earliest structures to feature the Hellenistic order on its exterior was a tomb, at Belevi in Asia Minor (see Appendix V). Another possibility is that the form developed in decorative metal work, for which Corinth was famous. The enigmatic bronze lamp, with its top in the form of a palm, which Kallimachos created for the Erechtheion in Athens (Pausanias 1.26.7) may have resembled a Corinthian column, and some have speculated that a Corinthian column was used to support the Nike held in the right hand of Pheidias's Athena Parthenos.[13] Further, the unusual form of the Choregic Monument of Lysikrates in Athens [264], a structure dating from 334 B.C. which commemorated a victory in a theatrical competition and is the earliest monument to use the Corinthian order on

264 Athens, the Choregic Monument of Lysikrates. 334 B.C.

its exterior, looks as if it might imitate a decorative metal stand (the monument supported a bronze tripod).

The first appearance of the Corinthian order in Greek architecture was in the cella of the temple of Apollo at Bassae, finished in the last quarter of the fifth century B.C. The Corinthian column at Bassae could conceivably have had funereal associations, since the construction of the temple appears to have had something to do with the great plague which broke out early in the Peloponnesian War; or it could have simply been decorative and appropriate for interiors because it combined Ionic proportions with a round capital. But it is also possible that the form had especially sacred associations, like the bronze palm lamp in the Erechtheion, and was thus deemed appropriate for the inner sanctum of a shrine. In the fourth century B.C., when the Corinthian order was increasingly widely adopted in sacred architecture, it was always used in interiors – e.g. in the tholoi at Delphi and Epidauros, the Philippeion at Olympia, and the temples of Athena Alea at Tegea and Zeus at Nemea – and this tradition in its use continued, as we have seen, in the early Hellenistic period in the temple at Didyma and the Arsinoeion at Samothrace. Whether, at the beginning, Corinthian was considered appropriate for interiors because it was particularly sacred, or whether it gradually became sacred because it was commonly used in interiors, is an unanswerable question. But there does

seem to be some justification for concluding that by the beginning of the Hellenistic period Corinthian was looked upon as the most sacred and serious of the architectural orders. John Onians has recently elaborated upon this idea with the interesting suggestion that the different architectural orders came to have a hierarchical significance in the minds of Hellenistic architects, with Doric being thought of as mundane, Ionic as intermediate, and Corinthian as the most sacred.[14] He points to structures like the Temenos of the Ruler Cult (see p. 274) at Pergamon, where the outer courtyard was Doric, the colonnade leading to the antechamber of the shrine was Ionic, and the inner shrine was Corinthian. The hierarchical arrangement, he further proposes, was used in secular structures like the gymnasia at Miletos and Priene, where Doric was used for the courtyard, Ionic for major passageways, and Corinthian for the principal lecture halls.

Assuming that the Corinthian order was an ultra-sacred form originally considered appropriate for inner shrines, how did it come to be brought outside and placed on the exterior of temples? Leaving aside the enigmatic Choregic Monument of Lysikrates, which is not really a building, the earliest structure to use the Corinthian order on its exterior is the Propylon of Ptolemy II built *ca.* 280 B.C. as an entrance to the Sanctuary of the Great Gods at Samothrace. This gateway is hexastyle amphiprostyle, and it is interesting that only the six columns which face the interior of the sanctuary are Corinthian; those which face outside are Ionic. Corinthian was clearly still considered in some sense an interior order with sacred connotations.

The earliest datable temple to use the Corinthian order on its exterior is the Olympieion (Temple of Zeus Olympios) in Athens [265]. The Olympieion is still one of the most prominent monuments of the city of Athens. It was planned to be a Doric temple, and work on it was begun in the later sixth century B.C. by the Athenian tyrant Peisistratos and his sons. With the fall of the Peisistratid tyranny, however, the building was abandoned, and its enormous stylobate, which was all that the Peisistratean architects had managed to finish, remained for centuries as a ruin. Probably shortly after his accession in 175 B.C., in the wake of a recent visit to Athens, Antiochos Epiphanes revived the project. To design the new temple, he commissioned an architect named Cossutius, whom Vitruvius calls a Roman citizen (Vitr. 7, praef. 15).[15] The scale of Cossutius's temple, which called for 104 columns measuring 16.89 m in height, was so vast that it could not be completed during Antiochos's relatively brief reign, and after the king's death it resumed its role as a grand fragment in Athens. The Emperor Augustus gave consideration to resuming work on it, but it was not until the time of Hadrian, in 132 A.C., that the work was finally completed.

265 Athens, the temple of Zeus Olympios (the 'Olympieion'). 175–164 B.C., completed in the 2nd century A.C.

Antiochos Epiphanes presented himself, and perhaps thought of himself, as a kind of god incarnate, an avatar of Zeus. Most probably it was he who, with his usual bravado, grandiloquence, and extravagance, decided once and for all to usurp a particularly sacred form, the Corinthian column, which had hitherto been used with great restraint, bring it outdoors, and spread it lavishly over the ancient world as an expression of the sublimity of the deity whom he embodied (see Appendix III.7). Although few, then or later, took Antiochos seriously, many apparently took Cossutius's temple seriously, particularly in late Republican and early Imperial Rome, where Corinthian became the dominant order for religious architecture. Antiochos's decision thus had greater influence than even he, in his candid moments, would have expected.

12

Alexandria and the Pharaoh

Because of the overwhelming importance of Alexandrian poets and scholars in the development of Hellenistic literature, some scholars have quite naturally speculated that the artists of Alexandria played a similarly influential role, and, as a consequence, various features of style and subject matter – for example, impressionism, social realism, and allegory – have been held to be uniquely Alexandrian.[1] The fact is, however, that there is relatively little sculpture and painting preserved from Hellenistic Egypt, and what there is does not suggest that Alexandrian art diverged in any significant way from Hellenistic art elsewhere. Alexandria was undoubtedly in the mainstream of artistic developments, but it does not seem to have dominated them, and, in fact, other centers such as Pergamon, Rhodes, Athens, and, later, Rome were probably more important.

What is unique about the art of Ptolemaic Egypt is not so much its originality as its split personality. Just as the population of the Ptolemaic realm consisted of an urbanized Greek and Macedonian elite, which followed Greek cultural traditions and had little serious contact with the rest of the country, and a native Egyptian population that lived very much as it had thousands of years earlier in the time of the early Pharaohs, so too the art of Hellenistic Egypt had distinct Alexandrian and Pharaonic traditions. And like the cultures and populations whose values they expressed, these two traditions remained substantially impervious to one another. Greek artists, as we shall see, occasionally absorbed a few Egyptian motifs into Alexandrian art in order to evoke a certain local charm, but the Pharaonic tradition went on almost as if the Greeks had never existed.

The Ptolemies, who were Hellenistic kings in Alexandria and the most recent dynasty of Pharaohs elsewhere in Egypt, were patrons of both artistic traditions and respected their separateness, just as they respected the separateness of the cultures involved. If they were constructing a building or commissioning a work of sculpture in Alexandria or Ptolemais they would employ Greek artists to create works in a familiar Hellenistic style, with at most an Egyptian decorative motif or two to give the work a quaint, local flavor. If, on the other hand, they were subsidizing a work whose effect was intended to reach the Egyptian population outside of the Greek cities they would retain Egyptian craftsmen who worked in the ancient Pharaonic style. The thoroughness of this stylistic duality is particularly well documented in Ptolemaic royal portraiture. It would be hard to invent a more vivid contrast, for example, than that which we find in two portraits of Arsinoe II, one a marble head in Alexandria and the other a figure in Egyptian red granite now in the Vatican [266–267]. The head in marble [266] is identified as Arsinoe on the basis of a very close resemblance to the best coin portraits of her. Its mixture of austere beauty with a feeling of equally austere strong will, both qualities unified by a subtly modulated Praxitelean surface, make it one of the finest Greek portraits from Ptolemaic Egypt. Like all the best portraits of the early Hellenistic period it was designed to capture not only the appearance but also the personality of its subject (see Chap. 3). By comparison the red granite portrait in ancient Pharaonic style [267] seems like a symbol rather than a representation. It is identified as Arsinoe beyond any doubt by its inscription, but if the inscription were lacking it is doubtful that anyone, either now or in Antiquity, would have been able to recognize its subject instantly. The millennia-old canon of Pharaonic royal portraiture eclipses all but a hint of a specific personality.

The Alexandrian tradition

As stated at the outset, it has sometimes been claimed that Alexandrian sculpture and painting had a number of original, unique features that made them distinctive in Hellenistic art. In the case of sculpture, for example, softly modulated, *sfumato* surfaces have been held to be characteristically Alexandrian.[2] It is true that a number of heads found in Egypt have such a quality, but this post-Praxitelean sensuousness is a feature of many early Hellenistic sculptures, and there is no justification for thinking of it as distinctively Alexandrian as opposed to, let us say, Rhodian or Chiot. The same is true of works in

266 Portrait of Queen Arsinoe II (316–269 B.C.). Marble.
Alexandria, Graeco-Roman Museum. H. 0.24 m.

267 Arsinoe II, portrait in Pharaonic style. Red granite.
Rome, Vatican Museums. H. 2.48 m. without plinth.

other styles. The powerful head of a Gaul from Gizeh [268], for example, blends features of the Hellenistic baroque as developed at Pergamon with features of the Lysippan Alexander portraits (see Chaps. 1 and 4). The Gizeh Gaul is perhaps a portrait of a Gallic mercenary in the service of the Ptolemies rather than part of a battle monument similar to those of Attalos I. In any case there is nothing in it which can be claimed as uniquely Alexandrian. Ptolemaic portraiture clearly drew on diverse traditions which had their purest expression elsewhere. The Lysippan tradition, for example, also influenced a head in Alexandria which, because of its resemblance to coin types, is identified as Ptolemy VI Philometor [269]. Here the Lysippan construction of the head and neck is blended not with an excited baroque style, as was the case with the Gaul, but with the smoothed-out, idealized quality of some of the later images of Alexander (p. 30). The less mannered and more realistic tradition of 'psychological portraiture' that was developed in Athens in the third century B.C. (see Chap. 3) was also sometimes adopted by the Ptolemies, beginning with the founder of the dynasty (see p. 28) and applied with particular

effectiveness in two heads in Boston which have reasonably been thought to represent Ptolemy IV Philopator and his ill-fated queen, Arsinoe III [270 and 271]. The sensitive, and seemingly sad, face of Arsinoe is perhaps the finest work in this style from Hellenistic Egypt and may reveal more about the psyche of its subject than she would have openly acknowledged.[3] The same tradition of fusing a Praxitelean softness of surface with restrained realism and a certain penetration into the subject's personality also characterizes a portrait recently acquired by the Antikenmuseum in West Berlin which, because of its similarity to coin portraits, has been identified as the last

268 Head of a Gaul from Gizeh. Marble. *Ca.* 250–200 B.C.
Cairo, Egyptian Museum. H. 0.375 m.

269 Portrait identified as Ptolemy VI (*ca.* 186–145 B.C.).
Marble. Alexandria, Graeco-Roman Museum.
H. 0.41 m.

and most famous of all the Ptolemaic queens, Kleopatra VII [272].[4]

Genre figures, particularly figurines of children, dwarfs, deformed people, unusual (from the Greek point of view) racial types, aged peasants, and the like, constitute another category which has been thought to be an Alexandrian creation, a realistic reflection of the street life of a great polyethnic city.[5] Figures of this sort, however, seem to have been symptomatic of a widespread interest in social realism in the art of the later Hellenistic period in general (see Chap. 6). It is not improbable that Alexandria played an important role in their development, but there are many examples of such figures which have no known connection with Alexandria, and we are not obliged to conclude that the trend either originated in or was confined to the city.

A similar conclusion is probably justified in the case of Ptolemaic painting. A number of highly problematical literary sources which mention various prominent painters who worked in Alexandria have led some scholars to credit Alexandrian artists with the invention of an impressionistic style and with the development of landscape painting.[6] Since none of the works of the painters in question survives, these contentions cannot be conclusively refuted, but the painting which does survive

from Alexandria inclines one to be skeptical. Alexandria is surrounded by a group of extensive cemeteries which contained not only painted grave stelai marking the site of burials but also a variety of underground painted tombs. Some of these tombs were designed on the plan of a house, and the dead were laid out on imitation couches (*klinai*) or in sarcophagi which resembled couches. The walls of such tombs were frequently painted with funeral subjects in the same way that a house would have been painted with secular subjects. More common and more modest than the *kline* tombs were the *loculus* tombs, which consisted of simple chambers or corridors pierced with a series of niches (*loculi*). When the body or cremated remains of the deceased were placed in a *loculus* it was sealed with a slab made of stucco, cement, or stone. Sometimes these *loculus* slabs were painted like grave stelai. Although Alexandrian tomb paintings were certainly a more demotic and humble enterprise than paintings executed under the patronage of the Ptolemaic

270 Portrait identified as Ptolemy IV (*ca.* 244–205 B.C.).
Marble. Boston, Museum of Fine Arts. H. 0.275 m.

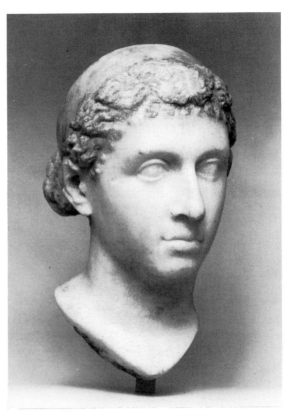

272 Portrait identified as Kleopatra VII (69–30 B.C.).
Marble. West Berlin, Antikenmuseum, Staatliche
Museen Preussischer Kulturbesitz. H. 0.295 m.

271 Portrait identified as Arsinoe III (*ca.* 235–204 B.C.).
Marble. Boston, Museum of Fine Arts. H. 0.35 m.

court, it is nevertheless reasonable to expect them to
betray some of the features of the most sophisticated
painting of their time, just as Attic white-ground lekythoi
do for Classical Greek art. If this expectation is justified,
one can only conclude that Alexandrian painting con-
formed with and followed the general character of paint-
ing in other parts of the Hellenistic world. Blanche
Brown's careful and convincing study of painted stelai,
loculus slabs, and tombs suggests that although these
monuments underwent some internal stylistic develop-
ment there is nothing in them which is anomalous,
unexpected, or strikingly original.[7]

A good representative example of the best Alexandrian
tomb painting is the frieze of riders and female worship-
pers from Tomb I in the Mustafa Pasha cemetery a few
miles east of Alexandria. This frieze was painted on
stucco-covered stone over a doorway which led into the
main burial chamber of the tomb [273]. What survives
now is largely underpainting, but enough is preserved to
make the general design of the figures clear. Three riders
and two standing women bear offering bowls (*phialai*)
with which they will apparently offer worship at an altar

273 Painting from a tomb in the Mustafa Pasha cemetery, Alexandria. Later 3rd century B.C. *In situ.* H. 0.60 m.

274 'Queens' vases' from Alexandria. Faience. (a) *Ca.* 280–270 B.C. London, British Museum. H. 0.324 m. (b) *Ca.* 240 B.C., from Xanthos in Lycia. Antalya Museum. H. as preserved 0.24 m.

just to the left of the central rider. The foreshortened rearing horses of the riders echo similar figures on late-fourth-century Attic red-figure vases of the Kerch style. Likewise the drapery of the female figures is in a tradition which derived from Attic art of the late fourth century B.C. and was represented in the third century by, among other works, the figures on Ptolemaic queens' vases (Appendix II) [274].[8] Without a known provenience the Mustafa Pasha painting could just as easily be called Attic as Alexandrian. Since the tomb dates from the third century B.C., most probably from the second half of the century, it is clear that even in the heyday of Alexandria a skillful painter could work in a style that was not only current elsewhere in the Hellenistic world but was also in fact well established several generations earlier.[9]

What all this may suggest, in fact, is that Ptolemaic painting was fundamentally conservative. It is known that some of the Ptolemies had a particular fondness for paintings of the Sikyonian school, the school of the fourth-century master Pamphilos and his pupils Apelles and Melanthios, and that they viewed the works of this school as something like 'old masters' and made efforts to collect them. The Achaean political leader Aratos served as a kind of agent for Ptolemy III Euergetes and helped to acquire choice examples of Sikyonian drawing and painting for the king's collection; and a substantial number of paintings by artists of the Sikyonian school are recorded to have been on exhibition in a great festival pavilion set up *ca.* 276 B.C. in Alexandria by Ptolemy II (Athenaios 197A, quoting the Hellenistic historian Kallixeinos of Rhodes; see Appendix III). Far from demanding that their painters be original and non-conformist, it seems likely that the Ptolemies encouraged them to be traditionalists, if not out and out neoclassicists.

If there is an area where Alexandrian art appears to have been distinctive and also perhaps highly influential in the rest of the Hellenistic world, it is not in the major arts of painting and sculpture but rather in the decorative arts. Tableware, in particular, made of gold, silver, and glass may have been an Alexandrian speciality. Scholars have sometimes wanted to liken the artistic direction of Alexandria to that of Paris in the heyday of the Impressionists, but a more appropriate analogy would probably be the Paris of Fabergé.

The decorative arts in Alexandria

The most impressive evidence for the quality of Alexandrian decorative metalwork comes from a 'treasure' of gold and silver objects discovered at Touk-el-Qaramous in the Nile delta in 1905 and 1906. These vessels were found in a mud-brick building behind a temple of uncertain dedication. The mud-brick building was apparently the temple treasury and had been abandoned some time in the third century B.C. Coins found with the gold and silver vessels date them to the first half of that

275 Rhyton from Touk-el-Qaramous. Silver. *Ca.* 300–250 B.C. Cairo, Egyptian Museum. H. 0.17 m.

276 Bowl from Touk-el-Qaramous. Silver. *Ca.* 300–250 B.C. Cairo, Egyptian Museum. H. 0.135 m.

century. There is a distinctly cosmopolitan cast to the objects in this treasure, with Greek, Egyptian, and Persian features intermingled. Of the four gold bracelets illustrated in the initial publication of the finds, for example, one is in the form of what looks like an Egyptian snake with jewelled eyes, another ends in two Hellenized-looking Egyptian sphinxes, a third has two Persian-style griffins, and the fourth has a purely Greek

Eros hidden in elegant foliage. The Persian character of a silver *rhyton* [275] from the treasure is so striking that the archaeologist who first published it speculated that it might be an object plundered in the Near East.[10] But as has been noted in connection with the funeral vehicle of Alexander, a Persianizing trend, perhaps intended tc evoke memories of the early conquests of Alexander and the Diadochoi, is a feature of early Hellenistic art, and it is thus reasonable to assume that the *rhyton*, like the other vessels in the treasure, was made in Ptolemaic Egypt. This clearly was the case, for example, with a silver offering bowl [276], the shape of which probably goes back to Achaemenid Persia but which is decorated with an Egyptian lotus-leaf design.

Bowls of the last type appear to have been common in Ptolemaic Egypt,[11] and, as several scholars have suggested, they are of particular importance in the history of the minor arts of the Hellenistic age because they served as the model for the class of terracotta vessels known as 'Megarian bowls' and thus had an influence which extended well beyond Ptolemaic Egypt.[12] Megarian bowls are hemispherical mold-made vessels decorated with clay stamps. They apparently originated in Athens, where the earliest datable examples have been found, but eventually the ware was found in many parts of the Hellenistic world.[13] The earliest types were decorated with floral designs – usually a rosette in the form of a medallion at the bottom of the vase and a series of lotus or palm leaves stretching upward from the medallion along the outside of the vessel. Later they came to be decorated with figural scenes illustrating a variety of myths and legends, including episodes from epic poetry. Some of these scenes, as already noted, are of considerable interest for the study of narration in ancient art (see Chap. 9). A comparison of an example of the floral type in Athens with the silver bowl from Touk-el-Qaramous [276] shows that the influence of Alexandrian metalwork on early Megarian bowls is too close to be accidental. It looks as if Megarian bowls were consciously invented by Athenian potters to serve as an inexpensive version of Ptolemaic silverplate, and it has recently been persuasively argued that there was a specific historical occasion which prompted the invention.[14] After winning independence from Macedonia in 229 B.C. the Athenians took steps to protect themselves from future Macedonian pressure by developing friendly ties with the Ptolemies. In *ca.* 224 B.C. they introduced the cult of Ptolemy III Euergetes into Athens and accompanied it with the establishment of an appropriate festival, the *Ptolemaia*. In all probability there was a procession connected with this festival similar to the one in Alexandria described by Kallixeinos (see Appendix III.4). It does not stretch the imagination to think of Ptolemaic gold and silver vessels being carried in this procession, dazzling the Athenian onlookers, and creating a taste for similar objects.

277 'Gold glass' bowl, probably from Alexandria. *Ca.* 300–250 B.C. London, British Museum. H. 0.114 m.

In addition to being a center for the creation of gold and silver plate there is a strong likelihood that Alexandria in the third century was the place of origin of a certain type of elaborate glassware known as 'sandwich glass' or 'gold glass.' Among the many vessels in Kallixeinos's description of the great procession of Ptolemy II there were two which are described as ὑάλινα διάκρυσα, probably best translated as 'glass vessels embellished with gold' or 'woven through with gold.'[15] This description would seem to fit an attractive type of Hellenistic glass bowl in which a layer of gold leaf, cut into intricate floral designs, was pressed between an inner and an outer layer of transparent glass [277]. Sixteen examples of the type are known. Their dates are the subject of some controversy, but most scholars would trace their origin to the first half of the third century B.C. Although they have been found in a variety of places, mostly in Italy, and only one fragment can be traced to Egypt, their closest stylistic affinities are with Alexandrian vessels in metal, terracotta, and faience. These stylistic parallels, combined with the apparent date of the vessels and the evidence of Kallixeinos, make the attribution of gold sandwich glass to Alexandria plausible, if not provable.[16] Certainly the elegance, preciousness, and suavité of a vessel like that in the British Museum [277] would seem more at home at the court of Arsinoe II and her contemporaries than anywhere else in the Hellenistic world.

Perhaps because of the great premium set on costly materials, pottery was the one aspect of the decorative arts in Alexandria that seems not to have reached any great distinction. One class of vases, a type known as 'Hadra ware' after the cemetery in which many examples of it were found, is, however, of passing interest for the small footnote that it adds to the history of ancient painting. Many Hadra vases were used as cinerary urns which were placed in niches in underground tombs. The

278 Hydria, Hadra ware. Painted pottery. *Ca.* 250 B.C. New York, Metropolitan Museum. H. 0.36 m.

overall range of dates for the ware is disputed but perhaps extends from *ca.* 300 B.C. to the early second century B.C.[17] The Hadra vases are *hydriae* with the major element in their painted decoration applied in a broad band just below the shoulder. The great majority of them are decorated with rather crudely drawn figures – floral motifs, sacrificial bulls' heads, Nikai, griffins, and the like – in a brownish glaze. On a few examples, however, this band is coated with a white slip on which polychrome figures are painted in tempera. In spite of the fact that the great majority of examples has been found in Alexandria, it has recently been proposed that the type with glaze directly on the clay ground originated in Crete. The polychrome variety, however, is probably an Alexandrian creation, and it is this type that is of the greatest art historical interest. The figures depicted on them represent objects of everyday use – mirrors, shields, boxes, fans, pairs of shoes, bowls of flowers – and are rendered in an illusionistic style using shading, foreshortening, and systematic lighting [278]. There is nothing unusual or surprising in the use of shading on these vases. Greek painters had been refining this technique since the fifth century B.C., and it was undoubtedly part of the normal technical training of Alexandrian painters. What is remarkable about these white-ground Hadra vases is their humble but unusual subjects, which deserve to be

recognized as the earliest 'still-life' paintings in the western tradition.[18] The Alexandrians clearly loved objects, and one wonders if a sophisticated tradition of still-life painting might not have first flourished in the opulent world of Ptolemy Philadelphos, a tradition of which the Hadra vases are a modest reflection.

Finally, we may turn to what is probably the best known, most admired and most problematical example of Alexandrian decorative art – the sardonyx cameo bowl (or cup; its exact function is uncertain) known as the Tazza Farnese. This vessel, which measures 20 centimeters (about 8½ inches) in diameter, is known to have been acquired by Lorenzo de Medici in 1471 from the treasures of Pope Paul II. Through the Medici it passed into the Farnese collection and from there to the modern Museo Archeologico in Naples. Its history before 1471 is not recorded, but it is tempting to speculate that it was a Ptolemaic royal treasure which came into the hands of the Roman emperors after the death of Kleopatra VII and that at the time of the collapse of the Roman Empire it was passed on to the Papacy. At any rate, the scene carved on the inside of the bowl is clearly Hellenistic in character [279], and virtually all scholars, even when they disagree about its date and interpretation, agree that it must somehow be connected with Alexandria.

In the lower center of the elaborate and elegantly carved scene on the inside of the Tazza Farnese, a female figure who wears a dress characteristic of Isis with a characteristic knot between the breasts is represented reclining on a sphinx. In her upraised right hand she holds what seem to be sheaves of grain. To the left of this figure a majestic bearded god sits against a gnarled tree and holds a cornucopia in his left hand. On the right side of the scene recline two sensuous, partially nude female figures. The lower figure has her back turned toward the viewer so that her spine and buttocks are visible, a composition that seems to have been developed by Hellenistic artists in the second century B.C.[19] In her left hand she holds a bowl which is reminiscent of the Tazza Farnese itself. The upper female figure puts her right hand on a cornucopia which seems to rest on her lap and with her left hand arranges her hair. In the center of the scene, framed by all these figures, strides a restless-looking male figure who is beardless but seems to have a mustache. On his left wrist hangs what appears to be a seed bag, and in his left hand he holds a knife or blade of some sort. The object which he holds up in his right hand (partially hidden behind the cornucopia of the bearded figure to the left) has been identified as a plow. At the top of the scene two male figures fly across the sky. One holds a cloak which billows out over his head, while the other blows a horn or a shell.

A definitive interpretation of this scene as an allegory of the fertility of the Nile was first proposed in 1900 by Adolf Furtwängler in his great work on ancient gems, and

279 The Tazza Farnese. Sardonyx cameo bowl. Date disputed, probably *ca.* 100 B.C. Naples, Archaeological Museum. Diam. 0.20 m.

while modifications to Furtwängler's interpretation have been proposed from time to time, his interpretation still serves as a basic point of departure for many who study the scene. Furtwängler identified the seated figure with the cornucopia as the Nile himself and the Isis-like figure seated on the sphinx as Eutheneia, the personification of 'Abundance' or 'Prosperity,' who was sometimes identified as the consort of the Nile. The male figure with the plow was interpreted as a conflation of Isis's son Horus and the Eleusinian hero Triptolemos, who first taught the art of agriculture to mankind. The two female figures on the right were seen as Horai, or 'Seasons,' specifically the two annual seasons of flood and growth along the Nile, and the male figures overhead as the Etesian winds that bring these seasons to Egypt. The 'message' of the Tazza Farnese, for those who were able to read it, was that the prosperity of Ptolemaic Egypt derived from a cosmic process through which the winds regularly brought floods to the Nile and, in the wake of these floods, a season of fertility which enabled men to apply their skill as farmers and reap the river's bounty.

The Tazza Farnese gives visual form to the same sophisticated bucolic atmosphere that is found in the poetry of Theokritos and to the learned atmosphere of the poetry of Kallimachos. Both poets would have found it appealing. A cameo of this size and intricacy must have been extremely rare, perhaps unique. Whoever made it clearly designed it for a refined audience whose understanding could be taken for granted. The idea that the bowl was made for one of the Ptolemies and expresses the sophisticated, educated taste of the Alexandrian court is not far-fetched. Undoubtedly if we were Alexandrian intellectuals we would be able to detect other subtleties which now elude us. The 'Triptolemos' figure, for example, is a puzzle. His dishevelled hair has been likened to that of a satyr. The fact that he seems to have a mustache but no beard is even more peculiar. Ancient Greeks were either clean shaven or wore a full beard; only foreigners, like Gauls, wore mustaches and no beard. Gauls played a prominent part in Ptolemaic Egypt as mercenary soldiers. Is this figure a Gaul, and if so is there some subtle political allusion (e.g. the need for beating swords into ploughshares) that we miss? The fact that the Tazza continues to be at least partly enigmatic to 'outsiders' probably would have pleased its designer.

The great majority of scholars have been willing to accept the Tazza Farnese as a Hellenistic work,[20] but just where it should be dated within the Hellenistic period is a matter of dispute. Estimates have ranged from the third to the late first century B.C. The two most detailed attempts to date it precisely are those of Jean Charbonneaux and F. L. Bastet. Charbonneaux accepted Furtwängler's principle of allegorical interpretation, but argued that the three figures in the center of the scene on the Tazza, the Eutheneia, the Sphinx, and the 'Trip-

tolemos,' were actually portraits of three Ptolemaic rulers, a queen represented as Isis, a deceased king (the sphinx) visualized as Osiris, and a living king represented as Horus. The triad of rulers who best fit these roles, Charbonneaux proposed, was that of Ptolemy V Epiphanes (the Sphinx), who died in 180 B.C., Ptolemy VI Philometor (Horus), and Kleopatra I (Isis), the widow of the former and mother of the latter, who died in 176 B.C. If these identifications are correct the date of the Tazza is probably best assigned to *ca.* 180–176 B.C.

The portraits of the Tazza Farnese are sufficiently general, however, as to preclude any certain identification. (The Triptolemos–Horus, in particular, does not look like any known Ptolemy.) This uncertainty prompted Bastet to see if he could date the Tazza purely on the basis of style and then to see if there were any historical figures whose portraits could be correlated with a stylistic date. On the bottom of the Tazza there is carved the head of a Gorgon set against an aegis and surrounded by writhing snakes, two of which are intertwined beneath its chin. The Gorgon's animated wreath of hair and pathetic expression are part of the legacy of Hellenistic baroque (see Chap. 5), and the closest parallels for them (see, for example, [28]) seem to date to *ca.* 100 B.C. Other features, such as a mannered quality in the drapery of the 'Nile' and 'Isis,' the rear view of the lower Season, and the body structure of the 'Winds' also point to this date. If this is the most probable date of the Tazza, its portraits, if one chooses to believe in them, could represent Ptolemy VIII Euergetes II, who died in 116, Kleopatra III, and their son Ptolemy X Alexander I, who ruled jointly with his mother after 107 B.C.

An even later date has recently been proposed by Dorothy Thompson, who sees the 'Triptolemos' figure as Octavian bringing peace and fertility to a waiting world after the troubled era of civil strife in the late Roman Republic had finally been brought to an end. Even if this interpretation proves difficult to sustain, the stylistic arguments adduced to support a date late in the Hellenistic period, supplementing those of Bastet, are persuasive. On balance, a date in the first century B.C., perhaps 100–50 B.C., which would allow for a mixture of baroque, mannered, and neoclassical features, is most probable.

Ptolemaic Pharaonic art and its influence on the Greeks

Ptolemaic art in Pharaonic style should not, technically, even be classed as Hellenistic, since the term 'Hellenistic' implies something that is Greek in origin and inspiration. Nevertheless, in order to emphasize how thoroughly split the personality of Ptolemaic official art was, it will be useful to look at a few of the most impressive Ptolemaic creations in the ancient Egyptian style. In addition to official portrait sculpture in the Pharaonic style, like the

280 Edfu, temple of Horus. 3rd to 1st century B.C.

portrait of Arsinoe II described above, the Ptolemies also subsidized the creation of large new temples in the old style. The most majestic of these are the temple of Horus at Edfu [280] and of Horus and Sebek (a crocodile-headed god of the Nile) at Kom Ombo.[21]

The great temple at Edfu has all the basic characteristics of earlier Pharaonic temples: huge pylons leading to a colonnaded court, followed by a vestibule, a hypostyle hall, and finally the innermost shrine [281]. The degree of Ptolemaic commitment to the construction of the temple is reflected by its long history. The main shrine was begun by Ptolemy III Euergetes in 237 B.C. and finished under Ptolemy IV Philopator. Relief sculptures were added to it by Ptolemy VI Philometor and Ptolemy VIII Euergetes II. The latter also had the vestibule constructed. The courtyard and pylon were added by Ptolemy IX Lathyros and Ptolemy XI Alexander II, and the final touches were added by Ptolemy XII Auletes in *ca.* 57 B.C.

The temple at Kom Ombo, which was built *in toto* by Ptolemy VI Philometor but had decorative details added to it later, is essentially similar in plan except for the fact that it contains two chapels in its innermost shrine. To do justice to all the decorative details of these great structures would be beyond the scope of this chapter, but one illustration may be used to emphasize how thoroughly Egyptian they are. [282] is a relief from Kom Ombo depicting Horus bestowing gifts on Ptolemy VIII and the two Kleopatras. That the two titanic women in the relief, 'the Sister' and 'the Wife,' could be transmuted into such docile and familiar-looking images of holy queenship

testifies to the amazing persistence, coherence, imperturbability, and perhaps impenetrability of the Pharaonic style. The Ptolemies used it but made no attempt to infuse it with their own personality.

What was the degree of interpenetration, if any, between the Greek and Pharaonic styles? There clearly was borrowing of Egyptian motifs in Greek art, as, for example, the sphinx on the Tazza Farnese (see [279]) and lotuses etc. in Alexandrian metalwork (see [276]), but in these cases the borrowed motifs were always adapted to the Greek style. There was also occasionally a simple juxtaposition of Pharaonic forms and Greek forms in the same architectural context. Examples of an actual mixing of the two styles, however, are rare and usually tentative and ineffective.

Juxtaposition of Pharaonic and Greek forms in the same architectural context may have been a symptom of the ascendancy of the Egyptian component in the population of Ptolemaic Egypt after the battle of Raphia. One of the earliest datable examples of it is preserved in yet another of those literary descriptions of Alexandria which Athenaios took from Kallixeinos of Rhodes (see Appendix III.4). In this case the description is of a luxurious river boat built for Ptolemy IV Philopator (Athenaios 204E–206C). The plans of the two decks of this boat were laid out rather like the plan of a Greek villa with a colonnaded entrance vestibule, porticoes, dining rooms, bedrooms, and shrines. Most of the rooms of the boat appear to have been Greek in style, like the main dining room which was panelled with expensive wood

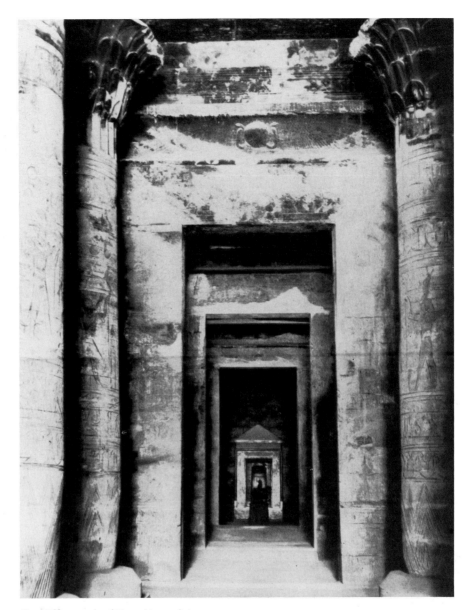

281 Edfu, temple of Horus, inner shrine.

and fitted with a Corinthian colonnade decorated with ivory and gold (205 B–C); or the tholos-shaped sanctuary of Aphrodite with a marble image of the goddess (205 D); or the Bacchic dining room which was equipped with a little cave containing portraits of the royal family (205 F). But in addition to these there was still another dining room, apparently on the first floor and reached by a secret circular staircase, which is described as follows:

After this there was an open space which occupied the spot right above the underlying vestibule. A circular stairway was placed there leading to the hidden portico and to a *symposion* with nine

couches, of which the construction was in the Egyptian style. For the columns which were placed here rose with rounded profiles, and the drums of the columns were differentiated with a black drum followed by a white drum set in an alternating pattern. The capitals of some of them are circular, and the complete design of them is like rosebuds which have opened a little. But around the part called the *kalathos* ['basket'] there are no volutes as on the Greek column, nor are there rough leaves, but rather there are the calyxes of river lotuses and the fruit of palms [dates] which have recently bloomed. In some cases there are several other varieties of flowers sculptured on them. The part below the root, which rests upon the drum connected to the capital, has a design which is like the interwoven flowers and leaves of the Egyptian

282 Relief depicting Horus, Ptolemy VIII, Kleopatra II, and Kleopatra III, on the temple of
Horus and Sebek at Kom Ombo. Mid-2nd century B.C.

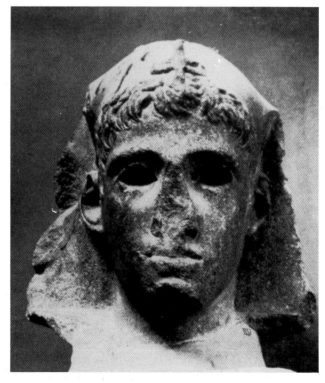

283 Portraits of Ptolemy VI (*ca.* 186–145 B.C.). Granite. (a) Athens, National Archaeological
Museum. H. 0.60 m. (b) Alexandria, Graeco-Roman Museum. H. 0.61 m.

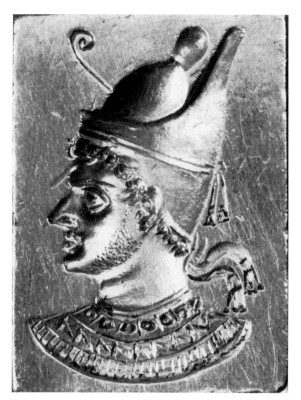

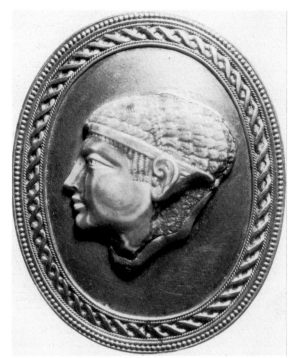

285 Sardonyx gem with portrait of a Ptolemaic queen. 2nd or 1st century B.C. Boston, Museum of Fine Arts. H. 38 mm.

284 Gold ring with Ptolemaic portrait. Probably 2nd century B.C. Paris, Louvre. 25 x 34 mm.

bean-plant. In this manner, then, the Egyptians make their columns. They also vary their walls with white and black bricks, and sometimes they make them from the stone called alabaster.

Among the surviving examples of the juxtaposition of Greek and Pharaonic forms in painting the most impressive is Tomb II, dating from the middle of the second century B.C., in the Anfushi cemetery on the island of Pharos in Alexandria. Here the landing of the staircase leading into the tomb has funereal scenes in purely Egyptian style, while the grave chambers have what seem to be Bacchic scenes painted in a purely Greek style.

The most interesting examples of attempts at an actual fusion (as opposed to juxtaposition) of the two styles are a pair of portraits of Ptolemy VI Philometor, one now in Athens [283a], the other in Alexandria [283b], and two Ptolemaic gems which probably also date from the second century B.C. [284 and 285]. The head in Athens is made of Egyptian granite but was found in the harbor in Aegina. Most probably it was made in Egypt but set up by Philometor for political purposes somewhere in Greece, perhaps in the sanctuary of Isis at Methana.[22] The Egyptian headdress, the granite of which it is made, and the rather simplified features give the portrait an Egyptian feeling, but the locks of hair projecting beneath the headdress and the modulation of the surface around the

eyes and forehead were clearly designed to appeal to Greek sensitivities. The portrait from Aboukir, now in Alexandria, is identified as Philometor on the basis of its similarity to the head in Athens. Its principal gesture to Greek taste is seen in the naturalistically tousled locks of hair beneath the headdress. Otherwise, with its hard outlines around the eyes and the mouth, and the largely unmodulated surfaces of the face, it is basically in the Pharaonic tradition. A similar range in emphasis, as Noshy has suggested,[23] is detectable in the two gems in question. On a gold ring in the Louvre [284] we are confronted with a portrait of a Ptolemaic king wearing the crown of upper and lower Egypt which is basically an exercise in Hellenistic realism. The fact that the shoulders of the bust are fully frontal, however, while the head is in profile is an allusion to the familiar format of Pharaonic reliefs. If the ring is mainly Greek, a sardonyx cameo in Boston [285] with the portrait of a Ptolemaic queen wearing a 'vulture cap' (now broken away) as well as a diadem is basically Egyptian. Its schematic locks of hair and the stylized ear as well as the essentially frontal eye on a profile face are clearly designed in the Pharaonic manner, but again there is a soft modulation around the nose, mouth, and chin which remind one that the queen, like the other rulers of the dynasty, was a displaced Macedonian.

APPENDICES

APPENDIX I
The chronology of Hellenistic sculpture

The most difficult problem which Hellenistic art poses for those who study it is how to date much of its sculpture. In the Archaic period the gradual development of naturalistic representation, both for anatomy and drapery, serves as a fairly reliable criterion. For Classical sculpture, literary sources and inscriptions have made it possible to establish a substantial number of fixed points (the temple of Zeus at Olympia, the Parthenon, the Mausoleum at Halikarnassos, etc.), and the overall stylistic development of the period is so well understood that disputes about dates often involve only a decade or so. In the case of Hellenistic sculpture, on the other hand, there is no single stylistic criterion by which particular statues can be dated and, considering the length of the period, there are relatively few fixed points in its development. As we have seen there were many styles – baroque, rococo, neoclassical, realistic – in use during the Hellenistic period, and some of them were certainly used at the same time. In a few cases, in fact, it can be documented that the same artists resorted to distinctly different styles, depending upon what sort of sculpture they were called upon to make (Dionysios and Timarchides, for example; see p. 75). To compound the confusion even more, there were also frequent revivals of older styles as well as an overlapping of new styles. The result of all this is that when a work of Hellenistic sculpture is not dated by historical circumstances (as are, for example, the friezes of the Altar of Zeus at Pergamon) estimates for its date can vary dramatically. The popular portrait type identified as Menander, for example, has been dated by some eminent authorities to *ca.* 300 B.C. and by other equally eminent authorities to *ca.* 30 B.C. So wide a divergence in the dating of an Archaic or Classical work is unthinkable. Probably the most dismaying of all disputed dates is that of a statue of a youth from Tralles in Asia Minor, now in Istanbul [286]. Because of the Polykleitan style of its head a few scholars have dated it to the 5th century B.C. Others, because of its cross-legged stance, which resembles that of figures on later Attic grave stelai, have assigned it to the 4th century B.C. Some see it as a work of post-Lysippan realism, to be assigned to the 3rd century B.C. Perhaps the majority of scholars see it as an eclectic work of the late Hellenistic period, one which mixes realistic and neoclassical elements; but still others see it as a creation of the Roman period and date it as late as the time of Hadrian. The estimated dates for the Tralles youth range, in other words, over more than 600 years.

The most obvious way to date works of Hellenistic sculpture whose date is not fixed by external evidence is to isolate and define the most typical stylistic features of works which are fixed points and then determine to what extent the undated works

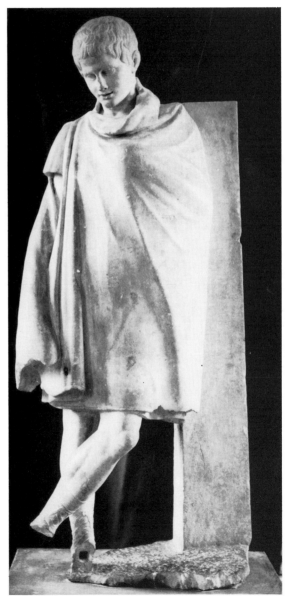

286 Youth, from Tralles. Marble. For the date, see text. Istanbul, Archaeological Museum. H. 1.475 m.

287 Statue of the priestess Nikeso from Priene. Marble. 300–250 B.C. East Berlin, Staatliche Museen. H. 1.73 m.

288 Statue of Themis by Chairestratos. Marble. *Ca.* 300–250 B.C. Athens, National Archaeological Museum. H. 2.22 m.

have features which resemble them. This procedure is, of course, much more problematical than it might at first seem. What does one do, for example, with statues that have a composition resembling works of one period, anatomy resembling works of another, and drapery similar to works of still another? Before getting into this problem and looking at some of the attempts that have been made to devise reliable criteria for dating Hellenistic sculpture, it will be useful to sum up what our principal fixed points are.

Fixed points

(This list omits Archaistic sculptures, which constitute a separate problem and have been reviewed in Chap. 8. It also omits coin portraits which, as noted in earlier chapters, are often helpful in identifying particular sculptured portraits but cannot

record a sculptural style in detail. An asterisk indicates that the work is known only in copies.)

1. The Alexander Sarcophagus (pp. 38ff.) [32–33, 37–38]. Dated to 325–311 B.C. by archaeological evidence and by its association with Abdalonymos.
2. Minor votive and 'record' reliefs. Dated 329 B.C., *ca.* 317 B.C., and 294 B.C. by inscriptions.[1]
3. The Tyche of Antioch by Eutychides* (pp. 3, 55) [1]. Dated *ca.* 300 B.C. on the basis of literary evidence.
4. The portrait of Demosthenes by Polyeuktos* (p. 62) [55–56]. Dated 280 B.C. on the basis of literary evidence.
5. The portraits of Epicurus, Hermarchos*, and Metrodoros (pp. 66–9) [60, 62, 64]. Dated *ca.* 300–270 B.C. Although it is unlikely, these portraits could be posthumous, in which case their use as chronological fixed points is vitiated.

289 Statues of Dioskourides and Kleopatra. House of Kleopatra, Delos. Marble. 138/7 B.C. *In situ.* H. 1.67 m and 1.52 m.

6. Statue of the priestess Nikeso [287], datable by its inscription to the first half of the 3rd century B.C. (*Inschriften von Priene*, no. 173).

7. The Themis of Chairestratos [288]. Dated 300–250 B.C. on the basis of its dedicatory inscription.

8. Tarentine tomb sculptures (p. 112) [114–115]. Dated *ca.* 325–275 B.C., with some perhaps as late as 250 B.C.

9. The Gallic dedications of Attalos I* (pp. 83–97) [85–96].

Dated *ca.* 230–200 B.C., although many details are disputed.

10. Ptolemaic faience 'queens' vases' (see p. 273) [274]. These are technically not works of sculpture but clearly reflect sculptural style. Dated examples range from *ca.* 270 B.C. to 204 B.C.

11. Sculptures from the Altar of Zeus at Pergamon (pp. 97–110) [99–109]. Dated *ca.* 180–160 B.C. on the basis of their historical context.

12. The sculptures by Damophon from Lykosoura (p. 165) [166–168]. Dated *ca.* 180–160 B.C., although this dating has recently become controversial and a later date is possible (see p. 312, Chap. 8, note 2).

13. The Monument of Aemilius Paullus at Delphi (p. 156) [162–164]. Dated *ca.* 167 B.C. because of its association with the battle of Pydna.

14. The Athena and other neoclassical sculptures of Euboulides (p. 165) [169]. Dated *ca.* 130 B.C. by literary, epigraphical, and archaeological evidence.

15. Draped figures from Delos: Dioskourides and Kleopatra [289], dated 138/7 B.C., and a figure of Isis dated 128/7 B.C. The dates are deduced from inscriptions.

16. Late portraits from Delos (p. 73) [75–77]. Not precisely datable, but historical circumstances place them between 166 and 69 B.C., with most of them dating probably to *ca.* 100–88 B.C.

17. Sculptures from the Mahdia shipwreck (pp. 139–40) [149 and 151]. The date of the wreck, in the first quarter of the first century B.C., provides a *terminus ante quem*, but when the various sculptures were actually made is arguable.

18. The Stephanos Youth* (p. 175) [183]. Dated *ca.* 50 B.C. on the basis of Stephanos's association with Pasiteles.

19. The friezes from the temples of Artemis Leukophryene at Magnesia (see p. 246) and of Hekate at Lagina. The temples are probably datable to *ca.* 150–100 B.C.

20. (?) The Nike of Samothrace (pp. 113–17) [117]. Datable to *ca.* 190 B.C. if the association of it with the battle of Magnesia is correct.

Criteria for dating other works

The criteria which are often used to assign dates to works which cannot be dated by external evidence fall into four categories: composition, surface modeling, drapery style, and content.

A. Composition

This has been the most often employed and most controversial criterion. The most far-reaching and influential use of it was in a system proposed by Gerhard Krahmer in two classic articles published in the 1920s (see bibliography). The development of the ways in which Hellenistic sculptors designed their statues, Krahmer proposed, could be divided into three basic phases. The first, which he called the *schlicht* ('plain' or 'smooth' style), was dominant from the beginning of the Hellenistic period down to the time of the Gallic dedications of Attalos I at Pergamon (i.e. the last quarter of the 3rd century B.C.). The compositions of this period were characterized by what Krahmer called 'closed' form. Although the statues of this period often had considerable torsion, on the model of the Apoxyomenos [39] and other works of Lysippos, their planes and drapery lines tended to focus on and be unified by a single point within the composition. A typical example was the Anzio Girl [49], in which the direction of the head, the lines of the drapery, and the turning of the body all lead the eye to the tray which she holds. Such a composition has the effect of closing the composition in upon itself. When an object like the tray was missing this effect was sometimes achieved simply by a downward glance that fixed a point directly in front of the statue and closed it in, as, for example, in the case of the Conservatori Girl [51], which Krahmer took to be a Lysippan work. The date of this *schlicht* phase in the early and middle 3rd century B.C. was assured, Krahmer felt, both by the Lysippan

290 Poseidon, from Melos. Marble. *Ca.* 150 B.C. Athens, National Archaeological Museum. H. 2.17 m.

associations of many figures and also by the Demosthenes of Polyeuktos [55–56].

Beginning in the 220s B.C. a new style began to appear which Krahmer termed the middle Hellenistic 'pathetic' style. It was characterized, at first tentatively and later extensively, by what he called 'open form.' In mature works of this style, like the Zeus from Pergamon [112], the Poseidon of Melos [290], or the Barberini Faun [146], all of which Krahmer dated to around the middle of the 2nd century B.C., the planes of the sculptural surface radiate outward in various directions in the manner of a multifaceted gem. Krahmer also saw an incipient phase in the open style, however, in which the composition was essentially closed but allowed one feature, usually a face, to break out dramatically from the closed form. Thus the essentially closed pyramidal composition of the Dying Gaul and his Wife [86] is broken by the anguished outward glance of the Gaul's face. Using the Gaul both as a stylistic index and also as a fixed chronological point, Krahmer assigned works with a similar composition, most notably the Pasquino group [119] and the Terme Boxer [157], to the period around 200 B.C.

Although it had a lingering afterlife, Krahmer felt that the open style had essentially run its course by 100 B.C. In the late 2nd and 1st centuries B.C. a new type of composition came into vogue in which figures were designed to be seen from a single viewpoint, a type of composition which is succinctly expressed in German by the term *einansichtig*. Unfortunately, from the standpoint of later scholarship, Krahmer cited the Laokoön group [124], then confidently dated to *ca.* 50 B.C., as the most

typical example of this new composition, but other works usually considered late Hellenistic, like the Dresden Hermaphrodite group [140], were also analyzed. Krahmer rejected the view that *einansichtig* groups were borrowed from painting and felt that they were a purely sculptural solution, anticipated in works like the Poseidon of Melos [290], to the problem of reconciling open form with clear visual planes. He did not argue that all late Hellenistic sculptures were *einansichtig* but did feel that 'one-view' composition was an index of a late Hellenistic date.

Krahmer's ideas and terminology exercised considerable influence on later writers, as a look at familiar works like Bieber's *The Sculpture of the Hellenistic Age* will confirm. Few scholars today would be willing to use 'closed' and 'open' form as a fool-proof index for dating, but the insights which they represent are still respected and often serve as points of departure for other attempts to date Hellenistic sculpture on the basis of composition.

It should be noted that virtually all scholars who specialize in dating by composition tacitly begin with an assumption that a modern artist might find questionable: namely, that in any given period of Hellenistic art a sculptor could be expected to use only one type of composition (closed, open, multi-viewpoint, single-viewpoint) to the exclusion of others. Thus if the 'boy strangling a goose' type has a multi-viewpoint composition it *must* belong to the 3rd century B.C. and could not be a work of Boethos of Chalcedon (see pp. 128, 140), and if the Pasquino group is found to have a single-viewpoint composition, it *must* date to the later 2nd century B.C.[2] It is a characteristic of Classical art historians that they expect uniformity and evolutionary regularity in all periods of Greek art, yet one wonders, particularly in the case of the Hellenistic period, whether this expectation is realistic and dependable. As noted above, there is some evidence that Hellenistic sculptors were capable of altering their styles to suit the commission that was at hand. That Boethos, working in the mid-2nd century B.C., might have employed a compositional type characteristic of the 3rd century B.C. in order to create a rococo parody of works like the Attalid battle groups is neither impossible nor perhaps even improbable.

B. Surface modelling

The use of surface details as a criterion for dating will be sufficiently obvious that it need not be expounded at great length. Deep carving, surface undulation, and exaggerated swelling of anatomical features, in the manner of the Gigantomachy of the Pergamon altar [99–109], suggest a date in the late 3rd or early 2nd century B.C. Restrained realism in the tradition of the Demosthenes of Polyeuktos [55–56] could imply an early-3rd century date; and smooth planes with sharp edges, as in the Athena of Euboulides [169], can be taken to imply late Hellenistic neoclassicism. Given the frequently eclectic nature of Hellenistic sculpture, however, other elements in any given sculpture obviously have to be taken into account before a reasonable judgment can be rendered.

C. Drapery

The manner in which drapery is designed is often one of the most reliable indices for dating sculptures which have drapery, but its use is bedeviled by the fact that earlier styles were constantly revived throughout the Hellenistic period, with the result that a work of the late 2nd century B.C. can be mistaken for a work of the early 3rd century B.C. and vice versa. In spite of this problem and the inevitable possibility that some styles were contempor-

291 Statue by Apollodoros of Phocaea. Marble. *Ca.* 150 B.C. London, British Museum. H. 1.67 m.

ary or at least overlapped one another, it does seem to be possible to define several distinct styles of drapery which can be correlated with particular periods. The early and middle 3rd century B.C. was typified by the essentially balanced and orderly drapery of the Themis of Chairestratos [288], which echoes compositions of the 4th century B.C.[3] The drapery of the Themis can be distinguished from its fourth-century model, however, by its greater structural independence and its increased variegation of surface texture. Earlier patterns of drapery tended to be subordinate to the contours and main divisions of the body, whereas in the Hellenistic period the drapery was often used to mark them. The left knee and hip of the Themis are essentially hidden, for example, by folds of drapery, as they also are in the Demosthenes of Polyeuktos [55–56]. This structural independence and emphasis on texture appears in a different form on the statue of the priestess Nikeso from Priene, datable on the basis of epigraphical evidence to the middle of the 3rd century B.C. [287]. Here the mantle wound around the body is enriched with strong vertical striations which have a form of

292 Bronze statuette, known as the 'Baker Dancer.' Date
disputed. 250–150 B.C. New York, Metropolitan
Museum. H. 0.21 m.

seem to be typical of the middle and late 2nd century B.C. A
datable example of it, although not of the most sophisticated
workmanship, is the Kleopatra from Delos (138/7 B.C.) [289].
Other examples, datable to the mid-2nd century B.C., come from
Pergamon. Perhaps the most impressive example of virtuosity in
this style is the torso from Erythrai in Asia Minor, now in the
British Museum, signed by the sculptor Apollodoros of Phocaea
[291].

In the late 2nd and early 1st centuries B.C. this rich style, which
essentially goes with 'Hellenistic baroque' sculpture, continued
to be used at times, but there were also, as one might expect,
frequent revivals of older styles. A figure from Thasos dating to
ca. 100 B.C., for example, calls back the more stable and
harmonious drapery style of the 4th century B.C. and reveals
itself as Hellenistic only by its richness of texture and still
somewhat baggy contour.

D. Content
Dating Hellenistic sculptures by the character of their subject
matter is a particularly treacherous enterprise but is nevertheless
sometimes resorted to when all else fails. Works which betray a
dramatic or pathetic quality are sometimes assigned to the late
3rd or early 2nd century B.C. because of a presumed parallel with
the sculptures of Pergamon. Figures that seem to have a playful,
rococo character are put in the late 2nd or early 1st century B.C.
on the assumption that a rococo phase in Hellenistic art, as Klein
proposed (see p. 127), ought to be later than its baroque phase. If
a work seems to revive pre-Hellenistic motifs (dancing Maenads,
procession of gods, etc.), it is usually assigned to the neo-Attic
phase of Hellenistic sculpture.

One obvious difficulty with attempting to date works on the
basis of these broad criteria is the subjectivity involved in
identifying the criteria. What seems pathetic or realistic to one
person may seem comic or rococo to another (see Chap. 6).

One of the most perplexing problems confronting scholars who
attempt to date works of Hellenistic sculpture on the basis of the
above criteria is that they often lead to contradictory conclu-
sions. The Terme Boxer [157], for example, shows, in the turn of
its head, Krahmer's incipient open form and might therefore be
dated to the late 3rd century B.C. Its pathetic realism, however,
would make it a more likely candidate for the late 2nd century
B.C. A delightful bronze statuette in the Metropolitan Museum
known as the 'Baker Dancer' (after the collector who first
acquired it) [292] should on the basis of its open form and
contrasting textures of drapery (transparency in the mantle
reveals other drapery underneath) be dated to the mid-2nd
century B.C., yet an eminent authority argues that the specific
type of garment that the dancer wears, and the dancing motif
itself,[4] belong to the 3rd century. The Pasquino group [119] has
usually been dated to *ca.* 200 B.C. on the basis of its structural
similarity to the group of the Gaul and his Wife [86], but it has
recently been argued that the composition of the group lacks the
true three-dimensionality of the Gallic group, that it is closer to
later groups which emphasize one particular viewpoint, that
details of it betray the influence of the Altar of Zeus, and that it
should thus be dated to the second half of the 2nd century B.C.[5]

To attempt to review and resolve all the disputes about the
dates of particular Hellenistic sculptures would require a
second, probably polemical, book, which would in the end be
inconclusive. Chronology, for the most part, belongs to Plato's
realm of *doxa* (opinion). In this book I have frequently given my

their own and yield neither to anatomical structure nor even to
the major folds of the garment.

Toward the end of the 3rd century B.C. one can detect in the
Ptolemaic queens' vases [274] the beginnings of a new overall
structure for draped female figures in which garments tended to
be belted just under the breasts, the shoulders were made to seem
small, and the drapery around the feet spread out in a 'baggy'
fashion, thus creating a conical form for the whole figure. In the
2nd century this form is combined with an intensification of the
structural independence of drapery. As already observed in
connection with statues of the high Pergamene style like the
'Tragoidia' [113], drapery forms now sometimes not only mask
anatomical forms but also at times conflict with them. Along
with this increased structural independence there is also a new
emphasis on richness of texture, the most remarkable form of
which involves a revival of the illusion of transparency, not,
however, to reveal anatomy, as in the Classical period, but
rather to reveal heavier drapery underneath [291–292]. Traces
of this technique have been observed on terracottas datable to
the 3rd century B.C., but in large-scale stone sculpture it would

own feelings about where particular sculptures belong in the history of Hellenistic art, but these opinions are offered without dogmatic certitude. In Krahmer's time the Laokoön was confidently dated to *ca.* 50 B.C. A few decades later Gisela Richter

made a good case for placing it in the mid-2nd century B.C. Now the evidence from Sperlonga (see pp. 120–6) has pushed it into the 1st century A.C. This story alone should make scholars humble.

APPENDIX II

The ruler cult and its imagery

The models for the organization of Hellenistic kingship and for the nature that a king ought to project were established by Alexander. At the beginning of his career, as king of Macedonia, he ruled by virtue of what has been called a 'quasi-constitutional' position.[1] He had been elected by the Macedonian army, the free citizens of the realm in arms, and he could be deposed by them. His peers, the 'companions,' were Macedonian aristocrats, like Ptolemy and others, who had their own land and family associations in Macedonia. When Alexander conquered the Persian Empire it was inevitable that this position would change. It was unthinkable, at least in principle, that the Great King, the ruler of most of the world, could be deposed by a vote of the Macedonian land-holders. It was undoubtedly for this reason, as well as to meet the exigencies of administration, that Alexander made a determined effort to shape a new aristocracy in which his recently conquered eastern subjects would play a role. The members of this new inner circle increasingly held their positions not as a result of the traditional aristocratic status of their families but simply because the king had appointed them. Power and order in the kingdom came to depend almost entirely on the personality and will of the king. The Successors, each eager to solidify his own new realm, did their best to perpetuate this model because it seemed adaptable to the circumstances in which they found themselves. 'Resting as it did on a king-made aristocracy,' as the historian William Scott Ferguson observed, 'and not, as in Macedon and in Persia, on a nobility that sprang from the soil, Hellenistic kingship possessed a strongly marked cosmopolitan character. It was a type of monarchy that could be applied in any Empire . . .'[2]

But what, aside from sheer power and luck, gave the king his right to rule? If it was not freely given by his countrymen, where did his power come from? The answer worked out by Alexander and his advisors seems to have been that his power came to him by virtue of his divine ancestry and the fact that he was himself, in a sense, a god. Almost all subsequent Hellenistic monarchs (the most notable exception being the Antigonids, who followed traditional Macedonian custom) seized upon this idea of the king's divinity as the justification of their right to rule, and from it grew the Hellenistic ruler cult and its imagery.

The habits of thought that made it possible for the idea of the divine ruler to be accepted in Hellenistic society are diverse and complex. The idea that the king was a divinity who sojourned temporarily on earth was a religious conception of Pharaonic Egypt, and Egyptian thought undoubtedly played some role in shaping the Ptolemaic ruler cult. But the deification of rulers in the Hellenistic world was an institution whose significance was primarily political rather than religious, and the thinking behind it was probably more Greek than Egyptian. The Greeks had long accepted the possibility that a mortal man, as a result of great achievements, could become a god after death. It had been thus with Herakles, Dionysos, and Asklepios. Even lesser figures, for example the founders of cities or important military leaders,

were frequently worshipped after their deaths as 'heroes' in the Archaic and Classical periods. It was not, therefore, a complete departure from tradition when Euhemeros, the early Hellenistic utopian novelist, proposed that all the gods had once been mortal beings whom their subjects had later deified.

Even the worship of living men had its precedents in Greece before the time of the Hellenistic monarchies. The Spartan admiral Lysander, for example, had been worshipped during his lifetime by the Samians after he freed them from Athenian control *ca.* 403 B.C. (Plutarch, *Lysander* 18). The honors accorded Lysander were clearly a sort of *political deification*, a public expression by the worshippers of gratitude for what they considered a significant political benefaction. The Athenians, with little hesitation, deified and worshipped Demetrios and Antigonos after their 'liberation' of Athens in 308 B.C. It is unlikely that anyone ever looked on these men as deities in a personal, spiritual sense. No one ever prayed to a Hellenistic king for personal spiritual solace. There were other cults which filled that need (see p. 8). But cities or states could use the vehicle of public worship to acknowledge the palpable reality of political power. The spirit in which king-worship was carried forward is best captured by a song that, according to Athenaios, the Athenians directed at Demetrios.

> The other gods either do not exist or are far off, either they do not hear, or they do not care; but you are here and we can see you, not in wood or stone, but in living truth. (Athenaios 253D)

All of these strands in Greek thought regarding the deification of mortals seemed to come into a single focus in the figure of Alexander. Tradition, his own temperament, and hard political realities combined to affirm his divine status. First, as a mortal who had done great deeds and as a descendant of a family that claimed Herakles as its ancestor, he was a natural subject for a hero cult. Second, the personal mysticism which led him to see something special in his own nature (a mysticism already abetted by his mother Olympias's stories about his miraculous birth and by his visit to the oracle of Zeus Ammon in Egypt, where the prophetic priest who was the god's voice was said to have greeted him as the son of Zeus) was further stimulated by the assertion of Kallisthenes, a philosopher in his retinue, that in addition to Ammon three other oracular sources and omens had declared him to be the son of Zeus.[3] And, third, there was the practical need, already cited, to put his rule over his Macedonian and Greek subjects on a new footing. This need was translated into policy when, in 324 B.C., the Greek cities of the League of Corinth were requested to recognize him as a god. The League of Corinth had been founded by Philip II after 338 B.C. as an offensive and defensive alliance. As king of Macedonia and Philip's successor Alexander could convene the League and had a vote on its council, but he had no legal right to intervene in the internal affairs of the member cities. In 324, when he wanted to

repatriate a large number of wandering exiles to their native Greek cities, he found he had no accepted justification for doing so. Deification provided him with a way out of the impasse without the use of force. By becoming a god he rose above the pacts that restrained him as a man. His deification became, in other words, a legal sanction for, and a legal acknowledgment of, his actual power.[4]

After Alexander's death, political deification of the Diadochoi from time to time by different cities was not uncommon. In addition to Demetrios and Antigonos, the honor was accorded to Lysimachos, Kassander, Seleukos, and Ptolemy. For a full-fledged ruler cult to develop, all that was required was a formalization of this practice so that it could be applied on a regular basis to each successive ruler of a particular dynasty.

a

b

c

d

293 (a) Gold octadrachm of Ptolemy II (285–246 B.C.), obverse, superimposed portraits of Ptolemy II and Arsinoe II. London, British Museum. Diam. approx. 30 mm. (b) Gold octadrachm issued by Ptolemy II with portrait of Arsinoe II on the obverse. Athens, National Archaeological Museum. Diam. approx. 29 mm. (c) Silver tetradrachm of Alexander Balas with portraits on the obverse of Alexander and his wife, Kleopatra Thea. *Ca.* 150 B.C. Diam. approx. 29 mm. (d) Silver tetradrachm with portraits of Antiochos VIII and Kleopatra Thea. *Ca.* 125–121 B.C. Diam. approx. 30 mm.

This final step was taken by the Ptolemies. Ptolemy I had seized the body of Alexander while it was being transported from Babylon to Macedonia for burial and placed it in a shrine in Alexandria. At first this shrine was probably the center of an ordinary Greek hero cult. Alexander was, of course, the founder of Alexandria. Although Ptolemy I used the Alexander cult to promote his image as a legitimate successor to Alexander, he himself never claimed honors as god. Around 280 B.C., after the first Ptolemy's death, however, his son Ptolemy II Philadelphos arranged for the formal deification of his father and his mother, Berenike, as the 'Savior Gods' (*Theoi Soteres*). Then, probably in the 270s, Philadelphos and his wife Arsinoe II were officially deified, while still living, as the 'Sibling Gods' (*Theoi Adelphoi*) and were offered worship in the shrine of Alexander. This crucial development in the Ptolemaic state religion was vividly reflected in the changing imagery of Ptolemaic coinage. A golden octadrachm issued by Ptolemy II [293a], probably around the time of his own deification, shows, on the reverse, portraits of Ptolemy I and his wife Berenike with the inscription *theon*, 'of the gods'; on the obverse of the same coin are portraits of Ptolemy II and Arsinoe with the inscription *adelphon*, 'of the siblings.' Probably the words on each side of the coin should be taken as a single inscription, that is, '[a coin] of the divine siblings.' After her death in 270 B.C. Arsinoe's image was endowed with more explicit and time-honored symbols of divinity. On the serene portrait of her which graces another golden octadrachm issued by Ptolemy II [293b] the horn of Zeus Ammon can be seen projecting from beneath the veil that covers her head.

After the time of Ptolemy II each successive Ptolemaic king and queen was deified after his or her accession and worshipped as part of a royal household. The royal line became the object of a state religion, and worship in the cult became an act of patriotic allegiance. In instituting a regular procedure for the worship of the *living* monarch, it seems probable that Ptolemy II was influenced to some degree by native Egyptian traditions. The reigning Pharaoh had been recognized as a living deity, a son of Amun, from the time of the Old Kingdom, and had been honored with appropriate rituals, including a special coronation ritual through which his divinity was officially affirmed. The later Ptolemies all went through this ritual, and it seems likely that the earlier kings, and perhaps even Alexander, did so too. In addition, each member of the dynasty adopted traditional Pharaonic cult names along with his Greek cult titles ('Soter,' 'Euergetes,' etc.).

While Egyptian traditions may have stimulated the Ptolemies to develop their ruler cult, however, the Greek elements in it nevertheless seem predominant. In the pre-Ptolemaic Egyptian cult, for example, a deceased Pharaoh no longer played any significant role in ritual, whereas in the Ptolemaic ruler cult the deceased members of the dynasty continued to be worshipped as tutelary deities of the state. The ruler cult seems basically to have been a fusion of Greek hero cults with the institution of political deification, augmented perhaps by a certain amount of Egyptian ritual solemnity. It is essentially a Hellenistic Greek creation.

One interesting, if somewhat obscure, group of monuments, Ptolemaic faience wine jugs with portraits of queens, can be appropriately discussed at this point because they illustrate not simply the influences of the worship of rulers but the very functioning of the cult itself. A typical aspect of the ruler cult, in Ptolemaic Egypt and elsewhere, was the organization of festivals in which offerings were made for the welfare of the reigning monarch. Such offerings were apparently made not only at established shrines of the royal cult like the Sema in Alexandria (see p. 276) but also at temporary altars around the country. The faience jugs in question were apparently mass-produced for such offerings. They probably held libations of wine which pious subjects of the Ptolemies would present to a priest or priestess of the royal cult. Portraits of the reigning queen regularly adorned these jugs.[5] They depict the queen holding a cornucopia in her left hand and a libation bowl in her right, with an altar placed to the right of her and a sacred pillar on the left [274].

Since these portraits were accompanied by inscriptions identifying the queen represented, many of the jugs are datable. They range from the time of Ptolemy II Philadelphos and Arsinoe II down to that of Ptolemy VIII Euergetes II (reigned 164–116 B.C. with interruptions). Some of the surviving jugs have been found in graves. This may be because their use in the worship of the reigning king and queen, who were identified with Isis and Osiris, made them seem suitable for the cult of the dead. It is more probable, however, that they were simply treasured as memorabilia, like medallions from the golden jubilee of Queen Victoria or coffee cups commemorating the bicentennial celebration of the United States.

As works of art these faience vases show an interesting fusion of, and sometimes tension between, Greek and Egyptian stylistic traditions. This is perhaps not surprising since the idea of making faience offering vessels as well as many of the aspects of the cult which they served were Egyptian, while the recipients and promoters of the cult were, of course, Macedonian. The design of the figures of the queens is fundamentally Greek. They wear familiar Greek dress – a sleeveless chiton and a himation, which is wrapped around the waist and draped over the left arm. Their pose is also Greek; the weight is on the right leg, the left leg is flexed, and the left shoulder is slightly raised. The right hip projects in a prominent S-curve, and the whole body, from the left foot up to the head, is characterized by a spiral torsion. In short, they present an amalgam of Polykleitan, Praxitelean, and Lysippan features long familiar in Greek sculpture. There are, however, on some of the figures, traits which one would normally associate with the art of Pharaonic Egypt. On a vessel in the British Museum honoring Arsinoe II [274a], for example, the head of the queen is shown in profile with a sharp-edged cavity for the eye, and the drapery is divided into areas with regular parallel folds (as over the left foot) arranged to form contrasting angles. The degree of Egyptianization varies from vessel to vessel, as can be seen by comparing the example in the British Museum with one from Xanthos in Lycia, which seems almost purely Greek [274b]. The pure Greek style is, however, rare. Dorothy Thompson, whose lucid monograph on these vessels has done so much to make them meaningful, suggests that the intrusion of an Egyptian flavor into the figures stemmed from the fact that the workshop which produced them, although presumably run by Greeks, employed Egyptian craftsmen.[6]

The history of these faience vessels in some ways mirrors the history of Ptolemaic Egypt as a whole and of the ruler cult in particular. As time went on the Egyptian elements on the jugs came to prevail over the Greek. Drapery patterns became schematized and unnaturalistic, and the figures began to seem more like standard images of Isis than like portraits. This trend probably reflects the general resurgence of the power of the native Egyptians in the Ptolemaic kingdom which began after native regiments made a significant contribution to the Ptolemaic victory over the Seleucids at the battle of Raphia in 217 B.C. The end result was a kind of archaism which has parallels elsewhere in the late Hellenistic period (see Chap. 8)

but whose inspiration was not the art of Archaic Greece but rather that of pre-Greek Egypt.

Once the cult of the Ptolemies was fully developed and came to be known outside of Egypt, the idea of an organized ruler cult was quickly adopted, with local variations, elsewhere in the Hellenistic world. Antiochos I had deified his father, Seleukos I, upon the latter's death. Shortly thereafter, a special priesthood was organized for the worship of the living monarch and his royal ancestors in the cities and provinces of Seleucid Asia. The Seleucids omitted Alexander from their royal line and traced their ultimate descent from Apollo (rather than, as in the case of the Ptolemies, from Herakles through Alexander). The kings of Pergamon traced their descent from Dionysos, and although worshipped in their lifetime, they were not given the title *theos* until after death. But behind these and other variations the basic function of the ruler cults – to confirm the legitimacy of the ruling line, to provide a symbolic way of expressing allegiance to it, and to convey what the character of the rulers was like – remained constant.

As a striking example of how the imagery of the ruler cult, particularly that of the Ptolemies, stayed alive and played a role in royal iconography, we may cite a late Seleucid silver tetradrachm issued by Alexander Balas and Kleopatra Thea between 150 and 145 B.C. [293c] in which the king and queen are shown in overlapping profiles. Both rulers wear the royal diadem, but Kleopatra also wears the 'kalathos' (basket-shaped headdress) and has a cornucopia placed behind her. What is striking about this coin is its Egyptian quality. The format of the two superimposed rulers was first invented, as already noted, for Ptolemy II Philadelphos and Arsinoe [293a]. The cornucopia was connected with Isis and Serapis and frequently appears on Ptolemaic coins. The kalathos was also an attribute of Serapis (see p. 279) and was used in a variety of Egyptian rites, including a public 'Procession of the Kalathos' instituted by Philadelphos. Alexander Balas was virtually put on his throne by Ptolemy VI and Kleopatra was Ptolemy's daughter, and hence the new government owed its existence to Egypt and had Egyptian backing. The coin in question would undoubtedly have conveyed this message to thoughtful Antiochenes. Not only would they have sensed that the coin had an Egyptian design, but they would also have noticed that the image of the Ptolemaic princess, now queen, dominated it and overlapped the portrait of Balas (on the earlier coin of Ptolemy Philadelphos it was the king's image which had been foremost). It is interesting to note that toward the end of her life, as she struggled to dominate her restive son, Antiochos Grypos, Kleopatra revived the type [293d]. The Antiochenes again must have gotten the message, as did Grypos, who proceeded to poison the Queen Mother.

Shrines of the ruler cult and their images

For the temples and shrines in which the liturgical rites of the ruler cult were actually carried out the evidence is very limited. The existence of many such shrines is attested in literary references and inscriptions, but archaeological evidence for what they looked like is found at only a few sites.[7] For the appearance of the most famous shrines of the ruler cults, like the Sema in Alexandria, we can only use our imagination. The Sema is known to have contained Alexander's gold sarcophagus, and it probably contained a suitable image of the 'divine Alexander,' one perhaps resembling the bronze statuette from Cairo that depicts him draped in a long aegis. Over the centuries portraits of successive Ptolemies must have been added to it, and in the

end it must have seemed more a monument to the history of Hellenistic Egypt than a temple for a living king.

Only at Pergamon do there seem to be some actual physical remains of the center of a major ruler cult. On the citadel of Pergamon, east of the Altar of Zeus and just south of the palace of the Attalids [247], there is a structure which, because of its similarity to other known hero shrines like the 'Heroon' at Kalydon, has been identified as a 'Temenos of the Ruler Cult.' The building, which measures about 45 x 60 m, consists of a spacious courtyard flanked on its north, west, and south sides by a Doric colonnade. Off the east side of the courtyard is a large anteroom, reached through an Ionic colonnade which gave access to what looks like a cult room with a niche for images. It has been suggested that two colossal marble heads, found elsewhere amid this dislocated debris at Pergamon, are from these images.[8] One of them is the famous head of Alexander [5], which, as already suggested, represents a baroque intensification of the Lysippan portrait type; the other is a head which is accepted by most scholars as a portrait of Attalos I [25].[9] This head of Attalos underwent an interesting but puzzling modification at some point in Antiquity. Its hair, which was originally rendered in a compact form, set closely against the skull and tied by a rather wide diadem, was chiselled away and replaced by a new, more 'bushy' head of hair (carved separately and attached to the original portrait) with a thinner diadem. Why this was done no one knows. One attractive suggestion is that the portrait was executed late in Attalos's life, and that when he died in 197 B.C. and was deified, the head was modified to make him look younger and more like a divine hero.[10] If we accept the hypothesis that these two portraits do belong to the Temenos of the Ruler Cult, put them back, in our minds, on their pedestals in the niche of its cult room, supply mental torches to illuminate them, and conjure up priests to burn incense before them, we may approach the 'feeling' of the ruler cult. Admittedly, however, we might also simply be day-dreaming. At any rate, the evidence of Pergamon does suggest that the shrines of the ruler cult were relatively uncomplicated structures, simply, in fact, chambers with niches or pedestals and an altar.[11] Their effect must have come mainly from the quality of their portraits and ornaments.

A much more spectacular example of such a shrine, although somewhat out of the mainstream of Hellenistic culture, survives in the provincial kingdom of Kommagene at the site of Nemrud Dagh. Kommagene, in the mountains of northern Syria (present-day Turkey) between Cappadocia and Mesopotamia, achieved independence from the Seleucids in the 2nd century B.C. and was ruled by a dynasty which claimed descent both from Darius I of Persia and from Alexander the Great. The most memorable of its rulers was Antiochos I (*ca.* 64–38 B.C.), whose mother was Laodike, a daughter of the Seleucid king Antiochos VIII Grypos, and whose father was named Mithradates Kallinikos. The mixture of Iranian and Greek elements in both the blood and the names of these rulers was also reflected in their monumental art. Antiochos I prospered early in his career as an ally of Pompey. Later he adopted a pro-Parthian policy and was finally deposed by Marc Antony. Between this rise and fall he was able to undertake one venture which has made him memorable: he constructed a great tomb for himself, equipped with facilities for the worship of his divine self on Mount Nemrud. The tomb itself was a great tumulus about 150 m in diameter and 50 m high. On its east, west, and north sides were three terraces cut out of the rock of the mountain. The terraces on the east and west were arranged as courtyards with a row of colossal statues on their

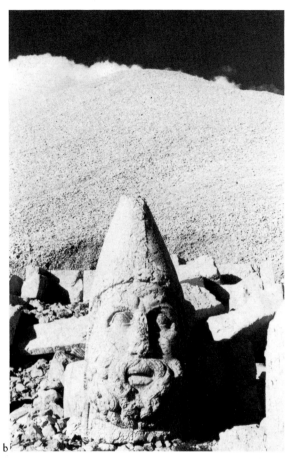

294 Nemrud Dagh, tomb of Antiochos I of Kommagene. *Ca.* 64–38 B.C. (a) head of Antiochos, (b) head of Zeus-Ahuramazda. *In situ.* H. approx. 1.65 m.

main axes and rows of sculptured orthostates along their sides. Portions of several of these colossal statues, some of which were nearly 10 m high, survive and are identifiable by their inscriptions. On each terrace the order of statues was the same: the first figure was a fusion of Apollo, Mithras, Helios, and Hermes; the second was the Tyche of Kommagene; the third was a fusion of Zeus and Ahuramazda; the fourth was Antiochos himself; and the fifth was a fusion of Herakles, Artagnes (a local deity), and Ares. In the grandiose faces of Zeus and Antiochos [294] we are perhaps looking at the last fling of 'Hellenism,' that is, the

superimposition of Greek traditions on the oriental world conquered by Alexander. The oriental headdress of the figures, their hieratic stolidity, and simply their hugeness make one think of the art of the ancient Near East. But Antiochos has the face, particularly the mouth, of an Apollo, and Zeus has the bushy beard and knotted brow of Hellenistic baroque. The Hellenistic ruler cult involved a fusion of Greek political thought with oriental religious beliefs, and the hybrid colossi of Nemrud Dagh may be the truest, if not the most sophisticated, embodiments of it.

APPENDIX III

Aspects of royal patronage

A substantial amount of literary evidence exists for the patronage of the visual arts by Hellenistic rulers. A number of important passages have already been cited in the chapters on Royal Iconography, and Pergamon, and elsewhere. This appendix brings together some additional passages (and some archaeological evidence relevant to them) that are of particular interest for the role of royal patronage in the development of

Hellenistic architecture, city planning, sculpture, painting, decorative arts, and general iconography.

1. The founding and development of Alexandria

Arrian's description of the founding of the city in 331 B.C. (Arrian, *Anabasis* 3.1) suggests that Alexander himself played

an active role in selecting its site and in designating what were to be its principal components:

> The site seemed to be a perfect one on which to found a city, and he felt that the city would be prosperous. A strong yearning to undertake the task accordingly seized him and he himself marked out the basic divisions of the city, indicating where the agora was to be built; he also indicated where temples were to be established as well as to which of the Greek gods they were to be dedicated, and he specified that one should be dedicated to the Egyptian goddess Isis; he also marked out the route where the wall was to run around the city. Upon these foundations he offered sacrifice, and the sacrificial omens were favorable.

Arrian's description of the original components of Alexandria imply that from the beginning it was designed to be an essentially Greek city with Greek institutions. It was the first of those cities which, in the wake of Alexander's conquest, were to carry the institutions of Greek culture into the heart of the non-Greek regions of the Mediterranean and the Middle East and to embody in space and time what the verb 'Hellenize' and the adjective 'Hellenistic' conveyed in words and thought. The cities of the Hellenistic world soon become schools in which many who were not Greeks by blood would come to be Greek, or at least partly Greek, in culture, and Alexandria was the model for them. Plutarch records that the seers who offered the first sacrifices at Alexandria predicted that the city would become 'the nurse of all nations' (*Alexander* 26.6). Arrian's reference to a temple of Isis, however, suggests that Alexander thought of his city not only as a place to propagate Greek civilization but also as a place to harmonize it with elements of other cultures. Such an aim would certainly have been in keeping with the policies he adopted after the conquest of Persia. The temples established at Alexandria, in fact, seem from the first to have anticipated and set the tone for the main line of development of Hellenistic religion. Their fusion, or at least juxtaposition, of Greek and non-Greek religious traditions paved the way for the cosmopolitanism and mysticism which were the most distinctive aspects of Hellenistic religious experience. The cult of Isis and that of her hybrid, Graeco-Roman consort Serapis would play a fundamental role in this development. Whether the cult of Serapis actually existed at the time of the founding of Alexandria is uncertain. Most sources connect the development of the cult in Egypt with the Ptolemies. The Alexander Romance of Pseudo-Kallisthenes (1.30–3), however, records that Alexander commissioned an architect named Parmenion to construct a temple of Serapis in Alexandria, that a shrine of the god already existed in the area, and that the divine guidance of Serapis was influential in the planning of the new city.

According to Vitruvius (2, praef. 1–4) and other sources, Alexander had the advice and assistance in laying out Alexandria of a prominent Macedonian architect and city-planner named Deinokrates. What little is known about the topography of the ancient city buried under modern Alexandria suggests that substantial portions of it were divided up into a grid of parallel and perpendicular streets and that groups of grid blocks were allocated to public spaces, sanctuaries, and, later on, to palaces. Most probably Deinokrates was a practitioner of the 'Hippodamian' principles of city-planning developed in Greece in the 5th century B.C. (see p. 247). There can also be little doubt that the architects who designed the temples referred to by Arrian used the familiar orders of Greek architecture. The basic plan and form of Alexandria was, in short, Greek, and it was through this new city that the non-Greek world was first introduced to the physical feeling and aesthetic sensibility that were part of the Greek way of life.

The founding of Alexandria undoubtedly commended itself to Alexander for some very immediate and practical reasons. It was in a commercially advantageous spot, and it could serve both as a supply depot for the Macedonian army and as a useful port for naval operations. Its long-range importance, however, resided in the idea that it embodied and in the ideas that emanated from it. It offered a model for the way in which an island of Greek culture could be occupied and maintained in a sea of non-Greek peoples and customs. Once the idea of an island of this sort was established, it spread throughout the Near East. Alexander himself, and after him, with an almost missionary-like zeal, the Seleucid kings, went on to found dozens of cities in the regions formerly controlled by Persia, and for about a century and a half they served as both outposts and bulwarks of Hellenistic culture (see *infra*).

Strabo, book 17, writing in the last quarter of the 1st century B.C., gives an extensive, in spite of lacunae, description of Alexandria, but in most cases it is not clear how much of what he describes goes back to early Ptolemaic times. Furthermore, Roman rebuilding, subsidence of the coastline, and drastic disturbances of the terrain in modern times make it impossible, except in a few instances, to correlate the buildings described by Strabo with the spotty archaeological evidence discovered in modern Alexandria. It seems clear, however, that the main outlines of ancient Alexandria took shape during the reigns of the first four Ptolemies, and a review of its components, even if they can now be appreciated only in the imagination, does help to give one an intuitional feeling for what one of the great Hellenistic cities was like.

Approaching Alexandria from the sea one first encountered the island of Pharos with its famous lighthouse and sanctuary of Isis. Connecting Pharos with the mainland was an artificial causeway or dike measuring seven stades in length (about 1.4 km) and hence called the 'Heptastadion.' This causeway seems to have been one of the first great engineering projects at Alexandria, and probably belongs to the time of Ptolemy I or even to that of Alexander and his regent Kleomenes. It divided the sea between Pharos and the mainland into two large harbors, the survivors of which, much altered, still exist today. Somewhere to the south of the Heptastadion was an intersection, at right angles, of two spacious avenues, 30 m wide, one of which ran roughly east–west. This intersection seems to have constituted the center of town. Apparently to the east of it, along the shore of the Eastern harbor, was a complex of buildings and gardens called 'the Palaces' or the 'Royal Grounds' (*ta Basileia*). This area, which Strabo says occupied as much as a quarter or a third of the city, was the private preserve of the Ptolemaic dynasty. In it were the Museum begun by Ptolemy I and expanded by Ptolemy II, with its famous library and covered walk (*peripatos*), and the Sema, a structure containing the tombs of Alexander and the Ptolemies. Alexander's tomb had been installed in Alexandria in the time of Ptolemy I. The construction of this larger Mausoleum which brought the tomb of the city's founder and of his Ptolemaic successors under one roof was the work of Ptolemy IV Philopator. The new tomb apparently had a pyramidal roof and thus echoed not only the early tombs of Pharaonic Egypt but also later Mausolea like those at Halikarnassos and Belevi. Within the Royal Grounds there was also a building known as the 'Inner Palace,' presumably the private residence of the Ptolemies, a theater, and even a zoo,

created by Ptolemy II Philadelphos and described in the memoirs of Ptolemy VIII (see p. 10).

Beyond the Royal Grounds to the east the shore of the eastern harbors was occupied by warehouses and the Emporion, an area for commercial exchange. From the western harbor, called Eunostos, a canal led southward to Lake Mareotis. Along this canal to the east was an area which in Strabo's time was thought of as an old quarter of the city. It contained the oldest sanctuaries of the city, presumably those which went back to the time of Alexander and Ptolemy I. The most famous of these was the temple of Serapis, which also happens to be the one Alexandrian sanctuary whose site has been identified and excavated. The archaeological remains of the Serapeion are so scanty that it is impossible to reconstruct even its general plan. It is known, however, that the shrine was surrounded by a limestone colonnade, one side of which measured about 75 m. Foundation deposits, consisting of two sets of ten plaques inscribed in Greek and Egyptian and made of gold, silver, bronze, faience, Nile mud, and glass, were found beneath the remains of this colonnade in 1944. These plaques record that the builder (or perhaps rebuilder, assuming that the shrine existed earlier) of the Serapeion was Ptolemy III Euergetes. They can also be taken as an indication of how thoroughly Egyptian religious rituals had come to permeate the work of the Greek architects who worked for the Ptolemies. In addition to the main temple of Serapis, the Serapeion colonnade also enclosed shrines of Isis, Harpokrates, Anubis, and the *theoi adelphoi*. Just how these shrines were disposed in relation to one another is not clear, but it is tempting to speculate that the appearance of the whole sanctuary may have been, on a much greater scale, something like that of the temple of Isis at Pompeii – i.e. an area enclosed by colonnades which contained works of art and special rooms for cult practices, dominated by a broad-fronted temple with a high flight of steps leading up to its main chamber, and dotted by smaller shrines and sacred tokens.

Strabo mentions other buildings, for example a large gymnasium on one of the main avenues in the center of town, which one would expect to find in a Hellenistic city, and the existence of a substantial agora is known from inscriptions.

2. Antioch and Seleucid city building

Our knowledge of the founding of Antioch is dependent for the most part on late sources which may sometimes be tinged with fantasy or betray the influence of standard legends. When the city was laid out, for example, the position of its gate was said to be marked by Seleukos's war elephants and the line of its streets to have been traced in wheat, a process reminiscent of Pseudo-Kallisthenes' account of the founding of Alexandria and one which sounds more like a literary formula than an architectural technique (Libanios, *Antiochikos* 90; Pseudo-Kallisthenes 1.31–3). A few hard facts, however, do emerge from our sources, and these provide us with some interesting information about Seleucid city-building. Antioch was one of four major cities founded by Seleukos as soon as he seized control of Syria, the others being Seleukeia in Pieria (the port of Antioch), Laodikeia on the sea, and Apameia. All of these seem to have been laid out on a grid plan, and there is evidence that a standard sized block, measuring about 112 x 58 m, was used in each of them.[1] This suggests that something like a master plan for the mass production of cities was worked out at a very early stage by Seleukos's architects in order to facilitate the urbanization and Hellenization of Asia. A late source mentions an architect named

Xenarios as the designer of Antioch and adds that he was assisted by three aides, Attaios, Perittas, and Anaxikrates, who were charged with writing a treatise on the founding of the city (Tzetzes, *Chiliades* 7.118.176–80). One wonders if this treatise was not so much an encomium on the glory of the city as a practical handbook that could be applied by other architects to other sites.

Antioch is situated in a well-watered and salubrious spot on the left bank of the river Orontes, between the river and Mt Silpius. Because of the great expansion of the city in the Roman and Early Christian periods, most traces of the original Seleucid city have been obliterated. Traces of the Seleucid wall, however, suggest that the city covered about 2.2 sq km and was situated between the river and a main road which led south to the suburb of Daphne and to the sea of Laodikeia. In Roman times this road was flanked with porticoes which ran for miles and were one of the architectural marvels of ancient urban design; at the time of the founding of the city, however, this road seems to have been a boundary rather than a central thoroughfare. The grid plan, interestingly, seems to have been aligned not to follow the line of the river but rather to take maximum advantage of the sun and of prevailing winds in different seasons. The agora of the Seleucid city was on its western side, flanking the river. Most probably there was a central street dividing the site, to the east of it. Such a division of commercial and sacred areas is suggested by the plan of the Seleucid military colony of Europos (later Dura-Europos) on the Euphrates (see infra).

The most famous monument of early Antioch was not a building, however, but rather the statue of the Tyche or 'Fortune' of the city [1] by Eutychides, one of the pupils of Lysippos. Its fame stemmed not only from the fact that it served as a convenient symbol of a city but also because it captured a feeling about the nature of life which had a wide appeal in the Hellenistic age (see pp. 3 and 55).

About 8 km south of Antioch Seleukos also oversaw the creation of a suburb called Daphne. Wooded, healthful, and peaceful, Daphne quickly became a retreat, a cultural recreation center, and something like a spa. Its most important monument was a temple to Apollo, which Seleukos was said to have consecrated after witnessing various sacred omens. The colossal acrolithic image of Apollo in this temple was made by a sculptor named Bryaxis. A description of it by Libanios as well as representations on coins indicate that the god was shown holding a lyre in his right hand and a libation bowl in his left.[2] According to Pliny (*NH* 34.73) Bryaxis also did a bronze portrait of Seleukos. The date and identity of this sculptor are discussed below.

After the founding of Antioch, which set the tone and served as a model for the social organization of the Seleucid realm, Seleukos and Antiochos I embarked upon a vigorous program of city building which was carried forward by their successors later in the century. Some of the new settlements took the form of full-fledged *poleis* with rights of citizenship, Greek laws, Greek governmental institutions, and internal autonomy. Probably most of them, however, were military colonies, intended not only to ensure security and adequate defense in various parts of the kingdom but also to provide a home and livelihood for army veterans.

Initially the citizens or enfranchised members of these settlements were Macedonians and Greeks who zealously guarded their ethnic exclusiveness. (Even in the late Hellenistic period the descendants of the original settlers of Dura-Europos treasured their family genealogies with a feeling of pride analogous to that

295 Dura-Europos, plan of the Hellenistic city. Reconstruction by H. F. Pearson.

of Americans who are descended from those who sailed on the Mayflower.) In time, however, as the Asiatics who lived in and around these cities learned to read and speak Greek and to appreciate Greek cultural institutions, some even adopted Greek names, and as they gradually achieved full citizenship, distinctions became blurred and were replaced by a kind of cosmopolitan outlook. In a few areas of the Seleucid realm, in fact, there seem to have been Greek-style *poleis* inhabited almost exclusively by Asians.[3]

A skeleton outline of what one of these towns would have looked like can be extracted from the Seleucid remains of Dura-Europos, a military colony in the Syrian desert on the west bank of the Euphrates [295]. Europos, as the city should properly be called in the Hellenistic period (it was named after Europos in Macedonia, where Seleukos was born; the local name 'Dura' was added in the period after the city fell to the Parthians, *ca.* 100 B.C.), was founded *ca.* 300 B.C. at the behest of Seleukos by a military commander named Nikanor. The city stood on a rocky plateau with a cliff overhanging the Euphrates on the east and steep ravines to the north and south, and was clearly founded with an eye for its strategic position in the eastern region of the Seleucid kingdom.

From the beginning, presumably like all of the new Seleucid cities, Europos was surrounded by a substantial fortification wall. The most imposing portion of the wall, with its massive towers and gate, ran along the western side of the city, which faced the desert and was not rendered naturally defensible by ravines and cliffs. The streets of the town, like those of the great new capital at Antioch, were laid out on a rigorous grid plan, even though this required the use of stairs where the ravine which carried the main road through the eastern part of the city made its topography irregular. To the north of the principal east–west road an area was set aside for an agora; to the south of this road was a quadrant for sanctuaries of Apollo and Artemis, patron deities of the Seleucid dynasty. Two projecting spurs of the plateau, one on the northeast and the other on the southeast, were apparently set aside for military and civil administration respectively.

It is probably reasonable to assume that Europos (of which only about a third has been excavated) also had gymnasia, a theater, stoas, and other familiar architectural forms associated with Greek culture, since traces of such structures have been found among the very fragmentary remains of other cities founded by the Seleucids in Syria, for instance Apameia and Laodikeia, and even oriental cities such as Babylon and Damascus which the Seleucids sought, with mixed success, to Hellenize.

During the tumult of the 'Syrian Wars' between the Seleucids

and the Ptolemies in the 3rd century B.C. Europos was neglected by the Seleucids, and although there was an attempt to redeem it from neglect in the time of Antiochos the Great and Antiochos Epiphanes, the Hellenistic city never reached the level of importance that Seleukos had apparently intended for it and others like it. Sometime in the second half of the 2nd century B.C. it came under Parthian control, and thereafter its buildings and its cultural institutions gradually took on an oriental character.

3. The Serapis of Bryaxis

Serapis (also spelled Sarapis) was an Egyptian deity of the underworld who emerged from a fusion of Osiris with the cult of the Apis bull at Memphis. The origins of the deity seem to go back to Pharaonic Egypt, but he is best known to history in a Hellenized form which evolved in the early Ptolemaic period. The Ptolemies did not exactly 'create' Serapis, since there is some evidence that the god was known in a Hellenized form even before their time,[4] but they clearly did much to develop the god's cult and imagery to the point where, in the late Hellenistic and Roman periods, he became one of the most important deities of the ancient world. According to a story told by Plutarch (*De Iside et Osiride* 361F–362A) and Tacitus (*Hist.* 4.83–4) Ptolemy I had repeated dreams in which Serapis appeared to him and instructed him to have a statue of the god transferred from Sinope, the Greek city in Asia Minor on the east coast of the Black Sea, to the Serapeion in Alexandria. In theory Ptolemy I could have transferred this image to Alexandria any time after 321 B.C. Other sources imply, however, that the transfer took place very late in his career, or even during the reign of one of his successors. Tacitus, for example, knew of an alternate version of the story in which the statue was brought by Ptolemy III, and it is a fact that Ptolemy III was responsible for building a major new temple in the sanctuary of Serapis at Alexandria (see p. 277). One version of Eusebios's *Universal History* dates the introduction of the statue to the time of Ptolemy II, *ca.* 278 B.C.; another version to 286. Cyril of Alexandria dates it to the period between 284 and 281 B.C., during most of which the first two Ptolemies were co-regents.[5] The preponderance of the evidence, in short, seems to date the advent of the statue to the first half of the 3rd century B.C., perhaps *ca.* 285–282 B.C., at the very end of the reign of Ptolemy I.

In a puzzling passage, Clement of Alexandria, citing the philosopher Athenodoros of Tarsus (1st century B.C.) as his source, names Bryaxis, 'not the Athenian, but another artist of the same name,' as the sculptor of a famous image of Serapis (*Protrepticus* 4.48.1–3). A sculptor of this name was apparently one of the artists most favored by the Diadochoi, since, as already noted, he made the colossal statue of Apollo for Seleukos's temple at Daphne. Whether he is the same as the prominent artist who worked along with other famous artists on the sculptures of the Mausoleum at Halikarnassos is a difficult question to answer. The sculptor who was employed on the Mausoleum was probably a Carian who had worked for a time in Athens.[6] Since Mausolos died in 353 B.C. and the work on the Mausoleum was carried out in the years immediately thereafter, we must assume that Bryaxis was already a mature artist in the middle of the 4th century B.C. The statue in the temple at Daphne, on the other hand, could not have been begun before 300 B.C. It is not impossible that the sculptor who worked on the Mausoleum survived long enough to work at Daphne in his old age, but the odds seem against it. Another possibility is that the sculptor who worked for the Diadochoi was a different, later

296 Serapis, head based on the cult statue by Bryaxis. Marble. Roman or late Hellenistic version of an original of the late 4th or early 3rd century B.C. Athens, National Archaeological Museum. H. 0.26 m.

Bryaxis, perhaps a descendant of the Mausoleum sculptor. Or, if the sculptor of the Apollo was the same as the Mausoleum sculptor, it may be that his Apollo was a work done prior to 300 B.C. for some other shrine and that Seleukos had it transported to Daphne at the time of the founding of Antioch. Something of this sort may conceivably also have happened in the case of the Serapis of Bryaxis. Although Clement's garbled version of this information associates Bryaxis with a king of the Pharaonic period, it is probably fair to assume that the Bryaxis to whom he refers was an artist of the 4th or 3rd centuries B.C. and that the image he created was a work of Ptolemaic times. If this Bryaxis created his image *ca.* 285 B.C., he could not be the sculptor of the Mausoleum and would have to be a 'younger Bryaxis.' Clement's observation that he was 'not the Athenian' perhaps suggests this. On the other hand, if the story that the image was transferred from Sinope is true, it could have been made much earlier and might well have been the work of the Mausoleum sculptor.

Many images of Serapis survive from the Roman period, and while there are variations among them, they all seem to derive from a basic prototype in which the god was seated, wore a chiton and a himation, bore on his head a kalathos (a basket which held a standard measure of grain), held a scepter in his left hand, and placed his right hand on a figure of Kerberos, the

three-headed dog who protected the entrance to the Under-world. The head of this type is characterized by a full beard, a mustache, long strands of hair cascading down the side of the head, and several corkscrew curls of hair arranged in parallel strands along the forehead [296]. Most probably the creator of this type was Bryaxis. In it he seems to have wanted to fuse the majesty of Pheidias's Zeus at Olympia with the personal appeal of Asklepios and the mysterious quality of Pluto. Clement describes the image as a dazzling one: 'There were filings of gold and silver on its surface, and also of bronze, iron, and lead, and in addition to these, tin. Nor did it lack any of the Egyptian gems – fragments of sapphire, haematite, and emerald, and still others of topaz. After grinding all these to a powder he colored the mixture to a dark blue tone (and owing to this the color of the image is rather dark) and blending all this with the dye left over from the funeral of Osiris and Apis, he modelled the Serapis' (*Protrepticus* 4.48.3). One must envision this colossal, dark image sparkling mysteriously in its semi-dark shrine, the embodiment of an awesome force but a force with which one could communicate. It seems to have been the final great expression in art of the drift toward the personal and mystical aspects of religious experience which typified the Hellenistic age.

It is probable that Bryaxis's Serapis was placed in the Serapeion in Alexandria, since it is to the origin of the Alexandrian image that our literary sources devote their attention. Admittedly, however, Clement does not say where the Bryaxan statue was, and a plausible case has been made for its having been set up in the Serapeion in Memphis rather than Alexandria.[7] Competition among the Diadochoi, however, was a kind of sport, and with Seleukos proudly displaying his Bryaxan image in the smart new suburb at Daphne, it seems unlikely that Ptolemy would have permitted *his* Bryaxan image to be hidden away in Memphis, far from the new, glittering shrines of Alexandria.

4. Ptolemaic festival art

The lavishness of the artistic life of Alexandria is vividly conveyed in two long and elaborate descriptions of a temporary festival pavilion built *ca.* 276 B.C. by Ptolemy II Philadelphos and of a parade that was part of the same festival. These descriptions are preserved in the *Deipnosophistai* (197A–202B) of Athenaios (*ca.* 200 A.C.) and are quoted from the writings of the Hellenistic scholar Kallixeinos of Rhodes (mid-2nd century B.C.) who wrote a book about the city of Alexandria. The following excerpts from Kallixeinos's narrative are typical.

The pavilion:

Placed by the supporting piers of the pavilion were one hundred marble statues by artists of the first rank. In the spaces between these were panels by painters of the Sikyonian school, alternating with selected portraits, gold embroidered tunics, and extremely beautiful soldiers' cloaks, some with portraits of kings woven into them, others with mythological scenes. Above these there were oblong shields, alternately of silver and gold, hung all around. In the spaces above these, measuring eight cubits, recesses were built, six along the short sides. In these recesses there were figures arranged to face one another as if in drinking parties; the draped garments on them were real. They represented characters from tragic, comic, and satyric drama; beside them there were also gold drinking cups. Between the recesses were left niches, in which golden Delphic tripods with bases were set up. On the highest part

of the ceiling there were gold eagles facing one another, their size being fifteen cubits. On the two sides of the pavilion were one hundred golden, sphinx-footed couches.

The procession:

Amidst these walked a man over four cubits tall bearing a golden horn of Amaltheia. He was called "the Year." Following after him came a very beautiful woman, equal to him in size, adorned with much gold and with a conspicuous tunic, and holding in one hand an Egyptian wreath and in the other a palm staff. She was called *Penteteris*. The Four Seasons followed her, elaborately decked out and each carrying the fruits appropriate to her. [Satyrs, athletes, and actors followed.] ... After these came a four-wheeled float, fourteen cubits long and eight cubits wide, which was drawn by 180 men; on it was a statue of Dionysos ten cubits tall pouring a libation from a gold goblet and wearing a dark red chiton which reached to his feet; over this there was a diaphanous saffron-colored robe. Over his shoulder there was thrown a dark red cloak studded with gold. Set out in front of him was a gold Lakonian krater holding fifteen measures [150 gallons] and a gold tripod, on which there was a gold incense burner and two gold offering bowls, filled with cassia and saffron. Over him there was a canopy decorated with ivy, grape vines, and other fruits, and attached to it were wreaths, ribbons, *thyrsoi*, tambourines, fillets, and also satyric, comic, and tragic masks.

On another four-wheeled cart, which carried a representation of the return of Dionysos from India, there was a figure of Dionysos twelve cubits high seated on an elephant, with a purple cloak on his shoulders and wearing a crown of golden ivy and grape leaves. In his hands he held a gold *thyrsos*-spear, and his shoes were bound on his feet with gold laces. Seated in front of him on the elephant's neck was a Satyr five cubits high, crowned with a gold pine wreath; with his right hand he was making a sign with a gold goat horn. The elephant had gold trappings and around his neck was a gold garland of ivy.

Then came images of Alexander and Ptolemy crowned with ivy wreaths of gold. The image of Virtue [*Arete*] which stood beside Ptolemy had a gold olive crown. Priapos also appeared with them, wearing a gold ivy wreath. The City of Corinth stood by Ptolemy and was crowning him with a gold diadem.

... After these came the division of the procession in honor of Zeus, and others in honor of all the other gods, and after all these that of Alexander, whose gold statue was placed on a chariot drawn by real elephants, with Victory and Athena occupying the space on each side of him.

Not only do these passages evoke something of the pomp and splendor of Alexandria in the time of the early Ptolemies but they also give us an insight into what seem to have been typical characteristics of Alexandrian art. Five points in particular are worth noting. (1) First is the fact that art at Alexandria was, as one might expect, cosmopolitan and drew upon the artistic resources of the whole Greek world. The fact, for example, that paintings of the Sikyonian school hung in the festival pavilion shows that Alexandria was in touch with the artistic mainstream of old Greece. The Sikyonian school was the school of Pamphilos and his pupils Melanthios and Apelles. Since Apelles is known to have visited Egypt in the time of Ptolemy I, it may be that the paintings in the pavilion were done in Alexandria by artists of this renowned school. It is also possible, however, that

they were 'collected' by the first two Ptolemies from other parts of the Greek world, since it is known that in the next generation Ptolemy III also had a taste for Sikyonian paintings and actively collected them (see p. 255). (2) Second, there is the importance of Dionysiac and theatrical imagery at Alexandria. (Since Dionysos was the patron god of the theater, the two go together.) Such imagery becomes all-pervasive in the decorative arts of the later Hellenistic period (see the mosaics of Delos, for example (pp. 215ff.)), and one wonders if the inspiration for it was not primarily Alexandria's. Dionysos was particularly popular at Alexandria because he was identified with Osiris, who was in turn a divine analogue of the living Pharaoh. Further, because Dionysos had been a mortal, had struggled, and had become a god, and because he had been a conqueror in the east and had returned in triumph (a story particularly emphasized in the procession described by Kallixeinos), the rulers of Egypt, from Alexander down to Ptolemy XII 'Neos Dionysos,' had felt it appropriate to associate themselves with him.[8] (3) Third, and related to the importance of Dionysiac imagery, is the importance of Alexandria in developing a 'royal iconography' in Hellenistic art (see Chap. 1); and (4) fourth, is the presence of an intellectualizing trend in early Alexandrian art represented by the many personifications used in the procession (the Year, Penteteris, Virtue). The latter is no doubt connected with the scholarly atmosphere which began to permeate Alexandrian intellectual life in the wake of the founding of the Museum (see Chap. 5). These qualities are effectively represented by the statue group which depicted Ptolemy being crowned with a diadem by the City of Corinth. It is probable that the Ptolemy who was depicted in this group was Ptolemy I and that the figure of Corinth was an allusion to the Corinthian League, the political body of which Alexander was the leader when he first attacked Persia and which first sanctioned his deification. In other words the group was intended to emphasize the legitimacy of the Ptolemaic dynasty as successors of Alexander, and like much of the imagery of the festival was more political than religious in character.[9] Finally, (5) fifth, Kallixeinos's descriptions testify to the prominence, richness, and popularity in Alexandria of the decorative arts – the bowls and other vessels in precious metals and glass, jewelry, gems, ornaments for furniture, figurines, and the like that have been discussed in Chap. 12.

5. Hieron of Syracuse

Both literary and archaeological evidence make it clear that artistic activity and taste in the western Greek world during the Hellenistic age were dominated by Syracuse, particularly during the long and fruitful reign of Hieron II. Hieron seems to have wanted to make Syracuse a western Alexandria and to establish himself as a patron of art, science, and literature on a level with the Ptolemies. He was the patron of Archimedes; the historian Timaios of Tauromenion (*ca.* 356–260 B.C.), who wrote a history of Sicilian affairs that was used by both Polybios and Diodoros, seems to have availed himself of Hieron's patronage toward the end of his career; and Theokritos wrote a skillful, though apparently not successful, poetic appeal for Hieron's favor (*Idyll* 16).

Patronage of the visual arts by Hieron and his family enriched not only Syracuse and other Sicilian cities which were under its influence, but also sanctuaries and cities outside of Sicily. Diodoros (16.83) and Athenaios (40) speak of a vigorous building program in Syracuse through which Hieron embellished the city with new temples, stoas, gymnasia, and other public buildings.

Some traces of the building activity still survive among the remains of a newly laid out western quarter known as 'Neapolis,' most notably a sumptuously rebuilt theater and a great stone altar 200 m long. Elsewhere in Sicily there are similar monuments which attest the spread of Hieron's patronage. Morgantina, in the mountains of eastern Sicily, for example, with its spacious dignified city plan and interesting early mosaics (see p. 212), perhaps gives us a hint of what the central area of Syracuse was like.

But perhaps the most significant testimonial to the importance of Hieron's Syracuse as a center of Hellenistic art comes from a literary passage. Athenaios (207C) took from a writer named Moschion, otherwise unknown, a description of a great luxury ship, the *Syracusia*, which was built for Hieron II and later sent by him as a gift to one of the Ptolemies, probably either Philadelphos or Euergetes. The description is similar in character to those already analyzed which Athenaios took from Kallixeinos. The *Syracusia* was 'lavishly equipped with paintings and statues, as well as with vessels for drinking.' Around the outside of the ship, probably on its cabin but perhaps at the gunwale levels, were 'a row of Atlases six cubits high … including a triglyph frieze above them,' an arrangement which sounds something like the façade of Hieron's great altar. Within the ship was 'a shrine of Aphrodite … with a floor made of agate and other pleasing stones … walls and a ceiling of cypress wood, and doors of ivory and fragrant African wood.' Of greatest interest, however, were the floors of the rooms which made up the crew's quarters. 'All of these had mosaic flooring composed of many sorts of stones, in which the whole story of the *Iliad* was represented in a marvelous fashion.' Some scholars have speculated that it was for the *Syracusia*, later called the *Alexandris*, that tessellated mosaics were invented (see Chap. 10, note 4).

The influence of the art of Hieronic Syracuse seems to have been transmitted to the rest of the Hellenistic world not only through the *Syracusia* but through other benefactions and dedications. Polybios mentions, for example, a number of generous gifts which Hieron gave to the Rhodians in 224 B.C. to help them recover from the effects of a disastrous recent earthquake (Polybios 5.80). In addition to donations of money and oil, he mentions dedications of 'silver cauldrons with their bases, and *hydriai*' (presumably elaborate metalwork similar to that known from Ptolemaic Egypt) and also a statue group representing 'the people of Rhodes being crowned by the people of Syracuse.' Portraits of Hieron, some dedicated by his family and others by the people of Syracuse, were seen by Pausanias (6.12.4 and 6.15.6) in the sacred precinct of the panhellenic sanctuary at Olympia. Several of these, including an equestrian figure, were executed by a Syracusan artist named Mikion son of Nikeratos.[10]

6. Attalid patronage

The evidence for the extent of Attalid patronage further documents the historical importance of Pergamon as an influential center for the development of Hellenistic art. In a few instances, as in the case of the Stoa of Attalos in Athens [297], the effects of Pergamene influence are still tangible, but even when the archaeological remains are lacking, the references to Attalid patronage in inscriptions and literary sources is impressive. This evidence may be divided for convenience into three categories: additions to or refurbishment of sanctuaries, secular structures for the adornment of towns, and statues of various Attalids set up in gratitude by recipients of their beneficence.[11]

Attalid temple building outside Pergamon began as early as Philetairos, who constructed shrines for the Helikonian Muses and for Hermes at Thespiai in Boeotia. Eumenes II constructed a new temple for Poseidon at Kalaureia on the island of Poros and seems also to have contributed to the expansion of the sanctuary of Asklepios on Kos (see p. 231). In Asia Minor in addition to a group of temples at Aigai, near Pergamon, in Aeolis, and a temple of the cult of Queen Apollonis (wife of Attalos I, mother of Eumenes II and Attalos II) at Kyzikos, the Attalids also took responsibility for rebuilding the ancient shrine of the Mother of the Gods at Pessinus in the heart of Galatia. There is also evidence for votive statues as well as stoas and other practical structures dedicated by the Attalids in the major Hellenic sanctuaries. At Delos, for example, Attalos I set up yet another sculptural group celebrating his Gallic victories (see p. 95) and also a stoa in the southern part of the sanctuary of Apollo, facing the sea. The position of this building offers an interesting insight into the competitive relationship that existed between the Hellenistic monarchs even in matters of piety and art. Around 210 B.C. Philip V built another portico just to the west of Attalos's, effectively cutting off its view toward the sea. A pilgrim who wished to view the sea from Apollo's sanctuary was thus obliged to forgo Attalos's generosity in favor of Philip's. At Delphi Attalos I constructed another stoa east of the oracular temple of Apollo. At either end of the stoa were sanctuaries associated with Pergamene cults and legends: on the west one of the hero Neoptolemos, father of Pergamos, the eponymous hero of the town, and on the east one of Dionysos, the god most closely connected with the fate of the Pergamene hero Telephos (see p. 198). Eumenes II also contributed to a reconstruction of the theater at Delphi and to the construction of a new stoa, connected with the theater, outside the Apollo sanctuary.

Among the secular civic buildings contributed to various cities by the Attalids were a gymnasium and a stadium in Miletos, colonnaded market buildings similar to those in Pergamon at Assos and Aigai, and a theater in Rhodes, but the most spectacular of such offerings were two large stoas in Athens, one on the south slope of the acropolis built by Eumenes II and the other in the agora built by Attalos II. The stoa of Eumenes was probably built to serve users of the theater of Dionysos and the sanctuary of Asklepios. Only its foundations, which stretch 161.8 m from the theater to the later Odeion of Herodes Atticus, now remain. In the case of the Stoa of Attalos in the agora, however, we are fortunately able to appreciate the full effect of the building and to share some of the sense of splendor with which Attalid generosity embellished Hellenistic Greece [297]. Architectural details of this building were so well preserved that it was possible for the American excavators of the agora to reconstruct it *in toto* during the years 1953–56. The stoa is 116.38 m long and has two storeys. Following what came to be a canonical arrangement in Hellenistic and Roman times, the lower colonnade is in the Doric order and the upper storey has double Ionic columns. The lower third of the Doric columns were left unfluted in order to avoid damage from commercial traffic. At the back of the building on each level were long rows of shops and offices. These faced long, bright hallways which served for recreation, business, leisurely or philosophical conversation, and also for viewing, in cool comfort, activities in the agora such as the Panathenaic festival. The grand interior vistas of each of these hallways were divided only by an elegant row of supporting columns (Ionic on the lower level and columns with rather exotic Egyptian palm capitals on the upper storey). At each end of the building were stairways reached through arched doorways and lighted by arched windows. (The southern stairway was remodeled in later times and has been reconstructed in its later form.) The grandeur, refinement, and sense of gracious ease which the Stoa of Attalos brought to the heart of Athens's venerable civic center typifies the spirit of Attalid Pergamon at its best.

Portrait statues of the Attalids abounded in Greece and Asia

297 Athens, the Agora. The Stoa of Attalos (reconstructed). Donated by Attalos II of Pergamon (159–138 B.C.).

Minor. At Delphi, in front of the Attalid stoa, were statues of Attalos I and Eumenes II, set up by the council that governed Delphi, and among the varied monuments to the east of the temple of Apollo were two statues of Eumenes II, dedicated by his Aitolian allies. Another statue of Eumenes, a great bronze group showing him in a four-horse chariot, stood on a tall base (the so-called 'Monument of Agrippa') just to the west of the Propylaia at the entrance to the Athenian acropolis. In the agora at Sikyon, which Attalos I had aided *ca.* 210 B.C. with 10,000 bushels of wheat, there stood a colossal bronze statue of the king as well as another portrait of him in gold (Polybios 18.16.3).

It is unnecessary to multiply this list in order to make the basic point: the Attalids left their mark upon the appearance of Hellenistic Greece to a degree rivalled by no other Hellenistic power.

7. Antiochos Epiphanes

When he was unceremoniously dispatched from Egypt by the Romans after an abortive invasion in 168 B.C., Antiochos sought to compensate for his humiliation by turning his attention to Antioch and at Daphne in 167 B.C. celebrated an enormous 'triumph' to commemorate his 'conquest of Egypt.' This celebration, which consisted of a great procession and thirty days of games, was designed, it would seem, both to assuage his own ego and also to take at least trivial revenge on the Romans by outdoing the games held by Aemilius Paullus at Amphipolis in the same year. The procession, which is described by Polybios, is of interest for the insights that it provides into the iconography of Hellenistic official art and also for the impression it conjures up of the decorative arts in Antioch, which seem to have rivalled those of Alexandria (see p. 280) in their sumptuousness. It began with elaborately arrayed military units, cavalry, ephebes, elephants, oxen, cartloads of ivory and metalwork, and so on.

Then came a group of sculptures, including an interesting group of personifications.

> It is impossible to enumerate the great number of images. For images of all the gods and demigods spoken of or thought of among men were carried along, and also those of heroes, some gilded and some draped with garments interwoven with gold. Beside all of these were placed the relevant myths as handed down in traditional accounts worked in costly materials.[12] After these followed images of Night and of Day, of Earth and of Heaven, and of Dawn and Noon. As to the number of gold and silver vessels, one might guess how great their number was by this fact. A thousand slaves of one of the king's companions, a secretary named Dionysios, marched in the procession with silver vessels, of which none weighed less than 1,000 drachmas. And after that came 600 royal slaves carrying gold vessels. (Polybios 30.25.13–16; Athenaios 195A-B)

Probably the most conspicuous example of Antiochos's patronage of the visual arts in the Hellenistic world was his construction of temples to Zeus. The king's promotion of the cult of Olympian Zeus was designed to provide a unifying factor for the diverse populations of the Seleucid kingdom and also, because of Antiochos's view of himself as, in some sense, an earthly manifestation of Zeus, to enhance his own prestige as a ruler. According to Livy (41.20.9), Antiochos oversaw the construction in Antioch itself of a temple to 'Jupiter Capitolinus.' The Capitoline Jupiter, Jupiter Optimus Maximus, was the Latin equivalent of Zeus Olympios, and Livy in this passage may simply be using a convenient Latin expression for the Greek cult. Given Antiochos's Roman education and pro-Roman tastes, however, it is not impossible that he actually introduced the Roman cult into Antioch. If he did so, he may have found it appropriate to call upon a Roman architect to

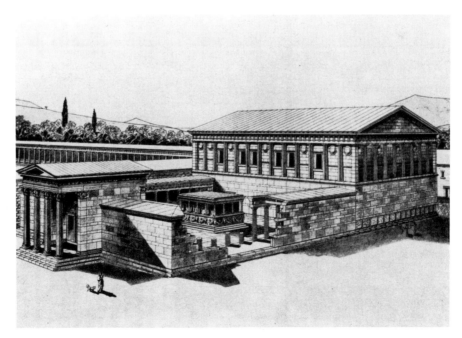

298 The Bouleuterion at Miletos, reconstruction drawing. 175–164 B.C.

build his temple. He did, in any case, as has already been described, hire an architect who was a Roman citizen to execute the grandest of his Zeus temples, the temple of Zeus Olympios in Athens (see p. 248).

The existence of Zeus temples as far apart as Antioch, Athens, and Olba in Cilicia[13] suggests, of course, that Antiochos's promotion of the Zeus cult was far-reaching, and there is literary and epigraphical evidence relating to other sites which some scholars have seen as confirmation of this view. In the temple of Jerusalem, for example, Antiochos ordered the installation of a notorious shrine of Zeus. It has also been supposed that the rebuilding of the temple of Zeus at Olympia, after it was severely damaged by an earthquake *ca.* 175 B.C., was substantially subsidized by Antiochos, and that a temple of Zeus at Lebadeia in Boeotia, along a principal route to Delphi, was begun between 175 and 171 B.C. with money donated by Antiochos.[14]

Even when he had no particular theme to promote, as he did with the shrines of Zeus, there is evidence that Antiochos was willing to make generous subsidies for building projects in Greece. He donated money for a new theater in Tegea, for example, and for a city wall around Megalopolis (Livy 41.20.6). His major expenditures for building, however, quite naturally took place in Antioch, where he oversaw the construction of a new quarter called 'Epiphania' in his honor. From literary descriptions of the quarter, which was on the slopes of Mt Silpios adjacent to the original settlement of Seleukos I, we know that it contained a new agora, several temples, and a Bouleuterion (Council House) for the city council of Antioch.[15] Although no trace of these structures survives, one can perhaps form some idea of what the Bouleuterion at Antioch was like from the remains of the Bouleuterion at Miletos, which was built in honor of Antiochos by two wealthy Milesians, Timarchos and Herakleides [298]. The Milesian Bouleuterion is an interesting structure in that it draws upon forms which had evolved in Greek architecture over many centuries in a free-wheeling way, sometimes emulating them, sometimes mixing them in new ways, and sometimes defying them. The ground plan of the building consisted of a propylon, an open courtyard in which there was a hero shrine, and the council chamber proper, which took the form of a semicircular theater inserted into a rectangular hall. All three architectural orders were employed on the building. The propylon and the shrine in the courtyard used the lavish Corinthian form that, as already noted, may have been particularly associated with Antiochos. The colonnade of the peristyle courtyard was Doric, and the four columns that served as inner supports for the roof of the council chamber were Ionic. Running around the upper half of the exterior of the council chamber were engaged Doric columns separated by windows, an arrangement which may have been intended to echo the design (using the Ionic order) of the west façade of the Erechtheion in Athens. The most unusual feature of the building, however, was that the council chamber had pediments on its sides, i.e. on its short ends, so that from the exterior its axis seemed to be the opposite of what it was in the interior. This kind of 'façade architecture,' in which the exterior of a building bore no rational relationship to its interior, was something new in Greek architecture and is probably a reflection of the baroque taste that pervaded Hellenistic art in the first half of the 2nd century B.C. (see Chaps. 5 and 11). It leads one to wonder whether the lost architecture of Seleucid Asia which matured under Antiochos Epiphanes did not have a substantial influence on similar developments in Roman architecture. Between the time of Cossutius and Apollodoros of Damascus, the architect of

Trajan and Hadrian, the interplay between Rome and Syria seems to have been particularly lively. Antiochos's Roman upbringing and Diadochoi-like flamboyance may have fused to produce a style that pleased both Hellenistic and Roman Imperial sensitivies.

The fusion of Hellenistic architectural form with Roman taste that Antiochos's patronage brought about proved to be his most lasting contribution to Hellenistic culture. Long after his eccentric and vainglorious personality was forgotten or ceased to matter the Corinthian forms of the Olympieion continued to be emulated in Greek and Roman architecture.

8. The Roman triumph over Mithradates

Given the turbulent nature of his career, one might expect that Mithradates never had time to become a patron of art and artists, but this seems not to have been the case. Although there is almost no archaeological evidence to document the artistic richness of Pontos during his reign, the literary sources which describe the booty carried off by Lucullus and Pompey for their triumphs in Rome leave no doubt that this richness existed. In Lucullus's procession of 63 B.C., for example, Plutarch mentions, in addition to vast amounts of military equipment, 'a large gold statue of Mithradates himself, six feet high, a long shield set with stones, and twenty loads of silver vessels . . .' (Plutarch, *Lucullus* 37). Pliny, who had access to the official records of Pompey's triumph of 61 B.C., records that it contained, among other dazzling riches, '. . . three golden dining couches, vessels made of gold and gems set out on nine sideboards, thirty-three crowns made of pearls, and a square golden mountain, on which stood stags, lions, and fruit trees of all kinds and which was entwined with a golden vine' (*NH* 37.14) and also 'a silver statue of Pharnaces I . . . and likewise one of Mithradates' (*NH* 33.151). His account is supplemented by Appian, the chronicler of the Mithradatic Wars, who says that the procession contained Mithradates' throne, his scepter, and a gold portrait of him measuring eight cubits in height (*Mithradatic Wars* 17.116–17).

Appian also mentions other 'images' in this procession which, while not part of the Mithradatic spoils, reflect an important artistic current of the time. He speaks of '. . . portraits of those who were not present in the procession . . . notably Mithradates and Tigranes, fighting, being conquered, and fleeing. The besieging of Mithradates, the night when he fled, and the silence were represented; the virgins who chose to die with him were depicted standing by, and there were paintings of the sons and daughters who died before him and also images of the barbarian gods adorned in the fashion of the fatherland.' Appian does not explicitly state that all of these subjects were in the form of paintings (some of them could have been sculptures arranged in *tableaux*), but it is probable that they were. They sound like the sort of historical triumphal paintings which Metrodoros had prepared for Aemilius Paullus a few generations earlier (see p. 155) and which, a few generations later, would be translated into the more enduring form of Roman 'historical reliefs.'

APPENDIX IV

Bactria and India

Bactria is the ancient name of the region of Asia between the Oxus River and the Hindu Kush mountains, an area which included portions of modern Afghanistan, Pakistan, and the

Uzbek region of the Soviet Union. When Alexander seized control of Bactria from the Persians in the 320s, he found a substantial number of Greeks already living there. They had come centuries before as mercenaries and prisoners of the Persians. In the late 4th and early 3rd centuries B.C. this early Greek population was augmented by a substantial number of Greek army veterans who were encouraged to settle in the region, first by Alexander and then by the Seleucids, to serve as a bulwark against incursions by wild nomads. Although Seleukos I had given the formal status of a satrapy to Bactria, it was far from Antioch and difficult to control. Not surprisingly the area slowly drifted away from Seleucid control and eventually became independent. Somewhere around 250 B.C. a Greek governor named Diodotos, who had been a satrap under Antiochos I, ceased to pay tribute to the Seleucids and began to issue coins on which he gave himself the title of *Basileus*. The Seleucids at the time were occupied with a series of wars with the Ptolemies and with one another, and a measure of their powerlessness to do anything about Bactria's defection can be seen in the fact that Antiochos II's only response was to offer his daughter in marriage to Diodotos.

The history of the Greek kingdom in Bactria and of those which expanded from it into northern India is little known. A small amount of information is preserved in various classical writers, chiefly Polybios and Strabo, and in some Indian sources, but much of the history has been reconstructed, with ingenuity but also with much uncertainty, from coins and their inscriptions. It is these coins which have earned Bactria a place in the history of Hellenistic art and hence in this book. They are among the finest examples of the numismatic (and, indirectly, glyptic) art of the age. Not only do they provide additional striking examples of the tradition of realistic portraiture which was particularly favored in the minor kingdoms, but they also furnish some indisputable masterpieces of design [299]. One gets the impression that the Greek kings of Bactria and India may have thought of coinage as an important symbol of and link with their Greek cultural heritage and hence have gone to some expense to ensure that their coins were designed by first-rate artists. Whether these designers were natives of the area or whether they were brought in from the Mediterranean heartland of the Hellenistic world is difficult to say. The style of the coins is from beginning to end Greek. Their obverses, moreover, are always inscribed in clear Greek, and the Greek deities depicted on the reverses often betray the influence of other traditions in Hellenistic coinage. (Demetrios I is shown with the elephant-scalp helmet [299a] first developed on Ptolemaic coinage (see [15]), and Menander uses an archaistic Athena [299b] similar to that on coins of Ptolemy I, Antigonos Gonatas, and Philip V.[1]) All this would seem to point to Greek artists, probably imported from the west. On the other hand, some of the coins minted in India by the kings Demetrios, Menander (*ca.* 155–130 B.C.), and others have inscriptions on the reverses in the native Indian language, Karoshti, and some of the seemingly Greek deities on them may really be eastern deities in disguise.[2] It seems likely that, at least in some cases, prototype designs prepared by Greek master die-makers were turned over to local craftsmen for adaptation and reduplication.

The careers of the rulers who issued these remarkable coins are known only in sketchy form if at all, and their dates can only be given, in most cases, in approximate terms.[3] Diodotos was succeeded by his son, Diodotos II (*ca.* 288–235 B.C.), who, perhaps because of his policy of placating the Parthians, was overthrown by a local governor in Bactria named Euthydemos.

King Euthydemos I (235–200 B.C.) was a native of Magnesia in Asia Minor and had married a daughter of Diodotos I. He is one of the few Bactrian rulers who, thanks to Polybios (10.49 and 11.39), emerges temporarily into the light of familiar Hellenistic history. When Antiochos the Great embarked on his great eastern campaign, one of his goals was to bring Bactria back into the Seleucid empire. In 208 B.C. Antiochos met Euthydemos's army on the borders of Bactria and won a partial victory. The Bactrians retired to a fortified city called Zariaspa, to which Antiochos proceeded to lay siege. Euthydemos held out against him doggedly for two years. But finally, when the Seleucid army was becoming restless and discouraged by the length of the siege, he proposed through an intermediary a peace settlement in which he would keep the title of king but become a nominal vassal of the Seleucids. Antiochos accepted, took a few war elephants as compensation, and arranged to have one of his daughters marry Euthydemos's son. What is most interesting about this peace settlement is not its practical details but the moral justification which Euthydemos offered for it. He urged Antiochos not to remove him from power because 'a considerable horde of nomads is on the march, from which we are both in danger, and if they are admitted into the country, it will certainly lapse into barbarism' (Polybios 11.39.5). Apparently the Bactrian kings, like the Attalids, saw themselves as a bulwark of civilization against the threat of barbarism. The coin portraits of Euthydemos I suggest a dour, resourceful, hard-bitten *condottiere* who was a match for both Seleucids and barbarian nomads [299c]. This is all the more true if the remarkable stone portrait in the Villa Albani [71], one of the most powerful of all the Hellenistic portraits in the realistic tradition, also represents him (see p. 70). The choice of a weary Herakles on the reverse of his coins perhaps symbolizes Euthydemos's view of himself as an heroic competitor engaged in a ceaseless struggle with savage forces.

Bactrian kings may have had the custom of creating or conquering certain areas as separate fiefdoms for their sons. In the next generation one of Euthydemos's sons, Demetrios I (*ca.* 200–185), crossed the Hindu Kush and entered India. Another son, Euthydemos II, ruled in Bactria, and still another king, Antimachos I, who may have been yet another son of Euthydemos I,[4] ruled to the north in Sogdiana. The stern, bulky face of Demetrios [299a], wearing the elephant scalp that had been used earlier to identify Alexander as a conqueror of India, shows a strong family resemblance to his father. The down-to-earth face of Antimachos wearing the Macedonian sun hat called the *kausia*, presumably as a sign that he was a successor of the Macedonian conquerors, shows, if not a family resemblance, at least a kinship in spirit.[5]

How far Demetrios's conquests in northwest India went is a matter of debate. Tarn and others have concluded that he conquered Gandhara, crossed the Indus to take control of the city of Taxila from the crumbling Mauryan dynasty and penetrated into the middle Ganges region. Narain doubts this and ascribes these conquests to later rulers.[6] Demetrios I was succeeded at some point in Gandhara (the western Punjab, now mostly in Pakistan) by Demetrios II Aniketos (180–165 B.C.), who was probably his son.[7] While the younger Demetrios was consolidating his control over Gandhara a revolt was raised against his line by a usurper named Eukratides. It has been speculated that Eukratides I (171–155), as he came to be called, was a relative of the Seleucid kings and acted with their support.[8] Demetrios was forced to return to Bactria to deal with Eukratides. It would appear that Demetrios besieged the small

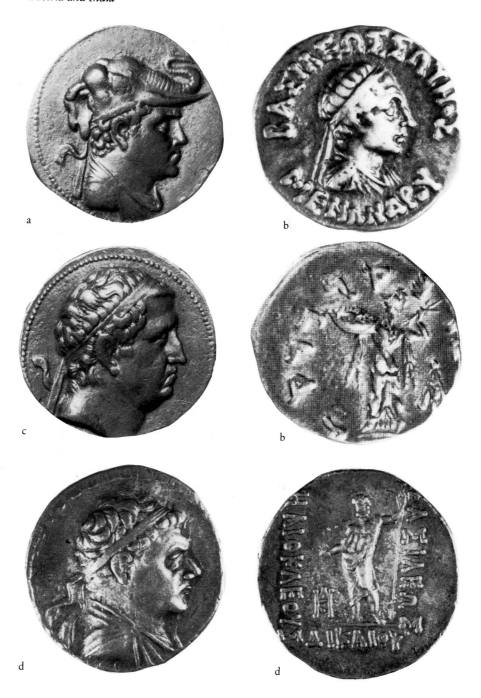

a

b

c

b

d

d

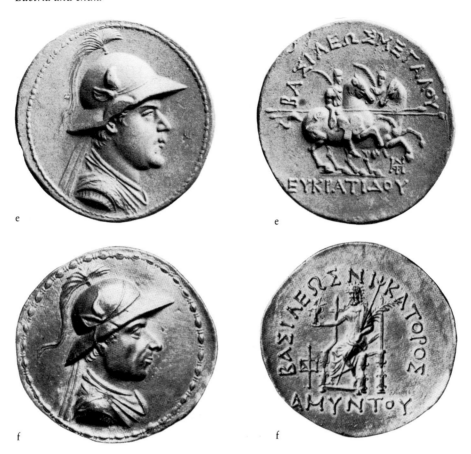

299 Coins of Baktria and India (**a**) Silver tetradrachm with portrait of Demetrios I wearing an elephant scalp helmet. *Ca.* 190 B.C. Boston, Museum of Fine Arts. Diam. 34 mm. (**b**) Silver drachma of Menander with his portrait on the obverse and an archaistic Athena on the reverse. *Ca.* 150 B.C. New Haven, Yale University Library, Numismatics Collection. Diam. 16 mm. (**c**) Silver tetradrachm of Euthydemos I. *Ca.* 200–190 B.C. Boston Museum of Fine Arts. Diam. 30 mm. (**d**) Silver tetradrachm of Heliokles with his portrait on the obverse and Zeus on the reverse. *Ca.* 155–140 B.C. New Haven, Yale University Library, Numismatics Collection. Diam. 32 mm. (**e**) Gold double decadrachm of Eukratides with his portrait on the obverse and the Dioscuri on the reverse. *Ca.* 160 B.C. Paris, Bibliothèque Nationale. Diam. approx. 54 mm. (**f**) Silver double decadrachm of Amyntas. *Ca.* 85–75 B.C. Kabul Museum. Diam. approx. 67 mm.

revolutionary army with a much larger force, but that Eukratides managed to launch some daring cavalry charges against the besiegers and Demetrios was killed. Eukratides then proceeded to eliminate the other sons of Demetrios I and establish himself as the 'Great King' of the region, ruling over Bactria, the areas to the north of Bactria, and Gandhara. It was probably to commemorate his victory over Demetrios that Eukratides issued a series of gold, silver, and copper coins bearing his own portrait on the obverse showing him wearing a cavalry helmet and, on the reverse, a beautifully designed depiction of the divine cavalrymen, the Dioscuri, rushing into battle with their lances set [299e]. Eukratides' crested helmet on these coins is decorated with a bull's horn and ear, attributes which are perhaps an allusion to his Seleucid blood, since they appear on coins of Seleukos I, but which, in any case, place these Bactrian coins in the main line of development of Hellenistic 'royal iconography' (see Chap. 1). The Greek inscription which surrounds the image of the Dioscuri reads 'of the Great King, Eukratides,' a title which suggests that for a time Eukratides had, like the Persians and Alexander before him, come to dominate all the local rulers of the region.[9] These coins were clearly aimed at an audience which was capable of understanding the subtle political iconography of Greek numismatics. Perhaps originally the type was issued as a commemorative medallion for a limited group of educated Greeks and only later adapted for general use on ordinary coinage. Certainly the major example of the type in gold, the largest ancient gold coin ever minted (20 staters), cannot have been in wide circulation and must have been valued mainly as a work of art.

Eukratides had two sons, Plato and Heliokles, and one of them apparently assassinated him *ca.* 155 B.C. Heliokles (*ca.* 155–140 B.C.), whose matter-of-fact, wrinkled face appears on coins that were perhaps influenced by the realistic numismatic portraits of Pontos [299d; compare 28], appears to have been the last, or nearly the last, king of Bactria. Toward the end of his reign the country was overrun by those nomads from the north whom Euthydemos had feared more than half a century before – the Sakas and the Yueh-chi or Kushans. On the other side of the Hindu Kush, however, which the Greeks generally referred to as 'India,' a series of Graeco-Indian kingdoms survived down into the 1st century B.C., and the ruler of one of them, Menander, became the most renowned of all the Greek kings of the East.

Menander (155–130 B.C.) was a successor of Demetrios II and had held on to Demetrios's conquests in Gandhara even in the face of Eukratides' opposition. After Eukratides' death he became the chief ruler of the region. Of all the Greek kings of Bactria and India, Menander seems to have been the only one who rose above the warrior-prince level and became something of an idealist. He was also the only one we know of who was seriously involved with the non-Greek culture of the East. There is no doubt that he became a Buddhist, and the conversations between him and a Buddhist sage named Nagasena, which are recorded in a Buddhist scripture, the *Milinda-panha, Questions of Milinda* (Milinda = Menander), probably have a basis in historical fact. The Karoshti inscriptions on his coins refer to him as the *Maharaja Dharmika* (Greek *Basileus Dikaios*), 'the King who is the upholder of righteous law,' and one of his copper coins seems to show the Buddhist wheel of law called the *Dharma Chakra*. Menander's deep involvement with India was also political and military. The Mauryan dynasty of Chandragupta and Ashoka, which had dominated northern India in the 3rd century B.C. and had dealt with the Seleucids as equals, had fallen into decay by the mid-2nd century, and Menander,

perhaps thinking of himself as something like a new Ashoka, moved into the vacuum. In moving down the Ganges Valley and briefly taking the former Mauryan capital at Pataliputra (modern Patna), he penetrated farther into India than any other Greek conqueror.

Menander's coinage, like his mind and his kingdom, appears bicultural. The coins are regularly inscribed in both Greek and Karoshti, and on their reverses appear Athena and Nike but also such non-Greek oddities as the two-humped Bactrian camel, the elephant, and, as already noted, the Buddhist wheel of law. As was the case with Eukratides, however, the eastern subjects appear only on the demotic bronze coinage. On the more artful and official-looking silver coinage that was undoubtedly used in foreign exchange, the effect is, except for the Karoshti inscriptions on the reverse, fundamentally Greek [299b]. Menander's diademed portrait, in which he looks like a slightly more serene counterpart of Antiochos III, is purely Hellenistic in style; so, too, is the armed archaistic Athena on the reverse, an image which, as already noted, was derived from the coinage of Egypt and Macedonia and was probably intended to remind the world of Menander's descent from the followers of Alexander.

After Menander no Indo-Greek king was of great importance. The names of a number of minor, regional rulers who came after him, some apparently descended from the line of Euthydemos and some from Eukratides, are preserved, but they need not concern us here.

Given the fact that Menander ruled a kingdom that extended into the Ganges valley, was converted to Buddhism, and is still remembered in a Buddhist scripture, it would not be surprising to find that, in spite of their desire to hold fast to their Greek heritage, other kings of Bactria and India were in some ways significantly influenced by eastern culture; and the recent excavation of one of their cities in northern Afghanistan confirms that this was the case. The site of Ai-Khanum, perhaps the ancient Eukratidia, has such typically Greek buildings as a theater and a gymnasium, but it also has a huge palace and smaller houses which seem derived from Persian prototypes. These latter are, however, partly ornamented with purely Greek decorative forms (e.g. Corinthian columns and pebble mosaics). This fusion of Greek and eastern traditions also characterizes the works of art found at the site. In contrast to Ptolemaic Egypt, where Pharaonic and Alexandrian artistic styles remained for the most part separate (see Chap. 12), the patrons and artists of Bactria seem to have welcomed a certain eclecticism. But in one way even the mixed finds of Ai-Khanum confirm Euthydemos's feelings about the need to preserve a Greek language in Bactria that is so evident on Bactrian coins. The language of the city was Greek, and it was used on a very sophisticated level to preserve Greek thought. One prominent public inscription preserved maxims of the Delphic oracle; and in the oriental style palace there was miraculously preserved the imprint of a Greek manuscript containing fragments of Greek poetry and of a philosophical treatise. The clear inscriptions on Bactrian coins convey the same message: the Greek language was the fundamental prerequisite for a Greek cultural identity.

The most elemental dispute among scholars about the Indo-Greek kingdoms concerns the extent to which they can properly be called Hellenistic and thought of as having made some significant contribution to Hellenistic culture. The two most eminent authorities on the subject differ drastically in their views. To W. W. Tarn '. . . there were not four Hellenistic dynasties – Seleucids, Ptolemies, Antigonids, Attalids – but five, and on any showing the Euthydemids, both in the extent of their

rule and what they tried to do, were vastly more important than the Attalids... The Greek empire of Bactria and India was a Hellenistic state... as a Hellenistic state it must be treated.'[10] To A. K. Narain, on the other hand, the Indo-Greeks' 'history is part of the history of India and not of the Hellenistic states; they came, they saw, but India conquered.'[11] As is the case with most such controversies, the truth probably lies somewhere between the two extremes. It is absurd to say that the Indo-Greek kingdoms made a contribution to Hellenistic culture equivalent to that of the Attalids. On the other hand their coinage seems to tell us that they continued to look back to Greece for their roots and felt that it was their Greek heritage which made them distinct from the other people, savage and civilized, in whose lands they dwelt and over whom they sometimes ruled. The doggedness with which they clung to their Greek images to the end must mean that these images had a powerful appeal for them. Their coins were perhaps seen as an embodiment of their cultural identity. In the 1st century B.C. when the Indo-Greeks

were largely cut off from the west and were slowly being engulfed by the 'barbarian' (in the Greek sense) people around them, coins were still flaunted like banners of Hellenism. The most impressive examples are the great silver double decadrachms issued by a king named Amyntas of whom little is known except that he ruled in the Kabul valley somewhere around 85–75 B.C. [299f]. These are the largest silver coins ever issued in the ancient world. Amyntas's portrait with its crested helmet clearly looks back to, and emulates with pride, the portraits of earlier Bactrian kings. On the reverse an Olympian-looking seated Zeus, with scepter and palm branch, holds in his hand an image of his warrior daughter Athena. Around these figures the Greek letters boldly proclaim, 'of King Amyntas, the Conqueror.' Whom he conquered is not known, and, taking a broad view of Hellenistic history, not important. In a generation or two the Indo-Greeks vanished. But it is typical of their society that, even in this late phase, Amyntas wanted the world to think of him, like Seleukos I long before, as a *Nikator*.

APPENDIX V

The tomb at Belevi

Unfortunately the scant remains of Dura-Europos and the other Seleucid cities do not give us a clear idea of what a typical building of Seleucid Syria was like. It would be interesting to know whether they were built in purely Greek style or whether, like the funeral chariot of Alexander (see p. 19), they fused

Greek and eastern elements. Some evidence to suggest that the latter was the case may be provided by the strange tomb at Belevi, 11 km north of Ephesos [300]. The basis of this structure was an outcrop of natural rock cut into the form of a cube measuring about 15 x 24 m on the sides and over 11 m high. This

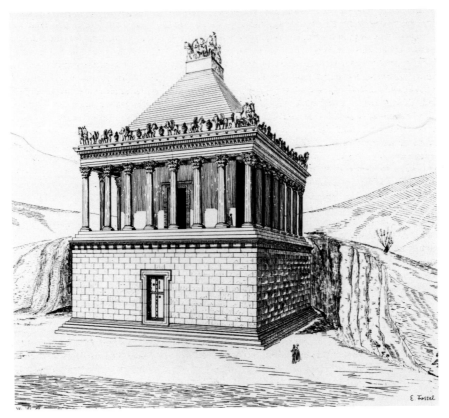

300 Mausoleum of Belevi, reconstruction drawing. Probably early or mid-3rd century B.C.

cube was faced with stone and capped with a Doric frieze of triglyphs and metopes. Above it was a chamber constructed of marble blocks and surrounded by a Corinthian colonnade. Surmounting this colonnade was a group of free-standing winged lions, carved in marble and arranged in heraldic pairs facing large marble urns. The roof of the upper chamber apparently culminated in a pyramid, like the famous Mausoleum at Halikarnassos, at the top of which there was probably a chariot group. The coffered ceiling of the *pteroma* between the Corinthian colonnades and the upper chamber was decorated with sculptured reliefs which showed athletic contests, perhaps funeral games, and the traditional motif of Greeks fighting centaurs. The centaur coffers are remarkable for the fact that the Greeks on them appear not as the familiar unarmed, semi-nude Lapiths but rather as armed soldiers. Finally, in a chamber which was cut into the rock-cube which formed the base of the monument there was found a large stone sarcophagus with the figure of a diademed ruler, presumably the man for whom the tomb was built, reclining on top of it.

The tomb at Belevi is obviously a mixture of diverse oriental and Greek elements. The idea of a rock-cut tomb itself is Persian and, perhaps under the influence of the Persian Empire, it spread to Lycia and other non-Greek areas of Asia Minor. The winged lions who protect the tomb seem to have originated in Mesopotamia but again were widely disseminated throughout the Near East in the time of the Persian Empire. Also oriental is the motif of the banqueting ruler, which was particularly popular in tombs dating from the 6th century B.C. onward in the Persian dominated regions of Asia Minor.[1] On the other hand, the style of the sculptures in the coffers of the ceiling and the use of the Corinthian order are purely Greek. Belevi provides, in fact, one of the earliest examples of the use of the Corinthian order on the exterior of a building and in that respect is not only Greek but also forward-looking in style (see Chap. 11).

It is not known who was buried in the tomb at Belevi and when exactly the tomb was constructed. One appealing suggestion is that it is the mausoleum of Antiochos II, who died in 246 B.C. at Ephesos under mysterious circumstances while visiting his first wife, Laodike.[2] Obviously considerable wealth and power were required to build this large, elaborate memorial, and Laodike and Seleukos II had these at their disposal. Building a prominent memorial to Antiochos II near Ephesos was perhaps intended to advertise the legitimacy of the claim to the Seleucid throne of Seleukos II as compared to those of Antiochos's second wife, Berenike, and her son. Some scholars have argued that the tomb should be dated in the 4th century B.C., when Ephesos was still under Persian domination.[3] The problem of dating this monument is admittedly a difficult one to resolve, but a Seleucid date seems probable for several reasons. First, the diadem worn by the figure on the sarcophagus seems to be that of a Hellenistic monarch; second, the mixture of Greek and oriental decorative elements on the tomb seems to reflect a fashion that was established for the funeral chariot of Alexander (see p. 19); third, the metamorphosis of Lapiths into soldiers on the coffer reliefs seems to be influenced by the new vogue for historical battle monuments first established by the Granikos Monument of Lysippos and reflected in the 'Alexander Sarcophagus' (see pp. 38ff.); fourth, the use of the Corinthian order on the exterior of the building is more likely to have taken place in the 3rd century B.C. than in the 4th (see p. 248); and fifth, the torsion of a statue of an oriental servant which stood near the sarcophagus reflects a style which the school of Lysippos seems to have popularized and promulgated in the early 3rd century B.C. (see pp. 55–8).

ABBREVIATIONS

AJA = *American Journal of Archaeology*
ArchAnz = *Archäologischer Anzeiger*
ArchCl = *Archeologia Classica*
ASAtene = *Annuario della scuola archeologica di Atene*
AthMitt = *Mitteilungen des deutschen archäologischen Instituts, Athenische Abteilung*
AvP = *Altertümer von Pergamon* (Berlin 1885–)
BABesch = *Bulletin van de Vereeniging tot Bevordering der Kennis van de Antike Beschaving*
BCH = *Bulletin de correspondance hellénique*
Bieber, *Alexander* = Margarete Bieber, *Alexander the Great in Greek and Roman Art* (Chicago 1964)
Bieber, *SHA* = Margarete Bieber, *The Sculpture of the Hellenistic Age* (revised edition, New York 1961)
Brown, *PPM* = Blanche R. Brown, *Ptolemaic Painting and Mosaics and the Alexandrian Style* (Cambridge, Mass. 1957)
Brunn–Bruckmann = H. Brunn, F. Bruckmann, *Denkmäler griechischer und römischer Skulptur* (Munich 1888–1947)
BSA = *Annual of the British School at Athens*
CAH = *Cambridge Ancient History*
CR = *Classical Review*
Curtius, *Wandmalerei Pompejis* = Ludwig Curtius, *Die Wandmalerei Pompejis* (Cologne 1929; reprint Hildesheim 1960)
Dittenberger, *Syll³* = W. Dittenberger, ed., *Sylloge Inscriptionum Graecarum* (3rd edition, Leipzig 1915–1924)
Dohrn, *Tyche* = Tobias Dohrn, *Die Tyche von Antiochia* (Berlin 1960)
EAA = *Enciclopedia dell'arte antica* (Rome 1958–1966)
EAD = *Exploration archéologique de Délos* (Paris 1909–)
Fraser, *PA* = Peter Fraser, *Ptolemaic Alexandria* (Oxford 1972)
Fuchs, *Vorbilder* = Werner Fuchs, *Die Vorbilder der neuattischen Reliefs* (*JdI Ergänzungsheft* 20) (Berlin 1959)
Furtwängler, *Gemmen* = Adolf Furtwängler, *Die Antiken Gemmen* (Leipzig, Berlin 1900)
GöttNachr = *Nachrichten von der Gesellschaft der Wissenschaften zu Göttingen*
Hansen, *Attalids* = Esther V. Hansen, *The Attalids of Pergamon* (2nd edition, Ithaca and London 1971)
Havelock, *HA* = Christine M. Havelock, *Hellenistic Art* (Greenwich, Conn. 1971)
Helbig, *Führer⁴* = Wolfgang Helbig, *Führer durch die öffentlichen Sammlungen klassischer Altertümer in Rom* (4th edition, ed. H. Speier, Tübingen 1963)
IG = *Inscriptiones Graecae* (1873ff)
IvP = *Die Inschriften von Pergamon* (1890–1969) = *AvP* VIII

Jacoby, *FgrH* = Felix Jacoby, *Die Fragmente der griechischen Historiker* (Berlin 1923–)
JdI = *Jahrbuch des deutschen archäologischen Instituts*
JHS = *Journal of Hellenic Studies*
Karouzou, *CatNatMus* = Semni Karouzou, *National Archaeological Museum, Collection of Sculpture* (Athens 1968)
Klein, *Rokoko* = Wilhelm Klein, *Vom antiken Rokoko* (Vienna 1921)
Kraay–Hirmer, *Greek Coins* = Kraay, Colin M. and Hirmer, Max, *Greek Coins* (New York 1966)
Kyrieleis, *Bildnisse* = Helmut Kyrieleis, *Bildnisse der Ptolemäer* (Berlin 1975)
Laurenzi, *Ritratti* = L. Laurenzi, *Ritratti Greci* (Florence 1941)
Lippold, *Gr. Plastik* = Georg Lippold, *Die griechische Plastik, Handbuch der Archäologie* III.1 (Munich 1950)
Loewy, *IgB* = Emanuel Loewy, *Inschriften griechischer Bildhauer* (Leipzig 1885; reprint Chicago 1976)
MAAR = *Memoirs of the American Academy in Rome*
MonPiot = *Monuments et mémoires publ. par l'Académie des inscriptions et belles lettres, Fondation Piot*
OGIS = W. Dittenberger, *Orientis Graeci Inscriptiones Selectae* (Leipzig 1903–5)
ÖJh = *Jahreshefte des österreichischen archäologischen Instituts*
Overbeck, *SQ* = J. Overbeck, *Die antiken Schriftquellen zur Geschichte der bildenden Künste bei den Griechen* (Leipzig 1868; reprint Hildesheim 1959)
PapOxy = *Oxyrhynchus Papyri*, ed. B. P. Grenfell, A. S. Hunt (London 1898–)
Pernice, *HKP* = Erich Pernice, *Die hellenistische Kunst in Pompeji* VI: *Pavimente und figürliche Mosaiken* (Berlin 1938)
Picard, *Manuel* = Charles Picard, *Manuel d'archéologie grecque, La sculpture* III, IV (Paris 1948–63)
RE = Pauly–Wissowa, *Real-Encyclopädie der klassischen Altertumswissenschaft*
Richter, *EGGE* = Gisela M. A. Richter, *Engraved Gems of the Greeks and the Etruscans* (London 1968)
Richter, *Portraits* = Gisela M. A. Richter, *The Portraits of the Greeks* (London 1965)
Richter, *SSG⁴* = Gisela M. A. Richter, *The Sculpture and Sculptors of the Greeks* (4th edition, New Haven and London 1970)
RivIstArch = *Rivista del R. Istituto d'Archeologia e Storia dell'Arte*
Robertson, *HGA* = Martin Robertson, *A History of Greek Art* (Cambridge 1975)

Abbreviations

RömMitt = Mitteilungen des deutschen archäologischen Instituts, Römische Abteilung

Salzmann, *Kieselmosaiken* = Dieter Salzmann, *Untersuchungen zu den antiken Kieselmosaiken* (Berlin 1982)

Stewart, *Attika* = Andrew F. Stewart, *Attika, Studies in Athenian Sculpture in the Hellenistic Age* (London 1979)

Tarn, *HC* = W. W. Tarn, *Hellenistic Civilization* (3rd edition, London 1952)

Weitzmann, *IRC* = Kurt Weitzmann, *Illustrations in Roll and Codex (Studies in Manuscript Illumination* 2) (Princeton 1947; 1970, with addenda)

BIBLIOGRAPHY

GENERAL BIBLIOGRAPHY

(1) HELLENISTIC ART

Charbonneaux, Jean; Martin, Roland; Villard, François, *Hellenistic Art* (New York 1973)

Hanfmann, George, 'Hellenistic Art,' *Dumbarton Oaks Papers* 17 (1963) 79–94

Havelock, Christine M., *Hellenistic Art* (Greenwich, Conn. 1971; 2nd edn, paperback, New York 1981)

Onians, John, *Art and Thought in the Hellenistic Age* (London 1979)

Schlumberger, Daniel, *L'Orient hellénisé, L'Art grec et ses héritiers dans l'Asie non Mediterranéenne* (Paris 1970) (influence of Hellenistic art on cultures of the Near and Middle East)

Webster, T. B. L., *The Art of Greece: The Age of Hellenism* (New York 1966)

(2) HELLENISTIC SCULPTURE

Alscher, Ludger, *Griechische Plastik* IV: *Hellenismus* (Berlin 1957)

Bieber, Margarete, *The Sculpture of the Hellenistic Age* (revised edn, New York 1961)

Dickins, Guy, *Hellenistic Sculpture* (Oxford 1920)

Lawrence, A. W., *Later Greek Sculpture and its Influence on East and West* (New York 1927)

Linfert, Andreas, *Kunstzentren Hellenistischer Zeit* (Wiesbaden 1976)

(3) HELLENISTIC COINAGE

Davis, Norman and Kraay, Colin M., *The Hellenistic Kingdoms: Portrait Coins and History* (London 1973)

Jenkins, G. Kenneth, *Ancient Greek Coins* (London 1972)

Kraay, Colin M. and Hirmer, Max, *Greek Coins* (New York 1966)

Newell, Edward T., *Royal Greek Portrait Coins* (New York 1937)

Seltman, Charles, *Greek Coins* (London 1955)

(4) GEMS

Boardman, John, *Greek Gems and Finger Rings* (London 1970), pp. 359–72

Furtwängler, Adolf, *Die antiken Gemmen* (Berlin and Leipzig 1900; Amsterdam 1964), sections V and VI

Richter, Gisela M. A., *Engraved Gems of the Greeks and the Etruscans* (London 1968), pp. 133–72

(5) DECORATIVE ARTS

Coche de la Ferté, Étienne, *Les bijoux antiques* (Paris 1956)

Higgins, Reynold A., *Greek and Roman Jewellery* (London 1961)

Hoffman, Herbert; Davidson, Patricia F., *Greek Gold, Jewelry from the Age of Alexander* (Catalogue, Museum exhibition, Boston, Brooklyn, Richmond, 1965–66)

Strong, Donald, *Greek and Roman Silver Plate* (London 1966)

(6) PORTRAIT SCULPTURE (See also bibliography under Chaps. 2 and 3)

Buschor, Ernst, *Das hellenistische Bildnis* (Munich 1949; 2nd edn, Munich 1971)

Hafner, German, *Späthellenistische Bildnisplastik* (Berlin 1954)

Hekler, Anton, *Greek and Roman Portraits* (London 1912)

Laurenzi, Luciano, *Ritratti Greci* (Florence 1941)

Protzmann, H., 'Realismus und Idealität in Spätklassik und Frühhellenismus,' *JdI* 92 (1977) 169–203

Richter, Gisela M. A., *The Portraits of the Greeks* (London 1965) (abridged and rev. edn, ed. R. R. R. Smith, Ithaca, New York, 1984)

Schefold, Karl, *Die Bildnisse der antiken Dichter, Redner, und Denker* (Basel 1943)

(7) SCULPTURE, SPECIFIC SITES

Marcadé, Jean, *Au musée de Délos* (Paris 1969)

Merker, Gloria, *The Hellenistic Sculpture of Rhodes* (Studies in Mediterranean Archaeology XL, Göteborg 1973)

BIBLIOGRAPHY FOR INDIVIDUAL CHAPTERS

References are arranged according to the order of the topics discussed in the chapters of this book. Comprehensive works are cited first, followed by more specialized references. For individual works of art, emphasis is on basic articles and books that provide additional useful bibliography. References to individual works of art in general studies like Bieber's *The Sculpture of the Hellenistic Age*[2] are not itemized unless they provide the most comprehensive discussion of the subject available. When detailed bibliography on particular points has been given in the notes, only basic references are repeated here.

Introduction

(1) HELLENISTIC HISTORY (general)
Austin, Michel M., *The Hellenistic World from Alexander to the Roman Conquest* (Cambridge 1981) (literary and epigraphical sources in translation); Cary, Max, *A History of the Greek World from 323 to 146 B.C.* (2nd edn, London 1951); Delorme, Jean, *Le monde hellénistique 323–133 B.C.* (Paris 1975) (sources in translation); Rostovtzeff, Michael I., *The Social and Economic History of the Hellenistic World* (Oxford 1941); Walbank, Frank W., *The Hellenistic World* (London 1981; Cambridge, Mass. 1983); Will, Edouard, *Histoire politique du monde hellénistique* (Nancy 1966–67; 2nd edn 1979)

(2) HELLENISTIC CULTURE
Ferguson, John, *The Heritage of Hellenism* (London 1973); Grant, Michael, *From Alexander to Cleopatra, The Hellenistic World* (New York 1982); Hadas, Moses, *Hellenistic Culture, Fusion and Diffusion* (New York and London 1959); Petit, Paul, *La civilisation hellénistique* (Paris 1965); Préaux, Claire, *Le monde hellénistique, La Grèce et l'Orient (323–146 av. J.C.)* (Paris 1978); Schneider, Carl, *Kulturgeschichte des Hellenismus* (Munich 1967–69), abridged as *Die Welt des Hellenismus* (Munich 1975); Tarn, W. W., *Hellenistic Civilisation* (3rd edn, London 1952)

(3) HELLENISTIC PHILOSOPHY
 a. General: Long, A. A., *Hellenistic Philosophy* (London 1974); Clark, Gordon H., *Selections from Hellenistic Philosophy* (New York 1940)
 b. Cynicism: Dudley, Donald R., *A History of Cynicism* (London 1937)
 c. Epicureanism: Rist, J. M., *Epicurus, An Introduction* (Cambridge 1972) (basic, with full bibliography); Bailey, Cyril, *Epicurus, The Extant Remains* (Oxford 1926) and *The Greek Atomists and Epicurus* (Oxford 1928); De Witt, Norman W., *Epicurus and his Philosophy* (Minneapolis 1954); Farrington, Benjamin, *The Faith of Epicurus* (London 1967); Moreau, Joseph, *Stoïcisme, Epicurisme: tradition hellénique* (Paris 1979); Usener, Hermann Karl, *Epicurea* (Leipzig 1887; Stuttgart 1966) (collection of texts)
 d. Stoicism: Rist, J. M., *Stoic Philosophy* (Cambridge 1969) (basic); Arnim, Hans F. A. von, *Stoicorum Veterum Fragmenta* (Leipzig 1903–24) (texts); Arnold, E. V., *Roman Stoicism* (Cambridge 1911); Christensen, Johnny, *An Essay on the Unity of Stoic Philosophy* (Copenhagen 1962); Edelstein, Ludwig, *The Meaning of Stoicism* (Cambridge, Mass. 1966); Pohlenz, Max, *Die Stoa* (Göttingen 1964)
 e. Popular philosophy: Bevan, Edwyn, 'Hellenistic Popular Philosophy,' in *The Hellenistic Age* (Cambridge 1923; New York 1970)

(4) HELLENISTIC SOCIAL AND POLITICAL THOUGHT
Aalders, G. J. D., *Political Thought in Hellenistic Times* (Amsterdam 1975); Baldry, H. C., *The Unity of Mankind in Greek Thought* (Cambridge 1965); Ferguson, John, *Utopias of the Classical World* (London, Ithaca 1975)

(5) HELLENISTIC RELIGION
 a. General: Nilsson, Martin P., *Geschichte der griechischen Religion* II: *Die hellenistische und römische Zeit* (Munich 1961); Nock, Arthur Darby, *Conversion, The Old and the New in Religion from Alexander the Great to Augustine of Hippo* (Oxford 1933)
 b. Selection of texts: Grant, Frederick C., ed., *Hellenistic Religions, The Age of Syncretism* (New York 1953)
 c. Mystery religions: Godwin, Joscelyn, *Mystery Religions in the Ancient World* (San Francisco 1981); Nilsson, Martin P., *The Dionysiac Mysteries of the Hellenistic and Roman Age* (Lund 1957)
 d. Egyptian cults: Bell, H. I., *Cults and Creeds in Graeco-Roman Egypt* (2nd edn, Liverpool 1952); Dunand, Françoise, *Le culte d'Isis dans le bassin oriental de la Mediterranée* (Leiden 1973); Hornbostel, Wilhelm, *Sarapis* (Leiden 1973); Solmsen, Friedrich, *Isis Among the Greeks and Romans* (Cambridge, Mass. 1980); Stambaugh, John E., *Sarapis Under the Early Ptolemies* (Leiden 1972); Vidman, Ladislav, *Isis und Serapis bei den Griechen und Römern* (Berlin 1970); Witt, R. E., *Isis in the Graeco-Roman World* (London 1971)

(6) HELLENISTIC LITERATURE AND HISTORIOGRAPHY
 a. General: Webster, T. B. L., *Hellenistic Poetry and Art* (London 1964); Barber, E. A., 'Alexandrian Literature,' in *The Hellenistic Age* (Cambridge 1923; New York 1970); Körte, Alfred and Handel, Paul, *Die hellenistische Dichtung* (2nd edn, Stuttgart 1960)
 b. Biography and autobiography: Misch, Georg, *A History of Autobiography in Antiquity* (Cambridge, Mass. 1951); Momigliano, Arnaldo D., *The Development of Greek Biography* (Cambridge, Mass. 1971)
 c. Kallimachos: Pfeiffer, Rudolf, *Callimachus* (Oxford 1949–53); Trypanis, C. A., *Callimachus* (Loeb Classical Library, Cambridge, Mass. 1975)
 d. Menander: Goldberg, S. M., *The Making of Menander's Comedy* (Berkeley and Los Angeles 1980); Webster, T. B. L., *An Introduction to Menander* (2nd edn, Manchester 1974)
 e. Polybios: Walbank, Frank W., *Polybios* (Berkeley and Los Angeles 1972) and *A Historical Commentary on Polybios* (Oxford 1957–79)
 f. Theokritos: Gow, A. S. F., *Theocritos* (Cambridge 1950); Walker, Steven F., *Theocritus* (Boston 1980)

(7) HELLENISTIC SCHOLARSHIP
Fraser, Peter M., *Ptolemaic Alexandria* (Oxford 1972), Chapter 8; Parsons, E. A., *The Alexandrian Library* (London 1952); Pfeiffer, Rudolf, *History of Classical Scholarship from the Beginning to the End of the Hellenistic Age* (Oxford 1968)

(8) PARTICULAR MONUMENTS

a. Relief of Archelaos: Pinkwart, Doris, 'Das Relief des Archelaos von Priene,' *Antike Plastik* 4 (1965) 55–65 and *Das Relief des Archelaos von Priene und die Musen des Philiskos* (Kallmünz 1965); Schede, M., 'Zu Philiskos, Archelaos, und den Musen,' *RömMitt* 35 (1920) 70–82; Watzinger, Carl, *Das Relief des Archelaos von Priene* (Berliner Winckelmannsprogramm 63, Berlin 1903)

b. Tyche of Antioch: see under Chap. 2

c. Hediste stele: see under Chap. 9

d. Alexander Mosaic: see under Chap. 1

Chapter 1 Royal iconography

1. Funeral carriage of Alexander: Müller, Kurt F., *Der Leichenwagen Alexanders des Grossen* (Leipzig 1905)

2. Portraits of Alexander (see also under Chap. 3): Bernoulli, Johann Jakob, *Die erhaltenen Darstellungen Alexanders des Grossen* (Munich 1905); Bieber, Margarete, *Alexander the Great in Greek and Roman Art* (Chicago 1964); Gebauer, K., 'Alexanderbildnis und Alexandertypus,' *AthMitt* 63–4 (1938–9) 1–106; Hölscher, T., *Ideal und Wirklichkeit in den Bildnissen Alexanders des Grossen* (Heidelberg 1971); Kleiner, G., 'Das Bildnis Alexanders des Grossen,' *JdI* 65–6 (1950–1) 206–30. Schwarzenberg, E., 'Der lysippische Alexander,' *Bonner Jahrbücher* 167 (1967) 58–118 and 'The Portraiture of Alexander,' *Alexandre le Grand: image et réalité, Fondation Hardt, Entretiens*, 22 (1975) 223–67

3. Apelles: Mustilli, D., in *EAA*, s.v. 'Apelle.' See also p. 304, note 7.

4. Pyrgoteles: Guépin, J. P., 'Leonine Brows and the Shadow of Pyrgoteles,' *BABesch* 39 (1964) 129–39; Guerrini, L., in *EAA*, s.v. 'Pyrgotele.' See also under 'Gems, General.'

5. Neisos Gem: Furtwängler, *Gemmen* p. 158; Richter, *EGGE*, p. 153, no. 603.

6. Vienna Cameo: See p. 304, note 11

7. Gonzaga Cameo: Kyrieleis, H., 'Der Kameo Gonzaga,' *Bonner Jahrbücher* 171 (1971) 162–93

8. Coinage of Alexander: Bellinger, Alfred R., 'Essays on the Coinage of Alexander the Great,' *Numismatic Studies* 11 (New York 1963); Bauslaugh, Robert A. 'The Numismatic Legacy of Alexander the Great,' *Archaeology* 37.4 (1984) 34–41. See also under (2) above and under 'Hellenistic Coinage, General'

9. Ptolemaic portrait coins: See under Chap. 12

10. Portraits of Demetrios Poliorcetes: Newell, Edward T., *The Coinages of Demetrios Poliorcetes* (Oxford 1927; Chicago 1978). Also: Richter, *Portraits*, p. 256; Laurenzi, *Ritratti*, no. 50

11. Portrait of Philetairos: Lehmann-Hartleben, K., 'Some Ancient Portraits: 1, Philetairos,' *AJA* 46 (1942) 198–204; Westermark, Ulla, *Das Bildnis des Philetairos von Pergamon* (Stockholm 1960)

12. Portraits of Mithradates VI: Kleiner, G., 'Bildnis und Gestalt des Mithradates,' *JdI* 68 (1953) 73–95; Krahmer, G., 'Eine Ehrung für Mithradates VI Eupator in Pergamon,' *JdI* 40 (1925) 183–205; Winter, F., 'Mithradates VI Eupator,' *JdI* 9 (1894) 245–8

13. Lion hunt iconography: Wreszinski, Walter, *Löwenjagd im alten Aegypten* (Morgenland 23, 1932)

14. Alexander Sarcophagus: Graeve, Volkmar von, *Der Alexandersarkophag und seine Werkstatt* (Istanbuler Forschungen 28, Berlin 1970); Schefold, Karl, *Der Alexander-Sarkophag* (Berlin 1968); Winter, Franz, *Der Alexandersarkophag von Sidon* (Strassburg 1912)

15. Kinch tomb: Kinch, K. F., *Le tombeau de Niausta, tombeau Macédonien* (Copenhagen 1927)

16. Alexander mosaic: Andreae, Bernhard, *Das Alexandermosaik* (Opus Nobile 14, Bremen 1959) and *Das Alexandermosaik aus Pompeji* (Recklinghausen 1977); Fuhrmann, Heinrich, *Philoxenos von Eretria* (Göttingen 1931); Winter, Franz, *Der Alexander-Mosaik aus Pompeji* (Strassburg 1909)

Chapter 2 Lysippos and his school

1. General: Collignon, Maxime, *Lysippe, Étude critique* (Paris 1905); Johnson, Franklin P., *Lysippos* (Durham, N.C. 1927); Kleiner, G., 'Über Lysipp,' in *Festschrift Bernhard Schweitzer, Neue Beiträge zur Klassischen Altertumswissenschaft* (Stuttgart 1954), pp. 227–39; Maviglia, Ada, *L'Attività di Lisippo ricostruita su nuova base* (Rome 1914); Moreno, Paolo, *Testimonianze per la teoria artistica di Lisippo* (Rome 1973); Morgan, Charles, 'The Style of Lysippos,' *Hesperia*, Suppl. VIII (1949) 228–34; Picard, Charles, *Manuel d'archéologie grecque: La Sculpture*, IV (Paris 1963), pp. 423–753; Schuchhardt, W. H., 'Der junge Lysipp,' in *Festschrift Schweitzer* (see above), pp. 222–6; Sjöqvist, Erik, *Lysippus* (Cincinnati 1966) and 'The Early Style of Lysippos,' *Opuscula Atheniensia* 1 (1953) 87–97

2. Apoxyomenos: (in addition to almost all general studies of Lysippos) Gardner, P., 'The Apoxyomenos of Lysippos,' *JHS* 25 (1905) 234–59

3. Eros: Döhl, Hartmut, *Der Eros des Lysipp* (Göttingen 1968)

4. Colossal Zeus at Tarentum: Dörig, J., 'Lysipps Zeuskoloss von Tarent,' *JdI* 79 (1964) 257–78; Moreno, P., 'Le Zeus de Lysippe à Tarente,' *Revue archéologique* (1971) 289–90

5. Figures of Herakles: Chelotti, M. A., 'Osservazioni sull'Eracle del tipo Farnese,' *Annali della Facoltà di Lettere e Filosofia, Bari* 16 (1973) 169–96; Furtwängler, A., 'Der Herakles des Lysipp in Konstantinopel,' *Sitzungsberichte der Akademie der Wissenschaften zu München* (1902) 435–42; Löffler, E., 'Lysippos' Labors of Herakles,' *Marsyas* 6 (1954) 8–24; Moreno, P., 'Il Farnese ritrovato,' *Mélanges de l'école française de Rome, antiquité* 94 (1982) 379–526; Visscher, Fernand de, *Héraklès Épitrapézios* (Paris 1962)

6. Portrait of Aristotle: Studniczka, Franz, *Das Bildnis Aristoteles* (Leipzig 1908). See also Richter, Laurenzi, Schefold under General Bibliography (6) above.

7. Borghese Faun: Brunn–Bruckmann, *Denkmäler*, no. 435; Von Steuben, in Helbig, *Führer⁴* II, no. 1995

8. Kairos: Stewart, A. F., 'Lysippan Studies, 1. The Only Creator of Beauty,' *AJA* 82 (1978) 163–71; Schwarz, G., 'Der Lysippische Kairos,' *Grazer Beiträge* 4 (1975) 243–66

9. Tyche of Antioch: Dohrn, Tobias, *Die Tyche von Antiochia* (Berlin 1960)

10. Anzio Girl: See Chap. 2, notes 22–3 and also Lauter, H. 'Neues zum Mädchen von Antium,' *AthMitt* 86 (1971) 147–61

11. Doidalsas: Laurenzi, L., 'La personalità di Doidalses di Bitinia,' *ASAtene* 24–6 (1946–48) 167–79; Laurenzi in *EAA*, s.v. 'Doidalses'; Lullies, Reinhard, *Die kauernde Aphrodite* (Munich 1954)

12. Conservatori Girl: Von Steuben in Helbig, *Führer⁴* II, no. 1480

13. Bronze Hermes in Naples: Johnson, *Lysippos*, 177–82; Maiuri, A., 'L'Ermete in riposo del Museo Nazionale di Napoli,' *Bollettino d'Arte* 33 (1948) 181–3 (on restoration)

Chapter 3 Personality and psychology in portraiture

For basic information about individual portrait types and extensive illustrations, see Richter, *The Portraits of the Greeks*. The following list singles out works of particular importance and supplements Richter's references with some important works published since 1965.

1. **Egyptian and Greek portraiture:** Bothmer, Bernard, *Egyptian Sculpture of the Late Period* (The Brooklyn Museum 1960); Drerup, Heinrich, *Ägyptische Bildnisköpfe griechischer und römischer Zeit* (Münster 1957)

2. **Satrap portraits:** Robertson, *HGA*, pp. 506–7; Schwabacher, W., 'Satrapbildnisse,' in *Charites, Festschrift Ernst Langlotz*, ed. K. Schauenburg (Bonn 1957), pp. 27–32

3. **Philosopher portraits** (supplementing the general works of Richter and Schefold): Lorenz, Thuri, *Galerien von griechischer Philosophen- und Dichterbildnissen bei den Römern* (Mainz 1965)

4. **Epicurus and his followers:** Dontas, G. 'Eikonistika B',' *Archaiologikon Deltion* 26 (1971) 16–33; Frischer, Bernard, *The Sculpted Word: Philosophical Recruitment in Ancient Greece* (Berkeley and Los Angeles 1982); Kruse-Berdolt, Veronika, *Kopienkritische Untersuchungen zu den Porträts des Epikur, Metrodor, und Hermarch* (Diss. Göttingen 1975)

5. **Pontic coin portraits:** Kleiner, G., 'Pontische Reichsmünzen,' *Istanbuler Mitteilungen* 6 (1955) 1–21

6. **Delos group:** Michalowski, Casimir, *Les portraits hellénistiques et romaines* (*EAD* XIII, 1931); Stewart, *Attika*, Chapter 3

7. **Late Hellenistic portraiture and Rome:** Zanker, Paul, 'Zur Rezeption des hellenistischen Individualporträts in Rom und in den italischen Städten,' in *Hellenismus in Mittelitalien* (*Abhandlungen der Akademie der Wissenschaften in Göttingen, Phil.-Hist. Kl., Dritte Folge* 97, 1976), pp. 581–619

8. **Roman Republican portraiture, General:** Schweitzer, Bernhard, *Die Bildniskunst der römischen Republik* (Leipzig 1948)

9. **Barberini Togatus:** von Heintze in Helbig, *Führer*[4] II, no. 1615

10. **General from Tivoli:** von Heintze in Helbig, *Führer*[4] III, no. 2304

11. **Menander:** Ashmole, B., 'Menander: An Inscribed Bust,' *AJA* 77 (1973) 61

12. **Pompey:** Toynbee, Jocelyn M. C., *Roman Historical Portraits* (London 1978), pp. 24–8

13. **Augustus, 'Actium Type':** Zanker, Paul, 'Studien zu den Augustus-Porträts, I: Der Actium-Typus,' *Abh. Gott. Akad.* (see no. 7 above) 85 (1973)

Chapter 4 The sculpture of Pergamon

1. **Historical background:** Allen, R. E., *The Attalid Kingdom. A Constitutional History* (Oxford 1981); Hansen, Esther V., *The Attalids of Pergamon* (*Cornell Studies in Classical Philology* 36) (Ithaca and London 1971); McShane, R. B., *The Foreign Policy of the Attalids* (Urbana, Illinois 1964)

2. **Pergamene art, General:** Schober, Arnold, *Die Kunst von Pergamon* (Vienna 1951); detailed bibliography in Hansen, *Attalids*, pp. 496–501

3. **Pergamene sculpture, General:** *Die Altertümer von Pergamon* VII: *Die Skulpturen mit Ausnahme der Altarreliefs*, ed. F. Winter (Berlin 1908); Bieber, *SHA*, Chapter VIII

4. **Pergamene sculptors:** For general references see Hansen, *Attalids*, pp. 299–303; on Phyromachos see Stewart, *Attika*, Chapter 1

5. **Gallic dedications:** Künzl, Ernst, *Die Kelten des Epigonos von Pergamon* (Würzburg 1971) is basic. Also: Bienkowski, P. R., *Die Darstellungen der Gallier in der hellenistischen Kunst* (Vienna 1908); Schober, Arnold, 'Epigonos von Pergamon und die frühpergamenische Kunst,' *JdI* 53 (1938) 126–49; Wenning, Robert, *Die Gallieranatheme Attalos I* (Berlin 1978)

6. **Individual sculptures:** See the general works listed above. For description, condition, and basic references see also:

 a. **Dying Trumpeter in Capitoline:** Von Steuben in Helbig, *Führer*[4] II, no. 1436

 b. **Gaul and Wife in Terme:** Fuchs in Helbig, *Führer*[4] III, no. 2337; Künzl, Ernst, *Frühhellenistische Gruppen* (Cologne 1968), pp. 118–27

 c. **Delos Gallic group:** See Chap. 4, note 21

 d. **Zeus in Istanbul:** *Antike Denkmäler* III (Berlin 1926), pp. 18–19, pl. 19

 e. **Other individual sculptures:** *AvP* VII

7. **Altar of Zeus, Gigantomachy Frieze:**

 a. **Basic:** *Altertümer von Pergamon* III.2, *Die Friese des grossen Altars.* ed. H. Winnefeld (Berlin 1910); Kähler, Heinz, *Der grosse Fries von Pergamon* (Berlin 1948)

 b. **Introductory:** Rohde, Elisabeth, *Pergamon, Bauberg und Altar* (Berlin 1976); Schmidt, Eva Maria, *Der grosse Altar zu Pergamon* (Leipzig 1961) (also in English and French translations)

 c. **Extensive references:** Hansen, *Attalids*, pp. 498–500; Rohde, *Bauberg*, pp. 86–8 (see under (b) above)

 d. **References of particular importance for the issues discussed in Chapter 4** (in chronological order): Puchstein, O., 'Zur pergamenischen Gigantomachie,' *Sitzungsberichte der preussischen Akademie der Wissenschaften, Phil.-Hist. Kl.* (Berlin 1888), pp. 1231–49 and 1889, pp. 323–45; Robert, Carl, 'Archäologische Nachlese, XX: Die Götter in der pergamenischen Gigantomachie,' *Hermes* 46 (1911), 217–49; Lücken, G. von, 'Die Götter auf der Nordseite des Pergamonaltars,' *JdI* 54 (1939) 97–104; Picard, Charles, 'Les énigmes de la frise nord extérieur au socle du grand autel de Pergame,' *Comptes rendus de l'Académie des inscriptions et belles-lettres* (1940) 158–76; Kähler, *Der grosse Fries* (see under (a) above); Simon, Erika, *Pergamon und Hesiod* (Mainz 1975); Pfanner, Michael, 'Bemerkungen zur Komposition und Interpretation des grossen frieses von Pergamon,' *ArchAnz* (1979) 46–57

8. **Telephos frieze:** See under Chap. 9.

Chapter 5 Hellenistic baroque

1. **Tarentine tomb sculpture:** Bernabò-Brea, L., 'I rilievi tarentini in pietra tenera,' *RivIstArch*, n.s. 1 (1952) 5–241; Carter, Joseph Coleman, 'Relief Sculptures from the Necropolis of Taranto,' *AJA* 74 (1970) 125–37; and *The Sculptures of Taras* (*Transactions of the American Philosophical Society* 65, part 7, Philadelphia 1975); Klumbach, Hans, *Tarentiner Grabkunst* (Reutlingen 1937)

2. **Groom relief in Athens:** See Chap. 5, n. 4.

3. **Nike of Samothrace:** Charbonneaux, Jean, 'La main droite de la Victoire de Samothrace,' *Hesperia* 21 (1952) 44–6 (hand discovered in 1950); Lehmann, Karl and Phyllis, *Samothracian Reflections* (Princeton, N. J. 1973) 181–99; Thiersch, H., 'Die Nike von Samothrake, ein rhodisches Werk und Anathem,' *GöttNachr* (1931) 336–78

4. **Pasquino Group:** Schweitzer, Bernhard, 'Das Original der sogenannten Pasquino-Gruppe,' *Abhandlungen der Sächsischen Akademie der Wissenschaften, Leipzig, Phil.-Hist. Kl.* 4

(1936) and 'Die Menelaos-Patroklos Gruppe,' *Die Antike* 14 (1938) 43–72, are basic; most recently on the date: Nitsche, Andreas, 'Zur Datierung der Pasquino Gruppe,' *ArchAnz* (1981) 76–85; on the replica from Sperlonga: Andreae, B., in *Antike Plastik* 14 (1974) 36–8, 87–95

5. Marsyas and Scythian Group: Amelung, Walther, *Führer durch die Antiken in Florenz* (Munich 1897) 61–4; Schober, Arnold, 'Zur pergamenischen Marsyasgruppe,' *Strena Buliciana* (Zagreb 1924) 31–4

6. Blind Homer: Boehringer, Erich and Robert, *Homer, Bildnisse und Hinweise* (Breslau 1939)

7. Pseudo-Seneca: Strandman, B., 'The Pseudo-Seneca Problem,' *Opuscula Academica, Konsthistorisk Tidskrift* 19 (1950) 53–93

8. Laokoön: Bieber, Margarete, *Laocoön: The Influence of the Group Since its Discovery* (New York 1942, 2nd edn, Detroit 1967); Blanckenhagen, Peter von, 'Laokoön, Sperlonga, und Vergil,' *ArchAnz* 84 (1969) 256–75; Magi, F., *Il repristino del Laocoonte* (Atti della Pontificia Academia Romana di Archeologia, Memorie, ser. 9, Rome 1960); Sichtermann, Helmut, *Laokoön* (*Opus Nobile* 3) (Bremen 1957)

9. Sperlonga: Conticello, Baldo and Andreae, Bernhard, *Die Skulpturen von Sperlonga* (*Antike Plastik* xiv) (1974), with extensive references; Stewart, Andrew F., 'To Entertain an Emperor: Sperlonga, Laokoon, and Tiberius at the Dinner Table,' *Journal of Roman Studies* 67 (1977) 76–90

Chapter 6 Realism, rococo, and the exotic

1. General: Klein, Wilhelm, *Vom antiken Rokoko* (Vienna 1921); Bieber, *SHA*, Chapter 10

2. Later European rococo: Levey, Michael and Kalnein, Wend Graf, *Art and Architecture of the 18th Century in France* (Harmondsworth 1972); Schönberger, Arno and Soehner, Halldorf, *The Rococo Age, Art and Civilization in the 18th Century* (New York 1960); on Clodion: Munhall, Edgar and Poulet, Anne, *Clodion Terracottas in North American Collections* (The Frick Collection, New York, Exhibition, June–September 1984); Thirion, Henri, *Les Adam et Clodion* (Paris 1885)

The following references supplement general studies of Hellenistic sculpture and basic information given in museum guides and catalogues:

3. Boethos: Fuchs, Werner, *Der Schiffsfund von Mahdia* (Tübingen 1963), pp. 12–14; Rumpf, A., 'Boethoi,' *ÖJh* 39 (1952) 86–9

4. Satyr gigantomachy in the Palazzo dei Conservatori: Von Steuben in Helbig, *Führer*⁴ II, no. 1467

5. Satyr and Snake Group from Split: Schober, Arnold, 'Eine neue Satyrgruppe,' *RömMitt* 52 (1937) 83–93

6. Dwarfs from Mahdia wreck: Fuchs, *Schiffsfund*, pp. 16–18 (see (3) above)

7. Children: Klein, Anita, *Child Life in Greek Art* (New York 1932); Rühfel, Hilde, *Das Kind in der griechischen Kunst* (Mainz 1984)

8. Old women, fishermen, etc.: Himmelmann, Nikolaus, *Über Hirten-Genre in der antiken Kunst* (Abhandlungen der rheinisch-westfälischen Akademie der Wissenschaften 65, Opladen 1980) and *Archäologisches zum Problem der griechischen Sklaverei* (Akademie der Wissenschaften und der Literatur, Mainz, Abhandlungen der geistes- und sozialwissenschaftliche Klasse, 1971, no. 13); Laubscher, Hans P., *Fischer und Landleute* (Mainz 1982); Richardson, Bessie E., *Old Age Among the Greeks* (Baltimore 1936)

9. Nilotic mosaics: Bendinelli, G., 'Influssi dell' Egitto ellenistico sull' arte romana,' *Bulletin de la société royale d'archéologie d'Alexandrie* 24 (1929) 21–38 and 'Éléments alexandrins dans la peinture romaine de l'époque de l'empire,' *op. cit.* 26 (1931) 227–41

10. Nilotic mosaic from Praeneste: See under Chap. 9

11. Hermaphrodite: Robertson, *HGA*, pp. 551–2

ADDENDUM Bayer, E., *Fischerbilder in der hellenistischen Plastik* (Bonn 1983)

Chapter 7 Rome as a center of Hellenistic art

1. General: Becatti, Giovanni, *Arte e gusto negli scrittori latini* (Florence 1951); Jucker, Hans, *Vom Verhältnis der Römer zur bildenden Kunst der Griechen* (Bamberg 1950); Pollitt, J. J., 'The Impact of Greek Art on Rome,' *Transactions of the American Philological Association* 108 (1978) 155–74; Richter, Gisela M. A., *Ancient Italy* (Oxford 1951); Ridgway, Brunilde S., *Roman Copies of Greek Sculpture* (Ann Arbor 1984); Vermeule, Cornelius C., *Greek Sculpture and Roman Taste* (Ann Arbor 1977); Vessberg, Olaf, *Studien zur Kunstgeschichte der römischen Republik* (Lund 1941); Zanker, Paul, 'Zur Funktion und Bedeutung griechischer Skulptur in der Römerzeit,' in *Le classicisme à Rome aux Iers siècles avant et après J.-C., Entretiens sur l'antiquité classique* 25 (1979) 283–314

2. Booty from Roman conquests: Pape, Magrit, *Griechische Kunstwerk aus Kriegsbeute und ihre öffentliche Aufstellung in Rom* (Diss. Hamburg 1975); Waurick, G., 'Kunstraub der Römer: Untersuchungen zu seinen Anfängen anhand der Inschriften,' *Jahrbuch des römisch-germanischen Zentralmuseums, Mainz,* 22 (1977) 1–46

3. Tarentum treasure: Wuilleumier, Pierre, *Le trésor de Tarente* (Paris 1930); Belli, Carlo, *Il Tesoro di Taras* (Milan–Rome, N.D. *ca.* 1980). **Tarentine painting:** Phillips, Kyle M., 'Perseus and Andromeda,' *AJA* 72 (1968) 1–23.

4. Monument of Aemilius Paullus: Kähler, Heinz, *Der Fries vom Reiterdenkmal des Aemilius Paullus in Delphi* (Berlin 1965); Reinach, A. J., 'La frise du monument de Paul-Emile à Delphes,' *BCH* 34 (1910) 433–68

5. Porticus Metelli and other Roman buildings: Coarelli, Filippo, *Guida archeologica di Roma* (Verona 1974); Nash, Ernest, *Pictorial Dictionary of Ancient Rome* (New York 1961); Platner, S. B. and Ashby, T., *A Topographical Dictionary of Ancient Rome* (Oxford 1929; reprint Rome 1965)

6. Scipionic circle: Astin, Alan, *Scipio Aemilianus* (Oxford 1967)

7. Villa of the Papyri, Herculaneum: Comparetti, Domenico, *La Villa dei Pisoni in Ercolano e la sua biblioteca* (Naples 1879); Comparetti, Domenico and De Petra, Giulio, *La Villa ercolanese dei Pisoni* (Torino 1883); Lorenz, Thuri, *Galerien,* pp. 10–14 (see under Chap. 3 (3) above); Pandermalis, D., 'Zum Programm der Statuenausstattung in der Villa dei Papiri,' *AthMitt* 86 (1971) 173–209

8. School of Timarchides, Polykles, etc.: See under Chap. 8.

9. Arkesilaos: Borda, M., 'Arkesilaos,' *Bollettino della Commissione Archeologica Communale di Roma* 73 (1949–50) 189–204; Bieber, M., 'Die Venus Genetrix des Arkesilaos,' *RömMitt* 48 (1933) 261–76; Weickert, Carl, 'Ein römisches Relief aus der Zeit Caesars,' in *Festschrift Paul Arndt* (Munich 1932) 48–61

10. Pasiteles: Borda, Maurizio, *La Scuola di Pasiteles* (Bari 1953)

Chapter 8 Style and retrospection: neoclassicism and archaism

1. **Neoclassicism in Hellenistic art, general:** Becatti, Giovanni, 'Attikà: saggio sulla scultura attica dell'ellenismo,' *RivIstArch* 7 (1940) 7–116; Richter, Gisela M. A., *Three Critical Periods of Greek Sculpture* (Oxford 1951), Chapter 3 and 'Was Roman Art of the First Century B.C. and A.D. Classicizing?' *Journal of Roman Studies* 48 (1958) 10–15; Stewart, *Attika*, Chapter 2

2. **Damophon:** Becatti, 'Attikà,' 40–52 (see (1) above); Despinis, G. J., 'Ein neues Werk des Damophon,' *ArchAnz* 81 (1966) 378–85 (identification of the head of Damophon's Apollo at Messene); Dickins, Guy, 'Damophon of Messene. Part I. His Date,' *BSA* 12 (1905–06) 109–36, and 'Damophon of Messene, II,' *BSA* 13 (1906–07) 357–404 (on the restoration of the group), and 'Damophon of Messene, III,' *BSA* 17 (1910–11) 80–7 (re-examination of the group in the light of numismatic evidence). See also the references in Chap. 8, note 2

3. **Eukleides:** Becatti, 'Attikà,' 25–8 (see (1) above); M. Marziani in *EAA*, s.v. 'Eukleides'

4. **Euboulides:** Becatti, 'Attikà,' 28–33, 52–5 (see (1) above)

5. **School of Timarchides, Polykles, etc.:** Becatti, 'Attikà,' *passim* (see (1) above); Coarelli, F., 'Polykles,' *Studi Miscellanei* 15 (1969) 75–89; Stewart, *Attika*, pp. 42–5

6. **Athena Parthenos from Pergamon:** *AvP* VII, no. 24, Beiblatt 2.3, pp. 33–46

7. **Aphrodite of Melos (Venus de Milo):** Charbonneaux, Jean, *La Vénus de Milo (Opus Nobile* 6) (Bremen 1958) and 'La geste de la Vénus de Milo,' *La Revue des arts* 6 (1956) 105–6

8. **Copying industry:** Richter, Gisela M. A., 'How were the Roman Copies of Greek Portraits made?' *RömMitt* 59 (1962) 52–8, and also *Portraits*, pp. 24–8 and *Ancient Italy* (Ann Arbor 1955), pp. 105–16

9. **Neo-Attic Reliefs:**

 a. **General:** Bieber, *SHA*, 182–6; Fuchs, Werner, *Die Vorbilder der neuattischen Reliefs* (*JdI Ergänzungsheft* 20, Berlin 1959); Hauser, Friedrich, *Die Neu-Attischen Reliefs* (Stuttgart 1889); Loewy, Emmanuel, *Neuattische Kunst* (Leipzig 1922)

 b. **Maenad types:** Hauser, *Neu-Attischen Reliefs, passim* and Fuchs, *Vorbilder*, pp. 72–96 are basic (see (a) above); also: Gullini, G., 'Kallimachos,' *ArchCl* 5 (1953) 133–62; Rizzo, Giulio Emanuele, *Thiasos: Bassorilievi greci di soggetto dionisiaco* (Rome 1934)

 c. **Nike parapet copies:** Fuchs, *Vorbilder*, pp. 6–20 (see (a) above)

 d. **Vessels from the Mahdia Wreck:** Merlin, Alfred and Poinssot, Louis, *Cratères et candélabres de marbre trouvés en mer près de Mahdia* (Tunis and Paris 1930)

10. **Stephanos Youth:** Borda, *Scuola di Pasitele* pp. 22–42 (see under Chap. 7 (10) above); Brunn–Bruckmann, no. 301; Zanker, Paul, *Klassizistische Statuen* (Mainz 1974), pp. 49–68

11. **Menelaos Group:** Brunn–Bruckmann, no. 309; Zanker in Helbig, *Führer*⁴ III, no. 2352

12. **Archaism (in chronological order):** Hauser, *Die Neu-Attischen Reliefs* (see (9a) above); Bulle, Heinrich, *Archaisierende griechische Rundplastik* (*Abhandlungen der königlich bayerischen Akademie der Wissenschaften, Phil.-Hist. Kl.* 30, Band 2, Munich 1918); Schmidt, Eduard, *Archaistische Kunst in Griechenland und Rom* (Munich 1922); Feubel, Renate, *Die attischen Nymphenreliefs* (Heidelberg 1935); Folman, Michel, *Introduction à l'étude de la sculpture archaisante* (Montpellier 1935); Becatti, Giovanni, 'Lo stile arcaistico,' *La Critica d'Arte* 6 (1941) 32–48; and 'Revisione critiche, anfore panatenaiche e stile arcaistico,' *Atti della Pontificia Accademia Romana di Archeologia, Rendiconti* 17 (1941)

85–98; Havelock, Christine M., 'Archaistic Reliefs of the Hellenistic Period,' *AJA* 68 (1964) 43–58; and 'The Archaic as Survival versus the Archaistic as a New Style,' *AJA* 69 (1965) 331–40; Harrison, Evelyn B., *The Athenian Agora* XI: *Archaic and Archaistic Sculpture* (Princeton 1965); Herdejürgen, Helga, *Untersuchungen zur thronenden Göttin aus Tarent und zur archaischen und archaistischen Schrägmanteltracht* (Waldsassen-Bayern 1968); Willers, Dietrich, *Zu den Anfängen der archaistischen Plastik in Griechenland* (*AthMitt*, Beiheft 4) (Berlin 1975); Ridgway, Brunilde S., *The Archaic Style in Greek Sculpture* (Princeton 1977), Chapter 11; Hadzi, Martha Leeb, 'A Note on the Frieze of the Propylon and Archaistic Art,' in Lehmann, Phyllis W., Spittle, Denys, et al., *Samothrace* 5: *The Temenos* (Princeton 1982)

Chapter 9 Pictorial illusion and narration

1. **Odyssey landscapes** (in chronological order): Nogara, Bartolomeo, *Le Nozzi Aldobrandini, I Paesaggi con scene dell' Odissea e le altre pitture murali antiche* (Milan 1907); Dawson, Christopher, *Romano-Campanian Mythological Landscape Painting* (*Yale Classical Studies* IX, New Haven 1944); Vlad Borrelli, L., 'Un nuova frammento dei Paesaggi dell' Odissea,' *Bollettino d'Arte* 41 (1956) 289–300; Schefold, Karl, 'Origins of Roman Landscape Painting,' *The Art Bulletin* 42 (1960) 87–96; Andreae, Bernhard, 'Der Zyklus der Odyseefresken im Vatican,' *RömMitt* 69 (1962) 106–17; Gallina, Anna, *Le pitture con paesaggi dell'Odissea dall' Esquilino* (*Studi Miscellanei* 6, 1964); Blanckenhagen, Peter von, 'The Odyssey Frieze,' *RömMitt* 70 (1963) 100–46

2. **Tomb of hunting and fishing:** Romanelli, Pietro, *Le pitture della Tomba della Caccia e della Pesca* (*Monumenti della pittura antica scoperti in Italia*, Rome 1938)

3. **Tomb of the Diver:** Napoli, Mario, *La Tomba del Tuffatore* (Bari 1970)

4. **Macedonian tombs:**

 a. **General:** Gossel, Berthild, *Makedonische Kämmergräber* (Diss., Munich 1980); Miller, Stella G., 'Macedonian Tombs: Their Architecture and Architectural Decoration,' in *Studies in the History of Art* 10: *Macedonia and Greece in Late Classical and Early Hellenistic Times*, ed. E. N. Borza, B. Barr-Sharrar (National Gallery of Art, Washington 1982)

 b. **Lefkadia:** Petsas, Photios, *O Taphos ton Leukadion/The Tomb of Lefkhadia* (Athens 1966), in Greek

 c. **Vergina:** Andronikos, Manolis, 'Vergina, The Royal Grave in the Great Tumulus,' *Athens Annals of Archaeology* 10 (1977) 1–39, reprinted as *The Royal Graves at Vergina* (Athens 1978), and 'Regal Treasures from a Macedonian Tomb,' *National Geographic* 154 (July 1978) 54–77, and 'The Royal Tombs at Vergina: A Brief Account of the Excavations,' in *The Search for Alexander* (Exhibition catalogue, New York Graphic Society, Boston 1980)

 d. **On the date of Vergina Tomb II:** Lehmann, P. W., 'The So-called Tomb of Philip II: A Different Interpretation,' *AJA* 84 (1980) 527–31; Fredricksmeyer, E. A., 'Again the So-called Tomb of Philip II,' *AJA* 85 (1981) 330–4; Calder, W. M., 'Diadem and Barrel Vault: A Note,' *AJA* 85 (1981) 334–5; Lehmann, P. W., 'The So-called Tomb of Philip II: An Addendum,' *AJA* 86 (1982) 437–42; Adams, W. L., 'The Royal Macedonian Tombs at Vergina: An Historical Interpretation,' *The Ancient World* 3 (1980) 67–72; Giallolombardo, A. M. P. and Tripodi, B., 'Le tombe regali di Vergina: quale Filippo?' *Annali della Scuola Normale Superiore di Pisa* 10 (1980) 989–

1001; Prag, A. J. N., Musgrave, J. N., Neave, R. A. H., 'The skull from Tomb II at Vergina: King Philip of Macedon,' *JHS* 104 (1984) 60–78

5. Tomb at Kazanlak: Micoff, Vasil, *Le tombeau antique près du Kazanlak* (Sophia 1954); Vasiliev, Assen, *The Ancient Tomb at Kazanlak* (Sophia 1960); Zhivkova, Liudmila, *Das Grabmal von Kazanlak* (Recklinghausen 1973); see also the review of Micoff by D. B. Thompson, *AJA* 60 (1956) 295–6

6. Etruscan tomb painting of the Hellenistic period: Pallattino, Massimo, *Etruscan Painting* (Geneva 1952), pp. 103–28

7. Painted stelai from Volos: Arvanitopoulos, A. S., *The Painted Stelai of Demetrias-Pagasai* (Athens 1928), in Greek

8. Centuripe ware: Libertini, Guido, *Centuripe* (Catania 1926); Richter, Gisela M. A., 'Polychrome Vases from Centuripe in the Metropolitan Museum,' *Metropolitan Museum Studies* 2 (1929–30) 187–205 and 'A Polychrome Vase from Centuripe,' *Metropolitan Museum Studies* 4 (1932–3) 45–54

9. Hellenistic reliefs: Beyen, H. G., 'Das Münchner Weihrelief,' *BABesch* 27 (1952) 1–12; Bieber, *SHA*, pp. 152–5; Schober, Arnold, 'Vom griechischen zum römischen Relief,' *ÖJh* 27 (1932) 46–63; Schreiber, Theodor, *Die hellenistischen Reliefbilder* (Leipzig 1894); and 'Die hellenistischen Reliefbilder und die augusteische Kunst,' *JdI* 11 (1896) 73–101

10. The Telephos frieze: Robert, Carl, 'Beiträge zur Erklärung des pergamenischen Telephos-Frieses,' *JdI* 2 (1887) 244–59 and *JdI* 3 (1888) 45–65, 87–105; Schrader, Hans, 'Die Anordnung und Deutung des pergamenischen Telephos-frieses,' *JdI* 15 (1900) 97–135; Winnefeld, H., *Die Friese des grossen Altars*, *AvP* III.2 (Berlin 1910); Stähler, Klaus Peter, *Das Unklassische im Telephosfries* (Münster 1966)

11. Homeric bowls: Courby, Fernand, *Les vases grecs à reliefs* (Paris 1922), pp. 275–447; Hausmann, Ulrich, *Hellenistische Reliefbecher aus attischen und böotischen Werkstätten* (Stuttgart 1959); Robert, Carl, *Homerische Becher* (Berliner Winckelmanns-programm 50, Berlin 1890)

12. Iliac tablets: Jahn, Otto, *Griechische Bilderchroniken* (Bonn 1873); Sadurska, Anna, *Les tables iliaques* (Warsaw 1964); Weitzmann, *IRC*, pp. 36–41; also, for passing comments on the relation of the tablets to Medieval manuscript illustration, Bianchi-Bandinelli, Ranuccio, *Hellenistic-Byzantine Miniatures of the Iliad* (Olten, U. Graf 1955)

13. Narration: Blanckenhagen, Peter von, 'Narration in Hellenistic and Roman Art,' *AJA* 61 (1957) 78–83; Weitzmann, *IRC*

14. Nilotic mosaic from Praeneste: Gullini, Giorgio, *I mosaici di Palestrina* (Rome 1956); Schmidt, Eva, *Studien zum barberinischen Mosaik in Palestrina* (Breslau 1927); Whitehouse, Helen, *The Dal Pozzo Copies of the Palestrina Mosaics* (Oxford 1976)

Chapter 10 Hellenistic mosaics

1. Pebble mosaics:
a. General: Salzmann, Dieter, *Untersuchungen zu den antiken Kieselmosaiken* (Berlin 1982) is basic; Dunbabin, K., 'Technique and Materials of Hellenistic Mosaics,' *AJA* 83 (1979) 265–77; Robertson, Martin, 'Greek Mosaics,' *JHS* 85 (1965) 72–89 and 'Greek Mosaics: A Postscript,' *JHS* 87 (1967) 133–6

b. Pella: Petsas, P., 'Mosaics from Pella,' in *La mosaïque gréco-romaine* (Colloques internationaux du centre national de la recherche scientifique, Paris 1965) 41–56

c. Olynthos: Robinson, David M., *Excavations at Olynthos*, Vols. II, V, VIII, and XII (Baltimore and London 1930–46)

2. Ganymede mosaic, Morgantina: Phillips, Kyle M., 'Subject and Technique in Hellenistic-Roman Mosaics: A Ganymede Mosaic from Sicily,' *The Art Bulletin* 42 (1960) 243–62

3. Delos: Bruneau, Philippe, *EAD* XXIX, *Les mosaïques* (Paris 1972); Chamonard, Joseph, *EAD* XIV, *Les mosaïques de la maison des masques* (Paris 1933)

4. Pergamon: Kawerau, Georg and Wiegand, Theodor, *Die Paläste der Hochburg*, *AvP* V.1 (Berlin and Leipzig 1930)

5. Alexandria: Brown, Blanche R., *Ptolemaic Painting and Mosaics and the Alexandrian Style* (Cambridge, Mass. 1957)

6. Pompeii: Pernice, Erich, *Die hellenistische Kunst in Pompeji*, Band VI, *Pavimente und figürliche Mosaiken* (Berlin 1938)

Chapter 11 Hellenistic architecture

1. General: Fyfe, Theodore, *Hellenistic Architecture* (Cambridge 1936), out of date in many respects; Martin, Roland, in Charbonneaux, Martin, Villard, *Hellenistic Art*, pp. 3–94 (see under General Bibliography (1) above); see also the general handbooks on Greek architecture of W. B. Dinsmoor, G. Gruben, and A. W. Lawrence.

2. Lindos: Dyggve, Ejnar, *Lindos, Fouilles de l'acropole* III.1: *Le sanctuaire d'Athena Lindia et l'architecture lindienne* (Berlin and Copenhagen 1960)

3. Kameiros: Jacopi, G., 'Esplorazione archeologica di Camiro, II,' in *Clara Rhodos* VI-VII (Rhodes 1932–33), pp. 223–78

4. Kos: Schazmann, Paul, *Asklepieion, Baubeschreibung und Baugeschichte* (Kos, Ergebnisse der deutschen Ausgrabungen, ed. Rudolf Herzog, Vol. I, Berlin 1932)

5. Pergamon: Basic introduction to city plan: Rohde, *Pergamon, Bauberg* (see under Chap. 4 (7b) above); in English: Hansen, *Attalids*, Chapter VII; detailed information in *Die Altertümer von Pergamon*, Vol. I (topography and city plan, ed. A. Conze et al. 1912–13); Vol. II (sanctuary of Athena Polias Nikephoros, ed. R. Bohn, 1885); Vol. III.1 (Altar of Zeus and Upper Market, ed. J. Schrammen, 1906); Vol. IV (theater terrace, ed. R. Bohn 1896); Vol. V.1 (the palaces, ed. G. Kawerau, T. Wiegand 1930); Vol. V.2 (the Trajaneum and other monuments, ed. H. Stiller, 1895); Vol. VI, (Gymnasium, ed. P. Schazmann, 1923); Vol. IX (temenos of the ruler cult, ed. E. Boehringer, F. Krauss 1937); Vol. X (the Hellenistic arsenal, ed. A. von Szalay, E. Boehringer 1937); Vol. XI (the Asklepieion, ed. E. Boehringer, O. Ziegenaus, G. de Luca, 1968)

6. Cori: Delbrueck, Richard, *Hellenistische Bauten in Latium* II (Strassburg 1912), pp. 23–36; Vitucci, P. B., *Forma Italiae, Cora* (Rome 1968)

7. Terracina: Lugli, Giuseppe, *I Santuari celebri del Lazio antico* (Rome 1932), pp. 109–14, and *La tecnica edilizia romana* (Rome 1957), pp. 144–8, and *Forma Italiae, Anxur-Terracina* I.1 (Rome 1926), pp. 166–75

8. Temple of Fortuna at Praeneste: Fasolo, Furio and Gullini, Giorgio, *Il santuario della Fortuna Primigenia a Palestrina* (Rome 1953); Kähler, Heinz, *Das Fortuna Heiligtum des Palestrina Praeneste* (Annales Universitatis Saraviensis, Phil.-Lett. 7, 3/4, Saarbrucken 1958), pp. 189–240

9. Didyma: Fehr, Burkhard, *Zur Geschichte des Apolloheiligtums von Didyma* (Marburger Winckelmann-Programm 1971–2), pp. 14–59; Günther, Wolfgang, *Das Orakel von Didyma in hellenistischer Zeit* (Istanbuler Mitteilungen, Beiheft 4, 1971); Knackfuss, Hubert, *Didyma, Die Baubeschreibung* (Berlin 1941); Voightländer, Walter, *Der jüngste Apollontempel von*

Didyma (*Istanbuler Mitteilungen*, Beiheft 14, 1975); for a short introduction in English: Berve, Helmut and Gruben, Gottfried, *Greek Temples, Theaters, and Shrines* (New York 1962), pp. 463–70

10. **Sardis:** Butler, H. C., *Sardis, Architecture* 1: *The Temple of Artemis* (Leyden and Princeton 1922); Gruben, Gottfried, 'Beobachtungen zum Artemis-Tempel von Sardis,' *AthMitt* 76 (1961) 155–96; Hanfmann, George M. A. and Waldbaum, Jane C., *A Survey of Sardis and its Major Monuments Outside the City Walls* (Cambridge, Mass. 1975), Chapter V

11. **Samothrace:**

a. **General:** Conze, Alexander, *Archäologische Untersuchungen auf Samothrake* (Vienna 1875); Lehmann, Karl, *Samothrace, A Guide to the Excavations and the Museum* (4th edn, Locust Valley, N.Y., 1975)

b. **Arsinoeion:** G. Niemann, in Conze, *Archäologische Untersuchungen*, pp. 77–87 (see (a) above); Lehmann-Hartleben, K., 'Preliminary Report on the Second Campaign of Excavation in Samothrace,' *AJA* 44 (1940) 328–58

c. **Hieron:** Lehmann, Phyllis W., *Samothrace* III: *The Hieron* (New York 1969)

12. **Macedonian tombs:** See under Chap. 9 (4) above

13. **Priene:** Schede, Martin, *Die Ruinen von Priene* (2nd edn, Berlin 1964); Wiegand, Theodor and Schrader, Hans, *Priene: Ergebnisse der Ausgrabungen und Untersuchungen 1895–1898* (Berlin 1904). For a short introduction in English, see Akurgal, Ekrem, *Ancient Civilizations and Ruins of Turkey* (Ankara 1970), pp. 185–206. On the restoration of the Athena Temple: Bauer, Otto, 'Vorläufiger Bericht über die Neuarbeitung des Athenatempels zu Priene in den Jahren 1965/66,' *Istanbuler Mitteilungen* 18 (1968) 212–20

14. **Magnesia on the Maeander:** Humann, Carl, *Magnesia am Maeander* (Berlin 1904) is basic; Drerup, H., 'Zum Artemistempel von Magnesia,' *Marburger Winckelmann-Programm* (1964) 13–22; Von Gerkan, Armin, *Der Altar des Artemis-Tempels in Magnesia am Maeander* (Berlin 1929)

15. **Teos:** Bequignon, Y. and Laumonier, A., 'Fouilles de Teos,' *BCH* 49 (1925) 281–321; Akurgal, *Ancient Civilizations*, pp. 139–42 (see under (13) above)

16. **The Corinthian order and its development:** Bauer, Heinrich, *Korinthische Kapitelle des 4. und 3. Jahrhunderts vor Chr.*, *AthMitt*, Beiheft 3 (1973); Williams, Caroline, 'The Corinthian Temple of Zeus Olbios at Uzuncaburç: A Reconsideration of its Date,' *AJA* 78 (1974) 405–14

17. **Ptolemaic gateway at Samothrace:** Frazer, Alfred, 'Macedonia and Samothrace: Two Architectural Late Bloomers,' in Borza, Barr-Sharrar, *Macedonia* (see under Chap. 9 (4a) above)

18. **Olympieion in Athens:** Welter, G., 'Das Olympieion in Athen,' *AthMitt* 47 (1922) 61–71 and *AthMitt* 48 (1923) 182–9; for basic data, in English, Travlos, John, *Pictorial Dictionary of Ancient Athens* (London 1971), pp. 402–11

19. **Monument of Lysikrates:** Travlos, *Pictorial Dictionary*, pp. 348–51 (see under (18) above)

Chapter 12 Alexandria and the Pharaoh

1. **Alexandria and its culture:** Fraser, Peter, *Ptolemaic Alexandria* (Oxford 1972), with extensive bibliography, is basic

2. **Alexandrian art, general:** Grimm, Günter and Johannes, Dieter, *Kunst der Ptolemäer und Römerzeit im Aegyptische Museum, Kairo* (Mainz 1975); Noshy, Ibrahim, *The Arts in Ptolemaic Egypt* (London 1937); Poulsen, Frederick, 'Gab es eine alexandrinische Kunst?', *From the Collections of the Ny Carlsberg Glyptotek* 2 (1938) 1–52. Bonacasa, N., Di Vita, A. (ed.), *Alessandria e il mondo ellenistico-romano, Studi in onore di Achille Adriani* (*Studi e materiali*, Istituto di Archeologia, Università di Palermo, vols. 5 and 6, Rome 1984) contains a wide variety of articles

3. **Alexandrian sculpture:** Adriani, Achille, *Documenti e ricerche d'arte Alessandrina*: I: *Sculture monumentali del Museo Greco-Romano di Alessandria* (Rome 1946), II. *Testimonianze e monumenti di scultura alessandrina* (Rome 1948); Bieber, *SHA*, Chapter VI

4. **Ptolemaic portraiture:** Kyrieleis, Helmut, *Bildnisse der Ptolemäer* (Berlin 1975)

5. **Alexandrian painting:**

a. **General:** Brown, *Ptolemaic Painting and Mosaics* (see under Chap. 10 (5) above)

b. **Mustafa Pasha Tomb:** Adriani, A., in *Annuaire du Musée gréco-romain* (Alexandria) (1933–5), pp. 109–12

6. **Decorative arts in Alexandria:**

a. **General:** Segall, Berta, *Tradition und Neuschöpfung in der früh-alexandrinischen Kunst* (*Berliner Winckelmannsprogramm* 119/120, 1966). See also references in Chap. 12, notes 10 and 11

b. **Touk-el-Qaramous Treasure:** Edgar, C. C., 'The Treasure of Toukh-el-Qaramous,' in M. G. Maspero, ed., *Le musée égyptien*, Cairo II (1906) 57–62; Grimm, Johannes, *Kunst der Ptolemäer* (see under (2) above)

c. **Megarian bowls and Alexandrian metalwork:** Parlasca, K., 'Das Verhältnis der megarischen Becher zum alexandrinischen Kunstwerk,' *JdI* 70 (1955) 129–54; Rotroff, Susan I., *The Athenian Agora* XXII: *Hellenistic Pottery, Athenian and Imported Moldmade Bowls* (Princeton 1982), esp. pp. 6–13. See also the references in Chap. 9 (11) above

d. **Alexandrian glassware:** See references in Chap. 12, note 15

e. **Hadra ware:** Guerrini, Lucia, *Vasa di Hadra* (*Studi Miscellanei* 8, 1964); Brown, *PPM*, pp. 9–11, 60–7; Cook, Brian F., *Inscribed Hadra Vases in the Metropolitan Museum of Art* (*The Metropolitan Museum of Art Papers* (New York 1966) and 'A Dated Hadra Vase in the Brooklyn Museum,' *Brooklyn Museum Annual* 10 (1968–9) 115–38; Callaghan, P. J., 'The Trefoil Style and Second-Century Hadra Vases,' *BSA* 75 (1980) 33–47. See also the articles by Callaghan and Cook in *Alessandria e il mondo ellenistico-romano* (section 2 above), pp. 789–803. On the possible Cretan origin of Hadra ware see Callaghan in *BSA* 73 (1978) 15

f. **The Tazza Farnese:** Bastet, F. L., 'Untersuchungen zur Datierung und Bedeutungen der Tazza Farnese,' *BABesch* 37 (1962) 1–24; Charbonneaux, J., 'Sur la signification et la date de la Tasse Farnèse,' *MonPiot* 50 (1958) 85–103; Furtwängler, *Gemmen* II, pp. 253–6; Merkelbach, R., 'Die Tazza Farnese, die Gestirne der Nilflut, und Eratosthenes,' *Zeitschrift für ägyptische Sprache und Altertumskunde* 99 (1973) 116–27; Thompson, D. B., 'The Tazza Farnese Reconsidered,' in *Das ptolemäische Ägypten* (Mainz 1978), pp. 112–22

7. **Ptolemaic architecture in the Pharaonic style:**

a. **Brief introduction in English:** Lange, Kurt and Hirmer, Max, *Egypt* (London 1957), pp. 358–61

b. **Kom Ombo:** Morgan, Jacques Jean Marie de, *Kom Ombos* (Vienna 1909)

c. **Edfu:** Rochemonteix, Maxence de, and Chassinat, Émile, *Le temple d'Edfou* (Paris 1892, Cairo 1918)

8. **Gems:** See under General Bibliography (4) above; also, Milne, J. G., 'Ptolemaic Seal Impressions,' *JHS* 36 (1916) 87–

101; on the cameo in Boston: Furtwängler, *Gemmen* II, p. 277 and Noshy, *Arts in Ptolemaic Egypt*, pp. 139–40 (see under (2) above); on the ring in the Louvre: Richter, *EGGE*, p. 159, no. 626 and Noshy, *loc. cit.*

ADDENDUM La Rocca, Eugenio, *L'Età d'oro di Cleopatra. Indagine sulla Tazza Farnese* (Rome 1984)

Appendix I The chronology of Hellenistic sculpture

Horn, Rudolf, *Stehende weibliche Gewandstatuen in der hellenistischen plastik* (*RömMitt*, Ergänzungsheft 2, 1931); Krahmer, Gerhard, 'Stilphasen der hellenistischen Plastik,' *RömMitt* 38/39 (1923–4) 138–84 and 'Die einansichtige Gruppe und die späthellenistische Kunst,' *GöttNachr, Phil.-Hist. Kl.* (1927) 53–91; Künzl, Ernst, *Frühhellenistische Gruppen* (Cologne 1968); Thompson, D. B., 'A Bronze Dancer from Alexandria,' *AJA* 54 (1950) 371–85 (on the 'Baker Dancer'); see also Bieber, *SHA*, p. 203, and A. Linfert, *Kunstzentren Hellenistischer Zeit* (Wiesbaden 1976).

Appendix II The ruler cult and its imagery

1. **General:** Cerfaux, Lucien and Tondriau, Julien, *Le culte des souverains* (Tournai 1957); Ferguson, William Scott, in *CAH* VII (Cambridge 1928), pp. 13–22; Heuss, Alfred, *Stadt und Herrscher des Hellenismus* (Leipzig 1937); Nock, A. D., 'Notes on the Ruler Cult,' *JHS* 48 (1928) 21–43; Ritter, Hans Werner, *Diadem und Königsherrschaft* (Munich 1965); Taeger, Fritz, *Charisma: Studien zur Geschichte des antiken Herrscherkulte* (Stuttgart 1957); Wilcken, U., 'Zur Entstehung des hellenistischen Königskult,' *Sitzungsberichte der preussischen Akademie der Wissenschaften, Berlin* (1938) 298–321.

2. **Queens' vases:** Thompson, Dorothy Burr, *Ptolemaic Oinochoai and Portraits in Faience, Aspects of the Ruler Cult* (Oxford 1973)

3. **Temenos of the Ruler Cult at Pergamon:** *AvP* IX: *Das Temenos für den Herrscherkult*, ed. E. Boehringer, F. Krauss (Berlin 1937)

4. **Nemrud Dagh:** Dorner, F. K., in *EAA*, s.v. 'Nemrud Dagh' and 'Zur Rekonstruktion der Ahnengalerie des Königs Antiochos I von Kommagene,' *Istanbuler Mitteilungen* 17 (1967) 195–200; Goell, T., 'Nemrud Dagh: The Tomb of Antiochos I, King of Commagene,' *Archaeology* 5 (1952) 136–44 and 'The excavation of the Hierotheseion of Antiochos I of Commagene on Nemrud Dagh (1953–1956),' *Bulletin of the American Schools of Oriental Research* 147 (1957) 4–22. See also Akurgal, *Ancient Civilizations*, pp. 348–51 (see under Chap. 11 (13))

Appendix III Aspects of royal patronage

1. **Alexandrian topography:** Fraser, *PA*, Chapter 1, with extensive references

2. **Antioch and Seleucid building projects**
a. **Antioch:** Downey, Glanville, *A History of Antioch in Syria from Seleucus to the Arab Conquest* (Princeton 1961) and *Ancient Antioch* (Princeton 1963)
b. **Dura-Europos:** Hopkins, Clark, *The Discovery of Dura-Europos* (New Haven 1979); Matheson, Susan B., *Dura-Europos* (Yale University Art Gallery, 1982); Perkins, Ann, *The Art of Dura Europos* (Oxford 1973); Rostovtzeff, Michael I., *Dura Europos and its Art* (Oxford 1938)

3. **Serapis of Bryaxis:** See under Introduction (5d) above; also, Adriani, A., 'Alla ricerca di Briasside,' *Atti dell'Accademia dei Lincei, Memorie*, Ser. VIII (1948) 435–73

4. **Ptolemaic festival art:**
a. **On the pavilion:** Studniczka, Franz, *Das Symposion Ptolemaios II* (*Abhandlungen der königlich sächsischen Gesellschaft der Wissenschaften, Leipzig, Phil.-Hist. Kl.* 30.2, 1914)
b. **On the procession:** Franzmeyer, Wilhelm, *Kallixeinos' Bericht über das Prachtzelt und Festzug Ptolemaios II* (Strassburg 1904); Rice, E. E., *The Grand Procession of Ptolemy Philadelphus* (Oxford Classical and Philosophical Monographs, 1984)

5. **Hieron of Syracuse:** Berve, Helmut, *König Hieron II* (*Abhandlungen der bayerischen Akademie der Wissenschaften, Phil.-Hist. Kl.*, N.F. 47, Munich 1959); Schenk, Alexander, Graf von Stauffenberg, *König Hieron der Zweite von Syrakus* (Stuttgart 1933), esp. Chap. 4; for a brief introduction in English: Woodhead, A. G., *The Greeks in the West* (New York 1962), pp. 107–12

6. **Attalid patronage:** Hansen, *Attalids*, pp. 284–98, 390–433

7. **Antiochos Epiphanes:** Mørkholm, Otto, *Antiochos IV of Syria* (Copenhagen 1966)

8. **Mithradates:** See under Chap. 7 (2) above

Appendix IV Bactria and India

1. **General:** Davis, Kraay, *Hellenistic Kingdoms*, pp. 230–49 (see General Bibliography (3) above); Narain, A. K., *The Indo-Greeks* (Oxford 1957); Tarn, W. W., *The Greeks in Bactria and India* (Cambridge 1951)

2. **Coins:** Allouche-Le Page, M.-Th., *L'Art monétaire des royaumes Bactriens* (Paris 1956); Mitchiner, Michael, *Indo-Greek and Indo-Scythian Coinage* (London 1976, in progress); Narain, A. K. *The Coin Types of the Indo-Greek Kings* (1955; reprint Chicago 1976). See also under General Bibliography (3)

3. **Ai-Khanum:** Bernard, P., 'Ai Khanum on the Oxus,' *Proceedings of the British Academy* 53 (1967) 71–95 and 'An Ancient Greek City in Central Asia,' *Scientific American* (January 1982) 148–59

Appendix V The tomb at Belevi

See references in the notes

NOTES

Introduction

1 The founding of colonies by the Greeks of the Archaic and Classical periods might seem to be an exception to this rule. Colonies, however, were really an extension of the culture of the polis by cellular division. The colonists were known to one another before they set out, had a charter that guaranteed their rights and relationships, and maintained close, formal ties with their 'mother city.'

2 The Greek word τύχη means 'fortune,' 'fate,' or 'chance' in a general sense. It also refers to the personification of these ideas as a goddess. The distinction between the proper and common noun is usually made by capitalizing the first letter of the former.

3 See, for example, *OGIS* 229, line 62; *OGIS* 16.

4 For a summary of the other pre-Hellenistic examples, see Dohrn, *Tyche*, pp. 41–2.

5 A good example is the gold stater of Euagoras II of Cyprus (361–351 B.C.). See Kraay–Hirmer, *Greek Coins*, no. 679. In general see W. Deonna, 'La couronne murale des villes et des pays personnifiés dans l'antiquité,' *Genava* 18 (1940) 127–86.

6 See Dohrn, *Tyche*, Taf. 25; S. B. Matheson, *Ancient Glass in the Yale University Art Gallery* (New Haven 1980), pp. 102–3, fig. 276.

7 Menander's reputation as a realist was established soon after his death with the often repeated expostulation of the grammarian Aristophanes of Byzantium (*ca.* 257–180 B.C.): 'O Menander, O life, which of you imitated the other?' (ed. Nauck, p. 249). See also Quintilian, *Inst. Or.* 10.1.69–70.

8 See W. S. Ferguson, *Hellenistic Athens* (London 1911; reprinted Chicago 1974), p. 301 (dedication of a statue of Ariarthes V in Athens); also p. 307.

9 Their effect is crisply portrayed by Ferguson, *Hellenistic Athens*, pp. 74–5.

10 Samothrace was the exception, and it may be for that reason that Samothrace was particularly popular in the Hellenistic period. See Karl Lehmann, *Samothrace, A Guide* (4th edn, Locust Valley, N.Y. 1975), chapter 1, esp. p. 30.

11 For the Greek text see *BCH* 51 (1927) 378–80.

12 To name just a few: Hesiod; lyric poets like Archilochos, Xenophanes, and Theognis; the historians Thucydides and Xenophon; the orators Isocrates and Demosthenes. This tradition in Greek literature is reviewed in George Misch, *A History of Autobiography in Antiquity* (Cambridge, Mass. 1951).

13 Misch, p. 155, cites the *Antidosis* of Isocrates (353 B.C.) as '… the first conscious and deliberate literary autobiography.' The *Antidosis*, however, is really a defense of the principles which guided Isocrates' professional life, contains a minimal amount of autobiographical detail, and reveals nothing that could be described as personal or intimate.

Xenophon's *Anabasis* is in part a personal memoir but is written in an objective style (Xenophon refers to himself in the third person), and there are long passages in the narrative in which Xenophon plays no role. Perhaps the best candidate for being the first intimate memoir in western literature, as C. J. Herington has suggested to me, is the *Epidemiai* (*The Visits*) of Ion of Chios (*ca.* 490–425 B.C.). In this work Ion seems to have given vivid and detailed descriptions of his meetings with prominent figures of his time who visited Chios. The quality of this work can be gauged by a quotation from it, recording a meeting of Ion and Sophocles, preserved in Athenaios 603E–604D.

14 Athenaios 276A (Jacoby, *FgrH* II.B 241 F16). The work from which the excerpt comes seems to have been either a biography of Arsinoe or an essay about her.

15 This is clear from Plutarch, *Aratos* 3.2. Plutarch, and probably most ancient literary critics, viewed Aratos's lack of an elegant literary style as a fault.

16 Pyrrhos of Epirus: Jacoby, *FgrH* II.B. 229; Demetrios of Phaleron: *ibid.* II.B.228.

17 If Pliny's praise of the effectiveness of Apelles' portraits (*NH* 35.88–90) can be said to constitute reliable historical evidence, the same must have been true of Hellenistic painted portraits.

18 Tarn, *HC*, p. 2.

19 Diogenes Laertios 6.62. The literal meaning and the philosophical implications of the Greek word need to be kept in mind, since 'cosmopolitan' in modern English has come to mean not much more than 'well-travelled and possessed of a sophisticated manner.'

20 Tarn's view is argued most fully in his lecture *Alexander the Great and the Unity of Mankind* (London 1933). See also appendix 25 of his *Alexander the Great*. The chief critique of Tarn's view is that of Ernst Badian, *Historia* 7 (1958) 425–44. H. C. Baldry, *The Unity of Mankind in Greek Thought* (Cambridge 1965), pp. 113–21, gives an excellent review of the question.

21 Baldry, *Unity of Mankind*, p. 171.

22 Some scholars have felt that Plutarch in this passage is either oversimplifying Zeno's view of things or simply speaking for himself. Diogenes Laertios (7.32–3) asserts that Zeno admitted only those who were wise, and therefore good, to his

ideal state. This restriction might seem to contradict Plutarch's assertion that according to Zeno we should regard *all men* as our fellow citizens. See Baldry, *Unity of Mankind*, p. 160, who feels that in the passage cited by Plutarch, Zeno was referring to the distant future, and also O. Murray's review of Baldry's book *CR* 80 (1966) 368–71. J. M. Rist, *Stoic Philosophy* (Cambridge 1969), p. 65, doubts Baldry's contention that Zeno was thinking only of the future but asserts that the phrase 'all men' really referred only to free men, that is, to mankind exclusive of slaves. But the contradiction may be more apparent than real. The *Politeia* was presumably a utopian tract in which Zeno tried to depict what society would be like if all men were wise or were willing to live in a way that would make them wise. Obviously most men of his own time would not have fitted into it, but that does not mean that it was not designed, in theory, for 'all men.' Other sources make it clear that those who were at a disadvantage in existing Greek society – women, slaves, foreigners – would not have been barred from citizenship in the ideal state.

23 The sources are Athenaios 98D–F; Strabo 7 fr. 35; Clement, *Protrepticus* 4.54 (48P). Some writers have attached considerable importance to the scanty evidence for this community, which was called 'Ouranopolis' (e.g. Tarn, *Alexander and the Unity of Mankind*, pp. 21–4; J. Ferguson, *The Heritage of Hellenism* (London 1973), pp. 62–3). Others, like Baldry, *Unity of Mankind*, pp. 124–5, are more skeptical.

24 It was this similarity between the figures of Homer and Zeus that gave rise to the early identification of the relief as the 'Apotheosis of Homer.' This popular name is still sometimes applied to it.

25 Aelian, *Var. Hist.* 13.22. For references see Fraser, *PA* II, p. 862 note 423. (Fraser himself is skeptical about a connection between the relief and the sanctuary.)

26 For the date of *ca.* 125 B.C., M. Schede, *RömMitt* 35 (1920) 65–82; for an earlier date see the opinions of Fraser and Guarducci quoted in Richter, *Portraits*, p. 54.

27 The Muses have sometimes been connected with Rhodes on the basis of the questionable assumption that they are identical with the Apollo and nine Muses by Philiskos of Rhodes, a group which stood in Pliny's time near the Porticus Octaviae in Rome (*NH* 36.34) (see W. Amelung, *Die Basis des Praxiteles aus Mantineia* (Munich 1895), pp. 43ff. and 79ff.; *contra*: Lippold, *Gr. Plastik*, pp. 333–4). A sculptor named Philiskos of Rhodes is known to have been active *ca.* 100 B.C., but whether he was the sculptor of the group seen by Pliny is not known. Nor can it be affirmed that the Muses in Rome were brought from Greece by Metellus when he built the structure that preceded the Porticus Octaviae (see p. 00). Many of the works described by Pliny in the same passage seem to have been classicizing sculptures of the later 2nd and 1st centuries B.C., but once again, it cannot be proved that the Muses of Philiskos were in the same style. For a review of this question see Bieber, *SHA*, pp. 129–30.

In any case, there is no strong evidence for calling the Archelaos relief Rhodian, as has often been done (references in Lippold, *Gr. Plastik, loc. cit.*, note 11). It could equally well have been made in Alexandria. The fact that Archelaos was from Priene does not bear on the question one way or another. Greek artists were itinerant. Many Greeks who were not citizens of the Alexandrian polis lived and worked there.

Chapter 1 Royal iconography

1 For example, Miltiades and other Athenian generals at Marathon were depicted in Mikon's painting of that battle in the Stoa Poikile in Athens (Pausanias 1.15.3). Miltiades also appeared in Pheidias's sculptural group celebrating Marathon at Delphi (Pausanias 10.10.1), and the Spartan admiral Lysander was represented in a similar monument at Delphi commemorating the Spartan victory at Aigospotamoi (Pausanias 10.9.7).

2 *NH* 7.125; Plutarch, *Alexander* 4.1. On the other sources see F. P. Johnson, *Lysippos* (Durham, N.C. 1927), pp. 301–6. The assertion perhaps holds true only for the later stages of Alexander's career. The Athenian sculptor Leochares did a portrait of Alexander, which was in the Philippeion in Olympia in Pausanias's time (5.20.9), and also worked, along with Lysippos, on the Krateros Monument at Delphi (see *infra*). The portrait in the Philippeion, probably done *ca.* 338–336 B.C., was part of a group which included portraits of Alexander's mother, father, and grandfather and perhaps represented Alexander as a boy.

3 Wolfgang Radt, 'Der "Alexanderkopf" in Istanbul,' *ArchAnz* (1981) 583–96, has recently argued that, because of its scale, style, and details of workmanship, this head belongs to the Gigantomachy of the Altar of Zeus at Pergamon (see Chap. 4). He considers it possible that the head may have belonged to one of the gods on the frieze, or even one of the Giants, but also speculates that Alexander may have been represented on the frieze fighting alongside the gods. Not having had the opportunity to examine the head again in the light of Radt's technical arguments, I suspend judgment on this remarkable thesis. The features of the head make me virtually certain that it represents Alexander, but its context at Pergamon remains an open question.

4 The convincing association was first proposed by Franz Winter, *ArchAnz* (1895) 162–3.

5 See Pliny, *NH* 35.85–6; Aelian, *Var.Hist.* 2.3.

6 As suggested by Bieber, *Alexander*, p. 49. On the other hand, Pliny's assertion (*NH* 35.93) that Apelles painted a substantial number of portraits of Alexander and Philip may suggest that the painter was in the employ of the royal family over a long period.

7 P. Mingazzini, 'Una copia dell' Alexandros Keraunophoros di Apelle,' *Jahrbuch der Berliner Museen* 3 (1966) 7–17.

8 'Left' and 'right' refer to the intaglio figure on the gem itself. In impressions from the gem, of course, the two sides would be reversed.

9 Furtwängler, *Gemmen* II, pp. 250–3; Richter, *EGGE*, no. 611.

10 The snake could be taken as an allusion to the form of the god who, it was said, had lain with Olympias and sired Alexander (Plutarch, *Alexander* 2.4; 3.1) or to the serpent which guided Alexander to the oracle of Zeus Ammon at Siwa.

11 A tiara and veil similar to those worn by the female figure on the cameo appear on coin portraits of Arsinoe II and also on portraits that apparently represent Kleopatra I, wife of Ptolemy V and mother of Ptolemy VI. See Richter, *Portraits*, fig. 1836; Kyrieleis, *Bildnisse*, Taf. 70. On the identity of the portraits on the cameo see, in particular, F. Eichler, E. Kris, *Die Kameen in Kunsthistorischen Museen, Wien* (Vienna 1927), pp. 47–8.

12 See Nancy T. De Grummond, 'The Real Gonzaga Cameo,'

AJA 78 (1974) 427–9, where evidence is presented that the cameo once in the possession of the Gonzaga family in Mantua was the Vienna, not the Leningrad, cameo.

13 Kyrieleis, *Bonner Jahrbücher* 171 (1971) 162–93.

14 E.g. the 'Gemma Augustea' in Vienna or the 'grande camée de France' in the Bibliothèque Nationale in Paris. See G. M. A. Richter, *Engraved Gems of the Romans* (London 1971), nos. 501 and 502.

15 *Scalpo*, 'carve,' 'engrave,' is the verb regularly used by Pliny in connection with Pyrgoteles' art (*NH* 7.125 and 37.8).

16 Amyntas III (ruled 393–370 B.C.) and Perdikkas III (ruled 365–359 B.C.) also used the Herakles type. See Kraay–Hirmer, *Greek Coins*, pl. 169, nos. 560, 561. On Philip's issue see C. Seltman, *Greek Coins* (London 1955), pl. XLVI, nos. 10–13. On the descent of the Macedonian royal line from Herakles: Herodotus 8.138; Thucydides 2.99.

17 The coins do not, in a strict sense, represent Pheidias's statue, which held a Nike rather than an eagle in its right hand (Pausanias 5.11.1). Kraay, in Kraay–Hirmer, *Greek Coins*, pp. 249 and 264, suggests that the seated Zeus on Alexander's coins was derived from the seated figure of Baal on the coins of Tarsus issued by the Persian satrap Mazaeus. It is possible, however, that the reverse is true and that Mazaeus's coins date from the period after he became the subordinate of Alexander.

18 *Greek Coins*, p. 205.

19 See H. H. Scullard, *The Elephant in the Greek and Roman World* (London 1974), esp. pp. 131–45; Tarn, *HC*, pp. 61–2.

20 Elagabalus's commitment to the Alexander type may have been inherited from his father Caracalla, who is said to have filled Rome with sculptured and painted portraits of Alexander (Herodian, *Caracalla* 8.1).

21 The head has the small mouth, *anastole*, and turn of the neck normally associated with portraits of Alexander. Some scholars have rejected the identification as Alexander, however, and take the head to be a Helios in the tradition of the colossal Helios of Chares, Lysippos's pupil (see p. oo). For references see Von Steuben in Helbig, *Führer*[4] II, no. 1423. But since features of Helios were appropriated for the imagery of the Hellenistic ruler cult at an early stage (see [15d]) and were of considerable importance in the imagery of apotheosis in Roman art, there is nothing implausible in the identification of the head as Alexander.

22 Proposed by E. B. Harrison, *Hesperia* 29 (1960) 382–9; against this view: A. Krug, *Gnomon* 46 (1974) 695; G. Schwartz, 'Zum Sogenannten Eubouleus,' *The J. Paul Getty Museum Journal* 2 (1975) 71–84.

23 Pliny, *NH* 35.106. Protogenes was active on Rhodes during Demetrios Poliorcetes' famous siege of Rhodes in 305 B.C. (Pliny, *NH* 35.104–5; Plutarch, *Demetrios* 22). Pliny's statement (*NH* 35.106) that Protogenes undertook to represent the exploits of Alexander after being advised to do so by Aristotle may suggest, however, that Protogenes also did representations of the king during his lifetime (Aristotle died in 322 B.C.).

One can only speculate on the significance of the 'Alexander and Pan.' Perhaps they were paired because Pan had come to the aid of the Greeks against the Persians in 480 B.C. (Herodotus 6.105). Or perhaps the idea was that Pan and Alexander both had the capacity to throw their enemies into panic. (At a later date Antigonos Gonatas put the image of Pan on his coinage to commemorate this power of the god

(see Seltman, *Greek Coins*, p. 223).) Or possibly, in keeping with a growing taste among Hellenistic intellectuals, Pan was allegorized to signify 'all,' and the idea of the painting was that Alexander had become the master of all.

24 Seltman, *Greek Coins*, p. 222.

25 Seleukos is represented with horns on a series of coins issued in the central Asiatic part of his kingdom. See Seltman, *Greek Coins*, pl. LII, nos. 4 and 5. This type was probably influenced by an ancient tradition of horned head-dresses as symbols of kingship in Asia. On this topic in general: R. M. Boehmer, 'Die Entwicklung der Hörnerkrone bis zum Ende der Akkad-Zeit,' *Berliner Jahrbuch für Vor- und Frühgeschichte* 7 (1967) 273–91; E. Strommenger, M. Hirmer, *5000 Years of the Art of Mesopotamia* (New York 1964), Pls. 152–4, 158–9, 162–3, 164 and *passim*.

26 *Greek Coins*, p. 243

27 See Laurenzi, *Ritratti*, nos. 43, 48, 50, 51, 54–7.

28 The original of the sculptured portrait of Philetairos is dated by Westermark (see bibliography) to *ca.* 250 B.C. on the basis of its similarity to a particular group of coin portraits (her 'Group IV'). Even later dates have been suggested. The original may have been a posthumous portrait set up by Eumenes I or Attalos I.

On the bronze head in Naples see Richter, *Portraits*, p. 261 (Ptolemy II); Laurenzi, *Ritratti*, no. 65 (Antigonos Gonatas), with further references.

29 This head is sometimes identified as Pyrrhos of Epirus (e.g. by Havelock, *HA*, pp. 29–30, following a suggestion first made by Helbig). The subject wears a wreath of oak leaves (the national emblem of Epirus, derived from the famous oak at Dodona) and bears some resemblance to a helmeted head in Naples, once again from the Villa of the Papyri at Herculaneum, which has plausibly been identified as a copy of an early-3rd-century portrait of Pyrrhos (see Laurenzi, *Ritratti*, p. 110, no. 51; Richter, *Portraits*, figs. 1762–63). The style of the Copenhagen head, as Laurenzi has pointed out (p. 125, no. 83) shows the influence of the sculpture of the Altar of Zeus at Pergamon, and it is difficult to think of a reason for a posthumous portrait of Pyrrhos at a time when the Epirote monarchy had been replaced by a federal league and when, after Pydna, Epirus was devastated by the Romans.

30 First identified as Mithradates by Franz Winter, 'Mithradates VI Eupator,' *JdI* 9 (1894) 245–8. Laurenzi, *Ritratti*, p. 132, no. 102, sees the decorative quality of the lion skin and a certain '*freddezza*' in the surface qualities of the head as indications of late Hellenistic academicism and dates it to *ca.* 90 B.C. Long sideburns, it should be noted, occur on the portrait of Alexander on the Alexander mosaic but not, in any obvious form, in the sculptural tradition.

31 *JdI* 40 (1925) 183–205.

32 The monument was dedicated by Krateros's son, also named Krateros, sometime after the elder Krateros's death in 321 B.C. See p. 49.

33 K. Schefold, *Der Alexander-Sarkophag* (Berlin, 1968), pp. 9, 31, argues for the earliest possible date on stylistic grounds, but he probably exaggerates the suddenness and all-pervasiveness of stylistic change in the last third of the 4th century B.C. V. von Graeve, *Der Alexandersarkophag von Sidon und seine Werkstatt* (*Istanbuler Forschungen* 28, Berlin 1970), deduces from the dress and weapons of the figures that the sarcophagus cannot be earlier than 326 B.C.

34 For example, compare the rider on block G of the Nike

temple with the rider to the right of the lion in the lion hunt scene (see Travlos, *Pictorial Dictionary of Ancient Athens* (London 1971), fig. 209).

35 The directional flow of the end panels moves toward the hunt scene rather than the battle. On the question of which of the two long sides should be considered the primary one, see Schefold, *Der Alexander-Sarkophag*, pp. 7, 33–4.

36 Charbonneaux, *Revue des Arts* 2 (1952) 219–23, has suggested that the figure with the diadem is Demetrios Poliorcetes and that the rider to the right is Antigonos Monophthalmos. Demetrios and Antigonos did not assume the royal diadem, however, until 306 B.C., a date that seems too late for the sarcophagus. Furthermore the rider to the right seems too young, even allowing for the pervasive generalization of the figures on the sarcophagus, to be Antigonos.

37 This assumes, of course, that the tomb has been correctly identified and dated. Since there is as yet no thorough and final publication of the finds and the date and identification of it are controversial (see bibliography) these conclusions must be tentative.

38 Salzmann, *Kieselmosaiken*, pp. 19, 29, argues for a date not later than 310 B.C. based on the forms of the floral borders of the mosaics as well as their overall stylistic qualities. Robertson, *JHS* 85 (1965) 89 allows more leeway and even considers the time of Antigonos Gonatas (after 277 B.C.) a possibility.

39 The swordsman in the mosaic, like a fair number of other monuments of the 5th and 4th centuries, may 'quote' the Harmodios figure of the Tyrannicides group of Kritios and Nesiotes. By this time the tyrant-slayer motif had probably lost its original political connotations and come simply to mean 'hero.' For replicas and representations of the Tyrannicides group see S. Brunnsaker, *The Tyrant Slayers of Kritios and Nesiotes* (Stockholm 1971), pp. 42–72, 99–110.

40 Arrian, *Anabasis* 1.16.4, mentions figures of 25 companions. Plutarch, *Alexander* 16.7, speaks of 34 soldiers who died in the battle, 9 of whom were infantrymen, and implies that all were depicted in the Granikos group. Velleius Paterculus 1.11.34 mentions the portrait of Alexander.

41 E.g. Johnson, *Lysippos*, p. 225; Bieber, *Alexander*, p. 36.

42 The House of the Faun was excavated between 1830 and 1832. By the time of the first edition of Heinrich Brunn's *Geschichte der griechischen Künstler* (Stuttgart 1859), p. 171, the idea that the mosaic might be connected with Philoxenos's painting was already a matter for routine consideration. There are, it should be noted, other works mentioned in the literary sources which might also be associated with the prototype of the mosaic, i.e. Aristeides's *proelium cum Persis* (Pliny, *NH* 35.99) and the battle of Issos by Helen, daughter of Timon (see Overbeck, *SQ* 1976).

43 Alexander's interest in commemorating his battles and using them as symbols of achievement is attested by a remarkable, in fact unique, coin type issued in Babylon in 323 B.C., which depicted his battle against the war elephants of the Indian king Poros. See Seltman, *Greek Coins*, pl. 49, nos. 6 and 7.

Chapter 2 Lysippos and his school

1 The sources are reviewed in F. P. Johnson, *Lysippos* (Durham, N.C. 1927), pp. 58–73; see also E. Sjöqvist, *Lysippus* (Cincinnati 1966), pp. 9–10.

2 See Pliny, *NH* 34.55.

3 For the sources see Johnson, *Lysippos*, pp. 311–17, nos. 80–86.

4 Since Lysippos's early career is not the primary concern of this chapter, discussion of the figure of Agias from the Daochos group at Delphi has been omitted. This work is ascribed to Lysippos on the basis of a tenuous thread of assumptions derived from a lost inscription. (For the details see Johnson, *Lysippos*, pp. 123–5.) The proportions of the Agias have with good reason been thought to show the influence of Lysippos, but that the work was actually by him is doubtful.

5 See G. E. Rizzo, *Prassitele* (Milan–Rome 1932), pls. 27–9; Picard, *Manuel* III, pp. 439–62.

6 Wine was the city's most exportable commodity. There is nothing implausible in the story that Lysippos was invited to exercise his skill in what we would call 'industrial design.' The Greeks drew no rigid distinction between 'fine art' and 'craft.'

7 One plausible suggestion for the date of Lysippos's visit to Tarentum is sometime between 332 and 326 B.C. when Alexander's uncle, Alexander of Epirus, went to Italy to assist the Tarentines in a war with their Italic neighbors. See Johnson, *Lysippos*, p. 61 with further references.

8 The type is ascribed to Lysippos on the basis of a copy in the Pitti Palace in Florence which bears the inscription ΕΡΓΟΝ ΛΥΣΙΠΠΟΥ 'a work of Lysippos.' The inscription, generally accepted as being ancient, seems to be a label rather than a signature. Libanios, *Ekphraseis* 15, describes the type but does not mention Lysippos. On the Pitti Palace copy see W. Amelung, *Führer durch die Antiken in Florenz* (Munich 1897), no. 186; Sjöqvist, *Lysippus*, pl. 14; Loewy, *IgB*, no. 506.

9 C. Picard, 'L'Héraclès Épitrapezios de Lysippe,' *Revue Archéologique* 17 (1911) 257–70; *Manuel* IV, pp. 578–9.

10 See D. R. Dudley, *History of Cynicism* (London 1937), pp. 43, 57; Diogenes Laertios 6.2.

11 Cornelius Vermeule emphasizes this point particularly in connection with late Antiquity: 'Toward the end of Antiquity, and sooner, the Weary Herakles became more than just a decorative figure for gymnasia and baths. The Lysippic Herakles stood as a symbol of the cares, imperial, civic, and even spiritual, which the pagan ancients and their Judeo-Christian successors carried on their shoulders' (*AJA* 79 (1975) 322). I would modify this statement only by proposing that this seriousness was part of the Weary Herakles image from the beginning.

12 de Visscher, *Héraclès Épitrapezios*, pp. 33–9.

13 Suggested by Frederick Poulsen, *From the Collections of the Ny Carlsberg Glyptotek* I (1931), p. 40 and II (1939), pp. 169–82. That the patriotic Lykourgos would have hired a Sikyonian, rather than an Athenian, for this assignment is perhaps doubtful.

14 An 18th-century engraving depicts this type of head on a seated statue formerly in the Ludovisi collection in Rome and now in Copenhagen. On the basis of this engraving F. Poulsen (*loc. cit.* and also *Ny Carlsberg Glyptotek, Ancient Sculpture* (Copenhagen 1951) no. 415c) produced an impressive restoration of the statue that won the enthusiastic endorsement of Sjöqvist (*Lysippus*, pp. 22–3). Bernard Frischer has demonstrated conclusively, however, that the association of the Socrates head with this statue is the work of a 17th-century restorer (see *The Sculpted Word, Philosophical Recruitment in Ancient Greece* (Berkeley and

Los Angeles 1982), pp. 168–74). Recent evidence provided by a statue base from the Pompeion in Athens and from a statuette found in the 'Prison of Socrates' make it more probable, as a number of scholars had earlier speculated, that the Lysippan portrait represented Socrates standing. For the references see Frischer, *loc. cit.*

15 Sjöqvist, *Lysippus*, p. 24.

16 The suggestions that it stood in Pella or stood on a knuckle-bone base in Olympia are based on the weakest of evidence. See the sensible criticisms of A. F. Stewart, *AJA* 82 (1978) 163 n. 2.

17 E.g. Stewart, *op. cit.*, p. 163.

18 So J. Dörig in J. Boardman, W. Fuchs, J. Dörig, M. Hirmer, *The Art and Architecture of Ancient Greece* (London 1967), p. 447. The most ingenious interpretation of the meaning of the Kairos is that of A. F. Stewart, *AJA* 82 (1978) 163–71, who argues, on the basis of a use of the term in Plutarch, that *kairos* was a Pythagorean term which in the visual arts referred to the 'right choice' or 'right balance' of elements within a canon. The Kairos, he proposes, was a kind of answer to Polykleitos's Doryphoros and was intended to demonstrate how Lysippos had harmonized proportion, movement, and detail. Stewart makes a lucid and learned case, yet I am bothered by the feeling that it may be too ingenious to be true. If the Kairos had really been the *explicatio* of Lysippos's art, the early art historian Xenokrates, who was a pupil of a pupil of Lysippos and a perpetuator of the principles of his school, would certainly have known about it, and the meaning of the work would have been passed on to Pliny (as was the case with the Doryphoros). Pliny does not even mention the Kairos.

19 The manuscripts give this son's name as Laippos in *NH* 34.66, but it seems probable that this is a mistake for Daippos, the form that appears in 34.87 and in Pausanias 6.12.6 and 6.16.35. Of another son mentioned in 34.66, Boedas, little can be said with confidence. Pliny mentions an *adorans*, 'a man praying,' by him (34.73), and some have associated this reference with a bronze figure of a boy in Berlin on which the arms have been restored to make it seem as if the figure were praying. The Berlin figure has few Lysippan characteristics, however, and probably dates from a later century. See Havelock, *HA*, no. 82; Bieber, *SHA*, pp. 39–40, fig. 93.

20 The main sources for the Colossos of Rhodes are Pliny, *NH* 34.41; Strabo 14.652; Sextus Empiricus, *Adv. Math.* 7.107. For others see Overbeck, *SQ* 1539–54.

The head in Rhodes is identified as Helios because of a series of holes which run around the back of the preserved part of the hair (the back of the head and a portion of the hair were apparently done in stucco, now missing) and probably served to hold solar rays made of metal. See L. Laurenzi, 'Un immagine del Dio Sole rinvenuta a Rodi,' *Memorie pubblicati a cura dell' Istituto Storico-Archeologico di Rodi* 3 (1938) 19–26. Gloria Merker, *The Hellenistic Sculpture of Rhodes* (Studies in Mediterranean Archaeology XL, Göteborg 1973), pp. 29–30, expresses doubt about the identification because the holes are not all of the same size and speculates that the head might be a portrait of Alexander.

21 Pausanias 6.2.6. attests that Eutychides was a pupil of Lysippos and mentions the Tyche as one of his chief works.

22 For the sources and various opinions see Von Steuben in Helbig, *Führer*[4] III, no. 2270. In particular see Carpenter,

MAAR 18 (1941) 70–3. The existence of a bronze statuette of the type in the Terme reinforces the view that the Anzio Girl is a copy. See C. Anti, 'Una piccola replica della Fanciulla d'Anzio,' *Bollettino d'Arte* 13 (1919) 102–6.

23 Von Steuben, *loc. cit.*, draws the analogy to Pompeiian paintings of Iphigeneia and her attendants. P. Mingazzini, *JdI* 81 (1966) 173–85 suggests the Delphic Sibyl Phemonoe.

24 A. Furtwängler, *Münchner Jahrbuch der bildenden Kunst* 2 (1907) 9. Bieber, *SHA*, p. 40, R. Carpenter, *Greek Sculpture* (Chicago 1960), p. 181, and many others accept the suggestion.

25 Restored are: part of the knot of the hair; point of the nose; right wrist; part of the right hand; part of both feet; the legs of the stool; and details of the drapery. There is also a bronze statuette of the type in the Louvre: see Dohrn, *Tyche*, p. 43, Taf. 41.

26 *Greek Sculpture*, p. 183.

Chapter 3 Personality and psychology in portraiture

1 Pliny, *NH* 34.83 speaks of a self-portrait of the sculptor and architect Theodoros of Samos (active *ca.* 560–520 B.C.), and it has been speculated that some late-6th-century heads might be genuine portraits, e.g. the 'Sabouroff head' (see Robertson, *HGA*, pp. 110–11). Indisputable examples of portraiture, however, do not appear until after 480 B.C.

2 The Tyrannicides group in the Athenian agora (see Chap. 1, note 39), set up in 477 B.C., if it can be considered a portrait group, would be one early example of a dedication outside of a sanctuary. Pausanias, 1.8.2, also records a portrait of Kallias the son of Hipponikos in the agora. The agora, however, was dotted with sanctuaries and was in some respects like a sacred area.

3 The Ostian herm of Themistokles has seemingly individualized features which might be thought unusual for the 5th century. Since, however, there is dispute as to whether it is a copy of an actual 5th-century portrait or of a 4th-century evocation of Themistokles, since the body type to which the head belonged is not known, and since there is no way of knowing from which of the recorded portraits of Themistokles, if any, it derives, no firm conclusions can be drawn about its place in the development of Greek portraiture. See Richter, *Portraits*, pp. 97–9; A. Linfert, 'Die Themistokles-Herme in Ostia,' *Antike Plastik* 7 (1967) 87–94.

4 Pausanias 1.25.1 records seeing a portrait statue of Anacreon on the Athenian acropolis. The extant type, known in a variety of copies, is most probably derived from this work. It is noteworthy that one of the inscribed herm-portraits of Anacreon, in Rome, emphasizes his role by adding the word *lyrikos* after his name. See Richter, *Portraits*, p. 76, no. 1, fig. 274. Brunilde Ridgway, *Roman Copies of Greek Sculpture* (Ann Arbor 1984), has recently argued that statues in Greek sanctuaries were normally not allowed to be copied (on the Anacreon portrait see p. 54), but the argument is debatable.

5 Pliny, *NH* 34.75. Pausanias 1.25.1 and 1.28.2 mentions portraits of Pericles and his father Xanthippos on the Athenian acropolis along with that of Anacreon. It is probable that the portrait seen by Pausanias was the same as the one mentioned by Pliny.

6 The Lateran Sophocles type may be a copy of a portrait set up in the newly designed theater of Lykourgos in the 340s or early 330s B.C. Whether this portrait should be classified as a

secular or religious dedication is problematic. The theater in Athens was sacred to Dionysos, and dramatic performances were quasi-religious rites.

7 Plutarch, *Demosthenes* 32. The hands on the Copenhagen copy of the statue are restored on the basis of a pair of clasped hands, apparently not belonging to any surviving statue, found in Rome and now in the Vatican. See Richter, *Portraits*, p. 216, fig. 1407.

8 Four statues of Olympiodoros are mentioned by Pausanias (1.26.3), one at Eleusis, one at Delphi, and two in Athens. No sculptors are mentioned. The portrait in Delphi was set up by the Phokians of Elateia in gratitude for Olympiodoros's help in fighting Kassander. The other portraits probably also commemorated him as an anti-Macedonian liberator.

9 The reasoning that has led to this identification is admittedly tenuous. One version of the 'Hypereides' head, on a double herm in Compiègne, is paired with a partially preserved female head which has been taken to be a portrait of Phryne, the courtesan who was Praxiteles' mistress and whom Hypereides defended on a charge of impiety. See F. Poulsen, 'Un portrait de l'orateur Hypéride,' *Monuments Piot* 21 (1913) 47–58. J. F. Crome, 'Aristipp und Arete,' *ArchAnz* (1935) cols. 1–11 identifies the portrait as Aristippos.

10 *Pap. Oxy.* xv (1922) no. 1800, frag. 8, lines 30–3.

11 Richter, *Portraits*, p. 210.

12 A lost inscription, once in the Villa Mattei in Rome, recorded a portrait of Hypereides by a sculptor named Zeuxiades (Loewy, *IgB* no. 483). This may have been the pupil of Silanion mentioned by Pliny, *NH* 34.51. Zeuxiades was a contemporary of the pupils of Lysippos.

13 E.g. Robertson, *HGA*, p. 504.

14 Pliny, *NH* 34.76. See D. M. Lewis, *BSA* 50 (1955) 1–12. Ridgway, *Roman Copies* (see n. 4 above), p. 54, argues against the validity of the reconstruction.

15 Diogenes Laertios 3.25. Pausanias 6.4.5 records that Silanion was an Athenian. The portrait mentioned by Diogenes was set up in the Academy by a Persian named Mithradates, but whether or not the extant Plato type derives from this dedication is uncertain. See Richter, *Portraits*, p. 169.

16 A headless herm which once bore a portrait of Aristotle and was dedicated by Alexander has been found in the Athenian agora (see Richter, *Portraits*, fig. 1014). On the assumption that Alexander would have commissioned his court sculptor to make such a portrait, the work is often ascribed to Lysippos. The identification of the type as Aristotle is based on the general similarity of the Vienna head and other examples to a drawing of an inscribed bust which was found in the 16th century and is now lost (Richter, *Portraits*, p. 171).

17 On the replicas thought to represent the Epicurus type see V. Kruse-Berdolt, *Kopienkritische Untersuchungen zu den Porträts Epikur, Metrodor, und Hermarch* (Diss., Gottingen 1975). On none of the replicas is the right arm preserved. Kruse-Berdolt suggests that the right arm was bent upward, with the hand near the beard, thus enhancing the meditative effect that I have suggested here. This interpretation is vehemently attacked by Bernard Frischer, *The Sculpted Word: Philosophical Recruitment in Ancient Greece* (Berkeley and Los Angeles 1982), pp. xx–xxi and 129–98, who argues that the arm was gesturing outward, thus indicating that Epicurus was to be thought of as actively teaching his doctrines. Frischer interprets the statue as a kind of public advertisement by the Epicurean School of its capacity to offer philosophical salvation to the people of its time.

Frischer effectively demolishes the suggestion made by Richter, following Lippold, that a drawing by Preisler published in 1732 represented an inscribed statue of Epicurus in a largely unrestored state (see Richter, *Portraits*, p. 199). The statue in question was once in the Ludovisi collection and is now in the Palazzo Margherita (the American Embassy) in Rome. The evidence assembled by Frischer makes it very probable that the statue never had an inscription and that it was extensively restored at the time when Preisler drew it (see esp. pp. 152–4). Frischer's research leaves some doubt, in fact, as to whether the replicas of the type in question can with certainty be connected with Epicurus at all. (He himself believes that they can and should.)

The arguments for and against the different interpretations of the original position of the right arm are too complicated to summarize here. I incline to follow Kruse-Berdolt because replicas of the statues of Metrodoros and Hermarchos, which one would expect to have been modelled on that of Epicurus, appear to have had one arm (Metrodoros's left; Hermarchos's right) bent upward, rather than projecting outward. But it is impossible to feel certainty on this question, and Frischer's point of view is certainly defensible.

18 Sidonius Apollinaris, *Epistulae* 9.9.14, says that the portraits of Chrysippos usually showed him with his fingers contracted, as if he were counting with them. Cicero, *De Finibus* 1.11.39, refers to a seated statue of Chrysippos in the Kerameikos in Athens 'with hand extended,' (*porrecta manu*). It is by combining the information in these two passages with Pliny's reference to the work of Euboulides that the 'Chrysippos of Euboulides' is recreated.

19 Richter, *Greek, Etruscan, and Roman Bronzes* (Metropolitan Museum of Art, New York 1915), no. 120, first identified it as Hermarchos but subsequently opted for Epicurus (*Greek Portraits* IV, *Collection Latomus* vol. LIV, 1962, pp. 40–1). The structure of the face seems to me more like that of Hermarchos.

20 The base of a missing portrait found on Rhodes and signed by the sculptor Ploutarchos, son of Heliodoros, of Apameia is sometimes associated with the portrait of Poseidonios. See G. Hafner, *Späthellenistische Bildnisplastik* (Berlin 1954), p. 11.

21 So Bieber, *SHA*, p. 87 (for earlier references see her note 69); Laurenzi, *Ritratti*, no. 77; Richter, *Portraits*, pp. 270–1; and many others. A notable dissenter is Andrew Stewart, *Attika*, pp. 82–4, who, without arguing his case in detail, dates the head to the mid-1st century B.C. on the basis of stylistic similarities to other heads that are assigned to the late Hellenistic period.

22 The identification is again based on a similarity to coin types. The wide-brimmed hat of this portrait appears on a number of Bactrian coins. See [299] and Richter, *Portraits*, figs. 1978, 1984.

23 Among other possibilities suggested are Philip V, Perseus, Antiochos II, and Alexander Balas. The suggestions are reviewed briefly by Helga von Heintze in Helbig, *Führer*[4] III, no. 2273. A number of scholars have identified the figure as a Roman *triumphator* rather than a Greek. J.-Ch. Balty, for example, in 'La statue de bronze de T. Quinctius Flamininus ad Apollonis in circo,' *Mélanges de l'école française de Rome, antiquité* 90 (1978) 669–86, proposes that it

represents Flamininus. The evidence used is, once again, a similarity to numismatic portraits. For earlier proposals identifying the figure as a Roman, see Balty's note 2.

24 The year 88 B.C., when the army of Mithradates VI of Pontos sacked Delos and massacred many of its inhabitants, is probably a *terminus ante quem*. See the excellent discussion of the dates of the heads in Stewart, *Attika*, pp. 65–70, who argues that most of them date between 100 and 88 B.C. (in opposition to those who spread the dates out over the 1st century to as late as 40 B.C.)

25 R. Bianchi-Bandinelli, *Rome: The Center of Power* (New York 1970), p. 79.

26 The principal Virgilians were Lippold, Crome, and Carpenter (see bibliography in Richter, *Portraits*, p. 235).

27 The bust is in the J. Paul Getty Museum in Malibu, California. See Ashmole, *AJA* 17 (1973) 61.

Chapter 4 The sculpture of Pergamon

1 Pliny, *NH* 34.51 dates the sculptor to the 121st Olympiad (295–292 B.C.). This was perhaps the date of his birth rather than his *floruit*. Phyromachos's image of Asklepios at Pergamon is mentioned by Diodoros 31.46 and by Polybios 32.15.

2 The Delos base: *IG* XI.4.1212; Loewy, *IgB* no. 118. The dedication to Athena: *IvP* nos. 132–4.

3 Telesilla: Tatian, *c. Graecos* 52 (Overbeck, *SQ* no. 917). Alcibiades: Pliny, *NH* 34.88. Hansen, *Attalids*, p. 300 suggests a connection between the Delian portraits (*IG* XI.4.1206–8) and figures of Alkippe (sister of the hero Kaikos) and Demaratus, an early king of Teuthrania, by Nikeratos. For the references on this complex question see *Attalids*, pp. 290 and 300.

4 *IG* XI.3.313a, line 33; Pliny, *NH* 33.156; Athenaios 782B.

5 *JdI* 8 (1893) 131–4.

6 For the references: Schober, *JdI* 53 (1938) 131. See also Hansen, *Attalids*, p. 302.

7 Schober, *RömMitt* 51 (1936) 104–24.

8 See E. Künzl, *Die Kelten des Epigonos von Pergamon* (Würzburg 1971), pp. 18–22.

9 Künzl, *Kelten*, p. 22.

10 Künzl, *Kelten*, pp. 23–30.

11 R. Wenning, *Die Galateranatheme Attalos I* (Berlin 1978), pp. 5–11, 17–18.

12 H. Brunn, 'I doni di Attalo,' *Annali dell' istituto de corrispondenza archeologica* 42 (1870) 292–323.

13 For a concise review, with references: Hansen, *Attalids*, pp. 306–10.

14 Among German scholars the later date has become virtually orthodox (e.g. Lippold, Krahmer, Horn, Schober, Kähler, Wenning). English speaking scholars have tended to favor the earlier date (e.g. Carpenter, Bieber, M. Robertson, A. F. Stewart). See the excellent review of this question by Stewart, *Attika*, pp. 19–23.

15 G. Lippold, *Kopien und Umbildungen griechischer Statuen* (Munich 1923), pp. 111–13; A. Schober, *Kunst von Pergamon* (Vienna 1951), pp. 121–32.

16 P. R. Bienkowski, *Die Darstellungen der Gallier in der Hellenistischen Kunst* (Vienna 1908), pp. 66–78.

17 The possibilities are reviewed and criticized by Schober, 'Zur Amazonengruppe des attalischen Weihgeschenckes,' *ÖJh* 28 (1933) 102–11, esp. 109–11.

18 For my own satisfaction I have sometimes conjured up an arrangement in which the victors were placed on top of the wall of the acropolis and the vanquished *outside* the wall on the south slope of the acropolis above the theater. The illusion created would then have been that the forces of barbarism had attempted to storm the Acropolis, as the Amazons had done in legend and the Persians in fact, and that the victors had repelled them. Such a theatrical setting would have made an effective adjunct to the theater. I must admit, however, that if this was indeed the arrangement, it is surprising that Pausanias did not comment on it.

19 The inscription is: *IG* XI.4.1105.

20 *IG* XI.4.1110.

21 First proposed as Pergamene group by P. Wolters, 'Kriegerstatue aus Delos,' *AthMitt* 15 (1890) 188–98. See also Bieber, *SHA*, p. 108. For the more recent view: J. Marcadé, *Au Musée de Délos* (Paris 1969), pp. 364–5.

22 A somewhat later date, i.e. 166 B.C. after Eumenes' defeat of the Gauls, has been proposed by P. Callaghan, 'On the Date of the Great Altar of Pergamon,' *University of London, Bulletin of the Institute of Classical Studies* 28 (1981) 115–21. This proposal is based on the date assigned to fragments of pottery found beneath the Altar (and thus providing a *terminus post quem*). That the date of these sherds, which is based principally on parallels between their decorative motifs and those on certain Pergamene coins, can be fixed with such precision seems to me doubtful. It also seems doubtful to me that the Altar project could have been planned, organized, and executed in the five or six year period that Callaghan allows. Callaghan's suggestion is, however, possible, and the article, which contains interesting speculations on the historical significance of the Altar, deserves serious consideration.

23 A second frieze, telling the story of the Pergamene hero Telephos, ran around the inside of the Ionic colonnade. Its character and significance are discussed in Chap. 9 in connection with pictorial narration.

24 For example, the Dexileos stele in the Kerameikos Museum in Athens (G. M. A. Richter, *A Handbook of Greek Art* (6th edn, London and New York 1969), fig. 217) or slab 1022 from the Mausoleum of Halikarnassos (B. Ashmole, *Architect and Sculptor in Classical Greece* (New York 1972), fig. 191).

25 For this and subsequent references see the bibliography.

26 E. Simon, *Pergamon und Hesiod* (Mainz 1975), pp. 56–7.

27 For perspective on this question see Simon, *op. cit.*, pp. 41–5 and the review of Simon by Evelyn Harrison, *AJA* 82 (1978) 567–8.

28 For example, see F. Vian, *Répertoire des gigantomachies figurées dans l'art grec et romain* (Paris 1951), p. 87, no. 400, pl. XLVIII (an early-4th-century lekythos in Berlin).

29 *IvP* nos. 70–84. For analysis see D. Thimme, 'The Makers of the Pergamon Gigantomachy,' *AJA* 50 (1946) 345–57.

30 On the possibility of a group of Muses at Pergamon see Schober, *Kunst von Pergamon*, p. 109.

Chapter 5 Hellenistic baroque

1 Heinrich Wölfflin, *Principles of Art History*, Eng. trans. by M. D. Hottinger (New York and London 1932), pp. 73–123.

2 Niketas Choniates, *On the Statues of Constantinople* 5. The text is given in F. P. Johnson, *Lysippos* (Durham, N.C. 1927), pp. 286–7.

3 Chamber Tomb I on the Via Umbria. The most complete

discussion is by J. C. Carter, *AJA* 74 (1970) 125–37. The monument is referred to as Tomb 24 in Carter's *The Sculpture of Taras* (*Transactions of the American Philosophical Society*, vol. 65, part 7, Philadelphia 1975).

4 In the major publication of the relief by W. H. Schuchhardt, 'Relief mit Pferd und Negerknaben im National-Museum in Athen N.M. 4464,' *Antike Plastik* 17 (1978) 75–97, it is dated to the 2nd century B.C. Cornelius Vermeule, 'The Horse and Groom Relief in Athens,' *Studies Presented to Sterling Dow* (Durham, N.C. 1984) 297–300, has recently proposed that the relief is a 'riderless horse' funereal monument set up in honor of the Athenian military leader Leosthenes who died during the Athenian siege of Lamia in 322 B.C. He points out cogent stylistic similarities between the relief and late Attic grave stelai, particularly that of Aristonautes.

I prefer to associate the monument with the Macedonian domination of Athens in the late 4th and early 3rd centuries B.C., i.e. with the hegemony of Demetrios Poliorcetes or shortly thereafter. A Macedonian helmet, it is to be noted, is painted in the area above the horse's hindquarters. Whether the relief is funereal or not is open to debate. It may be, but even if it is, the usual argument that it must date to before 317 B.C., when Demetrios of Phaleron's sumptuary laws outlawed expensive grave monuments, does not seem binding in this case. It is doubtful that the retinue of Demetrios Poliorcetes or the agents of Antigonos Gonatas would have felt bound by the law of 317.

5 See Kraay–Hirmer, *Greek Coins*, fig. 574; E. T. Newell, *Coinages of Demetrius Poliorcetes* (Oxford 1927; Chicago 1978), no. 23.

6 On the inscription and letter forms: Thiersch, *GöttNachr* (1931) 337–78. On the ship's prow base: C. Blinkenberg, *Lindos, Fouilles de l'acropole* II; *Inscriptions* (Berlin–Copenhagen 1941), no. 88, pp. 302–14.

7 The name arises from the fact that a torso of the figure of Menelaos outside the Palazzo Braschi in Rome came to be associated with a (probably) imaginary tailor whose barbed political criticisms, in verse, were posted near the statue in the 16th century. On the post-Classical history of the statue see F. Haskell, N. Penny, *Taste and the Antique* (New Haven and London 1981), pp. 291–6.

The best preserved copies are the restored group in the Loggia dei Lanzi in Florence and a head in the Vatican. The condition of the copies is reviewed by Schweitzer, *Die Antike* 14 (1938) 43–72.

8 Among those arguing for a later date on the basis of composition and details of surface: E. Künzl, *Frühhellenistische Gruppen* (Cologne 1968), pp. 148–55 (later 2nd century B.C.); Schober, *JdI* 53 (1938) 143–5 (2nd century); V. Müller, 'A Chronology of Greek Sculpture 400 B.C. to 40 B.C.,' *Art Bulletin* 20 (1938) 359–418, esp. p. 402 (155–145 B.C.); H. Walter, 'Zur spälthellenistischen Plastik,' *AthMitt* 76 (1961) 153 (1st century B.C.). Schweitzer's date has recently been defended by A. Nitsche, *ArchAnz* (1981) 76–85 using evidence provided by representations of the group on Etruscan gems.

9 Specifically Schweitzer cited the leopard and the snaky-tailed bird on the helmet as symbols of Libya and Ethiopia, regions to which Menelaos was destined to wander after his departure from Troy.

10 The group is reconstructed from a copy of the Marsyas in the Vatican and from several partial copies of the Athena in Rome, Frankfurt, Dresden and elsewhere. On the basis of Pliny, *NH* 34.57 the original is often ascribed to the early Classical sculptor Myron and hence dated to *ca.* 450 B.C. A date later in the 5th century is also possible. For references see B. S. Ridgway. *The Severe Style in Greek Sculpture* (Princeton 1970), pp. 85 and 91.

11 Two series of replicas of the Marsyas type are recognized, an older or 'white' group, represented by the torso in Istanbul, and a younger or 'red' group, represented by the red marble replica in the Palazzo dei Conservatori in Rome. The former is thought to copy the original group and the latter is thought to be a late Hellenistic variant which accentuates the pathos of the figure. See bibliography.

12 *AvP* VII, pp. 128–9, no. 111, Pl. XXVI; A. Schober, *Strena Buliciana* (Zagreb 1924), pp. 31–4 and *Die Kunst von Pergamon* (Vienna 1951), pp. 73–4, Pl. 35.

13 That the head represents a literary figure is made virtually certain by its pairing on a double herm in the Villa Albani with the Menander type. For a review of the many suggestions about the identity of the pseudo-Seneca see Richter, *Portraits*, pp. 58–66.

14 F. Zevi, 'Tre iscrizioni con firme di artisti greci,' *Atti della Pontificia Accademia Romana di Archeologia, Rendiconti* 42 (1969–70) 95–116, esp. 110–14; G. M. A. Richter, 'New Signatures of Greek Sculptors,' *AJA* (1971) 434–5.

15 On the exact findspot: C. C. Van Essen, 'La découverte du Laocoon,' *Mededelingen der Koninklijke Nederlandse Akademie van Wetenschappen, AFD. Letterkunde*, N.R. XVIII, 12 (1955) 291–305.

16 Pliny also seems to say that the work was carved from a single block ('ex uno lapide . . . fecere summi artifices'), which is not the case (it is made from seven blocks) unless he means that it is made from one kind of stone (essentially true, except for a portion of the base). It is, of course, possible that the surviving work is not the one that Pliny saw, but it is more likely that Pliny simply did not notice the finely finished work's seams, which would only have been noticeable from the back.

17 G. M. A. Richter, *Three Critical Periods in Greek Sculpture* (Oxford 1951), pp. 66–70.

18 A sensation enhanced by the fact that in the early days of the excavation the leg of the Polyphemos was for a time identified as a fragment of a colossal version of the Laokoön. The story is nicely told by G. Säflund, *The Polyphemos and Scylla Groups at Sperlonga* (Stockholm 1972), pp. 9–11.

19 Andreae, in *Antike Plastik* XIV, pp. 90–5. Andreae bases his interpretation on Ovid, *Metamorphoses* 13 where Odysseus argues that he and not Ajax carried Achilles off the field at Troy.

20 On the grottoes at Rhodes see H. Lauter, 'Kunst und Landschaft – Ein Beitrag zum Rhodischen Hellenismus,' *Antike Kunst* 15 (1972) 49–59.

21 Pliny, *NH* 36.14 describes the discovery of the Luna quarries as 'recent,' even from the perspective of his own time (i.e. the 70s A.C.). For the literary sources, with commentary, see O. Vessberg, *Studien zur Kunstgeschichte der römischen Republik* (Lund 1941), pp. 62–5. For the archaeological evidence: L. Banti, 'Antiche lavorazione nelle cave Lunensi,' *Studi Etruschi* 5 (1931) 475–97, esp. p. 487; Marion E. Blake, *Ancient Roman Construction in Italy from the Prehistoric Period to Augustus* (Washington 1947), p. 53. Specifically on the Laokoön: B. Andreae in *Gnomon* 39 (1967) 87–8.

22 *ArchAnz* 84 (1969) 256–75.

23 Blanckenhagen, review of *Antike Plastik* XIV in *AJA* 80 (1976) 103.

Chapter 6 Rococo, realism, and the exotic

1 Described by Lucian, *Herodotus sive Aëtion* 4. The general character of Aëtion's painting seems to be echoed by the *putti* in many Pompeiian paintings, most notably those from the House of the Vettii. See Curtius, *Wandmalerei Pompejis*, pp. 123–43.

2 Bieber, *SHA*, p. 147.

3 For the Herculaneum painting: Curtius, *Wandmalerei Pompejis*, fig. 9; K. Schefold, *Pompejanische Malerei* (Basel 1952), Taf. 46.

4 Klein, *Rokoko*, pp. 62–3.

5 See, for example, E. Buschor, *Die Plastik der Griechen* (Berlin 1936), p. 100; R. Horn, *RömMitt* 52 (1937) 157; H. Kähler, *Der grosse Fries von Pergamon* (Berlin 1948), p. 171; R. Lullies and M. Hirmer, *Greek Sculpture* (revised edn, New York 1960), no. 248, pp. 99–100; L. Alscher, *Griechische Plastik* IV; *Hellenismus* (Berlin 1957), p. 58. Carpenter, *Greek Sculpture*, p. 221, agrees with the late Hellenistic date.

6 For the Delos portrait base and the base from Rhodes: J. Marcadé, *Recueil des signatures de sculpteurs grecs* II (Paris 1957), no. 28.

7 The interpretation of the figure is based on the facts that he crowns himself with a wreath, a symbol of victory in competition, and leans on a herm, a symbol of the institution of the gymnasium with its various contests.

8 *NH* 35.155; also 34.84. Pliny is speaking of *caelatura* = τορευτική. Boethos was admired for decorative metal work (goblets, etc.) as well as for sculpture.

9 *NH* 34.84 'infans ... anserem strangulat.' The word or words between *infans* and *anserem* are distorted in the manuscripts, which read *sex anno* or *sex annis* or *exime* or *eximiae*. These readings are grammatically impossible but the original idea may have been that the child was six years old or that the work was 'outstanding.' Traube restores *amplexando*, i.e. 'strangles the goose by embracing it.'

10 Rumpf, *ÖJh* 39 (1952) 86–9. Rumpf identifies three sculptors named Boethos. Laurenzi, *EAA*, s.v. 'Boethos', identifies five.

11 Compounding the problem is the fact that Pausanias 5.17.4 mentions a gilt statue of a youth by 'Boethos of Carchedon' (Carthage). It seems likely that Carchedon is a mistake for 'Calchedon,' but some have taken Pausanias's reference to indicate an altogether different sculptor, 'Boethos of Carthage' (e.g. T. B. L. Webster, *The Art of Greece: Age of Hellenism* (New York 1966), p. 76).

12 Lucian, *Herodotus sive Aëtion* 4; Pliny, *NH* 35–78. It is possible, however, that Lucian's Aëtion is a later artist.

13 Pliny, *NH* 36.32 mentions a drunken old woman, *anus ebria*, by Myron at Smyrna. Pliny is quite clearly ascribing the work to the famous sculptor of the mid-5th century B.C., Myron of Eleutherai. Many scholars have assumed that Pliny is mistaken and that the sculptor of this figure was a Hellenistic artist named Myron of Thebes, whose signature, it is proposed, occurs on an inscription from Pergamon (*IvP* no. 136: ΜΥΡΩΝ ΘΗΒΑΙΟΣ). The Pergamene inscription, however, is probably a label, not a signature, for a work of

the 5th-century Myron that was acquired by the Attalids. Eleutherai, Myron's home city, was on the border of Boeotia, of which Thebes was the principal city. In preparing labels for their collection the Attalids probably decided to give Myron a well-known ethnic, comparable to 'Athenian' on a label for a work of Praxiteles (*IvP* no. 137). A Hellenistic Myron of Thebes probably never existed. On the Attalid sculpture collection see *infra*, Chap. 8, p. 166.

14 H. P. Laubscher, *Fischer und Landleute* (Mainz 1982), pp. 49–58. For references to the differing views of modern critics (Picard, Richter, et al.) see Laubscher, pp. 5–6, esp. p. 6, note 14. On the early interpretation of the 'Seneca type' see F. Haskell, N. Penny, *Taste and the Antique* (New Haven and London 1981), pp. 303–5.

15 The most thorough and recent analysis of the chronology of the putative originals and of the copies is that of Laubscher, *Fischer und Landleute*, pp. 12–40. See also Lippold, *Gr. Plastik*, pp. 331 and 378; N. Himmelmann, *Über Hirten-Genre in der antiken Kunst* (*Abhandlungen der rheinisch-westfälischen Akademie der Wissenschaften* 65, Opladen 1980), pp. 83–99.

16 G. M. A. Richter, *Catalogue of Greek Sculptures in the Metropolitan Museum of Art* (Cambridge, Mass. 1954), p. 111, suggests that it may be an original because it is 'so fresh and fluid in execution.' Also accepted as an original by Lippold, *Gr. Plastik*, p. 378; Brunn–Bruckmann, no. 370; and, tentatively, by Laubscher, p. 35.

17 The probability of a Roman date is suggested by Brunilde Ridgway, *Fifth-Century Styles in Greek Sculpture* (Princeton 1981), p. 234. In her view it is the realism of the figures, rather than a bucolic quality, that makes them seem Roman.

18 Laubscher, *Fischer und Landleute*, pp. 88–9, suggests the possibility that figures of this type were set up in public parks (for the existence of which there is some evidence) in large Hellenistic cities. Regardless of where they were set up, however, the question of their meaning and function remains.

19 I am grateful to Faye Hirsch for stimulating my thinking on this question. Other possibilities are reviewed by Laubscher, *Fischer und Landleute*, pp. 85–96.

20 Among the ancient Greeks an aristocratic contempt for peasants on the one hand, and a wistful nostalgia for the rustic world in which peasants live on the other were not thought of as contradictory. Laubscher, *Fischer und Landleute*, p. 96, elaborates on this point.

21 Proposed by Rhys Carpenter, 'Apollonios Nestoros,' *MAAR* 6 (1927) 133–6; refuted by M. Guarducci, *ASAtene* 37/38 (1959–60) 361–5.

22 The torso, which has been in the Belvedere of the Vatican since the early 16th century, is perhaps more memorable for its influence on later European art (see Haskell and Penny, *Taste and the Antique*, pp. 311–14) than for its significance in its own time. Because it is represented as seated on a panther skin, it may represent Marsyas or a satyr. The identification of it as Herakles, favored in earlier centuries, is less likely but not impossible. Apollonios's signature is of the sort common among copyists, and it may be that the work is a replica, or at least a variant, of a Hellenistic baroque creation of the 3rd or 2nd century B.C. Bieber, *SHA*, p. 179, sees a classicizing trait, characteristic of the 1st century B.C., in the smooth, veinless surface of the torso, but apparently nothing of its original surface is preserved (G. Daltrop, *The*

Vatican Collections, The Papacy and its Art (New York
1982), p. 64).

23 Phyllis Williams (Lehmann), 'Amykos and the Dioskouroi,'
 AJA 49 (1945) 330–47.

24 E.g. the House of Lucretius Fronto: Curtius, *Wandmalerei
 Pompejis*, fig. 171; K. Schefold, *La peinture pompéienne*
 (Brussels 1972), pl. LVI. Sarcophagi: F. Matz, *Die Dionysis-
 chen Sarkophage* (Berlin 1968–69), esp. Part II, nos. 95–141
 and Part III, nos. 237–45.

25 Tatian, *Orat. ad Graec.* 53 (Overbeck, *SQ* no. 917). Tatian
 gives the name as Glaukippe.

26 See Bieber, *SHA*, Fig. 624.

Chapter 7 Rome as a center of Hellenistic art

1 In addition to Plutarch, Polybios 30.10.2 and Livy 45.27.7
 mention the monument. They describe it as consisting of
 several columns, but the archaeological evidence confirms
 Plutarch.

2 As suggested by H. Kähler, *Der Fries vom Reiterdenkmal
 des Aemilius Paullus in Delphi* (Berlin 1965), p. 10, abb. 2.
 The exact measurements of the upper plinth are 1.25 m ×
 2.45 m.

3 Because of the damaged state of the figures it is not obvious
 in all cases which of them represents a Roman and which a
 Macedonian. Some Romans are clearly identifiable by their
 long quadrangular or oval shields (the *scutum*). The
 Macedonians carry round shields with characteristic surface
 decorations. Other distinctions can be made on the basis of
 helmets, swords, and body armor. The clearest delineation of
 the differences is given by Kähler, *Der Fries vom Reiter-
 denkmal*, pp. 34–5.

4 Kähler, *Der Fries vom Reiterdenkmal*, p. 18.

5 See the articles by E. B. Harrison and E. Pemberton, *AJA* 76
 (1972) 353–78 and 303–10.

6 Velleius Paterculus 1.11.2–5. The Porticus Metelli was
 replaced in the time of Augustus by the Porticus Octaviae.
 The two temples, and also the Granikos Monument,
 remained within the Augustan portico.

7 For further details on the controversy: J. Pollitt, 'The Impact
 of Greek Art on Rome,' *TAPA* 108 (1978) 155–74.

8 On Damasippos in general: Cicero, *Att.* 12.29.33; on his
 bankruptcy: Horace, *Sat.* 2.3.16 and 2.3.64.

9 The sources are catalogued in *TAPA* 108 (1978) 170–4.

10 Reconstructing the genealogy of this family of sculptors is a
 controversial matter. For different interpretations see
 Becatti, *RivIstArch* 7 (1940) 18; J. Marcadé, *Recueil des
 signatures des sculpteurs grecs* II (Paris 1957), p. 131;
 Stewart, *Attika*, pp. 42–6. See also Chap. 8, p. 174 and note
 12.

11 The style of the cult image of Venus Genetrix is not known
 for certain and has long been a matter for speculation. Some
 scholars have suggested that Arkesilaos's image may have
 been an adaptation of a graceful sculptural type, known in
 many Roman variants, which is thought to have been a
 creation of the late 5th century B.C. and is often associated
 with the Athenian sculptor Kallimachos. The type is usually
 conventionally referred to as the 'Venus Genetrix type'
 because it seems to be represented on a group of Hadrianic
 coins which bear the inscription 'Venus Genetrix.' On the
 sculptural type, see W. Klein, *Praxiteles* (Leipzig 1898), pp.
 53–63, with an extensive list of replicas and representations
 (Klein ascribed the original to Alkamenes); Werner Fuchs,

'Zum Aphrodite Typus Louvre–Neapel und seiner neuattis-
chen Vorbilder,' in *Neue Beiträge zur klassischen Alter-
tumswissenschaft* (Festschrift Bernhard Schweitzer, Stutt-
gart 1954), pp. 206–7, with further references; G. Gullini,
'Kallimachos,' *ArchCl* 5 (1953) 133–62. On the coins, see
Gullini, p. 139, and H. Mattingly, E. A. Sydenham, *The
Roman Imperial Coinage* II (London 1926), pp. 372, 387,
477–9, Pl. XIV, no. 287.

If the Venus Genetrix type is connected with Arkesilaos's
cult image, the image was apparently more in the neoclassi-
cal tradition of the late Hellenistic period (see Chap. 8) than
in the rococo tradition, and given the eclectic nature of the
art of the time, it is quite possible that Arkesilaos worked in
both styles. It should be noted, however, that the original
temple of Venus Genetrix was extensively restored by Trajan
(rededication in 113 A.C.), probably because it had been
destroyed by fire, and it may be that the image by Arkesilaos
did not survive into the 2nd century A.C. The Hadrianic coins
may therefore have no connection with it. For a thorough
study of the history of the temple of Venus Genetrix and a
valuable review of the facts and possibilities relating to the
statue by Arkesilaos, see Roger B. Ulrich, *The Temple of
Venus Genetrix in the Forum of Caesar in Rome: The
Topography, History, Architecture, and Sculptural Pro-
gram of the Monument* (Diss., Yale University 1984).

12 The title of the work is given variously as *Nobilia Opera* or
 Mirabilia Opera. On the significance of this work see Pollitt,
 The Ancient View of Greek Art (New Haven 1974), pp. 78–
 9. For the sources on Pasiteles: Overbeck, *SQ*, nos. 2167,
 2202, 2262–4; Pollitt, *Art of Greece, Sources* (Englewood
 Cliffs, N.J. 1965), pp. 206–7.

Chapter 8 Style and retrospection

1 For the other images described by Pausanias see Pollitt, *Art
 of Greece, Sources* (Englewood Cliffs, N.J. 1965), pp.
 204–6.

2 On the date of Damophon's career, which has recently, as a
 result of the proposals of Levy, become a matter of contro-
 versy, see: Dickens, *BSA* 12 (1906) 109–36; I. C. Thallon,
 'The Date of Damophon of Messene,' *AJA* 10 (1906) 302–
 28; W. B. Dinsmoor, 'An Archaeological Earthquake at
 Olympia,' *AJA* 45 (1941) 399–427; E. Levy, 'Sondages à
 Lykosoura et date de Damophon,' *BCH* 91 (1967) 518–45.
 On the basis of coins and other fragments found in the new
 soundings Levy at one time proposed a Hadrianic (i.e. 117–
 38 A.C.) date for the work of Damophon. It seems more
 probable, however, that the Hadrianic material attests a
 refurbishment of the temple, one of many examples of
 Hadrian's pious and nostalgic philhellenism. Levy's redating
 is essentially retracted in *BCH* 96 (1972) 986 and 1003.

3 Loewy, *IgB* nos. 223–9.

4 O. Walter, *ÖJh* 19/20 (1919) 1–14, and Lippold,
 Gr.Plastik, p. 274, date it 340–310 B.C.; M. Marziani, *EAA*
 s.v. 'Eukleides,' dates it *ca.* 250 B.C.; Becatti, *RivIstArch* 7
 (1940) 25–8, suggests the last decades of the 3rd century
 B.C.; Bieber, *SHA*, p. 158, and Karouzou, *Cat. Nat. Mus.* p.
 191, date it in the 2nd century B.C.

5 *IvP* nos. 135–44 (see Chap. 6, note 13).

6 For the inscriptions that document this line: Loewy, *IgB* nos.
 144, 230, 341. The bronze herm from Herculaneum is
 probably to be dated in the second half of the 1st century B.C.
 See H. Lauter, *Zur Chronologie römischer Kopien nach*

Originalen des V. Jh. (Bonn 1966), p. 48.

7 See Heinrich Brunn, *Geschichte der griechischen Künstler* I (Braunschweig 1853), p. 560.

8 See the analysis of Fuchs, *Vorbilder*, p. 15.

9 Vitruvius 4.1.10 gives the epithet as *katatechnos*, which could mean 'the artificial one,' but is most probably a mistake made either by Vitruvius or by a copyist in the manuscript tradition.

10 On the replicas see Fuchs, *Vorbilder*, pp. 108–18. The suggestion of A. Merlin and L. Poinssot, *Cratères et candélabres de marbre trouvés en mer près de Mahdia* (Tunis and Paris 1930), p. 61, endorsed by Deubner (*ArchAnz* (1939) 340) and by Fuchs, that the creator of the type was Boethos of Chalcedon (see p. 140) is worth considering.

11 On the meaning of Pliny's often discussed phrase *cessavit deinde ars ac . . . revixit* in this passage see Pollitt, *The Ancient View of Greek Art* (New Haven 1974), p. 27, with further references.

12 Exactly where the Apollo stood is not at all clear from the obscure and controversial wording of Pliny's text. Some scholars put a comma after the phrase *ipsam deam* in *NH* 36.35 and conclude that Timarchides made an image of Juno for the temple of Juno Regina, which was built by M. Aemilius Lepidus between 187 and 179 B.C. and later incorporated into the Porticus Metelli, and that Timarchides' sons Dionysios and Polykles made yet another image of Juno in the same temple for Metellus (see Stewart, *Attika*, p. 43); but this text is subject to many interpretations.

The following is probably a reasonable basic family tree for the line of Polykles:

(1) Polykles I (active *ca.* 156 B.C.; Pliny, *NH* 34.51)

(2) Timarchides I (3) Timokles (Neo-Attic sculptors; Pausanias 10.34.6–8)

(4) Dionysios (5) Polykles II (employed by Metellus)

(6) Timarchides II (signature recorded in *IG* II/III² 4302)

The statue of Gaius Ofellius on Delos (see p. 75), it will be remembered, was made by Dionysios the son of Timarchides and Timarchides the son of Polykles, but whether this pair was nos. 2 and 4 or 4 and 6 is not clear.

For the sources on the controversy about this genealogy see Chap. 7, note 10. Stewart, *Attika*, pp. 43–4, extends the genealogy of the family by using epigraphical sources and offers interesting proposals about the connection of these artists with Aetolia and the Romans. But it is not certain that the different Polykles whom he identifies in inscriptions are identical with artists mentioned in the literary sources (or that they were even artists at all).

13 Lucian, *Anacharsis* 7 is sometimes taken to be a reference to this work. See Bieber, *SHA*, p. 18, fig. 17.

14 The change from the Archaic style to the Early Classical style did not, obviously, take place in a single day, and particularly in certain outlying parts of the Greek world the Archaic style continued to be used well after 480 B.C. The 'lingering Archaic style,' as Ridgway aptly calls it (*The Archaic Style in Greek Sculpture* (Princeton 1977), pp. 317–18), should be distinguished from a genuinely 'archaistic' style, which

involves a conscious revival of Archaic forms in a milieu where the Archaic style was not the dominant one.

15 Almost certainly not to be connected with the famous Athenian sculptor of the late 5th century B.C., although this has been maintained by some writers, e.g. Richter, *SSG*⁴, p. 186 and E. Schmidt, *Archaistische Kunst in Griechenland und Rom* (Munich 1922), pp. 62–3. The latter interprets the relief as a conscious attempt to forge a work of Kallimachos in the Hellenistic period.

16 The tripod which held it presumably commemorated a victory in an Athenian theatrical contest. The figures were originally identified as Herakles, Dionysos, and a Maenad. Evelyn Harrison suggests, however, that the figure with the club may be Theseus and that the other two figures could be characters connected with Theseus in a drama (perhaps Aigeus and Medea). See *The Athenian Agora* XI: *Archaic and Archaistic Sculpture* (Princeton 1965), pp. 79–81.

17 Havelock, *AJA* 68 (1964) 48–51.

18 Full references are given in the bibliography. In the notes that follow the major sources will be cited by the author's name alone, except in cases where more than one work by the same author is involved.

19 For a review of other examples see Havelock, *AJA* 69 (1965) 333–4.

20 In Athens they also seem to have been used as votive objects to celebrate victories, perhaps because Hermes, as a protector of gates, was also thought of as a protector of the city. On the use of Athenian herms see Harrison, *The Athenian Agora* XI, pp. 108–17.

21 Harrison, *The Athenian Agora* XI, pp. 53, 98–107. It cannot be proved, of course, that these and other examples copy the image by Alkamenes, but the likelihood that they do is very great.

22 I leave aside, as does Evelyn Harrison, the distinction between 'archaistic' and 'archaizing' that is observed by some writers (the former referring to a thoroughgoing use of Archaic stylistic features and the latter indicating a selective incorporation of Archaic details in works that are primarily in another style). The distinction does not seem to me necessary, and as Harrison points out (p. 50), it is linguistically indefensible.

23 Havelock (1965) 335.

24 Harrison, p. 63.

25 His works were frequently copied in the Roman period, but there is no tradition of an 'Alkamenean Archaism' in the 5th and 4th centuries B.C.

26 E. Schmidt, *Archaistische Kunst*, pp. 70–91.

27 Havelock (1965), p. 332; Becatti, *RendPontAcc* (1941) 85–95.

28 On the four gods base: Havelock (1964), pp. 47–8; Harrison, pp. 55, 67, pl. 64a-d.

29 On the Epidauros base: Schmidt, pp. 28–30; Becatti, *Critica d'Arte* 6 (1941) 42; Hadzi, in *Temenos* (see below), p. 312, fig. 252. The strongest argument for keeping the Epidauros base in the 4th century B.C. is a fragment of a decree relief from the Athenian agora, datable to 321/320 B.C., which preserves the feet and lower part of the garment of an apparently Archaistic figure similar to that of the Epidauros base. See Harrison, no. 133 (pl. 31). So little of the agora relief survives, however, that it is difficult to make a conclusive judgment.

The frieze from Samothrace is connected with the Propylon to the Temenos, which is dated by its excavators to

350–330 B.C. See P. W. Lehmann, D. Spittle, et al., *Samothrace 5: The Temenos* (Princeton 1982). (The date is based primarily on the similarity of architectural details of the Propylon to other buildings of the 5th and 4th centuries and on the assumption that its architect was Skopas. See pp. 142–7. The evidence of the pottery found in the excavation is inconclusive and may even point to a later date.) The frieze is thoroughly published and discussed at length by M. L. Hadzi, pp. 172–220, 233–52, who defends the 4th-century date. Havelock (1964), p. 50, note 28 expresses doubt about the excavators' date. Her view is countered by P. W. Lehmann, *Skopas in Samothrace* (Northampton, Mass. 1974), p. 35, note 89.

30 See especially Bulle's list, *Archaisierende griechische Rundplastik* (Munich 1918), pp. 31–2; Becatti, *Critica d'Arte* 6 (1941) 32–48.

31 The Meleso statuette: Willers, *Zu den Anfängen der archaistischen Plastik in Griechenland* (Berlin 1975), Taf. 32.3. The agora oinochoe: Harrison, pl. 63b.

32 Bulle, no. 35; discussed by Harrison, pp. 57, 63; Willers, p. 60.

33 Harrison, pp. 74–5.

34 Illustrated in Richter, SSG⁴, figs. 557–9.

35 An Archaic prototype is postulated by A. Giuliano, *ArchCl* 5 (1953) 48–54.

36 L. Richardson, *AJA* 74 (1970) 202.

Chapter 9 Pictorial illusion and narration

1 Panel 1 seems to have depicted the Aeolian Islands (fragments of flying figures, probably winds, are preserved); panel 7 probably continued the Circe episode; panels 10 and 11 probably showed the episode of the Sirens (a more recently identified fragment seems to belong to one of these panels: see Vlad Borelli, *Bollettino d'Arte* 41 (1956) 289–300).

2 See *infra*, note 27.

3 See *infra*, note 29.

4 Etruscan and Lucanian tomb painting contribute something to our understanding of how color was used, particularly in the early 5th century, and a few monuments, described in this chapter, give hints as to how landscape was dealt with in late Archaic painting. In other respects, however, Italian tomb painting does not reflect the mainstream of Classical Greek painting.

5 The sources, and the problem about Agatharchos's exact date within the 5th century, are reviewed in Pollitt, *The Ancient View of Greek Art* (New Haven 1974), pp. 240–5.

6 Vincent J. Bruno, *Form and Color in Greek Painting* (New York 1977), pp. 25–6.

7 See Ph. Petsas, *O Taphos ton Leukadion* (Athens 1966), p. 179.

8 The east (rear) wall of the tomb depicts a seated woman or goddess; the south wall shows three seated women (the Fates?). These figures are less well preserved and not yet fully published, but it seems fair to say that they are less impressive and more conventional than the scene on the north wall.

9 This term was adopted from Wölfflin for use in ancient art by Otto Brendel in his review of M. Gabriel's *Masters of Campanian Painting* in *Art Bulletin* 36 (1954) 237. See also Bruno, *Form and Color*, p. 25.

10 Some have dated the relief to the 3rd century B.C., most notably Gisela Richter, who argued that the man depicted in the act of sacrifice was none other than King Euthydemos I of Bactria (*Portraits*, p. 278). Although there is some resemblance between this figure and the portrait in the Villa Albani that has been identified as Euthydemos [71], it is doubtful that the two represent the same person. The relief is of Pentelic marble and is probably Attic, although Bieber (*SHA*, p. 27) considers it Rhodian. In any case the likelihood that the king of Bactria would have commissioned this relatively modest monument in a (for him) far off minor sanctuary seems slight. For further references see the bibliography.

11 See A. Bruecker, 'Wann ist der Altar von Pergamon errichtet worden?' *ArchAnz* (1904) 218–24; Hansen, *Attalids*, pp. 247–8.

12 For example, the well-known cup by the Brygos Painter in the Louvre: P. Arias and M. Hirmer, *Greek Vase Painting* (New York 1961), fig. 139; J. Henle, *Greek Myths, A Vase Painter's Notebook* (Bloomington and London 1973), p. 146, figs. 71, 72.

13 For a general discussion of these types of narration see Weitzmann, *IRC*, pp. 12–33. He adopts the terms 'monoscenic' and 'simultaneous' for the types of narration described here, and 'cyclic method' for the more traditional term 'continuous narrative.'

14 Arias–Hirmer, *Greek Vases*, fig. 125.

15 For the sources and a review of the question see F. Brommer, *Der Parthenonfries* (Mainz 1977), pp. 147–9.

16 Hausmann, *Hellenistische Reliefbecher aus Attischen und böotischen Werkstätten* (Stuttgart 1959), pp. 45–51.

17 Another bowl in Berlin, on which the inscriptions are less well preserved, depicts an even more varied series of scenes illustrating *Odyssey* 22.310–77. Here the figure of Odysseus appears three times. See: Hausmann, *Hellenistische Reliefbecher*, p. 54, no. 18; Weitzmann, *IRC*, fig. 7; Courby, *Les Vases grecs à relief* (Paris 1922), p. 290, no. 17; Robert, *Homerische Becher* (Berliner Winckelmannsprogramm 50, Berlin 1890), p. 14, fig. B.

18 The example in the Museo Capitolino known as the 'Bilderchronik' must date from at least as late as the 1st century because its inscription details events up to the time of Tiberius. See O. Jahn, *Griechische Bilderchroniken* (Bonn 1873), pp. 8–9, 77–8, Taf. 6 (L). Sadurska, *Les tables Iliaques* (Warsaw 1964), pp. 16–17 dates the majority of the tablets between 50 B.C. and 50 A.C., but assigns one related monument, the Tabula Albani, to as late as the Antonine period (no. 19, see p. 94).

19 Weitzmann, *IRC*, p. 40.

20 The various opinions are conveniently reviewed in Weitzmann's addenda to *IRC*, pp. 225–9.

21 *Hellenistische Reliefbecher*, pp. 19–22, 41.

22 Weitzmann, *IRC*, p. 129 doubts the existence of a continuous running frieze but does not altogether rule it out. The case for a running background is made by T. Birt, *Die Buchrolle in der Kunst* (Leipzig 1907), pp. 269–315; P. G. Hamberg, *Studies in Roman Imperial Art* (Copenhagen 1945), pp. 129–30; H. Bober, review of Weitzmann, *Art Bulletin* 30 (1948) 284–8.

23 Cassiano Dal Pozzo. The drawings, in the Royal Library, Windsor Castle, are now thoroughly published by H. Whitehouse, *The Dal Pozzo Copies of the Palestrina Mosaic* (Oxford 1976).

24 The unrestored areas of the mosaic seem to be identifiable by the presence of cement, with pulverized terracotta mixed into it, between the tesserae.

25 *RömMitt* 70 (1963) 100–46.

26 *Ibid.*, p. 129.

27 Gallina, Nogara, Vlad Borelli (see bibliography, Chap. 9 (1)).

28 R. Bianchi Bandinelli, *Storicità dell'arte classica* (Florence 1950; 3rd edn, Bari 1973), pp. 318–19; G. E. Rizzo, *La Pittura ellenistico-romana* (Milan 1929), p. 75; A. Rumpf, 'Classical and Post-Classical Greek Painting,' *JHS* 67 (1947) 10–21, esp. p. 20.

29 Purely Roman creation: H. Diepolder, 'Untersuchungen zur Komposition der römisch-campanischen Wandgemälde,' *RömMitt* 41 (1926) 1–78, esp. pp. 11 and 77. Principally a Roman creation but synthesizing aspects of the Greek tradition: H. G. Beyen, *Die pompejanische Wanddekoration* (The Hague 1960), pp. 274, 312–15, 327; K. Schefold, *Pompejanische Malerei, Sinn und Ideengeschichte* (Basel 1960), pp. 84–5 and somewhat more tentatively in *La Peinture pompéienne* (Brussels 1972), p. 14; and C. Dawson, *Romano-Campanian Landscape Painting* (*Yale Classical Studies* IX, New Haven 1944).

30 I take the word *antiqui*, which Vitruvius uses to describe these painters, to mean 'old fashioned' or 'old time artists,' i.e. artists of the Romano-Campanian Second Style (*ca.* 100–20 B.C.), the style which Vitruvius compares favorably with the ornate, fantastic Third Style that was just coming into vogue in his own time.

31 Likewise, as Leslie Baier has pointed out to me, the concentration on the Laestrygonian episode need not imply that the Odyssey landscapes have been excerpted from a much more extensive cycle. The Laestrygonian episode is one of the most detailed descriptions of a topographical setting in the narrative of Odysseus's wanderings (*Od.* 10.80–102), and since these paintings are essentially a form of literary illustration, it was perhaps quite natural for the artists to devote particular attention to this story.

Chapter 10 Hellenistic mosaics

1 A complete catalogue up to *ca.* 1980 appears in Salzmann, *Kieselmosaiken*, pp. 81–127.

2 See Pliny, *NH* 35.67; V. J. Bruno, *Form and Color in Greek Painting* (New York 1977), pp. 31–40.

3 See Salzmann, *Kieselmosaiken*, pp. 59–75. Dunabin, *AJA* 83 (1979) 265–77 gives an excellent analysis of the various techniques but doubts that they can be placed in a sequential development.

4 Athenaios 206D. See Phillips, *Art Bulletin* 42 (1960) 242–62, with a review of earlier literature on the theory in note 8, p. 245. Salzmann, *Kieselmosaiken*, p. 61 and P. Bruneau, 'Le sens de ΑΒΑΚΙΣΚΟΙ (Athénée V, 207C) et l'invention de l'opus tessellatum,' *Revue des études grecques* 80 (1967) 325–30 dispute the theory by arguing, among other points, that ἀβακίσκος does not necessarily mean *tessera*.

5 Proposed by Martin Robertson, *JHS* 85 (1965) 88.

6 The exact spot in Alexandria where this mosaic was found is not recorded. Its right border was mended with tesserae at some later time, presumably after it suffered damage.

7 See Robertson, *JHS* 85 (1965) 88. A later date is proposed by Blanche Brown, *PPM*, pp. 77–82. She also dates the pebble mosaic to the 1st century B.C. and takes both it and the Erotes mosaic to be neoclassical works.

8 Salzmann, *Kieselmosaiken*, pp. 75–7.

9 Robertson, *JHS* 85 (1965) 82–3; Salzmann, *Kieselmosaiken*, pp. 14–20. The 4th-century painter Pausias was particularly renowned for his flower paintings (Pliny, *NH* 35.125).

10 See Lucian, *Zeuxis* 3. See Pollitt, *Art of Greece, Sources* (Englewood Cliffs, N.J. 1965), pp. 156–8.

11 The mosaic was discovered in 1964 in the 'House of the Jewels' (northern section of the town adjacent to the House of the Diadoumenos). It dates from *ca.* 125 B.C. See P. Bruneau, J. Ducat, *Guide de Délos* (Paris 1966), pp. 65, 117: Bruneau, *EAD* XXIX, pp. 79–80.

12 Nonnos, *Dionysiaka* 21, lines 1–169. The complex literary tradition and the importance of the mosaic for this tradition are analyzed by Bruneau and Vatin in *BCH* (1966) 391–427.

13 Dolphin with anchor: Bruneau–Ducat, *Guide*, no. 121 (pl. 15.2); Bruneau, *EAD* XXIX, p. 72. Erotes and dolphins from the House of the Dolphins, signed by the mosaicist [Askle]piades of Arados (in Phoenicia): *Guide*, no. 111; *EAD* XXIX, pp. 234–9; Tritoness, from the House of the Tritons: *Guide*, no. 59; *EAD* XXIX, p. 82.

14 Proposed in *EAD* XIV, pp. 8, 41–2; criticized by Bruneau in *EAD* XXIX, pp. 106–7.

15 Bruneau, *EAD* XXIX, pp. 58–9 and 246–51; also T. B. L. Webster, *The Art of Greece: Age of Hellenism* (New York 1966), pp. 150–4.

16 'In that place' = Latin *ibi*. Whether the doves were part of the same mosaic pavement that depicted 'the unswept room' or whether *ibi* simply means that the mosaic was also at Pergamon, is unclear.

17 Delos: *Guide*, pl. 12.2; *EAD* XXIX, pl. A2. Pompeii: Pernice, *HKP*, Taf. 64–7. Malta: Pernice, *HKP*, Taf. 1.4.

18 The date of the Sophilos mosaic is based on its border motifs, particularly the crenellations and a perspective meander. These closely resemble the borders of the mosaic floor in the northwest room of Palace V at Pergamon. See the valuable analysis of Brown, *PPM*, pp. 70–3.

19 Pernice, *HKP*, pp. 149–65, Taf. 54–6.

20 Pernice, *HKP*, p. 159, Taf. 60.

21 These are the suggestions of T. B. L. Webster. See his excellent discussion of the mosaics in *Age of Hellenism*, pp. 129–30.

22 Of the other three, one is in the House of the Labyrinth and two are in the museum in Naples. See Pernice, *HKP*, p. 175, Taf. 75. The date of the group is based on the fact that the example in the House of the Labyrinth is integrated into a design which belongs to the Second Style of Pompeiian wall decoration. Pernice also likens the lighting on the architecture depicted in Naples 10017 (Taf. 75.1) to the borders of the Alexander mosaic (p. 176).

Chapter 11 Hellenistic architecture

1 The dominant terrace to the north of the Athena temple and the theater bore, in the 2nd century A.C., a temple to the deified emperor Trajan. Except for a small exedra dating from the time of Attalos II, the Hellenistic monuments of this terrace, if such there were, have not survived.

2 Vitruvius 7, praef. 16. Vitruvius calls them the architects of the 'temple of Apollo at Miletos,' which is taken by most scholars to be a reference to Didyma, since Didyma was under the control of, and considered part of, Miletos.

3 B. Fehr, *Marburger Winckelmann-Programm* (1971/72), pp. 14–59, proposes that the interior plan of the temple was influenced by Iranian palace architecture, which became familiar to Greek architects when the Middle East became

part of the Seleucid kingdom. See also H. Von Steuben, 'Seleukisische Kolossaltempel,' *Antike Welt* 12 (1981) 3–12. On the operation of the cult see Günther, *Das Orakel von Didyma in hellenistischer Zeit* (*Istanbuler Mitteilungen*, Beiheft 4, 1971), pp. 110–27.

4 The connection is suggested by Martin Robertson, *A Shorter History of Greek Art* (Cambridge 1981), p. 176. Buildings outside of Macedonia that have plausible associations with Macedonian architecture seem to confirm a Macedonian taste for façade architecture. See Stella Miller, 'Macedonian Tombs: Their Architecture and Architectural Decoration,' in B. Barr-Sharrar and E. N. Borza (eds.), *Macedonia and Greece in Late Classical and Early Hellenistic Times*, *Studies in the History of Art* x (Washington, D.C. 1982), pp. 153–71.

5 Vitruvius 7, praef. 12 cites Satyros and another architect whose name has become distorted in the manuscript tradition but may be read as 'Pytheos' as the architects of the Mausoleum. Pliny, *NH* 36.31 records that a marble chariot placed on the peak of the Mausoleum was sculptured by an artist named Pythis. It is usually assumed that this is also a reference to Pytheos and that he was a sculptor as well as an architect. On the sources and possibilities see H. Riemann in *RE* 24 (1963) s.v. 'Pytheos.'

6 See the clear statement of the problem in D. S. Robertson, *A Handbook of Greek and Roman Architecture* (Cambridge 1954), pp. 106–11, where it is described, in a manner that probably would have pleased Pytheos, as the 'worm in the Doric bud.'

7 Hermogenes has sometimes been dated to 200 B.C. on the basis of an inscription from Priene (*Inschriften von Priene*, no. 207) which has been thought to connect his name with a design for a temple and of an inscription from Pergamon (dealing with a settlement of differences between the citizens of Teos and the guild of Dionysiac artists who resided there, Dittenberger, *Syll.*³ no. 601, lines 563–6) of *ca.* 193 B.C. which has been thought to refer to Hermogenes' temple of Dionysos at Teos. In both cases, however, it is doubtful that the inscriptions really do relate to Hermogenes and his work, and other inscriptions make it probable that his work on the temple of Artemis at Magnesia on the Maeander took place *ca.* 150–130 B.C. The problem is thoroughly reviewed in Armin von Gerkan, *Der Altar des Artemis-Tempels in Magnesia am Mäander* (Berlin 1929), pp. 27–35. More recently, Pierre Gros, 'Le dossier Vitruvien d'Hermogénès,' *Mélanges de l'école française de Rome, antiquité* 90 (1978) 687–703 has defended an earlier date (late 3rd century to 175 B.C.). Also arguing for an earlier date: Walter Hahland, 'Der Fries des Dionysostempels in Teos,' *ÖJh* 38 (1950) 66–109 and Wolfram Hoepfner, 'Zum ionischen Kapitell bei Hermogenes und Vitruv,' *AthMitt* 83 (1968) 213–34, esp. p. 222.

Vitruvius's ambiguous phrase 'Magnesiae Hermogenis Alabandei et Apollonis a Menesthe facta' (3.2.6) has sometimes been taken to mean that Hermogenes was a native of Alabanda, but the phrase could also mean that the temple of Apollo built by Menesthes was in Alabanda. The inscription from Priene cited above has sometimes been taken to prove that Hermogenes was a native of that city, but this conclusion is also problematical.

8 This depends on who designed, and what date is assigned to, the Ionic temples at Sminthe in the Troad and Messa in Lesbos. They have sometimes been dated to the 3rd century

B.C. but may in fact be the work of Hermogenes. See W. B. Dinsmoor, *The Architecture of Ancient Greece* (London 1950), p. 272.

9 *The Architecture of Ancient Greece*, p. 273.

10 Substantial portions of the frieze, which was over 180 m long, are preserved in the Louvre and in Istanbul. Its subject is a humdrum, derivative, unimaginative Amazonomachy. See C. Humann, *Magnesia am Maeander* (Berlin 1904), pp. 84–9, 184, pls. v, xII–xIV; E. Herkenrath, *Der Fries des Artemisions von Magnesia* (Berlin 1902); and, most recently, Davesne, Alain, *La frise du temple d'Artemis à Magnésie du Méandre* (Paris 1982).

11 See G. Gruben, *Die Tempel der Griechen* (3rd edn, Munich 1980), pp. 364–72.

12 See A. Schott, 'Akanthus,' *ÖJh* 44 (1959) 54–79, esp. pp. 72–9 (with further references to W. Riezler, *Weissgrundige attische Lekythen*, Munich 1914); A. Fairbanks, *Athenian White Lekythoi* (*University of Michigan Studies*, Humanistic Series, vol. vII, New York and London 1914), pls. 27.2, 29, 31.2, 31.3.

13 See N. Leipen, *Athena Parthenos, A Reconstruction* (Royal Ontario Museum 1971), pp. 36–40, esp. 38, with further references.

14 *Art and Thought in the Hellenistic Age* (London 1979), pp. 72–9.

15 Vitruvius 7, praef. 15. Cossutius's name is preserved in inscriptions on an aqueduct dating from the time of Antiochos Epiphanes situated on the slope adjacent to Antioch. See *Antioch on the Orontes* 2, ed. R. Stillwell (Princeton 1938), 'Greek and Latin Inscriptions,' pp. 160–1, no. 90, and L. Jalabert, R. Mouterde, *Inscriptions grecques et latines de la Syrie* (Paris 1929–), no. 825. The fact that Cossutius was a Roman citizen does not necessarily mean that he was ethnically a Roman. He may have been a Greek from southern Italy. See J. M. C. Toynbee, 'Some Notes on Artists in the Roman World,' *Latomus* 8 (1949) 310.

Chapter 12 Alexandria and the Pharaoh

1 See notes 5 and 6 below.

2 The idea that 'lo sfumato delle forme' was a characteristic of Alexandrian sculpture was first promulgated by Walter Amelung, 'Dell' arte Alessandrino a proposito di due teste rinvenute in Roma,' *Bollettino della commissione archeologica communale di Roma* (1897) 110–42, esp. p. 138. Most of the works on the basis of which Amelung formed his judgment are not in Alexandria and cannot be proven to have come from there. Amelung's proposals are refined by A. Adriani, *Testimonianze e monumenti di scultura alessandrina* (*Documenti e ricerche d'arte alessandrina* II, Rome 1948), esp. pp. 14–19, pls. v–xI. See also Bieber, *SHA*, p. 89.

3 The two heads are said to have been found together and acquired simultaneously in Alexandria. Bieber, *SHA*, p. 90 suggests that they are from votive statues which copied the cult images of Ptolemy IV and Arsinoe III in the shrine of the royal family (the Sema) in Alexandria. The realism of the portraits, however, makes this doubtful. In general on these two heads see Kyrieleis, *Bildnisse*, pp. 44–5, 104.

4 The thick diadem and 'melon coiffure' of the head are paralleled on silver coins of Askalon and on a series from Antioch issued by Antony and Kleopatra in 37/36 B.C. See Kyrieleis, *Bildnisse*, p. 124, Taf. 107.

5 See I. Noshy, *The Arts in Ptolemaic Egypt* (London 1937), pp. 97–101; Bieber, *SHA*, pp. 95–7.

6 For a review of the question: Brown, *PPM*, pp. 1–2, 83–95; Pollitt, *Ancient View of Greek Art* (New Haven 1974), pp. 327–34.

7 Brown has identified four styles in the *loculus* slabs and funerary stelai: first, a style inspired by Attic art of the late 4th century; second, an elegant 'post-Praxitelean' style of the early 3rd century; third, a more dynamic and dramatic style of the later 3rd century, contemporary with the Attic Gallic monuments; and fourth, a popular, relatively artless style that co-existed with the others and lasted beyond them. See *PPM*, esp. pp. 45–51. Because the evidence for Brown's conclusions is so limited and in such poor condition, one hesitates to accept her stylistic edifice as indisputable fact, but it is certainly plausible.

8 For this type of horse on Kerch Style vases see A. Rumpf, *Malerei und Zeichnung* (*Handbuch der Archäologie* 4.1, Munich 1953), pl. 50.7. Note also the rearing horse just to the left of Darius's chariot in the Alexander Mosaic [2]. Examples of the draped female type which leads to the queens' vases and the Mustafa Pasha tomb can be seen in the Praxitelean base from Mantineia (Richter, *SSG*⁴, figs. 726–8), the 'Mourning Women Sarcophagus' in Istanbul (Lippold, *Gr. Plastik*, pl. 82; Picard, *Manuel* IV.2, p. 22, fig. 97) and in Tanagra figurines (G. Kleiner, *Tanagrafiguren* (Berlin 1942)); R. H. Higgins, *Greek Terracottas* (London 1967), pp. 97–8).

9 Adriani, *Annuaire du musée gréco-romain* (1933–35), pp. 173–4, argues for the late 3rd or early 2nd century on the basis of architectural details. Brown, *PPM*, pp. 55–6, argues for a date in the early 3rd century on the basis of the style of the paintings. The close parallel between the female figures in the Mustafa Pasha painting and the queen's vase from Xanthos [274b], which Thompson argues must be dated to 'at least as late as 240 B.C.,' suggests to me a date in the second half of the 3rd century B.C. (see *Ptolemaic Oinochoai and Portraits in Faience: Aspects of the Ruler Class* (*Oxford Monographs on Classical Archaeology*, Oxford 1973), pp. 150–1, no. 75).

10 C. C. Edgar, in M. G. Maspero, ed., *Le musée égyptien, Cairo* II (1906) 61. The view that many of the objects from the treasure are not of Egyptian origin has also been argued more recently by Herbert Hoffmann and Patricia Davidson, *Greek Gold, Jewelry from the Age of Alexander* (exhibition catalogue, Boston, Brooklyn, Richmond 1966), pp. 173–5. Alexandria, however, was a cosmopolitan city with a heterogeneous population, and it seems more probable that the objects were made there rather than in obscure areas of Persia or South Russia.

11 See, for example, related examples from Thmuis-Mendes illustrated in F. W. Von Bissing, *Catalogue général des antiquités égyptiennes du Musée du Caire, Metallgefässe* (Vienna 1901), pl. III, esp. no. 3584, and also the plaster casts from Mit Rahine (Memphis) which appear to have been made in the Roman period from Ptolemaic originals (see O. Rubensohn, *Hellenistisches Silbergerät in antiken Gipsabgüssen*, Berlin 1911).

12 See bibliography under Hausmann, Parlasca, and Rotroff.

13 The term 'Megarian' was used for these bowls by Otto Benndorf (*Griechische und sicilische Vasenbilder*, Berlin 1883) in 1883 because some of the earliest published examples were thought to have come from Megara. The term

has been retained for convenience and is used conventionally.

14 See S. I. Rotroff, *The Athenian Agora* XXII: *Hellenistic Pottery, Athenian and Imported Moldmade Bowls* (Princeton 1982), pp. 11–13.

15 This view is proposed by D. Harden, *Journal of Glass Studies* 10 (1968) 41 and seems preferable to 'gold-mounted,' proposed by M. L. Trowbridge, *Philological Studies in Ancient Glass* (*University of Illinois Studies in Language and Literature* XIII, nos. 3–4 (Urbana 1930), p. 154.

16 The Alexandrian origin is proposed by A. Adriani, 'Un vetro dorato alessandrino dal Caucaso,' *Bulletin de la société archéologique d'Alexandrie* 42 (1967) 105–27, and D. Harden, 'The Canosa Group of Hellenistic Glasses in the British Museum,' *Journal of Glass Studies* 10 (1968) 21–47; Axel von Saldern, 'Glass Finds at Gordion,' *Journal of Glass Studies* 1 (1959) 23–49, esp. 47–8. These scholars accept a date for gold-glass in the 3rd century B.C. The case for a later date (2nd century) is argued by Andrew Oliver, Jr, 'A Gold-Glass Fragment in the Metropolitan Museum of Art,' *Journal of Glass Studies* 11 (1969) 9–16.

17 A view of the vases bear inscriptions recording the regnal year of the Ptolemaic king who was on the throne when the person whose vase held died. These are usually held to extend from *ca.* 259 to 209 B.C., but the inscriptions do not, in fact, specify in which Ptolemy's reign the recorded regnal year falls, and hence some uncertainty exists about the dates of these as well as of the overall chronology. For varying views about the chronology see the studies of Brown, Guerrini, Cook, and Callaghan given in the bibliography, p. 300, Chapter 12, section e.

18 There are admittedly portions of Pharaonic Egyptian and Minoan paintings, and also of Etruscan tomb paintings, which, taken in isolation, have qualities of still-life painting, but these are parts of larger narrative complexes dominated by human or animal figures. The objects depicted on the Hadra vases are subjects in themselves.

19 Compare, for example, the Nereid on a gold and silver lid from Canosa, now in Taranto: Havelock, *HA*, no. 177.

20 The possibility that it dates from the period of the Roman Empire cannot be entirely ruled out, but even if this could be proved to be the case, one would have to say that its style and subject matter were of Hellenistic inspiration.

21 Other temples were constructed at Denderah, Esneh, and Philae. A general summary appears in Noshy, *Arts in Ptolemaic Egypt*, pp. 67–73.

22 The proposal of J. Six, 'Ein Porträt des Ptolemaios VI Philometor,' *AthMitt* 12 (1887) 212–22. Further references in Richter, *Portraits*, p. 266; Kyrieleis, *Bildnisse*, pp. 59–60, 174. The head is securely identified by a hieroglyphic inscription.

23 *Arts in Ptolemaic Egypt*, pp. 139–40.

Appendix I: The chronology of Hellenistic sculpture

1 For references see Richter, *SSG*⁴, p. 258.

2 These are the views of E. Künzl, *Frühhellenistische Gruppen* (Cologne 1968), pp. 77–81, 148–55.

3 See Robertson, *HGA*, pp. 457–9, pl. 146.

4 Thompson, *AJA* (1950) 371.

5 Künzl, *Frühhellenistischen Gruppen*, pp. 148–55.

Appendix II: The ruler cult and its imagery

1 See Tarn, *HC*, p. 47 (following W. S. Ferguson).

2 *CAH* VII (1928), p. 11.

3 For details and for the sources see Tarn, *Alexander the Great* II (Cambridge 1948), appendix 22.1, esp. pp. 356–7.

4 The facts that Alexander's formal deification was decreed for very practical reasons and that most Greeks viewed deification as a political institution do not necessarily contradict the suggestion that Alexander himself took the idea of his divinity seriously. Practicality and mysticism were always interwoven in his nature. Nor do they preclude the possibility, in fact, probability, that some non-Greeks, particularly Egyptians, to whom the divinity of the ruler was an age-old concept, accepted the king's divinity as an actual fact.

5 The use of the jugs is lucidly reconstructed by Dorothy Thompson, *Ptolemaic Oinochoai and Portraits in Faience, Aspects of the Ruler Cult* (Oxford 1973), pp. 118–19.

6 Ibid., pp. 104–5.

7 The written evidence suggests that these shrines were not only monuments in themselves to the character and achievements of different dynasties but also that they served as centers for the creation of much of Hellenistic royal imagery, particularly portraiture. In an inscription which records a public letter written by Antiochos II in 193 B.C., for example, the king announces the creation of a new corps of priestesses whose duty will be to carry out the worship of his wife Laodike and who 'will wear crowns of gold decorated with portraits of the queen' (*OGIS*, no. 224: C. B. Welles, *Royal Correspondence in the Hellenistic Age* (New Haven 1934), nos. 36–7). Portraits of one sort or another were essential for shrines of the ruler cult, and since these shrines existed not only in the great capital cities like Alexandria but also in virtually every modest-sized city within a particular Hellenistic kingdom, thousands of such portraits must have been produced.

8 A. Schober, *Die Kunst von Pergamon* (Vienna 1951), p. 118.

9 The identification was made by Winter, *AvP* VII, 144–7, no. 130. See also Laurenzi, *Ritratti*, no. 73; Richter, *Portraits*, pp. 273–4. The diadem indicates that the portrait represents a king. Philetairos and Eumenes I did not have the title of king; the features of Eumenes II are known; and the remaining Attalids would seem to be too late.

10 Winter, *loc. cit.* Hansen, *Attalids*, p. 351, gives a convenient summary of the issues.

11 Comparable in format, and smaller, is a shrine erected for Mithradates VI on Delos. See P. Bruneau, J. Ducat, *Guide de Délos* (Paris 1966), p. 140.

Appendix III: Aspects of royal patronage

1 At Antioch the dimension *ca.* 112 × 58 m; at Laodikeia 112 × 57 m. For the sources and commentary see G. Downey, *A History of Antioch in Syria from Seleucus to the Arab Conquest* (Princeton 1961), p. 70; J. Sauvaget, 'Plan de Laodicée-sur-mer,' *Bulletin d'études orientales* 4 (1934) 81–114.

2 Libanios, *Or.* 60.6.9–11. See G. Downey, *Ancient Antioch* (Princeton 1963), p. 43 and fig. 17.

3 See Tarn, *HC*, p. 159 for examples.

4 A number of sources connect Serapis in various ways with Alexander (see Fraser's discussion, *PA*, pp. 247–8), and the Alexander Romance (Pseudo-Kallisthenes 1.30–3) places special emphasis (see section 1 of this appendix) on the importance of Serapis in the founding of Alexandria. There is also the tradition that the cult of Serapis existed at Sinope before Ptolemaic times (see *infra*).

5 Eusebius II, pp. 119–20 (ed Schöne); Cyril, *Adv. Iulianum* I.13.

6 A base with the signature of a sculptor named Bryaxis has been found in Athens: Richter, *SSG*[4], figs. 770–1.

7 The case is made by John Stambaugh, *Sarapis under the Early Ptolemies* (London 1972), pp. 14–26. Stambaugh suggests that the Bryaxan image at Memphis showed the god standing, wearing a kalathos, and holding a cornucopia, like the silver statuette from Paramythia in Epirus, now in the British Museum. The statue in Alexandria, he feels, was seated, had a shorter beard, and lacked the kalathos, like the representations of Serapis on coins of Ptolemy IV and the image from Serapeion B at Delos. The Alexandrian image, he further proposes, was intended to show Serapis as a divine analogue of the Ptolemaic kings and was hence essentially political in character, while the Memphite image, being more closely associated with Osiris and Apis, was more chthonic.

8 See L. Cerfaux, J. Tondriau, *Le culte des souverains* (Tournai 1957), pp. 156–61, 192–3. A. D. Nock, 'Notes on the Ruler Cult,' *JHS* 48 (1928) 21–43, argues that the full development of the Neos Dionysos cult in Egypt was the work of Ptolemy II.

9 The group could also be a reference to Ptolemy's placing of a garrison in Corinth (Diodoros 20.37.2) in an attempt to preserve its independence in the face of encroachments by Antigonos and Kassander (309–308 B.C.), but this seems less probable.

10 Andrew Stewart, *Attika*, p. 8 suggests that the Nikeratos referred to by Pausanias was the Athenian who worked at Pergamon (see p. 84) and that his son Mikion was an Athenian émigré who moved to Syracuse when the Macedonian occupation of Athens made life difficult for Athenian sculptors.

11 The references are collected in Hansen, *Attalids*, pp. 284–98.

12 The phrase 'in costly materials' (ἐν διασκευαῖς πολυτελέσι) could refer to works of art of some sort or to scrolls.

13 Modern Uzuncaburç in southern Turkey. This temple was at one time dated to the reign of Seleukos I, which would make it the earliest Corinthian temple, but recent research makes a date in the time of Antiochos Epiphanes very probable. See Caroline Williams, 'The Corinthian Temple of Zeus Olbios at Uzuncaburç: A Reconsideration of its Date,' *AJA* 78 (1974) 405–14.

14 On the temple in Jerusalem: I Macc. 1.54. Pausanias 5.12.4 records that Antiochos dedicated an elaborate curtain woven with oriental designs in the temple of Zeus at Olympia, and Dinsmoor, *Architecture of Ancient Greece*, pp. 268–9, deduces from this that Antiochos probably subsidized the rebuilding of the whole temple. Dinsmoor also follows Fabricius, Wilhelm, and others in associating Antiochos's patronage with a building inscription from Lebadeia that relates to an unfinished temple (Dittenberger, *Syll.*[3], no. 972; A. Wilhelm, 'Bauinschrift aus Lebadeia,' *AthMitt* 22 (1897) 179–82). The evidence is, however, inconclusive and debatable. For further references and a sober review of Antiochos's activities in Greece, see O. Mørkholm, *Antiochos IV of Syria* (Copenhagen 1966), pp. 51–63.

15 The principal source is Malalas (Bonn ed.) 205.14–15; 234.2–3. See Downy, *History of Antioch*, pp. 99–102.

Appendix IV: Bactria and India

1 For the coins of Menander: N. Davis, C. Kraay, *The Hellenistic Kingdoms: Portrait Coins and History* (London 1973), figs. 162–7; for similar types: C. Seltman, *Greek Coins* (London 1955), pl. L.8; LI.1; LVIII.1–3.

2 A. K. Narain, *The Indo-Greeks* (Oxford 1957), p. 19, suggests, for example, that the Artemis on the coins of Diodotos I may be the Bactrian Anahita.

3 For convenience, I use here the dates proposed by Narain in *The Indo-Greeks*. They are deduced from very complex evidence and, as Narain acknowledges (p. 181), are approximate and often hypothetical.

4 Proposed by W. W. Tarn, *The Greeks in Bactria and India* (Cambridge 1951), pp. 75–6; questioned by Narain, *Indo-Greeks*, pp. 46–7.

5 Tarn, *loc. cit.*, felt that the smile on the portrait of Antimachos was echoed in the 'pedigree portrait' of Euthydemos on a coin issued by Euthydemos's grandson Agathokles and that this unusual smile indicated some relationship between Antimachos and Euthydemos. See figs. 2 and 4 on Tarn's plate of coin portraits.

6 Tarn, *Greeks in Bactria*, pp. 129–82; Narain, *Indo-Greeks*, pp. 28–45.

7 Narain, *Indo-Greeks*, pp. 51–2, speculates on the basis of a resemblance between their coin types that Demetrios II was a descendant of Antimachos I.

8 Tarn, *Greeks in Bactria*, pp. 196–202.

9 Seltman, *Greek Coins*, p. 235, argued that *Basileos Megalou* was simply a translation of the Indian *Maharajasa* and that the Greek therefore does not imply any unusual claim to greatness. It seems more likely, however, that the Karoshti is a translation of the Greek.

10 Tarn, *Greeks in Bactria*, pp. xx-xxi.

11 Narain, *Indo-Greeks*, p. 11.

Appendix V: The tomb at Belevi

1 For examples and references see G. Hanfmann, *From Croesus to Constantine* (Ann Arbor 1974), pp. 18–19.

2 The suggestion is that of J. Keil made in the original field reports for the excavations at Belevi: *ÖJh Beiblatt* 28 (1933) cols. 28–44, esp. col. 40; 29 (1934–35) cols. 103–51; 30 (1936–37) cols. 173–93. A 3rd-century date is endorsed by Hanfmann, *op. cit.*, p. 38; G. Kleiner, *Diadochen-Gräber* (Wiesbaden 1963), p. 83; E. Akurgal, *Ancient Civilizations and Ruins of Turkey* (Istanbul 1970), pp. 171 and 362.

3 C. Praschniker, 'Die Datierung des Mausoleums von Belevi,' *Anzeiger der österreichischer Akademie der Wissenschaften* 85 Jg. (1948) 271–93 (last third of 4th century B.C.). Keil, in an article in the same periodical in the following year (86 Jg. (1949) 51–61) renounced his earlier proposal about the date and followed Praschniker. F. Miltner, *Ephesos* (Vienna 1958), pp. 10–12, dates the tomb between the destruction of the temple of Artemis at Ephesos (356 B.C.) and the time of Lysimachos.

SOURCES OF ILLUSTRATIONS

DAI = Deutsches archäologisches Institut

1. Musei Vaticani, Archivo Fotografico
2. Alinari 12050
3. Arvanitopoulos, *Graptai Stelai Demetriados-Pagason*, pl. 2
4. Courtesy of the Trustees of the British Museum
5. Archaeological Museum, Istanbul
6. *The Search for Alexander*, fig. 155
7. Giraudon, Paris
8. Giraudon, Paris
9. *Jahrbuch der Berliner Museen* 3 (1961) fig. 1
10. Furtwängler, *Gemmen*, Pl. 32.11
11. Kunsthistorisches Museum, Vienna
12. *Bonner Jahrbücher* 171 (1971) p. 163, fig. 1
13a. Hirmer Fotoarchiv, Munich
13b. Museum of Fine Arts, Boston
14–15a-d. Hirmer Fotoarchiv, Munich
16. Archaeological Museum, Istanbul
17. Alinari 5972
18. Courtesy of the Trustees of the British Museum
19. Archaeological Museum, Istanbul
20a-b. Hirmer Fotoarchiv, Munich
21. Alinari 11229
22. DAI, Rome
23. Alinari 11050
24. Alinari–Anderson 23391
25. Staatliche Museen zu Berlin, Antiken Sammlung
26. Ny Carlsberg Glyptotek, Copenhagen
27a-c. Hirmer Fotoarchiv, Munich
28a-c. Hirmer Fotoarchiv, Munich
29. Giraudon, Paris
30. *AvP* VII, Beiblatt 25, fig. 168
31. Réunion des musées nationaux, Paris
32. Archaeological Museum, Istanbul
33. Archaeological Museum, Istanbul
34. Archaeological Museum, Pella
35. Ionian and Popular Bank of Greece
36. Alinari 23264
37. Archaeological Museum, Istanbul
38. Archaeological Museum, Istanbul
39. DAI, Rome
40. Réunion des musées nationaux, Paris
41. DAI, Rome
42. DAI, Rome
43. Alinari 35351
44. Kunsthistorisches Museum, Vienna
45. Alinari–Anderson 2034

46. Alinari–Anderson 1926
47. DAI, Rome
48. TAP Service, Athens
49. Alinari–Anderson 2090
50. DAI, Rome
51. Alinari–Anderson 1680
52. DAI, Rome
53. Ny Carlsberg Glyptotek, Copenhagen
54. DAI, Rome
55. Ny Carlsberg Glyptotek, Copenhagen
56. Yale University Art Gallery, photo by J. Szaszfai
57. Nasjonalgalleriet, Oslo
58. DAI, Rome
59. Fitzwilliam Museum, Cambridge
60. The Metropolitan Museum of Art, Rogers Fund, 1911 (11.90)
61. Giraudon, Paris
62. Soprintendenza archeologica per la Toscana, Florence
63. Courtesy of the Trustees of the British Museum
64. Ny Carlsberg Glyptotek, Copenhagen
65. DAI, Rome
66. Giraudon, Paris
67. The Metropolitan Museum of Art, Rogers Fund, 1910 (10.231.1)
68. Ravenna, Museo Nazionale, inv. n. 349 – Archivo Fotografico Soprintendenza per i Beni Ambientali e Architettonici di Ravenna, neg. n. 31380.
69. Alinari 11126
70. Giraudon, Paris
71. DAI, Rome
72. Alison Frantz
73. Wim Swaan
74. Alinari 6271
75. *EAD* XIII, pl. XXIII
76. *EAD* XIII, pl. XXI
77. *EAD* XIII, pl. XXVII
78. *EAD* XIII, fig. 13
79. Ny Carlsberg Glyptotek, Copenhagen
80. DAI, Rome
81. Alinari 1190
82. Courtesy, Museum of Fine Arts, Boston, Catharine Page Perkins Fund
83. Staatliche Museen zu Berlin
84. Alinari 6498
85. DAI, Rome
86. Alinari 6265
87a-c. DAI, Rome

88. Alinari 17376
89. Alinari 23119
90. Giraudon, Paris
91. Alinari 12906
92. Alinari 23121
93. DAI, Rome
94. Alinari–Anderson 23120
95. TAP Service, Athens
96. DAI, Athens
97. Bildarchiv Foto Marburg
98. Simon, *Pergamon und Hesiod*, Übersichtstafel
99–111. Staatliche Museen zu Berlin, Antiken Sammlung
112. Archaeological Museum, Istanbul
113. Staatliche Museen zu Berlin, Antiken Sammlung
114. *AJA* 74 (1970) pl. 28, fig. 3
115. *AJA* 74 (1970) pl. 27
116. TAP Service, Athens
117. Giraudon, Paris
118. Alinari 11148
119. *Abhandlungen der sächsischen Akademie der Wissenschaften, Phil.-Hist. Kl.* 43, nr. 4 (1936) Taf. 1
120. Schede, *Meisterwerke der türkischen Museen zu Konstantinopel*, Band 1, Taf. 17
121. Alinari–Brogi 3152
122. Courtesy, Museum of Fine Arts, Boston, H. L. Pierce Fund
123. Alinari 11244
124. DAI, Rome
125. *Antike Plastik* XIV, fig. 12 in text
126–130. DAI, Rome
131. Alinari–Anderson 1646
132. Alinari–Anderson 1696
133. Kunsthistorisches Museum, Vienna
134. Alinari 27194
135. The Metropolitan Museum of Art, Rogers Fund, 1943 (43.11.4)
136. Graeco-Roman Museum, Alexandria
137. Alinari 11123
138. TAP Service, Athens
139. Rodenwaldt, *Die Kunst der Antike, Hellas und Rom*, fig. 461
140. Brunn–Bruckmann, *Denkmäler*, 731
141. DAI, Rome
142. DAI, Rome
143. DAI, Rome
144. Alinari 22573
145. Alinari 5983
146. Photo Koppermann, Munich
147. Alinari 23771
148. Courtesy of the Trustees of the British Museum
149. DAI, Rome
150. Alinari 12049
151. DAI, Rome
152. The Metropolitan Museum of Art, Rogers Fund, 1909
153. Alinari–Anderson 1754
154. Photo Koppermann, Munich
155. Giraudon, Paris
156. DAI, Rome
157. Alinari 6275
158. Alinari 6667
159. Alison Frantz
160. Alinari 6273
161. Wuilleumier, *Trésor de Tarente*, pl. 1.1; 2.1; 2.2

162. Kähler, *Der Fries vom Reiterdenkmal des Aemilius Paullus in Delphi*, Frontispiece.
163. École française d'archéologie, Athens
164. Kähler (see no. 162), pl. 22
165. Alinari–Anderson 23372
166–170. TAP Service, Athens
171. Staatliche Museen zu Berlin, Antiken Sammlung
172. Giraudon, Paris
173. DAI, Rome
174. Alinari 29351
175. Hauser, *Die Neu-Attischen Reliefs*, pl. 11
176. Alinari 29352
177. Alinari–Anderson 2000
178. Giraudon, Paris
179. Alinari–Anderson 1691
180. Alinari–Anderson 23259
181. Giraudon, Paris
182. Courtesy of the Trustees of the British Museum
183. Brunn–Bruckmann, *Denkmäler*, 301
184. Alinari 6289
185. Giraudon, Paris
186. Alinari 11121
187. DAI, Rome
188. Agora Excavations, American School of Classical Studies, Athens
189. Alinari 34806
190. Courtesy of the Trustees of the British Museum
191. *AvP* VII, taf. IX
192. Giraudon, Paris
193. Alinari–Anderson 23152
194. Alinari–Brogi 5116
195–200. Alinari 38030–38034
201. A. Koudoura and Chr. Lephakis (courtesy Ph. Petsas)
202. Wim Swaan
203. A. Perissinotto
204. Courtesy of M. Andronikos
205. Andronikos, *The Royal Graves at Vergina*, fig. 6 and *The Finds from the Royal Tombs at Vergina*, pl. XLIa
206. DAI, Rome
207. Arvanitopoulos (see no. 3), pl. 3
208. The Metropolitan Museum of Art, Fletcher Fund, 1930 (30.11.4)
209. Alinari 39104
210. Photo Koppermann, Munich
211. Courtesy of the Trustees of the British Museum
212. Photo Koppermann, Munich
213. Rohde, *Pergamon, Bauberg und Altar*, taf. III
214a. Staatliche Museen zu Berlin, Antiken Sammlung
214b. Robert, *Homerische Becher*, p. 8, abb. A
215. Alinari 27113
216–220. Staatliche Museen zu Berlin, Antiken Sammlung
221. Alinari–Anderson 41156
222. Alinari 27288
223. Ionian and Popular Bank of Greece
224. Fototeca Unione, Rome
225. Archaeological Museum, Pella
226. Ionian and Popular Bank of Greece
227. École française d'archéologie, Athens
228. *EAD* XIV, pl. I
229. École française d'archéologie, Athens
230. École française d'archéologie, Athens
231. École française d'archéologie, Athens
232. Alinari 7258

233. Alinari–Anderson 24158
234. *AvP* V, pl. xv
235. DAI, Cairo
236a. Alinari–Anderson 25770
236b. Alinari–Anderson 25771
237. Alinari 12055
238. Alinari 12053
239. Pernice, *HKP*, pl. 54.1
240. Alinari–Anderson 25767–25769
241. Alinari 12057
242. Yale Classics Department, photo collection
243. DAI, Rome
244. Wim Swann
245. Blinkenberg, *Lindos* II, pp. 8–10
246. Herzog, Schazmann, *Kos* I, pl. 40
247. Hansen, *Attalids*, opp. p. 260
248. DAI, Rome
249. Hirmer Fotoarchiv, Munich
250. Berve, Gruben, *Greek Temples, Theaters, and Shrines*, p. 463, fig. 129
251. Hirmer Fotoarchiv, Munich
252. Photo by J. J. Pollitt
253. Conze, *Archäologische Untersuchungen auf Samothrake*, taf. 54
254. Conze, *ibid.*, taf. 55
255. Lehmann, *Samothrace* III, pl. CVI
256. *AthMitt* 76 (1961) taf. V
257. DAI, Istanbul (photo W. Schiele)
258. Schede, *Die Ruinen von Priene*, abb. 27
259. Schede, *ibid.*, abb. 33
260. Humann, *Magnesia am Maeander*, abb. 30
261. Humann, *ibid.*, abb. 32
262. Staatliche Museen zu Berlin, Antiken Sammlung
263. Bildarchiv Foto Marburg
264. Alison Frantz
265. Alison Frantz
266. *Bulletin, Société royale d'archéologie – Alexandrie* (1938) pl. VII
267. Alinari 35690
268. DAI, Cairo
269. *Bulletin* (see no. 266) pl. X

270–271. Courtesy, Museum of Fine Arts, Boston, H. L. Pierce Fund
272. Staatliche Museen für preussischer Kulturbesitz, Berlin, Antikenmuseum
273. *La Critica d'Arte* 6 (NS 1, 1941) Tav. X
274a. Courtesy of the Trustees of the British Museum
274b. M. Mellink
275–276. DAI, Cairo (Courtesy Günther Grimm)
277. Courtesy of the Trustees of the British Museum
278. The Metropolitan Museum of Art, Purchase, 1890 (90.3.60)
279. Alinari 19089
280. Hirmer Fotoarchiv, Munich
281. Lange, Hirmer, *Egypt*, pl. 259
282. Bevan, *A History of Egypt under the Ptolemaic Dynasty*, fig. 54
283. *ArchCl* 14 (1962) pl. 35
284. Réunion des musées nationaux, Paris
285. Museum of Fine Arts, Boston (Courtesy C. C. Vermeule)
286. Archaeological Museum, Istanbul
287. Staatliche Museen zu Berlin, Antiken Sammlung
288. TAP Service, Athens
289. DAI, Athens
290. TAP Service, Athens
291. Courtesy of the Trustees of the British Museum
292. The Metropolitan Museum of Art, Bequest of Walter C. Baker, 1971 (1972.118.95)
293 (a, d) Hirmer Fotoarchiv, Munich; (b, c) Kraay, Hirmer, *Greek Coins*, figs. 802 and 755
294. Classics Department, Yale University
295. Yale University Art Gallery (Courtesy S. B. Matheson)
296. Photo by J. J. Pollitt
297. Photo by J. J. Pollitt
298. Kleiner, *Die Ruinen von Milet*, abb. 53
299. (a, c) Museum of Fine Arts, Boston; (b, d) Yale University Library, Numismatics Collection (Courtesy John Burnham); (e) Seltman, *Greek Coins*, pl. LV.5; (f) Davis, Kraay, *The Hellenistic Kingdoms*, figs. 174–175
300. Austrian Archaeological Institute, Vienna (drawing E. Fossel)

INDEX

Abbreviations used in index: (A)=Architect, (P)=Painter, (S)=Sculptor, (R)=Representation of. Numbers in boldface indicate principal citation

Abdalonymos 38, 40, 45
Aboukir 263
Achaean League 10, 152, 153
Acheloos (R) 178
Achilles (R) 124, 130; Achilles and
 Penthesileia group 118
Acilius Glabrio 151
actors 7, 218, 227
Aemilius Paullus 45, 82, 151–2, 155, 160,
 162; monument of 155–8, 268
Aeneas (R) 203
Aeneid 121
Aeschines 62, 63
Aetion (P) 31, 141
Aetolia, Aetolian League 1, 150, 151, 152,
 155
Agatharchos (P) 187, 188
Agon of Boethos 140
Ai-Khanum 288
Aiakos (R) 190
Aigeira 166
Alba Fucens 51, 52
Alcibiades (portrait) 84
Alexander Balas 274
Alexander Mosaic 3, 21, 45–6, 148, 157,
 191–2, 212, 306 n.42
Alexander Sarcophagus 19, 38–45, 157,
 266, 290
Alexander Severus 28
Alexander the Great 1, 6, 11, 51, 53, 148,
 271; portrait from Pergamon 21, 29,
 110, 274; Azara herm portrait 21;
 coin portraits 25–8; funeral carriage
 of 19–20; painting of, by Aetion
 141; portrait as Zeus 23; portrait from
 Pella 21; portraits of (general) 3–4,
 20–31, 110, 156, 280
Alexandria: Anfushi cemetery 263; art of
 154, 250–9; decorative arts 204, 255–
 9; Erotes mosaic 130, 141, 212, 222;
 general 5, 9, 10, 16, 30, 143, 146,
 250; Library 13–14, 28, 109, 276;
 mosaics (general) 212, 222; Museum
 13, 28, 276; plan of city 275–7;
 procession in 148, 280–1; Sema 30,
 273, 274, 276; Serapeion 277, 279–
 80; tomb paintings 252–5
Alexandrian style 56, 251
Alexandris (ship) 281
Alkamenes (S) 180, 181–2

Alkippe (R) 148
Alkyoneus (R) 109
Amazonomachy 93, 215, 242
Ambracia 155
Ambrosia (R) 216
Amphion (R) 117
Amphitrite 105
Amyntas, King 289
Anacreon (portrait) 59, 60
anastole 21, 34, 36
Andreae, Bernhard 124
Andriskos 83, 152
Ankara 80
Antigonos Doson 3
Antigonos Gonatas 6, 7, 8, 34, 41, 80, 84
Antigonos of Karystos 9, 84, 118, 148
Antigonos Monophthalmos 45, 271
Antioch 5, 29, 277, 283, 284
Antiochos Grypos 274
Antiochos Hierax 80, 81, 85, 89
Antiochos I of Kommagene 274
Antiochos I of Syria 35, 79, 80, 274
Antiochos II of Syria 289
Antiochos III of Syria 81, 116, 151, 155,
 279, 285; portrait of 70, 71
Antiochos IV Epiphanes, of Syria 140, 151,
 248, 249, 279, 283–4
Antipater 63
Antiphilos (P) 31, 38, 161
Antisthenes (portrait) 84, 120
Antony (Marcus Antonius) 92
Anytos (R) 165
Anzio Girl 56, 268
Apameia: peace of 81; town plan 278
Apelles (P) 3, 22, 23, 29, 31, 32, 38, 45,
 46, 188, 255, 280
Aphrodite (R) 105, 261; by Doidalsas 56;
 with Pan 131, 139; Aphrodite of
 Melos 167
Apollo (R) 118, 119, 154, 161; by
 Bryaxis 277; by Timarchides 162,
 174
Apollodoros (P) 188
Apollodoros, author 107, 109, 242
Apollodoros of Phocaea (S) 270
Apollonios of Rhodes 9, 14, 16
Apollonios of Tyana 28
Apollonios, son of Archias 169
Apollonios, son of Nestor (S) 146
Apollonios and Tauriskos (S) 110, 118

Apollonis, Queen 83, 282
Apoxyomenos 48
Apuleius 8
Apulian pottery 154
Aratos of Sikyon 11, 107, 255
archaism 15, 175–84
Archelaos of Priene, relief by 16
Archimedes 153, 281
Ares 107
arete 20; personification of 280–1
Ariadne (R) 149
Aristarchos of Samos 14
Aristeas (S) 133
Aristeides (P) 45, 161; Dionysos by 83,
 158
Aristophanes (comic poet) 4
Aristophanes of Byzantium 14
Aristotle 3, 13, 53, 66, 190, 246–7
Aristoxenos of Tarentum 9
Arkesilaos (S) 163, 165, 173, 175
Arkesilaos, philosopher 79
Arktinos 122
Arrian 46, 148, 275, 276
Arsinoe II 9, 16, 274; portrait of 250,
 273
Arsinoe III 9, 16: portrait of 251
Artemis (R) 105, 154; archaistic statue
 from Pompeii 184; Artemis and
 Iphigeneia group 118
asarotos oikos 221–2
Asinius Pollio 163
Asteria (R) 105
ataraxia 8
Atargatis 8
Athena (R) 104, 122, 162, 165, 180; on
 coins 28; by Euboulides 161;
 Parthenos, from Pergamon 167, 235;
 by Pheidias 247
Athena Promachos 89, 183
Athenaios 3, 10, 49, 255, 260, 280, 283
Athenodoros (S) 121, 122, 126
Athens 6, 8, 52, 66, 81, 150; Acropolis
 59, 89; Agora 62; Attalid Dedication
 90–4, 112; Erechtheion 247;
 Kerameikos 69; Nike Temple 40,
 157, 169, 182; Olympieion 248, 284;
 Stoa of Attalos 281–2
Attalos I 80–1, 84, 85, 91, 95, 150;
 portrait of 34, 89, 274
Attalos II 82, 83, 91, 110, 158, 198, 282

Attalos III 83
Atticus, T. Pomponius 160
attributes 32
Augustus (portrait) 77
Ausonius 110
autarkeia 8
autobiography 9
Azara herm 21

Bactria 28, 71, 284–9
Baker Dancer 270
Baldry, H. C. 11
Barberini Faun 134, 149, 162, 268
Barberini mosaic *see* Praeneste, Nilotic
 mosaic
Barberini Togatus 76
baroque style 7, 10, 29, 111, 270
Bassae, temple of Apollo 181, 248
Bastet, F. L. 259
Beautiful head (Pergamon) 110
Becatti, Giovanni 180, 182
Belevi, tomb 247, 276, 289–90
Belvedere torso 146, 311 n.22
Berenike I 273
Bernini, Gianlorenzo 111, 134
Bieber, Margarete 127, 269
Bion of Borysthenes 6, 13, 146
Bithynia 71, 81, 82, 83, 97
Blanckenhagen, Peter von 126, 208
Boethos of Chalcedon (S) 128, 140–1, 269
Bolos of Mendes 148
book illustration 204–8
Borghese Faun 53
Borghese krater 163, 173, 175
Boscoreale 192
Boxer, Terme 13, 146, 268, 270
Boy and goose group *see under* Boethos of
 Chalcedon
Brown, Blanche 253
Brunn, Heinrich 86, 90
Bryaxis (S) 277, 278–80
Bulle, Heinrich 180, 183

Cameo, Gonzaga 24, 28
Cameo, Vienna 23–4
Caria 85
Carpenter, Rhys 58
Carthage 150, 153
Cato, M. Porcius 159, 160
centaurs (R) 133
Centuripe ware 192, 194–6
Chairestratos (S) 267, 269
Chamonard, J. 218
Charbonneaux, Jean 259
Chares of Lindos (S) 55
Cheiron (R) 130
children (R) 128
chronology, sculpture 265–71
Chrysippos (portrait) 69
Chrysostom, John 29
Cicero 47, 158, 159, 160; portrait of 75,
 77, 78
Circe (R) 185
Claudius, C. (Aedile) 160
Clement of Alexandria 279–80
Clodion, Claude Michel 127
coinage: Alexander 24–5; Ptolemaic 26–
 8, 273
coins, portraits on 25
comedy, representations of 216, 227

Conservatori girl 57, 268
Constantinople 49
Contorniates 29
Cori, Temple of Hercules 235
Corinth 152; image of 46, 280–1; sack
 of 83, 153, 158, 159
Corinthian bronzes 158
Corinthian order 247–9
cosmopolitan outlook 10–13, 142
Cossutius (A) 158, 248, 249, 284
Crassus 161
Crete 257
Cupid and Psyche group 127
Cybele 8
Cyclops group, Sperlonga 122–4
Cynics, cynicism 7, 8, 10, 11, 12, 146
Cyprus, battle of 114
Cyril of Alexandria 279

daimon 4
Daippos (S) 55
Damasippos 161
Damophon of Messene (S) 165, 167, 268
Daphne, suburb of Antioch 277, 279, 280,
 283
Daphnis (A) 236
Daphnis (R) 130
Darius III 3, 46
Deimos (R) 107
Deinokrates (A) 276
Delos: Attalid dedications 81, 85, 95, 282;
 general 130; House of the Masks
 216; mosaics 148, 215–18; portraits
 from 34, 58, 71–5, 76, 268; sculpture
 from 140
Delphi 19, 38, 49, 79, 83; Attalid
 dedications 282
Demeter (R) 165
Demetrias-Pagasai *see under* Volos
Demetrios I of Bactria 285
Demetrios I of Syria 72
Demetrios of Alopeke 64
Demetrios of Phaleron 2, 14, 54, 63
Demetrios Poliorcetes 6, 8, 45, 114, 271;
 portraits of 31–2, 55
Demetrios the Topographos (P) 207–8
Demosthenes (portrait) 62–3, 66, 70, 71,
 78, 266, 269
Despoina (R) 165
Didyma, temple of Apollo 236–8
Diodoros 12, 19, 86, 207
Diodotos I and II of Bactria 285
Diogenes (Cynic) 7, 11, 65
Diogenes Laertios 11, 52, 53, 79
Dion (Macedonia) 41
Dione (R) 105
Dionysios (S) 75, 162, 163, 174, 313 n.12
Dionysos 8; in Lesser Attalid Group 92–
 3; in mosaics (R) 216; infant (R)
 134, 172; painting of, by Aristeides 83,
 158; triumph of 28, 139, 148, 280;
 Dionysos and Poet relief 197
Dioscuri (R) 22, 106, 288
Dioskourides (mosaicist) 227–8
Dioskourides, statue of (Delos) 268
Dirke (R) 117, 118
Doidalsas (S) 57
Doryphoros of Polykleitos 47, 169, 175
Dura-Europos 3, 277, 278
dwarfs (R) 138

Edfu, temple of Horus 260
Egypt: Pharaonic 38, 59, 250, 259–63;
 Ptolemaic 17, 28, Chapter 12
Egyptian gods, cult of 8; *see also* Isis *and*
 Serapis
Elagabalus 28
Elateia 162
Electra (R) 175
elephant-scalp helmet 28
Engonasin (R) 107
Enkelados (R) 109
Enyo (R) 107
Eos (R) 104, 107, 110
Ephesos, temple of Artemis 22
Ephialtes (Giant) (R) 109
Epicurus (portrait) 10, 66–7, 162, 266;
 Epicureanism 8, 9, 10
Epidauros, temple of Asklepios 111
Epigenes 85, 89
Epigonos (S) 84, 85, 96, 133
Epirus 152
Eratosthenes 9, 11, 208
Eretria 155
Erinyes (R) 106
Eros (R) 130, 133, 134, 216, 256; sleeping,
 in New York 138; Enagonios 140
Erotes (R) 130, 139, 141, 212, 222
Erythrai 270
ethos 20, 66
Etruscan tomb painting 187, 192
Eubouleus type 30
Euboulides (S) 69, 165, 184, 268, 269
Eucheir (S) 165
Eudamos of Rhodes 116
Eukleides (S) 165–6
Eukratides, King 285
Eumenes I of Pergamon 79
Eumenes II of Pergamon 2, **81–3**, 84, 91,
 110, 151, 156, 198, 282, 283
Euphranor (S,P) 161
Eupompos (P) 47
Euripides (portrait) 67
Eusebios 279
Euthydemos I of Bactria 285; portrait of
 70, 71, 285
Euthykrates (S) 33, 38, 45, 55
Eutychides (S) 3, 55, 266, 277
exotic subjects 147–9

Fabius Maximus 49, 153, 154
Farnese Bull 110, 117–18
Ferguson, William Scott 271
fishermen (R) 141
Flamininus, T. Quinctius 150–1, 155
Furies *see* Erinyes
Furtwängler, Adolf 56, 180, 257–8

Galatai *see* Gauls
Galatia 82
Gallienus 28
Gallus, M. Fadius 161
Ganymede (R) 212
Gaugamela 46
Gaul: Chiaramonti 89; from Gizeh 251
Gauls: Attalid images of 45, 81, **83–97**,
 119; description of 86, 259; Dying
 Trumpeter, Pergamon 85, 86, 89, 90,
 91, 92; Gaul and wife group,
 Pergamon 13, 85, **86–9**, 92, 118, 146,
 268; history 79–81; painting of 45

gems, portrait 22–5
Giants (R) 91, 101, 102, 109, 122; satyrs and Giants group 131
Gilgamesh 26, 38
glass 256
Glykon of Athens (S) 50
Gnosis (mosaicist) 41, 210, 213
goose, geese, in sculpture 128, 140–1
Gordian III 28
Gordion 210
gorgoneion 259
Graces (R) 177
Granikos Monument *see* Lysippos
Granikos, battle of 46
Grimani reliefs, Vienna 196
Groom relief, Athens 112, 118, 310 n.4
grotesque figures 134

Hadra ware 256–7
Hagesandros (S) 121, 122, 125
Halikarnassos, Mausoleum 41, 276, 279, 290
Hannibal 81, 82, 150, 153
Harrison, Evelyn B. 180, 182, 183
Hauser, Friedrich 169, 172, 180
Hausmann, Ulrich 204
Havelock, Christine 180, 182
Hediste, stele of 4, 194
Hekate (R) 180, 182
Helen (R) 215
Heliodoros (S) 130
Heliokles, King 288
Helios (R) 29, 104, 105, 106, 110
Hellenistic Ruler, Terme 72–3
Hephaistion 40, 45
Herakleitos (mosaicist) 222
Herakleitos of Athmonon 45
Herakles: (R) 106, 130; Alexander and 20, 26, 28, 38, 271; on coins 25; Cynic concept of 52; Herakles Farnese *see* Lysippos; head of, from Pergamon 110; images by Lysippos 49–52; Herakles and Prometheus group at Pergamon 37
Herculaneum 130, 169, 183; equestrian statuette 43; Villa of the Papyri 33, 34, 71, 162
Hermaphrodite (R): sleeping type 149; *symplegma* 131, 149, 268
Hermarchos (portrait) 67–9, 266
Hermes 75; (R) 57, 172, 178, 188, 191; Propylaios 180, 181–2
Hermodoros (A) 158
Hermogenes (A) 240, 244–6, 316 n.7
Herodotos 12
Herondas 140
Hesiod 107, 109, 120; portrait of 162
Hieron II of Syracuse 153, 211, 222, 281
Hieronymos 152
Himerios 54
Hippodamos of Miletos 247
Historia Augusta 29
Holkham Hall 148
Homer (R) 16, 84, 119, 143
Homeric bowls 196, 200–2
Horai (R) 259
Horus (R) 259
Hypereides (portrait) 63

Iamboulos 12

Iliac tablets 202–3
Iliad 118, 203, 281
India 28, 284–9
individualism 7–10
Invitation to the dance group 131
Iphigeneia (R) 118
Isis 8, 197, 259, 273, 274, 276, 277
Isogonos (=Epigonos) 84
Issos, battle of 46

Jerusalem 284
Jockey, from Artemiseion 147

Kähler, Heinz 107, 157
Kaikos river 81, 85, 148
Kairos, by Lysippos 53
kalathos 274
Kallimachos (poet) 13, 14, 16, 148, 208, 242
Kallimachos (S), 5th century 172, 247
Kallimachos (S), Hellenistic 177, 182
Kallisthenes 271
Kallistratos 154
Kallixeinos 28, 46, 255, 260, 280–1
Kameiros, Rhodes 231
Karneades (portrait) 70
Kassander 13, 31, 41, 45, 46, 49, 63
Kassandreia 49
Kazanlak, tomb 190, 191
Kerch style 255
Keto (R) 105
Kinch Tomb 45
Klaros, temple of Apollo 237
Kleanthes, Stoic philosopher 9, 109; portrait of 67
Klein, Wilhelm 127, 128, 134, 140
Kleomenes of Sparta 13
Kleopatra, statue of, Delos 268, 270
Kleopatra II and III 260
Kleopatra VII (portrait) 251
Kleopatra Thea 274
Klytios (R) 109
Kom Ombo, temple 260
Kommagene 274–5
Kos: Asklepieion 29, 231, 282; coinage 28
Krahmer, Gerhard 37, 268–70
Krateros Monument *see* Lysippos
Krates (Cynic philosopher) 7, 11
Krates of Mallos 14, 101, 107, 120
Kresilas (S) 60
Künzl, Ernst 89
Kydias (P) 161
Kynoskephalai, battle of 150

Laestrygonians (R) 185
Lagina, temple of Hekate 268
Lagynos, Lagynophoria 9, 143, 144, 146
Laodikeia, Syria 278
Laokoön group 111, 120–2, 124, 125, 133, 134, 268
Lapiths and centaurs (R) 242
Laubscher, H. P. 143
Lebadeia 284
Lefkadia, Macedonian tomb 188–90, 191, 240
Leochares (S) 30, 38, 304 n.2
Libanios 277

Lindos, Rhodes 140; temple of Athena 230–1
lion-hunt motif 38
Livy 154, 155, 157, 159, 162, 283
Louvre-Freiburg relief 182
Lucian 31, 141
Lücken, G. von 107
Lucullus, L. 163
Lykon (philosopher) 79
Lykophron 14
Lykorgos (myth) 216
Lykosoura, sculptures from 165, 268
Lykourgos, Athenian statesman 53, 67
Lysander, monument of, Delphi 271
Lysikrates, Choregic monument of 274
Lysimache 64
Lysimachos 1, 26, 28, 32, 33, 36, 79
Lysippos 38, 41, 47–54, 111, 161; Apoxyomenos 48, 55, 268; Granikos Monument 7, 41–3, 49, 112, 157, 158, 290; Herakles Epitrapezios 50–1, 52; Herakles Farnese type 50–1, 73, 112, 146; Krateros Monument 38, 49; portrait of Agias 306 n.4; portrait of Alexander with lance 23; portrait of Aristotle 53; portrait of Socrates 52; portraits of Alexander 7, 20–3, 29, 49, 65–6, 70, 71; school of 3, 17, 33, 55–8, 290; statue of Eros 48; statue of Herakles at Tarentum 49, 51, 55, 111, 112, 154; statue of Kairos 53, 55, 58, 307 n.18; statue of Poseidon 31–2; statue of Zeus at Tarentum 49, 55

Macedonia 79, 150
Macedonian coins 25, 26
Macrianus, Titus 28
Maenads (neo-Attic) 170–2
Magnesia: battle of 81, 151; temple of Artemis 246, 268; temple of Zeus 246
Mahdia shipwreck 138, 139, 141, 173, 268
Marcellus, M. Claudius 153, 159, 160
Marsyas and Scythian (R) 118–19
Martial 51
Mausolos (portrait) 64
Megalopolis 284
Megarian bowls 200, 256
Melanthios (P) 255, 280
Meleager of Gadara 13
Menander (poet) 2, 4–6, 11, 150, 228; portrait of 77, 78, 265
Menander, King 285, 288
Menedemos of Eretria 84
Menekrates (S) 110, 113, 118
Menelaos (R) 118, 124
Menelaos (S) 175
Mentor (engraver) 161
Messene, relief from 38
Metellus, Q. Caecilius 43, 83, 152, 158, 162, 304 n.27
Methana 263
Metrodoros (portrait) 67–9
Metrodoros (P) 45, 155, 157, 158, 160, 162, 266
Michaelis, A. 84
Michelangelo 121
Mikion (S) 281
Miletos 28, 282; Bouleuterion 284
Minotaur (R) 228

Mithradates VI of Pontos 284; portraits of 35–7
Mnemosyne (R) 16, 165
Moirai (R) 107
Morgantina 212, 281
mosaics 130, 141, 148, **210–29**
Mummius, Lucius 83, 153, 158–9
Munich, votive relief in 197
Muses (R) 16, 165, 304 n.27
Mustafa Pasha tomb 253
Mykonos 95
Myonnesos 116
Myron 'of Thebes' 143, 144, 311 n.13
Myron (S), 5th century 161, 166, 175
mystery religions 8–9

Naoussa 45
Narain, A. K. 289
Nealkes (P) 148
Neisos gem 23, 30
Nemrud Dagh 274–5
neo-Attic style 164, 169–72
neoclassicism 15, 164–75
Neoptolemos (Macedonian) 45
Nereus (R) 105
Nero, Golden House of 120
New Comedy 4–6, 227
Nike (R) 31, 105, 169, 256
Nike of Paionios 19, 114
Nike of Samothrace 113–16, 268
Nikephoria, Pergamon 97
Nikeratos (S) 84, 95, 148, 281
Nikeso, statue of 56, 267
Nikestas Choniates 51
Nikomachos (P) 191
Nikon (artist) 154
Nile (R) 259
Nilotic scenes 148, 226
Niobid krater, Louvre 187
Nobilior, M. Fulvius 151, 155
Noshy, I. 263
nymphs (R) 105, 131, 172, 178
Nyx (R) 104, 108

Octavian (portraits) 77, 259
Odysseus (R) 122, 124, 185, 202
Odyssey 202
Odyssey landscapes 185–6, 208–9
Ofellius Ferus, C. 75, 163
oikoumene 7, 16
Okeanos (R) 105
Olba (Cilicia) 284
old men and women, images of, 142–3
Olympia, temple of Zeus 284
Olympias 23, 26, 271
Olympiodoros 63
Olympos (shepherd) 130
Olynthos 40, 210, 214
Onians, John 248
open composition 110, 268
opus vermiculatum 212
Orestes (R) 175
Orion (R) 106
Orontes river (R) 55
Osiris 259, 273, 281

Paestum, tomb of the Diver 187
Paionios (A) 236
Palladium, theft of (R) 122, 124
Pallas, from Herculaneum 183, 184

Pamphilos (P) 255
Pan (R) 130, 133, 162, 177
Panaitios 160
Panathenaic amphorae 28, 180
Papias (S) 133
paradoxographia 147
Parmenion 45
Parrhasios (P) 161, 210
Pasiteles (S) 163, 165, 175, 268
Pasquino group **118**, 124, 125, 146, 268, 269, 270
Patroklos (R) 118, 124
Pausanias 45, 50, 83, 90, 91, 162, 165, 172, 182, 187, 247, 281
Pausias (P) 210
Pella: mosaics 40–1, 210, 213–15; portrait of Alexander 21, 152
Penteteris (R) 280–1
Penthesileia (R) 118
Perdikkas 45
Pergamon: Attalid victory monuments 7, 9, 45, **83–97**, 102, 112, 133, 266, 268; Altar of Zeus 81, 82, 97, 120, 266, (Gigantomachy frieze) 7, 14, 91, **97–110**, 122, 131, 167, (Telephos frieze) 157, 196, 197, **198–200**, 204, 205; Athena Sanctuary 85, 89; city plan 233–5; Classical sculpture at 166; Dying Gaul and Wife group, Terme 13, 85, **86–9**, 118; Dying Trumpeter, Capitoline 85, 86, 89, 90, 91; figures of Persians 89, 90, 92; group of Mithradates VI 37; head of Alexander from 21, 29; history 17, 79–83; mosaics 221–2; round base on acropolis 89; Temenos of the Ruler Cult 29, 110, 235, 248, 274
Perikles (portrait) 59, 60
peronetris, peronema 143
Persephone (R) 108, 191
Perseus, King 1, 21, 82, 151, 152, 155, 194
Persian: art 256; dress 40
Persians, in Pergamene art 89, 90, 92
Pessinus 282
Peukestes (portrait) 55
Pfanner, Michael 107–8
Phaethon (R) 107
Phanis (S) 56
Pharnabazus 64
Pharnaces I of Pontos 82
Pheidias 22, 26, 49, 84, 155, 161, 162, 164, 165, 167, 247, 280
Philetairos 79; portrait of 33, 71, 81, 84, 95, 162
Philip 'the Arab' 28
Philip II of Macedonia 40
Philip V of Macedonia 21, 81, 150, 151, 155, 194, 282
Philiskos (S) 304 n.27
Philopoimen 83
Philostephanos of Cyrene 148
Philoxenos of Eretria (P) 31, 45, 46
Phobos (R) 107
Phyromachos (S) 84, 120
Picard, Charles 107
Piso, L. Calpurnius 162
Plato 12, 190; portrait of 53, 64
Plautus 227
Pliny (the Elder) 22, 33, 45, 46, 47, 50, 55, 56, 60, 69, 84, 85, 110, 118, 120, 121,

130, 140, 141, 148, 155, 158, 162, 163, 172, 173, 191, 205, 277, 279
Plutarch 3, 6, 7, 9, 10, 11, 12, 20, 21, 34, 46, 92, 93, 151, 152, 155, 156, 157, 159, 160, 183, 271, 276
Pluto (R) 191
Polemos (R) 23, 46, 107
Polybios 2, 12, 76, 82, 83, 91, 152, 153, 155, 160, 281, 283, 285
Polydoros (S) 121, 122, 126
Polyeuktos (S) 62, 63, 66, 71, 266, 269
Polygnotos (P) 161, 187
Polykleitos (S) 47, 73, 161, 169, 175
Polykles (S) 149, 162, 169, 173, 313 n.12
Pompeii: House of the Faun 3, 139, 141, 148, 223; House of the Vettii 22; mosaics 141, 222–8; painting *see* Romano-Campanian painting; Villa of Mysteries 192, 196
Pompey 148; portrait of 34
Ponos 52
Pontios (S) 172
Pontos 81, 97; coin portraits 71
Porphyrion (R) 109
portraiture 10, 20–37, 59–78
Poseidippos 53
Poseidon: on coins 31–2; Lateran type 31; Poseidon of Melos 30, 73, 174, 268, 269
Poseidonios 12; portrait of 70
pothos 29, 30, 52
Poulsen, F. 53
Praeneste: Nilotic mosaic 148, 196, 205–7; temple of Fortuna 235–6
Praxiteles (S) 2, 48, 154, 161, 162, 163, 166, 174
Priene: coins 28; sculpture from 30, 56, 267; temple of Athena 15, 243–4; town plan 246
Prometheus (R) 37
proplasmata 163
Protogenes (P) 31, 188
Prousias I of Bithynia 81
Prousias II of Bithynia 83, 151, 156
Pseudo-athlete, Delos 58, 72
Pseudo-Kallisthenes 276, 277
Pseudo-Seneca 84, 119–20, 143, 162
Psyche (R) 127
Ptolemy I 2, 14, 19, 26, 28, 31, 33, 46, 273, 279, 280
Ptolemy II 24, 34, 204, 255, 256, 257, 273, 280; portrait of 71, 162
Ptolemy III 11, 32, 255, 260, 277, 279, 281
Ptolemy IV 9, 16, 146, 260; portrait of 251
Ptolemy V 259
Ptolemy VI 207, 259, 260, 263, 274; portrait of 251
Ptolemy VIII 10, 259, 260
Ptolemy IX 260
Ptolemy X 259
Ptolemy XI 260
Ptolemy XII 260, 281
Puchstein, Otto 105, 106, 107
Pydna, battle of 17, 45, 82, 122, 151, 156, 157
Pylades (R) 175
Pyrgoteles (gem maker) 22, 23, 25, 35

Pyrrhos of Epirus 6, 112, 152, 153, 155; portrait of 305 n.29
Pytheos (A) 243, 247
Pythokritos of Rhodes (S) 114–16

Queens' vases 56, 267, 270, 273

Raphia, battle of 260, 273
realism 63, 141–7
Rhadymanthos (R) 190
Rhodes: colossos of 55; history 150, 151, 247, 281; mosaics 211
Richter, Gisela 122, 271
Robert, Carl 105, 106, 107
rococo style 31, 110, 127–41, 270
Roman portraits 75–7
Romano-Campanian painting 154, 186, 192, 208
Romans, role in Hellenistic history 11–12, 81–2, 83, 150–63
Rome: Ara Pacis 198; Atrium Libertatis 163; Baths of Caracalla 118; Capitoline 49, 154; Classical Greek art in 161; Forum of Augustus 22, 23; Forum of Caesar 163; Palatine 155; Porticus Metelli 158, 162, 163, 174; Porticus Octaviae 57, 130, 162, 304 n.27; *Saepta* 130; temple of Fortuna Virilis 158; theater of Pompey 148, 149
ruler cult 271–5

Salpion (S) 172
Salzmann, Dieter 212
Samothrace 113, 117, 152; Arsinoeion 238; Hieron 239; Propylon of Ptolemy II 248; Propylon to the Temenos 183, 313 n.29
Sardis 28, 79; temple of Artemis 239–40
satyrs (R) 105, 130, 131, 133
Schmidt, Eduard 180, 182
Schober, Arnold 89
scholarship, Hellenistic 13–15
Schreiber, Theodor 196
Schweitzer, Bernard 118
Scipio Aemilianus 151, 160
Scipio, L. 155, 162
Scipionic Circle 152, 160
Scylla (R) 122, 124
Scythian (R) 118
Sejanus 122
Selene (R) 105
Seleukeia 277
Seleukos I 1, 6, 8, 32, 45, 79, 274, 277
Seltman, Charles 26, 32
Seneca type *see under* fishermen
Serapis 8, 274, 276; image of, by Bryaxis 279–80
shepherds, sculptures of 141

Side (Cilicia) 116
Sidon 38, 40
Sikyon 28, 50, 53, 283
Sikyonian school of painting 255, 280–1
Silanion (S) 53, 64
Silenos (R) 172, 216
Simon, Erika 107
Sinope 82
Siwa, oracle of Zeus Ammon 26
Sjöqvist, Eric 53
skenographia 188
skiagraphia 191
Skopas (S) 161, 163
Socrates (portrait) 52
Sophilos (mosaicist) 222
Sophocles, portrait, Lateran type 22, 62, 67
Sosibios (S) 172
Sosikrates 95
Sosos (mosaicist) 221–2, 223
Sperlonga, sculptures in 122–6
Split, satyrs and snake group 133
Statius 51
Stephanos (S) 163, 175, 184, 268
Stesichoros 202, 203
Stoicism 9, 12, 13, 15, 16, 146
Strabo 154, 158, 276–7, 285
Stratonikos (silversmith) 84
Suetonius 28, 122
Sulla 75, 205
symplegma groups 130, 131, 139
Syracuse 153, 281
Syracusia see *Alexandris*

Tacitus 122, 279
Tarentine sculpture and painting 112, 154
Tarentum (Taras) 49, 51, 55, 112; treasure 154
Tarn, W. W. 11, 288
Tarquinia: tomb of Typhon 192; tomb paintings 187
Tatian 148
Tazza Farnese 24, 257–9
Tegea 284
Teisikrates (S) 33, 55
Telephos frieze *see* Pergamon, Altar of Zeus
Teles 6, 13, 146
Teos, temple of Dionysos 244
Terracina, temple of Jupiter 235
tesselated mosaics 211
Thasos 270
theater, imagery of 7, 216, 227, 281
Themis of Chairestratos 267, 269
Theokritos 143, 146, 196, 209, 259, 281
Theorrhetos (S) 110
Theseus (R) 215, 228
Thespiae 81
Thmuis, Egypt 222
Thompson, Dorothy 259, 273

Thrace 81
Thucydides 12
Tiberius 24, 28, 122
Timanthes (P) 161
Timarchides (S) 162, 163, 169, 174, 313 n.12
Timokles (S) 174
Tiryns, pebble mosaic 210
Tissaphernes 64
Titans 101, 107
Titus, Domus of 120, 121
Tivoli, Hadrian's Villa 133, 148, 222
Tolistoagii 81, 85
Torino, relief from 54
Touk-el-Qaramous 154, 155, 255–6
Tragedy (Tragoidia) (R) 110, 270
Triptolemos (R) 259
Triton (R) 105
Trumpeter, of Epigonos 85, 86, 91, 133
Tryphon 35
Tubicen *see* Trumpeter
Tyche 2, 3, 4, 6, 8, 9
Tyche of Antioch 3, 55, 56, 266, 277
Typhon 109
Tzetzes 277

Utopian ideas 13

Varro, Marcus Terentius 163
Velleius Paterculus 158
Venus de Milo *see* Aphrodite of Melos
Venus Genetrix 163, 312 n.11
Vergina, tombs and paintings 40, 111, 191–2, 210, 242
Verres, Gaius 158
Vindex, Novius 51
Virgil 121, 122, 126, 209
Vitruvius 158, 209, 216, 223, 240, 243, 244, 247, 276
Volos 4, 155, 192, 194

Weitzmann, Kurt 204
Wenning, Robert 89
Winnefeld, H. 107
Wölfflin, Heinrich 111

Xanthos, Lycia 273
Xenarios (A) 277
Xenokrates (S) 55

Zeno (Stoic) 9, 12; portrait of 69, 162
Zenodotos 14
Zethos (R) 117
Zeus 22, 283; (R) 16, 26, 35, 102, 104, 105, 110, 154, 161, 166, 275; Zeus Ammon 24, 26, 28, 32, 271; statue from Pergamon 30, 73, 268
Zeuxis (P) 161, 188, 210, 214